BEACHES OF THE TASMANIAN COAST & ISLANDS

A guide to their nature, characteristics, surf and safety

ANDREW D SHORT

Coastal Studies Unit
School of Geosciences
University of Sydney
Sydney NSW 2006

SYDNEY UNIVERSITY PRESS

COPYRIGHT © AUSTRALIAN BEACH SAFETY AND MANAGEMENT PROGRAM

Coastal Studies Unit and **Surf Life Saving Australia Ltd**
School of Geosciences F09 1 Notts Ave
University of Sydney Locked Bag. 2
Sydney NSW 2006 Bondi Beach NSW 2026

Short, Andrew D
 Beaches of the Tasmanian Coast and Islands 1-920898-12-3
 A guide to their nature, characteristics, surf and safety Published March 2006

Other books in this series by A D Short:
• *Beaches of the New South Wales Coast,* 1993 0-646-15055-3
• *Beaches of the Victorian Coast and Port Phillip Bay,* 1996 0-9586504-0-3
• *Beaches of the Queensland Coast: Cooktown to Coolangatta,* 2000 0-9586504-1-1
• *Beaches of the South Australian Coast and Kangaroo Island,* 2001 0-9586504-2-X
• *Beaches of the Western Australian Coast: Eucla to Roebuck Bay,* 2005 0-9586504-3-8

Forthcoming book:
 Beaches of the Northern Australian Coast: The Kimberley, Northern Territory and Cape York
 1-920898-16-6
 Beaches of the New South Wales Coast (2nd edition) 1-920898-15-8

Published by:
Sydney University Press
University of Sydney
sydney.edu.au/sup

Copies of all books in this series may be purchased online from Sydney University Press at:

http://purl.library.usyd.edu.au/sup/marine

Tasmanian beach database:
Inquiries about the Tasmanian beach database should be directed to Surf Life Saving Australia at
 sls.com.au

Cover photographs: West Sandy Point, North Coast.
Cover design: Jacqui Owen and David Sams

Table of Contents

To Professor J L (Jack) Davies, who from Tasmania discovered the Australian coast and inspired a
generation of coastal geomorphologists

Preface

This is the sixth and penultimate book in a series on the beaches of the Australian coast. They have all been produced by the Australian Beach Safety and Management Program (ABSMP), a collaborative project of the Coastal Studies Unit (CSU) University of Sydney and Surf Life Saving Australia (SLSA). The project has compiled a database on everyone of Australia 10 685 mainland beaches, together with 833 beaches on 30 inhabited islands. Descriptions of all these beaches are contained in the books.

The coast of Tasmanian ranges from readily accessible to virtually inaccessible in the southwest, resulting in a range of technique to obtain data on the states 1269 mainland beaches, as well as the 348 beaches of the five major islands (Maria, Bruny, Robbins-Walker, King and Flinders). Field investigations for this project commenced in 1990 when I spent a month inspecting the coast accompanied by my family. This was followed up with a second equally long investigation in 1996.

Oblique aerial photographs of the beaches were first taken of much of the coast in 1978, with a comprehensive flight to take digital image s on the entire mainland coast and all islands, except King, in 2003. Dr Werner Hennecke took part is this fight and many of his images are used in this book.

In compiling a book of this magnitude there will be errors and omissions, particularly with regard to the names of beaches, many of which have no official name, and many local factors. If you notice any errors or wish to comments on any aspects of the book please communicate them to the author at the Coastal Studies Unit, University of Sydney, Sydney NSW 2006, phone (02) 9351 3625, fax (02) 9351 3644, email: A.Short@geosci.usyd.edu.au or via Surf Life Saving Tasmania (03) 6272 7788 or Surf Life Saving Australia (02) 9130 7370. In this way we an update the beach database and ensure that future editions are more up to date and correct.

Andrew D Short
Narrabeen Beach, November 2005

Acknowledgments

The author has undertaken several trips to Tasmania the more recent involved directly in the project that resulted this book.

First of all, my wife and family accompanied me in the 1990 and 1996 field trips to Tasmania, always providing field assistance.

Dr Werner Hennecke who accompanied me on the 2003 aerial photography field has kindly permitted me to use many of his images from that flight. These are labelled in the book accordingly, all other images are by the author.

My former colleague Professor J L (Jack) Davies kindly donated his collection of vertical black and white vertical aerial photographs, which proven an invaluable resource in identifying the location and nature of all the beaches.

The project has received the financial support of the Australia Research Council through an ARC Grant (1990-92), ARC Collaborative Research Grant (1996-1998) and ARC SPIRT Grant (1999-2001), and through contract work for the Defence Science and Technology Organisation.

The project has been supported by Surf Life Saving Australia since its inception with CEO Greg Nance providing his full support and encouragement, while Katherine McLeod kept the database in order. The beach figures were expertly drafted by Cathi Greve and all other figures by Peter Johnson.

At Surf Life Saving Tasmania, initially Ken Knight and in more recent years Tony Van den Enden provided every assistance with local information.

At the University of Sydney Publishing Service thanks to Jacqui Owen and David Sams who designed the cover and to Josh Fry for tremendous assistance in getting the book ready for publication; while at the Sydney University Press Ross Coleman, Creagh Cole and Susan Murray-Smith all assisted in the production and marketing of this book.

Finally, as the entire beach database was complied and the book was written at my home office, I thank my wife Julia, and children Ben, Pip and Bonnie for putting up with its intrusion into our home life, as well as accompanying me to most parts of the Tasmanian coast.

Abstract

This book is about the entire Tasmanian coast, together with the coast of Maria, Bruny, Robbins-Walker, King and Flinders islands.

It begins with three chapters that provide a background to the physical nature and evolution of the Tasmanian coast and its beach systems. Chapter 1 covers the geological evolution of the coast and the role climate, wave, tides and wind in shaping the present coast and beaches. Chapter 2 presents in more detail the sixteen types of beach systems that occur around the Tasmanian coast, while chapter 3 discusses the types of beach hazards along the coast and the role of Surf Life Saving Tasmania in mitigating these hazards. Finally the long chapter 4 presents a description of every one of the 1269 mainland beaches, as well as 348 beaches on Maria, Bruny, Robbins-Walker, King and Flinders islands. The description of each beach covers its name, location, physical characteristics, access and facilities, with specific comments on its surf zone character and physical hazards, as well as its suitability for swimming, surfing and fishing. Based on the physical characteristics each beach is rated in terms of the level of beach hazards from the least hazardous rated 1 (safest) to the most hazardous 10 (least safe). The book contains 367 original figures which include 314 photographs, which illustrate all beach types, as well as beach maps and photographs of all beaches patrolled by surf lifesavers and many other popular beaches.

Keywords: beaches, surf zone, rip currents, beach hazards, beach safety, Tasmania

Australian Beach Safety and Management Program (ABSMP)

Awards

NSW Department of Sport, Recreation and Racing
Water Safety Award – Research 1989
Water Safety Award – Research 1991

Surf Life Saving Australia
Innovation Award 1993

International Life Saving
Commemorative Medal 1994

New Zealand Coastal Survey
In 1997 Surf Life Saving New Zealand adopted and modified the ABSMP in order to compile a similar database on New Zealand beaches.

Great Britain Beach Hazard Assessment
In 2002 the Royal National Lifeboat Institute adopted and modified the ABSMP in order to compile a similar database on the beaches of Great Britain.

Hawaiian Ocean Safety
In 2003 the Hawaiian Lifeguard Association adopted ABSMP as the basis for their Ocean Safety survey and hazard assessment of all Hawaiian beaches.

Handbook on Drowning: Prevention Rescue Treatment, 2006
This handbook was product of the World Congress on Drowning held in Amsterdam in 2002. The handbook endorses the ABSMP approach to assessing beach hazards as the international standard.

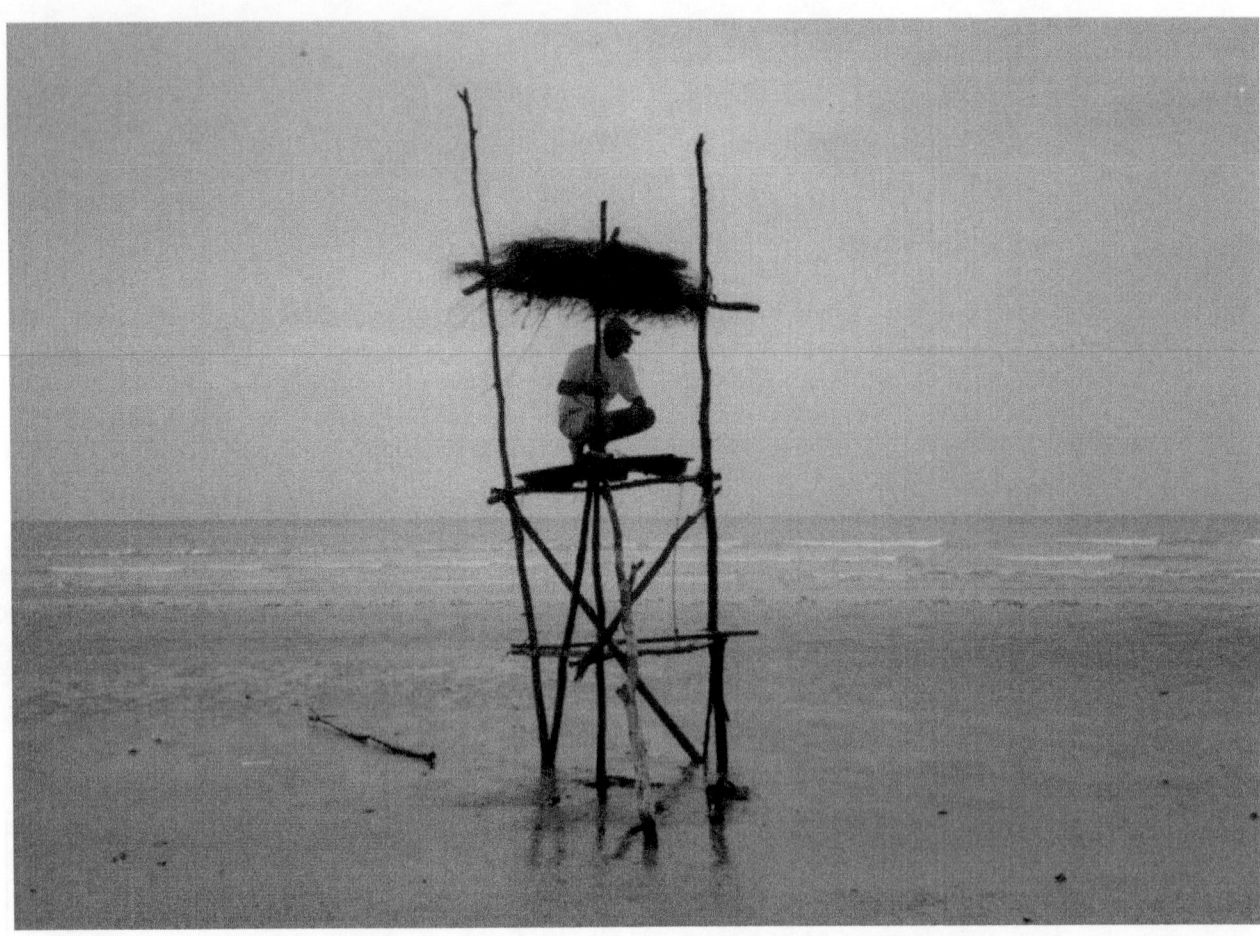

The author surveys a beach on a remote section of the Northern Territory coast. The height of the fishing platform is an indication of the high tide range along the northern Australian coast.

1 THE TASMANIAN COAST

Tasmania is Australia's island state, the only one to be entirely surrounded by oceans and seas, and as a consequence while it is the smallest in area it has the fifth longest coastline. Bedrock geology dominates the Tasmanian coast, occupying 60% of the shoreline, the remaining 40% containing 1269 predominantly sandy beaches. This book is about all those beaches, together with an additional 348 beaches on the five major islands (Maria, Bruny, Robbins-Walker, King and Flinders); in all 1617 beaches (Table 1.1).

Table 1.1 Tasmanian coastal characteristics

	Tasmanian coast	Five major islands	Total
Total length (km)	2237	793	3030
Sandy (beach)	876	347	1223
coast (km)	(39%)	(44%)	(40%)
Rocky coast (km)	1361	446	1807
	(61%)	(56%)	(60%)
Number beaches	1269	348	1617

Tasmania is also Australia's southernmost state, lying between 39.5 and 43.5°S, which exposes it to a humid temperate climate. It is also exposed to the prevailing flow of strong westerly winds of the roaring forties, and associated waves and ocean currents that continuously circle the Southern Ocean south of Australia. As an island however it has shorelines facing all directions and while the rugged west coast faces squarely into the high energy Southern Ocean, the east coast is a more moderate energy lee shore; the north coast is also sheltered from the high ocean waves but exposed to the westerly winds; while the large southeast bays afford a wide range of orientation and degree of shoreline sheltering. The result is a range of beach types dominated by the higher energy wave-dominated beaches (91%), with a lesser number of tide-modified (4%) and tide-dominated beaches (5%) in sheltered locations. In addition to the ocean regimes, bedrock geology in the form of headlands, rock reefs and islands play a major role in the coast and its beaches. The beaches average only 0.7 km in length, primarily a consequence of the bounding headland and reefs. The predominantly rocky foreshore and nearshore also act to lower and refract the ocean waves as they approach the shore, resulting in many moderate to lower energy wave-dominated beaches, on coasts exposed to higher ocean waves.

Beach systems

A *beach* is a wave-deposited accumulation of sediment, usually sand, but occasionally cobbles and boulders. They extend from the upper limit of wave swash, approximately 3 m above sea level, out across the surf zone or sand flats and seaward to the depth to which average waves can move sediment shoreward. Tasmania has a full spectrum of high through low energy beaches. On the exposed high wave energy sections of the west coast the beaches can extend to depths of between 30 and 50 m and as much as several kilometres offshore (Fig.

1.1a). In the sheltered bays of the southeast wave height and energy decrease substantially and the beaches range from the more exposed, with wind waves averaging about 1 m (Fig. 1.1b), to essentially waveless, sandy tidal flats (Fig. 1.1c). Likewise in the west north coast low waves and tides to 2-3 m result in extensive tidal flats.

a.

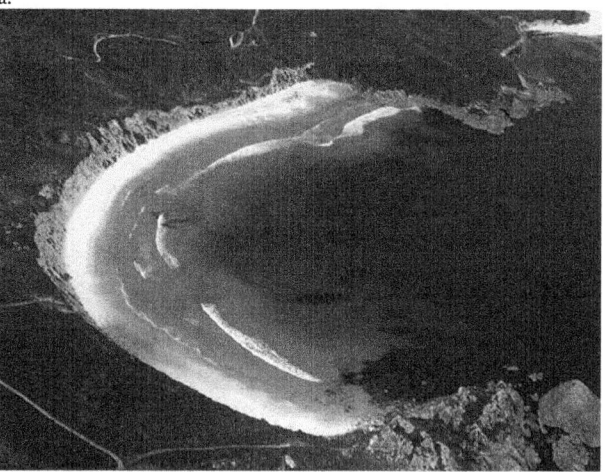
b.

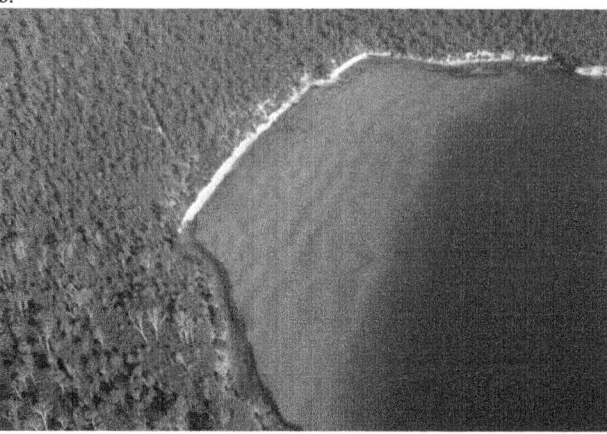
c.

Figure 1.1 Examples of the range of Tasmanian beach systems. a) High energy rip-dominated Surprise Bay beach (T 571) (W Hennecke); b) moderate energy Tiddys Beach (T 787); and c) low energy Monk Bay filled with ridged sand flats (T 351-2) (W Hennecke).

To most of us the beach is that part of the dry sand we sit on or cross to reach the shoreline and the adjacent surf zone. It is an area that has a wide variety of uses and users (Table 1.2). This book will focus on the dry or

subaerial beach plus the surf zone or area of wave breaking, typical of the beaches illustrated in Figure 1.2.

All Tasmanians live within 100 km of the coast and many travel to the coast for their holidays while others are frequent beachgoers and have their favourite beach. The beaches most of us go to are usually close by our home or holiday area. They are usually at the end of a sealed road,

with a car park and other facilities. Often, they are patrolled by lifesavers. These popular, developed beaches, however, represent only a minority of the state's beaches. In Tasmania there are eleven surf life saving clubs (SLSCs), which patrol about 25 beaches, with another 20 beach patrolled by lifesavers on jetskis (Table 1.3).

Table 1.2 Types of Tasmanian beach users and their activities

Type	User	Location
Passive	sightseer, tourist	road, car park, lookout
Passive-active	sunbakers, picnickers, beach sports	dry beach
Active	beachcombers, joggers	dry beach, swash zone
Active	fishers, swimmers	swash, inner surf zone
Active	surfers, water sports	breakers & surf zone
Active	skis, kayaks, windsurfers	breakers & beyond
Active	IRB, fishing boats	beyond breakers

Table 1.3 Tasmanian beaches: surf life saving clubs and access type

Facility/access type	Tasmanian coast beaches	Five major islands beaches	Total beaches
Surf life saving clubs	11	0	11
Patrolled beaches	25	0	25
Coastal national park/ reserve	850	249	1099
Sealed roads	315	19	334
Gravel roads	178	56	234
Sand/dirt 4WD access	338	178	516
Foot access only	423	80	503
No access	15	15	30
Total beaches	2129	348	1617

A number of factors have combined to limit access to and development of the Tasmanian coast and beaches. The first is the small island population, which reduces development pressure; second, is the predominantly rocky coast and often rugged hinterland which physically restricts access to the coast and often precluded its use as agricultural land; and third, is the fact that the majority (67%) of the state's beaches are located in coastal national parks and reserves, which further limits access and development. As a result only 24% of the beaches are serviced by a sealed road and another 15% by gravel road. The remainder can only be accessed by 4WD (27%) or on foot (33%). This means that more than half of the island's beaches are difficult to access and little used. As a consequence the majority of the beaches are in a natural state and will continue so into the future.

This book is a product of the *Australian Beach Safety and Management Program*, a co-operative project of the University of Sydney's Coastal Studies Unit, Surf Life Saving Australia (SLSA) and Surf Life Saving Tasmania. It is part of the most comprehensive study ever undertaken of beaches on any part of the world's coast. In Tasmania it has investigated every beach on the mainland coast and on the five major islands. The project has already published similar books on the beaches of New South Wales (1993), Victoria (1996), Queensland (2000), South Australia (2001) and Western Australia (2004), with the final book on the Northern Australian coast to

follow. The program also maintains a database on every Australian mainland beach, together with those on 30 major inhabited islands. For information about this database contact SLSA.

This book begins with an introduction to the Tasmanian coast: its geology, climate and coastal processes (Ch. 1); followed by an overview of the types of beach systems (Ch. 2); then the hazards associated with Tasmanian beaches (Ch. 3); and finally in Chapter 4, a description of every beach in the state. This chapter is organised into four regions: the east, southeast, west and north coasts, together with five major islands: Maria, Bruny, Robbins-Walker, King and Flinders.

Geology of the Tasmanian coast

Tasmania, whilst an island, is geologically part of the Australian continent and shares a common geological history with Victoria and eastern Australia. Tasmania also has quite a varied geology for this relatively small size, consisting of a Western Tasmania Terrane composed of ancient Precambrian and Cambrian sedimentary and volcanic rocks, the central Tamar Fracture Zone which extends the Tamar to the Derwent, and an Eastern Tasmania Terrane dominated by middle Palaeozoic dolerite and granite (Figure 1.2). This section briefly outlines Tasmania's geological evolution and coastal geology.

Figure 1.2 Tasmanian geology with generally higher Pre-Cambrian rocks in the west, sedimentary rocks and granite in the northeast, and the massive area of Jurassic dolerite covering the centre and southeast (see Table 1.4 for Geological Periods).

Table 1.4	Geological Timescale
Period	Duration (Ma)
Quaternary	2
Tertiary	65-2
Cretaceous	135-65
Jurassic	180-135
Triassic	230-180
Permian	280-230
Carboniferous	345-280
Devonian	405-345
Silurian	425-405
Ordovician	500-425
Cambrian	600-500
Precambrian	>4500-600

Range; and the quartzites of Port Davey on the western coast. There are some Precambrian deposits greater than 3 billion years old, while the sediments themselves may be up to 1,100 to 1,200 Ma. These rocks, which occur mainly in the western and northwestern part of the state, were originally laid down as sands, silts and mud and metamorphosed during an early mountain building episode 750 to 1,000 Ma. Later Precambrian rocks are much less altered and include dolomites, such as those in the Hastings area in southern Tasmania, and dolerite sills and dykes in the northwest. The older central-west rocks formed during the Delamerian orogen and are part of a Precambrian craton, which includes the extensive granite intrusion on King Island about 760 Ma.

The *Western Tasmania Terrane* consists of **Precambrian** (>600 Ma) and Cambrian sediments and volcanic accumulated in a number of troughs underlain by ancient Precambrian rocks. These form the nucleus of the island and are only exposed in the Dove River and upper Forth gneiss and schists; the hornblende-schists exposed in river valleys on the margins of the central plateau; the Mount Lyell schists which underlie the West Coast

During the **Cambrian period** (600 Ma), sedimentary rocks were deposited over a long period of time, in shallow marine environments prior to the formation of the eastern terrane. The *eastern Tasmania Terrane* is part of the Lachlan Fold Belt, which extends north through Victoria and New South Wales and into Queensland. It was initiated by an arc-continent collision in the early Cambrian (~510 Ma) when Cambrian to Devonian

marine sediments were pushed westward onto the
Australian craton. In Tasmania this is known as the
Tyennan orogeny (515-490 Ma), which experienced four
phases. First, during the Early to mid-Cambrian (515 Ma)
Tasmania collided with oceanic arc, resulting in fore-arc
lithologies thrust over Proterozoic sedimentary rocks, as
at Ulverstone. Second, in the Middle Cambrian an
extension phase resulted in rapid subsidence and
volcanism. Third, in the middle to late Cambrian these
was a north-south compressional phase and east-west
folding. Finally, the late Cambrian experienced a
reactivation of earlier extensional faults, which was
accompanied by major uplift of western Tyennan block,
resulting in mountains such as Mount Murchison, Mount
Owen, and Mount Jukes. Later, sandstones, mudstones,
and then limestone were formed in warm shallow seas.

Sediments continued to be deposited during the **Silurian**
period (425-405 Ma) in the form of sands, silts, and mud
over most of Tasmania. Some of the mudstones have
since been altered to slate.

The **middle Devonian** (405-345 Ma) saw another phase
of mountain building known as the Tabberabberan
Orogeny. Large scale folding took place north-south from
Queenstown to Sheffield, and east-west from Sheffield to
Deloraine. This covered practically all of Tasmania (and
much of eastern Australia and Antarctica). This was
followed in the mid-Devonian to early Carboniferous by
the emplacement of granite batholiths. Most of these
mountains have been subsequently eroded away. The
Devonian rocks are best represented by the massive
conglomerates and quartzites, which form the West Coast
Range extending from Mount Lyell on Macquarie
Harbour, through Mounts Jukes, Owen, Lyell, Murchison
and Geikie, to Mount Black.

The **Carboniferous** (345-280 Ma) began with deposition
of a series of marine limestones, shales and grits, which
occupy the whole of the southeastern corner of Tasmania
and one outlier on the northern coast in the Mersey
Valley. In the **late Carboniferous** (345-280 Ma) ice
covered large areas, not only in Tasmania, but also on
mainland Australia.

Sedimentary rocks including coal deposits were laid
down during the **Triassic** (230-180 Ma).

During the **Jurassic** (180-135 Ma) extensive sills and
dykes intruded large volumes of dolerite sheets up to
500 m thick into earlier sedimentary rocks over the
eastern half of Tasmania. Faulting and up-thrusting of
these rocks, coupled with their resistance to erosion, has
resulted in several prominent landforms capped by
dolerite such as Mount Wellington near Hobart, Cradle
Mountain and Ben Lomond. This tectonic activity was
probably related to tensional stress between continental
blocks prior to break-up of Gondwanaland. Some sills
were reactivated during the early Tertiary and today the
dolerite dominates the eastern half of the island forming
many of the headlands (Fig. 1.3).

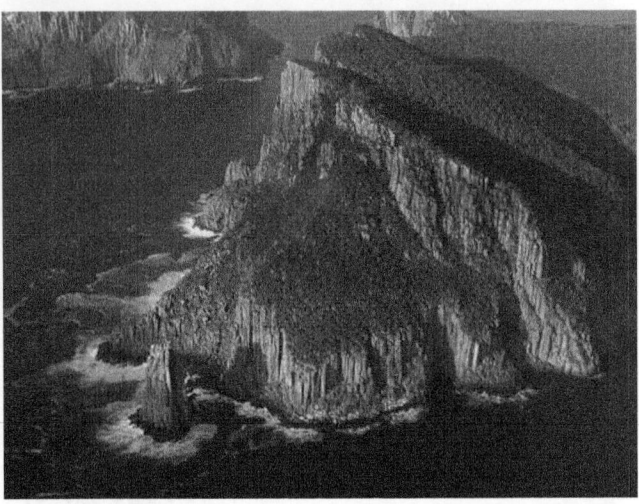

*Figure 1.3 Cape Pillar is an excellent example of the
columnar basalt formed during the Jurassic.*

The **Cretaceous** period (135-65 Ma) was mainly a time
of erosion, apart from syenite dykes intruded into the
Jurassic dolerite, some volcanic activity in the northeast
and deposition of sediments near Cygnet in southern
Tasmania.

During the **Tertiary** period (65-2 Ma), volcanic activity
resulted in extensive lava flows in the northwest which
filled many river valleys with basalt and formed a
250 km^2 lava plain, which is now dissected by the
Mersey-Forth, Leven, Blythe, Emu and Hellyer rivers.
Limestones rich in marine fossils, such as Fossil Bluff
near Wynyard, were formed, and widespread faulting
gave Tasmania much of its present-day shape.

While the foregoing outlines the geology of the state,
much of it predates the evolution of the Tasmanian coast,
which only began to form about 150 Ma with the final
separation from Gondwanaland.

Gondwanaland breakup (205-55 Ma)

The Australian continent started to break away from the
rest of Gondwanaland during the Jurassic-Cretaceous
(205-135 Ma) (Fig. 1.4). The rifting began in the
northwest shelf region, then proceeded anticlockwise
southward along the Western Australian coast during the
Cretaceous (135-65 Ma) causing rifting between India
and Australia. It then continued eastward between
Australia and Antarctica which separated Tasmanian
from Antarctica and formed the western and southern
Tasmanian coastline by 120 Ma (Fig. 1.5). The eastern
coast did not begin to form until the late Cretaceous (75-
55 Ma), when seafloor spreading separated the Lord
Howe Rise and New Zealand from the Australian
continent forming the Tasman Sea and east Australian
and Tasmanian coasts.

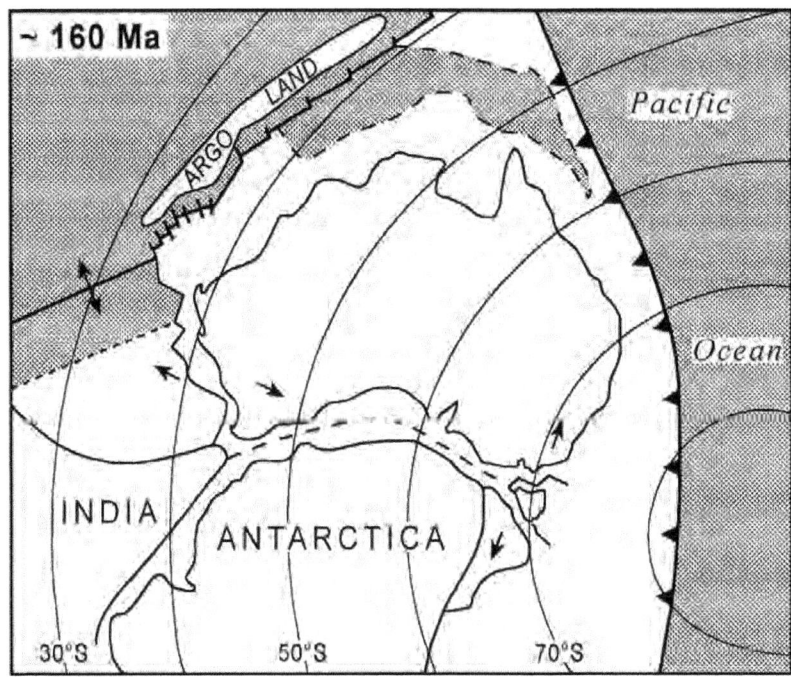

Figure 1.4 160 Ma Tasmania was landlocked within Gondwanland, as the separation of Australian began in the northwest.

The rifting across the southern Australian coast also produced a buckling of the plate and the formation of Sorell, Otway, Bass and Gippsland sedimentary basins during the late Jurassic-early Cretaceous (140-120 Ma). They rapidly filled with thick (up to 8 km) alluvial fan and fluviatile sediments and some volcanics of Mesozoic and Cainozoic age. In the Bass Basin this buckling defined the present north Tasmanian coast.

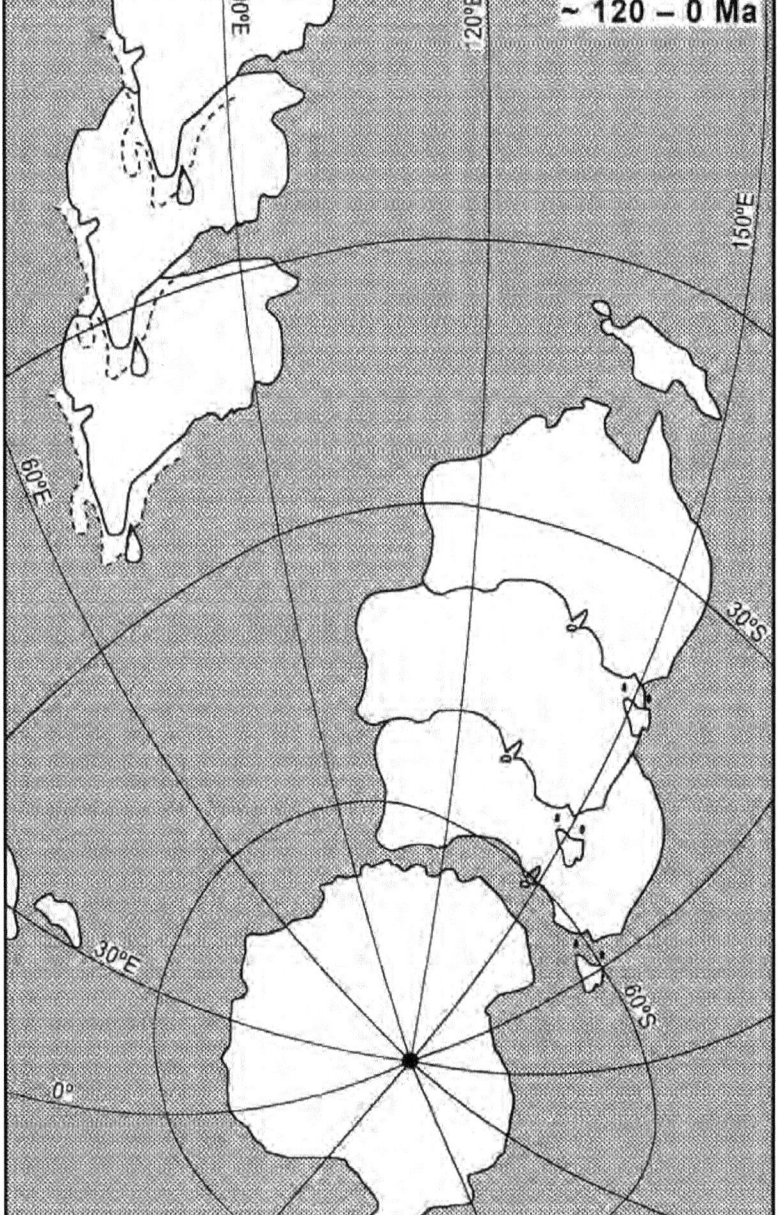

Figure 1.5 120 Ma Australia separated from Antartica and formed the southern coast, including Tasmania. It has since migrated 3000 km northward.

The **Bass Basin** is a late Mesozoic-Cainozoic intracratonic sedimentary basin, that trends northwest to southeast between Tasmania and Victoria (Fig. 1.6). It is separated from Otway Basin in the west by King Island-Mornington Rise and Gippsland basin in the east by Bassian Rise which extends from Wilsons Promontory through the Kent Group and Flinders Island. It covers an area of 65 000 km^2 and has an average depth of 30-90 m, with no surface exposures during high sea level stands. At low sea levels however the basin is exposed and Tasmania is linked to Victoria. The basin has basal non-marine Cretaceous to Eocene units interbedded with quartz sandstone, claystone, siltstone, coal and extrusive and intrusive basalts. These grade upward into late Eocene to Pliocene shales and marls, which are capped by Pliocene marls and limestone deposited in a carbonate-rich open basin-shelf environment, which continues to today (Fig. 1.7).

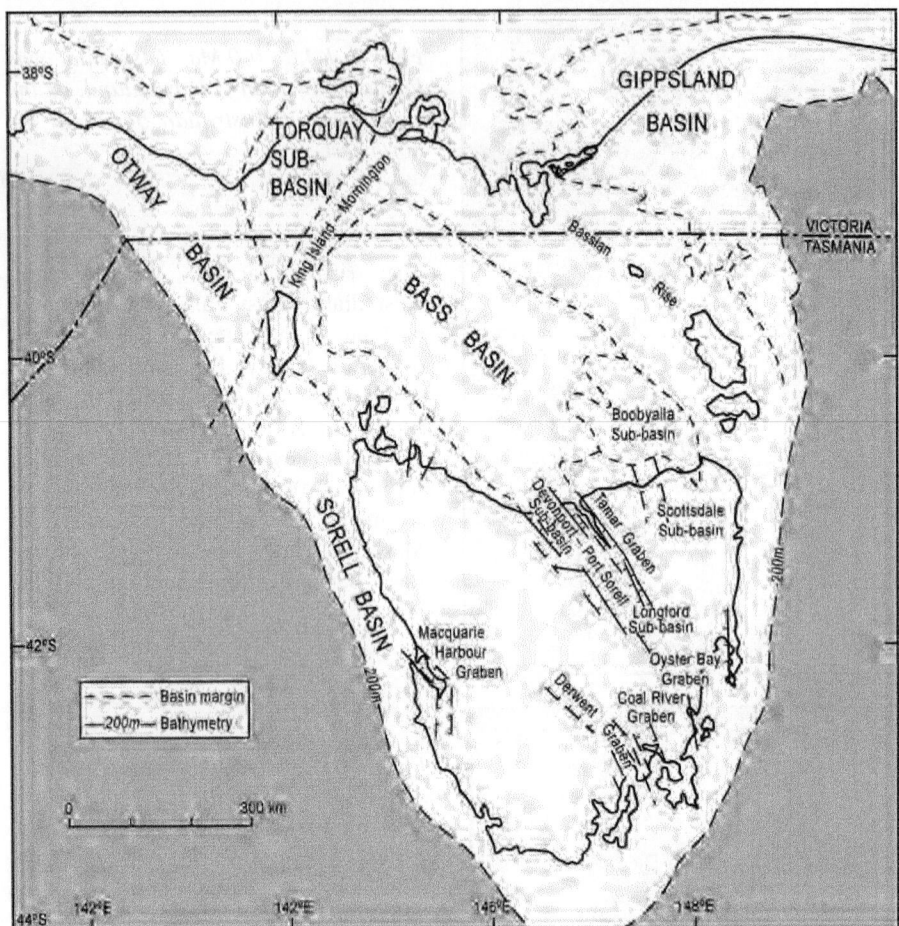

Figure 1.6 Tectonic regions of Tasmania including the Otway, Bass and Gippsland basins that form the depression occupied by Bass Strait. Smaller basins and garben dominate northeast and southeast coasts and bays.

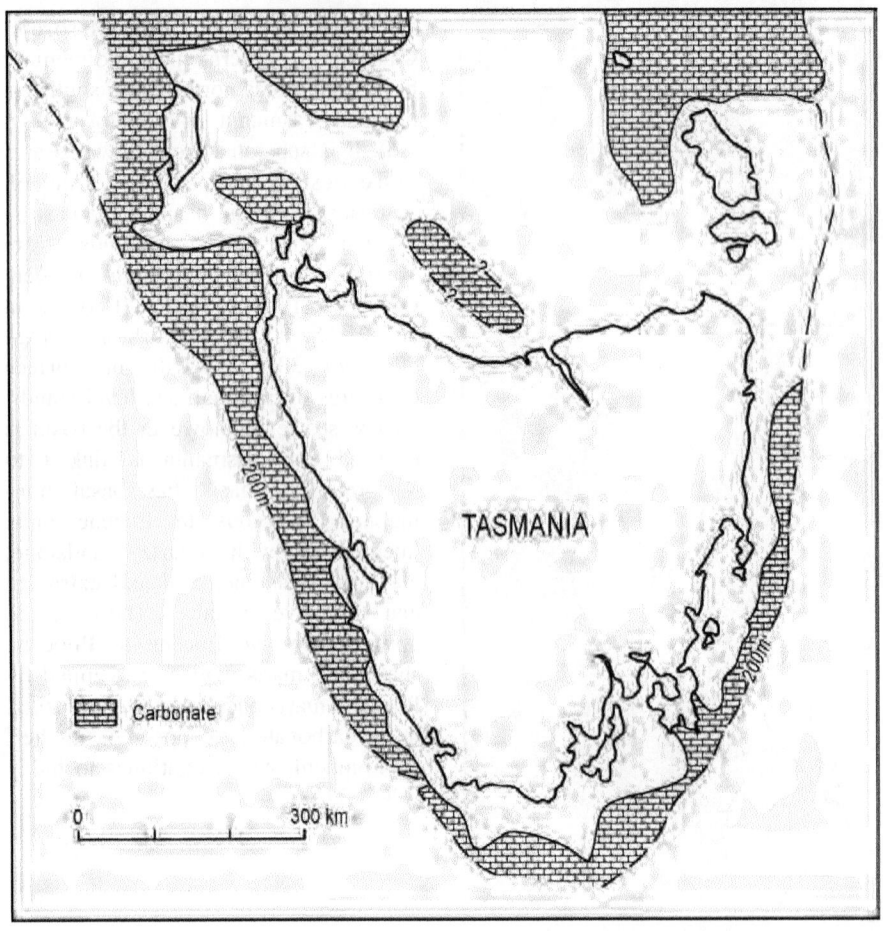

Figure 1.7 Distribution of carbonate-rich sediments on the Tasmanian contintental shelf.

Quaternary climate and sea level

The Quaternary covers the past 2 Ma of earth's history and is divided into the Pleistocene (2 Ma-10 ka) and Holocene (10 ka to present). This period has been characterised by cyclical fluctuations in the earth's surface temperature, with cooler periods leading to the growth of massive ice sheets in North America and Europe, followed by their melting during warmer periods. These fluctuations are also accompanied by a fall in sea level as the ice builds up, and a rise as it melts, with maximum changes in sea level up to 120 m. During the Quaternary there have been as many as 20 major shifts in temperature and sea level, when sea level has fallen to 120 m then risen to approximately its present level, and many more secondary shifts, when it has oscillated between these extremes.

In Australia the cooler periods result in the overall climate of the continent becoming cooler, drier and windier, with a minor accumulation of permanent ice on the slopes of Mount Kosciusko, while in Tasmania small ice caps formed on the Central Plateau, parts of the West Coast Range and Ben Lomond, together with cirque and valley glaciers in the southernwestern mountains, in all about 1,300 km² of ice cover. However during cooler periods as sea level falls the continental shelf is exposed, greatly increasing the size of the Australian continent, changing the location of the shoreline and linking Tasmania to Victoria (Fig.1.8). During warmer periods, as at present, the climate is warmer, more humid and less windy and the sea level rises to about its present position, flooding the continental shelf, including Bass Strait and shrinking the size of the continent and Tasmania. Figure 1.9 illustrates the fluctuating level of the sea in the Australian region during the late Quaternary and the rapid rise in sea level to its present level during the Holocene.

Quaternary climate and sea level changes have had four major impacts around the entire Tasmanian coast. First, they have periodically exposed and flooded the continental shelf including Bass Strait, at the same time shifting the shoreline tens to hundreds of kilometres backwards and forwards across the shelf and strait. Second, each time sea level has risen, accompanied by waves and winds, it has, particularly in the west and northeast, driven sediment eroded from the shelf towards and onto the shore to form beaches and coastal dunes. Third, during periods of low sea level, these deposits are stranded well above sea level, during which time most have been exposed to soil-forming processes, which have lead to the deep weathering and podsolisation of the dunes. Fourth, when sea level has returned each time to near its present level it has in some locations deposited multiple sequences of beaches and dunes, either in front of the older beaches or on top of these deposits. As a consequence of the above, some of the modern Tasmanian (Holocene) coastal deposits lie either over or in front of older Quaternary deposits.

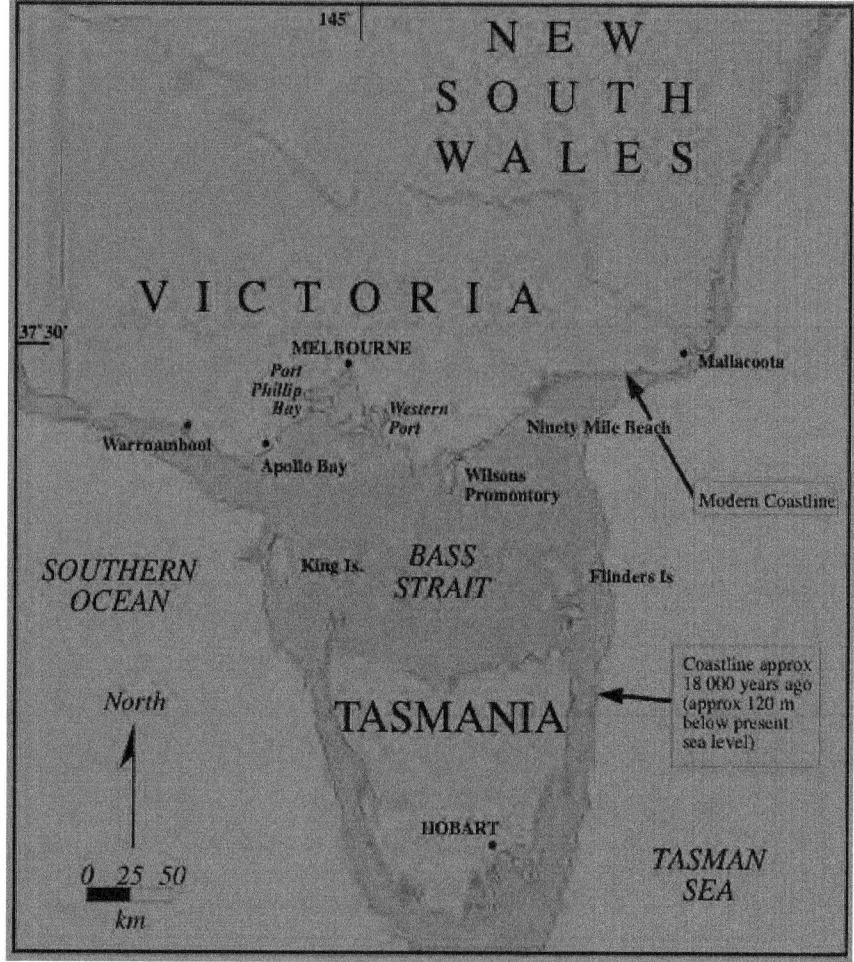

Figure 1.8 Location of southeast Australian shoreline 18 000 years ago at peak of glacial maxima and low sea level and today. At lower sea levels Bass Strait is exposed and Tasmania linked to the mainland.

Australia Beach Safety and Management Program

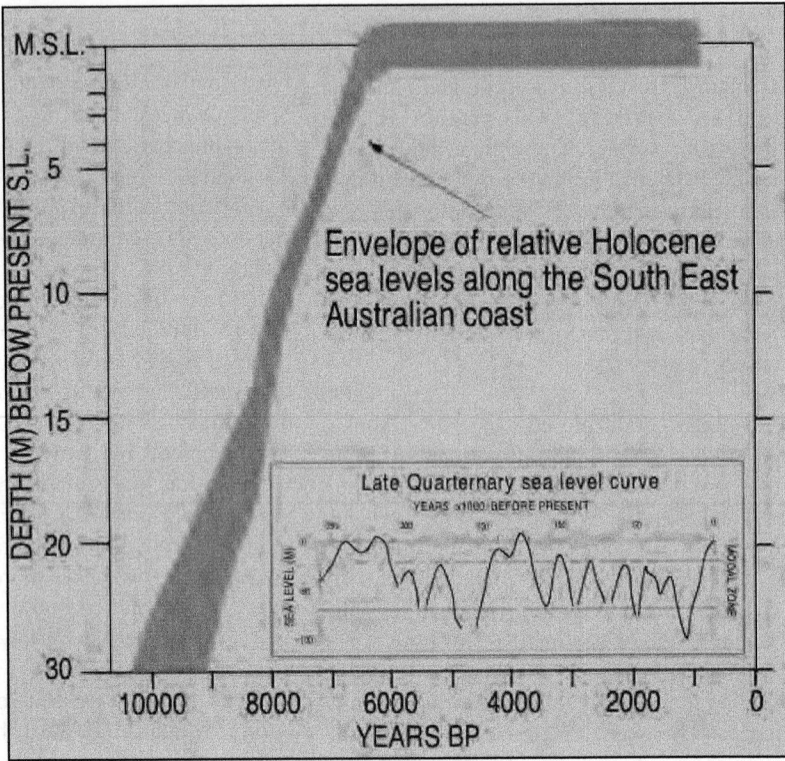

Figure 1.9 Two plots showing the Holocene rise and still-stand in sea level (upper) and the larger scale late Quaternary sea level fluctuations (lower). Along many parts of the Tasmanian coast the Holocene sea level rose to 1-2 m above the present level about 6 ka, before falling to its present location.

Tasmanian coast

The Tasmanian coast was formed as a result of continental rifting and buckling during the Cretaceous. The west coast of Tasmania was the last part of southern Australia to separate from Antarctica about 120 Ma. This was followed by seafloor spreading in the Tasman Sea area (75-55 Ma) which separated southeast Australia, including eastern Tasmania, from the Lord Howe Rise and New Zealand and opened up the Tasman Sea. The north coast resulted from the crustal warping which accompanied the separation, forming the Bass Basin and when flooded Bass Strait. There are several smaller onshore basins forming depression and bays which have partially filled with non-marine and volcanic successions in the Tamar, Macquarie Harbour, Derwent, Coal River and Oyster Bay grabens as well as Devonport-Sorell and Scottsdale sub-basins.

The coast can be divided into four regions based on the regional geology and orientation, which also influence wave, tide and wind regimes.

The *west coast* is dominated by often high relief Precambrian metamorphic rocks between South East Cape and Nye Bay. Between Nye Bay and the northern tip at Woolnorth Point it consists of a mixture of Precambrian metamorphosed and unmetamorphosed Precambrian rocks, together with sections of Cambrian sedimentary and volcanic rocks and Silurian conglomerates. Much of the coast is dominated by the rocks, their headlands and adjacent rocky reefs. The only extensive beach systems are associated with the Macquarie Harbour sub-basin, whose graben mouth is filled with Quaternary sediment between Hells Gate and Trial Harbour.

The *north coast* tends to transect the run of the geology resulting in a highly variable geology and rock type along the coast. On the western section of the coast Precambrian unmetamorphosed rocks dominate the northwest corner, though they only outcrop along the north coast on Hunter and Robbins islands, in Brickmaker Bay, and between Rocky Cape and Boat Harbour. Elsewhere extensive raised Quaternary deposits fill the Smithton Basin between Woolnorth Point and Stanley, and Tertiary basalt dominates much of the coast between The Nut at Stanley and Devonport. To the east of Devonport more extensive Quaternary marine and aeolian deposits link the prominent headlands, the latter composed of Precambrian rocks in the centre and a mix of Jurassic dolerite, Devonian sedimentary rocks and Carboniferous granite.

The *east coast* consists of two sections. In the northeast between Cape Portland and Schouten Island Carboniferous granite tends to dominate, with lesser area of Tertiary limestone and basalt and Cambrian volcanics. The Oyster Bay graben marks a change in the geology with the extensive Jurassic dolerite dominating the coast and hinterland between Great Oyster Bay and Cape Pillar. There are lesser areas of Triassic sandstone, and on Maria Island Carboniferous granite.

The *southeast coast* between Cape Pillar and South East Cape, including Bruny Island, is dominated both by rocks and structure. The rocks consist of Jurassic dolerite which dominates all the way to South East Cape, interspersed with some areas of Triassic sandstone and Permian sediments including coal measure. The structure of the coast is influenced by the Coal River and Derwent grabens, which are responsible for the Frederick Henry-

Norfolk bay and Derwent-Storm bay depressions respectively, and the resulting highly indented and irregular shoreline.

King Island is part of the ancient Precambrian craton that dominates the western half of the state. The west and north coast of the island is dominated by Precambrian granites which outcrop both along and off the coast as reefs. The southeast coast between Naracoopa and Grassy is composed of Cambrian sediments, while much of the island is blanketed by Quaternary aeolian deposits.

Flinders and *Cape Barren islands* are part of the Bassian Rise and are dominated by Carboniferous granites, with small areas of Devonian sedimentary rocks, and a covering of Quaternary terrestrial and marine sediments. Many of the small islands and reefs located off the west and east coast of Flinders are composed of Devonian granite.

Climate

Climate contributes to the formation and dynamics of coasts and beaches in two main areas. First, climate interacts with the geology and biology to provide the geo- and bio-chemistry to weather the land surface, which, together with the physical forces of rain, runoff, rivers and gravity, erode and transport sediments to the coast. Secondly, at the coast it is also the climate, particularly winds, which interact with the ocean to generate waves and currents that are essential to move and build this sediment into beaches and dunes.

On a global scale, beaches can be classified by their climate. The *polar beaches* of the Arctic Ocean and those surrounding Antarctica, including Australia's large Antarctic Territory and Tasmania's Macquarie Island, are all dark in colour and composed of coarse sand, cobbles and boulders. The coarse beaches have steep swash zones and, because of the coarse sediment and often frozen surfaces, there are no dunes. All these characteristics are a product of the cold polar climate, which permits little chemical weathering, hence the dark unstable minerals in the sediments, while the dominance of cold physical weathering ensures a supply of coarse sediments.

Temperate middle latitude beaches typical of southern Australia including Tasmania have sediments composed predominantly of well-weathered quartz sand grains, with variable amounts of biotic fragments (shell, algae, etc). In addition, wind and wave energy associated with the strong mid latitude westerly wind stream is relatively high. The waves produce energetic surf zones, while the winds can build massive coastal dune systems, as is typical of the exposed west and east north coasts of Tasmania.

Tropical beaches of northern Australia reside in areas of lower winds of the equatorial low pressure system (the doldrums) during the summer, while exposed to the more moderate velocity easterly Trade winds during the winter. Consequently wave energy is low to moderate at best.

The areas of lower waves and winds tend to have steep high tide beaches fronted by tidal flats with little or no surf and few dunes. Their sediments are often well-weathered quartz sands derived from plentiful tropical rivers and bleached coral and algal fragments derived from fringing coral and algal reefs. Fringing reefs also dominate many of the tropical beaches particularly around the Kimberley coast. The most exposed tropical beaches face into the Trade winds and receive moderately high waves and may be backed by transgressive dune systems, as occurs on Cape York.

Tasmanian climate

Tasmania's climate is determined by three factors - its temperate latitude; its island status surrounded by the Southern Ocean and Bass Strait, with no part of the island more than 115 km from the coast; and its relief, in particular the high western ranges.

Tasmania is located between 39.5° and 43.5°S, placing it in the path of the humid westerly wind stream associated with the passage of mid latitude cyclones and associated cold fronts. The westerly winds bring humid maritime air particularly during the winter months, while during autumn and spring east coast lows can form and bring rainfall to the northeast. The result is a temperate climate with no dry season (Fig. 1.10).

Rainfall is highest in the west where the mountains rise to between 500 and 1600 m and receive both frontal and orographic rainfall, with much of the south-central western mountains receiving over 2200 mm to peak at 3200 mm in from Strahan. In contrast the central region is in a rain shadow in lee of the mountains with rainfall decreasing to less than 600 m in the midlands (Fig. 1.11). In the Hobart region rainfall decreases from 1400 mm on Mount Wellington (1270 m) to 600 mm along the Derwent to 500 mm at Risdon. The northeast region of the state receives rainfall between 800 and 1200 mm, as a result of both the formation of east coast lows off the coast feeding humid easterly air, coupled with the higher terrain which rises to 1500 m at Ben Lomond. Throughout the state rainfall occurs year round with a winter maximum, except in the southeast where it is more uniform through the year.

Temperatures are mild to warm in summer and cool in winter. They are moderated throughout the year by the surrounding maritime environment. Average annual maximum is 15°C around the coast, with a minimum of 6°C increasing to 9°C along the north coast (Fig. 1.12). The 7°C coast range is doubled inland as a result of a slight continental effect. Summer mean maximum temperatures range from 18-23°C, with mean summer minimums from 10-15°C. During winter the mean maximum is between 9° and 14°C and mean minimum between 5° and 8°C. Frosts occur around the coast from March or April and are one of the main factors excluding mangroves from Tasmania.

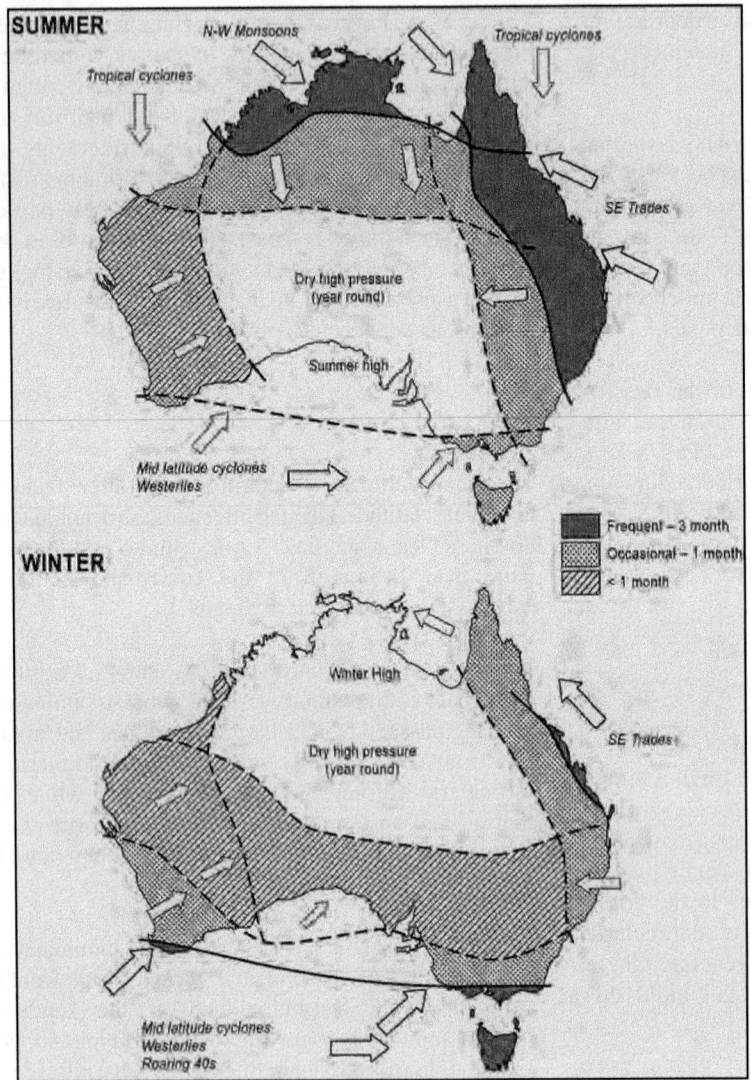

Figure 1.10 While Australia is influenced by three major pressure systems, Tasmania is dominated by one - the mid-latitude cyclones which track south of the continent bringing westerly winds and year round rain to Tasmania, with a winter maximum.

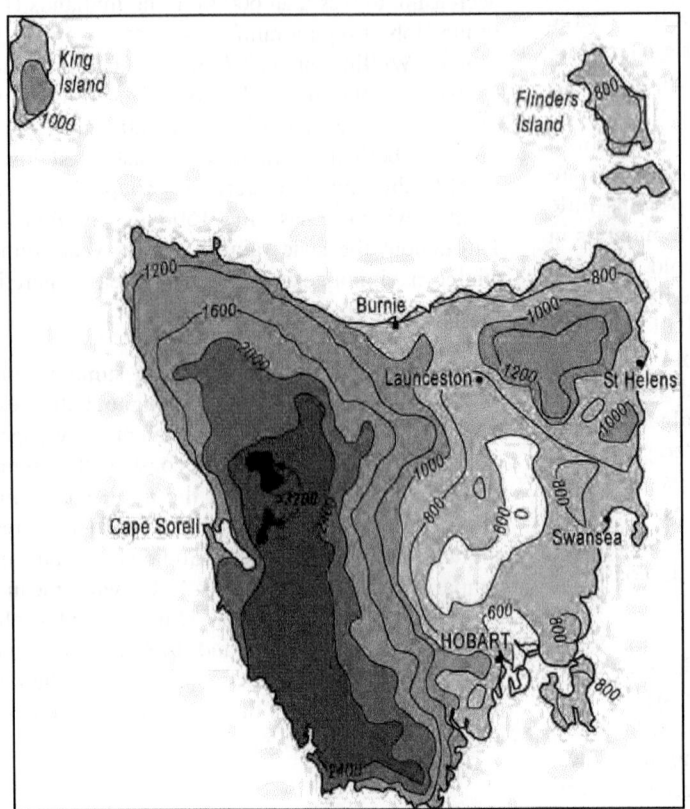

Figure 1.11 Tasmania's rainfall is derived primarily from westerly winds, which generates an orographic maxima along the western ranges and a rain shadow to the east. A secondary maxima in the northeast is generated by occasional east coast lows and the higher terrain.

Australian Beach Safety and Management Program

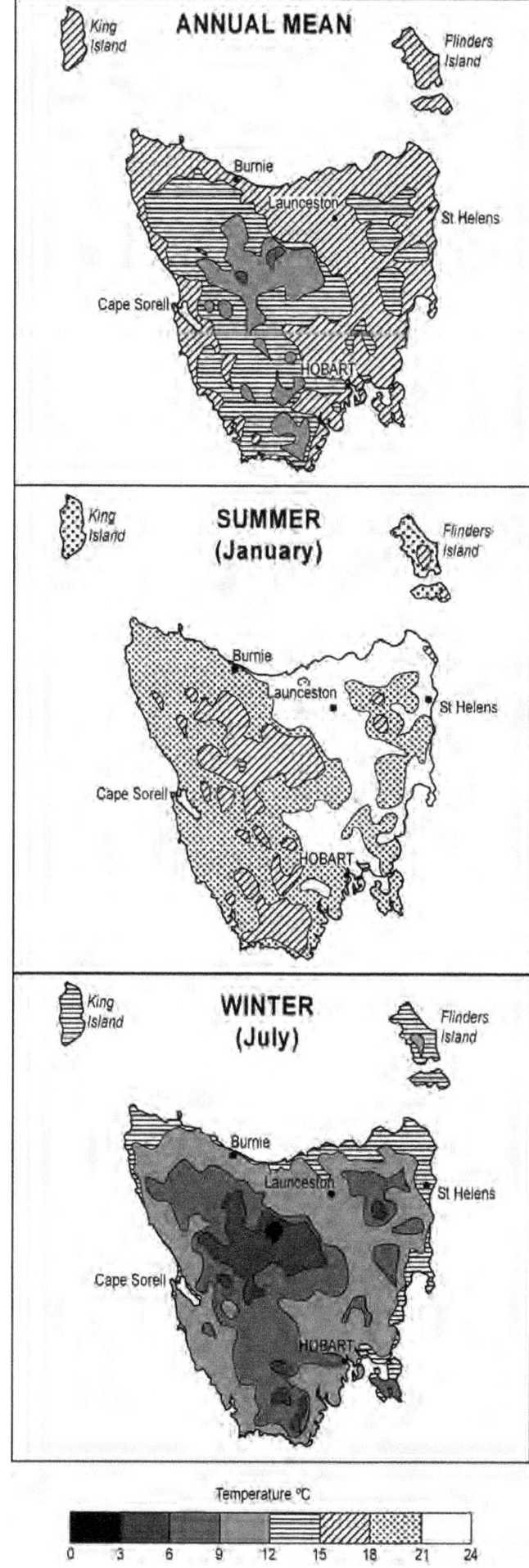

Figure 1.12 Tasmania's annual, January and July mean temperatures.

Winds are predominantly from the west, through they range from northwest to southwest, associated with the continual passage of mid latitude cyclones and their associated cold fronts. In summer both westerly and northerly winds dominate in the morning at Currie and Hobart (Fig. 1.13). The northerly winds can bring warmer continental air and occasional heat wave conditions. Summer afternoons are dominated by a more westerly flow at Currie and a southeast sea breeze flowing up the Derwent at Hobart. The direction of seabreeze varies around the coast owing to its variable orientation. It tends to arrive from southeast along the southeast and east coast, northwest along the north coast and southwest on the west coast. During winter westerly winds dominate at most locations throughout the day. These winds tend to be west to southwesterly on the west coast, then rotate in crossing the island and mountains resulting in west to northwesterly winds on the east coast.

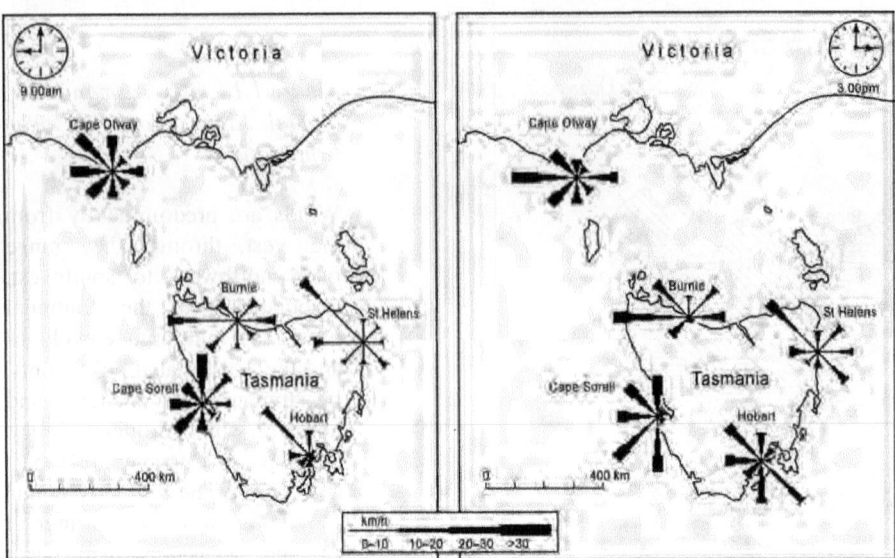

Figure 1.13 9 am and 3 pm wind roses for Tasmania and Bass Strait.

Ocean Processes

Oceans occupy 71% of the world's surface. They therefore influence much of what happens on the remaining land surfaces, particularly on islands like Tasmania. The oceans are also the immediate source of most of the energy that drives coastal systems. Approximately half the energy arriving at the world's coastlines is derived from waves; with much of the rest arriving as tides, while the remainder is contributed by other forms of ocean and regional currents. In addition to supplying physical energy to build and reshape the coast, the ocean also influences beaches through its temperature, salinity and the rich biosphere that it hosts.

There are eight types of ocean processes that impact the Tasmanian coast. These are listed in Table 1.5 and briefly discussed below.

Ocean waves

There are many forms of waves in the ocean ranging from small ripples to wind waves, swell, tidal waves, tsunamis and long waves, including standing and edge waves; the latter lesser known but very important for beaches. In this book, the term 'waves' refers to the wind waves and swell, while other forms of waves are referred

to by their full name. The major waves and their impact on beaches are discussed in the following sections.

Wind waves

Wind waves, or sea, are generated by wind blowing over the ocean. They are the waves that occur in what is called the area of wave generation; as such they are called *sea*. Five factors determine the size of wind waves:

- *Wind velocity* - wave height increases exponentially as wind velocity increases;
- *Wind duration* - the longer the wind blows with a constant velocity and direction, the larger the waves become until a fully arisen sea is reached; that is, the maximum size sea for a given velocity and duration;
- *Wind direction* will determine, together with the Coriolis force, the direction the waves will travel;
- *Fetch* - the area of sea or ocean surface is also important; the longer the stretch of water the wind can blow over, called the *fetch*, the larger the waves can become;
- *Water depth* is important, as shallow seas will cause wave friction and possibly breaking. This is not a problem in the deep ocean, which averages 4.2 km in depth, but is very relevant once waves start to cross the Tasmanian continental shelf and particularly in the relatively shallow Bass Strait.

Table 1.5 Major ocean processes impacting the coast

Process	Area of coastal impact	Type of impact
waves – sea & swell	shallow coast & beach	wave currents, breaking waves, wave bores
tides	shoreline & inlets	sea level, currents
shelf waves	shoreline & inlets	sea level fluctuations
ocean currents	continental shelf	currents
local wind currents	nearshore & shelf	currents
upwelling & downwelling	nearshore & shelf	currents & temperature
storm surge	shallow coast & beach	rise in sea level
ocean temperature	entire coast	sea temperature
biota	entire coast	varies with environment & depth contributes carbonate sediments

The biggest seas occur in those parts of the world where strong winds of a constant direction and long duration blow over a long stretch of ocean. The part of the globe where these factors occur most frequently is in the Southern Ocean between 40° and 50°S, where the westerly gales of the Roaring Forties and Raging Fifties prevail. Satellite sensing of all the world's oceans found that the world's biggest waves, averaging 6 m and reaching up to 20 m, occurred most frequently around the Southern Ocean, centred on 40°S and including a band running south of Australia. Waves from this source dominate the west and southeast coast of Tasmania.

Swell

Wind waves become swell when they leave the area of wave generation, by either travelling out of the area where the wind is blowing or when the wind stops blowing. Wind waves and swell are also called free waves or progressive waves. This means that once formed, they are free of their generating mechanism the wind and they can travel long distances without any additional forcing. They are also progressive, as they can move or progress unaided over great distances.

Once swell leaves the area of wave generation, the waves undergo a transformation that permits them to travel great distances with minimum loss of energy. Whereas in a sea the waves are highly variable in height, length and direction, in swell the waves decrease in height, increase in length and become more uniform and unidirectional. As the speed of a wave is proportional to its length, they also increase in speed (Fig. 1.14).

Wave Type	Breaking	Shoaling	Swell	Sea
Environment	Shallow water – surf zone	Inner continental shelf	Deep water >> 100m	Deep water >>100m Long fetch = sea/ocean surface Wind velocity↑waves↑ Wind duration↑waves↑ Wind direction = wave direction
Distance travelled	~100 m	1 to 100 km	100s to 1000s km	100s to 1000s km
Time required	Seconds	Minutes	Hours to days	Hours to days
Wave profile	←SWELL ←SEA			
Water depth	1.5 x wave height	<100m	>>100m	>>100m
Wave character	Wave breaks Wave bore Swash	Higher Shorter Steeper Same speed	Regular Lower Longer Flatter Faster	Variable height High Short Steep Slow
Example:				
Height (m)	2.5 to 3	2 to 2.5	2 to 3	3 to 5
Period (sec)	12	12	12	6 to 8
Length (m)	0 to 50	50 to 220	220	50 to 100
Speed	0 to 15	15 to 60	66	33 to 45 **(km/h)**
Distance travelled			1600	800 to 1100 **(km/day)**

Ocean wave generation, transformation and breaking.

Figure 1.14 Waves begin life as 'sea' produced by winds blowing over the ocean or sea surface. If they leave the area of wave generation they transform into lower, longer, faster and more regular 'swell', which can travel for hundreds to thousands of kilometres. As all waves reach shallow water, they undergo a process called 'wave shoaling', which causes them to slow, shorten, steepen and finally break. This figure provides information on the characteristics of each type of wave. The Tasmanian coast receives year round swell on the west and southeast coasts, with shorter wind waves or seas associated with the accompanying westerly winds and summer sea breeze conditions.

A quick and simple way to calculate the speed of waves in deep water is to measure their period, that is, the time between two successive wave crests. The speed is equal to the wave period multiplied by 1.56 m. Therefore a 12 sec wave travels at 12 x 1.56 m/s, which equals 18.7 m/s or 67 km/hr. In contrast, a 5 sec wave travels at 28 km/hr, whereas a 14 sec wave travels at 79 km/hr. What this means is that the long ocean swell is travelling much faster than the short seas and that as sea and swell propagate across the ocean, the longest waves travel fastest and arrive first at the shore.

Swell also travels in what surfers call 'sets' or more correctly *wave groups*, that is, groups of higher waves followed by lower waves. These wave groups are a source of long, low waves (the length of the groups) that become very important in the surf zone, as discussed later.

Swell and seas will move across the ocean surface as *progressive waves*, through a process called orbital motion. This means the wave particles move in an orbital path as the wave crest and trough pass overhead. This is the reason the wave form moves, while the water, or a person or boat floating at sea, simply goes up and down, or more correctly around and around. However when waves enter water where the depth is less than 25% of their wave length (wave length equals wave period squared, multiplied by 1.56; for example, a 12 second wave will be 12 x 12 sec x 1.56 = 225 m in length and a 5 second wave only 39 m long) they begin to transform into shallow water waves, a process that may ultimately end in wave-breaking. Using the above calculations this will happen on the open coast when the long 12-14 sec swell reaches between 50 and 80 m depth, while in Bass Strait the shorter 5-8 sec seas will begin to feel bottom between 10 and 25 m.

Wave types: sea and swell

Waves are generated by wind blowing over water surfaces.

Large waves require very strong winds, blowing for many hours to days, over long stretches of deep ocean.

Sea waves occur in the area of wave generation, in close vicinity to the mid latitude cyclones and with summer sea breeze conditions right around the coast. Seas dominate the sheltered southeast bays and the western Bass Strait coast.

Swell are sea waves that have travelled out of the area of wave generation. Swell dominates the west and open southeast coasts and can travel up the east Tasmanian coast.

Wave shoaling

As waves move into shallow water and begin to interact with the seabed or 'feel bottom' four processes take place affecting the wave speed, length, height, energy and ultimately the type of wave breaking (Fig. 1.15).

- *Wave speed* decreases with decreasing water depth.
- Variable water depth produces variable wave speed, causing the wave crest to travel at different speeds over variable seabed topography. At the coast this leads to *wave refraction*. This is a process that bends the wave crests, as that part of the wave moving faster in deeper water overtakes that part moving slower in shallower water.
- At the same time that the waves are refracting and slowing, they are interacting with the seabed, a process called *wave attenuation*. At the seafloor, some potential wave energy is transformed into kinetic energy as it interacts with the seabed, doing work such as moving sand. The loss of energy causes a decrease or attenuation in the overall wave energy and therefore lowers the height of the wave.
- Finally, as the water becomes increasingly shallow, the waves shoal, which causes them to slow further, and decrease in length but increase in height, as the crest attempts to catch up to the trough. The speed and distance over which this takes place determines the type of *wave breaking*.

Wave breaking

Waves break basically because the wave trough reaches shallower water (such as the sand bar) ahead of the following crest. The trough therefore slows down first, while the crest in deeper water is still travelling a little faster. Depending on the slope of the bar and the speed and distance over which this occurs, the crest will attempt to 'overtake' the trough by spilling or even plunging forward and thereby breaking (Figs. 1.15 & 1.16)

There are three basic types of breaking wave:

- *Surging breakers,* which occur when waves run up a steep slope and transform from an unbroken wave to swash in the process of breaking. Such waves can be commonly observed on steeper beaches when waves are low, or after larger waves have broken offshore and reformed in the surf zone. They then may reach the shore as a lower wave, which finally surges up the steep beach face as swash.

- *Plunging or dumping waves,* which surfers know as a tubing or hollow wave, occur when shoaling takes place rapidly, such as when the waves hit a reef or a steep bar and/or are travelling fast. As the trough slows, the following crest continues racing ahead and as it runs into the stalling trough, its forward momentum causes it to both move upward, increasing in height and throw forward, producing a curl or tube.

- *Spilling breakers*, on the other hand, occur when the seabed shoals gently and/or waves are moving slowly, resulting in the wave breaking over a wide zone. As the wave slows and steepens, only the top of the crest breaks and spills down the face of the wave. Whereas a plunging wave may rise and break in a distance of a few metres, spilling waves may break over tens or even hundreds of metres.

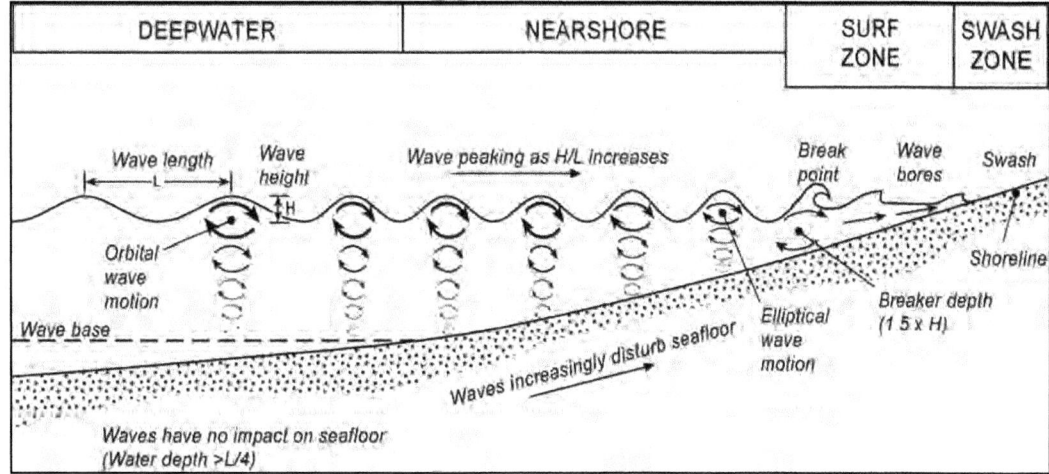

Figure. 1.15 *As waves move into shallow coastal waters they shoal and in doing so slow, shorten, steepen and may increase in height. At the break point they break and move across the surf zone as wave bores (broken white water) and finally up the beach face as swash. Below the surface, the orbital wave currents are also interacting with the seabed, doing work by moving sand and ultimately building and forever changing beach systems.*

Figure 1.16 *Long regular swell breaking at Rheban Beach (T 275).*

Broken waves

As waves break they are transformed from a clear progressive wave to a mass of turbulent white water and foam called a *wave bore*. It is also called a *wave of translation*, as unlike the unbroken progressive wave, the water actually moves or translates shoreward. Surfers, assisted by gravity, surf on the steep part of the breaking wave. Once the wave is broken, boards, bodies and whatever can be are propelled shoreward with the leading edge of the wave bore, while the turbulence in the wave bore is well known to anyone who has dived into or under the white water.

Surf zone processes

Ocean waves can originate thousands of kilometres from a beach and can travel as swell for days to reach their destination. However, on reaching the coast, they can undergo wave refraction, shoaling and breaking in a matter of minutes to seconds. Once broken and heading for shore, the wave has been transformed from a progressive wave containing potential energy to a wave bore or wave of translation with kinetic energy, which can do work in the surf zone.

There are four major forms of wave energy in the surf zone - broken waves, swash, surf zone currents and long waves (Table 1.6).

- *Broken waves* consist of wave bores and perhaps reformed or unbroken parts of waves. These move shoreward to finally reach the shoreline where the bore immediately collapses and becomes swash.

- *Swash* runs up the beach as *uprush* to the upper limit of the swash, and end of the wave. Some soaks into the beach, while the remainder runs back down as *backwash*. Some of the backwash may reflect out to sea as a reflected wave, albeit a much smaller version of the original source.

Table 1.6 *Wave motions in the surf zone*

Wave form	Motion	Impact
Unbroken wave	orbital	stirs sea bed, builds ripples
Breaking wave	crest moves rapidly shoreward	wave collapses
Wave bore	bore moves shoreward	shoreward moving turbulence
Swash	runs up-down beach face	controls beach face accretion & erosion
Surf zone currents	water flows shoreward, longshore & seaward (rips)	moves water and sediment in surf, builds bars, erodes troughs
Long waves	slow on-off shore motion	determines location of bars & rips

- *Surf zone currents* are generated by broken and unbroken wave bores and swash. They include orbital wave motions under broken or reformed waves; shoreward moving wave bores; the uprush and backwash of the swash across the beach face; the concentrated movement of the water along the beach as a longshore current; and where two converging longshore or rip feeder currents meet, their seaward moving rip currents.

- The forth mechanism is a little more complex and relates to *long waves* produced by wave groups and, at times, other mechanisms. Long waves accompany sets of higher and lower waves. However, the long waves that accompany them are low (a few centimetres high), long (perhaps a few hundred metres) and invisible to the naked eye. As sets of higher and lower waves break, the accompanying long waves also go through a transformation. Like ocean waves they also become much shorter as they pile up in the surf zone, but unlike ocean waves, they do not break, but instead increase in energy and height toward the shore. Their increase in energy is due to what is called 'red shifting', a shift in wave energy to the red or lower frequency part of the wave energy field. These waves become very important in the surf zone, as their dimensions ultimately determine the number and spacing of bars and rips.

As waves arrive and break every few seconds, the energy they release at the break point diminishes shoreward as the wave bores decrease in height toward the beach. The energy released from these bores goes into driving the surf zone currents and into building the long waves. The long wave crest attains its maximum height at the shoreline. Here it is visible to the naked eye in what is called *wave set-up* and *set-down*. These are low frequency long wave motions with periods in the order of several times the breaking wave period (30 sec to a few minutes) that are manifest as the periodic rise (set-up) and fall (set-down) in the water level at the shoreline. If you sit and watch the swash, particularly during high waves, you will notice that every minute or two the water level and maximum swash level rise substantially then rapidly fall exposing the lower swash-inner surf zone.

The height of wave set-up is a function of wave height and also increases with larger waves and on lower gradient beaches, to reach as much as one-third to one-half the height of the breaking waves. This means that if you have 1, 2, 5 and 10 m waves, the set-up could be as much as 0.3, 0.6, 1.5 and 3.0 m high, respectively. For this reason, wave set-up is a major hazard on low gradient, high energy west coast beaches, such as Ocean Beach at Strahan.

Because the waves set up and set down in one place, the crest does not progress. They are therefore also referred to as a *standing wave*, one that stands in place with the crest simply moving up and down. These standing long waves are extremely important in the surf zone as they help determine the number and spacing of bars and rips, as is discussed in Chapter 2.

Tasmanian wave climate

Tasmania has three distinct wave climates. The very high energy west coast, the more sheltered low to moderate swell along the east coast, and the north coast which ranges from sheltered in the west to more exposed in the east. In addition the numerous large bays, particularly in the southeast, receive a range of generally low energy wind waves.

West coast

The Bureau of Meteorology maintains a Waverider buoy off Cape Sorell on the west coast. This buoy is exposed to all waves arriving on the west coast and records one of the world's highest energy wave regimes. The persistent passage of mid-latitudes cyclones and the long fetch, extending thousands of kilometres to South America, combine to produce long (12-14 s) swell that averages 3 m every day of the year, with a daily H_{max} of 5 m, meaning on average during every day some waves will reach 5 m. Figures 1.17 and 1.18 shows how high waves arrive year round, with the lowest months between November and January when waves average just over 2 m and peak at 4 m, followed by a gradual increase in height and period to a September maximum, when waves average about 4 m and peak at 6 m every day.

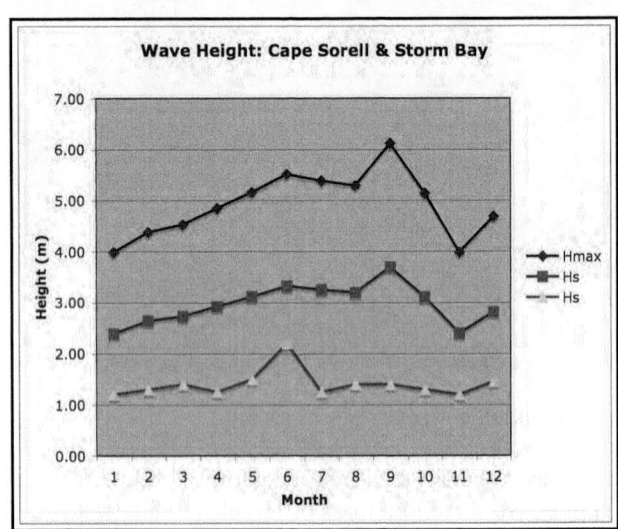

Figure 1.17 Monthly wave height at Cape Sorrell (upper) and Storm Bay (lower). Cape Sorrel data from Bureau of Meteorology.

North coast

The *north coast* is largely sheltered from the westerly swell by Hunter and King islands, and from easterly swell by Cape Barren and Flinders islands. As a result most wave energy is derived from the predominantly west through northerly winds that blow across the strait. Because of the location of the islands and orientation of the coast the fetch for the westerly winds increases to the east, in addition these winds tend to blow along and offshore in the west, and more onshore in the east. Therefore westerly waves range from low (<1 m) and short (< 4 s) in the west to longer and higher (2 m, 8 s) in

the east. Because waves are dependent on the prevailing winds they are closely correlated with the wind systems and range from high waves during westerly and northerly gales, to calms when winds are light or offshore.

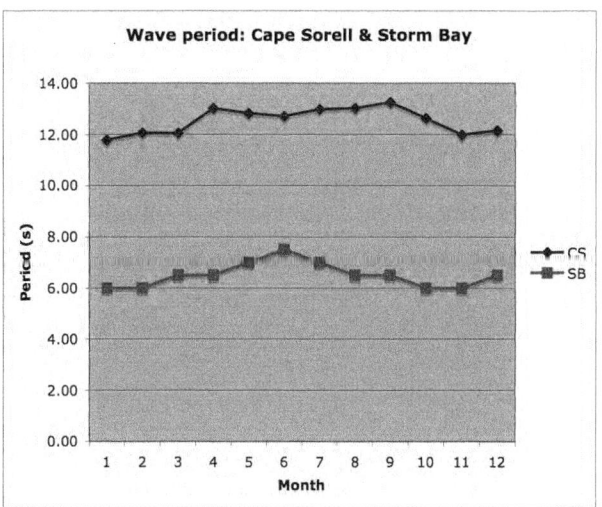

Figure 1.18 Monthly mean wave period for Cape Sorell) and Storm Bay (lower H_s) and period.

East Coast

The *east coast* receives waves from two major sources. First are the refracted westerly swell waves, which can arrive year round, but substantially reduced in height as they bend and travel up the coast. Second, are high easterly waves generated by east coast cyclones which tend to form several times during the year. Overall waves arrive from the south through east, averaging 1-1.5 m with a period of 10-14 s. These maintain a moderate wave climate, apart from sections sheltered by Maria Island.

Wave energy increases along the more exposed sections of the *southeast coast*, between Cape Pillar and South East Cape, as it becomes increasingly exposed to the prevailing westerly swell. Much of the coast is however indented and lies sheltered in Storm, Frederick Henry and Norfolk bays, or lies in the D'Entrecasteaux Channel in lee of Bruny Island. Only lowered refracted swell enters Storm and Frederick Henry bays, while Norfolk Bay and the D'Entrecasteaux Channel receive only wind waves. The waverider buoy in Storm Bay recorded a mean Hb of 1 m, with a short period of 6-7 sec (Figs. 1.17 & 1.18), indicating the dominance of the local wind waves over the westerly swell. The local waves climate therefore varies considerably around the southeast depending on exposure to the refracted westerly swell, the orientation of the shoreline and the extent of fetch to produce wind waves. Within the bays more exposed west- and south-facing shores tend to receive higher wind waves than the more sheltered east-facing shores.

Wave shoaling

To reach the shore deepwater swell and seas must cross the continental shelf and nearshore zone, and in doing so considerable wave transformation can take place depending on the width and depth of the shelf. In Tasmania two factors act to lower waves along parts of the coast.

Bedrock: The Tasmanian coast is predominantly rocky which results in numerous headlands, rocks, reefs, islets together with more than 100 islands around the coast and strait. All islands, rocks, reefs and headlands will block and intercept ocean waves and cause wave breaking, shoaling and refraction, resulting in lower energy waves in their lee.

Low nearshore gradients: Shallow continental shelves and low nearshore gradient result in wave attenuation, the shallower the water the greater the attenuation. In Bass Strait the relatively shallow sea floor (30 90 m depth) is shallower than most continental shelves and precludes the development of large waves. In the northwest between Woolnorth Point and Stanley, particularly in lee of Robbins Island, are extensive areas of low nearshore gradients and tidal flats. The low gradients result in greater wave attenuation and lower waves at the shore.

The breaker wave climate, as opposed to the deepwater wave climate, is therefore a function of the deepwater wave height, less the amount of wave energy (and height) lost as the waves cross the continental shelf and nearshore zone. This loss can range from near zero on deep, steep shelves, to 100% on wide and/or shallow shelves, particularly along the western Bass Strait coast. As a consequence breaker wave energy around Tasmania ranges from very high along exposed west coast beaches to very low in the sheltered northwest and the southeast bays.

Freak waves, king waves, rogue waves and tidal waves

Freak waves do not exist.

All waves travel in wave groups or sets. A so-called 'freak', 'king' or 'rogue' wave is simply the largest wave or waves in a wave group. The fact that these waves can also break in deep water, due to over steepening, also adds to their demeanour.

Unusually high waves are more likely in a sea than a swell. For this reason they are more likely to be encountered by yachtsmen, the so-called rogue wave, than surfers or rock fishermen.

Tidal waves arrive on the Tasmanian coast twice each day. These are related to the predictable movement of the tides and not the damaging *tsunamis* with which they are sometimes confused. Tidal waves are discussed in the next section.

Tides

Tides are the periodic rise and fall in the ocean surface due to the gravitational force of the Moon and the Sun acting on a rotating Earth. The amount of force is a function of the size of each and their distance from the Earth. While the Sun is much larger than the Moon, the Moon exerts 2.16 times the force of the Sun because it is much closer to earth. Therefore, approximately two-thirds of the tidal force is due to the Moon and are called the *lunar* tides. The other one-third is due to the Sun and these are called *solar* tides.

Because the rotation and orbit of the Earth and the orbit of the Moon and Sun are all rigidly fixed, the *lunar* tidal period, or time between successive high or low tides, is an exact 12.4 hours; while the *solar* period is 24.07 hours. As these periods are not in phase, they progressively go in and out of phase. When they are in phase, their combined force acts together to produce higher than average tides, called *spring tides*. Fourteen days later when they are 90° out of phase, they counteract each other to produce lower than average tides, called *neap tides*. The whole cycle takes 28 days and is called the lunar cycle, over a lunar month.

The actual tide is in fact a wave, more correctly called a *tidal wave*, and not to be confused with tsunamis. They consist of a crest and trough, which are hundreds of kilometres apart. When the crest arrives it is called *high tide* and the trough *low tide*. Ideally, the tidal waves would like to travel around the globe. However the varying size, shape and depth of the oceans, plus the presence of islands, continents, continental shelves and small seas complicate matters. The result is that the tide breaks down into a series of smaller tidal systems that rotate around an area of zero tide called an *amphidromic point*. In the Southern Hemisphere, the Coriolis force causes the tidal waves to rotate in a clockwise direction while they are anticlockwise in the Northern Hemisphere.

Tides in the deep ocean are zero at the amphidromic point and average less than 20 cm over much of the ocean. However three processes cause them to be amplified in shallow water and at the shore. The first is due to shoaling of the tidal waves across the relatively shallow (< 150 m deep) continental shelf. Like breaking waves they are amplified due to wave shoaling processes and increase in height (tide range). In the relatively shallow Bass Strait (30-90 m depth) the tides are amplified up to 3 m along most of the Bass Strait shoreline. Secondly, when two tidal waves arrive from different directions and converge, they may be amplified, as occurs as the tidal waves enter Bass Strait from the east and west. Finally, in certain large embayments the tidal wave can be amplified by a process of wave resonance, which causes the tide to reach heights of over 4 m as in the upper Tamar estuary.

Tides are classified as being micro-tidal when their range is less than 2 m, meso-tidal between 2 and 4 m, macro-tidal 4-8 m and mega-tidal when greater than 8 m, with

Australia's highest tides in King Sound (11 m), while the world's highest are in Canada's Bay of Fundy, which reach 14 m.

Tasmanian Tides

Tasmania experiences micro-tides around the east, southeast and west coasts where the mean spring range varies from a low of 0.6 m at Bramble Cove to 1.4 m on Swan Island and 1.5 m on King Island. They are amplified to meso-tides along the north coast, where they generally exceed 3 m and reach an absolute maximum tide range of 4.4 m at Launceston.

Tasmania experiences a substantial variation in both the tide range and the time of its arrival (Fig. 1.19; Table 1.7) which is a product of several factors. The tidal wave arrives from the east reaching Swan Island in the northeast coast up to 1 hour ahead of Hobart. It then moves clockwise around the southeast coast and up the west coast arriving 1.5 hours later at Cape Sorell and Pieman River. All the open coast tides are low (<1.3 m spring range), reflecting the relatively narrow, steep continental shelf. In Macquarie Harbour the narrow entrance restricts the tide inside to a range of about 0.3 m.

In Bass Strait the tides undergo considerable modification. The wave entering from the east is slowed considerably as it encounters the shallow strait, taking 5 hours to pass Flinders Island. In the meantime the part of the wave moving round the coast enters western Bass Strait 5 hours later, the two wave fronts meeting in Bass Strait. At the same time the relatively shallow strait leads to an amplification of the tide up to 3 m mean, and 4.4 m maximum, resulting in meso-tide conditions along most of the north coast, including parts of Flinders Island.

Tidal currents

Tidal currents are generally weak on the open east, south and west coasts, but strengthen considerably into inlets and estuaries such as Macquarie Harbour. The currents are strongest in Bass Strait because of the higher tide range and more constricted flow, especially around and between islands and into and out of the numerous inlets and estuaries.

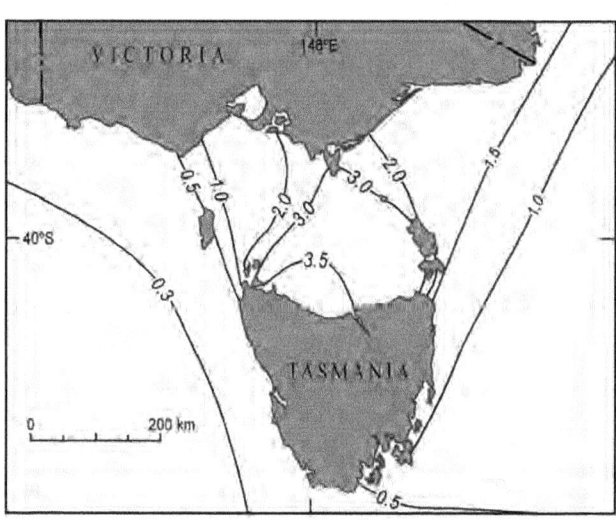

a.

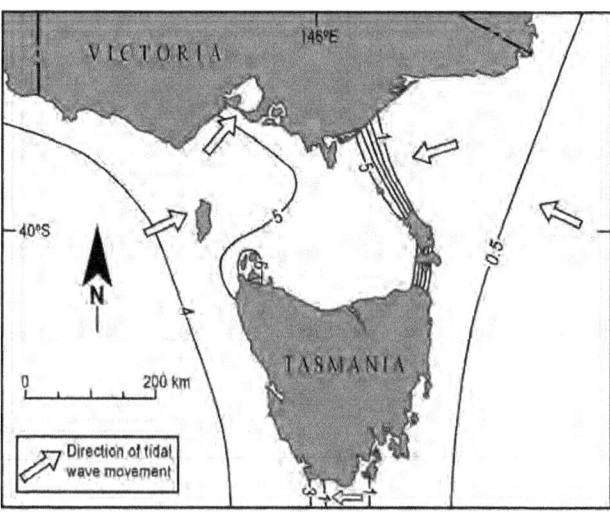

b.

Figure 1.19 Co-range and co-tidal lines for the Tasmanian coast. (a) Co- range indicates the spring tidal range in metres, which is highest in Bass Strait. (b) the co-tidal refers to the relative time of arrival. The tidal wave enters Bass Strait from the east as well as moving clockwise around the coast to enter the strait 5 hours later from the west.

Table 1.7 Tidal characteristics of Tasmanian ports

Location	Mean spring high tide (m)	Mean spring low tide (m)	Mean spring tide range (m)	Relative time of arrival 0 hr=Hobart - = before, (subtract) + = after (add)
East Coast				
Swan Is	1.4	0.2	1.2	+0.55
Eddystone	1.3	0.0	1.3	+0.02
Falmouth	1.4	0.2	1.2	+0.09
Bicheno	1.6	0.3	1.3	+0.11
South East				
Coles Bay	1.2	0.1	1.1	+0.03
Spring Bay	1.3	0.2	1.1	-0.02
Pirates Bay	1.1	0.0	1.1	-0.08
Impression Bay	1.3	0.0	1.3	+0.02
Hobart	1.5	0.2	1.3	0.00
West Coast				
Maatsuyker Is	1.2	0.0	1.2	+0.24
Bramble Cove	0.8	0.2	0.6	+0.51
Cape Sorell	1.0	0.1	0.9	+1.29
Granville Harbour	1.2	0.3	0.9	+1.25
Pieman River	1.1	0.2	0.9	+1.01
North Coast				
Three Hummocks	2.3	0.3	2.0	+0.44
Stanley	3.3	0.7	2.6	
Burnie	3.2	0.6	2.6	
Devonport	3.2	0.7	2.5	
Georgetown	3.1	0.7	2.4	
Launceston	3.9	0.9	3.0	+0.52
King Island				
Grassy	1.5	0.1	1.4	-0.14
Surprise Bay	1.5	0.1	1.4	-0.32
Flinders Island				
Big River Cove	2.7	0.6	1.9	-0.08
Lady Barron Hbr	1.6	0.3	1.3	-0.24

Other oceanographic processes

Shelf waves

Shelf waves are periodic oscillations in sea level that occur along the coast. Across the southern Australian coast there are two additional meteorologically driven sources of sea level oscillations, one a progressive wave, the other a standing wave. The progressive shelf waves move from west to east across the southern coast, with a period between waves of 5 to 20 days, that is, the time between crest and trough. They simultaneously reach the southern half of the west Australian coast and move across the southern coast, through Bass Strait and around Tasmania and on to eastern Australia and Macquarie Island. These waves raise sea level, for a few days at a time, by as much as 1 m, but more normally 50 cm or less.

The second standing wave type is more seasonal, with periods of several months, and affects the entire coast simultaneously, that is, they stand against the coast. These can also result in sea level oscillations, as much as 0.5 m. As tides on the open coast are normally of the order of a few decimetres, these waves can cause abnormally high or low tides, depending on whether the crest or trough is at the coast. They also make it difficult for the casual observer to determine the actual height of the tide.

Tsunamis received considerable attention following the 2004 Boxing Day tsunami in Aceh. While Australia receives low tsunamis generated along tectonic boundaries in the Pacific, Indian and even Southern oceans, no major damaging tsunami has been recorded in Australia since European settlement. Furthermore no evidence has been found to indicate such tsunamis may have impacted the Australian coast during the past several thousand years.

Ocean currents

Ocean currents refer to the wind-driven movement of the upper 100 to 200 m of the ocean. The major wind systems blowing over the ocean surface drive currents that move in large ocean gyres, spanning millions of square kilometres. The dominant current south of Australia is the great Antarctic Circumpolar Current, which runs westerly at relatively high speed (1-3 knots), driven by the strong westerly wind stream. This current runs continuously around the southern oceans, centred between 50° and 60°S, well south of the continent and Tasmania. Between the main current and the southern Australian coast, the currents, while still predominantly westerly, decrease in velocity owing to increasing distance from the main westerly wind-stream, more variable wind direction and the impact of the relatively shallow continental shelf. Closer to the coast the currents

become increasingly dependent on local winds, which are still predominantly westerly. In the Tasmanian region the currents are further influenced by the shallow Bass Strait. Figure 1.20 illustrates how the westerly currents flow though the strait and out over the eastern side where they cascade down the continental slope and mix with warmer waters of the East Australian Current.

Other currents

There are several other forms of ocean currents driven by winds, density, tides, shelf waves and ocean waves. It is not uncommon to have several operating simultaneously. Each will have a measurable impact on the overall current structure and must be taken into account if one needs to know the finer detail of the coastal currents, their direction, velocity and temperature. Around the Tasmanian coast, in addition to the ocean and tidal currents, the next most important are those associated with the shelf waves and wind-driven upwelling and downwelling. The latter are associated with regional winds, including sea breezes.

Along the southern and east coasts strong west through southwest winds push the surface waters to the left (north) causing a piling up of warmer ocean water at the coast which downwells to return seaward, while on the west coast the reverse will happen with the water being pushed offshore and cooler upwelling occurring. When strong northerly to easterly winds prevail, the water is also pushed to the left (west) pushing the warmer surface away from the shore, particularly along the south and east coast, which is replaced at the shore by the upwelling of cooler, deeper bottom water. At the same time on the west coast the northerly winds push water towards the shore causing downwelling.

Sea surface temperature

The sea temperature around the Tasmanian coast is a product of four main processes: first, the latitudinal location of the coast between 39.5° and 42.5°S determines the overhead position of the sun and the amount of solar radiation available to warm the ocean water; second, the Circum-polar current brings cool water to the west and south coasts; third, the East Australia Current brings warmer waters south along the entire east coast; and fourth, the wind-driven impact of upwelling and downwelling.

On a seasonal basis, the summer water temperature ranges are in high teens (18°-19°C), while during winter they cool to 12°-13°C. In all seasons the temperatures are highest in Bass Strait decreasing to the south and west (Fig. 1.21).

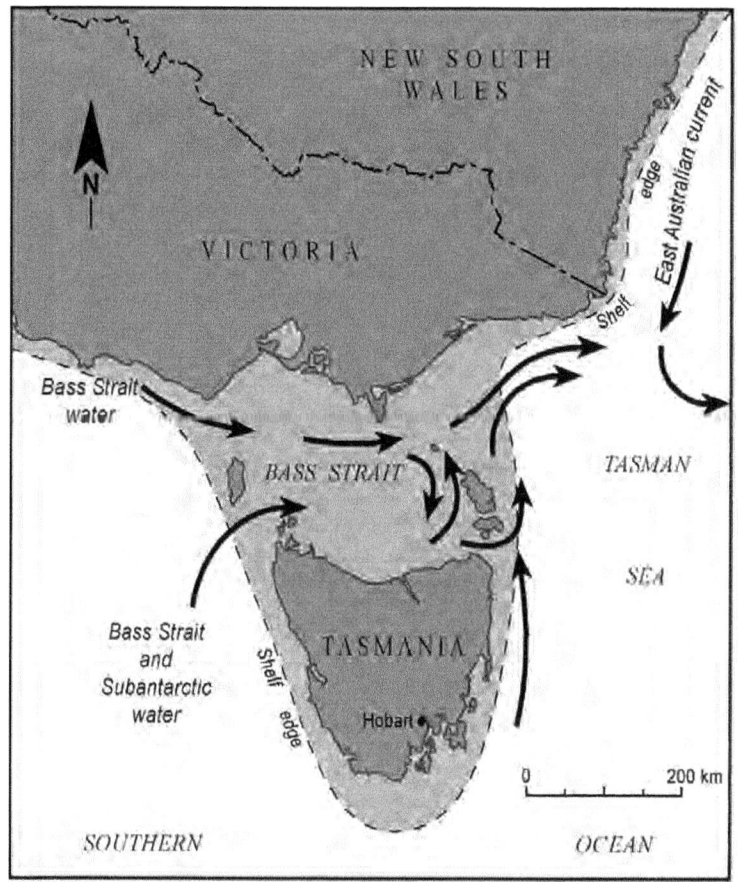

Figure 1.20 Major ocean currents impacting Tasmanian include the cooler Bass Strait waters moving west into the strait, and the warmer East Australian Currents waters which originate in the tropics.

Salinity

All oceans and seas contain dissolved salts derived from the erosion of land surfaces over hundreds of millions of years. Chlorine and sodium dominate and, together with several other minerals, account for the dissolved 'salt'. The salts are well-mixed and globally average 35 parts per thousand, increasing slightly into the dry sub-tropics and decreasing slightly in the wetter latitudes. Tasmania's well mixed oceans and seas maintain a relatively uniform salinity, with the only major changes occurring at river mouths and in large bays such as Macquarie Harbour which are diluted with freshwater.

Sea Surface Temperature (°C)

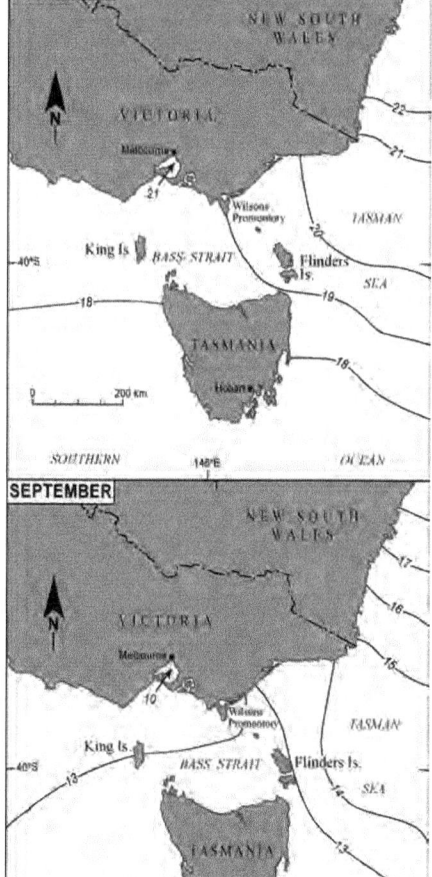

Figure 1.21 Tasmanian sea surface temperatures reach 18-19°C in summer, dropping to 12-13°c in winter

Biological processes

Biological processes are important around the entire Tasmanian coast and continental shelf. The temperate climate and cooler ocean waters promote a range of ecosystems, including extensive high tide salt marshes and giant subtidal kelp meadows, while the cooler temperatures exclude mangroves from the entire state. The island is however surrounded by a relatively narrow continental shelf that is rich in carbonate sediments, which along the northern west coast and western north coast contribute on average 25% of the beach and dune sediments.

Coastal dune vegetation

Coastal dunes occur around the entire Tasmanian coast. All dunes are vegetated by a predictable succession of plants beginning with herbs and grasses on the foredunes (Fig. 1.22), grading landward into a combination of shrublands, then eucalyptus woodlands and forests. The following overview of Tasmania's coastal dunes is taken from

Australia Beach Safety and Management Program

Kirkpatrick (1991) and Kirkpatrick and Harris (1999), who provide an excellent review of all of Tasmania's coastal vegetation communities. In Tasmania the nature of this distribution is also controlled regionally by the geology and exposure. The south and west coast is high energy, exposed to westerly winds which carry salt spray inland and dominated by quartz sands low in nutrients. The north and east coasts are lower energy and more fertile, while the southeast is dominated by the dolerite. The following lists some of the major plant communities and species found on dunes around the coast.

Primary stabilisers and foredunes species (grasses and succulents):

Most foredunes accumulate around *Spinifex sericeus, Ammophila arenaria* and *Austrofestuca littoralis,* together with some *Leucophyta brownii* and *Cakile edentula* and *C. maritima* (sea rocket) together with the native salt bushes *Atriplex billardierei* and *Chenopodium glaucum.* In many areas particularly in the east and north these have been invaded by the exotic *Ammophila arenaria* (marram grass), which excludes the native *Austrofestuca littoralis* (festuca) and *Spinifex sericeus.* Furthermore the tall marram grass causes a steepening of the dunes resulting in higher peaked dunes, compared to the native grasses, which result in lower and more rounded dunes.

On the south and east coasts *Carpobrotus rossii* (pigface), *Acaena pallida, Actites megalocarpa* (beach sowthistle) and *Stackhousia spathulata* (black stackhousia) are commonly associated with *Austrofestuca littoralis* on the foredunes.

Secondary stabilisers and hind dune species (shrubs and trees):

Shrubs and trees dominate inland of the active foredune. The most common species in the far northwest and northeast is *Leptospermum laevigatum* (tea tree). It occurs in association with *Ozothamnus turbinatus* (coastal everlasting daisy), *Olearia axillaris* (coastal daisy), *Acacia sophorae* (coastal wattle), *Correa alba* (coastal correa) and *Myoporum insulare* (coastal boobialla). Further inland *L. laevigatum* occurs with *Leucopogon parviflorus* (coastal beard heath) and occasionally *Acacia sophorae* or *Callitris rhomboidea.*

Eastern and northern successional dune zonation is typically:

Foredune grassland: *Austrofestuca littoralis,* with *Spinifex sericeus* or *Poa poiformis* (beach poa) tussock grassland. The *Poa* also occurs on some cliffed and rocky coasts.
Closed shrub: *Acacia sophorae-Myoporum insulare*
Open shrub: *Banksia marginata*
Open forest: *Eucalyptus viminalis* (ribbon gum)

On the larger west coast hind dunes *Leptospermum laevigatum* occurs as closed shrub on the dunes, with *Carex appressa* (dune sedge) tussock sedgeland in some

of the swales. Further inland the older parabolic dunes are covered by *Eucalyptus nitida.*

a.

b.
Figure 1.22 A low vegetated foredune at Taylors Beach (T 80) (a); and a higher hummocky foredune in the Peron dunes (T 103) (b).

Beach ecology

All tropical and temperate beaches house organisms living on and in the beach between the sand grains. The basis of beach ecosystems is the microscopic diatoms (phytoplankton) that live in the water column and microscopic meiofauna that live on and between sand grains including bacteria, fungi, algae, protozoa and metazoa. Feeding on these are larger organisms that live in the sand, including meiofauna such as small worms and shrimp and filter-feeding benthos such as molluscs and worms. In the water column they are also preyed upon by zooplankton such as amphipods, isopods, mysids, prawns and crabs. At the top of the food chain are the fish and sea birds, and the occasional mammals such as dolphins, dugongs, turtles and whales. High energy south and west coast beaches can house a high diversity and density of organisms and export nutrients to the coastal ocean.

A number of hard-bodied organisms also contribute their skeletal material to the beach in the form of sediment. When all organisms die, their internal and/or external skeletons can be broken up, abraded and washed onto beaches by waves.

Shelf biota

The biota of the southern Australian continental shelf makes a major contribution to the adjacent coast. The shelf contains a range of distinctive habitat assemblages grading from the inner, mid to outer shelf and including the upper continental slope (Fig. 1.23).

The shallow (30-70 m) *inner shelf* is dominated by wave action and contains a range of hard-bodied organisms, particularly molluscs, red algae, encrusting bryozoans, echinoids and soft kelps and sponges. Wave abrasion

occurs across the inner shelf permitting erosion and transport of the carbonate detritus. The mid to outer shelf and slopes are dominated by a range of *Bryozoan* species. The *mid shelf* (70-130 m depth) is reworked by shoaling waves and is a zone of carbonate production and accumulation. The *outer shelf* (130-180 m depth) is only reworked during storm wave conditions and contains finer bioclastic sands. The top of the *continental slope* (180-350 m depth) has extensive bryozoan/sponge/coral communities, which lead to the accumulation of muddy skeletal sands.

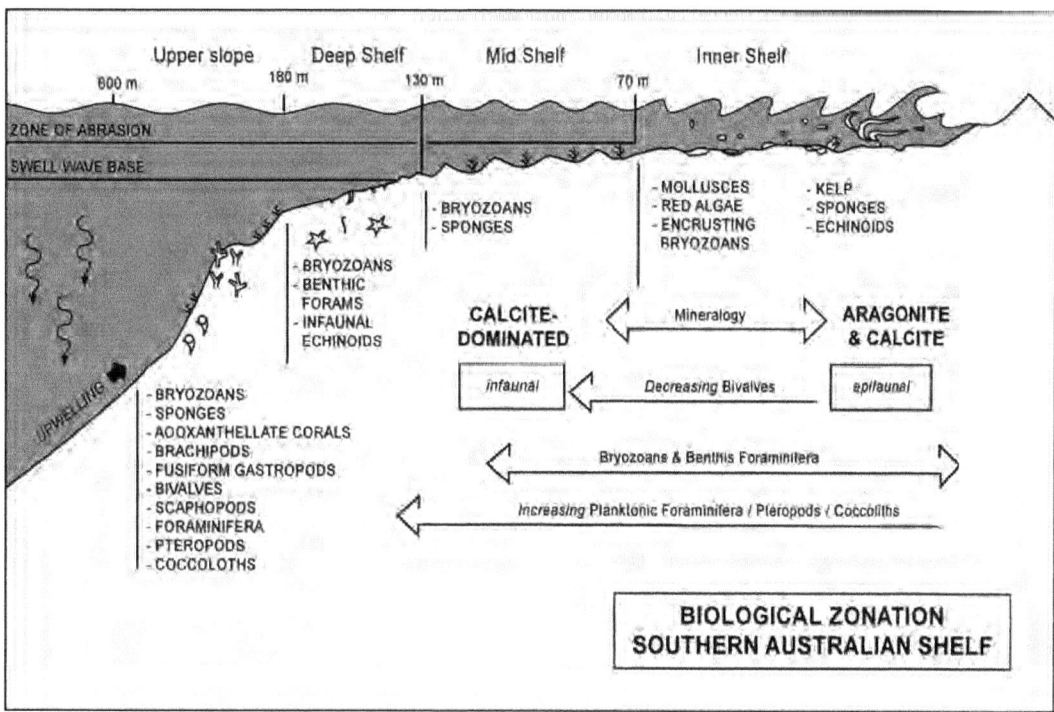

Figure 1.23 Typical shelf biota and zonation across a section of the South Australian continental shelf. Similar zonation exists across the high energy southern Australian continental shelf (Boreen, et al., 1993).

This massive area of carbonate production, commonly referred to as the shelf carbonate factory, is all the more important because during rising sea level massive volumes of carbonate detritus is reworked shoreward by waves and deposited as carbonate enriched beaches and dunes that occur along much of the northern west coast, western north coast and King Island. In addition, at present sea level sediment can continue to be moved shoreward from the shallow inner shelf region continuing the supply of shelf carbonate sand to the beaches.

Figure 1.7 illustrates the distribution of carbonate sediments around the Tasmanian continental shelf. The coast is rimmed by either pure quartz sediments, particularly in the south, and by mixed quartz-carbonate sediments. Carbonate-rich sediments however dominate the mid to outer shelf and contribute substantially to the high energy west, southeast and east coasts. In Bass Strait a mixture of quartz and carbonate sands surrounds King and Flinders islands, with the only area of muddy sediments in the deeper central strait region. The proportion of carbonate material in the beach sediments is listed in Table 1.8.

Table 1.8 Regional characteristics of Tasmanian beach sands (source Davies, 1978)

Region	Mean size (mm)	Sorting	% Carbonate
East coast - north	0.25	0.56	5.0
East coast - south	0.23	0.46	7.2
Southeast bays	0.18	0.47	4.6
South coast	0.22	0.39	20.3
West coast - south	0.24	0.39	12.8
West coast - north	0.22	0.43	24.1
North coast - west	0.19	0.53	24.5
North coast - east	0.28	0.72	20.3
Tasmania (mean)	0.22	0.49	18.8

2 BEACH SYSTEMS

Beaches throughout the world consist of sediment deposited by waves between the base of wave activity and the limit of wave run-up or swash. The entire *beach system* includes the dry (subaerial) beach, the swash and intertidal zone, the surf zone and, beyond the breakers, the nearshore zone (Fig. 2.1). Usually only the dry beach and swash zone are clearly visible, while bars and channels are often present in the surf zone but are obscured below waves and surf, and the nearshore is always submerged. The shape of any surface is called its morphology, hence *beach morphology* refers to the shape of the beach, surf and nearshore zone (Fig. 2.2).

Beach Morphology

As all beaches are composed of sediment deposited by waves, beach morphology reflects the interaction between waves of a certain height, length and direction and the available sediment: whether it be sand, cobbles or boulders, together with any other boundaries such as headlands, reefs and inlets.

Tasmanian beaches can be very generally divided into three groups: wave-dominated, tide-modified and tide-dominated. The *wave-dominated* beaches occur around the entire open east, south and west coasts, where they are exposed to persistent ocean swell and waves and low tides (<2 m). They are the dominant beach type accounting for 91.4% of all beaches. The tide-modified and tide-dominated beaches occur along the meso-tide range Bass Strait coast and in some of the sheltered southeast bays, where waves are very small. The *tide-modified* beaches are usually exposed to the prevailing seas in the areas of higher tide range and contribute 3.7%, while the *tide-dominated* are protected from high waves and become increasingly dominated by the tides resulting in a mix of beach and tidal flats, and account for 4.9%. The remainder of this chapter is devoted to a description of the higher energy wave-dominated beaches, followed by the tide-modified and tide-dominated beaches.

In two dimensions beaches consist of three zones: the subaerial beach, the surf zone and the nearshore zone, however the nature and extent of these zones varies considerably between the high wave energy beaches of the west coast and the sheltered low wave beaches of the west north coast and the larger southern bays (Fig. 2.2).

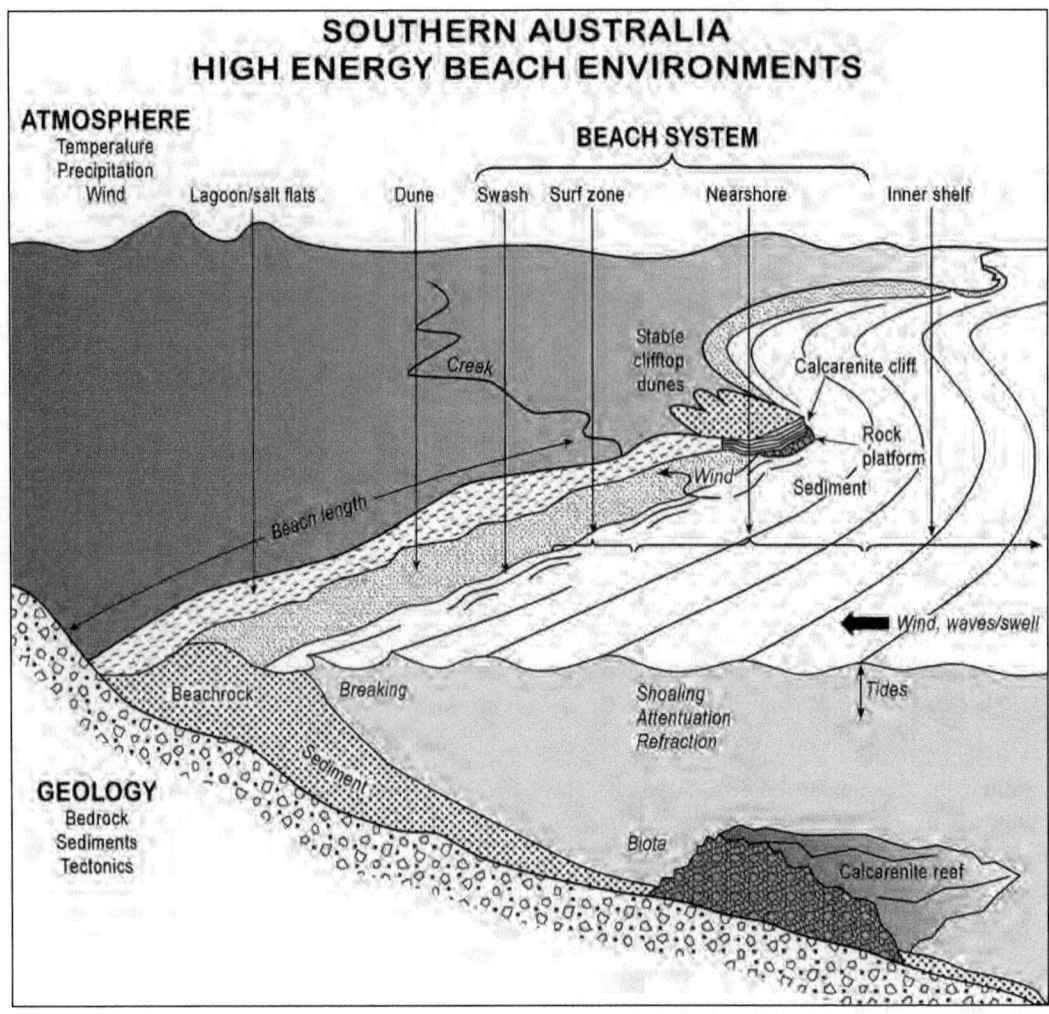

Figure 2.1 The beach system resides at the interface of the ocean, land and atmosphere, and is affected by all three together with input from the rich coastal biota.

Figure 2.2 Examples of a high energy (WI 9 left) and lower energy (T 40 right) Tasmanian beach systems.

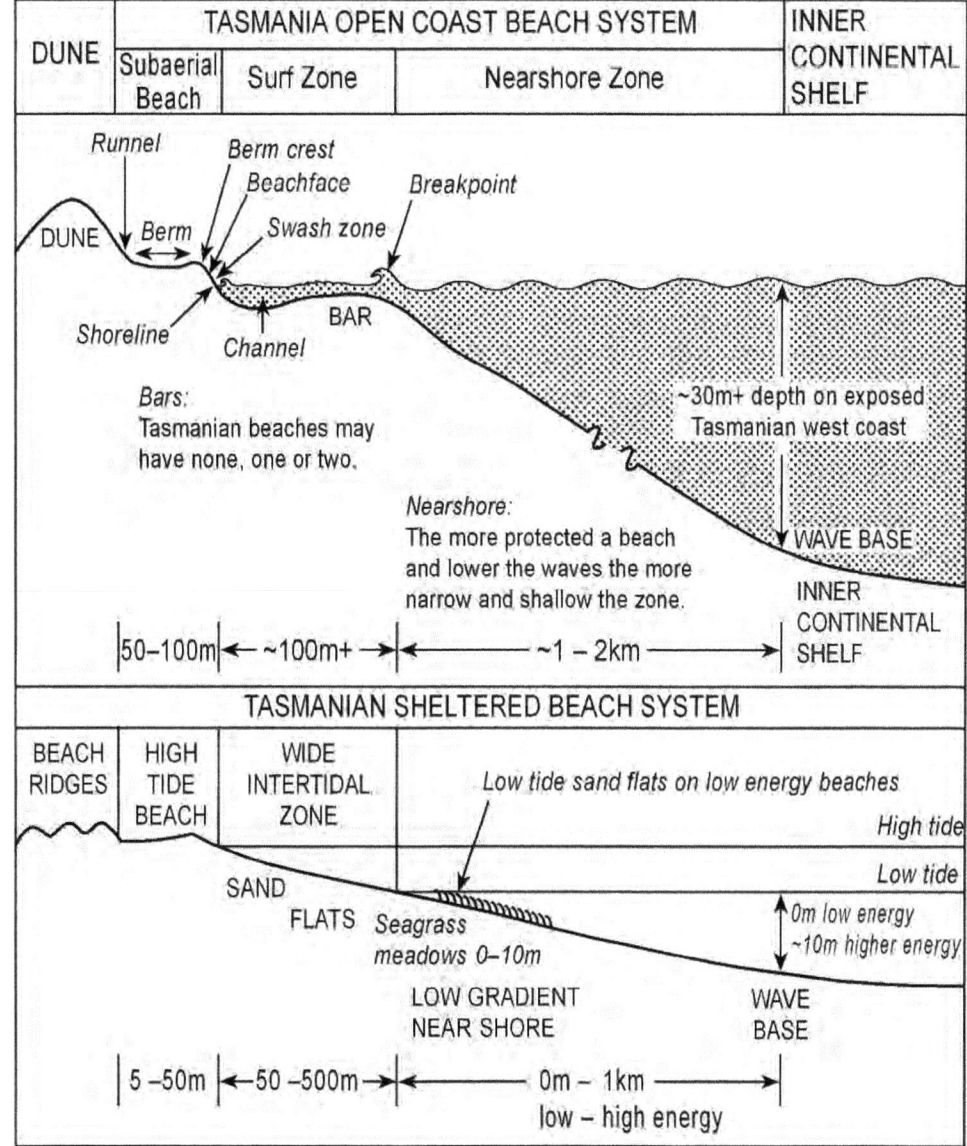

Figure 2.3 The higher energy open coast beaches (upper) consist of the dry subaerial beach above the shoreline, the surf zone containing bars, troughs and breaking waves, and the nearshore zone which extends seaward of the breaker zone out to modal wave base. Wave base is the depth to which ocean waves can move beach sands. Seaward lies the inner continental shelf. The approximate width and depth of each zone are indicated. In the more protected northwest and some larger bays (lower) the lower waves and higher tide result in a lower gradient and shallower beach, intertidal and nearshore zone, with wave base as shallow as low tide.

Australian Beach Safety and Management Program

Subaerial Beach

The *subaerial beach* is that part of the beach above sea level, which is shaped by wave run-up or swash. It starts at the shoreline, the intersection of the land and sea, and extends up the relatively steep swash zone or beach face, and may be backed by a flatter berm or cusps, which in turn may be backed by a runnel, where the swash reaches and collects at high tide. Behind the upper limit of spring tide and/or storm swash usually lies the edge of dune vegetation, which marks the rear of the beach. The dry beach varies in width from tens of metres on high energy wave-dominated beaches, to a few metres on very low energy tide-dominated beaches. The subaerial beach is that part which most people go to and consider 'the beach'. However, the real beach is far more extensive, in places extending several kilometres seaward, with the subaerial beach forming the figurative 'tip of the iceberg'.

Swash or intertidal zone

On wave-dominated beaches the swash zone connects the dry beach with the surf. The swash zone is the steeper part of the shoreline across which the broken waves run up and down, as swash or run-up and backwash. It also shifts with the tide as the shoreline moves up and down the beach. As wave height decreases and tide range increases, this zone tends to become flatter and considerably wider and is termed the intertidal zone on tide-modified to tide-dominated beaches. In areas of higher tide range it may beach several hundred metres in width.

Surf zone

The *surf zone* extends seaward of the shoreline and out to the area of wave breaking. This is one of the most dynamic places on earth. It is the zone where waves are continuously expending their energy and reshaping the seabed. It can be divided into the area of wave breaking, often underlain by a bar, and immediately shoreward, the area of wave translation where the wave bore (white water) moves toward the shoreline, transforming along the way into surf zone currents and, at the shoreline, into swash. Surf zones are up to 500 m wide on exposed west Tasmanian wave-dominated beaches, where waves average 3 m and break across a double and even triple bar system. They decrease in width and bar number as wave height decreases. On lower energy tide-modified beaches the surf zone is usually narrow and transient with the tide, while it is often nonexistent on tide-dominated beaches.

Nearshore zone

On wave-dominated beaches the *nearshore zone* is the most extensive part of the beach. It extends seaward from the outer breakers to the maximum depth at which average waves can mobilise beach sediment and move it shoreward. This point is called the *wave base*, referring to the base of wave activity. On the high energy west coast, where waves commonly reach several metres, it usually lies at a depth between 30 and 50 m and may extend 1, 2 or even 3 km out to sea. It decreases in depth and width as wave height decreases. On tide-modified beaches it is

usually at most a few metres deep, while on tide-dominated beaches it may terminate at low tide. A good indicator of its outer limit on sheltered lower energy shores is the fringe of the seagrass meadows, usually extending seaward of low tide.

Three dimensional beach morphology

In three dimensions, wave-dominated beaches become more complex. This is because most beaches vary alongshore, but do so in a predictable manner.

Beaches vary longshore on two scales. First, they are usually swash-aligned, meaning they are aligned parallel to the crest of the dominant wave. If the wave crest is refracted or bends as it approaches the shoreline, owing to the presence of obstacles such as reefs, rocks and headlands, then the beach will also be shaped to fit the wave crest. The overall effect of the refracting wave crests is to cause a spiral or curvature in the shape of the beach, so that the curvature increases toward the more protected end. This bending of the wave crests is called *wave refraction* (Fig. 2.4a), while the loss of wave energy and height is called *wave attenuation* (Fig. 2.4b). The decrease in wave height along the beach results in lower breakers, a narrower and shallower surf zone, a narrower and often steeper swash zone and a lower and narrower subaerial beach.

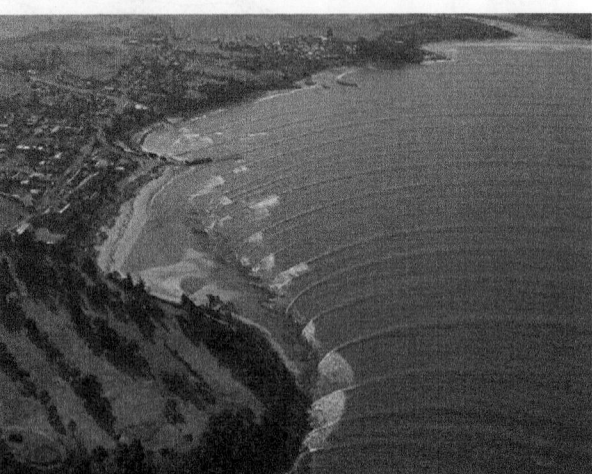
a.

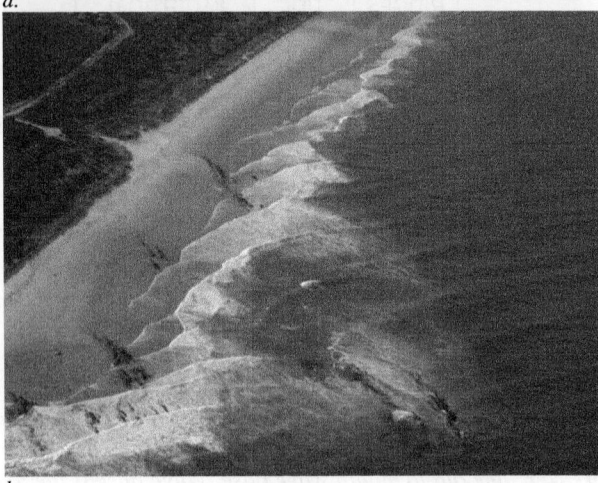
b.

Figure 2.43 a) Wave refraction around Waterloo Point at Swansea (T 196); b) wave breaking and refracting over the Paddys Island reef (T 110) (W. Hennecke).

Tasmanian beaches are usually bordered by headlands and reefs. They average 0.7 km in length, half the Australian average of 1.37 km. As a result there is considerable opportunity for these hard boundaries to influence the size and direction of waves arriving at many beaches and consequently the shape of the beach.

The second scale of longshore beach variation relates to any and all undulations on the beach and in the surf zone, usually spaced from a few metres to as much as 500 m or more on very high energy beaches. Variable longshore forms produced at this scale include regular beach cusps located in the high tide swash zone and spaced between 20 and 40 m, and all variation in rips, bars, troughs and any undulations along the beach, usually with spacing of between 200 and 500 m. These features are associated with rip circulation and are known as rip channels, crescentic and transverse bars, and megacusp horns and embayments. Each of these and their associated beach type and characteristics are described in section 2.3.

Beach Dynamics

Beach dynamics refers to the dynamic interaction between the breaking waves and currents and the sediments that compose the beach. In the long term (tens to thousands of years) this interaction builds all beaches and contributes sand to form backing dune systems. It can also ultimately erode these beaches. In the shorter term (days to months) changing wave conditions produce continual changes in beach response and shape, as sand is moved onshore (beach accretion) and offshore (beach erosion), together with the associated movement of the shoreline, bars and channels.

Five factors determine the character of a beach. These are the size of the sediment, the height and length or period of the waves, the characteristics of any long waves present in the surf zone and the tide range. The impact of each is briefly discussed below.

Beach sediment

The size of beach sediment determines its contribution to beach dynamics. Unlike in air where all objects fall at the same speed, sediment falls through water at a speed proportional to its size. Very fine sediment, like *clay*, will simply not sink but stay in suspension for days or weeks, causing turbid muddy water. *Silt*, sediment coarser than clay but finer than sand, takes up to two hours to settle in a laboratory cylinder (Table 2.1). As a consequence these fine sediments usually stay in suspension through the energetic surf zone and tidal inlets and are carried out to sea to settle in deep water on the continental shelf or beyond.

Sand takes between a few seconds for coarse sand, to five minutes for very fine sand, to settle through 1 m of water. For this reason it is fine enough to be put into suspension by waves, yet coarse enough to settle quickly to the seabed as soon as waves stop breaking. In the

energetic breaking wave environment, anything as fine or finer than very fine sand stays in continual suspension and is flushed out of the beach system into deeper, quieter water. This is why ocean beaches never consist of silts or mud. Most beaches consist of fine through coarse sand because it can be transported in large quantities to the coast and settle fast enough to remain in the energetic surf zone.

Table 2.1	Sediment size and settling rates	
Material	Size - diameter	Time to settle 1 m
clay	0.001-0.008 mm	hours to days
silt	0.008-0.063 mm	5 min to 2 hours
sand	0.063-2 mm	5 sec to 5 min
cobble	2 mm-6.4 cm	1 to 5 sec
boulder	> 6.4 cm	< 1 sec

Two hundred and fifty Tasmanian beaches described in this book consist of cobbles and boulders (Fig. 2.5). *Cobbles* and *boulders* require substantial wave or current energy to be lifted or moved and then settle immediately. They are therefore only rarely moved, such as during extreme storms, and then only very slowly and over short distances. Consequently, Tasmanian beaches containing such coarse sediment always have a nearby source, such as an eroding cliff or bluff or may lie at the mouth of gravel streams.

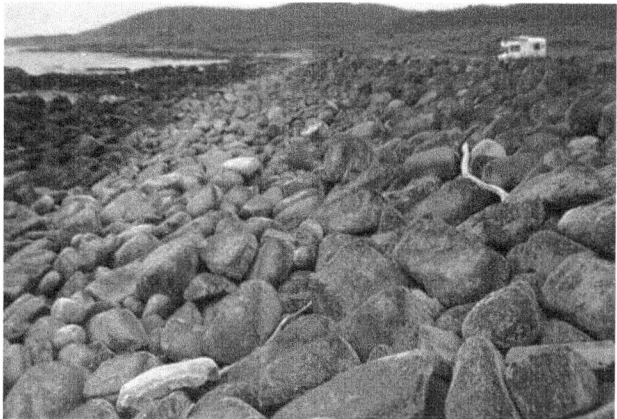

Figure 2.5 Mariposa Beach (T 121) is composed of boulders and located adjacent to the Tasman Highway

Depending on the nature of its sediment, each beach will inherit a number of characteristics. Firstly, the sediment will determine the mineralogy or composition of the beach. Sediment derived from the land via rivers and creeks is usually quartz sand or silica. In Tasmania quartz sand dominates the entire coast, averaging 80% and reaching 95% in the southeast bays. Carbonate sands, predominantly composed of shell fragments, are secondary, peaking at 25% on the north west coast (Table 1.8). Secondly, the size of the sediment will, along with waves, determine beach shape and dynamics. Fine sand produces a low gradient (1-3°) swash zone, wide surf zone and potentially more mobile sand. Medium to coarse sand beaches have a steeper gradient (4-10°), a narrower surf zone and less mobile sand. Cobble and boulder beaches are not only very steep (> 8°), but they have no surf zone and are usually immobile. Therefore, identical

waves arriving at adjacent fine, medium and coarse sediment beaches will interact to produce three distinctly different beaches. Most Tasmanian beach sands are fine to medium ranging from a mean of 0.17-0.28 mm (Table 1.8).

Likewise, three beaches having identical sand size, but exposed to low, medium and high waves, will have three very different beach systems. Therefore, it is not just the sand or waves, but the interaction of both, along with long waves and tides that determine the nature of our beaches.

Wave energy - long term

Waves are the major source of energy to build and change beaches. Seaward of the breaker zone, waves interact with the sandy seabed to stir sand into suspension and, under normal conditions, slowly move it shoreward. The wave-by-wave stirring of sand across the nearshore zone and its shoreward transport have been responsible for the delivery of all the sand that presently composes the beaches and coastal sand dunes of Tasmania.

The rate of sand supply is positively related to the wave height. The higher the waves, the greater the depth from which they can transport sand and the faster they can transport it. Consequently, high wave energy beaches can deliver the largest volumes of sand and potentially supply sand to build the biggest dunes. Along parts of the west and northeast Tasmanian coasts, massive amounts of up to 100,000 m^3 of sand have been transported onshore for every metre of beach.

Lower waves can only transport sand from shallow depths and at slower rates. Consequently, they build smaller barrier systems, usually delivering less than 10,000 m^3 for every metre of beach, as is typical of more sheltered parts of the coast. These beaches are also less dynamic, more stable and are less likely to be eroded.

Wave energy - short term

Waves are not only responsible for the long-term evolution of beaches, but also the continual changes and adjustments that take place as wave conditions vary from day to day. As noted above, a wave's first impact on a beach is felt as soon as the water is shallow enough for wave shoaling to commence, usually in less than 30 m water depth. As waves shoal and approach the break point, they increasingly interact with the seabed and undergo a rapid transformation, which results in the waves becoming slower and shorter, but higher, and ultimately breaking, as the wave crest overtakes the trough.

As waves break, they release kinetic energy, energy that may have been derived from the wind some hundreds or even thousands of kilometres away. This energy is released as turbulence, sound (the roar of the surf) and even heat. The turbulence stirs sand into suspension and carries it shoreward with the wave bore. The wave bore

decreases in height shoreward, eventually collapsing into swash as it reaches the shoreline.

Breaking waves, wave bores and swash, together with unbroken and reformed waves, all contribute to a shoreward momentum in the surf zone. As these waves and currents move shoreward, much of their energy is transferred into other forms of surf zone currents, namely longshore, rip feeder and rip currents, as well as long waves and associated currents. All this water has to return seaward and does so through three related mechanisms. It may simply reflect off the beach face and travel seaward as a reflected wave. It may flow sideways into a rip current, which then flows rapidly seaward, or it may contribute to the growth of standing (long) waves against the shoreline, which return water seaward via bed return flow, which plays a major role in shaping the surf zone. All three mechanisms are discussed in the following sections.

It is therefore the variation in waves and sediment that produces the seemingly wide range of beaches present along the coast, ranging from the steep, narrow, protected beaches to the broad, low gradient beaches with wide surf zones, large rips and massive breakers. Yet every beach follows a predictable pattern of response, largely governed by its sediment size and prevailing wave height and length. The types of beaches that can be produced by waves and sand are discussed below.

Beach Types

Beach type refers to the prevailing nature of a beach, including the waves and currents, the extent of the nearshore zone, the width and shape of the surf zone, including its bars and troughs, and the dry or subaerial beach. *Beach change* refers to the changing nature of a beach or beaches along a coast as wave, tide and sediment conditions change.

The first comprehensive classification of wave-dominated beaches was developed by the Coastal Studies Unit (CSU) at the University of Sydney in the late 1970s, followed by the first investigation of tide-dominated beaches at Cable Beach, Broome in 1980. The *wave-dominated* classification is now used internationally, wherever tide range is less than 2 m. In Australia it applies to most of the southern coast, from Fraser Island in the east around to Exmouth Peninsula in the west, and covers most of Tasmania. In the early 1990s the CSU undertook research along the central Queensland coast, which together with the earlier Broome investigations resulted in the identification of a range of *tide-modified* and *tide-dominated* beach types, most of which occur in Tasmania. Based on this work the full range of Tasmanian wave-dominated, tide-modified and tide-dominated beach types is summarised in Tables 2.2, 2.3 & 2.4, together with two additional types where rocks and/or reefs dominate the intertidal zone. In the following sections each of the beach types is described, together with examples and photographs of the twelve beach types that occur around the Tasmanian coast.

Table 2.2 Tasmanian beaches by number and length

	Beach Type	Number	Number %	Mean length (km)	Ω (km)	Total length (km)	Length (%)	Beach type (%)
	Wave-dominated							91.4
1	Reflective	786	61.9	0.52	1.18	406.6	46.3	
2	Low tide terrace	174	13.7	0.78	1.54	134.7	15.3	
3	Transverse bar & rip	193	15.2	1.34	2.46	258.5	29.4	
4	Rhythmic bar & beach	2	0.2	0.2		0.4	-	
5	Longshore bar & trough							
6	Dissipative	1	-			0.2	-	
	Tide-modified							3.7
7	R+LTT	28	2.2	0.6	0.9	16.91	1.9	
8	R+LT rips	1	0.1	0.25	-	0.25	0.0	
9	Ultra dissipative	8	0.6	1.98	1.97	15.85	1.8	
	Tide-dominated							4.9
10	R+sand ridges	33	2.6	0.53	0.74	17.6	2.0	
11	R+sand flats	35	2.8	0.64	0.78	22.3	2.5	
12	Retial flats	2	0.2	1.7	-	3.4	0.4	
13	R+mud flats							
	Beach+rock flats							
14	R+rock flats	7	0.6	0.18	0.05	1.25	0.1	0.1
		1269	100.0			877.9	100	100

Table 2.3 Tasmanian island beaches by number and length [1]

	Beach Type	Number	Number %	Mean length (km)	Ω (km)	Total Length (km)	Length (%)	Beach type (%)
	Wave-dominated							73.1
1	Reflective	88	25.3	0.41	3.84	36.0	10.4	
2	Low tide terrace	45	12.9	0.77	1.07	34.8	10.0	
3	Transverse bar & rip	58	16.7	1.90	2.94	110.1	31.8	
4	Rhythmic bar & beach	14	4.0	4.69	7.19	65.6	19.0	
5	Longshore bar & trough							
6	Dissipative	1	0.3	6.70	-	6.7	1.9	
	Tide-modified							0
7	R+LTT							
8	R+LT rips							
9	Ultra dissipative							
	Tide-dominated							20.7
10	R+sand ridges	23	6.6	0.85	1.59	19.6	5.7	
11	R+sand flats	49	14.1	0.61	0.93	29.9	8.6	
12	R+tidal flats	13	3.7	1.69	1.69	22.0	6.4	
13	R+mud flats							
	Beach+rock flats							
14	R+rock flats	57	16.4	0.37	0.33	21.1	6.1	6.1
		348	100			346	100.0	100

[1] Maria, Bruny, Robbins-Walker, King, Flinders.

Table 2.4 Tasmanian beach types by coastal regions (1-7) and major islands[1]

Beach type	1	2	3	4	5	6	7	M Is	B Is	R-W	K Is	F Is	Total
1 Reflective	56	100	164	128	91	125	119	15	19	1	10	43	871
2 Low tide terrace	58	42	15	30	27	3	2	1	9	1	22	12	222
3 Transverse bar & rip	45	7	14	65	55		6		17	3	19	19	250
4 Rhythmic bar & beach	1			1						4	2	8	16
5 Longshore bar & trough													0
6 Dissipative				1						1			2
7 R+LTT						24	4						28
8 R+LT rips						1							1
9 Ultra dissipative						8							8
10 R+sand ridges			32			2			20	3			57
11 R+sand flats			28			6		1	17	3		28	83
12 R+tidal flats						2		1		5		7	15
13 R+mud flats													0
14 R+rock flats			3	1		3		1	12		27	17	60
Total	160	149	256	226	173	174	131	19	94	21	80	134	1613

[1] 1 North East; 2 East; 3 South East Bays; 4 South West; 5 North West; 6 North coast: West; 7 North coast: East; Maria Is; Bruny Is; Robbins-Walker Is; King Is; Flinders Is.

Wave-dominated beach types

Wave-dominated beaches consist of three types: reflective, intermediate or dissipative, with the intermediate having four states as indicated in Figures 2.6 and 2.7. In Tasmania all wave-dominated beach types occur on the open coast (Tables 2.2 & 2.3).

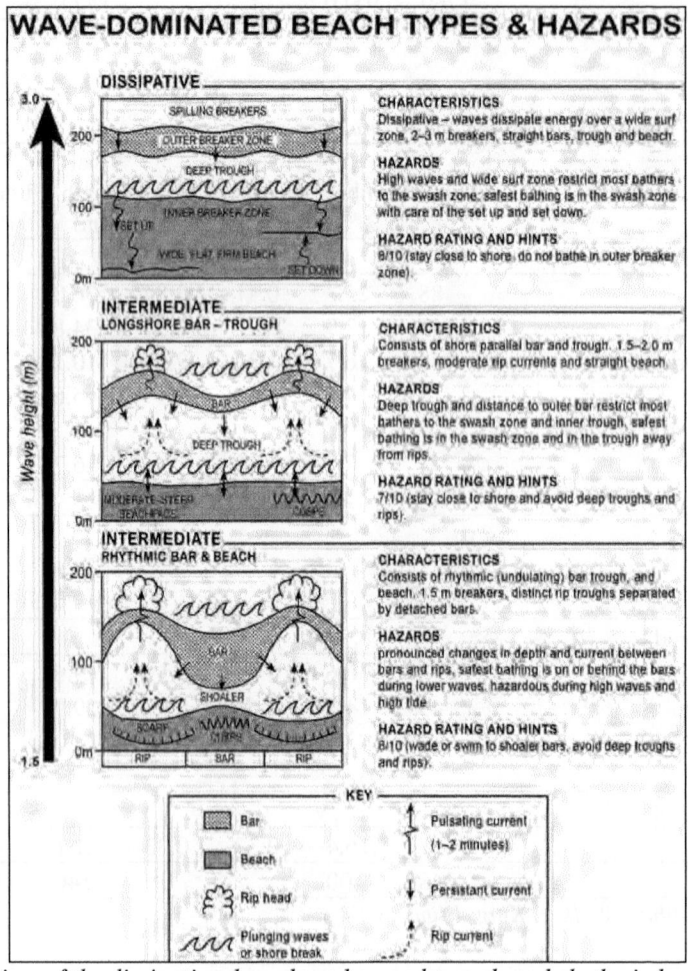

Figure 2.6 A plan view of the dissipative, longshore bar and trough and rhythmic bar and beach types. As wave height increases between the rhythmic and dissipative beaches, the surf zone increases in width, rips initially increase and then are replaced by other currents, and the shoreline becomes straighter. The physical characteristics and beach and surf hazards associated with each type are indicated, as well as its beach hazard rating.

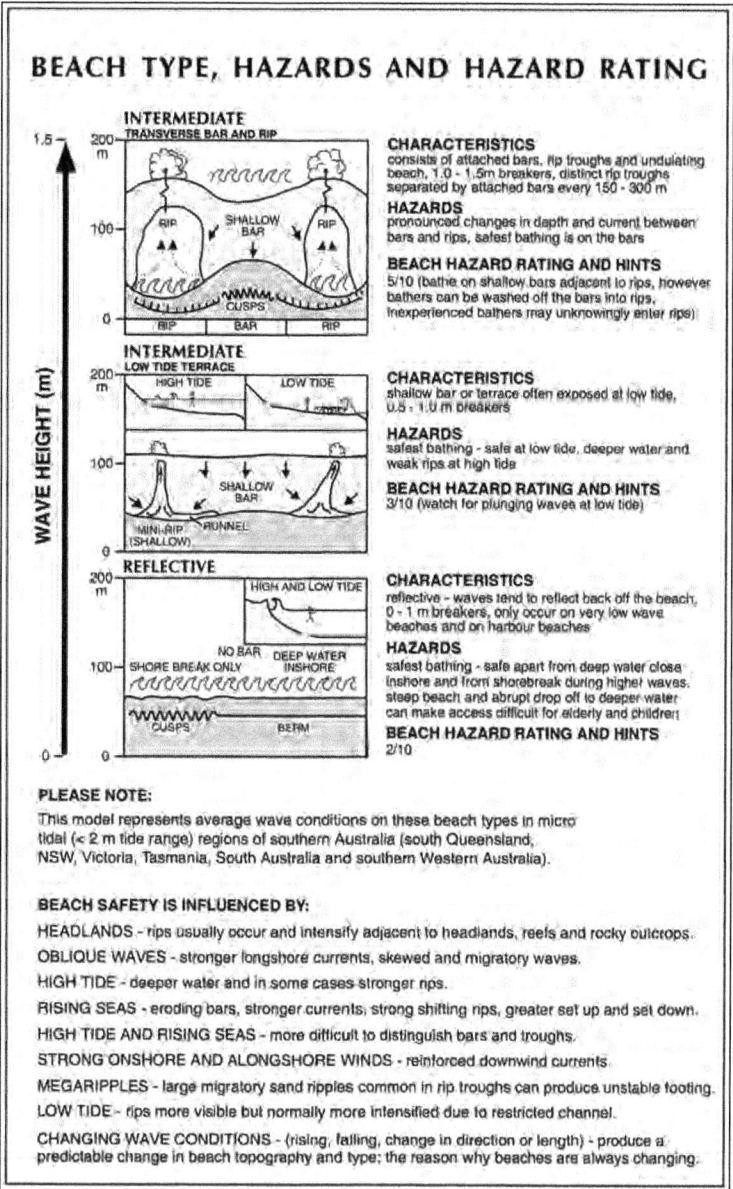

Figure 2.7 A plan view of the transverse bar and rip, low tide terrace and reflective beach types. As wave height increases between the reflective and transverse beaches, the surf zone and bar increase in width, rips form and increase in size, and the shoreline becomes crenulate. The physical characteristics and beach and surf hazards associated with each type are indicated, as well as its beach hazard rating.

Dissipative beaches (D)

Dissipative beaches occur where a combination of high waves and fine sand ensures that they have wide surf zones and usually two to occasionally three shore-parallel bars, separated by subdued troughs. The beach face is composed of fine sand and is always wide, low and firm, firm enough to support a 2WD drive car. In Tasmania there are only two fully dissipative beaches, at Lousy Bay in the southwest (T 582) and Back Banks on Robbins Island (RI 4). In addition there are four more beaches with a dissipative outer bar and lower energy inner bar types. Their rarity on the coast is a product of the lack of fine sand, as there are numerous beaches with waves high enough for forming this beach type, but only if the sand is also fine enough.

On dissipative beaches waves begin breaking as spilling breakers on the outer bar, which reform to break again and perhaps again, on the inner bar or bars. In this way they dissipate their energy across the surf zone, which may be up to 300-500 m wide (Fig. 2.8). This is the origin of the name 'dissipative'.

In the process of continual breaking and re-breaking across the wide surf zone, the incident or regular waves decrease in height and may be indiscernible at the shoreline. The water and energy contained in the wave at the break point is gradually transferred in crossing the surf zone to a lower frequency movement of water, called a standing wave. This is known as red shifting, where energy shifts to the lower frequency, or red end, of the energy spectrum.

a.

b.

Figure 2.8 a) High energy swell dominated dissipative beach with 600 m wide surf zone and waves averaging over 3 m every day, Ocean Beach (Strahan T 792); and b) dissipative sea dominated Bass Strait beach on Robbin Island (RI 4).

At the shoreline, the standing wave is manifest as a periodic (every 60 to 120 seconds) rise in the water level (set-up), followed by a more rapid fall in the water level (set-down). As a rule of thumb, the height of the set-up is 0.3 to 0.5 times the height of the breaking waves (i.e. 1-1.5 m for a 3 m wave). Because the wave is standing, the water moves with the wave in a seaward direction during set-down, with maximum flow and velocity (1-2 m per second) closer to the seabed, called bed return flow. As the water continues to set down, the next wave is building up in the inner surf zone, often to a substantial wave bore, 1 m plus high. The bore then flows across the low gradient beach face and continues to rise, as more water moves shoreward and sets up. This process continuously repeats itself every one to two minutes.

Because of the fine sand and the large, low frequency standing wave, the beach is planed down to a wide, low gradient, with the high tide swash reaching to the back of the beach, often leaving no dry sand to sit on at high tide.

Dissipative beach hazards

The wide surf zones and high waves associated with dissipative beaches keep most swimmers in the inner

swash and surf zone. They are relatively safe close inshore, while the mid to outer surf zone is only for the fittest and most experienced surfers.

Dissipative beach hazards

Most people do not venture far into dissipative surf zones as they are put off by their extremely wide surf and high outer breakers. However, if you do, this is what to watch out for:

- Outer surf zone - spilling breakers. Bigger sets break well seaward and catch surfers inside.

- Troughs - usually on/offshore currents, but chance of longshore and even rip currents, particularly under lower (< 1.5 m) wave conditions.

- Inner surf zone - watch for standing wave bores that can knock you over, fortunately shoreward. Set-down produces an often strong seaward flow, particularly closer to the sea bed, which may also drag children off their feet.

- Swash zone/beach face - this is where most bathers stay and where most get into trouble, owing to the set-up and set-down. Be aware that water level will vary considerably between set-up and set-down, and currents will reverse from onshore to offshore. At best you will be knocked over by the incoming bore, at worst you might be dragged seaward by the set-down. Children in particular are most at risk. Some young children, even babies in prams and parked cars, have been left on a seemingly safe part of the beach face, only to have a higher than usual set-up engulf them in water.

- **Summary:** Dissipative beaches are dangerous. In Tasmania they only occur in a few locations, but are more frequent when the seas are very big, so most people don't consider swimming, or at least not beyond the swash zone. Definitely for experienced swimmers and surfers only.

Intermediate beaches

Intermediate beaches refer to those beach types that are intermediate between the higher energy dissipative and lower energy reflective beaches. They tend to require waves greater than 0.5 m and can accommodate the highest waves along the west coast, which average 3 m, combined with fine to medium sand. The most obvious characteristic of intermediate beaches is the presence of a surf zone with bars and rips. On the Tasmanian coast 369 (29%) of the beaches are intermediate, while on the major islands 117 (38%) are intermediate. They are most common around the more exposed east and west coasts, and on Bruny, Robbins-Walker, King and Flinders islands, and less frequent on the north coast. In most locations they are however secondary to the lower energy reflective beaches (Table 2.3).

As intermediate beaches are produced by waves between 0.5 m and 2 m plus, they exist in a wide range of waves and associated beach conditions. For this reason, intermediate beaches are classified into four beach states. The lowest energy state is called *low tide terrace*, then as waves increase, the *transverse bar and rip*, then the *rhythmic bar and beach*, and finally the *longshore bar and trough*. Each of these beaches is briefly described below.

Longshore bar and trough (LBT)

The *longshore bar and trough* beach type does not occur as a modal inner bar type in Tasmania and will not be further discussed. For more information on this beach type see descriptions in Short (1993, 1996, 2000 and 2001).

Rhythmic bar and beach (RBB)

The *rhythmic bar and beach* type is the highest energy intermediate beach type that occurs in only two mainland locations, at Red Rocks in the northeast (T 53) and Abeona Head in the southwest (T 604). They are more common on Walker (4), King (2) and particularly Flinders (8) islands. The sixteen beaches total 20 km in length and represent 1.6% of the sandy coast. These energetic beaches occur where waves average at least 1.5 m and sand is fine to medium (Fig. 2.7).

Figure 2.9 High energy rhythmic bar and beach at Four Mile Beach (T 816). Note the waves breaking on the outer rhythmic bar and widely spaced rips.

Rhythmic bar and beaches consist of a rhythmic longshore bar that deepens where the rips cross the breaker zone, and in between broadens, shoals and trends shoreward, called a crescentic bar. It does not, however, reach the shore, with a continuous trough between the bar and beach occupied by shore-parallel rip feeder currents feeding the rips to either side of the bar. The shoreline is usually rhythmic with protruding megacusp horns in lee of the crescentic bar sections and commonly scarped megacusp embayments behind the rips. The surf zone may be up to 100-250 m wide and the bars, rips and megacusps spaced every 250-500 m alongshore.

The shallower crescentic sections of the rhythmic bar cause waves to break more heavily, with the white water flowing shoreward as a wave bore. The wave bore flows across the bar and into the backing rip feeder channel. The water from both the wave bore and the swash piles up in the rip feeder channel and starts moving sideways toward the adjacent rip embayment, which may be up to 200 m alongshore. The feeder currents are weakest where they diverge behind the centre of the bar, but pick up in velocity and intensity toward the rip, particularly close to shore. In addition, the rip feeder channels deepen toward the rip.

In the adjacent deeper rip channels, waves break less or often not at all. They may move unbroken across the rip to finally break or surge up the steeper rip embayment swash zone. The strong swash often causes slight erosion of the beach face and cuts an erosion scarp.

In the rip embayment, the backwash returning down the beach face combines with flow from the adjacent rip feeder channels. This water builds up close to shore as a standing wave (called wave set-up), then pulses seaward (sets-down) as a strong, narrow rip current. The currents pulse every 30 to 90 seconds, depending on wave conditions. The rip current accelerates with each pulse and persists with lower velocities between pulses. Rip velocities are usually less than 1 m per second (3.5 km/h), but will increase up to 2 m per second in confined channels and under higher waves.

To identify this beach type look for the pronounced longshore beach rhythms, i.e. the shoreline is very sinuous. The shallowest, widest bars and heaviest surf lie off the protruding parts of the shore (the megacusps). Water flows off the bars, into the feeder channel, along the beach to the deeper rip embayment, then seaward in the rip current.

Rhythmic bar and beach hazards

This is the most hazardous beach type commonly occurring on the Tasmanian coast. Most people are put off entering the surf by the deep longshore trough containing rips and their feeder currents. If you are swimming or surfing in a rhythmic bar and beach system, the following highlights some common hazards.

Rhythmic bar and beach hazards

- Bar - just to reach the bar requires crossing the rip feeder channel. This may be an easy wade at low tide or a difficult swim at high tide. Be very careful once the water exceeds waist depth, particularly if a current is flowing. Also, as you reach the bar, water pouring off the bar may wash you back into the channel.
- The centre of the bar is relatively shallow at low tide, but at high tide you run the risk of being washed into the rip feeder or rip channel.
- Rip feeder channel - depth varies with position and tide, both depth and velocity increase toward the rip.

- Rip - the rip channel is usually 2 to 3 m deep, with a continuous, but pulsating, rip current.
- High tide - deeper bar and channels, but weaker currents and rips.
- Low tide - waves break more heavily and may plunge dangerously, shallower bar and channels, but stronger currents and rips.
- Oblique waves - skew bar and rips alongshore.
- Higher waves - intensify wave breaking and strength of all currents.
- Summary: Caution is required by the young and inexperienced on rhythmic beaches, as the bar is separated from the beach by often deep channels and strong currents.

Transverse bar and rip (TBR)

The *transverse bar and rip* type is the most common and extensive of the intermediate beach types in Tasmania. There are 193 (25%) mainland and 58 (17%) island beaches of this type, which as a result of their above average length (1.34 and 1.9 km) occupy 29% of the mainland and 32% of the island sandy coasts, a total length of 368 km. These beaches are dominated by rips and are the location of most of Tasmania's beach rips. While the rips have an average spacing of 280 m they have a large standard deviation of 500 m owing to the variable level of wave energy around the coast, as discussed below.

Figure 2.10a High energy transverse bar and rip beaches, with the bars attached to the shore, separated by deep rip channels (arrows), near Lagoon River (T 825); b) Granite Beach (T 570).

Rip currents

Beach rips: Rip currents are a relatively narrow, seaward moving stream of water flowing over or through the sand bar (Fig. 2.11). They represent a mechanism for returning water back out to sea that has been brought onshore by breaking waves. They originate close to shore as the shoreward moving broken waves and wave bores are deflected alongshore at the shoreline. This water moves along the base of the beach as rip feeder currents. On normal beaches, two currents arriving from opposite directions usually converge in the rip embayment, turn and flow seaward across the bar and through the surf zone. The currents usually maintain a deeper rip feeder trough close to shore and a deeper rip channel cut into the bar and through the surf zone.

The converging feeder currents turn, accelerate and flow seaward through the surf zone, either directly or at an angle at speeds up to 1.5 m per second. As the confined rip current exits the surf zone and flows seaward of the outer breakers, it expands and may meander as a larger rip head. Its speed decreases and it will usually dissipate within a distance of two to three times the width of the surf zone.

Rip currents will exist in some form on ALL beaches where there is a surf zone, particularly when waves exceed 1 m. In Tasmania they occur right around the coast (Table 2.5) wherever there is surf, but are far more prevalent on the moderate energy east coast and northeast coast, the high energy west coast, as well as on Bruny, King and Flinders islands. On average 1695 beach rips are operating around the coast and islands each day. The largest rips occur along the most exposed northwest coast where they average 480 m, the largest average rip spacing in Australia and similar to high energy southern Australian coast beaches. Elsewhere they range from 320 m on the southwest coast, to around 250 m for most other locations, similar to southeast mainland Australia.

Topographic rips: Headlands and reefs in the surf can induce a strong seaward flow of water, called 'topographically controlled rip' or 'topo-rip'. During big seas these rips can expand to occupy an entire beach embayment and form large 'megarips', that is large scale topographically controlled rips. There are approximately 600 permanent topographic rips located around the Tasmanian coast and main islands, occurring on all coasts with surf and headlands and/or surf zone reefs, but most prevalent along the west coast primarily (Fig. 2.12).

In total, Tasmania and its main islands have about 1695 beach and 600 topographic rip systems operating on a typical day. Whereas the beach rips may shift slightly in location, the topographic rips are fixed in location.

Table 2.5 *Tasmanian rip systems*

Region	Number beaches	Beach rips	Mean spacing (m)	Ω Spacing (m)	Topo. rips
1 North East	34	292	247	21	68
2 East	15	159	247	29	59
3 South East	9	76	239	31	32
4 South West	22	88	318	67	116
5 North West	19	161	482	88	124
6 North coast West	5	15	150	0	62
7 North coast East	20	321	210	41	40
Sub total	124	1112			501
Maria Is	1	10	250	0	2
Bruny Is	7	66	250	0	16
Robbins-Walker Is	6	29	425	43	9
King Is	15	170	233	57	50
Flinders Is	14	308	235	48	21
Sub total	43	583			98
Total	167	1695			599

a. b.

Figure 2.11 a) Rip current and meandering rip head at Miles Beach (BI 10); b) large beach rip in well developed rip embayment at Sandy Cape beach (T 849).

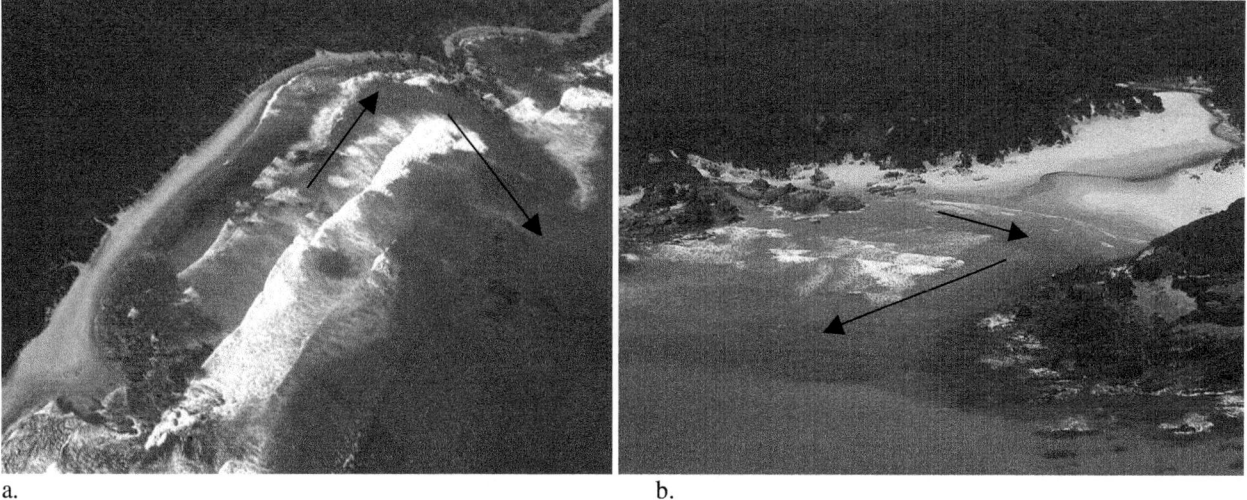

a. b.

Figure 2.12 Topographic rips at a) Whitehorses beach (T 733); and b) Waller Creek (T 765).

```
┌─────────────────────────────────────────────────┐
│               Rip current spacing                │
│                                                   │
│  •  spacing approximately = surf zone width x 4   │
│  •  in Tasmania rip spacing averages 280 m, ranges from │
│     150 to 500 m                                  │
│  •  also a function of beach slope, the lower the slope │
│     (hence wider the surf zone), the wider the rip spacing │
└─────────────────────────────────────────────────┘
```

TBR beaches are discontinuous alongshore as the alternation of shallow bars and deeper rip channels causes a longshore variation in waves breaking across the surf zone. On the shallower bars waves break heavily losing much of their energy. In the deeper rip channels they will break less and possibly not at all leaving more energy to be expended as a shorebreak at the beach face. Consequently, across the inner surf zone and at the beach face, there is an alternation of lower energy swash in lee of the bars and higher energy swash/shorebreak in lee of the rips.

The longshore variation in wave breaking and swash causes the beach to be reworked, such that slight erosion usually occurs in the embayments in lee of the rips and slight deposition in lee of the bars. This results in a rhythmic shoreline, building a few metres seaward behind the attached bars as deposition occurs and being scoured out and often scarped in lee of the rips. The rhythmic undulations are called megacusp horns (behind the bars) and embayments (behind the rips). Whenever you see such rhythmic features, which have a spacing identical to the bar and rips (150 to 500 m), you know rips are present.

The TBR surf zone has a cellular circulation pattern. Waves tend to break more on the bars and move shoreward as wave bores. This water flows both directly into the adjacent rip channel and, closer to the beach, into the rip feeder channels located at the base of the beach. The water in the rip feeder and rip channel then returns seaward in two stages. Firstly, water collects in the rip feeder channels and the inner part of the rip channel, building up a hydraulic head against the lower beach face. Once high enough, it pulses seaward as a relatively narrow accelerated flow, the rip. The water usually moves through the rip channel, out through the breakers and seaward for a distance up to twice the width of the surf zone.

The velocity of the rip currents varies tremendously. However, on a typical beach with waves less than 1.5 m, they peak at about 1 m per second, or 3.5 km per hour, about walking pace. However, under high waves they may double that speed. What this means is that under average conditions, a rip may carry someone out from the shore to beyond the breakers in 20 to 30 seconds. Even an Olympic swimmer going at 2 m per second would only be able to maintain their position, at best, when swimming against a strong rip.

Two other problems associated with rips and rip channels are their depth and their rippled seabed. The channel is usually 0.5 to 1 m deeper than the adjacent bar, reaching maximum depths of 3 m. Furthermore the faster seaward flowing water forms megaripples on the floor of the rip channel. These are sand ripples 1 to 2 m in length and 0.1 to 0.3 m high that slowly migrate seaward. The effect of the deeper water and ripples on swimmers is to provide both variable water depth in the rip channels and a soft sand bottom, compared to the more compact bar. As a result, it is more difficult to maintain your footing in the rip channel for three reasons: the water is deeper, the current is stronger and the channel floor is less compact. Also, someone standing on a megaripple crest that is suddenly washed or walks into the deeper trough, may think the bottom has 'collapsed'. This may be one source of the 'collapsing sand bar' myth, an event that cannot and does not occur.

Transverse bar and rip beach hazards

TBR beaches are one of the main reasons many Tasmanian beaches have good surf. However, the good surf is also a hazard to the unwary swimmer and most rescues and drowning occur with this beach type. The shallow bars tempt people into the surf, while lying to either side are the deeper, more treacherous rip channels and currents.

```
┌─────────────────────────────────────────────────┐
│                 TBR beach hazards                 │
│                                                   │
│  •  Bars - the centre of the attached bars is the best place │
│     to swim. They are shallow, furthest from the rip │
│     channels and the wave bores move toward the shore. │
│  •  Rips - the rips are the cause of most surf rescues, so │
│     they should be avoided unless you are a very  │
│     experienced surfer.                           │
│  •  Rip feeder channels - usually run along behind and to │
│     the sides of the bar, adjacent to the base of the beach. │
│     It carries water alongshore and delivers (feeds) it to │
│     the seaward flowing rip current.              │
│  •  In the rip embayment, the feeder currents converge │
│     and head out to sea. If you are not experienced, stay │
│     away from any channels, particularly if the water in │
│     it is moving and greater than waist depth.    │
│  •  Children on floats must be very wary of feeder │
│     channels as they can drift from a seemingly calm, │
│     shallow, inner feeder channel located right next to │
│     the beach, rapidly out into a strong rip current. │
│  •  Breakers - waves will break more heavily on the bar │
│     at low tide, often as dangerous plunging waves or │
│     dumpers. In the rip embayment, the shorebreak will │
│     be stronger at high tide.                     │
│  •  Higher waves - when waves exceed 1-1.5 m, both │
│     wave breaking and rip currents will intensify. │
│  •  Oblique waves - skew both the bars and rips   │
│     alongshore and may make the rips more difficult to │
│     spot.                                         │
│  •  Low tide - rip currents are more confined to the rip │
│     channel and as a result intensify at low tide. │
│  •  High tide - rip currents are weaker and may be │
│     partially replaced by a longshore current.   │
│  •  Summary: It is relatively safe on the bars during low │
│     to moderate waves, but beware, as many hazards, │
│     particularly  rips,  lurk  for  the  young  and │
│     inexperienced. Stay on the bar/s and well away from │
│     the rips and their side feeder currents.     │
└─────────────────────────────────────────────────┘
```

Low tide terrace (LTT)

Low tide terrace beaches are the lowest energy intermediate beach type and occur right round the coast and islands (Table 2.3 & 2.4). They occur on 177 (14%) mainland beaches primarily on the east, south and west coasts, with another 45 on the islands. They occur on the open coast where sand is fine to medium and wave height averages between 0.5 and 1 m. On the high energy west coast they occur where nearshore reefs and headlands lower waves to less than 1 m at the shore (Fig. 2.13).

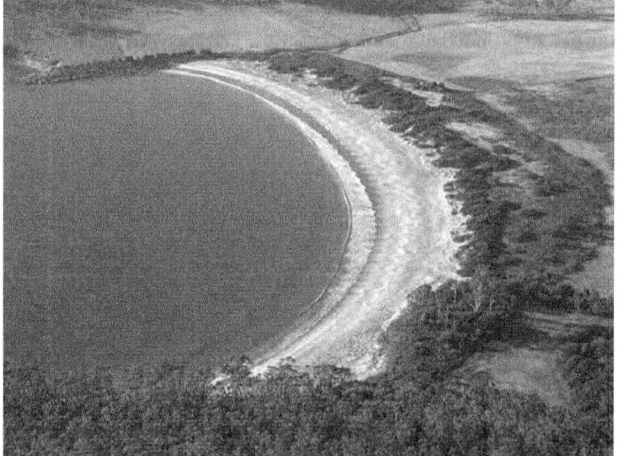

a.

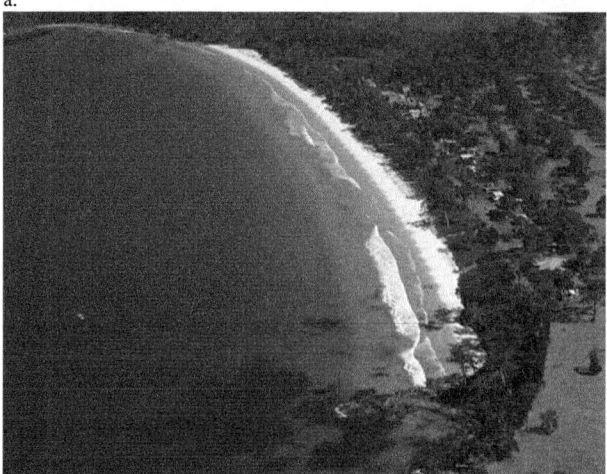

b.

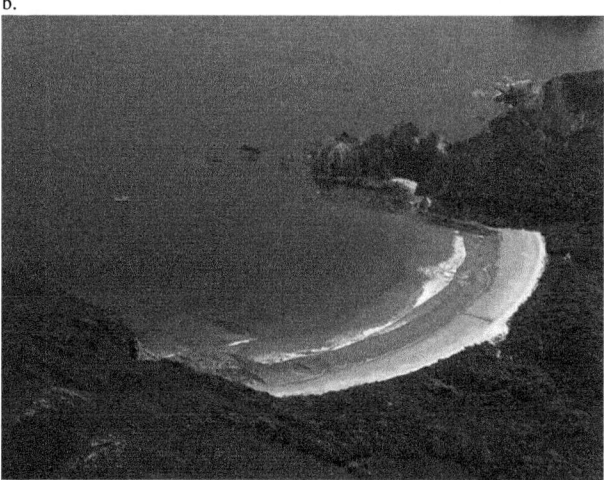

c.

Figure 2.13 Continuous low tide terrace beaches at a) Lagoon Bay (T 300), b) Roaring Bay Beach (T 510); and c) Norman Cove (T 631).

Low tide terrace beaches are characterised by a moderately steep beach face, which is joined at the low tide level to an attached bar or terrace, hence the name - low tide terrace. The bar usually extends between 20 and 50 m seaward and continues alongshore, attached to the beach. It may be flat and featureless, have a slight central crest, called a ridge, and may be cut every several tens of metres by small shallow rip channels, called *mini rips.*

At high tide when waves are less than 1 m, they may pass right over the bar and not break until the beach face, behaving much like a reflective beach. At spring low tide, however, the entire bar is usually exposed as a ridge or terrace running parallel to the beach. At this time, waves break by plunging heavily on the outer edge of the bar. At mid tide, waves usually break right across the shallow bar.

Under typical mid tide conditions, waves less than 1 m high break across the bar and a low surf zone is produced. The water is returned seaward, both by reflection off the beach face, especially at high tide, and via the mini rips, even if no rip channels are present. The rips, however, are usually weak, ephemeral and shallow.

Low tide terrace hazards

Low tide terrace beaches are the least hazardous of the intermediate beaches, because of their characteristically low waves and shallow terrace. However, changing wave and tide conditions do produce a number of hazards to swimmers and surfers.

Low tide terrace beach hazards

- High tide - deep water close to shore; behaves like a reflective beach.
- Low tide - waves may plunge heavily on the outer edge of the bar, with deep water beyond. Take extreme care if body surfing or body boarding in plunging waves, as spinal injuries can result.
- Mid tide - more gently breaking waves and waist deep water, however weak mini rips return some water seaward.
- Diving – be very careful diving into the surf as the water is usually shallow and can result in head and spinal injuries.
- Higher waves - mini rips increase in strength and frequency and may be variable in location.
- Oblique waves - rips and currents are skewed and may shift along the beach, causing a longshore and seaward drag.
- Most hazardous at mid to high tide when waves exceed 1 m and are oblique to shore, such as during a strong summer sea breeze.
- Summary: One of the safer beach types when waves are below 1 m high, at mid to high tide. Higher waves, however, generate dumping waves, strong currents and ephemeral rips, called *side drag, side sweep* and *flash rips* by lifesavers. Use care when surfing or diving under the waves.

Reflective beaches (R)

Reflective sandy beaches lie at the lower energy end of the wave-dominated beach spectrum. They are characterised by relatively steep, narrow beaches usually composed of coarser sand. On the Tasmanian open coast, sandy beaches require waves to be less than 0.5 m to be reflective. For this reason they are also found inside the entrance to bays, at the lower energy end of some ocean beaches and in lee of the reefs and islets that front many beaches.

In Tasmania there are 786 reflective beaches on the mainland, making them the most common beach type (62%), with another 88 on the islands (25%). They are however also the shortest of the beaches with a mean length of 0.52 km as they tend to form in protected pockets in lee of reefs and headlands, even along high energy sections of coast. As a result they have a total mainland length of 407 km, which represents only 46% of the sandy mainland coast.

Reflective beaches are a product of both coarser sand and lower waves. Consequently, all 217 Tasmanian beaches composed of gravel and cobbles and all 32 boulder beaches are always reflective, no matter what the wave height.

Reflective beach morphology consists of a steeper, narrow beach and swash zone, with beach cusps commonly present in the upper high tide swash zone. They have no bar or surf zone as waves move unbroken to the shore, where they collapse or surge up the beach face (Fig. 2.14).

The morphology is a product of four factors. First, low waves will not break until they reach relatively shallow water (< 1 m); second, the coarser sand results in a steeper gradient beach (5-10°) and relatively deep nearshore zone (> 1 m); third, because of the low waves and deep water, the waves do not break until they reach the base of the beach face; and finally, because the waves break at the beach face, they must expend all their remaining energy over a very short distance. Much of the energy goes into the wave runup and backwash, the rest is reflected back out to sea as a reflected wave, hence the name reflective.

The strong swash, in conjunction with the usually coarse sediment, builds a steep high beach face. The *cusps,* which usually reside on the upper part of the beach face, are a product of sub-harmonic edge waves, meaning the waves have a period twice that of the incoming wave. The edge wave period and the beach slope determine the edge wave length, which in turn determines the cusp spacing. On the Tasmanian coast cusp spacing can range from 20 to 40 m.

Another interesting phenomenon of most reflective beaches is that all those containing a range of sand sizes have what is called a *beach step.* The step is always located at the base of the beach face, around the low water mark. It consists of a continuous band containing the coarsest material available, including rocks, cobbles, even boulders and often numerous shells. Because it is so coarse, its slope is very steep, hence the step-like shape. They are usually a few decimetres in height, reaching a maximum of perhaps a metre. Immediately seaward of the step, the sediments usually fine markedly and assume a lower slope.

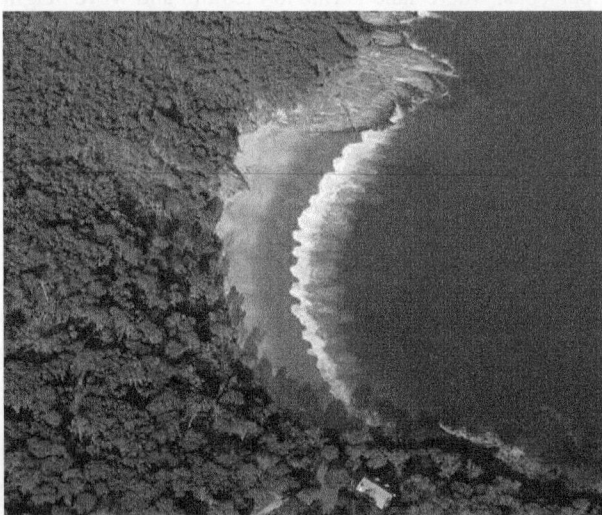
a.

b.

Figure 2.14 a) Steep, cusped reflective beach at Hepbum Point (T 189); and b) narrow reflective Hazards beach (T 170).

The reason for the step is twofold. The unbroken waves sweep the coarsest sediment continuously toward the beach and the step. The same waves break by surging over the step and up the beach face. However, the swash deposits the coarsest, heaviest material first, only carrying finer sand up onto the beach, then the backwash rolls any coarse material back down the beach. The coarsest material is therefore trapped at the base of the beach face by both the incoming wave and the swash and backwash.

Reflective beach hazards

The low waves and protected locations that characterise reflective beaches usually produce relatively safe swimming locations. However, as with any water body, particularly one with waves and currents, there are hazards present that can produce problems for swimmers and surfers.

Reflective beach hazards

- Steep, soft beach face - may be a problem for toddlers, the elderly and disabled people.
- Relatively strong swash and backwash - can knock children and unwary people off their feet.
- Step - causes a sudden drop off from shallow into deeper water.
- Deep water - absence of bar means deeper water close into shore, which can be a problem for non-swimmers and children.
- Surging waves and shorebreak - when waves exceed 0.5 m, they break increasingly heavily over the step and lower beach face. They can knock unsuspecting swimmers over. If swimming seaward of the break, swimmers may experience problems returning to shore through a high shorebreak.
- Most hazardous when waves exceed 1 m and shorebreak becomes increasingly powerful.
- Where fronted by a rock platform or reef, additional hazards are associated with the presence of the rock/reef.
- Summary: Low hazards under low wave conditions, so long as you can swim. Watch children as deep water is close to shore. Hazardous shorebreak and strong surging swash under higher waves (> 0.5 m).
-

Determining wave-dominated beach type

The type of wave-dominated beach that occurs on the coast is a function of the modal wave height, the wave period and the sand size. The wave period is essentially constant (12 to 13 seconds) for the western and southern half of the state, averages 10 to 12 seconds on the east coast, and generally less than 9 seconds on the fetch-limited north coast. Wave height is at a maximum on the west coast (3 m), decreasing into the southeast bays and up the east coast (1-2 m). On the north coast it is lowest along the sheltered west coast (~0.5 m) increasing to 1-2 m in the east. Finally, sand size averages fine to medium (Table 1.8).

Figure 2.15 provides a method for determining the predicted beach type based on these three parameters. Only the highest energy beaches composed of fine sand, with waves averaging over 3 m, produce dissipative beaches in Tasmania. The same waves on beaches composed of slightly coarser (fine to medium) sand produce high energy intermediate beach systems, in particular RBB and TBR. Where waves are reduced slightly to average between 1 and 1.5 m, they form moderate energy TBR beaches, while LTT beaches occur where waves have been reduced to around 1 m and reflective beaches where waves are lowered still further to average about 0.5 m.

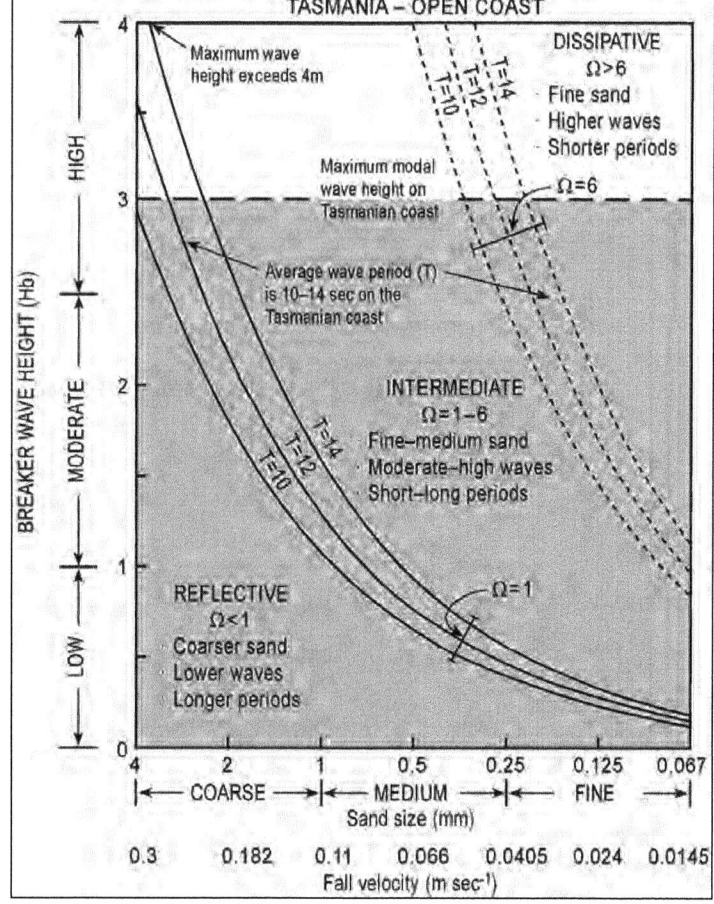

Figure 2.15a

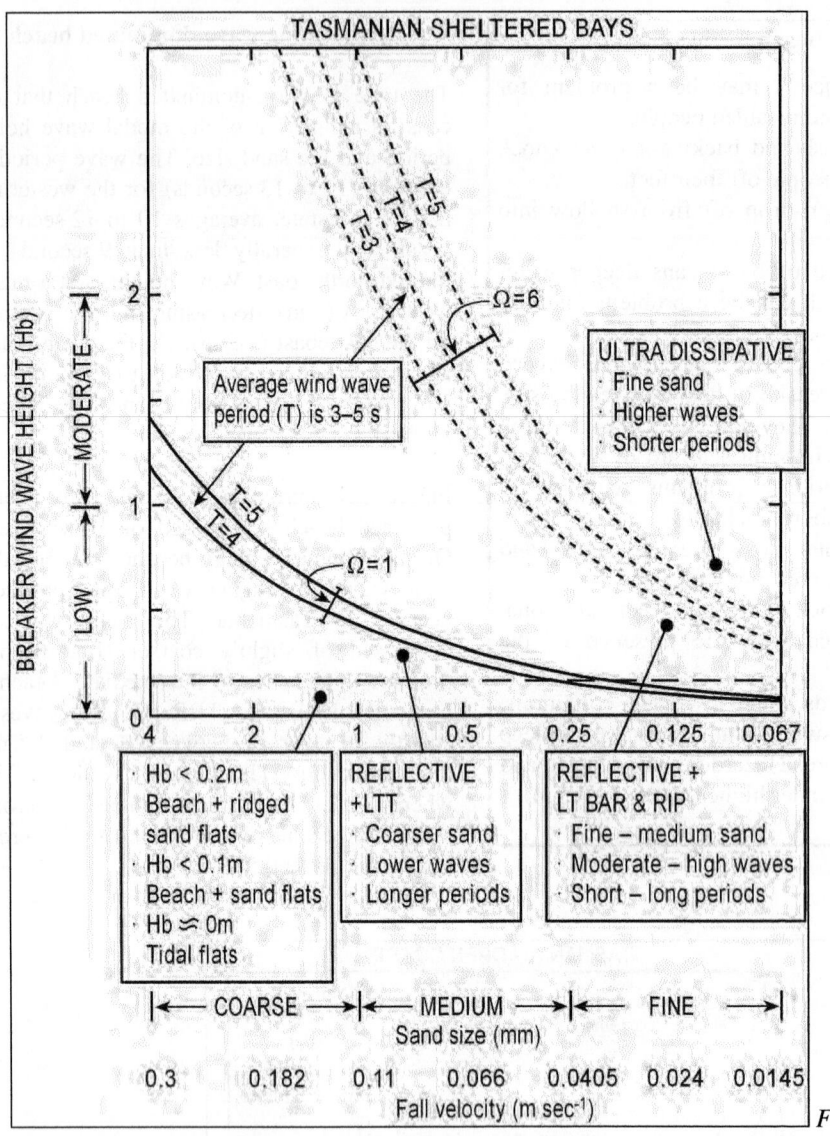

Figure 2.15 A plot of breaker wave height versus sediment size, together with wave period, that can be used to determine approximate Ω and beach type for high energy open coast (a) and sheltered beaches (b). To use the chart, determine the breaker wave height, period and grain size/fall velocity (mm or m/sec). Read off the wave height and grain size, then use the period to determine where the boundary of reflective/intermediate, or intermediate/dissipative beaches lies. Ω = 1 along solid T lines and 6 along dashed T lines. Below the solid lines Ω < 1 and the beach is reflective, above the dashed lines Ω > 6 and the beach is dissipative, between the solid and dashed lines Ω is between 1 and 6 and the beach is intermediate.

Tide-modified beaches

While most of the state is dominated by moderate to high waves and low tides resulting in wave-dominated beaches, the north coast experiences both meso tides (2-4 m) and generally lower fetch-limited waves, particularly in the more sheltered west north coast. As a consequence 37 beaches in this region are classified as tide-modified (Table 2.3). They represent 3% of the state's beaches and occupy 3.5% of the sandy shoreline.

By definition, tide-modified beaches occur when the tide range is between 3 and 12 times the wave height. As tides average 2-3 m along this section of coast, the waves are usually 1 m and less. Tide-modified beaches consist of three beach types - ultradissipative, reflective plus bar and rips and reflective plus low tide terrace (Fig. 2.16).

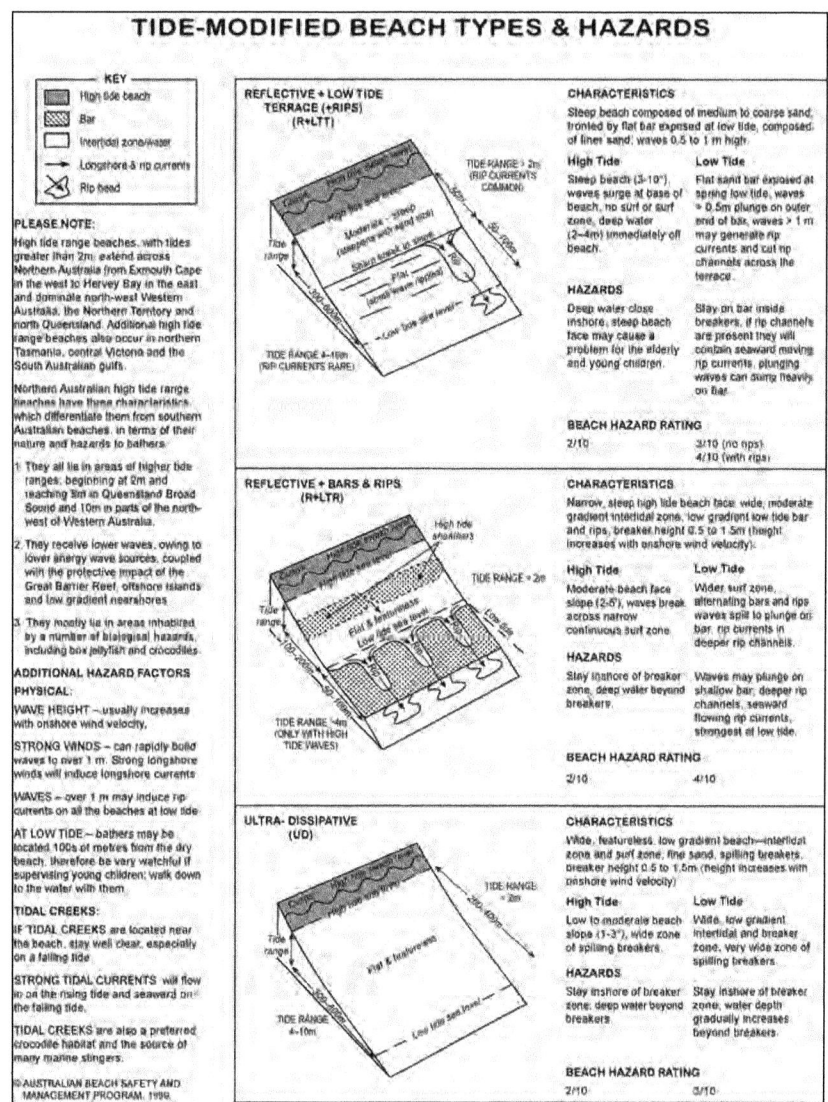

Figure 2.16 A three-dimensional sketch of the three tide-modified Tasmanian beaches: beach and low tide terrace, beach with low tide bars and rips, and ultradissipative.

Ultradissipative (UD)

Ultradissipative beaches occur in higher energy tide-modified locations, where the beaches are also composed of fine to very fine sand. They are characterised by a low to moderate gradient high tide beach, a very wide (200-400 m) intertidal zone, with a very low gradient (<1°) to almost horizontal low tide beach. Because of the low gradient right across the beach, waves break across a relatively wide, shallow surf zone as a series of spilling breakers (Fig. 2.17). This wide, spilling surf zone dissipates the waves to the extent that they are known as 'ultradissipative' beaches. During periods of higher waves (>1 m), the surf zone can be well over 100 m wide, though still relatively shallow. There are eight ultradissipative beaches on the west north coast. On these beaches the combination of tide exceeding 3 m, combined with the shorter period north through easterly wind waves (~1 m) and fine sand beaches produce the wide, low gradient ultradissipative systems.

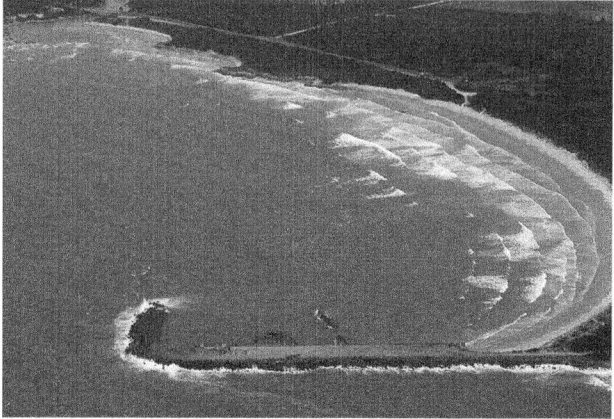

Figure 2.17 Ultradissipative Crayfish Creek Beach (T 999) during moderate sea conditions.

Basically the fine sand induces the low gradient, while the tide range moves the higher waves backwards and forwards across the wide intertidal zone every six hours. The two act to plane down the beach, while the lack of

stationarity or stability of the surf zone and shoreline precludes the formation of bars and rips.

Hazards:The major hazards associated with ultradissipative beaches are their usually higher waves, the relatively deep water off the beach at high tide, the long distance from the shore to the surf at low tide and the often considerable distance from the shoreline out to beyond the breakers. Currents run along the beach when waves arrive at angles, however rip currents are generally absent. Seaward of the breakers, however, shore-parallel tide currents may also increase in strength.

Reflective plus bar & rips (R+LTR)

Reflective beaches fronted by low tide bars and rips occur in similar environments to the ultradissipative, only on beaches with fine to medium sand. There is however only one R+LTR beach in Tasmania (Picnic Beach, T 1012), a result of the lack of waves high enough to maintain an energetic low tide surf zone on the high tide range beaches in the north of the state.

Reflective plus low tide terrace (R+LTT)

The lowest energy of the tide-modified beaches is the reflective high tide beach fronted by a low tide terrace. A total of 28 such beaches occur, all on the north coast and primarily in the west.

At high tide, waves surge up the steep beach face. This continues as the tide falls, until the shallower water of the terrace induces wave breaking increasingly across the terrace. At low tide, waves spill over the outer edge of the terrace, with the inner portion exposed and dry during spring low tide (Fig. 2.18). If rips are present, they will cut a channel across the terrace which is only active at low tide.

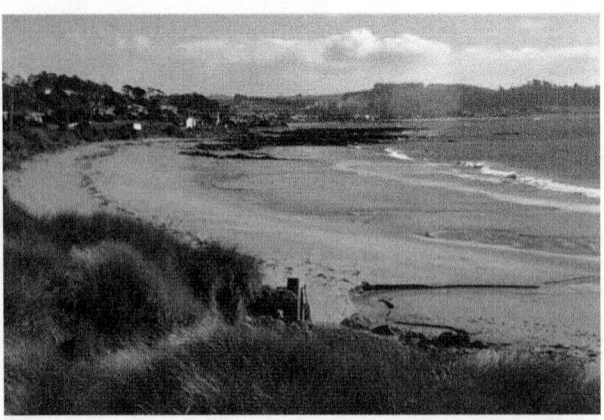

Figure 2.18 High reflective beach fronted by a low gradient low tide terrace at Cooee Beach (T 1083).

Hazards: These beaches undergo a marked change in morphology between high and low tide. At high tide hazards are associated with the waves surging against the steep high tide beach, together with the deeper water off the beach, while at low tide, waves spill across the broad, shallow terrace, with hazards associated with the deeper water off the terrace and the rips, if present.

Tide-dominated beaches

When the tide range begins to exceed the wave height by between 10 and 12 times, the tide becomes increasingly important in beach dynamics at the expense of the waves. In Tasmania these conditions tend to occur in very sheltered bays, where tides may still be less than 2 m, but the fetch-limited waves are very low (<0.5 m). They occur in the southeast bays including Frederick Henry and Norfolk bays, the west north in lee of Robbins-Walker islands, and on the sheltered sides and bays of Maria, Bruny, Robbins-Walker and Flinders islands. In all 73 mainland beaches and 85 island beaches are tide-dominated.

Basically there are four beach types - three with a high tide beach and sand flats, while the fourth is essentially a transition from sand flat to a tidal mud flat (Fig. 2.19). These beaches receive sufficient wave energy to both build the sandy, and often shelly, high tide beach, while wide low gradient tidal sand flats extend seaward of the base of the high tide beach and are exposed at low tide. The intertidal sand flats consist of three types. They grade with increasing tide dominance from the higher energy ridged flats, to flat featureless sand flats, to sand flats with tidal flow and drainage features, to finally mud flats, still with the high tide sand beach. Beyond these, pure intertidal flats dominate with no beach.

Reflective plus sand ridges (R+SR)

High tide beaches fronted by multiple sand ridges occur on 57 beaches primarily in the protected southeast bays (32), on Bruny Island (20), with two on the west north coast and three on Robbins Island.

These systems usually have a moderate to steep high tide beach, with shore-parallel, sinuous, low amplitude, evenly spaced sand ridges extending out across the inter- to sub-tidal sand flats (Fig. 2.20). The ridges are not to be confused with the higher relief (sand) bars of the higher energy beaches. The beach is only active at high tide when either very low wind waves or calms prevail. The intertidal zone and ridges are usually inactive. The exact mode of formation is unknown, though it is suspected that the ridges are active and formed during infrequent periods of higher waves which break again and again across each of the ridges.

In Tasmania the number of ridges averages 11 (Ω=4.5), ranging from 6 to 20, and can reach 40 in other Australian locations, while the sand flats range from 150 to 1,500 m in width, averaging 500 m (Ω=300 m). The ridges are very low amplitude, no more than a few centimetres to a decimetre from trough to crest and average about 50 m in spacing. They tend to parallel the coast, but can at times lie obliquely to the shore, while at other places they merge into more complex patterns.

TIDE-DOMINATED BEACH TYPES & HAZARDS

KEY

- High tide beach
- Intertidal zone
- → Tidal currents

PLEASE NOTE:

High tide range beaches, with tides greater than 2m, extend across Northern Australia from Exmouth Cape in the west to Hervey Bay in the east and dominate north-west Western Australia, the Northern Territory and north Queensland. Additional high tide range beaches also occur in northern Tasmania, central Victoria and the South Australian gulfs.

Northern Australian high tide range beaches have three characteristics which differentiate them from southern Australian beaches, in terms of their nature and hazards to bathers:

1. They all lie in areas of higher tide ranges, beginning at 2m and reaching 8m in Queensland Broad Sound and 10m in parts of the north-west of Western Australia.

2. They receive lower waves, owing to lower energy wave sources, coupled with the protective impact of the Great Barrier Reef, offshore islands and low gradient nearshores.

3. They mostly lie in areas inhabited by a number of biological hazards, including box jellyfish and crocodiles.

ADDITIONAL HAZARD FACTORS

PHYSICAL:

WAVE HEIGHT – usually increases with onshore wind velocity.

STRONG WINDS – can rapidly build waves to over 1 m. Strong longshore winds will induce longshore currents.

WAVES – over 1 m may induce rip currents on all the beaches at low tide.

AT LOW TIDE – bathers may be located 100s of metres from the dry beach, therefore be very watchful if supervising young children; walk down to the water with them.

TIDAL CREEKS:

IF TIDAL CREEKS are located near the beach, stay well clear, especially on a falling tide.

STRONG TIDAL CURRENTS will flow in on the rising tide and seaward on the falling tide.

TIDAL CREEKS are also a preferred crocodile habitat and the source of many marine stingers.

© AUSTRALIAN BEACH SAFETY AND MANAGEMENT PROGRAM. 1999.

BEACH + SAND RIDGES (R+SR)

TIDE RANGE 2–8m

CHARACTERISTICS

Steep high tide beach composed of coarser sand, fronted by an abrupt break in slope and a lower gradient, usually finer sand intertidal zone containing shore parallel, low amplitude sand ridges and runnels. Number of ridges ranges from 2 to 14.

High Tide	Low Tide
Steep beach (3–10°).	Wide, flat ridged intertidal flats, up to several hundred metres wide.
No waves unless strong on shore winds.	
Deep water off high tide beach.	

HAZARDS

Deep water off beach.	Tidal current may parallel the low tide shoreline.
	Long distance from dry beach to low tide level.

BEACH HAZARD RATING

1/10	1/10

BEACH + SAND FLATS (R+SF)

TIDE RANGE 2–8m

CHARACTERISTICS

Steep high tide beach composed of coarser sand, fronted by an abrupt break in slope and a lower gradient, usually finer sand, flat, featureless intertidal zone.

High Tide	Low Tide
Steep beach (3–10°).	Wide, flat intertidal sand flats, up to several hundred metres wide.
No waves unless strong onshore winds.	
Deep water off high tide beach.	

HAZARDS

Deep water off beach.	Tidal current may parallel the low tide shoreline.
	Long distance from dry beach to low tide level.

BEACH HAZARD RATING

1/10	1/10

TIDAL SAND/MUD FLATS (RTSF)

TIDE RANGE 2–8m

CHARACTERISTICS

Wide, low gradient, small high tide beach, intertidal sand flats, may contain tidal draining channels and may lie adjacent to deeper tidal channels, scattered mangroves commonly occur in higher intertidal zone. Usually calm, only low wind chop during strong onshore winds.

High Tide	Low Tide
Entire tidal flat covered by spring high tide.	Wide low gradient (<1°), sand flats up to several hundred metres wide exposed, may contain shallow tidal draining channels, may be fronted by deep tidal channels and currents.

HAZARDS

Generally low gradient entry to water only a potential hazard to young children (possible crocodile habitat).	Long distance to low tide shoreline; possible deeper tidal channel and currents (possible crocodile habitat).

BEACH HAZARD RATING

1/10	2/10

Figure 2.19 A three-dimensional sketch of three tide-dominated Tasmanian beaches: beach+ridged sand flats, beach+sand flats and tidal sand/mud flats.

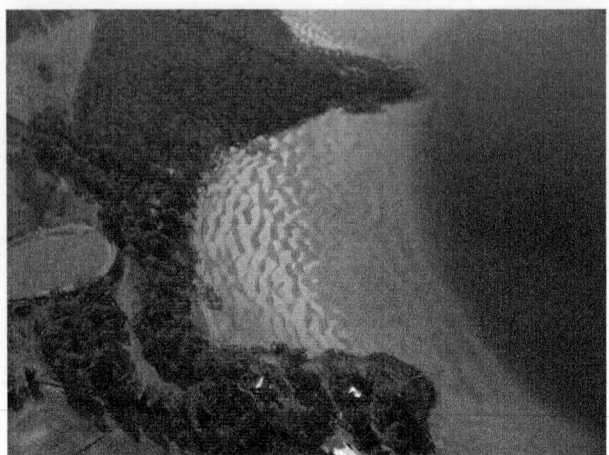

Figure 2.20 Low energy reflective high tide beaches fronted by ridged intertidal sand flats at Daltons beach (T 372) (W. Hennecke).

Reflective plus sand flats (R+SF)

The most common tide-dominated beach is the high tide beach fronted by very low gradient, flat, featureless sand flats (Fig. 2.21). There are 34 mainland R+SF beaches, together with 49 on primarily Bruny and Flinders islands. On the mainland they range in width from 50 to 100 m (mean=205 m, Ω=200 m), while on the islands they range from 50-500 m (mean=125 m, Ω=110 m).

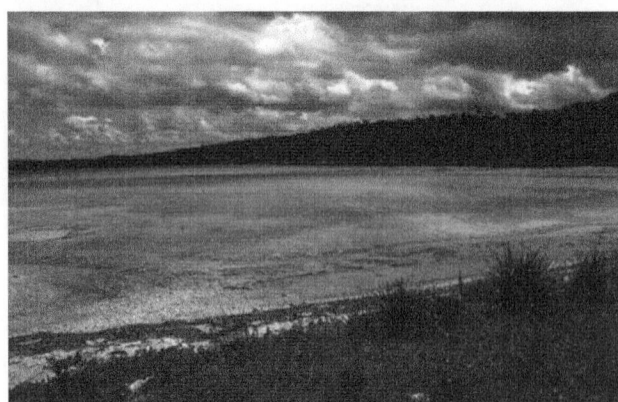

Figure 2.21 Low energy high tide reflective beach, fronted by wide intertidal sand flats at Dick Creek (T 369).

Reflective plus tidal sand flats (R+TSF)

The very low energy reflective beach plus tidal sand flats represents a gradation from the true high tide beaches of the above two beach types, to the vegetated tidal flats that dominate the tide-dominated sections of the coast. A number of these sand flats are labelled 'beaches' and known locally as such. The main difference between the reflective+sand flats and reflective+tidal sand flats is that the tidal flats may be vegetated with seagrass and even scattered mangroves on mainland Australia locations. Also the tidal sand flats usually have tide-generated drainage channels occupying parts of the flats (Fig. 2.21).

There are only 15 beaches of this type, just two on the mainland and 13 on the islands. These beaches have

wider sand flats ranging from 200 to 2500 m (mean=1125 m, Ω=680 m).

Figure 2.22 Low energy high tide beach fronted by wide intertidal tidal sand flats along Little Beach (RI 1). Note the imprint of tidal creek on the flats.

Hazards: There are three hazards associated with these low energy beaches and flats. First is the relatively deep water off the high tide beach. Second are tidal currents flowing both across the flats particularly where associated with tidal creeks and channels, and possibly paralleling the shore seaward of the flats. Third, is the great width of the flats and in places their undulating nature which result in people being stranded by the rising tide.

Beaches plus rock flats (R+rock flats)

There are 60 beaches fronted by intertidal rock flats, most located on Bruny, King and Flinders islands. The rock flats range in width from 50 to 150 m (mean=70 m, Ω=45 m). In each situation waves break at the edge and over the rocks, lowering waves at the shoreline. The high tide beach is usually steep and often cobble or boulder derived from the flats and is only active at high tide (Fig. 2.23). These are a more hazardous beach type, owing to the presence of the rocks in the sub- to intertidal zone, especially when exposed to moderate to high waves. Extreme care should be used in attempting to wade or swim off such a beach.

Figure 2.23 A narrow high tide beach fronted by irregular rocks flats at Gulches reef (T 674).

Larger scale beach systems

The beach systems described above are all part of larger scale beach and barrier systems, the barriers including backing beach and foredune ridges and, in places, sand dunes, as well as adjoining tidal creeks and inlets and headlands and reefs. Figure 2.23 provides a schematic overview of the typical arrangement of some of these beach and associated barrier systems. In general the lowest energy systems receive low waves and are backed by low beach ridge plains, as in parts of the west north coast (Fig. 2.24a). Moderate energy systems are backed by prograding foredune ridge plains. Such plains occur along parts of the north and east coasts and at the Remarkable Banks on Robbins island reach 7 km in width, their extent assisted by a slight fall in sea level (Fig. 2.24b). Moderate to higher energy beaches tend to have backing blowouts and parabolic dunes, as common along much of the east north coast, some of the east and parts of the west coast (Fig. 2.24c), while the highest energy stems are backed by massive dune transgression, as along the west and east north coasts (Fig. 2.24d).

c.

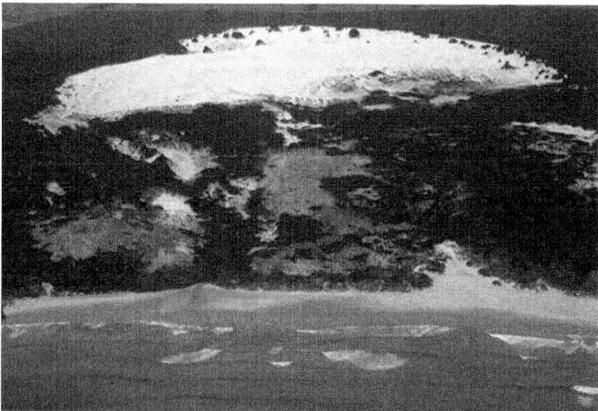

d.

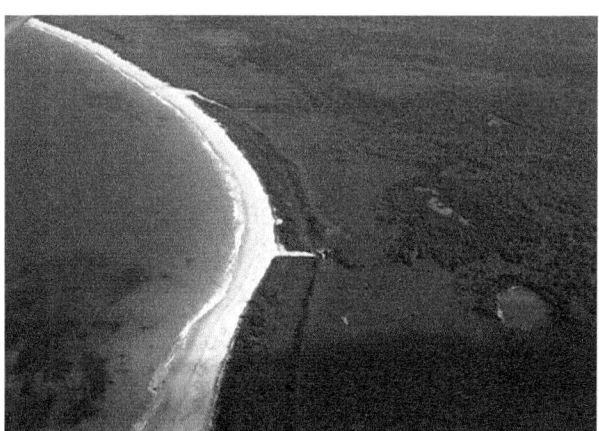

a.

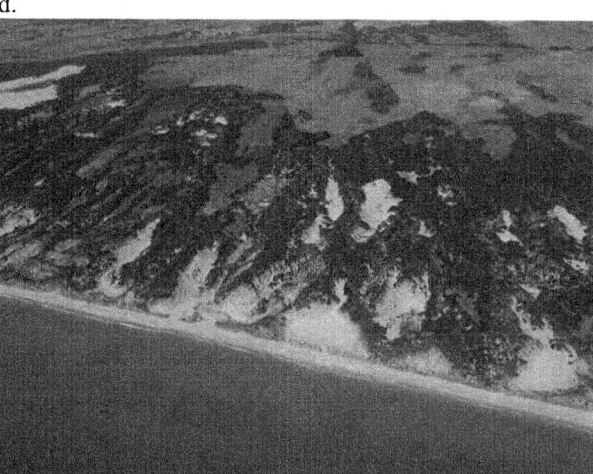

e.

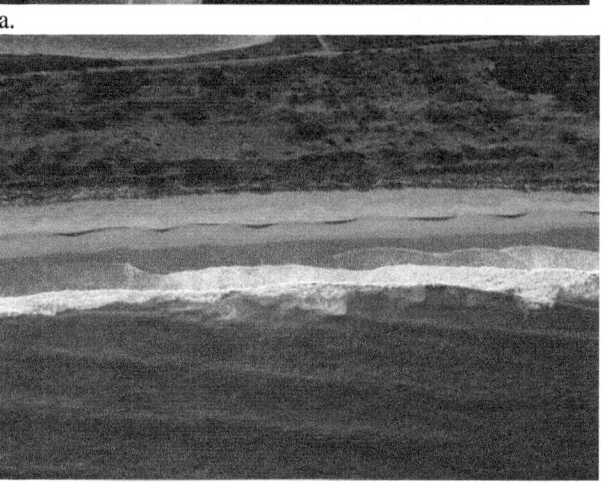

b.

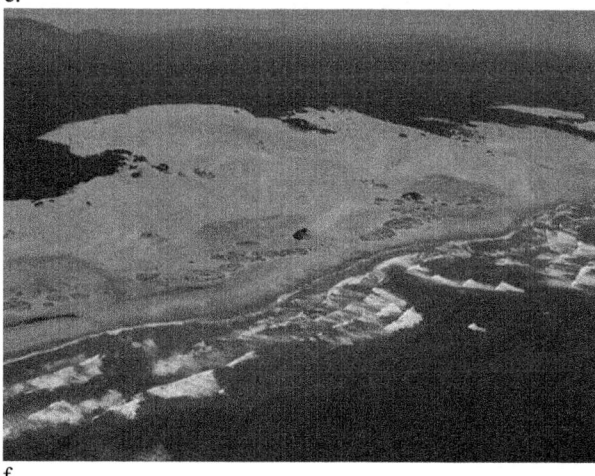

f.

Figure 2.25 A selection of Tasmanian dunes types: a) well vegetated foredune at Cod Bay (T 36); b) a series of hummocky foredunes at Wrinklers Beach (T 114); c) well developed parabolic dune in St Albans Bay (T 1223); d) a large parabolic dune behind Mount Cameron Beach (T 933); e) a series of nested active and stable parabolic dunes along Waterhouse Beach (T 1237); and f. massive active dune sheet in lee of Lagoon River beach (T 825).

3 BEACH HAZARDS AND SAFETY

All beaches contain variable water depth, deep water, breaking waves and currents, all of which can present hazards to beach users. This chapter reviews the types of beach hazards and how they can be mitigated and reduced through beach safety.

The Australian coast remained untouched until the arrival of the first Aborigines some tens of thousands of years ago. The coast and beaches that they found, however, no longer exist. Probably crossing to mainland Australia and on to Tasmania during one of the periods of glacial low sea level, they not only reached a far larger, cooler, drier and windier continent, but one where the shoreline was some tens of metres below present sea level. Hence the coast they walked and fished now lies out below sea level on the inner continental shelf.

The present Australian coast only formed some 6500 years ago, when sea level rose to approximately its present position. As it was rising, at about 1 m every 100 years, the Aborigines no doubt followed its progress by slowly moving inland and to higher ground, during which time Tasmania was separated from the mainland about 12 000 years ago. Therefore, we can assume that usage of the present Tasmanian beaches began as soon as the beaches began forming some 6000 years ago and continued in the traditional way until the 1800s.

Following the initial European settlements in Hobart in 1804 the beaches were largely ignored by the new settlers. It was not until the early 20th century that people began looking to the coast as a source of recreation, and in the process their attitude to beaches and coastal real estate changed dramatically, a process that continues today as more and more Australians choose to work and live near the coast.

The Surf Life Saving Movement

The formation of the surf life saving clubs (SLSCs) and the broader organisation of Surf Life Saving Australia is a result of two interrelated factors. First, many beachgoers have little or no knowledge of the surf and its dangers and require supervision. Secondly, the open coast of Tasmania is as dangerous as it is inviting to the unprepared.

The following brief history of Surf Life Saving Tasmania (SLST) is extracted from the SLST website at **http://www.slst.asn.au.**

The first recorded discussions on surf life saving in Tasmania took place at a committee meeting of the Burnie Tourist and Progress Association held in February 1919. The meeting resolved "that the Emu Bay Council be written to suggesting a life line with reel and belt be installed on West Beach and also in the vicinity of the bathing sheds on South Beach".

During the summer of 1921 **Burnie** became Tasmania's first surf life saving club, followed by **Devonport** (1927), **Ulverstone** (1928) and **Penguin** (1931) the latter the last club formed until after World War 2.

In 1930 the Burnie, Devonport and Ulverstone Clubs formed the Tasmanian Branch of the Surf Life Saving Association of Australia, now SLST. The first interclub carnival was held at the Devonport Bluff in February 1930 and the first state team competed in NSW during 1938.

With many club members enlisting in the armed forces during World War 2, Tasmanian surf life saving went into recess from 1942-47.

The formation of the **Low Head** Club in 1952 saw surf life saving move into the northeast of the state and it became statewide in 1957 when the Hobart's **Carlton** Club was formed in the south and the **Park Beach** Club in 1959. These two clubs later amalgamated to form the **Carlton Park** Club in 1975. In the meantime the **Clifton Beach** Club was formed in 1963 and the **Somerset** Club in 1969.

The original **Boat Harbour** Club only lasted from 1957-59, however it was reformed during the 1984-85 season and remains a strong club today.

The first Australian championships held in Tasmania to place over two weekends in 1962, with the interstate carnival held at Carlton and the interclub carnival held at Burnie. The national championships were subsequently held at Clifton Beach in 1969, 1976 and 1983.

The **Port Sorell** Club was formed in 1986 and during the 1989-99 season members of the old Low Head Club formed a life saving club in Launceston. The **Launceston** Club provides patrols for members of the public who swim in fresh water at Trevallyn Dam.

Clifton Beach SLSC has been operating a branch club at **Kingston Beach** since 1996.

The newest club located at **Scamander** commenced patrols in the 2005-06 summer. It is the first surf life saving club on the popular east coast.

There are now 12 surf life saving clubs in the state with a total membership of more than 1500. Since the formation of the Burnie club in the summer of 1921 there have been over 3000 recorded rescues performed by surf life saving club members.

Tasmanian Surf Life Saving Clubs and date founded

Burnie	1921
Devonport	1927
Ulverstone	1928
Penguin	1931
Clifton	1963
Somerset	1969
Carlton Park	1975
Boat Harbour	1984
Port Sorell (Freers Beach)	1986
Launceston LSC (Trevallyn Dam)	1989
Kingston (Clifton Beach SLSC)	1996
Scamander	2005

All beaches with surf life saving clubs are patrolled by volunteer surf lifesavers on weekends during the summer months. **Patrols usually begin on the first weekend in December and continue to the last weekend in March, including public holidays. Check with each club for exact dates and patrol hours.**

More than a century after the initial rush to the beaches and the foundation of the early surf life saving clubs, both beach usage and the 304 surf life saving clubs around the coast are accepted as part of Australian beaches and beach life. However, at the beginning of the 21st century, beach usage is undergoing yet another surge as the Australian population and visiting tourists increasingly concentrate on the coast. This is resulting in more beaches being used, more of the time, by more people, many of who are unfamiliar with beaches and their dangers. In addition, while this has led to an expansion of surf life saving clubs in Tasmania, still the vast majority of beaches have no surf life saving club or patrols.

There is now a greater need than ever to maintain public safety on these beaches, a service that is provided on patrolled beaches by volunteer lifesavers and paid lifeguards. This book is the result of a joint Surf Life Saving Australia, Surf Life Saving Tasmania and the Coastal Studies Unit project that is addressing this problem. The book is designed to provide information on each and every beach in Tasmania, as well as all beaches on Maria, Bruny, Robbins-Walker, King and Flinders islands; in all, 1269 mainland beaches and 348 on the five islands. It contains information on all nine patrolled ocean beaches including a map of each and their general characteristics and hazards. It also provides a description of every beach including its general characteristics, access and suitability for swimming and surfing. In this way, swimmers may be forewarned of potential hazards before they get to the beach and consequently swim more safely.

If you are interested in joining a surf life saving club or learning more about surf life saving, contact Surf Life Saving Australia, your state centre (listed below) or your nearest surf life saving club, or log in at http://www.slst.asn.au.

Surf Life Saving Australia	**Surf Life Saving Tasmania**
Locked Bag 2	GPO Box 1745
Bondi Beach NSW 2026	Hobart TAS 7001
Phone:(02) 9300 4000	Phone:(03) 6272 7788
Fax: (02) 9130 8312	Fax: (03) 6272 6500
Email: info@slsa.asn.au	Email: slst@slst.asn.au
Web: www.slsa.asn.au	Web: www.slst.asn.au
Surf Life Saving New South Wales	**Life Saving Victoria**
PO Box 430	PO Box 2288
Narrabeen NSW 2101	Oakleigh VIC 3166
Phone:(02) 9984 7188	Phone:(03) 9567 0000
Fax: (02) 9984 7199	Fax: (03) 9568 5988
Email: experts@surflifesaving.com.au	Email: mail@lifesavingvictoria.com.au
Web: www.surflifesaving.com.au	Web: www.lifesavingvictoria.com.au
Surf Life Saving Queensland	**Surf Life Saving Western Australia**
PO Box 3747	PO Box 1048
South Brisbane QLD 4101	Osborne Park Business Centre WA 6916
Phone:(07) 3846 8000	Phone:(08) 9244 1222
Fax: (07) 3846 8008	Fax: (08) 9244 1225
Email: slsq@lifesaving.com.au	Email: slswa@slswa.asn.au
Web: www.lifesaving.com.au	Web: www.mybeach.com.au
Surf Life Saving South Australia	**Surf Life Saving Northern Territory**
PO Box 108	PO Box 43096
Torrensville SA 5031	Casuarina NT 0811
Phone:(08) 8354 6900	Phone:(08) 8941 3501
Fax: (08) 8364 6999	Fax: (08) 8981 3890
Email: surflifesaving@surfrescue.com.au	Email: slsnt@dhl.com
Web: www.surfrescue.com.au	Web: www.slsnt.org

Physical beach hazards

Beach hazards are elements of the beach-surf environment that expose the public to danger or harm (Fig. 3.1). *Beach safety* is the mitigation of such hazards and requires a combination of common sense, swimming ability and beach-surf knowledge and experience. The following section highlights the major physical hazards encountered in the surf, with hints on how to spot, avoid or escape from such hazards. This is followed by the biological hazards.

There are seven major physical hazards on Tasmanian beaches:

1. water depth (deep and shallow)
2. breaking waves
3. surf zone currents (particularly rip currents)
4. tidal currents
5. strong winds
6. rocks, reefs and headlands
7. water temperature

In the surf zone, three or four hazards, particularly water depth, breaking waves and currents, usually occur together. In order to swim safely, it is simply a matter of avoiding or being able to handle the above when they constitute a hazard to you, your friends or children.

Water depth

Any depth of water is potentially a hazard.
- *Shallow water* is a hazard when people are diving in the surf or catching waves. Both can result in spinal injury if people hit the sand head first.
- *Knee depth* water can be a problem for a toddler or young child.
- *Chest depth* is hazardous to non-swimmers, as well as to panicking swimmers. In the presence of a current, it is only possible to wade against the current when water is below chest depth. Be very careful when water begins to exceed waist depth, particularly if younger or smaller people are present and if in the vicinity of longshore, rip or tidal currents.

b.

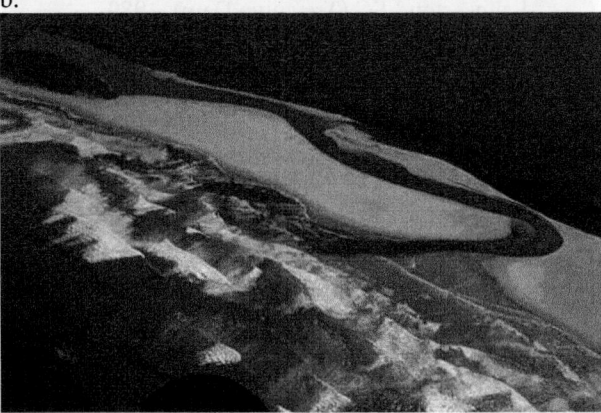
c.

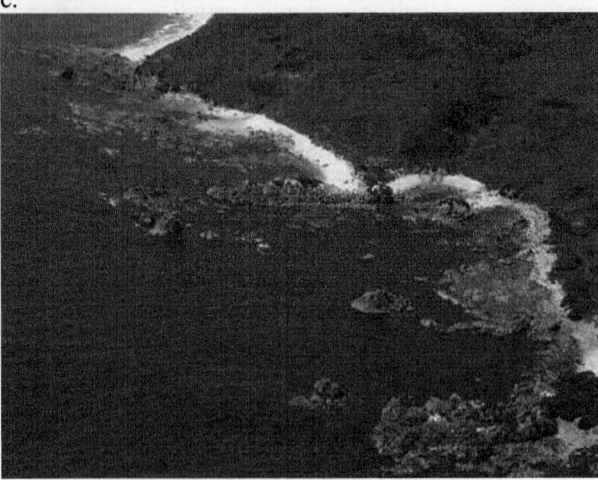
d.

Figure 3.1 Tasmanian physical beach hazards include high waves, rips (arrows) rocks, and tidal inlets, as illustrated in this series of photographs: a) well developed beach rips (T 623) (photo W. Hennecke); b) strong topographic rips and rocks (T 613); c) inlet flow, channel and rips (T 578); and d) rocky shore (T 775).

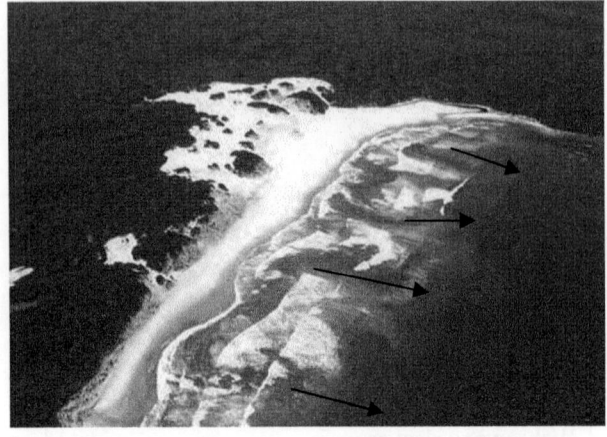
a,

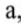

Water Depth
• Safest: knee deep - can walk against a strong rip current
• Moderately safe: waist deep - can maintain footing in rip current
• Unsafe: chest deep - unable to maintain footing in rip current
Remember: what is shallow and safe for an adult can be deep and distressing for a child.

Shallow water hazards

Spinal injuries are usually caused by people surfing dumping waves in shallow water, or by people running and diving into shallow water.

To avoid these:

- Always check the water depth prior to entering the surf.
- If unsure, WALK, do not run and dive into the surf.
- Only dive under waves when water is at least waist deep.
- Always dive with your hands outstretched.

Also

- Do not surf dumping waves.
- Do not surf in shallow water.

Breaking waves

As waves break, they generate turbulence and currents which can knock people over, drag and hold them under water, and dump them on the sand bar or shore. If you do not know how to handle breaking waves (most people don't), stay away from them. Stay close to shore and on the inner part of the bar.

If you are knocked over by a wave, remember two points - the wave usually holds you under for only two to three seconds (though it may seem like much longer), therefore do not fight the wave, you will only waste energy. Rather, let the wave turbulence subside, then return to the surface. The best place to be when a big wave is breaking on you is as close to the seafloor as possible. Experienced surfers will actually 'hold on' by digging their hands into the sand as the wave passes overhead, then kick off the seabed to speed their return to the surface.

If a wave does happen to gather you up in its wave bore (white water) it will only take you towards the shore and will quickly weaken, allowing you to reach the surface after two to three seconds and usually leave you in a safer more shoreward location than where you started.

Breaking waves and wave energy

Surging waves - low hazard when low

- break by surging up beach face - usually less than 0.5 m high
- can be a problem for children and elderly, who are more easily knocked over
- become increasingly strong and dangerous when over 0.5 m high

Spilling waves - moderately hazardous

- break slowly over a wide surf zone
- are good body surfing waves

Plunging (dumping) waves - the most hazardous waves

- break by plunging heavily onto sand bar
- strong wave bore (white water) can knock swimmers over
- very dangerous at low tide or where water is shallow

- waves can dump surfers onto sand bar, causing injury
- most spinal injuries are caused by people body surfing or body boarding on dumping waves
- to avoid spinal injury, do not surf dumping waves or in shallow water. If caught by a wave do not let it dump you head first; turn sideways and cover your head with your arms
- only very experienced surfers should attempt to catch plunging waves

Wave energy ≈ square of the wave height and is proportional to wave period.

Wave energy represents the amount of power in a wave of a particular height.

 0.3 m wave = 1 unit wave energy/power
 1.0 m wave = 11 units
 1.5 m wave = 25 units
 2.0 m wave = 44 units
 2.5 m wave = 70 units
 3.0 m wave = 100 units

Therefore, a 3 m wave is 10 times more powerful than a 1 m wave and 100 times more powerful than a 0.3 m wave. Likewise a 10 sec wave will have twice the energy of a 5 sec wave of the same height.

Surf zone currents and rip currents

Surf zone currents and particularly *rip currents* are the biggest hazard to most swimmers. They are the hardest for the inexperienced to spot and can generate panic when swimmers are caught by them. See the later section on how to identify and escape from rip currents.

The problem with currents, particularly rip currents, is that they can move you unwillingly around the surf zone and ultimately seaward (Fig. 3.2). In moving seaward, they will also take you into deeper water and possibly toward and beyond the breakers. As mentioned earlier, currents are manageable when the water is below waist level, but as water depth reaches chest height they will sweep you off your feet.

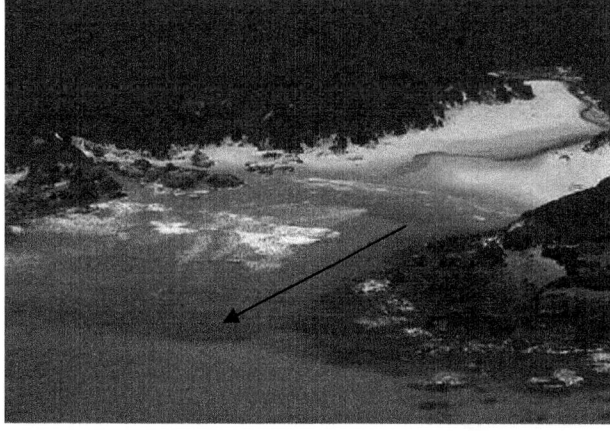

Figure 3.2 There are approximately 1700 beach rips and 600 permanent (topographic) rips operating at any one time along the more exposed sections of the

Tasmanian coast. This view shows well developed topographic rip (arrow) at Waller Ck (T 765).

Rip and surf zone current velocity

Breaking waves travel at 3-4 m/sec (10-15 km/hr)
Wave bores (white water) travel at 1-2 m/sec (3-7 km/hr)
Rip feeder and longshore currents travel at 0.5-1.5 m/sec (2-5 km/hr)
Rip currents under average wave conditions (< 1.5 m high) attain maximum velocities of 1.5 m/sec = 5.4 km/hr

(Note: Olympic swimmers swim at about 7 km/hr)
An average rip in a surf zone 50 m wide can carry you outside the breakers in as little as 30 seconds.

Tidal currents

Tide range is low and tidal currents are generally weak around the east, southeast and west coasts and only impact beach processes near tidal inlets. However, along the north coast tides increase to 3-4 m, particularly in confined estuaries like the Tamar where they can reach 4.4 m. As a consequence stronger tide currents occur along the north coast and particularly in the vicinity of tidal inlets where they maintain deeper tidal channels (Fig. 3.3a). These strong currents and deep channels are a very real hazard particularly on a falling tide as the currents flow seaward.

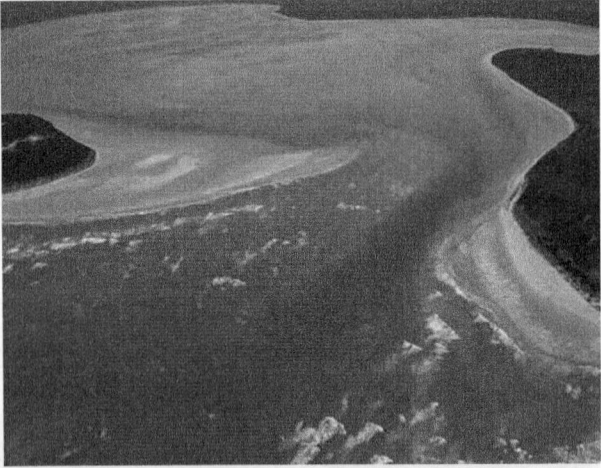

a.

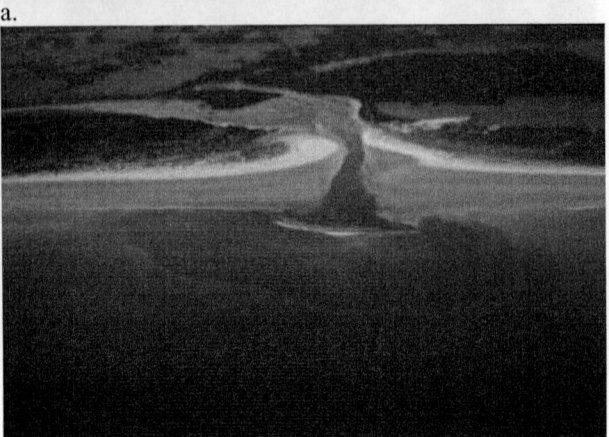

b.

Figure 3.3a) Deep tidal inlet flowing out between two beaches on Walker and Robbin islands; and b) the Black

River tidal inlet and pulsating flow fronts, indicating a pulsating tidal current (T 993-994).

When swimming or even boating in or near tidal creeks and inlets, always check the state and direction of the tide and be prepared for strong currents. Swimmers should not venture beyond waist deep water.

Strong winds

The Tasmanian coast is exposed to predominantly westerly winds associated with both the subtropical high and the passage of cyclonic cold fronts. The strongest winds are associated with the westerly cold fronts, which tend to hit from the west and gradually swing more to the south. As a consequence wind strength and direction must be factored into the hazard level whenever beaches are exposed to moderate to strong winds (Table 3.1).

Table 3.1 a) Wind hazard rating for Tasmanian beaches, based on wind direction and strength. Winds blowing on and alongshore will intensify wave breaking and surf zone currents, with strong longshore winds capable of producing a strong longshore drag. Their impact on surf zone hazards and beach safety is indicated by the relevant hazard rating, which should be added to the prevailing beach hazard rating.

	Light	Mod	Strong	Gale
Longshore	0	1	3	4
Onshore	0	1	2	3
Offshore	0	1	1	2

b) In waters sheltered from ocean swell sea wave height depends on strength of onshore or alongshore winds. Maximum sea height can reach about 3 m along the west coast. These seas are short and steep, compared to the longer ocean swell of the same height.

On-alongshore wind velocity	Max. sea wave height (m)*
Light	0.3
Moderate	0.5
Strong	1.0
Gale	3.0-4.0

** Wave period 2-5 sec.*

Whenever strong winds occur, their direction determines the impact they will have on beach and surf conditions, as follows:

- *Longshore winds,* particularly strong westerly winds, will cause wind waves to run along the beach, with accompanying longshore and rip currents also running along the beach. The waves and currents can very quickly sweep a person alongshore and into mobile rips on lower energy beaches or into deeper rip channels and stronger currents on higher energy beaches.
- *Onshore winds* will help pile more water onto the beach and increase the water level at the shore. They also produce more irregular surf, which makes it more difficult to spot rips and currents.

- *Offshore winds* tend to clean up the surf. However, if you are floating on a surfboard, bodyboard, ski or wind surfer, it also means it will blow the board offshore. In very strong offshore winds, it may be difficult or impossible for some people to paddle against this wind.

In addition all winds will increase the wind-chill factor, which in Tasmania's cooler waters can substantially increase the risk to people caught in coastal waters.

Wind generated waves and currents

Winds in the Southern Ocean are responsible for the high swell that arrives on the west coast and travels around the south and up the east coast, while locally generated westerly wind waves tend to dominate the north coast. If winds are of sufficient strength and duration they can generate locally wind-driven currents at the coast. In Tasmanian open waters, most wind-driven currents set to the east following the larger ocean currents to the south. Changes to this pattern occur during strong northerly winds, which push water offshore, causing upwelling in the east and downwelling in the west, while strong onshore winds push water onshore, causing downwelling.

Rocks, reefs and headlands

Most open coast Tasmanian beaches have some rocks, reefs and headlands. These pose problems on the state's higher energy beaches because they cause additional wave breaking, can generate strong topographic rips, and have hard and often dangerous surfaces. When they occur in shallow water and/or close to shore, they are also a danger to people walking, swimming or diving because of the hard seabed and the fact that they may not be visible from the surface.

Rocks, reefs and headlands

- If there is surf against rocks or a headland, there will usually be a rip channel and current (topographic rip) next to the rocks. There are 600 topographic rips around the Tasmanian coast.
- Rocks and reefs can be hidden by waves and tides, so be wary.
- Do not dive or surf near rocks, as they generate greater wave turbulence and stronger currents.
- Rocks often have hard and sharp shelled organisms growing on their surface which can inflict additional injury.
- If walking or fishing from rocks, be wary of being washed off by sets of larger waves.

Safe swimming

The safest place to swim is on a patrolled beach between the red and yellow flags, as these indicate the safest area of the beach and the area under the surveillance of the lifesavers. If there are no flags then stay in the shallow inshore or toward the centre of attached bars, or close to

shore if water is deep. However, remember that rip feeder currents are strongest close to shore and rip currents depart from the shore. The most hazardous parts of a beach are in or near rips and/or rocks, outside the flags or on unpatrolled beaches and when you swim alone.

Remember these points:
- DO swim on patrolled beaches.
- DO swim between the red and yellow flags.
- DO swim in the net enclosure (where present).
- DO observe and obey the instructions of the lifesavers or lifeguards.
- DO swim close to shore, on the shallow inshore and/or on sand bars.
- ALWAYS have at least one experienced surf swimmer in your group.
- NEVER swim alone.
- DO swim under supervision if uncertain of conditions.
- DO NOT enter the surf if you cannot swim or are a poor swimmer.
- DO NOT swim or surf in rips, troughs, channels or near rocks.
- DO NOT enter the surf if you are at all unsure where to swim or where the rips are.
- BE AWARE of hypothermia caused by exposure to cold air and water, particularly on bare skin and with small children. Wind will add to the chill factor.
- DO check the tides in the north, as there may be no water at low tide.
- DO be aware of strong tidal currents near inlets and tidal creeks.

Patrolled beaches

- Swim between the red and yellow flags.
- Obey the signs and instructions of the lifesavers or lifeguards.
- Still keep a check on all the above, as over 40 people are rescued from patrolled beaches in Tasmania each year.

Unpatrolled beaches

- Never swim alone.
- Always look first and check out the surf, bars and rips.
- Select the safest place to swim, do not just go to the point in front of your car or the beach access track.
- Try to identify any rips that may be present.
- Select a spot behind a bar and away from rips and rocks.
- On entering the surf, check for any side currents (these are rip feeder currents) or seaward moving currents (rip currents).
- If these currents are present, look for a safer spot.

Children
- NEVER let them out of your sight.
- ADVISE them on where to swim and why.

- ALWAYS accompany young children or inexperienced children and teenagers into the surf.
- REMEMBER they are small, inexperienced and usually poor swimmers and can get into difficulty at a much faster rate than an adult.

Beach Hazard Rating

The *beach hazard rating* refers to the scaling of a beach according to the physical hazards associated with its beach type under normal wave conditions, together with any local physical hazards. It ranges from the low, least hazardous rating of 1 to a high, most hazardous rating of 10. It does not include biological hazards, such as sharks, which are discussed later in this chapter. The beach characteristics and hazard rating for wave-dominated beaches are shown in Figures 2.4 and 2.5, for tide-modified beaches (Fig. 2.14) and tide-dominated beaches (Fig. 2.16).

The *modal beach hazard rating* indicates the level of hazard under typical or modal wave conditions for each beach type. Figure 3.4 lists the six wave-dominated, and three tide-modified and three tide-dominated beaches, together with their beach hazard rating under waves between less than 0.5 m and greater than 3 m. The modal wave height and modal hazard rating is indicated in BOLD. The rating ranges from a low of 1 on most tide-dominated and some tide-modified beaches, to a high of 10 on high energy dissipative beaches. The figure also indicates how the hazard rating will change under changing wave and beach type conditions, together with the more generalised hazards associated with each.

The *prevailing beach hazard rating* refers to the hazard rating prevailing at a given time as a result of the prevailing wave, tide, wind and beach type conditions. Figure 3.4 can be used to determine the prevailing hazard based on beach type and wave height, with Table 3.1 providing the additional wind hazard. If the beach also has local hazards such as rocks, reefs, headlands and inlets an additional 1 is added to the rating. The prevailing beach hazard rating is therefore a function of:

wave height + beach type + wind hazard + other local hazards

What this implies is that beach hazards are a function of some permanent features such as rocks and reefs, as well as more variable factors such as waves, tides and wind. It also means that the hazard rating will change both between beaches as well as over time on any particular beach or part of a beach. These changes can occur quickly as wave, tide and wind conditions change.

Beach Hazard Ratings

1 - least hazardous beach
10 - most hazardous beach

Beach hazard rating is the scaling of a beach according to the physical hazards associated with its beach type and local beach and surf environment.

Modal beach hazard rating is based on the beach type prevailing under average or modal wave conditions, for a particular beach type of beach.

Prevailing beach hazard rating refers to the level of beach hazard associated with the prevailing wave, tide, wind and beach conditions on a particular day or time.

Table 3.2 summarises the rating for all Tasmanian beaches.

BEACH HAZARD RATING GUIDE
Impact of changing breaker wave height on hazard rating for each beach type

Wave Dominated Beaches

BEACH TYPE \ WAVE HEIGHT	<0.5 (m)	0.5 (m)	1.0 (m)	1.5 (m)	2.0 (m)	2.5 (m)	3.0 (m)	>3.0 (m)
Dissipative	4	5	6	7	8	**9**	**10**	10
Long Shore Bar Trough	4	5	6	**7**	**7**	**8**	9	10
Rhythmic Bar Beach	4	5	6	**6**	**7**	8	9	10
Transverse Bar Rip	4	4	**5**	**6**	7	8	9	10
Low Tide Terrace	3	**3**	**4**	5	6	7	8	10
Reflective	**2**	**3**	4	5	6	7	8	10

Tide Modified Beaches
(at high tide - at low tide add 1)

Ultradissipative	1	2	4	6	8	10	10	
Reflective + Bar & Rips	1	2	3	5	7	9	10	
Reflective + LTT	1	1	2	4	6	8	10	

Tide Dominated Beaches
(at high tide - at low tide add 1)

Beach + Sand Ridges	1	1	2	Waves unlikely to exceed 0.5 - 1m
Beach + Sand Flats	1	1		*Note: if adjacent to tidal channel, beware of deep water and strong tidal currents.*
Tidal Sand Flats	1			

BEACH HAZARD RATING

Least hazardous: 1 - 3
Moderately hazardous: 4 - 6
Highly hazardous: 7 - 8
Extremely hazardous: 9 - 10

KEY TO HAZARDS

- Water depth and/or tidal currents
- Shorebreak
- Rips and surfzone currents
- Rips, currents and large breakers

NOTE: All hazard level ratings are based on a swimmer being in the surf zone and will increase with increasing wave height or with the presence of features such as inlet, headland or reef induced rips and currents. Rips also become stronger with falling tide.

BOLD gradings indicate the average wave height usually required to produce the beach type and its average hazard rating.

Figure 3.4 Matrix for calculating the prevailing beach hazard rating for wave-dominated, tide-modified and tide-dominated beaches, based on beach type and prevailing wave height and, on tide-modified beaches, state of tide.

*Table 3.2 Tasmanian physical beach hazard rating, by number of beaches and their length (excluding wind hazard) for (a) the mainland coast; and (b) the major islands. Modal conditions in **bold**.*

Hazard rating	Tasmania No.	Tasmania %	Tasmania mean km	Tasmania total km	Tasmania % km	Islands No.	Islands %	Islands mean km	Islands total km	Islands % km	Tas+Islands km	Tas+Islands % km
1	118	9.3	0.53	62.1	7.1	63	18.1	0.89	55.9	16.2	118.0	9.6
2	101	8.0	0.6	61.0	6.9	52	14.9	0.42	21.9	6.3	82.9	6.8
3	197	15.5	0.45	89.1	10.1	54	15.5	0.46	24.7	7.1	113.8	9.3
4	242	19.1	0.57	137.6	15.7	41	11.8	0.74	30.3	8.8	167.9	13.7
5	263	**20.7**	0.63	165.7	18.9	**68**	**19.5**	0.99	67.2	19.4	232.8	19.0
6	140	11.0	1.48	**207.7**	**23.6**	46	13.2	2.8	**128.3**	**37.1**	**336.0**	**27.5**
7	103	8.1	0.49	50.9	5.8	12	3.4	1.25	15.0	4.3	65.9	5.4
8	78	6.1	0.58	45.1	5.1	4	1.1	0.4	1.6	0.5	46.7	3.8
9	23	1.8	2.52	57.9	6.6	4	1.1	0.1	0.4	0.1	58.3	4.8
10	4	0.3	0.3	1.2	0.1	4	1.1	0.11	0.4	0.1	1.6	0.1
	1269	100		878.1	100	348	100		346	100	1224	100

Table 3.3 Tasmanian beach hazard rating by number of beaches for coastal regions (1-7) and major islands*

Hazard rating	1	2	3	4	5	6	7	M Is	B Is	R-W	K Is	F Is	Total
1		5	**96**	2		12	5	1	**30**	**10**		22	183
2	13	12	**46**	14		2	14	4	**19**	1	3	**26**	154
3	**31**	**37**	**47**	27	4	22	**31**	8	11	3	5	**29**	255
4	**27**	**42**	31	31	46	46	19	4	3	2	8	26	285
5	**30**	**32**	13	**50**	44	61	**31**		5	5	41	19	331
6	**44**	11	15	**20**	12	15	21	1	14		18	11	182
7	15	10	5	**38**	19	6	10		2		4	1	110
8			3	**36**	29	10			3		1		82
9				4	19				4				27
10				4					1	3			8
Total	160	149	256	226	173	174	131	19	94	21	80	134	1617

* See Table 4.1 for list of regions 1-7.

Table 3.3 provides an overview of beach hazard ratings around the entire Tasmanian coast and main islands. It highlights three aspects of the coast: first, the full range of hazards (1-10), a function of the wide range of wave-beach conditions around the coast; second, the generally wide range of hazards in each region indicating intraregional variation in wave and beach conditions; and third, a still substantial number of beaches (740, 46%) rating 5 and above, a product of the high wave conditions along much of the south and parts of the west coast, including eight rating an extremely hazardous 10. The high hazards are a product of the energetic west coast environment, the low hazards are a product of the many sheltered and lee shores, while the bulk of the beaches are of a moderate rating.

Compared with other Australian states (Table 3.4), Tasmania is similar to the other southern states, with a spectrum ranging from extremely hazardous rating 10, to a substantial number of sheltered beaches with a low rating, while the majority have a moderate rating.

Australian Beach Safety and Management Program

Table 3.4 Beach hazard rating of all Australian mainland beaches, by number of beaches.
Bold *indicates modal/bi-modal hazard rating/s. (Source: Short, 1993, 1996, 2000, 2001, 2005)*

Beach Hazard Rating	Qld	NSW	Vic	Tas	SA	WA	NT	Aust. Number	Aust. %
1	325		61	**118**	**320**	**1,171**	544	2539	23.8
2	**748**	45	36	101	271	880	**738**	**2819**	**26.4**
3	473	103	90	197	206	415	132	1616	15.1
4	58	134	**92**	242	154	226	54	960	9.0
5	13	85	66	**263**	125	175	11	738	6.9
6	**23**	232	109	140	93	119	9	725	6.8
7	9	112	**148**	103	**137**	137		646	6.0
8	1	7	77	78	117	**171**		451	4.2
9			11	23	20	76		130	1.2
10		3	2	4	11	41		61	0.6
Total	1650	721	692	1269	1454	3411	1488	10 685	100.0

Three factors contribute to the high number of hazardous beaches in the state. *First* is the prevailing high westerly swell, which averages 3 m and more year-round (Fig. 1.15). The high waves themselves are a hazard as well as the dangerous surf and rips they generate. *Second*, is the prevalence of rips on all exposed high energy beaches, with a total of 1695 beach rips usually present around most of the coast. These rips have an average longshore spacing of between 150 and 480 m, the latter on the west coast the largest in Australia. *Third*, is the presence of rocks, reefs and headlands along or at the boundaries of many beaches. These features are a hazard in themselves, as well as generating topographic (or headland) rips where surf breaks against the rocks and the associated currents are deflected seaward. In all there are 600 such rips also occurring right around the coast. When the beach and topographic rips are combined, on an average day 2300 rips are operating around the coast. This book identifies every beach where rips occur and provides information on their location and general spacing.

Sharks

This book is not designed to deal with biological hazards. However some mention must be made of sharks, as there have been a number of fatal shark attacks since 2000 in Western Australia at Cottesloe and Cowaramup, in South Australia at Cactus, Elliston and two off Adelaide and in Queensland off Cairns and on Stradbroke Island, and a non fatal attack at Sleaford Bay in South Australia..

There is no way of avoiding sharks once you enter their territory. If you are concerned about sharks then it is best to stay out of their domain. However all surfers and divers and many swimmers are prepared to spend some time in the ocean with the knowledge that the chances of being attacked are extremely small. On average just over one person per year is fatally attacked in all Australian waters, and as unfortunate as they are the above eight fatal attacks maintain this average. If you are at all concerned then swim only at patrolled beaches during patrol periods, where lookouts and at times aerial surveillance are used to spot sharks and warn swimmers and surfers of the presence of sharks.

The best reference for biological hazards is:

J A Williamson, P J Fenner, J W Burnett and J F Rifkin (editors), 1996, *Venomous and Poisonous Marine Animals - a Medical and Biological Handbook,* University of New South Wales Press, Sydney, 504 pp.

ISBN 0 86840 279 6

Available through UNSW Press or the Medical Journal of Australia.

This is an excellent and authoritative text, which provides the most extensive and up-to-date description and illustrations of these marine animals and the treatment for their envenomation.

4. TASMANIAN BEACHES

Tasmania has a mainland coast of 2235 km, together with another 793 km of shoreline around its five major islands. The mainland has 1269 beaches while the five islands contain an additional 348 beach systems (Table 4.1). Scores of smaller islands are also located in Bass Strait and in the south east. Compared to the other six Australian states and territory Tasmania ranks fifth in coast length and number of beaches (Table 4.2). In this book the coast is divided into four regions whose details are listed in Table 4.1 and locations illustrated in Figure 4.1. The beach descriptions commence at Cape Portland at the northeastern tip of the island and are presented clockwise around the coast, including the five main islands, finishing at Flinders Island.

Table 4.1 Tasmanian coast, main islands and beaches

Regions/Provinces	Length (km)	Cumulative km	Beaches	Cumulative beaches	Sandy coast km (%)	Regional maps	
						Figure	Page
East Coast							
1A Cape Portland-Cape Degerando	254	000-254	160	001-160	146 (57)	4.2	57
1B Cape Degernado-Cape Pillar	258	254-512	149	161-309	108 (42)	4.29	84
South Coast							
2 Cape Pillar-South East Cape	585	512-1097	256	310-565	129 (22)	4.58	113
						4.84	137
West Coast							
3A South East Cape-Cape Sorrell	448	1097-1545	226	566-791	99 (22)	4.114	164
						4.125	174
						4.140	188
3B Cape Sorrell-Woolnorth Point	244	1545-1789	173	792-964	121 (54)	4.154	201
						4.160	204
						4.170	213
North Coast							
4A Woolnorth Point-Devonport	222	1789-2011	174	965-1138	116 (52)	4.204	247
						4.222	262
4B Devonport-Cape Portland	226	2011-2237	131	1139-1269	157 (71)	4.253	282
						4.272	295
Total	**2237**		**1269**		876 (39)		
Main Islands							
Maria	65	0-65	19	MI 01-19	17 (26)	4.47	103
Burny	232	0-232	94	BI 01-94	58 (25)	4.98	150
Robbins-Walker	66	0-66	21	RI 01-10	32 (49)	4.204	247
				WI 01-10			
King	195	0-195	80	KI 01-80	91 (49)	4.192	233
Flinders	235	0-235	134	FI 1-134	149 (63)	4.288	307
Island total	793		348		347 (44)		
Book Total[1]	**3030**				1223 (40)		

[1] does not include ~100 smaller islands and their beaches

Table 4.2 Australian mainland and selected island coast and beaches

	Length (km)	Sandy coast km (%)	Beaches	Islands No./ Length (km)	Island beaches	Number other islands
Queensland	6089	3199 (53)	1601	18/na	110	100's
New South Wales[1]	1586	975 (62)	721	1/36[2]	15	2
Victoria[3]	1489	988 (66)	692	0	0	15
Tasmania	**2237**	**878 (39)**	**1269**	**5/793**	**348**	**~100**
South Australia	3273	2020 (62)	1454	4/602	301	101
Western Australia	10 194	4399 (43)	3411	1/36	63	100's
Northern Territory	5029	1902 (38)	1488	0	0	100's
Total	**29 897**	**14 361 (48)**	**10 636**	**30/na**	**837**	**1000's**

[1] Includes ACT (Jervis Bay).
[2] Lord Howe Island.
[3] Includes Port Phillip Bay.

Figure 4.1 Tasmanian coastal regions and coverage of regional maps

EAST COAST

Region 1A Cape Portland-Cape Degerando
Coast length: 254 km (0-254 km)
Beaches: 160 (T 1-160)
Regional maps: Figure 4.2 page 57
 Figure 4.29 page 84
 Figure 4.47 page 103 (Maria Island)

The east coast of Tasmania extends for 512 km from Cape Portland to Cape Pillar and can be divided into northeast and southeast sections. The northeast section (Fig. 4.2 Regional map 1) extends for 254 km south to Cape Degerando at the base of the Freycinet Peninsula. It is dominated by sandy beaches with 160 beach systems occupying 145 km or 57% of the coast, the remainder occupied by rocky shore. This section also includes the popular coastal towns of St Helens, Scamander and Bicheno. Much of the shoreline and many of the beaches are also contained within reserves, including the Mount William and Freycinet national parks and a series of smaller coastal reserves.

Figure 4.2 The East Coast between Cape Portland and Cape Degerando

In the following descriptions of each beach the table preceding each set of beaches contains the following information:

No.	Beach number/s (T XXX)
Beach:	Beach name
Rating :	Beach hazard rating 1-10 (see page 52) at high tide (HT) and low tide (LT)
Type:	Beach type (see pages 30-44) for full descriptions
Length:	beach length (m or km)

T 1-8 CAPE PORTLAND-TEBRAKUNNA BAY

No. Beach	Rating HT LT	Type	Length
T1 Cape Portland (E1)	2 3	R+rock flats	200 m
T2 Cape Portland (E2)	2 3	R+rock flats	300 m
T3 Tebrakunna Bay (1)	2 2	R	600 m
T4 Tebrakunna Bay (2)	2 2	R	1.3 km
T5 Tebrakunna Bay (3)	2 3	R→LTT	900 m
Spring & neap tidal range = 1.2 & 1.0 m			

Cape Portland is a 200 m wide, 10 m high basaltic headland that forms the northeastern tip of Tasmania. It is a relatively remote location backed by Cape Portland Wildlife Sanctuary and grazing land, with the nearest small town Gladstone 40 km to the south. The Cape Portland Wildlife Sanctuary covers 700 ha either side of the cape and extends along the shoreline to the lee of beaches T 1-4. A crenulate shoreline extends for 16 km east of the cape to the mouth of the Little Musselroe River. Beaches T 1-5 occupy a series of rock and reef-controlled crenulations that extends 11 km east of the cape with only beaches T 1-4 accessible along a beachfront vehicle track.

Beach **T 1** is located 400 m southeast of the tip of the cape on its eastern shoulder. It consists of a curving 200 m long narrow high tide reflective sand and cobble beach fronted by 100 m wide intertidal rock flats then reef extending a few hundred metres offshore. Waves are lowered by refraction around the cape, with a surf break over the reef off the eastern end of the beach. The beach impounds a shallow 7 ha lake. Beach **T 2** occupies an adjacent small embayment immediately to the east with an eastern 200 m long low point. It curves for 300 m to the east and is fronted by continuous 100 m wide intertidal rock flats then deeper reefs that fill the small embayment.

Beaches T 3, 4 and 5 are three adjoining crenulate beaches that form the shoreline of **Tebrakunna Bay**, each separated by sandy forelands formed in lee of the basalt reefs and islets that dominate the 2.5 km wide bay (Fig. 4.3). Beach **T 3** commences on the eastern side of the boundary point it shares with beach T 2, and curves to the east for 600 m. It consists of a narrow high tide reflective beach fronted by 300 m wide intertidal sand

and rock flats then a 500 m wide series of low bare islets that extend 1 km east into Tebrakunna Bay. The reefs lower waves to less than 0.5 m at the shore. A small jetty and a few buildings are located towards the western end of the beach. Its neighbour beach **T 4** curves to the east for another 1.3 km as a relatively rock free reflective beach. Some rock outcrops occur along the beach and the Tebrakunna Bay reefs lie 200-300 m offshore and extend right across the beach to link to the boundary with beach T 5. Beach **T 5** continues the sweep of the sandy shoreline for 900 m to the low basalt Lanoma Point. This beach is relatively free of the bay reefs and wave height increases eastward alongshore averaging about 1 m at the point, where it maintains a low tide terrace beach. Beaches T 3 and 4 are backed by a low foredune and a 100-300 m wide series of crenulate foredune ridges, while the northwest-facing beach T 5 is backed by now vegetated transgressive dunes that have been blown out to the east.

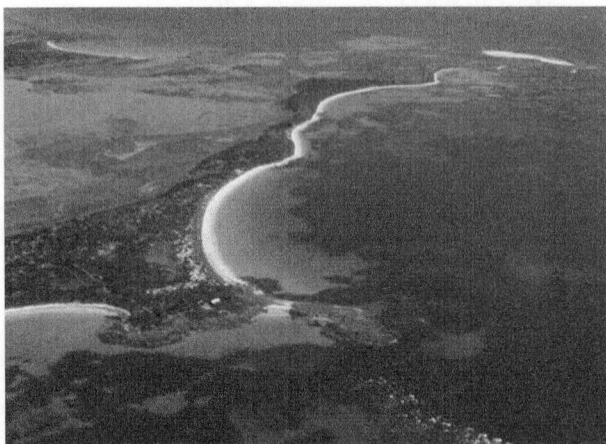

Figure 4.3 View of Lanoma Point (foreground) west across Tebrakunna Bay towards Cape Portland, including beaches T 1-6.

T 6-8 LANOMA POINT (E 1)

No. Beach	Rating HT LT	Type	Length
T6 Lanoma Pt (E1)	2 2	R	80 m
T7 Lanoma Pt (E2)	2 2	R	800 m
T8 Lanoma Pt (E3)	2 2	R	1.8 km
Spring & neap tidal range = 1.2 & 1.0 m			

Lanoma Point protrudes 200 m to the north as a low basalt point that widens to 100 m at its tip. It forms the eastern boundary of the Tebrakunna Bay beaches, with near continuous crescentic beaches trending 11 km east toward the Little Musselroe River mouth. Rocks and reefs extend north of the point, with the two 9 m high Foster Islands located 2 km due north.

Beach **T 6** is an 80 m long pocket of east-facing sand wedged in on the eastern side of the point with rocks to either side. It is exposed to occasional high waves which can wash right over the beach and backing low 50 m wide base of the point. A solitary house is located on the 10 m high basalt ridge 100 m south of the beach. Beach **T 7**

commences on the eastern side of the 200 m long ridge and curves as a semi-circular embayment to the east for 800 m to a narrow tombolo tied to a low rock islet. Both beaches are reflective with rocky seabed lying 100-200 m offshore.

Beach **T 8** is tied to the eastern side of the tombolo with a narrow strip of low sand separating it from beach T 9. The beach curves to the east as a double crenulate 1.8 km long reflective beach, paralleled by rocky seabed 100 m offshore. Strong westerly winds have blown out the rear of the beach, with a 200-300 m wide shore-parallel parabolic extending 2.5 km east to the shoreline of beaches T 9 and 10. The blowout has bypassed the foredune in lee of the central salient, which remains as a 15 m high vegetated dune. Cleared grazing land backs the dunes.

T 9-13 LANOMA POINT (E 2)

No.	Beach	Rating HT LT		Type	Length
T 9	Lanoma Pt (E3)	2	3	R→LTT	350 m
T 10	Lanoma Pt (E4)	2	3	R+rocks	150 m
T 11	Lanoma Pt (E5)	2	2	R+rocks	200 m
T 12	Lanoma Pt (E6)	2	2	R+rocks	100 m
T 13	Lanoma Pt (E7)	2	3	R→LTT	1.3 km
Spring & neap tidal range = 1.2 & 1.0 m					

Beaches T 9-13 are located between 2.5 and 5 km east of Lanoma Point. They are each bordered by low basalt points and backed by a mixture of transgressive dunes to either end with cleared grazing land in between (Fig. 4.4). Strong tidal currents flow immediately seaward of the eastern boundary point and have developed relatively shallow tidal shoals extending up to 500 m off each of the beaches, with a deeper channel off the point.

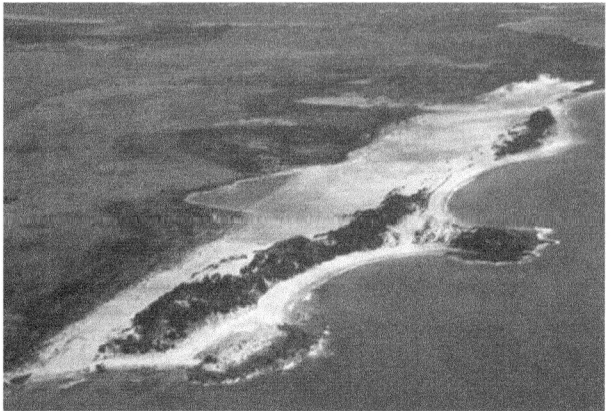

Figure 4.4 East of Lanoma Point is a series of low basalt points linked by beaches T 6-13 and backed by transgressive dunes.

Beach **T 9** is a north-facing 350 m long reflective beach curving between low basalt points and backed by a 15 m high foredune, then the 100 m wide terminal end of the transgressive dunes, which originate 3 km to the west in Tebrakunna Bay at beach T 5.

Beaches T 10, 11 and 12 are three pockets of rock-dominated sand located along the next 1 km of shoreline. Beach **T 10** is a 150 m long east-facing beach bordered by basalt rocks, with rocks also outcropping along and off the beach. Two active sand lobes and a central vegetated core terminate at the rear of the beach and have supplied sand to this small beach. Beach **T 11** lies immediately to the south and is a curving 200 m long northeast-facing reflective beach. It is bordered by low basalt rocks, with a few rocks also along and off the eastern end of the beach. It is backed by a 50 m wide zone of tea tree then cleared grazing land. Beach **T 12** lies a further 200 m down the shore and is a 100 m long pocket of and fronted by near continuous inter- and sub-tidal rocks and reefs then a sandy seafloor. A few shrubs then cleared grazing land back the beach.

Beach **T 13** is a curving 1.3 km long north-facing beach that commences immediately to the south. The beach is sheltered in its western corner, with waves increasing along the beach as it grades from reflective to low tide terrace at its eastern end against a low basalt point. The eastern half of the beach faces northwest exposing it to the strong westerly winds. These have activated the foredune, which has blown out across the 200 m wide point to beach T 14. A generally low foredune and deflated dune surface and infilled lake back the beach with some clumps of vegetated transgressive dune.

Musselroe Bay Conservation Area

Established:	1981
Area:	1750 ha
Coast length:	19 km (14-33 km)
Beaches	8 (16-24)

Musselroe Bay Conservation Area includes the lower reaches of the river and a 19 km long strip of coast between beaches T 16 and 24. The reserve includes a range of coastal environments including the river mouth-deltas and estuarine sections of the 60 ha Little Musselroe and 250 ha Great Musselroe rivers, the intervening beaches, dunes, rocky points and wetlands and backing vegetated longwalled parabolic dunes. It is accessible by car along the Little Musselroe and Musselroe roads.

T 14-17 MUSSELROE BAY

No. Beach	Rating HT LT		Type	Length
T14 Musselroe Bay (W3)	2	2	R	300 m
T15 Musselroe Bay (W2)	2	2	R	500 m
T16 Musselroe Bay (W1)	2	3	R+rocks	150 m
T17 Musselroe Bay	2	3	R+sand waves	4 km
Spring & neap tidal range = 1.2 & 1.0 m				

Little Musselroe Bay is a 4.5 km wide gently curving embayment that faces northeast towards Swan Island 5 km off the coast. It is bordered by a low basalt point in

the north and the low dune-capped rocks of Tree Point to the east. Beaches T 14, 15 and 16 are located at the western end of the bay and separated from the main beach T 17 by a narrow inlet that drains the Little Musselroe River estuary (Fig. 4.5). The gravel Little Musselroe Road reaches the western side of the inlet and rear of beach T 15. The three beaches receive waves usually less than 1 m, with strong tidal currents flowing westward around Tree Point which maintain shore transverse tidal sand waves off most of beach T 17.

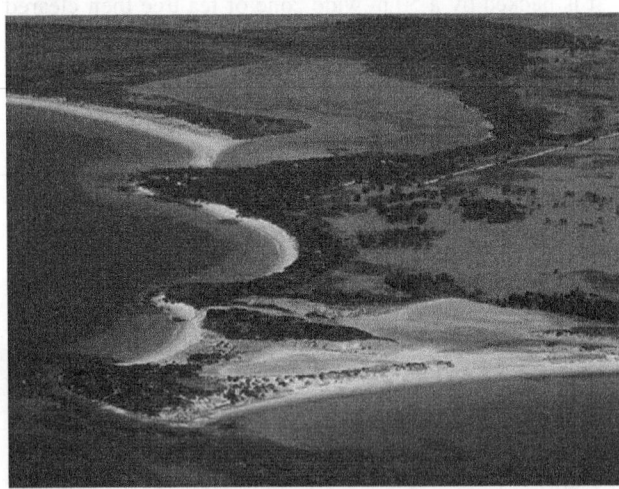

Figure 4.5 The northern end of Little Musselroe Bay showing the beaches T 13-17 and the estuary.

Beach **T 14** is a curving 300 m long east-facing reflective beach bordered by low basalt points, with a solitary rock outcropping toward the southern end of the beach. Seagrass meadows lie 50-100 m off the shore. Vegetating transgressive dunes from beach T 13 reach the back of the beach and have supplied sand to the system.

Beach **T 15** lies 100 m to the south and is a similar 500 m long steep reflective east-facing beach, which curves between low basalt points. It is backed by a well developed 10 m high foredune, then grazing land, with a cluster of houses behind the more densely vegetated southern end of the beach and extending onto the southern point. Beach **T 16** extends along the eastern base of the point for 150 m, as a sandy reflective beach bordered by the rock platforms of the point, with a central rock outcrop. The Little Musselroe Road terminates at the southern end of the beach, with a track out to the rear of the point and down to a boat ramp at the inlet.

A narrow tidal inlet separates the northern point from **Little Musselroe Bay** beach (**T 17**). The beach trends to the southeast, then east for 4 km finally curving to the northeast in lee of the low Tree Point, its eastern boundary. The entire beach receives waves averaging less than 1 m which maintain a steep reflective beach, backed by a continuous foredune, then the largely infilled wetlands of the shallow 60 ha estuary. Towards the eastern end of the beach where it curves to face northwest, there has been dune transgression across 100-200 m wide Tree Point to beach T 18. Strong tidal flows around Tree Point maintain shore-perpendicular tidal sand waves along the eastern half of the beach inducing variable nearshore and shoreline topography.

T 18-20 TREE POINT (S)

No. Beach	Rating HT LT		Type	Length
T18 Tree Pt (S1)	2	3	R+rocks	700 m
T19 Tree Pt (S2)	2	3	R+rocks	200 m
T20 Tree Pt (S3)	2	3	R+rocks	1.1 km
Spring & neap tidal range = 1.2 & 1.0 m				

Tree Point is a 10 m wide dune-capped basalt point that forms the eastern boundary of Little Musselroe Bay and marks a change in the direction of the shoreline with the coast to the east trending southeast into Great Musselroe Bay. The first 2 km of shoreline contain three beaches (T 18-20) each bordered by low basalt points together with outcrops along the beaches. At the southern end of beach T 20 is a 1 km long section of granite that separates it from the long Great Musselroe Bay beach (T 21). There is no vehicle access to any of the point beaches.

Beach **T 18** commences on the eastern side of Tree Point and trends to the southeast for 700 m to a slightly protruding sand-capped low basalt point. Some rocks outcrop along the northern end, with deeper rock reefs lying off much of the steep reflective beach. It is backed by vegetated transgressive dunes that have crossed the rear of the beach from Little Musselroe Bay (beach T 17).

Beach **T 19** lies on the southern side of the 100 m long point and curves slightly to the south for 200 m terminating at a 150 m long outcrop of rocks. The beach also has rock outcropping in the centre of the beach, with scattered rock reefs off the reflective beach. Beach **T 20** extends for 1.1 km from the small northern boundary point to the beginning of the southern granite outcrop. The beach faces northeast and receives waves averaging less than 1 m, which maintain a steep reflective beach. The northern half of the beach is relatively straight and free of rocks, while large granite boulders begin to outcrop on and just off the southern half causing it to curve slightly in lee of the southern rocks. Both beaches are backed by the dense scrubland which extends several hundred metres inland across the coastal plain, which consists of Pleistocene longwalled parabolic dunes.

T 21-22 GREAT MUSSELROE BAY

No. Beach	Rating HT LT		Type	Length
T21 Great Musselroe Bay	2	2	R	8.8 km
T22 Musselroe Pt (W)	3	4	LTT+rocks	200 m
Spring & neap tidal range = 1.2 & 1.0 m				

Great Musselroe Bay is a 10 km wide northeast-facing bay bordered by Tree Point to the north and Musselroe Point in the south. Beaches T 18-20 occupy the northern shoreline of the bay with the remainder dominated by beach T 21. The Great Musselroe River drains into an elongate 250 ha estuary behind the main beach and exits to the sea in lee of Musselroe Point. The small settlement

of **Poole** is located just inside the inlet mouth (Fig. 4.6), with the entire beach, estuary and both points located within the Musselroe Bay Coastal Reserve. The Musselroe Road provides access to Poole and the Musselroe Point area.

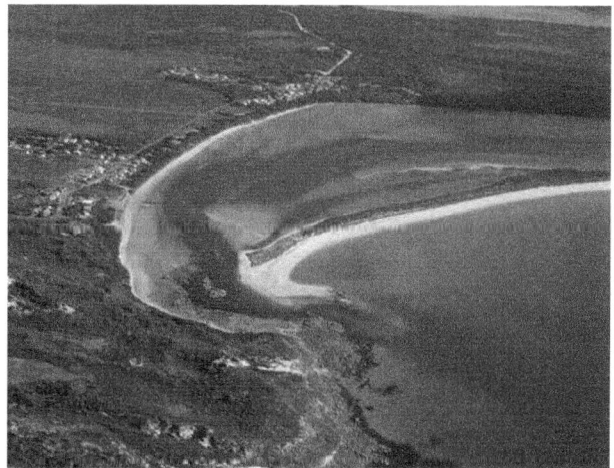

Figure 4.6 Great Musselroe Bay inlet at the southern end of beach T 21 and the small community of Poole (photo W. Hennecke).

Great Musselroe Bay beach (**T 21**) commences in the north against the 1 km long section of granite that rises to 48 m 500 m inland. The beach sweeps for 8.8 km to the southeast, then curves to the east and finally northeast, terminating at the narrow inlet, with the granite rocks of Musselroe Point forming the eastern inlet boundary. The bay receives waves averaging about 1 m, increasing slightly into the southern corner. Most of the beach is steep cusped and reflective with a low tide terrace forming during and following periods of higher waves. It is backed by a continuous well vegetated foredune, then a relatively narrow barrier that forms the western boundary to the 6 km long estuary. A small tidal delta is located off the inlet mouth, which is bordered by granite boulders and the granite of the point, with a right-hand surf break over the delta shoals during larger swell. The settlement of Poole is located across the estuary at the eastern end of the beach. It spreads along the sandy estuarine shoreline for 1.5 km, with several small fishing boats usually moored in the estuary.

Beach **T 22** is located on the western side of **Musselroe Point** 300 m north of the inlet. It is a 200 m long west-facing beach exposed to the prevailing westerly winds and wind waves. These maintain a low tide terrace beach bordered by the granite boulders of the point, the boulders continuing all the way around the point, in places backed by a high tide strip of sand. The beach is backed by vegetated parabolic dunes that cross the 500 m wide point to beaches T 23 and 24.

Mount William National Park		
Established:	1973	
Area:	13 439 ha	
Coast length:	35 km	(34-69 km)
Beaches:	32	(T 25-57)

Mount William National Park extends south along the coast from Musselroe Point for 35 km to Policemans Point at the entrance to Anson Bay and up to 8 km inland. The park includes 32 near continuous beach systems, their intervening granite headlands and backing coastal plains in the north, then the slopes of Mount William which rise to 216 m and 184 m high Bayleys Hill. Much of the plain consists of scrubs and heath covering the dunes and swales of the Pleistocene longwalled parabolic dunes, which originated up to 20 km to the west in Ringarooma Bay. There is vehicle access to the park in the north via Poole with a camping site behind beach T 25; along Stumpy Bay and the Top Site with several campsites along beaches T 27 and 28; and in the south at Picnic Rocks. The Eddystone Point lighthouse is accessed through the park, the point forming a prominent southeastern boundary to the park and site of the historic lighthouse and lighthouse keepers' houses.

T 23-26 MUSSELROE POINT-CAPE NATURALISTE

No. Beach	Rating HT LT		Type	Length
T23 Musselroe Pt (W)	4	5	LTT+rocks	150 m
T24 Musselroe Pt (S1)	4	5	LTT	1.5 km
T25 Musselroe Pt (S2)	4	5	LTT	800 m
T26 Cape Naturaliste (W)	4	5	LTT	2 km
Spring & neap tidal range = 1.2 & 1.0 m				

Musselroe Point is a low dune-capped granite headland, with Great Musselroe Bay extending to the west and a 5 km long sweep of sandy coast to the southeast containing beaches T 23-26. Musselroe Bay Coastal Reserve and the small Poole settlement are located to the west of the cape, while Mount William National Park begins just to the south at beach T 25. The gravel road from Poole reaches the rear of beaches T 24 and 25, with a national park campsite to the lee of beach T 25.

Beach **T 23** is located on the eastern side of the point and consists of a 150 m long sandy beach bordered by granite rocks and boulders and backed by the vegetated parabolic dunes that originate from the western side of the point. Waves average about 1 m and break across a 30 m wide low tide terrace. A 100 m long string of granite boulders separates it from beach **T 24**, which trends to the southeast for 1.5 km to a small sandy foreland formed in lee of shallow inshore reefs, with deeper reefs along much of the beach. Waves average just over 1 m and maintain a 50 m wide bar, which is cut by rips during and following periods of higher waves. It is backed by vegetated parabolic dunes that originate from the Poole area, with two access tracks from the Poole settlement reaching the rear of the beach. The beach at the end of the northern track is used to launch small boats during low waves.

Beach **T 25** curves to the south of the foreland for 800 m past a central rock outcrop to the next sandy foreland

located to the lee of a small rock islet located 100 m offshore. Wave and beach conditions remain the same with a foredune and vegetated parabolic dunes backing the beach. The national park campsite is located behind the southern end of the beach.

Beach **T 26** continues southeast of the foreland for 2 km to the prominent sandy Cape Naturaliste. Waves average just over 1 m along the beach, decreasing to the lee of the cape. These maintain a 40 m wide low tide terrace, with rips forming during periods of higher waves. A vegetated foredune then vegetated Pleistocene longwalled parabolic dunes and waterlogged deflation basins run at a tangent to the beach and across the rear of the cape. These form a heath-covered freshwater wetland.

T 27-29 STUMPYS BAY

No. Beach	Rating HT LT		Type	Length
T27 Stumpys Bay	3	3	R/LTT	3.9 km
T28 Stumpys Rock	3	4	R/LTT+rocks	1.3 km
T29 Boulder Pt (W 2)	3	3	R	600 m
Spring & neap tidal range = 1.3 & 0.3 m				

Stumpys Bay is an open curving east- to northeast-facing sandy shoreline bordered by Cape Naturaliste in the north and Boulder Point, 4.5 km to the south-southeast. In between are three gentle curving sandy beaches (T 27-29) with vehicle access to and camping at all three.

Stumpys Bay beach (**T 27**) commences on the southern side of Cape Naturaliste and curves to the south, then south-southeast for 3.9 km to a prominent sandy foreland formed in lee of Stumpys Rock, a series of granite boulders and reefs extending 600 m offshore. The beach receives waves averaging about 1 m which maintain an often cusped reflective to occasionally low tide terrace beach, with rips only occurring during periods of higher waves. It is backed by a 200 m wide series of 5-6 foredunes in the north-centre, which narrow to the south. The foredune is breached by three small streams include Gumhill Creek, with a usually blocked creek and small lagoon located against the southern foreland. The creeks drain longwalled parabolic dunes in the north and the slopes of Mount William in the south. Besides the rocks, scattered deeper reefs occupy much of the bay floor. There is vehicle access to two campsites located at the creek mouth and 1 km to the north.

Beach **T 28** extends south-southeast from the Stumpys Rock foreland for 1.3 km, to the next small creek and lagoon, which crosses the beach at a smaller foreland, formed in lee of a collection of granite boulders just off the beach. The moderately steep reflective to low tide terrace beach is backed by 3-4 foredunes, then an elongate wetland drained by the northern boundary and a central smaller creek. The vehicle track provides access to a campsite on the northern foreland, and a second site on the banks of the southern creek.

Beach **T 29** continues the near continuous beach from the foreland for another 600 m to the first set of rocks of Boulder Point, a 1.5 km long collection of granite boulders and intervening beaches (Fig. 4.7). The curving beach faces north and is sheltered from southerly waves by the point, with reflective conditions prevailing. Rocks and reefs dot the seafloor, with a couple of boulders towards the eastern end of the beach, and a small usually blocked creek located to their lee. As the beach curves to face west, the westerly winds have blown out the foredunes and a 300 m long shore-parallel parabolic dune and deflation hollow extends east of the beach to the lee of Boulder Point.

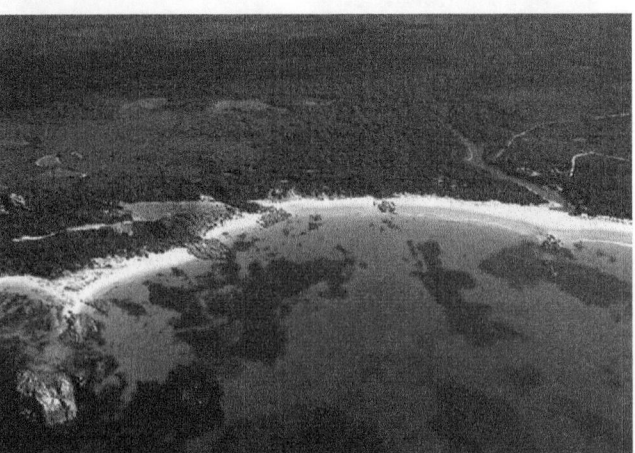

Figure 4.7 The southern end of Stumpys Bay and Boulder Point, with beach T 29 centre.

T 30-34 **BOULDER POINT**

No. Beach	Rating HT LT		Type	Length
T30 Boulder Pt (W1)	3	4	R	200m
T31 Boulder Pt	3	4	R	100m
T32 Tennis Ball Rock (N)	3	4	R/LTT+rocks	600m
T33 Tennis Ball Rock (S)	3	4	R/LTT	200 m
T34 Cobler Rock	3	4	R	80 m
Spring & neap tidal range = 1.3 & 0.3 m				

Boulder Point is the northernmost outcrop of a 1.5 km long string of granite boulders that lie along and just off the shoreline, with Tennis Ball Rock 500 m to the east and Cobler Rocks forming the eastern boundary. In between are five rock-bordered beaches (T 30-34). The beaches are only accessible on foot from the southern Stumpys Rock campsite, located several hundred metres west of the point.

Beach **T 30** is a sheltered 200 m long north-facing reflective beach tied to low granite boulder points at each end, with the rocky islet of Boulder Point extending 200 m off the eastern end. Parabolic dunes from beach T 29 parallel the rear of the beach, with a vegetated sidewall, then a granite based deflation basin to the rear. Beach **T 31** is located at the northern tip of Boulder Point, and consists of a curving 100 m reflective beach bordered by granite boulders with some rocks and reefs

extending off either end and outcropping on and off the beach. It is backed by the vegetated sidewall.

Beach **T 32** commences 100 m to the east and curves to the east for 600 m to a sandy foreland formed in lee of Tennis Ball Rock. The name relates to the whitish rounded granite islets off the beach. Several rocks also outcrop along and just off the shoreline. Waves are a little higher on the more exposed northern side of the point and reflective to low to terrace conditions usually prevail. The vegetated deflation hollow of the parabolic from beach T 29 backs the beach. Beach **T 33** lies immediately to the east and is a curving 200 m long beach backed by a densely vegetated 20 m high dune, with rocks to either end and scattered off the beach. A parabolic dune has blown out of the eastern end of the beach and transgressed 200 m east across the granite boulders to reach the western end of beach **T 34**. This is an 80 m long curving, pocket reflective beach, with a cluster of granite boulders tying each end, and the larger Cobler Rock located 100 m east of the beach.

T 35-38 COD BAY

No. Beach	Rating HT LT	Type	Length
T35 Cray Creek	3 4	R/LTT	1.3 km
T36 Cod Bay	3 4	R/LTT	4.2 km
T37 Rock Creek	3 4	R	350 m
T38 Bens Creek	3 4	R	850 m
Spring & neap tidal range = 1.3 & 0.3m			

Cod Bay extends for 13 km from the Cobler Rocks to the protruding boundary with Purdon Bay to the south. It is a slightly curving east- to east-northeast-facing sandy bay occupied by four near continuous beaches (T 35-38). The slopes of Mount William rise to the lee of the beaches, with several creeks reaching the shore and breaking out across the beaches. Granite rocks and boulders border each of the beaches and points and are scattered across the seafloor. The beaches are only accessible on foot from Stumpys Bay.

Beach **T 35** commences on the southern side of Cobler Rocks and curves to the south-southeast for 1.3 km to a prominent sandy foreland tied to a cluster of inshore boulders, with a larger 9 m high cluster located 100 m offshore. A narrow scarped foredune, then heathland, backs the beach, with the usually blocked Cray Creek and its narrow meandering lagoon draining out towards the southern end of the beach. A walking track from the Stumpys Rock campsite reaches the creek mouth.

Cod Bay beach (**T 36**) commences at the tip of the foreland and curves to the south, then south-southeast for 4.2 km to the next cluster of shore-attached granite boulders. Reflective to low tide terrace conditions prevail the length of the beach. It is backed by a 10 m high foredune, breached by two small creeks including Cobler Creek, and two to three inner foredunes, including a 300 m wide foredune plain south of the southern creek

(Fig. 4.8). The foredunes are backed by deflected creeks and elongate wetlands, with the entire system up to 500 m wide.

Beach **T 37** commences on the southern side of the boulders and trends to the southeast for 350 m. Larger rounded granite outcrops and surrounding boulders dominate each end, each surrounded by boulders, as well as some boulders on the northern end of the beach. The white sand beach faces northeast and receives waves averaging less than 1 m, which maintain a steep reflective beach. It is backed by a foredune destabilised by the backing elongate mouth of Rock Creek which usually drains across the southern end of the beach, then an inner vegetated foredune and a 200 m long infilled lagoon. A 50m wide granite outcrop separates it from beach **T 38**, a curving 850 m long northeast-facing reflective beach. The beach has an open northern half with an increasing number of boulders on and off the southern half of the beach, as it curves round to the boundary rocky point. It is backed by a vegetated foredune, and Bens Creek, which is deflected, to the south to cross the beach where the boulders begin to dominate.

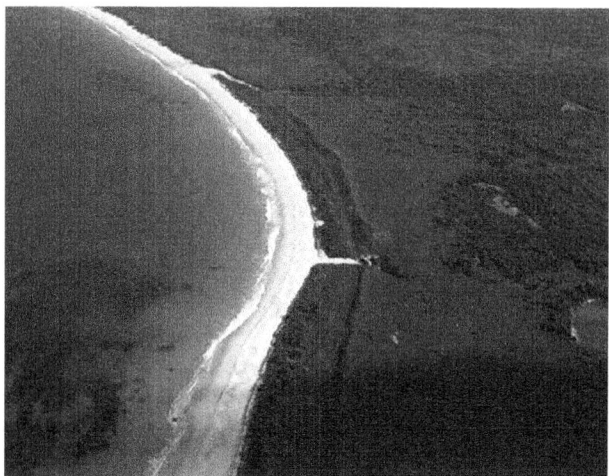

Figure 4.8 Cod Bay beach (T 36) is a lower energy white sand beach backed by a distinctive foredune ridge.

T 39-42 PURDON BAY

No. Beach	Rating HT LT	Type	Length
T39 Bens Ck (S)	3 4	R+rocks	500 m
T40 Purdon Bay (N)	3 4	R/LTT	1.3 km
T41 Purdon Bay (S)	3 4	R/LTT	1.1 km
T42 Deep Ck	3 4	R+rocks	550 m
Spring & neap tidal range = 1.3 & 0.3 m			

Purdon Bay is an open east-facing sandy embayment bordered by scattered granite boulders in the north and the granite rocks of Picnic Rocks to the south. In between are four near continuous white sand reflective beaches (T 39-42). The beaches are only accessible on foot with the closest vehicle access on the southern side of Deep Creek (beach T 42) in the south.

Beach **T 39** occupies the lee of a 500 m long section of scattered rocks that separates Cod from Purdon Bay. The reflective beach only has clear access to the water along its northern 100 m with the remainder dominated by the granite boulders. A scattered foredune backs the northern half, with heathland to the rear of the southern half of the beach. A small walkers' hut is located in the dunes at the northern tip of the beach, 200 m east of the mouth of Bens Creek.

Beach **T 40** begins at the end of the boulders and curves to the south for 1.3 km to the mouth of Broad Creek, which enters the centre of Purdon Bay. While the beach is relatively free of rocks, they dominate the seabed off the beach and lower waves at the shore resulting in usually cusped reflective conditions. Beach **T 41** commences on the southern side of the 100 m wide usually blocked creek mouth and curves to the south then southeast for 1.1 km to a gentle sandy foreland formed in lee of a nearly attached shore-perpendicular cluster of rocks. Both beaches are backed by a 5-10 m high vegetated foredune, and then an elongate deflected creek and wetlands, including a 500 m long shore-parallel lagoon that extends north to the lee of the northern beach.

Beach **T 42** continues on the southern side of the foreland for 550 m to the rocks on the southern side of the usually blocked mouth of Deep Creek. The rocks of Picnic Rocks lie at and off the creek mouth, with some rocks extending several hundred metres offshore. The rocks and northeast to northerly orientation of the beach lower waves to less than 1 m and maintain usually reflective conditions. The Deep Creek road terminates at the car park with picnic facilities located on the southern side of the creek.

T 43-49 PICNIC ROCKS-EDDYSTONE POINT

No. Beach	Rating HT	LT	Type	Length
T43 Picnic Rocks	3	4	R+rocks	300 m
T44 Picnic Rocks (S)	3	4	R+rocks	300 m
T45 Picnic Pt (N)	3	4	R/LTT	1.1 km
T46 Picnic Pt	3	4	R+rocks	100 m
T47 Picnic Corner	3	4	R/LTT	1.3 km
T48 Larc Beach (W)	3	4	R+rocks	50 m
T49 Larc Beach (E)	3	4	R+rocks	100 m
Spring & neap tidal range = 1.3 & 0.3 m				

Between Picnic Rocks and Eddystone Point, 4 km to the southeast, is a curving northeast-facing bay containing seven moderately sheltered, lower gradient reflective beaches (T 43-49), each bordered by granite rocks and boulders. There is good vehicle access to all the beaches along the Deep Creek and Eddystone Point roads, with camping facilities on the banks of Deep Creek and Picnic Point in the north, and the historic Eddystone Lighthouse on the eastern point.

Picnic Rocks are a collection of granite rocks, boulders and reefs that extend for 1 km alongshore between beaches T 42-44, and up to 500 m offshore (Fig. 4.9).

Beach **T 43** commences on the southern side of the granite point that separates it from beach T 42 and trends to the southeast for 300 m in two rock-bordered scallops, with numerous rocks just off the beach, and a seabed dominated by rocks. The Picnic Rocks camping and picnic areas are located along the southern side of Deep Creek, with a few fishing shacks located on the slopes behind the beach. Beach **T 44** curves to the south of the southern rock boundary for another 300 m to the southernmost cluster of Picnic Rocks. The beach is relatively free of rocks and forms a usually protected swimming 'bay'. A vegetated foredune then the Deep Creek road run along the rear of the beach.

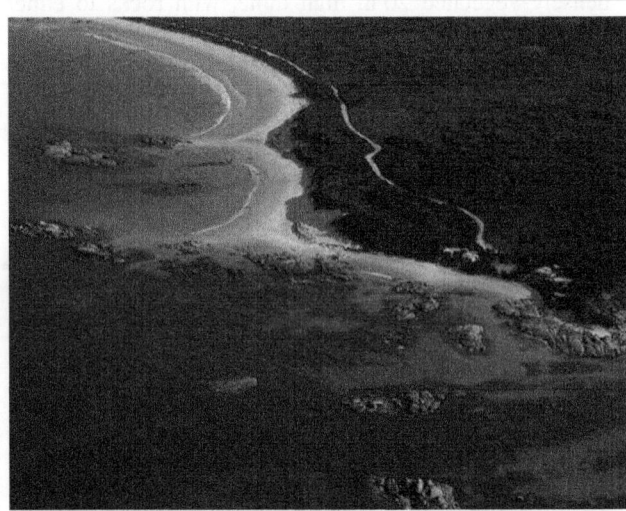

Figure 4.9 Picnic Rocks and beaches T 43-45.

Beach **T 45** sweeps for 1.1 km from the boundary rocks to the next cluster of rocks at Picnic Point, with a few rocks also outcropping along the southern end of the beach. Other than these it is relative free of rocks and forms a near continuous lower gradient reflective to low tide terrace beach. The Deep Creek road runs along the rear of the beach. Beach **T 46** is a 100 m long pocket of sand located between the two main rock outcrops that form Picnic Point. The rocks help shelter the beach, which is backed by a few fishing shacks and used for launching small fishing boats.

Beach **T 47** is a curving 1.3 km long northeast-facing reflective to low tide terrace beach located between Picnic Point and Picnic Corner in lee of Eddystone Point. The point and the beach's northerly orientation protect it from southerly waves, with fishing boats sometimes anchored in the corner and seaweed accumulating on the beach. It backed by a vegetated foredune, which increases in height into the southern corner, and a patchy wetland is shared with beach T 51. It is accessible along the Picnic Rocks and Eddystone Point roads with a few fishing shacks located on the southern headland overlooking the corner.

Larc Beach (T 48 & 49) is located on the northern side of Eddystone Point. It consists of two adjoining pockets of north-facing sand bordered by the sloping granite of the point. The western beach (**T 48**) is a 50 m long pocket of sand, with a small outcrop separating it from the 100 m long eastern beach (**T 49**). Both beaches are composed of

fine sand, which produces a low gradient reflective to low tide terrace beach and sandy bay floor. The Eddystone Point road passes the rear of the beach with a car park and short walking track down to beach T 49. The lighthouse is located 500 m southeast of the beaches (Fig. 4.10).

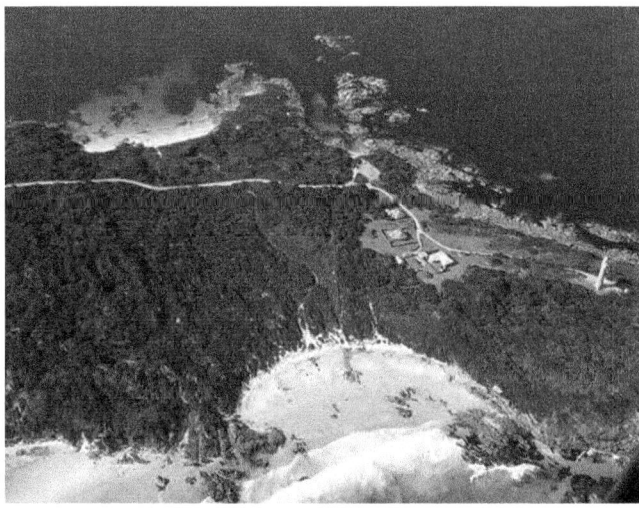

Figure 4.10 Eddystone Point showing the lighthouse and Larc Beach (top) and the point beach (T 50) foreground (photo W. Hennecke).

T 50-57 BAY OF FIRES

No. Beach	Rating HT LT		Type	Length
T50 Eddystone Pt	6	7	TBR	250 m
T51 Bay of Fires	6	6	TBR/RBB	1.8 km
T52 Red Rocks	6	6	TBR/RBB	1.2 km
T53 Red Rocks (S)	7	7	RBB+rocks	150 m
T54 Bayley Rock (N)	6	6	TBR	800 m
T55 Bayley Hummock (1)	7	7	TBR+rocks	100 m
T56 Bayley Hummock (2)	7	7	TBR+rocks	50 m
T57 Abbotsbury Beach	6	6	TBR	3.8 km
Spring & neap tidal range = 1.3 & 0.3 m				

The **Bay of Fires** is an open, slightly curving 10 km wide southeast-facing embayment exposed to the prevailing southerly waves and periodic strong southerly winds. It is bordered in the north by Eddystone Point and the entrance to Ansons Bay at Policemans Point in the south. In between are eight moderate energy near continuous rip-dominated beaches (T 50-57), separated by outcrops of Carboniferous granite. They are backed by some moderate dune transgression, and all are within the Mount William National Park. South of Eddystone Point there is no vehicle access. A walking track from the point reaches Bayley Hummock in lee of beach T 56.

The **Eddystone Point** beach (**T 50**) is located on the exposed southern side of the 29 m high granite point. It is 250 m long, bordered by the point to the east and a broken outcrop of rocks to the west. It faces due south exposing it to all southerly waves and winds. The winds have blown sand from the beach to blanket the point with now vegetated clifftop dunes. Waves average over 1 m

and maintain a 50-100 m wide surf zone, with a permanent rip running out past the southern rocks. The Eddystone Road terminates 100 m north of the beach with a track down to the shore.

Beach **T 51** commences on the western side of the boundary rocks and curves to the southwest for 1.8 km to the sandy foreland in lee of the Red Rocks, an inshore granite reef. This is one of the higher energy east coast beaches, with waves averaging up to 1.5 m which maintain a well developed bar and rip system, with usually several rips spaced about every 250 m. Beach **T 52** continues south of the foreland for another 1.2 km, terminating against the first of a 2 km series of rock outcrops. This is a similar higher energy rip-dominated beach, with usually four rips along the beach and against the southern rocks. Both active and inner vegetated 20 m high transgressive dunes back the beaches, and extend up to 700 m inland in the north to reach the rear of Picnic Corner (beach T 47).

Beach **T 53** is a 150 m long beach bordered by irregular granite points, together with a central outcrop at the shore. Permanent rips run out either side of the outcrops with a detached bar usually located in line with the points. It is backed by densely vegetated dune-draped granite slopes rising to 20 m.

Beach **T 54** is an 800 m long beach located in the centre of the rock outcrops, with **Bayley Rock** extending 100 m seaward and forming the southern headland. It receives waves averaging up to 1.5 m, which maintain a 50-100 m wide surf zone drained by permanent rips at either end of the beach. It is backed by some active and vegetated dunes climbing over the backing rocks to a height of 29 m and extending 250 m inland.

On the southern side of Bayley Point are two pockets of sand (beaches T 55 and 56). Beach **T 55** is a 100 m long strip of sand wedged into three gaps in the granite, and awash during high waves. A permanent central rip drains the exposed beach. The walking track reaches the point at the northern end of the beach. Beach **T 56** is located 100 m to the south and consists of a 50 m long pocket of sand wedged in between protruding granite points, with rocks extending off the northern point. The Bay of Fires Lodge is located above the southern side of the beach. The beaches are backed by densely vegetated dune-draped rocks called **Bayley Hummock**.

Abbotsbury Beach (**T 57**) commences on the southern side of the Hummock and curves to the south for 3.8 km to the mouth of Ansons Bay at Policemans Point. The beach forms a 500 m wide barrier, which has impounded the 450 ha lagoon. It is exposed to southerly waves, which maintain a rip-dominated 50-100 m wide surf zone with usually 10 rips forming along the beach. The inlet exits in lee of a rock reef, which has permitted an ebb tide delta to extend 200 m seaward in lee of the rocks, forming a right-hand surf break along the northern side of the shoals. The beach is backed by a mixture of active and vegetated transgressive dunes extending 100-200 m in across the barrier and reaching 20 m in height.

Bay of Fires Conservation Area

Established: 1982
Area: 3440 ha
Coast length: 19 km (69-79, 82-91 km)
Beaches: 23 (T 58-69, 78-89)

The Bay of Fires Conservation Area extends along the coast in two sections between Ansons Bay inlet and Binalong Bay separated by the freehold land at The Gardens. The northern 11 km long strip of natural shoreline is backed by farmland, between Ansons Bay inlet and Gardens Lagoon inlet. The 11 beaches in this section are only accessible on foot along the coast. The southern section contains 11 beaches and extends along 11 km of coast between Taylors Beach and Binalong Bay. These beaches are accessible off The Gardens Road and there are several camping areas between Sloop Rock and Jeanneret Beach.

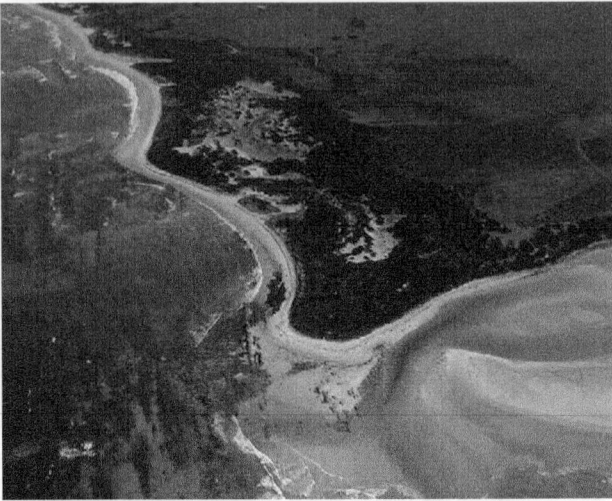

Figure 4.11 Ansons Bay inlet (right) and beaches T 58 and 59 extending south of Policemans Point.

southern half receives slightly higher waves that maintain a low tide terrace, with numerous rocks scattered along the beach and surf. The beach is backed by a generally vegetated 50-100 m wide foredune, then cleared farmland. A number of creeks including Yacca Creek converge on a small usually blocked lagoon behind the northern section of beach.

Pebbly Beach (T 60) is located at the end of the rocky section of shore and consists of a curving 300 m long sand and pebble beach, with wide intertidal rock platforms and reefs to either side and a 100 m long open central section of sand (Fig. 4.12). There is a left-hand surf break over the northern reef, and during higher waves a strong rip flows out the centre of the beach. It is backed by a 50-100 m wide foredune then cleared farmland. Jacks Lookout Creek drains onto the rock at the southern end of the beach.

T 58-61 POLICEMANS POINT-JACKS LOOKOUT

No. Beach	Rating HT LT	Type	Length
T58 Policemans Pt	4 5	R+rocks	500 m
T59 Policemans Pt (S)	4 5	R→LTT+rocks	1.7 km
T60 Pebbly Beach	4 5	R+rocks	300 m
T61 Jacks Lookout	4 5	LTT+rocks	300 m
Spring & neap tidal range = 1.3 & 0.3 m			

South of Ansons Bay inlet is a the 12 km long, 1 km wide Bay of Fires Coastal Reserve, which contains 11 beaches only accessible on foot from Ansons Bay in the north or The Gardens in the south. The east-facing shoreline is dominated by Devonian marine metasediments, which form several sections of rocky shore, including low points, rock platforms and inshore reefs which tend to lower waves at the shore. The hinterland consists of several densely vegetated dissected valleys with their small creeks reaching the shore. The lower slopes have been cleared for farming and abut the conservation area.

Policemans Point is a rock-tied sandy point that forms the southern boundary to Ansons Bay inlet. The South Ansons Bay Road terminates in lee of the point, where there remains an unutilised police reserve. Beach **T 58** curves for 500 m south of the point to a sandy foreland formed in lee of inshore reefs (Fig. 4.11). The reflective beach curves between the low rocky reef areas with only a central section free of rocks. It is backed by generally vegetated transgressive dunes and deflated surfaces that extend 200 m inland then a 10 ha wetland.

Beach **T 59** commences on the southern side of the foreland and trends to the south as a slightly crenulate beach to the lee of inshore reefs for 1.7 km to a 500 m long section of low rocky shore. The northern half of the beach is relatively free of rocks and reflective, while the

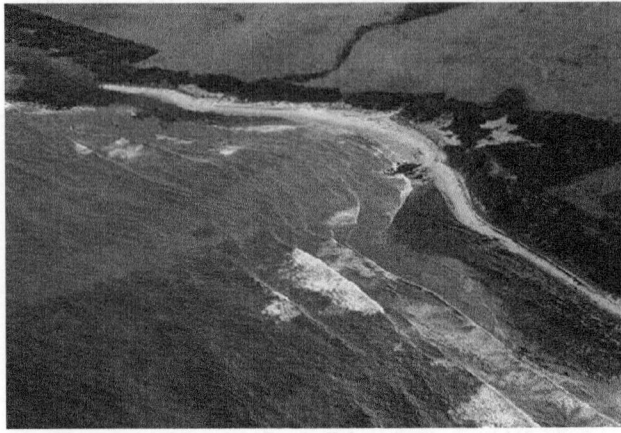

Figure 4.12 Pebbly Beach (T 60) is located in a gap in the rocky shoreline.

Jacks Lookout is a 1 km long section of rocky shore that extends south of Pebbly Beach. Beach **T 61** commences at the southern end of the low rocks and consists of an initially high tide sand beach fronted by 100 m wide rock flats, the beach widening along the southern 100 m to a rock- and reef-fronted low tide terrace. The rocks continue to the south backed by steep cobble-boulder beaches.

T 62-64 BREAK YOKE BEACH

No. Beach	Rating HT LT	Type	Length
T62 Break Yoke Beach (N)	5 6	LTT/TBR	2.8 km
T63 Break Yoke Beach	5 6	LTT/TBR	750 m
64 Break Yoke Beach (S)	5 6	LTT/TBR	750 m
Spring & neap tidal range = 1.3 & 0.3 m			

Break Yoke Beach is a 4 km long moderately exposed east-facing sandy beach bordered by the rocky shore of Jacks Lookout to the north and a 1 km long section of indented rocky shore in the south. The beach is broken into three sections (T 62, 63 and 64) by two small rocky points.

The northern section of the beach (**T 62**) trends to the south for 2.8 km between the southern rocks of beach T 61 to the first low rocky 50 m long point. This is the most exposed of the beaches along this section of shore with waves averaging over 1 m. These maintain a low tide terrace to transverse bar and rip during periods of higher waves, with rips spaced every 200 m along the shore. The beach is backed by a destabilised foredune that becomes increasingly blown out along the northern half of the beach, with blowouts and deflation hollows extending up to 300 m inland. Broadwater Creek reaches the centre of the beach and breaks out during heavy rain.

The central section of the beach (**T 63**) extends for 750 m between the two low rock outcrops, with Seal Lagoon Creek and its meandering 400 m long narrow lagoon to the rear. Vegetated bedrock backs the southern half of the beach, with dunes deflated to the bedrock behind the northern half. During higher waves the beach has two rips, one on either side of the usually blocked creek.

The southern section of beach **T 64** continues for another 750 m to the beginning of the next rocky section, with a rocky point and reef extending 200 m offshore and forming the southern boundary. During higher waves two to three rips form along the beach including a rip against the southern rocks. The beach is backed by a scarped, generally vegetated foredune.

T 65-69 BREAK YOKE CREEK-GARDEN LAGOON

No. Beach	Rating HT LT	Type	Length
T65 Break Yoke Ck	5 6	TBR+rocks	100 m
T66 Break Yoke Ck (S1)	5 6	TBR+rocks	50 m
T67 Break Yoke Ck (S2)	5 6	TBR+rocks	100 m
T68 Break Yoke Ck (S3)	5 6	TBR+rocks	100 m
T69 Garden Lagoon Beach	5 6	LTT/TBR	800 m
Spring & neap tidal range = 1.3 & 0.3 m			

Break Yoke Creek flows down 200 m high Clifford Hill to reach the coast at the mouth of a narrow valley occupied by beach T 65. This is the first in an 800 m long series of four small pocket beaches (T 65-68) that are backed by vegetated slopes rising to 80 m 1 km inland, with Garden Lagoon forming the southern boundary of the bedrock high.

Beach **T 65** is a 100 m long pocket of sand located between low rocks to the north and a 50 m wide sloping headland to the south. Break Yoke creek breaks out across the small beach, resulting in a 150 m wide sandy beach free of vegetation. Beach **T 66** is located in the next 100 m long gap in the bedrock and is a narrow 50 m long pocket of sand backed by exposed sloping bedrock. Beach **T 67** lies 50 m to the south and is a 100 m long pocket of sand occupying a V-shaped gap in the bedrock backed by a small valley. Beach **T 68** lies a further 100 m to the south and is a similar 100 m long pocket of sand backed by a small valley. All four beaches vary in width and when eroded usually have a permanent rip draining each small embayment. When filled with sand during lower wave conditions, their lengths increase slightly and reflective to low tide terrace conditions can prevail.

Garden Lagoon Beach (**T 69**) lies immediately south of the bedrock high. The 800 m long beach is formed across the mouth of a 700 m wide drowned valley. The 100 m wide beach-barrier impounds the usually blocked 10 ha Garden Lagoon, with the shallow lagoon fed by Baileys and three smaller creeks. The beach is slightly protected by a rocky point and reefs to the south, with usually low tide terrace conditions prevailing, while two to three rips form during higher waves. Cleared farm and freehold land of The Gardens covers the slopes bordering the southern boundary of the beach and lagoon.

T 70-71 THE GARDENS (N)

No. Beach	Rating HT LT	Type	Length
T70 Garden Lagoon (S1)	4 5	LTT	350 m
T71 Garden Lagoon (S2)	4 5	LTT	800 m
Spring & neap tidal range = 1.3 & 0.3 m			

The Gardens is the easternmost protrusion in a 3 km long section of metasedimentary and granodiorite shoreline and reefs, bordered to the north and south by valleys occupied by Garden and Big lagoons respectively. The moderately sloping rocky shoreline contains nine small beaches (T 70-78). The Gardens Road provides public access as far as Suicide Point and beach T 75, with private land and cleared farmland occupying the northern half of the point.

Beaches T 70 and 71 are two near continuous beaches that extend for 1.2 km south of Garden Lagoon (Fig. 4.13). A 400 m long crenulate boulder beach separates the lagoon from beach **T 70**, which curves to the south for 350 m to a sand and boulder foreland lying to the lee of inshore reefs. Waves average about 1 m and maintain a low tide terrace beach, with a right-hand surf break over the southern rocks-reef. It is backed by high tide boulders

and cleared farmland. Beach **T 71** continues to curve to the southeast as a double crenulate 800 m long sandy beach that terminates against the northern rocks of Mateys Gulch. This beach is slightly more protected by Fancy Reef located off the centre of the beach, with reflective to low tide terrace conditions prevailing. It is backed by a small grassy foredune, a row of shrubs then cleared grazing land, with a farmhouse overlooking the southern end of the beach.

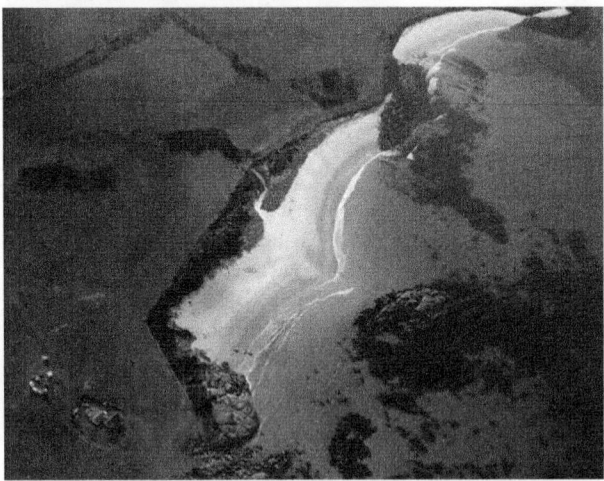

Figure 4.13 Beaches T 70 & 71 (photo W. Hennecke).

T 72-78 THE GARDENS (S)

No. Beach	Rating HT	LT	Type	Length
T72 Mateys Gulch	3	4	R+rocks	80 m
T73 Coffeys Gulch	4	5	LTT+rocks	100 m
T74 The Gardens	4	5	LTT+rocks	80 m
T75 Suicide Pt	4	5	LTT+rocks	250 m
T76 Suicide Pt (S)	4	5	LTT+rocks	50 m
T77 Honeymoon Pt	4	5	LTT+rocks	50 m
T78 Margerys Corner	4	5	LTT+rocks	100 m
Spring & neap tidal range = 1.3 & 0.3 m				

The southern half of The Gardens section of shore consists of 2 km of highly indented rounded granodiorite shoreline, containing eight small rock-dominated beaches (T 72-78). Rocks and reefs extend up to 1 km offshore, including the 7 m high Garden Reef. The Gardens Road runs as far as Suicide Point with private land and roads to the north. Several farm and holiday houses dot the cleared sloping hinterland.

Mateys Gulch (beach **T 72**) is a protected north-facing 80 m long white sand beach bordered by low sloping rocky points with a rock outcrop just off the centre of the beach. **Coffeys Gulch** (beach **T 73**) lies 200 m to the south with a farmhouse on the cleared slopes in between. It is a similar protected rock-strewn high tide beach, with rocks littered along and extending off beach as linear reefs. A farmhouse backs the beach and the western end of the gulch has a boat ramp for launching small boats out through the rocky reefs that dominate the shoreline.

Beach **T 74** is located 150 m to the south and is a similar rock-strewn protected north-facing sandy high tide beach, with rocks and reef almost encasing the beach. A farmhouse is located on its northern slopes.

Suicide Point is a low vegetated outcrop of granodiorite that is attached to the shore by beaches T 75 and 76. Beach **T 75** is a 250 m long east-facing more exposed sandy beach, which receives waves averaging about 1 m. These maintain a low tide terrace, with rocks outcropping on and off the beach. Scotsmans Creek breaks out across the southern end of the beach and The Gardens Road runs along the rear to terminate at its northern end. Beach **T 76** is a 50 m long pocket of sand wedged in between the point and the next section of rocky shore, with breaking waves often filling the gap between the rocks. A fishing hut is located on the southern side of the beach.

Honeymoon Point is a low protruding granodiorite point that forms the southern boundary of this rocky section of shore. Beach **T 77** is a 50 m long pocket of high tide boulders and low tide sand tucked in on the northern side of the point. An access road runs along the rear of the beach to two houses located at the tip of the point.

Margerys Corner (beach **T 78**) is a 100 m long south-facing beach that lies immediately west of Honeymoon Point. The beach is moderately sheltered by several inshore rocks and reefs, with usually reflective to low tide terrace conditions prevailing. It is backed by vegetated slopes rising to 10 m, with a house behind the eastern end of the beach and The Gardens Road above the western end.

T 79-81 TAYLORS BEACH

No. Beach	Rating HT	LT	Type	Length
T79 Taylors Beach (N)	5	6	LTT/TBR+rocks	450 m
T80 Taylors Beach	6	6	TBR	3 km
T81 Sloop Lagoon	3	4	R	50 m
Spring & neap tidal range = 1.3 & 0.3 m				

Taylors Beach and barrier extends for 4 km between The Gardens and Sloop Rocks and blocks the mouth of two drowned valleys now occupied by 100 ha Big and 25 ha Sloop lagoons and linked by a central 2 km long wetland. The Gardens Road crosses both inlets and runs along the rear of the main beach with a few car parks and access points to the beach. Big Lagoon divides the beach into two (T 79 and 80).

The northern end of the beach (**T 79**) extends for 450 m between the boundary rocks and the usually closed mouth of Big Lagoon. The beach faces southeast and receives waves averaging over 1 m which break amongst a series of rocks along the northern half of the beach, with the southern half free of rocks and usually containing a low tide terrace, with rips forming during periods of higher waves. A vegetated bluff backs the beach, with a row of several blufftop houses, then The Gardens Road.

The main Taylors Beach (**T 80**) curves gently to the south between the two usually blocked inlets of Big and Sloop lagoons. It is 3 km long and is exposed to all waves out of the east, which average over 1 m. These maintain a usually well developed transverse bay and rip system, with up to 15 rips spread along the beach, including a permanent rip in front of the mouth of Sloop Lagoon flowing out against the southern rocks (Fig. 4.14). The best beach access is just across the Sloop Lagoon bridge where there is a car park and access track. The beach is backed by a low vegetated 100 m wide foredune, including the road then the lagoons and central wetlands.

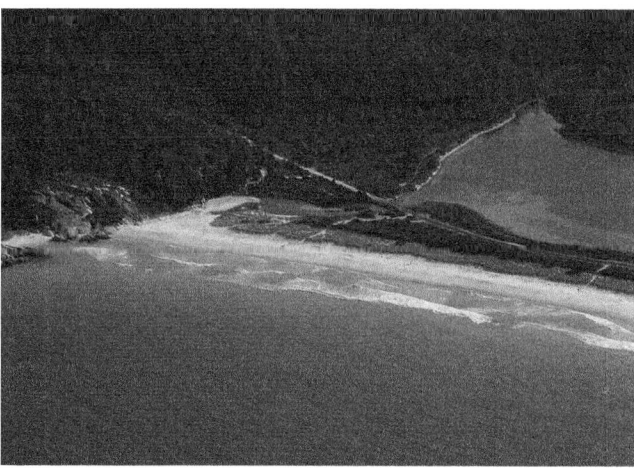

Figure 4.14 The southern end of Taylors Beach (T 80 & 81) at the blocked mouth of Sloops Lagoon inlet. Note the well developed rip channels.

Beach **T 81** is tucked in a 50 m wide gap in the rocks immediately adjacent to the southern end of the beach and lagoon entrance. It is backed by a low grassy foredune then dense vegetation. While the 50 m long beach faces north and is moderately protected from waves, the main beach surf zone can impinge upon the beach with the permanent southern rip running just outside the rocks. There is a car park and small camping area above the beach, which is a popular, though potentially hazardous, swimming spot.

T 82-88 SEATON COVE-JEANNERET BEACH

No. Beach	Rating		Type	Length
	HT	LT		
T82 Seaton Cove	3	4	R/LTT+rocks	50 m
T83 Cosy Corner	3	4	R+rocks	80 m
T84 Cosy Corner (S)	5	5	LTT/TBR	400 m
T85 Old Man Rocks	4	5	LTT+rocks	50 m
T86 Swimcart Beach (N)	5	5	LTT/TBR	250 m
T87 Swimcart Beach	5	5	LTT/TBR	1.2 km
T88 Jeanneret Beach	4	5	LTT/TBR	250 m
Spring & neap tidal range = 1.3 & 0.3 m				

The southern section of the Bay of Fires Conservation Area between Sloop Rock and Binalong Bay, incorporates a 5 km long section of granite headlands, rocks and sandy beaches. The Gardens Road parallels the rear of the coast and provides good access to the beaches and six associated campsites. Seven beaches (T 82-88) occupy the first 4 km of this section of coast.

Seaton Cove is a 100 m wide, 250 m deep U-shaped, east-facing cove surrounded by sloping granite rocks and densely vegetated headlands. The beach (**T 82**) is located at the apex of the cove and consists of a 50 m long strip of sand sloping into the rock-dotted sandy bay floor. Waves are lowered by the rocks and points to less than 1 m maintaining a usually reflective to low tide terrace sandy shore. A campsite is located on the northern side of the beach with a row of seven houses located on the southern slopes of the cove.

Sloping granite rocks fringed by boulders extend 500 m south of the cove to a sloping granite headland on the south side of which is **Cosy Corner**, a 100 m wide south-facing embayment containing an 80 m long protected reflective beach (**T 83**). Sloping granite points border the beach, with a 50 m wide granite reef off the centre resulting in waves averaging about 0.5 m at the shore. A walking track leads to the rear of the beach, where there is a campsite. One hundred metres of sand and rocks separate the beach from beach **T 84** which trends for 400 m south to Old Man Rocks with rocks also scattered along the northern end of the beach. This is a more exposed east-facing beach, with higher waves generating rips to each end of the beach and an occasional central rip. There is vehicle access to the centre of the beach, where there is a camping area, with a second campsite at the southern end adjacent to a small usually blocked lagoon.

Old Man Rocks is a 100 m long series of granite rocks and reefs, which extend off a small 100 m long headland. On the southern side of the headland is a 50 m long pocket of sand (**T 85**). The beach is bordered by bare granite rocks, with an outcrop off the centre of the beach and sandy gutters to either side. It faces southeast into the prevailing waves, which average over 1 m and break over the rocks and into the two gutters. A campsite and vegetated slopes are located behind the beach. Beach **T 86** commences 50 m to the south and continues for another 250 m to a cluster of granite boulders located on the northern side of the usually blocked Swimcart Creek (Fig. 4.15). The waves maintain a low tide terrace beach cut by rips towards either end during periods of higher waves. A vehicle track leads to the northern end of the beach, with campsites spread amongst the trees at the rear of the beach.

Swimcart Beach (**T 87**) commences at the boundary rocks and creek mouth and trends to the southeast for 1.2 km to Round Hill Point, a 17 m high dune-capped granite point, that extends 300 m seaward. The relatively straight beach receives waves averaging about 1 m, which maintain a low tide terrace with a few rips forming during periods of higher waves. The elongate 500 m long Swimcart Lagoon forms the northern boundary, with a picnic area by the lagoon. The remainder of the beach is backed by a 500 m wide barrier containing four low foredunes and swampy swales, with a vehicle track running the length of the beach to a southern beachfront

car park. The boundary of the reserve narrows to 100 m in lee of the point with a few houses located adjacent to the boundary.

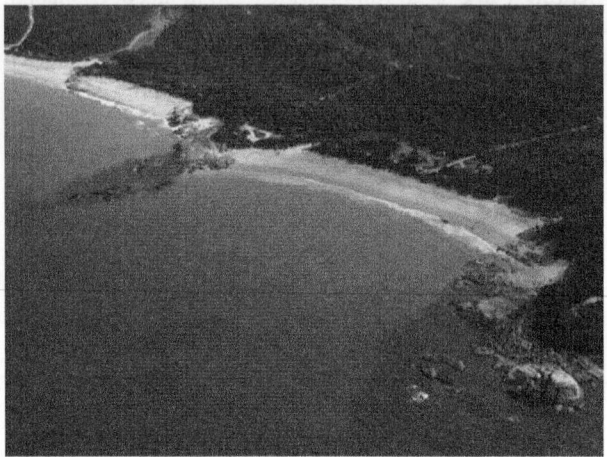

Figure 4.15 Old Man Rocks (right) and the Swimcart beaches (T 86 & 87).

Jeanneret Beach (T 88) is located on the southern side of Round Hill Point and consists of an embayed 250 m long east-southeast-facing beach, bordered by granite rocks and points, with a central rock outcrop. A rip runs out against the southern rocks during higher waves. It is backed by a low grassy foredune with a central car park and camping area behind the northern end of the beach. The Gardens Road is located 300 m to the west.

T 89-90 BINALONG BAY

No. Beach	Rating HT LT	Type	Length
T89 Binalong Bay	5 5	LTT/TBR	1.6 km
T90 Boat Harbour Pt	2 2	R+rocks	80 m
Spring & neap tidal range = 1.3 & 0.3 m			

Binalong Bay is a growing holiday settlement spread along the northern slopes of Boat Harbour Point (Fig. 4.16), with views north across Binalong Bay and beach. The bay is located 11 km northeast of St Helens and is one of the nearer and safer beaches to the town. The road into the bay runs along the south side of Grants Lagoon, past the southern end of the beach and out and around Boat Harbour Point. There are picnic areas located at the lagoon, beach, point and around in Skeleton Bay, plus the small boat harbour on the point. Fifty hectare Grants Lagoon backs the southern half of the beach and occasionally breaks out in the southern corner.

Binalong Bay beach (**T 89**) is 1.6 km long, faces northeast, with most winds blowing offshore and waves averaging about 1 m. The waves interact with the medium white sand to produce a moderately steep beach, usually fronted by a continuous narrow bar, with a few rips cutting across the bar during periods of higher waves. It is backed by a low vegetated foredune and the lagoon, with the usually blocked lagoon mouth backing the

southern end of the beach (Fig. 4.17). There is vehicle access and a few houses located behind the northern end of the beach. In the south there is pedestrian access to the beach via a footbridge at the southern picnic area on the shore of Grants Lagoon, with a second picnic area on the rocks immediately east of the beach.

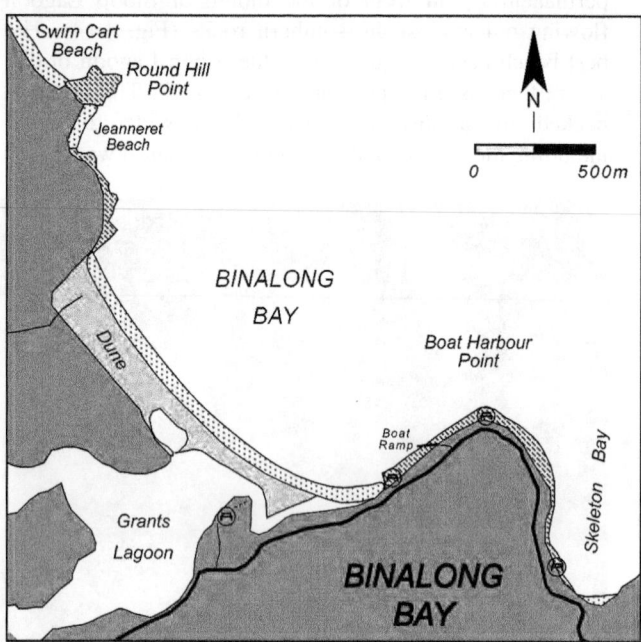

Figure 4.16 Binalong Bay township backs Boat Harbour Point, the bay and Jeanneret beaches to the north and the small Skeleton Bay to the south.

Figure 4.17 Binalong Bay beach (T 89) and Grants Lagoon.

Between the end of the beach and Boat Harbour Point is 500 m of northwest–facing rocky shore consisting of a 50-100 m wide zone of rounded granite, cut by channels and gullies. Binalong Gulch occupies a larger gully, which has been modified by the construction of a 50 m long breakwater to form a small boat harbour and launching ramp. Some sand occupies other gullies, with beach **T 90** occupying the largest area of sand on the eastern side of the point. It consists of an 80 m long high tide sandy beach fronted by a 100 m wide zone of rounded granite rocks and shallow tidal pools.

Swimming: Binalong Bay is a relatively safe beach under normal lower wave conditions. When waves are breaking across the bar, rips are usually present and care should be taken. There are some large rock pools, including beach T 90, on the point, which are an attractive and relatively safe location during calm seas.

Surfing: Usually a low shorebreak, with bigger swell required to produce rideable beach breaks.

Humbug Point Nature Recreation Area

Established: 1981
Area: 1620 ha
Coast length: 5 km (93-98 km)
Beaches: 3 (T 91-93)

Humbug Point Nature Recreation Area extends for 5 km south of Binalong Bay to Humbug Point. It incorporates 5 km of rocky coastal shoreline and several kilometres of low energy bay shoreline in Georges Bay. There is vehicle access to Skeleton Bay, Skeleton Rock, Grants Point and Little Elephant in the north and Dora Point in the south at the entrance to the bay. The rocky shoreline is backed by moderately steep densely vegetated granite slopes, which peak at 129 m Humbug Hill. Camping areas are located at Grants and Dora points.

T 91-93 SKELETON BAY-DORA POINT

No. Beach	Rating HT LT	Type	Length
T91 Skeleton Bay	3 4	R+rock flats	100 m
T92 Dora Pt (N)	3 4	R/LTT+rocks	200 m
T93 Dora Pt	3 4	R/LTT+tidal shoals	250 m
Spring & neap tidal range = 1.3 & 0.3 m			

Beaches T 91-93 are three small pockets of sand located along an otherwise rock-dominated shoreline. They are all located within Humbug Point Nature Recreation Area with two beaches (T 91 and 93) accessible by vehicle.

Beach **T 91** is located to the east of Binalong Bay in the southern corner of rocky 400 m wide **Skeleton Bay**. The 100 m long beach consists of a high tide strip of sand fronted by a continuous, irregular 50 m wide zone of intertidal rocks including some tidal pools. There is vehicle access to the rear of the beach, and a picnic area located on the shores of the bay 200 m west of the beach.

Beach **T 92** is located 1 km north of Dora Point and is moderately protected by St Helens Point, located 2 km due east. It is a 200 m long east-facing strip of reflective to low tide terrace sand. It is bordered by granite outcrops, together with rocks and reefs outcropping on and off the beach. The access road passes 500 m west of the beach with a walking track down to the shore.

Dora Point beach (**T 93**) is located at the western side of the entrance to the 2,000 ha Georges Bay. Strong tidal currents flow through the entrance and maintain a deep tidal channel and extensive ebb tidal delta, which extends a few hundred metres seaward of the beach. The beach is 250 m long and faces east across the tidal shoals and deeper channel towards St Helens Point. Waves are lowered by the point and shoals and average less than 1 m at the beach. While waves are usually low, beach conditions vary with the tidal shoals and tide conditions, with strong tidal current flowing seaward of the beach during the ebbing tide. The beach is accessible by vehicle with the camping area located 500 m south of the beach just inside the bay.

St Helens Point Conservation Area

Established: 1980
Area: 400 ha
Coast length: 18 km (104-122 km)
Beaches: 16 (T 94-110)

St Helens Conservation Area incorporates St Helens Point, Maurouard Beach and the Peron Dunes which extend for 8 km south of the point and are the most extensive and active transgressive dunes on the east coast. It then continues south past the rocky shoreline at Onion Creek to the northern end of Dianas Beach.

T 94-100 BLANCHE POINT-BURNS BAY

No.	Beach	Rating HT LT	Type	Length
T94	Blanche Pt	4	5LTT/TBR+tidal shoals	750 m
T95	Blanche Pt (E1)	2 3	R+rock flats	50 m
T96	Blanche Pt (E2)	2 3	R+rocks	150 m
T97	Burns Bay (W3)	2 3	R+rocks	100 m
T98	Burns Bay (W2)	2 3	R+rocks	50 m
T99	Burns Bay (W1)	2 2	R	50 m
T100	Burns Bay	2 2	R	100 m
Spring & neap tidal range = 1.3 & 0.3 m				

Blanche Point is part of the Georges Bay flood-tide delta that has been modified with the construction of a 500 m long training wall, designed to channelise the tidal flow between the wall and northern Dora Point, located 300 m to the north. The wall has resulted in the stabilisation of a sandy beach (T 94) between the end of the wall and the western rocky shoreline of St Helens Point. Beaches T 95-100 are located along the northwest-facing rocky shore between the junction with the rocky shore and Burns Bay. All the beaches are accessible either directly or from tracks off the St Helens Point Road.

Blanche Point beach (**T 94**) is a 750 m long northeast-facing moderately exposed beach located between the training wall and the western side of the point. The beach has been stabilised by the wall and has built up to 300 m seaward along the wall forming a low gradient low tide

terrace to occasionally transverse bar and rip beach. It is backed by a new low foredune, which becomes increasing blown out towards the seawall, possibly as a result of human traffic (Fig. 4.18). The beach receives waves averaging about 1 m, which towards the wall break over the extensive ebb tidal shoals. The western end of the beach is particularly hazardous owing to the strong tidal currents against the wall and increased likelihood of rips along the beach. During higher swell there can be rideable waves running off the tidal shoals.

Figure 4.18 Blanche Point beach (T 94) has formed since the construction of the training wall at the entrance to Georges Bay (photo W. Hennecke).

Beaches T 95-100 are a series of protected usually calm pockets of sand spread along the shore between Blanche Point beach and the boat ramp at Burns Bay and backed by 30 m high vegetated slopes in the west, which decrease in height towards the bay. The St Helens Point Road runs along the rear of the beaches. Beach **T 95** is a 50 m long strip of high tide sand bordered and fronted by granite rocks and boulders. Beach **T 96** is located 200 m to the east and is a 150 m long strip of sand located along the base of a slight protrusion in the rocky shore, with numerous granite boulders and reefs off the beach.

Beach **T 97** lies 50 m to the east and occupies a 100 m long curving embayment, with small rocky points to either end, and a few rocks off the beach. It is backed by 20 m high vegetated slopes then the road. Beach **T 98** is a 50 m long pocket of sand located between the next two granite points and adjacent to Burns Bay. A vehicle track runs to the rear of the beach.

Beaches T99 and 100 occupy **Burns Bay**. Beach **T 99** is a 50 m long pocket of sand on the western side of the small curving embayment. It faces northeast across the 100 m wide entrance to the bay. Beach **T 100** occupies the bulk of Burns Bay. It is a curving 100 m long sandy beach that faces west out the bay entrance. The boat ramp is located at the eastern end of the beach, with a car park and toilet block behind. Surfers park here to check out the northern side of St Helens Point, which during bigger south swell can produce a long left-hand break.

T 101-103 BEERBARREL-MAUROUARD BEACHES

No.	Beach	Rating HT LT	Type	Length
T101	Beerbarrel Beach (N)	5 7	TBR+rocks	100 m
T102	Beerbarrel Beach	5 7	TBR+rocks	300 m
T103	Maurouard Beach	6 7	TBR	8.5 km
Spring & neap tidal range = 1.2 & 0.0 m				

St Helens Point is one of the more prominent east coast headlands. The 58 m high point is composed of Carboniferous granodorite, with a tip of granite. It is bordered to the north by the moderately protected entrance to Georges Bay, with a series of exposed beaches stretching to the south including Maurouard Beach (T 103) one of the longer and higher energy beaches on the east coast. The St Helens Point road runs out to the northern boat ramp, with gravel roads leading to a central camping area and the two Beerbarrel beaches (T 102 and 103).

Beerbarrel Beach consists of two parts. The northern section (**T 101**) is a 100 m exposed, southeast-facing, low gradient beach bordered by the rocky shore of the point to the north and a 50 m wide rocky point to the south. It receives waves averaging about 1.5 m which break across a 50-100 m wide rock-studded surf zone, with a permanent rip flowing out against the southern rocks. The main beach (**T 102**) is 300 m long and includes a 50 m long pocket of sand at the western end. It extends from the dividing point to a 400 m wide 20 m high headland. It also has rocks in the inner surf zone with strong rips forming to each end. Both beaches are backed by a small grassy foredune then vegetated slopes rising to 40 m. There is a car park on the slopes behind the central headland with easy access to both beaches. There is surf amongst the rocks with best conditions during northerly winds. The point camping area is located 500 m north of the beach.

Maurouard Beach (**T 103**) (also known as Perons (and Perrins) Beach) commences on the southern side of the rocky point and curves to the southeast, then south in lee of St Helens Island for 8.5 km to the beginning of a 2 km long section of rocky shore. The beach is well exposed to southerly waves, which average about 1.5 m and maintain a well developed 100 m wide transverse to rhythmic bar and beach system, with at times up to 30 rips forming along the beach, including a permanent rip against the southern rocks. The bars and rips can produce some good breaks the length of the beach.

The entire beach is backed by the Peron Dunes, a 500 m wide zone of transgressive dunes, which become more destablised to the north and reach 20 m in height (Fig. 4.19). The dunes are vegetated with marram grass resulting in peaky vegetated dune topography, an artifact of the exotic grass. The St Helens Point Road backs the northern half of the dunes, with beach access on foot across the dunes, together with a northern car park on the

boundary point. A series of discontinuous wetlands backs the southern half of the dunes including Moriarty, Windmill and Jocks lagoons, none of which connect with the sea.

Figure 4.19 The Peron Dunes are the most extensive on the east coast and back the more exposed Maurouard or Perons beach (T 103).

T 104-108 ONION CREEK

No.	Beach	Rating HT LT		Type	Length
T104	Onion Ck (N)	6	6	TBR	200 m
T105	Onion Ck	6	6	TBR	250 m
T106	Onion Ck (S1)	6	7	TBR+rocks	150 m
T107	Onion Ck (S2)	6	7	TBR+rocks	70 m
T108	Onion Ck (S3)	6	7	TBR+rocks	100 m
Spring & neap tidal range = 1.2 & 0.0 m					

At the end of Maurouard Beach is the start of a 1.5 km long section of rocky shore containing five small rock-bound beaches (T 104-108). There is a vehicle track out to the northern two beaches including the mouth of Onion Creek, with the remainder only accessible on foot. St Helens Island, a 75 ha 29 m high granite outcrop, is located 2 km to the west.

Beach **T 104** is a 200 m long pocket of sand bordered by sloping rocky points and backed by vegetated slopes rising to 40 m. A 50 m wide rocky point separates it from beach **T 105,** a 250 m long beach formed at the mouth of a small valley, with Onion Creek breaking out against the northern boundary rocks. A 50-100 m wide foredune backs the remainder of the beach with a narrow meandering lagoon behind. The vehicle track terminates on the northern side of the creek mouth and a walking track commences at the southern end of the beach. Both beaches receive waves averaging up to 1.5 m which break across the boundary rocks and maintain a 50-100 m wide surf zone usually drained by rips against the northern and southern rocks and at times a central rip against the dividing point.

Beaches T 106-108 commence on the southern side of a 200 m wide rocky point and occupy the next 400 m of shore. Beach **T 106** is a 150 m long sandy beach backed by a finger of bedrock, which protrudes across the beach and at times into the surf. Beach **T 107** lies immediately to the south and is a 70 m long pocket of sand bordered and backed by rocks together with large rock outcrops on and just off the beach. Beach **T 108** extends the final 100 m to the southern rocks, and consists of a slightly more continuous sandy beach, with scattered rocks along the beach and fingers of rock extending seaward of each end. All three beaches are backed by vegetated slopes rising to 30 m, with a walking track along the backing ridge. They are fronted by a 50-100 m wide surf zone, which breaks amongst the rocks and can produce strong rips, and as a consequence they are unsuited for swimming.

T 109-110 DIANAS BEACH

No.	Beach	Rating HT LT		Type	Length
T109	Dianas (N)	6	6	TBR	650 m
T110	Dianas Beach	6	6	TBR/TBR	3.2 km
Spring & neap tidal range = 1.2 & 0.0 m					

Dianas Beach extends in two sections (T 109 and 110) for 3.8 km from the end of the rocky section of shore south of Maurouard Beach to Ring Rock, a sand and rock foreland in lee of Paddys Island. It is an exposed east-facing beach dominated by rips, with the beach and backing dunes all part of St Helens Point Conservation Area.

The north section of beach **T 109** extends south of the rocks for 650 m to the usually blocked mouth of Dianas Basin, a shallow 100 ha coastal lagoon fed by Basin Creek and the smaller Little Basin. The beach receives waves averaging up to 1.5 m, which break across a 100 m wide surf zone with usually a northern rip against the boundary rocks and one to two rips towards the inlet mouth. It is backed by a 200 m wide band of vegetated transgressive dunes, which have climbed 20 m up the boundary northern slopes.

The main Dianas Beach (**T 110**) commences at the inlet mouth and extends almost due south for 3.2 km to the rock-tied foreland. The inlet mouth is usually closed and consists of a 100 m long 200 m wide overwash chute. However when open strong tidal currents flow between the two beaches. The main beach is exposed to similar waves with rips spaced every 200-300 m extending south to the foreland. At the foreland there are linear ridges of rock, with waves breaking over the outer rocks and along the northern side of the foreland to produce a long right-hand break known as *Ring Rock* or *Paddys Island* (Fig. 4.20). Nine metre high Paddys Island is located 1 km offshore. The beach is backed by a foredune then 100-200 m wide zone of vegetated transgressive dunes, with the Tasman Highway paralleling the southern half of the beach. There is beach access in the north from two basin-

side picnic areas, in the centre via a footbridge at Crockers Arm and in the south at Paddys Island car park, the latter providing the best access to the surf.

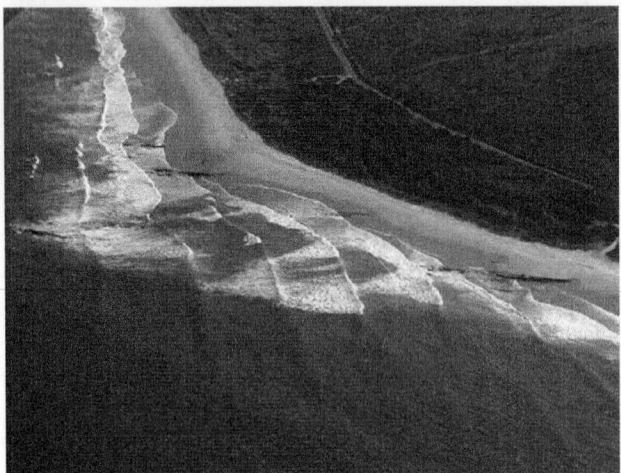

Figure 4.20 The right-hand Paddys Island break is located at the southern end of Dianas Beach (T 110).

Scamander Conservation Area

Established: 1979
Area: 400 ha
Coast length: 13 km (122-135 km)
Beaches: 6 (T 110-115)

Scamander Conservation Area is a 13 km long narrow strip of sandy coast located between the Tasman Highway and the shore. It commences at Dianas Beach and extends south along Beaumaris, Wrinklers and Steels beaches to the mouth of Henderson Lagoon at Falmouth.

T 111-113 BEAUMARIS BEACH

No.	Beach	Rating HT LT		Type	Length
T111	Beaumaris Beach	6	6	TBR/RBB	3.2 km
T112	Beaumaris (S)	6	6	TBR/RBB	1.2 km
T113	Shelly Point	6	7	TBR/RBB	200 m
Spring & neap tidal range = 1.2 & 0.0 m					

Beaumaris Beach is an exposed 4.5 km long east-facing beach located between the Paddys Island foreland and Shelly Point. Rocks and the point divide it into three sections (T 111-113). The Tasman Highway parallels the rear of the beach with a number of access points.

The main beach (**T 111**) extends west-southwest of the foreland for 3.2 km to a cluster of rocks. It is dominated by a rip-dominated 100 m wide surf zone with a deep longshore trough forming during periods of higher waves and up to 12 rips flowing across the bar. The beach is backed by a 100-200 m wide band of vegetated transgressive dunes, which are part of the Scamander Conservation Area. The small Yarmouth Creek reaches

the rear of the centre of the beach and occasionally breaks out across the beach, with the holiday settlement of Beaumaris spread along the highway either side of the creek. There is beach access in the north and on the northern side of the creek mouth.

The southern section of the beach (**T 112**) extends from a cluster of shore-tied rocks for 1.2 km to the submerged rocks of Shelly Point. This beach curves slightly to the southeast in lee of the point and is usually dominated by a few rips between the rocks and point. It is backed by a 50-100 m zone of hummocky foredune with the small Freshwater Creek reaching the centre of the beach. There is beach access midway down the beach and at a car park at the point. The *Dark Hollow* surf break is located towards the northern boundary rocks, with a second break at the point.

Shelly Point contains a 200 m long east-facing beach (**T 113**). It is bordered by intertidal and submerged rocks extending 200-300 m offshore, which together with submerged rocks spread off the beach make it unsuitable for swimming. The car park is located behind the beach, which provides access to the surfing breaks at the point and to either side. Closer to the highway is a small camping area.

T 114-115 WRINKLERS-STEELS BEACHES (SCAMANDER SLSC)

No.	Beach	Rating HT LT		Type	Length
T114	Wrinklers Beach	6	6	TBR/RBB	1.9 km
T115	Steels Beach	6	6	TBR/RBB	4.9 km
SCAMANDER SLSC					
Patrols:					
December-March (weekends & public holidays)					
Spring & neap tidal range = 1.2 & 0.0 m					

Wrinklers and Steels beaches are adjoining long sandy beaches that extend south from Shelly Point for a total of 6.8 km to the mouth of Henderson Lagoon at Falmouth. The beaches are separated by the usually closed mouth of the Scamander River at Scamander (Fig. 4.21). The coastal strip between the beaches and the highway is part of the Scamander Conservation Area.

Wrinklers Beach (T 114) commences on the southern side of the Shelly Point rocks and trends south-southwest for 1.9 km to the mouth of Scamander River. The beach is backed by a 100-150 m wide zone of vegetated hummocky dunes, then the Tasman Highway, with Wrinklers Lagoon backing the northern half of the beach and highway. The small 15 ha lagoon occasionally breaks out across the centre of the beach. The town of Scamander commences on the southern side of the highway extending for 1.5 km south to the river. The beach is well exposed to southerly waves, which maintain a rip-dominated surf zone with up to eight rips spaced every 200-300 m along the beach. There is a car park and camping area on the northern side of the inlet with foot access across the dunes to the beach.

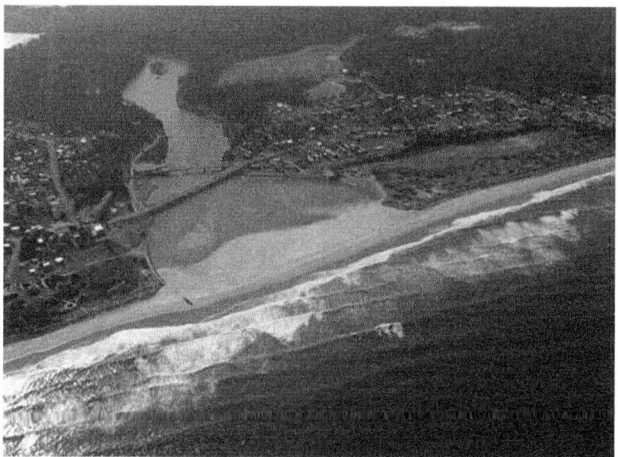

Figure 4.21 The blocked mouth of the Scamander River with Wrinklers Beach (T 114) to the right and Steels Beach (T 115) left. The Scamander surf life saving club patrols the southern Steels beach (photo W. Hennecke).

The **Scamander River** flows though a meandering lagoon to the 500 m wide river mouth. While the river is usually blocked during floods and high flow the beach to either side can be washed away with strong tidal flows through the mouth. The river mouth shoals also produce some good surf breaks. **Steels Beach (T 115)** commences at the river mouth and trends due south for 4.9 km curving slightly to the southeast in lee of the boundary Henderson Point at Falmouth. The Scamander surf life saving club patrols the area south of the river mouth. The beach receives waves averaging up to 1.5 m which maintain a well developed rip-dominated 100 m wide surf zone, with up to 20 rips forming along the beach, and at times linking to form a continuous longshore trough. When Henderson Inlet is open strong tidal currents and a rip flow along the point. The beach is backed by a 50-100 m wide hummocky vegetated foredune, then a continuous 200 m wide wetland, which links with the lagoon in the south, the lagoon deflected 2.5 km south to the inlet. The only access is in the north from the southern section of Scamander, with a 200 m long walk across the wetland and dune to the northern tip of the beach. When the lagoon mouth is blocked the southern end of the beach can be accessed from Falmouth.

Swimming: Rips are common along the beaches, and the river mouth when open has strong tidal currents. The best place to swim is in the area patrolled by the Scamander surf life saving club south of the river mouth.

Four Mile Creek Coastal Reserve

Coast length: 8 km (136-144 km)
Beaches: 8 (T 117-125)

Four Mile Creek Coastal Reserve is an 8 km long narrow strip of rocky shore containing eight beaches that extends from immediately south of Falmouth to include Four Mile Creek and McIntyre Beach and terminate at Ironhouse Point.

T 116-119 FALMOUTH

No.	Beach	Rating HT LT	Type	Length
T116	Falmouth (S1)	5 6	Boulder+LTT	150 m
T117	Falmouth (S2)	5 6	Boulder+LTT	80 m
T118	Falmouth (S3)	5 6	Boulder+LTT	100 m
T119	Mariposa Pt	5 6	Boulder+rocks	100 m
Spring & neap tidal range = 1.2 & 0.0 m				

Falmouth is a small holiday settlement spread over the slopes of 20 m high Henderson Point. Massive sloping granite and rocks dominate the shore from the point for the next 16 km down to Hughes Point with granite rocks bordering the northern and eastern side of the small settlement. Extending along the shore for 1.5 km south of the point are a series of small rocky embayments, containing some boulder beaches and low tide sand deposits (beaches T 116-119). The beaches south of the settlement (T 117-119) are located within the Four Mile Creek Coastal Reserve, which occupies a narrow strip along the shore, with farm and private land behind.

Beach **T 116** is a 150 m long high tide boulder beach, with a sandy low tide terrace partly covering the intertidal to subtidal rocks. Waves averaging over 1 m break up to 100 m offshore. It is backed by blufftop houses, with a gravel street terminating at the northern end of the beach. Beach **T 117** is located immediately to the south in the next small rocky embayment. It is a similar 80 m long high tide boulder beach with a pocket of intertidal sand, then subtidal rocks. The southernmost Falmouth street reaches a small point at the northern end of the beach.

Beach **T 118** occupies the next embayment and is a 100 m long high tide boulder beach, with sand extending across the beach and into the surf zone, together with some large granite outcrops on the beach and two rocky points to either end. It is backed by low bluffs and cleared farmland.

Beach **T 119** is located 700 m to the south on the northern side of Mariposa Point. The point provides some protection to the curving 100 m long embayed beach. It consists of a curving high tide boulder beach with a strip of intertidal sand, then shallow inter- and sub-tidal rocks filling the small bay, with waves breaking over the rocks up to 100 m offshore. The beach is backed by private land with a house occupying the point. A slipway and boat ramp are located in lee of the tip of the point.

T 120-121 MARIPOSA BEACH

No.	Beach	Rating HT LT	Type	Length
T120	Mariposa Beach	6 7	TBR	350 m
T121	Mariposa (S)	5 6	Boulder+LTT	300 m
Spring & neap tidal range = 1.2 & 0.0 m				

Mariposa Beach (T 120) is located on the southern side of 200 m long Mariposa Point. The east-southeast-facing sandy beach extends south for 350 m before grading into a boulder beach. This is a well exposed beach receiving waves averaging up to 1.5 m, which break across a 50-100 m wide surf zone usually dominated by 1 to 2 rips, together with rocks in the surf zone to either end. It is backed by a 10 m high vegetated and often scarped foredune, and small pond, with the Four Mile Creek Road reaching the coast at the southern end of the beach. A private house backs the northern end of the beach.

Beach **T 121** extends south of Mariposa Beach for another 300 m as a high tide boulder beach, with a low tide sandy terrace usually present, grading into a mixture of sand and exposed rocks, with a small creek crossing the southern end. The road runs along overlooking the beach, with the creek crossing under the road to reach the beach.

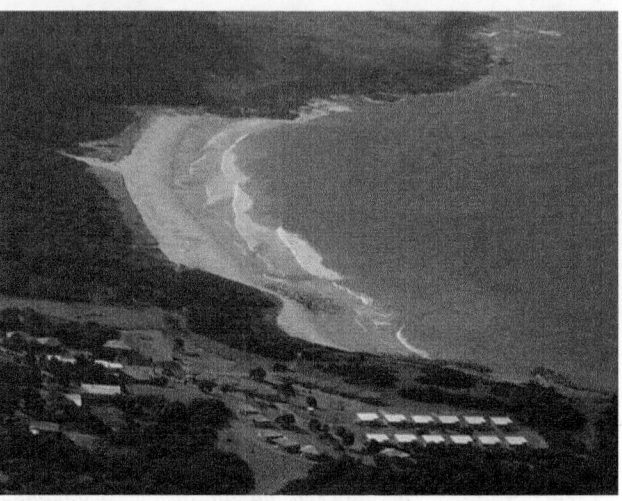

Figure 4.22 Four Mile Creek Beach and Burial Point (foreground) (T 122 & 123) (photo W. Hennecke).

T 122-123 FOUR MILE CREEK BEACH

No.	Beach	Rating HT	LT	Type	Length
T122	Four Mile Ck Beach	6	6	TBR	1.6 km
T123	Burial Point	6	6	Cobble+LTT	150 m
Spring & neap tidal range = 1.2 & 0.0 m					

Four Mile Creek drains into an open 2 km wide northeast-facing embayment containing beaches T 122 and 123 (Fig. 4.22). **Four Mile Creek Beach (T 122)** is a 1.6 km long east-northeast-facing beach bordered by a sloping granite-boulder-strewn point in the north and the usually blocked creek mouth and a low rocky point in the south. The beach receives waves averaging over 1 m which maintain a 50 m wide bar usually cut by several rips. It is backed by a low 50 m wide foredune, then a road which services a collection of houses behind the southern end of the beach. The old road bridge at the southern end of the settlement is for pedestrian use only. The Four Mile Creek Road circuits the rear of the beach, with a roadside car park providing access to the northern end of the beach. There are four surf breaks along the beach, a northern rock break called *Cattle Grids*, a left off the northern point, a bombie right off the southern point, and beach breaks along the beach.

Beach **T 123** is located in a small 200 m wide embayment at the southern end of Four Mile Creek Beach, and is bordered to the south by the sloping 20 m high Burial Point. The 150 m long beach consists of a high tide cobble beach fronted by a sandy bay floor, with rocky points bordering each side. It is backed by grassy slopes, with two houses and a boat ramp on the southern rocky shore of the bay.

T 124-125 MCINTYRE BEACH

No.	Beach	Rating HT	LT	Type	Length
T124	McIntyres Beach	5	6	LTT/TBR	800 m
T125	Ironhorse Pt	5	6	LTT/TBR	100 m
Spring & neap tidal range = 1.2 & 0.0 m					

One kilometre southeast of Burial Point is the next open embayment containing **McIntyres Beach (T 124)**. The beach curves to the southeast for 800 m and consists of a lower gradient beach with a usually attached bar cut by two to three rips. It is backed by a low grassy foredune breached by three small creeks, including the central Tin Creek. Wooded slopes extend inland, with the road 0.5-1 km to the west. There is vehicle access in the south via the holiday village.

Beach **T 125** is located at the southern end of the beach, past a small rocky point fringed by a cobble beach. The cobble beach continues around the rear of the 100 m long curving beach, with a sandy low tide terrace fronting the cobbles and at times linking with the main beach. The Cray Drop-In holiday village is located on the slope and crest of the eastern Ironhouse Point. It has cleared some of the cobbles to construct a small boat ramp, groyne and launching area on the eastern side of the bay.

Little Beach Coastal Reserve

Established: 1982
Area: 47 ha
Coast length: 11 km (144-154 km)
Beaches: 3 (T 126-128)

The Little Beach Coastal Reserve is an 11 km long narrow strip of rocky shore that extends from Ironhouse Point south to Little Beach and round Hughes Point to terminate at the mouth of Hughes Creek. It contains three beaches (T 126-128) and a small campsite at Little Beach.

T 126 LITTLE BEACH

No.	Beach	Rating HT LT		Type	Length
T126	Little Beach	6	6	TBR	200 m
Spring & neap tidal range = 1.0 & 0.0 m					

Little Beach is located 6 km south of Ironhouse Point with continuous sloping rocky shoreline in between. The beach (**T 126**) lies in a small valley at the mouth of Little Beach Creek, which is usually blocked to form a small lagoon. The beach is 200 m long, faces east and is bordered by sloping granite points backed by cleared farmland. Waves average over 1 m and usually maintain a permanent rip against the southern rocks. There are occasionally good surf breaks over the rocks at each end of the beach. The beach and small backing valley are part of the Little Beach Coastal Reserve, with a camping area, but no facilities, located on the slopes at the rear of the beach, just off the main road.

Lagoons Beach Conservation Area

Established: 1981
Area: 92 ha

T 127-131 HUGHES POINT-LAGOONS BEACH

No.	Beach	Rating HT LT		Type	Length
T127	Hughes Pt (S)	6	7	TBR+rocks	100 m
T128	Hughes Ck (N)	6	6	TBR	300 m
T129	Hughes Ck (S)	6	6	TBR	350 m
T130	Lagoons Beach (N)	6	6	TBR	2.5 km
T131	Lagoons Beach (S)	6	6	TBR	2.8 km
Spring & neap tidal range = 1.2 & 0.0 m					

Hughes Point is a sloping granite point to the south of which is an open 6 km long embayment bordered to the south by sand-draped 16 m high Piccaninny Point. In between are five near continuous beaches (T 127-131), including the longer Lagoons beaches. The Four Mile Creek Road backs the northern half of the embayment, linking with the Tasman Highway, which then runs along the rear of the southern half. The beaches are part of the Little Beach and Lagoons Beach Conservation Areas.

Beach **T 127** is a 100 m long pocket of exposed southeast-facing sand located 500 m southwest of Hughes Point. The beach is bordered by low granite points with considerable boulder debris to either end forming a storm boulder beach. Waves averaging up to 1.5 m break over the sand and rocks up to 100 m off the beach with a strong permanent rip flowing out against the northern rocks. Beach **T 128** lies immediately to the south and is a 300 m long southeast-facing beach bordered by low granite points and backed by irregular foredune and

vegetated granite slopes. The surf zone continues south with usually one to two rips draining the system.

Beach **T 129** commences on the southern side of the small boundary point against which **Hughes Creek** breaks out across the beach. The beach continues south for 350 m to the longer usually blocked mouth of Marsh Creek, which is deflected northward to the rear of Lagoons Beach. The two creeks result in an unstable largely unvegetated beach system, with only a central section of low grassy foredune. The rip-dominated surf zone continues south along the beach, with additional current prevailing when the creeks are open.

The northern section of **Lagoons Beach** (**T 130**) commences at the mouth of Marsh Creek and curves gently to the south for 2.5 km to the usually blocked mouth of Saltwater Creek. A 50-100 m wide rip-dominated surf zone continues south with up to 10 rips operating along the beach. It is backed by a low hummocky foredune, then the deflected Marsh Creek to the north and wetlands associated with the inlet to the south. There is a vehicle track off the Four Mile Creek Road to a car park and footbridge across March Creek that provides access to the northern end of the beach.

The southern section of Lagoons Beach (**T 131**) continues south of the 500 m long unstable inlet mouth for 2.8 km to northern side of Piccaninny Point. Waves averaging up to 1.5 m continue along the beach, decreasing slightly to the lee of the point with up to 12 rips forming along the beach. It is backed by a low semi-stable foredune then an elongate wetland associated with the inlet, three central creeks and the southern Piccaninny Creek which breaks out through the dune-backed southern end of the beach. There is vehicle access off the Tasman Highway to Piccaninny Point with a walk through the dunes to the beach.

T 132-135 TEMPLESTOWE BEACH

No.	Beach	Rating HT LT		Type	Length
T132	Piccaninny Pt (S)	6	8	LTT+rocks	300 m
T133	Templestowe Beach	6	6	TBR/RBB	5.2 km
T134	Black Dog Reef	3	3	R	200 m
T135	Long Point	4	6	Boulder	100 m
Spring & neap tidal range = 1.3 & 0.0 m					

Piccaninny and Long points form the boundaries of an open east-facing embayment containing the longer Templestowe Beach, together with three smaller beaches (T 132, 134 and 135) associated with the points. Apart from vehicle access to each of the points, there is no direct access to the Templestowe Beach.

Beach **T 132** is located on the southern side of Piccaninny Point and curves to the south for 300 m as a rock-dominated beach. It has a large rock platform at the north end, a 100 m long central rock outcrop and a smaller southern boundary outcrop all in amongst the

sand of the beach and surf zone. Waves break up to 100 m offshore over the bar and rocks with a permanent rip against the northern rocks. It is backed by a vegetated foredune, then cleared farmland.

Templestowe Beach (T 133) commences at the smaller rock outcrop and trends to the south for 5.2 km curving towards the southeast in lee of Long Point to terminate at the small sandy foreland in lee of Black Dog Reef. The beach is exposed to moderate waves averaging 1-1.5 m for most of its length which usually maintain a rip-dominated 50-100 m wide surf zone with rips spaced every 200-300 m. It is backed by a near continuous vegetated foredune then grazing land, with a few blowouts towards the southern end. Two small creeks cross the northern section of the beach, with the 50 ha Templestowe Lagoon occasionally breaking out across the southern end of the beach (Fig. 4.23). There are numerous beach breaks along the beach, however the only access is a 4WD track that reaches the shore close to the southern end of the beach.

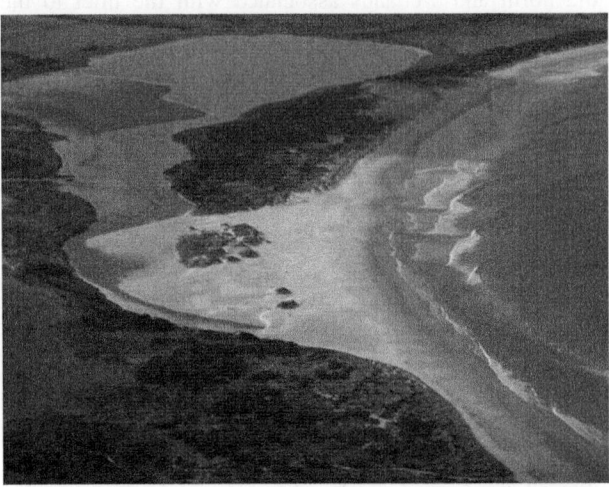

Figure 4.23 The southern end of Templestowe beach (T 133) and the blocked mouth of Templestowe Lagoon (photo W. Hennecke).

Long Point and **Black Dog Reef** protect the small north-facing beach **T 134**. It is a 200 m long lower energy reflective beach located between the boundary foreland and the beginning of Long Point. It receives waves averaging about 0.5 m, which surge up the reflective beach. A fishing hut is located on the vegetated slopes behind the foreland.

Long Point is a 21 m high granite headland blanketed by clifftop dunes. It protrudes 2 km to the east bordered by sloping granite rocks. On its eastern side is a small 60 m wide rocky embayment containing beach **T 135**. This is a curving 100 m long boulder beach, backed by semi-stable transgressive dunes that have blown up from the former sandy beach and over the point.

Seymour Beach Coastal Reserve		
Established:	1981	
Area:	68 ha	
Coast length:	5 km	(167-172 km)
Beaches:	1	(T 136)

Seymour Beach Coastal Reserve is a narrow 5 km long beach reserve that extends from the south side of Long Point to the mouth of the Douglas River and includes all of Seymour Beach and the backing foredune.

Denison Rivulet Coastal Reserve		
Established:	1983	
Area:	51 ha	
Coast length:	8 km	(172-180 km)
Beaches:	4	(T 137-140)

Denison Rivulet Coastal Reserve is an 8 km section of sandy shore including four beaches between Douglas River mouth and the end of Denison Beach. It also incorporates Old Mines Lagoon.

T 136-141 MACLEAN BAY

No.	Beach	Rating HT LT		Type	Length
T136	Seymour Beach	6→7		TBR→TBR+rocks	4.3 km
T137	The Porches	6	7	TBR+rocks	1.2 km
T138	Denison Beach (N)	6	6	TBR/RBB	2.5 km
T139	Denison Beach	6	6	TBR/RBB	2.4 km
T140	Denison Beach (S)	6	6	TBR/RBB	4.3 km
T141	Denisons (S)	6	7	TBR+rocks	200 m
Spring & neap tidal range = 1.3 & 0.0 m					

Maclean Bay is an open east-facing 12 km long embayment bordered by Long Point to the north and Diamond Island in the south. In between is a predominantly sandy shoreline containing six beaches (T 136-141). The Tasman Highway runs between 100-600 m to the rear of the coast and provides a number of access points to the shore. The Seymour and Denison beaches (T 136-140) form a continuous sandy beach broken only by a number of usually blocked creek mouths.

Seymour Beach (T 136) commences as a slightly protected south-facing beach in lee of Long Point and soon curves and trends to the south for 4.3 km to the rock-controlled, usually blocked mouth of Douglas River. The beach is well exposed to waves averaging up to 1.5 m which maintain a well developed rip-dominated surf zone, with up to 15 rips forming along the beach. A series of intertidal rocks extends a few hundred metres north of the river mouth, resulting in hazardous beach conditions. It is backed by a narrow vegetated foredune

then cleared grazing land, with Blind Creek reaching the centre of the beach.

Beach **T 137** commences at the river mouth and trends to the south for 1.2 km becoming increasingly dominated by rock reefs at the shore and in the inner surf, the rocks known as The Porches. It finally terminates at a small rock bluff. The rocks combined with the moderate waves maintain a number of permanent rips and generally hazardous beach conditions. The northern half of the beach is backed by a collection of holiday shacks set amongst a wooded field, with a narrow vegetated foredune and farmland backing the remainder.

Denison Beach commences on the southern side of the rocks and trends to the south in three sections (T 138-140) totalling 9.2 km. The northern section (**T 138**) is a 2.5 km long east-facing beach bordered by the northern rocks and the usually blocked mouth of Denison Rivulet. The 1-1.5 m high waves and rips continue along the beach with usually 8-10 rips flowing across the bar. A narrow foredune, the highway then sloping farmland back the beach, with a small car park and beach access at the rivulet in the centre of the beach.

Beach **T 139** continues south of the rivulet for another 2.4 km to the mouth of Old Mines Lagoon. This is a similar beach with 8-10 rips and a backing foredune and farmland. There is a collection of tree shaded holiday shacks at Toxteth Park immediately south of the rivulet. The highway crosses the rivulet 100 m west of the beach, with a car park and beach access 1.5 km south of the rivulet.

The southern section of the beach (**T 140**) commences at the usually blocked mouth of the 20 ha Old Miners Lagoon and curves to the south-southeast for 4.3 km to the southern boundary rocks, and while waves begin to decrease slightly to the south, several rips usually dominate the surf zone. The beach is backed by a vegetated 50-100 m wide foredune then a mixture of cleared and vegetated land including the Bicheno golf course.

Beach **T 141** is a curving 200 m long pocket beach located between rocky granite points, with some rocks outcropping on and off the beach. It is moderately protected by Diamond Island 1 km to the southeast, with waves averaging about 1 m, which usually maintain a rip against the northern rocks. The beach is backed by rocks and a small area of active dunes on the southern side, then cleared sloping farmland.

Bicheno Marine Reserve

Beaches: 4 (T 142-145)

Bicheno Marine Reserve covers an area that is bordered by the shoreline between the north side of Diamond Island to Peggys Point and seaward to a line between the tip of the island and Peggys Point. It also incorporates an area on the seaward side of Governor Island, which borders the Gulch.

T 142-147 BICHENO

No.	Beach	Rating HT LT		Type	Length
T142	Diamond	3	3	LTT	500 m
T143	Redbill Beach	4	5	LTT/TBR	1 km
T144	Waubs Bay	2	3	R/LTT	100 m
T145	Bicheno	2	3	R/LTT	200 m
T146	Rice Beach	2	3	R	100 m
T147	Muir Rock	2	3	R+rocks	150 m
Spring & neap tidal range = 1.3 & 0.0 m					

Bicheno is a popular holiday and fishing town, with a small port that has taken advantage of a natural gutter between Governor Island and Peggys Point, and is known as 'The Gulch'. Extending for 1 km to the north of the point are two small bays and the small Diamond Island, which between them contain four beaches (T 142-145), with beaches T 146 and 147 located in small rocky bays immediately south of the town (Fig. 4.24). The town provides a wide range of accommodation and facilities for visitors and travellers, while The Tasman Highway winds down the coast and through the town and close by the shore, with variable access to the beaches.

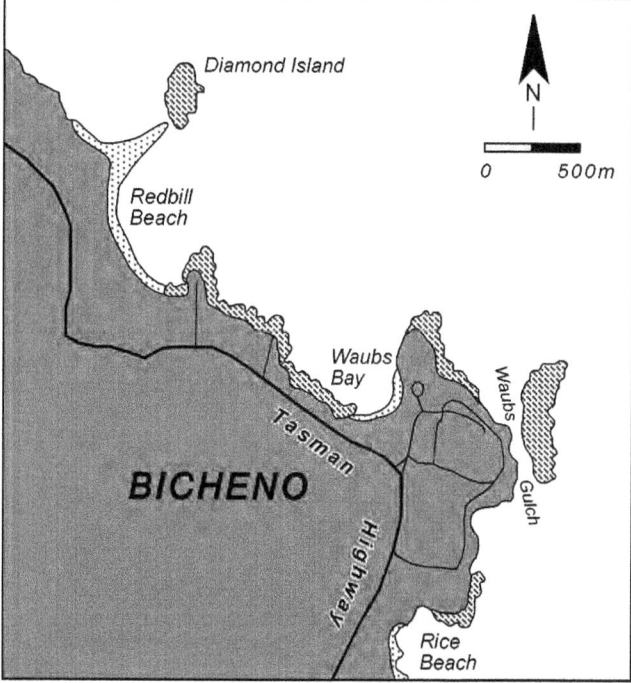

Figure 4.24 Bicheno occupies the shores of Waubs Bay with Diamond Island and Redbill Beach to the north and Rice beach to the south.

Diamond beach (**T 142**) is located on the north side of an active tombolo that heads out to, and occasionally attaches to Diamond Island (Fig. 4.25). When attached the beach is 500 m long and faces due north. When detached it is still connected by a shallow sand bar. It receives waves averaging less than 1 m which usually maintain a low gradient beach and continuous attached bar, with some low rock outcrops scattered along the beach. The beach is backed by a strip of trees then

cleared slopes containing a youth hostel, the Diamond Island Resort and private land and is best accessed from adjoining Redbill Beach. There is a penguin colony in lee of the sand spit and on the rounded Diamond Island, which is also a 5 ha nature reserve.

Figure 4.25 Diamond Island is linked to the mainland by Diamond and Redbill beaches (142 & 143).

Redbill Beach (T 143) is the main surfing beach for Bicheno. The 1 km long beach curves round between the Diamond Island spit and the southern rocks of Redbill Point and faces east out of the small bay. Waves average 0.5 m in the south increasing to 1 m at the spit. Rips commonly occur with usually three to four cutting across the central to northern section of the beach. A small grassy foredune backs the beach, then vegetated slopes leading to cleared land in the east and houses and a road behind the southern end. A 1.5 km long foreshore walking track leads from the Redbill Point around past Lynes Point to Waubs Bay.

Waubs Bay is the name of the anchorage in lee of Peggys Point and the site of the main boat ramp on the point. The ramp is protected by a small groyne and there are usually a few boats moored in the bay. Within the 500 m wide bay are two protected north-facing beaches (T 144 and 145). Beach **T 144** is a 100 m long pocket of sand located on the western side of the bay, while the main beach (**T 145**) extends for 200 m along the southern shore of the bay, with rounded granite rocks bordering and separating the two beaches (Fig. 4.26). The beaches receive low refracted waves averaging about 0.5 m. These surge up the steep, narrow beach, with a narrow attached bar present during higher waves. Higher waves also produce a heavy shorebreak, particularly at the rocky western end of the bay. Beach Street runs down to the middle of the beach where there is a car park and toilet facilities. The town of Bicheno is located on the slopes to the south of the bay, with a hotel on the eastern point. A 4 km long foreshore walking track follows the rocky coast around Peggys Point past the boat harbour in The Gulch to the blowhole and Rice Beach and on to Muirs Rock beach.

Figure 4.26 Waubs Bay at Bicheno contains two sheltered beaches (T 144 & 145), as well as providing a protected anchorage.

Rice Beach (T 146) is located in a small east-facing rocky bay on the southern side of Bicheno. The 100 m long beach faces east out of the bay and receives low refracted waves averaging about 0.5 m. The waves surge up a moderately steep reflective beach composed of coarse sand and gravel, with several large rock outcrops along the beach. It is backed by vegetated slopes and houses.

Beach **T 147** is located in the next rocky bay with Muir Rock located just off the northern headland. It is a 150 m long reflective coarse sand beach, fronted by scattered rocks, with the beach terminating in the south in lee of a rock platform. It is backed by cleared slopes and a house.

Swimming: Waubs Bay offers the safest swimming, while if swimming at Redbill stay at the lower energy southern end. The northern spit end can be dominated by strong rips. Diamond Beach is relatively safe, particularly when connected to the island, however it is isolated.

Surfing: The northern end of Redbill, also known as Surf Beach, is the best location to find ridable beach breaks, with the north side of *Diamond Island* providing a right-hand break during bigger swell.

Freycinet National Park

Established:	1916
Area:	16 803 ha
Mainland coast length:	96 km (188-284 km)
Mainland beaches:	31 (T 149-173, 176-181)

Freycinet National Park is the oldest coastal national park in Tasmania. Its establishment in 1916 is an indication of the early attention given to the spectacular scenery within the park. The core of the park is the three granite ridges reaching 485 km in The Hazards, 620 m on Freycinet Peninsula and 340 m on Schouten Island. The peninsula is connected to the mainland by a low sandy isthmus bounded by Hazards Beach and Wineglass Bay, the bay

beach one of the most photogenic beaches in Australia. The park was expanded northwards in 1992 and 1999 as far as Binghams Bay and includes the Friendly Beaches. Only this newer northern section and an area north of The Hazards are accessible by vehicle with the bulk of The Hazards and the peninsula only accessible on foot or boat, and the island only accessible by boat. Most visitors only get as far as the lookout overlooking Wineglass Bay, with hikers and campers proceeding further around and over The Hazards to access the bay and peninsula. There are walking trails and a number of campsites in the bay and on the peninsula and one on the island. Campsites at Isaacs Point in the north are accessible by car.

T 148-151 COURLAND BAY

No.	Beach	Rating HT LT		Type	Length
T148	Courland Bay	4	5	LTT/TBR	1 km
T149	Courland Bay (S)	4	5	LTT/TBR	500 m
T150	Courland Bay (S1)	4	5	TBR	500 m
T151	Butlers Pt (N)	4	5	LTT+ rocks	250 m
Spring & neap tidal range = 1.3 & 0.0 m					

Courland Bay is an open east- to southeast-facing bay bordered by 210 m high Cape Lodi in the north and 20 m high Butlers Point 4 km to the south. The bay contains four near continuous sandy beaches backed by steep vegetated slopes rising to 180 m above the southern shore of the bay. There is vehicle access in the north to beach T 148 and in the south to Butlers Point.

Beach **T 148** is the main beach extending for 1 km along the northern section of the bay. It faces east, receiving waves averaging over 1 m, which maintain a low tide terrace, cut by rips during higher waves. A vehicle track reaches the slopes above the northern end of the beach where a few holiday shacks are located, with dense vegetation backing the remainder. A small rock outcrop separates it from beach **T 149**, which continues along the mid-section of the bay for another 200 m, to the beginning of a steep rocky section. It usually has a low tide terrace, with a rip draining to the south during higher waves. It is backed by scarped bedrock slopes, which rise steeply to Tar Hill.

Beach **T 150** occupies the southern section of the bay and is a 500 m long beach bordered by rocky shore. It receives slightly higher waves, which usually maintain one to two rips (Fig. 4.27). It is backed by a hummocky semi-stable foredune and two stabilising blowouts, which have extended up to 200 m to the south across the low wetland to the rear of Butlers Point. A vehicle track runs around the rear of the dune to reach the southern end of the beach and link to a few fishing shacks located on the lower point.

Figure 4.27 Beach T 150 in Courland Bay usually has a couple of well developed rips, as seen in this view (arrows).

Beach **T 151** extends south around the base of Butlers Point and consists of a high to mid tide sand beach interfingering with inter- to subtidal ridges of rock. The two shacks are located above this beach. Waves averaging 1 m break over the rocks and sand.

T 152-154 FRIENDLY BEACHES

No.	Beach	Rating HT LT		Type	Length
T152	Friendly Beaches	4	5	LTT/TBR	2.5 km
T153	Isaacs Pt (N)	4	5	LTT/TBR	150 m
T154	Isaacs Pt (S)	4	5	LTT+rocks	200 m
Spring & neap tidal range = 1.3 & 0.0 m					

The **Friendly Beaches** are a chain of seven east-facing beaches that commence on the southern side of Butlers Point and extend south for 11 km to Friendly Point. The first three (T 152-154) occupy an open 3 km long embayment between Butlers and Isaacs points. They are backed by densely vegetated slopes that rise to over 200 m at Rogers Hill. There is vehicle access in the north to Butlers Point and in the south to Isaacs Point.

Beach **T 152** is the main beach extending for 2.5 km south of Butlers Point to the northern rocks of Isaacs Point. The beach faces east-southeast and receives waves averaging over 1 m which maintain a low tide terrace, cut by rips during higher waves. It is backed by a small grassy foredune, then dense forest, with a few small blowouts at the southern end of the beach, the beach terminating against a 100 m long collection of rocks.

Beach **T 153** continues south of the rocks for 150 m to the 100 m wide sloping Isaacs Point. Waves break across a 50 m wide bar, with a permanent rip against the southern 10 m high dune-draped granite point. There is vehicle access to a campsite at the rear of the beach and onto the point.

Beach **T 154** is a 200 m long beach wedged between Isaacs Point and the next section of rocky shore, with several large rock outcrops crossing the beach and extending into the surf. It is backed by a small foredune with the point to the north and the access track behind.

T 155-159 THE FRIENDLY BEACHES

No.	Beach	Rating HT LT	Type	Length
T155	The Friendly Beaches (1)	4 5	LTT/TBR	300 m
T156	The Friendly Beaches (2)	6 6	TBR	5 km
T157	The Friendly Beaches (3)	5 6	TBR→LTT	1.6 km
T158	Freshwater Lagoon	4 4	LTT	700 m
T159	Bluestone Bay	2 3	R/LTT	80 m
Spring & neap tidal range = 1.3 & 0.0 m				

To the south of Isaacs Point the Friendly Beaches (T 155-158) continue south for another 7 km to Friendly Point, to the south of which is the high rocky coast of The Hazards and Freycinet Peninsula. There is a gravel road out to the northern end of the main beach, which continues south behind the beach for 5 km to Saltwater Lagoon. The beaches and backing dunes are part of the Friendly Beaches Private Sanctuary and are open to the public.

Beach **T 155** commences on the southern side of Isaacs Point and curves slightly to the south for 300 m to a series of shore-perpendicular lines of rocks. Rocks are scattered off each end of the beach, with a more continuous 50 m wide bar in between cut by occasional rips during periods of higher waves. The access road reaches the rear of the beach with a few parking and campsites overlooking the beach.

The main **Friendly Beach (T 156)** extends due south from the northern boundary rocks for 5 km to the usually blocked mouth of Saltwater Lagoon. It is an exposed moderate to occasionally high energy beach with a rip-dominated surf zone, containing up to 15 or more rips spaced every 300 m along the shore. In addition to the rips there are patches on inshore rocks, which induce permanent rips. The rips and reefs provide a number of beach breaks the length of the beach. The beach is backed by a 200-300 m wide zone of transgressive dunes, which include active and vegetated dunes and deflated surfaces. An access road runs behind the dunes to three car parks behind the north and centre of the beach. Steep wooded slopes rise up 280 m to Mounts Peter and Paul behind the beaches.

Saltwater Lagoon is 20 ha coastal lagoon whose usually blocked entrance separates beaches T 156 and 157. Beach **T 157** continues south of the lagoon entrance for 1.6 km, curving to the southeast to terminate at a reef-tied sand foreland. Waves are highest at the lagoon entrance and usually three to four rips extend down the beach. As the waves drop to the lee of the reef and Friendly Point the rips tend to diminish and are replaced by a low tide terrace. The dunes remain active, but tend to narrow

along this beach. The beach is accessible by 4WD from Coles Bay.

Beach **T 158** commences at the foreland and curves to the southeast then east for 700 m terminating in lee of 100 m high Friendly Point. Waves decrease to about 1 m at the beach which usually has a continuous attached bar free of rips. The beach is exposed to strong northeast winds, which maintain a series of large and small blowouts, the larger ones crossing the 200 m wide barrier that impounds 20 ha **Freshwater Lagoon**. The lagoon breaks out occasionally across the centre to eastern end of the beach.

Friendly Point marks the beginning of 75 km of predominantly steeply sloping, high granite coast of Freycinet Peninsula. Five kilometres south of the point is the small rocky north-facing **Bluestone Bay,** which contains a protected pocket beach (**T 159**). The beach consists of an 80 m long strip of north-facing sand and some rocks, backed by a higher boulder beach. It is bordered by boulders and sloping granite and fronted by a patch of sand then a rocky bayfloor. The beach is accessible on foot from Coles Bay and has a camping site. Two kilometres further south is 115 km high Cape Tourville that has a lighthouse and is accessible by car.

T 160 WINEGLASS BAY

No.	Beach	Rating HT LT	Type	Length
T160	Wineglass Bay	2 3	R/LTT	1.7 km
Spring & neap tidal range = 1.3 & 0.0 m				

Wineglass Bay (T 160) is one of the more photogenic beaches in Australia, and certainly the most photographed in Tasmania. The view from the saddle track over The Hazards highlights the beautiful curving, brilliant white sand beach, with a foreground of bright blue water, and background of dense green vegetation. It is a good hour's hike to the bay from the Parsons Cove car park, with the best view from the saddle. The beach itself is 1.7 km long and curves round in a northeast-facing arc (Fig. 4.28). Waves are relatively low averaging 0.5-1 m and decreasing in height into the southern corner. They surge up a steep, white sand usually cusped beach face, with no bar and deep water right off the beach. The beach is backed by a low vegetated dune, which forms the eastern side of the 1.5 km wide isthmus bordered in the west by Hazards Beach (T 170). Indigo Creek occasionally drains across the more protected southern end of the beach, with boats often moored off the corner.

To the south of Wineglass Bay are 20 km of exposed steep, rugged granite shoreline bordered by 100m high Cape Forestier in the north and 60 m high Cape Degerando to the south.

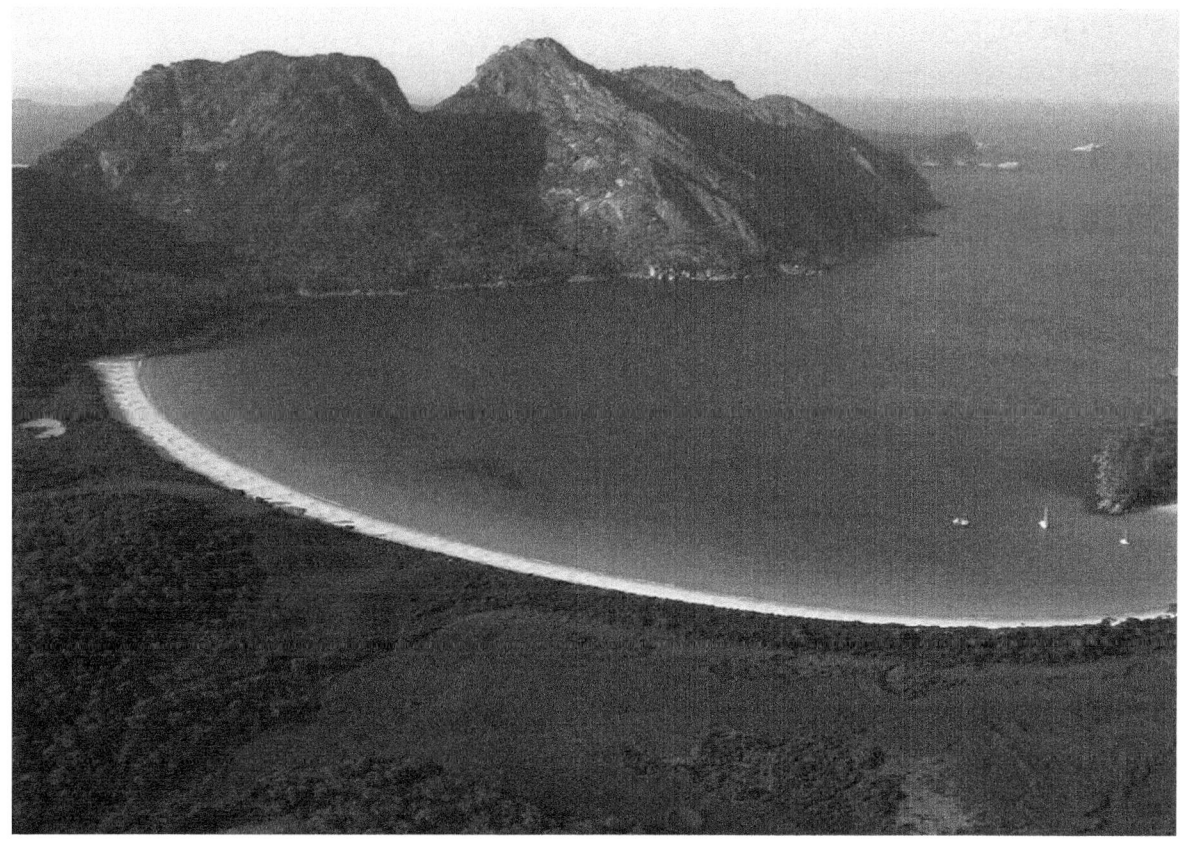

Figure 4.28 Wineglass Bay beach (T 160) is a lower energy reflective and usually cusped beach. On its northern boundary is the 485 m high The Hazards (left).

EAST COAST

Region 1B Cape Degerando-Cape Pillar
Coast length 254 km (254-512 km)
Beaches: 149 (T 161-309)

The southeast coast of Tasmania extends for 254 km from Cape Degerando at the tip of the Freycinet Peninsula to Cape Pillar at the base of the Tasman Peninsula (Fig. 4.29). This is a south-trending coastline that contains several large estuaries and bays, as well as Maria Island. On the mainland it contains 148 beaches, which occupy 43% of the 258 km of shoreline, the remainder dominated by rocky shore including some of the highest cliffs in Australia. Maria Island contains an additional 19 beaches on its 65 km of shoreline.

T 161-162 BRYANS BEACH

No.	Beach	Rating HT LT	Type	Length
T161	Passage Beach	3 3	R/LTT	300 m
T162	Bryans Beach	3 3	R/LTT	1.8 km
Spring & neap tidal range = 1.1 & 0.2 m				

Passage and Bryans beaches (T 161 and 162) are located on the southwestern tip of the Freycinet Peninsula 5 km west of Cape Degerando and face west into Great Oyster Bay. They are the two southernmost beaches on the peninsula and accessible only by boat or on foot along the Bryans Beach Track, with campsites at both ends of Bryans Beach.

Passage Beach (T 161) lies 1 km south of Bryans Beach and faces due west into the bay, with Schouten Island protecting it from south waves. It is named after the 1 km wide Schouten Passage between the peninsula and island. The 300 m long beach partly fills a bedrock valley with slopes rising to 200 m on either side. It receives low waves averaging less than 1 m, which maintain a reflective to occasionally low tide terrace beach, backed by a 50 m wide semi-stable foredune and a small wetland fed by Storynga Creek.

Bryans Beach (T 162) is a curving 1.8 km long southwest-facing beach formed across the mouth of a steep-sided valley and impounds 25 ha Bryans Lagoon, which is fed by creeks draining off 620 m high Mount Freycinet. Waves averaging less than 1 m reach the beach and maintain a reflective to low tide terrace beach backed by a continuous foredune. The largely infilled lagoon is deflected to the east occasionally breaking out across the eastern end of the beach.

Figure 4.29 East Coast: Region 1B, extends from the Freycinet Peninsula to Cape Pillar.

T 163-166 COOKS BEACH

No.	Beach	Rating HT LT		Type	Length
T163	Weatherhead Pt (E)	3	3	R/LTT	200 m
T164	Cooks Corner (1)	3	3	R/LTT	50 m
T165	Cooks Corner (2)	3	3	R/LTT	200 m
T 166	Cooks Beach	3	3	R/LTT	1.1 km
Spring & neap tidal range = 1.1 & 0.2 m					

Weatherhead Point forms the southwestern boundary of the Freycinet Peninsula, with the shoreline trending northeast into Promise Bay. Between the point and Cooks Beach are four beaches (T 163-166) occupying most of the 2 km of shore. The Bryans Beach Track passes along the main Cooks Beach to Cooks Corner where there is a campsite. The track then turns inland towards Bryans Beach 3 km to the south.

Beach **T 163** is located 500 m east of the wooded 18 m high Weatherhead Point. The beach faces northwest and receives low waves, which break across a 200 m long low gradient low tide terrace. The beach is bordered and backed by low rocky bluffs and backing wooded slopes.

Cooks Corner lies 1 km east of the point and consists of two north-facing beaches (T 164 and 165). Beach **T 164** is a 50 m pocket of sand with wooded slopes to the west and rear and a 100 m long section of low rocks separating it from beach T 165. The beach receives low waves and has a 30 m wide low tide terrace fringed by the rocks. The main beach (**T 165**) extends for 200 m between low rocky points and usually has a continuous low tide terrace with low waves to calm conditions. It is backed by dense vegetation and a camping hut behind the eastern end of the beach.

Cooks Beach (T 166) commences on the eastern side of the rocks and curves slightly to the northeast for 1.1 km to the beginning of a 2 km long section of rocky shore with moderate gradient vegetated slopes backing the northern half of the beach. Waves average less than 1 m and maintain a low tide terrace, while occasional higher waves generate a few rips along the beach. It has one outcrop of rock towards the northern end and is backed by a 10 m high foredune and a southern infilled wetland fed by Botanical Creek.

T 167-172 PROMISE BAY

No.	Beach	Rating HT LT		Type	Length
T167	Promise Bay (1)	3	3	R/LTT+rocks	200 m
T168	Promise Bay (2)	3	3	R/LTT+rocks	80 m
T169	Promise Bay (3)	3	3	R/LTT	50 m
T170	Hazards Beach	4	5	TBR→R/LTT	3 km
T171	Hazards (N)	3	4	LTT+rocks	60 m
T172	Lemana	3	3	R/LTT	80 m
Spring & neap tidal range = 1.1 & 0.2 m					

Promise Bay is a 4 km wide southwest-facing bay bordered by Fleurieu Point and The Hazards to the north and Weatherhead Point and The Freycinet Peninsula to the south. Hazards Beach links the two bedrock highs and forms the apex of the bay. The bay faces into Great Oyster Bay and usually receives low refracted waves from the south. In addition to the Cooks beaches (T 163-166) there are Hazards Beach (T 170) and five other small beaches located to either side (T 167-169, 171-172). The Hazards Beach and Peninsula tracks provide foot access to all six beaches.

Beaches T 167-169 occupy a 1 km long section of sloping rocky shore immediately south of Hazards Beach. Beach **T 167** is a narrow 200 m long west-facing beach, bordered by rocky points and backed by wooded slopes. It usually receives low waves which maintain a 20-30 m wide low tide terrace, with some rocks along the southern half of the beach. Beach **T 168** lies 200 m to the north round a small sloping wooded point. It is an 80 m long strip of sand with trees growing right down to the rear of the beach. It has a narrow low tide terrace and some submerged rocks off the beach. Beach **T 169** is located 100 m to the north past a low section of rocks. It is a 50 m long pocket of sand backed by the wooded slopes and fronted by a small attached bar. The southern end of Hazards Beach lies 200 m further north with access to the beach via the Peninsula Track or along the rocks at low tide.

Hazards Beach (T 170) is named after the mountains, not because it is necessarily hazardous. An hour's walk round or over The Hazards ridge is required to reach the beach. The beach is Wineglass Bay's western twin, and the two beaches form a 1.5 km wide isthmus tying the Freycinet Peninsula to the mainland (Figs 4.30 & 4.31). The 3 km long southwest-facing beach is sheltered within Great Oyster Bay and usually receives low refracted swell and wind waves. Occasional higher waves do form rips, particularly along the southern half of the beach. The rip holes are spaced about every 200 m and may persist for weeks after a high wave event. The northern half is partly sheltered by Refuge Island and receives lower waves and usually has reflective conditions. The beach is backed by a 50-100 m wide, 5-10 m high, vegetated foredune, including some inner vegetated blowouts. The Isthmus Track leaves the northern end of the beach for Wineglass Bay while the beach track uses the beach to reach the peninsula. There is a campsite at the southern end of the beach.

Beach **T 171** is located at the northern tip of Hazards Beach, being separated from the main beach by a 50 m long section of red rocks. The little beach faces south, is 60 m long and bordered and backed by bare red rocks, with densely wooded slopes behind. Rocks outcrop towards the western end of the beach, with a reef also located 50 m off the western end. The walking track runs behind the rear of the beach.

Figure 4.30 A northern section of Freycinet National Park, with the main town Coles Bay and the walking track to Wineglass Bay and Hazards Beach.

Figure 4.31 Hazards Beach (T 170) (foreground) links across a 1.5 km wide isthmus to Wineglass Bay (T 160) (top), which also links The Hazards ridge (left) with the Freycinet Peninsula.

Beach **T 172** is located 200 m to the west in a small 100 m wide rocky embayment. The 80 m long south-facing sandy beach occupies the rear of the embayment.

It is bordered by exposed rocky points, backed by densely vegetated wooded terrain that slopes gently into the bay. The bay has a sandy floor and usually low waves to calm conditions. Lemana Lookout is located on the walking track just west of the beach.

T 173-175 FISHERIES & PARSONS COVE

No.	Beach	Rating HT LT	Type	Length
T173	Fisheries	2 2	R	250 m
T174	Parsons Cove	2 2	R	200 m
T175	Parsons jetty	2 2	R	50 m
Spring & neap tidal range = 1.1 & 0.2 m				

Fisheries and Parsons Cove are two adjoining small beaches located on the southern side of Coles Bay and at the end of the road from Coles Bay village. The main car park for people accessing the walking tracks to Wineglass Bay and beyond is located on the slopes behind the Cove. The coves face north across the bay to the village. **Fisheries** beach (**T 173**) is a 250 m long strip of high tide sand, bordered by a rock platform and reef to the west and a 20 m high point containing a youth hostel to the east. The beach is usually calm with a strip of intertidal sand then seagrass meadows, as well as a couple of rock outcrops.

Parsons Cove is located on the eastern side of the point and contains a curving 200 m long main beach (T 174) and a second pocket of sand (T 175). The main beach (**T 174**) consists of a curving relatively steep high tide beach fronted by a low tide bar to sand flat, with usually calm conditions. Houses are located amongst the trees on the slopes behind the beach and small dinghies are stored on and launched off the beach. Beach **T 175** is located at the eastern end of the beach wedged in between a small rock outcrop and the boundary point, out from which an L-shaped rock jetty has been constructed to form a protected area for launching boats from a concrete ramp. A handful of small boats are usually moored in the enclosure.

T 176-179 HONEYMOON BAY

No.	Beach	Rating HT LT	Type	Length
T176	Honeymoon Bay (1)	2 2	R	50 m
T177	Honeymoon Bay (2)	2 2	R	30 m
T178	Honeymoon Bay (3)	2 2	R	40 m
T179	Honeymoon Bay (4)	2 2	R	60 m
Spring & neap tidal range = 1.1 & 0.2 m				

Honeymoon Bay is a 500 m wide rocky west-facing embayment located on the southern side of Coles Bay. The shoreline is dominated by sloping granite rocks backed by densely vegetated slopes that rise over 400 m to The Hazards. Located in gaps in the rocky shore are four small pockets of sand (beaches T 176-179).

Beach **T 176** is located at the base of the bay and at the foot of Dove Creek, which descends straight down from the crest of The Hazards. The beach is 50 m long and faces north, with rising rocky slopes to either side. It is accessible from the Fisheries Road, which runs around the top of the beach.

Beach **T 177** is located 200 m to the north and is a 30 m long pocket of sand located between two steep vegetated points. The road runs around the slopes immediately behind the beach and provides a view down to the beach. Beach **T 178** lies 100 m further north and is a 40 m long pocket beach with a vegetated point to the south and a lower rocky point to the north. There is vehicle access to a small car park on the northern point. Beach **T 179** is located on the northern side of the low 50 m wide point and consists of a semicircular 60 m long sandy beach located to the lee of two low rocky points with a 30 m wide gap in between. In addition there are two large boulders on and one just off the beach. This is a popular picnic and swimming area with three small car parks and picnic facilities backing the beach.

T 180-181 RICHARDSONS BEACH

No.	Beach	Rating HT LT		Type	Length
T180	Richardsons Beach	3	3	R	1 km
T181	Richardsons Beach (N)	3	3	R	300 m
Spring & neap tidal range = 1.1 & 0.2 m					

The two Richardsons beaches (T 180 and 181) form the eastern shore of Coles Bay and face west-southwest out of the bay into the larger Great Oyster Bay (Fig. 4.32). They are the northernmost beaches on the western side of the national park with the western national park boundary and ranger station located at the northern end of the beaches.

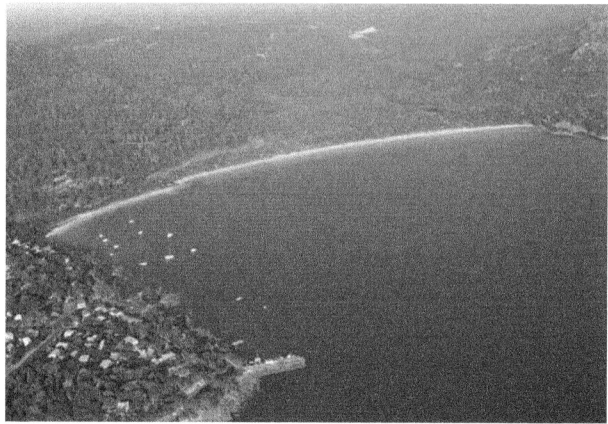

Figure 4.32 The Richardsons beaches (T 180 & 181) with Coles Bay community in the foreground.

The main **Richardsons Beach (T 180)** curves for 1 km to the north between the northern rocks of Honeymoon Bay and a low rocky outcrop that separates it from the northern beach (T 181). The beach receives some

occasional low swell and more often wind waves generated across the larger bay. These maintain a lower gradient reflective beach backed by a continuous low vegetated foredune, then the main access road, with a wetland behind. Camping areas are located behind both ends of the beach and the Freycinet Lodge is located above the southern end of the beach.

The northern beach (**T 181**) continues north from the 50 m wide boundary rocks for 300 m to the granite rocks of Coles Bay village. The park entrance ranger station and large car park are located behind the beach. In addition there is a caravan park, picnic shelter and barbecue facilities. The beach is a lower gradient reflective system with deeper water off the beach. It is relatively protected from waves, with boats moored off the northern end of the beach. There is also a boat ramp and jetty on the rocks just west of the northern end.

T 182-184 COLES BAY

No.	Beach	Rating HT LT		Type	Length
T182	Coles Bay boat ramp	2	2	R	80 m
T183	Coles Bay slipway	2	3	R+rocks	50 m
T184	Coles Bay (W)	2	3	R+rocks	40 m
Spring & neap tidal range = 1.1 & 0.2 m					

Coles Bay is a small community and holiday destination spread over a 100 ha, 20 m high granite headland that separates Coles Bay from Muirs Beach, with Great Oyster Bay to the west. It is also the gateway to the Freycinet National Park. There is a range of accommodation in the bay area and a limited range of commercial facilities. While longer beaches lie either side of the settlement, there are three small pockets of sand (T 182-184) amongst the rocks of the headland.

Beach **T 182** is located immediately east of the Coles Bay boat ramp on the southern side of the headland and 500 m west of the northern end of Richardsons Beach. It consists of a curving narrow, 80 m long pocket of low energy sand bordered by low rocks to the east, with the large boat ramp crossing the western end. Several small boat sheds back the centre of the beach, together with dinghies usually pulled up on the beach. The Coles Bay post office is located on the slopes behind the beach.

Beach **T 183** is located 200 m to the west and is a narrow, 50 m long strip of high tide sand fronted by inter- and subtidal rocks. A slipway is located immediately west of the small beach, which is backed by vegetated slopes then the houses of Coles Bay.

Beach **T 184** lies in a small 80 m wide U-shaped gully at the southwestern tip of the headland. It consists of a 40 m pocket of sand, bordered by massive granite rocks and points with the Esplanade Road passing above the rear of the beach. A picnic area is located on the small point immediately south of the beach.

Coles Bay Coastal Reserve

Established: 1981
Area: 455 ha
Coast length: 7 km (285-292)
Beaches: 8 (T 184-191)

Coles Bay Coastal Reserve is an irregular strip of shoreline and backing undeveloped land that commences on the southern side of Coles Bay headland at beach T 184 and includes Muirs Beach, Hepburn Point and beaches T 186-191. It is bordered in the north by the mouth of Great Swanport.

T 185 MUIRS BEACH

No.	Beach	Rating HT LT	Type	Length
T185	Muirs Beach	4 4	R/LTT	1.8 km
Spring & neap tidal range = 1.1 & 0.2 m				

Muirs Beach (T 185) lies on the north side of Coles Bay headland. It curves to the north, then northwest for 1.8 km and faces southwest into Great Oyster Bay. The beach is backed by a densely vegetated low foredune, then a narrow wetland through which the deflected Saltwater Creek flows the length of the beach to break out against the northern rocks. It receives slightly higher waves than the other Coles Bay beaches, with waves averaging over 0.5 m and producing a narrow, continuous bar along the beach. During occasional higher waves rips cross the bar, particularly towards the northern end. There is good road access to either end of the beach, together with a tidal pool and launching ramp at the southern Coles Bay end, while the Coles Bay caravan park is located behind the northern end.

Swimming: All the Freycinet Park and Coles Bay beaches are relatively safe owing to their protected locations away from high swell and usually low wave to calm conditions. Be careful however at Wineglass Bay as it is isolated and there is deep water right off the beach and any swell surges heavily up the beach, with a strong shorebreak in bigger swell. Hazards Beach and most of the Coles Bay beaches are more protected, apart from Muirs Beach, which in a bigger swell may have rips cutting across the bar.

T 186-189 MUIRS (W)-HEPBURN POINT

No.	Beach	Rating HT LT	Type	Length
T186	Muirs (W1)	4 5	R/LTT+rocks	300 m
T187	Muirs (W2)	3 3	R	100 m
T188	Muirs (W3)	4 4	R/LTT	250 m
T189	Hepburn Pt (E)	4 4	R/LTT	250 m
Spring & neap tidal range = 1.1 & 0.2 m				

At Saltwater Creek mouth the shoreline turns and trends west for 1.7 km to Hepburn Point, a 14 m high granite headland. In between is a rock-dominated section of south-facing shore, with four beaches (T 186-189) located in between a series of rocky points (Fig. 4.33).

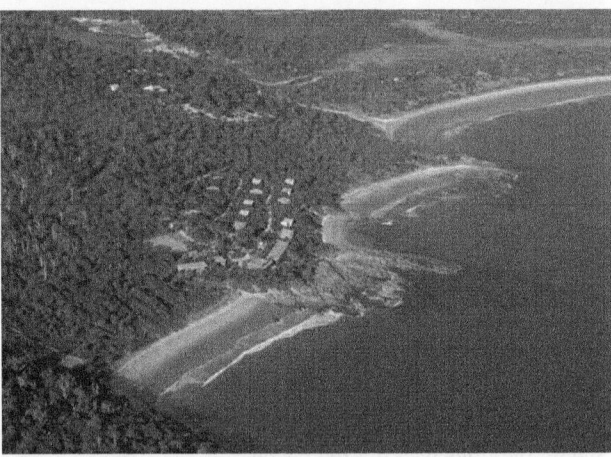

Figure 4.33 Muirs Beach (right) with Hepburn Point (left) and beaches T 185-188 in between (photo W. Hennecke).

Beach **T 186** commences immediately west of the rocky point that borders Saltwater Creek and Muirs Beach. The 300 m long beach curves slightly to the west to a small rock outcrop and is backed by sand-draped bluffs rising to 10 m. It has rock reefs off the eastern end and usually has a lower gradient low tide terrace. Beach **T 187** is a 100 m long pocket of more protected sand located between the boundary rock outcrop and a 200 m wide rocky point. The beach is usually reflective with low wave to calm conditions and a central rock outcrop. It is backed by blufftop holiday villas, with access tracks down to the beach.

Beach **T 188** is located on the western side of the 10 m high granite point, with the holiday villas spread across the rear of the point to the eastern end of the beach. The beach trends west for 250 m to a densely wooded 600 m wide headland. It usually receives waves averaging less than 1 m, which maintain a narrow low tide terrace. A small car park is located above the western end of the beach.

Beach **T 189** is a slightly curving 250 m long south-facing beach located immediately east of Hepburn Point. The beach is composed of medium to coarse sand resulting in a usually moderately steep reflective beach face, with well developed cusps. Most of the beach is backed by dense wooded slopes of the reserve, with a house above the western end of the beach, located on freehold land that occupies the point.

T 190-191 SWANWICK

No.	Beach	Rating HT LT	Type	Length
T190	Hepburn Pt (N)	4 5	Boulder+LTT	250 m
T191	Swanwick	4 5	R+tidal channel	500 m
Spring & neap tidal range = 1.1 & 0.2 m				

Swanwick is a small settlement at the mouth of Great Swanport. It is located on low dolerite bluffs overlooking the 100-200 m wide mouth of the Great Swanport inlet (Fig. 4.34) which connects to the larger Moulting Lagoon. Beaches T 190 and 191 are located immediately south and west of the community.

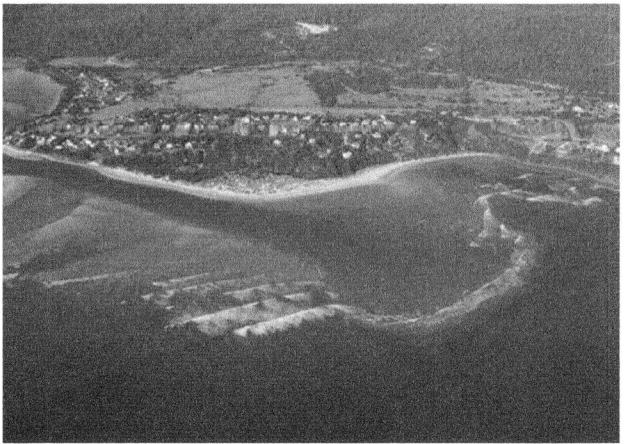

Figure 4.34 Great Swanport Inlet with beaches T 190 & 191 to right.

Beach **T 190** is a 250 m long southwest-facing strip of high tide boulders, fronted by a sandy low tide terrace, and bordered by boulders and rocks. The beach lies 1 km north of Hepburn Point and is backed by 10-20 m high vegetated bluffs and blufftop houses. The tidal shoals of Great Swanport often extend across the beach resulting in a wide low gradient sandy surf zone, with waves averaging about 1 m breaking across the shoals. At times the shoals may blanket the western boundary rocks.

Beach **T 191** lies immediately to the west and extends along the eastern side of Great Swanport inlet for approximately 500 m. This is a dynamic beach with usually low waves but strong tidal current, which results in considerable changes to the nature and length of the shoreline over time. Waves tend to break up to a few hundred metres offshore on the tidal shoals off the southern half of the beach, while closer to the inlet the deep tidal channel parallels the side shore of the beach. Depending on the shape of the tidal shoals there can be a long right-hand break along the shoals in towards beach T 190.

T 192-193 NINE MILE BEACH

No.	Beach	Rating HT LT	Type	Length
T192	Nine Mile Beach	4 5	LTT/TBR	13.1 km
T193	Meredith R mouth	3 4	R/LTT	700 m
Spring & neap tidal range = 1.1 & 0.2 m				

Nine Mile Beach (T 192) is one of the longer beaches on the east coast curving for 13.1 km (8.6 miles) from sandy Point Bagot at the entrance to Great Swanport to the usually blocked mouth of the Meredith River in the west. It faces due south into Great Oyster Bay and usually receives low swell waves averaging about 1 m, which maintain a low tide terrace along most of the beach. During periods of higher swell numerous rips are cut across the bar, with the rip holes often persisting for weeks afterwards. Closer to Point Bagot the extensive ebb tidal shoals of the inlet dominate the beach, with waves breaking along the edge of the shoals to produce a long left-hand break. At the other end between Meredith River and the boundary rocks waves decrease and reflective conditions usually prevail.

The western end of the beach borders the town of Swansea, with the Tasman Highway running 1 km to the west. Much of the beach is part of the Dolphin Sands subdivision, including beachfront allotments, some of which have been developed. The Dolphin Sands access road runs the length of the beach to Point Bagot, with public beach access points spaced about each kilometre along the road. The beach is backed by a 1 km wide barrier, the Great Swanport lagoon and wetlands. The barrier is composed of up to 25 low foredune ridges. Some of these ridges have been blown out in the past and in the 1960s and '70s some were transgressing as transverse dunes along a 6 km long central section, called the Yellow Sandbanks. However by the 1990s these were beginning to stabilise and are now being slowly developed for housing, with some houses sitting in amongst the still active dunes.

Beach **T 193** is the western corner of Nine Mile Beach and extends from the Meredith River mouth for 700 m to the south terminating against the dolerite rocks that underlie Swansea. The river mouth is usually closed and the beach is moderately sheltered by Waterloo Point, 2 km to the southeast, resulting in waves usually less than 1 m. These interact with the fine beach sand to maintain a lower gradient reflective to low tide terrace beach, backed by small vegetated coastal reserve, with vehicle access to the southern end.

Swansea and Coswell Beach Coastal Reserves

Established: 1983
Area: 17 ha
Coast length: 3 km (310-313 km)
Beaches 4 (T 198-201)

The Swansea and Coswell Beach coastal reserves are a narrow strip of shoreline that extends for 3 km south of Saltwater Creek (beach T 198) to Coswell Beach.

T 194-199 SWANSEA

No. Beach	Rating HT LT	Type	Length
T194 Swansea Caravan Park	2 3	R/LTT	250 m
T195 Jubilee Beach	2 3	R/LTT	500 m
T196 Waterloo Point	2 2	R/LTT→sand flats	300 m
T197 Schouten House Beach	3 4	R/LTT	1.1 km
T198 Swansea boat ramp	2 3	R/LTT	200 m
T199 Kennedia Beach	2 3	R/LTT+rocks	300 m
Spring & neap tidal range = 1.1 & 0.2 m			

Swansea is a small town located on 10-20 m high bluffs overlooking the northwest corner of Great Oyster Bay (Fig. 4.35). The Tasman Highway runs through the middle of the town and past the Jetty Beach. This is the first point since Bicheno that the highway is within sight of the coast. To the east of the town is the 15 km long Nine Mile Beach (T 192), while between the end of Nine Mile and for 5 km to the south are a series of six beaches (T 194-199) all wedged between low rocky headlands and bluffs. All these beaches are well up in the bay and receive relatively low waves, averaging 0.5-1 m, with the dominant winds blowing offshore.

The Swansea Caravan Park is located on 10 m high grassy bluffs above the western end of Nine Mile beach and overlooking a narrow 250 m long east-facing beach (**T 194**), which is bordered by low rocks and backed by the grassy bluffs. There are a couple of boat sheds behind the beach, with a few boats usually lying on the beach. The beach receives low waves averaging 0.5 m and usually has a small narrow surf breaking over a narrow low gradient continuous bar. A series of intertidal rocks extend off the southern end of the beach.

Jubilee Beach (T 195) is one of Swansea's main beaches, being situated immediately below the town centre and adjacent to the main jetty and boat ramp. The jetty extends 500 m bayward at the southern end of the curving 500 m long, east-facing beach. Steep, grassy bluffs and a few rocks back the northern end, with a car park, picnic area, playground and toilets located immediately behind the southern end of the beach next to the jetty. The beach receives waves averaging less than 0.5 m, and is often calm. It has a moderately steep beach face and narrow continuous bar.

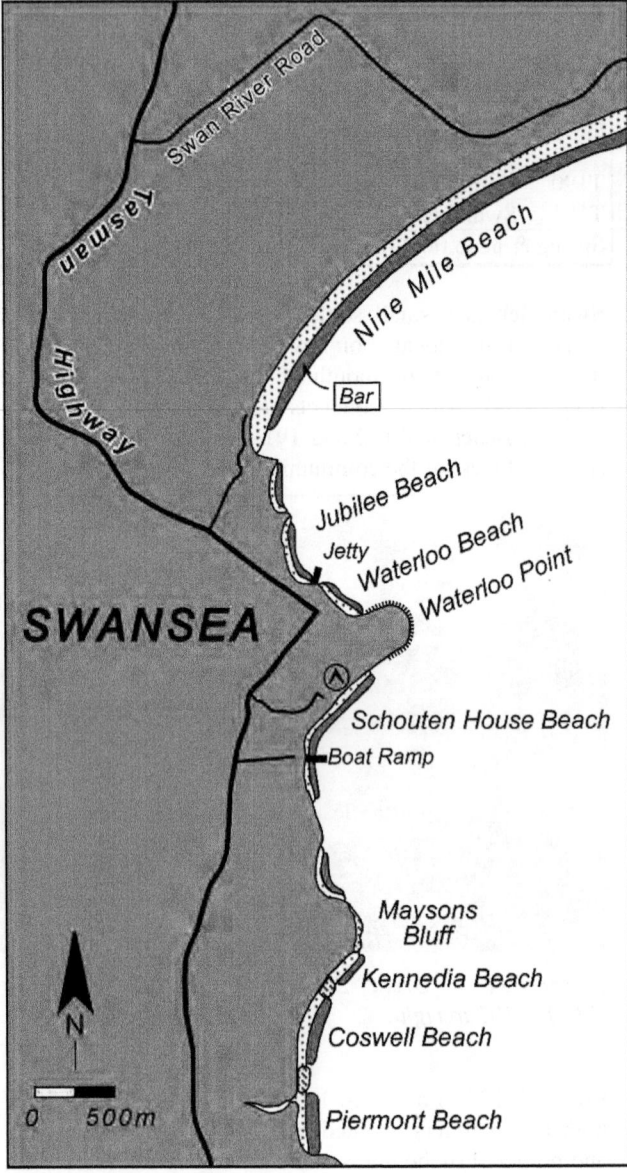

Figure 4.35 Swansea is located at the western end of the long Nine Mile Beach, with a series of small beaches extending to the south.

Waterloo Beach (T 196) is located between the southern side of Swansea jetty and Waterloo Point. It is a 300 m long, low energy north-facing beach. The beach is well protected by the point and is narrow, often calm with seagrass commonly covering the beach. Sand and some rock flats widen into the southern corner, with higher waves breaking along the edge of the flats to provide a right-hand surf break. A second break runs along the edge of the rocky point. The jetty car park backs the northern end, with a low grassy reserve behind the beach, which is backed by sloping bluffs and the main street of Swansea, while Swansea golf course occupies the point.

Schouten House Beach (T 197) is located on the south side of Waterloo Point and extends for 1.1 m south to the boat ramp. This is the main swimming and surfing beach at Swansea. It faces southeast and receives waves averaging 0.5-1 m, which break across a continuous low tide bar and at high tide against a steeper beach which grades into a very steep cobble beach toward Waterloo

Point (Fig. 4.36). The beach is backed by the golf course on the point, then a cemetery, caravan park and houses behind the middle of the beach. Saltwater Creek is dammed behind the southern end and forms a small lagoon, just beyond which is a low rocky outcrop now covered by a groyne and boat ramp and which marks the southern end of the beach.

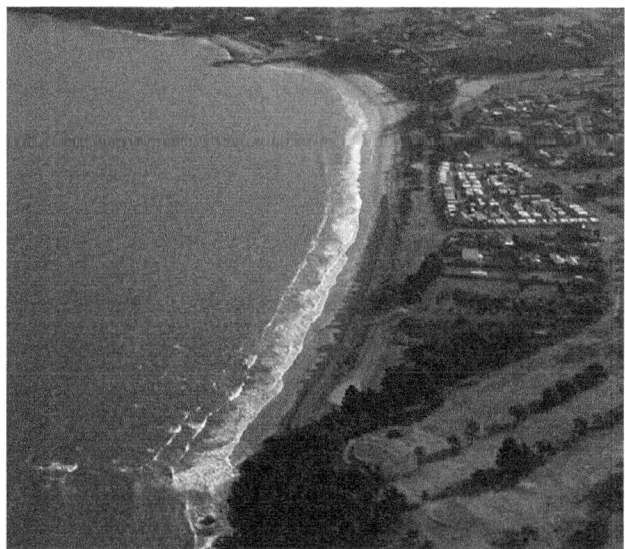

Figure 4.36 Schouten House Beach (T 197) extends from Waterloo Point to the mouth of Saltwater Creek.

Beach **T 198** extends south of the boundary rocks and boat ramp for another 200 m grading into intertidal rocks at the southern end. Waves averaging up to 1 m break across a low gradient continuous bar. It is backed by a large open car park, then houses on the backing slopes.

Kennedia Beach (T 199) is located 300 m to the south in the next small embayment bordered by the 10 m high grassy bluffs of Maysons Bluff to the south. This is a curving, east-facing 300 m long beach with intertidal rocks to either end and a more open sandy central section. Waves break across a low gradient 50 m wide bar. It is backed by tall pine trees then a growing residential sub-division on the backing grassy slopes.

T 200-205 MAYSONS BLUFF-CRESSY BEACH

No.	Beach	Rating HT LT	Type	Length
T200	Maysons Bluff	3 4	R/LTT	150 m
T201	Coswell Beach	3 4	R/LTT	400 m
	Coswell Beach Coastal Reserve			
T202	Piedmont Beach	3 3	R/LTT→sand flats	350 m
T203	Cowrie Beach	4 4	LTT	350 m
T204	Webber Pt	3 3	LTT/sand flats	100 m
T205	Cressy Beach	4 5	LTT/TBR	500 m
	Cressy Beach Coastal Reserve			
Spring & neap tidal range = 1.1 & 0.2 m				

Maysons Bluff marks the southern boundary of Swansea. The rocky coast continues to the south for 3 km to Webber Point, where it turns and trends southwest. In between the bluff and the south side of the point are six small beaches, each bordered by grassy sloping dolerite headland and points, with rocks and boulders outcropping along some of the beaches. The Tasman Highway parallels the coast about 1 km inland, with public access only to Coswell and Cressy beaches.

Beach **T 200** is located on the southern side of Maysons Bluff and consists of a 150 m long southeast-facing beach, bordered by the northern headland with a 50 m long cluster of rocks to the south. It receives waves averaging up to 1 m, which maintain a moderately steep, usually cusped high tide beach and 40 m wide low tide terrace. It is backed by a small hummocky foredune then cleared slopes with a house on the crest of the bluff. There is vehicle access and a small car park behind the northern end of the beach. **Coswell Beach (T 201)** continues south of the boundary rocks for another 400 m to the next cluster of rocks and boulders that have been deposited at the mouth of the small Stony River. Wave height decreases down the beach, which usually has a continuous 30 m wide low tide terrace. It is backed by a narrow vegetated foredune, and then cleared farmland.

Piedmont Beach (T 202) commences at the rock-strewn mouth of Stony River and continues to the south for another 350 m to the lee of Piedmont Point with wave height decreasing towards the point. The beach is fronted by boulders in the north and sand flats in the southern corner, with a mixture of sand and rocks in between. Waves wrap around the point and break along the edge of the sand flats to produce a right-hand break. The beach is backed by private land containing several houses.

Cowrie Beach (T 203) is located 600 m to the south in an open embayment between Piedmont and Webber points. The 350 m long gently curving beach faces east and receives waves averaging less than 1 m which maintain a cusped reflective high tide fronted by a narrow continuous bar. The beach trends east in the southern corner terminating in lee of a small rock outcrop. It is backed by a low grassy foredune, and then cleared farmland, with no formal public access.

Beach **T 204** is located immediately to the east in lee of Webber Point. It consists of a northeast-facing 100 m long curving pocket of sand, bordered by low rocks to the west and the 12 km high dolerite head to the rear and east. Sand flats have accumulated in the eastern corner and waves wrapping round the point break along the edge of the flats to produce a right-hand break. An abalone farm is located on the point and occupies the slopes behind the beach, with a small breakwater and water intake pipe on the point and water discharge from the farm flowing across the beach.

Cressy Beach (T 205) is a 500 m long, more exposed southeast-facing beach located on the southern side of Webber Point. It is part of the small **Cressy Beach Coastal Reserve**, with vehicle access off the highway to

a car park and picnic area at the southern end of the beach. The beach receives waves averaging 1 m and more, which maintain a well developed low tide terrace, which usually has one to two rips flowing across the bar. In addition rock outcrops along the southern end of the beach, which is bordered by rocky slopes and cleared 10 m high bluffs.

T 206-207 SPIKY BEACH

No.	Beach	Rating HT LT	Type	Length
T206	Spiky Beach	3 4	R+rocks	100 m
T207	Spiky (S)	3 5	R+rocks	70 m
Spiky Beach Coastal Reserve			*5 ha*	
Spring & neap tidal range = 1.1 & 0.7 m				

The two Spiky beaches (T 206 and 207) are located at the mouth of the small steep Lafarelle Gully which flows under the famous Spiky Bridge, a convict bridge built of 'spiky' stones. A gravel road off the highway runs down to the main beach with a car park on the cleared slopes behind the beach. The area between the highway and the two beaches makes up the small Spiky Beach Coastal Reserve.

Spiky Beach (T 206) is a 100 m long east-facing moderately protected reflective beach, bordered by dark dolerite slopes, with rocks also outcropping in the centre and extending off the southern end of the beach. It has a low narrow grassy foredune, and a moderate gradient beach face, which usually slopes into deeper water. A short walking track leads from the car park to the beach. Beach **T 207** is located immediately to the south and is a 70 m long sand beach bordered by rocky points, with a cluster of rocks in the centre of the beach. Lafarelle Gully, when it flows, crosses the centre of the small beach. The beach is slightly more exposed and a more hazardous beach with rocks dominating the surf.

T 208-209 KELVEDON BEACH

No.	Beach	Rating HT LT	Type	Length
T208	Dwarf Point	5 6	TBR+rocks	200 m
T209	Kelvedon Beach	5 5	TBR→LTT	2 km
Kelvedon Beach Coastal Reserve			*24 ha*	
Spring & neap tidal range = 1.1 & 0.2 m				

One kilometre south of Spiky Bridge the highway begins to parallel the coast for 9 km down to Mayfield Bay. The first two beaches (T 208 and 209) are located between Dwarf and Shelly points, and are part of the 24 ha Kelvedon Coastal Reserve. Most of the reserve and beaches are backed by a 2 km long pocket of Triassic conglomerate whose pebbles dominate the shoreline.

Beach **T 208** is a 200 m long southeast-facing, moderately exposed beach bordered by 10-20 m high

rocky coast to the north and sloping 50 wide Dwarf Point to the south. It is backed by 20 m high sloping bluffs, and then cleared farmland. Waves average over 1 m and break across a 50 m wide surf zone, with rocks outcropping in the centre of the beach, and a rip usually running out against the southern Dwarf Point.

Kelvedon Beach (T 209) extends southwest from Dwarf Point for 2 km, curving to the south in lee of the southern Shelly Point (Fig. 4.37). Two smaller streams and Kelvedon Creek back the beach, the latter forming a small, usually blocked lagoon. The beach faces southeast into the dominant swell with waves averaging over 1 m which maintain a continuous bar usually cut by up to 10 rips, with wave height decreasing in lee of Shelly Point where rips are usually absent. Numerous pebbles and cobbles dominate the sandy beach and form the crests of usually well developed cusps the length of the beach. The beach is backed by a low 100 m wide grassy foredune, which narrows to the south, then the highway. There is a beachside car park on the southern side of the creek, providing direct access to the beach.

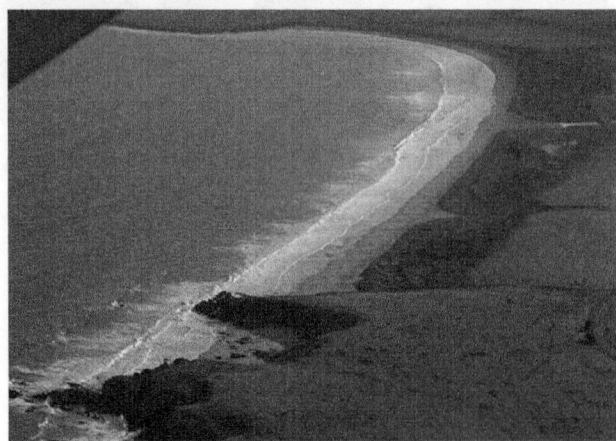

Figure 4.37 Kelvedon Beach (T 209) curves south from Dwarf Point (T 208)

T 210-214 SHELLY POINT-FREEMANS BEACH

No.	Beach	Rating HT LT	Type	Length
T210	Shelly Pt (S1)	6 7	LTT/TBR+rocks	50 m
T211	Shelly Pt (S2)	6 7	LTT/TBR+rocks	50 m
T212	Rope Gully (N)	5 6	LTT/TBR+rocks	80 m
T213	Rope Gully	5 6	LTT/TBR	80 m
T214	Freemans Beach	5 6	LTT/TBR+rocks	200 m
Spring & neap tidal range = 1.1 & 0.2 m				

Shelly Point is a 10m high granite headland, to the south of which is a 5 km long section of steep, rocky shoreline containing 10 pockets of sand (beaches T 210-219). The first five small beaches (T 210-214) occupy parts of the first 1.5 km of cliffed shoreline. The highway runs along on top of the bluffs usually within 100-300 m of the shore.

Beaches T 210 and 211 are adjoining pockets of sand bordered by 20 m high eroding cliffs and backed by steep

bluffs. Beach **T 210** is a 50 m long pocket of sand bordered by the steep rocky cliffs, with a steep sloping grassy bluff behind and cleared farmland on top of the bluffs. Beach **T 211** lies 300 m to the south and is a similar 50 m long pocket of sand, with steep cliffs surrounding the beach and no safe access down to the shore. Both beaches are exposed to southerly waves which usually break across a 50 m wide sand- and rock-strewn surf zone. A strong rip runs along the southern rocks of beach T 210. Neither is easy to access or suitable for swimming.

Beaches T 212 and 213 are located 300 m to the south and are two adjoining exposed pockets of sand. Beach T 212 is 80 m long and bordered and backed by steep 20 m high rocky cliffs, with rock platforms and debris to either end of the beach. A rip usually flows out against the northern rocks. Beach **T 213** lies 100 m to the south and is a similar 80 m long pocket of sand, backed by sparsely vegetated 20 m high rocky slopes, with the steep, narrow tree-lined Rope Gully entering the rear of the beach. Cleared slopes back the bluffs, with the highway 200 m inland.

Freemans Beach (T 214) is located 500 m to the south and consists of a narrow 200 m long strip of sand with rock outcrops and rock debris both along and just off the beach. Waves break amongst the rocks and sand resulting in hazardous conditions. The beach is backed by a steep boulder beach, then cleared farmland, with two houses on the cliffs above the southern end of the beach.

T 215-221 TIRZAH BEACH-MAYFIELD BAY

No.	Beach	Rating HT LT		Type	Length
T215	Tirzah Beach	4	5	LTT+rocks	150 m
T216	De Gillern Beach	4	4	LTT	300 m
T217	Mayfield Bay (N2)	4	5	LTT+rocks	80 m
T218	Mayfield Bay (N1)	4	4	LTT	150 m
T219	Brickfield Beach	3	4	LTT	500 m
T220	Mayfield Bay	3	4	LTT	1.3 km
T221	Mayfield Pt	3	4	LTT	800 m
Mayfield Bay Coastal Reserve *26 ha*					
Spring & neap tidal range = 1.1 & 0.2 m					

Mayfield Bay is a 2 km wide open east-facing bay, bordered in the south by Mayfield Point, with rocky shore extending to the north. The bay contains Mayfield Beach (T 220), with a series of five smaller rock-bound beaches (T 215-219) extending 2 km to the north. Beaches T 215 to 220 are located within the narrow Mayfield Bay Coastal Reserve, with a camping area at Brickfield Beach (T 219). Waves average about 1 m and decrease towards the point. The highway runs along the steep slopes behind the northern beaches and along the rear of Mayfield Beach.

Tirzah Beach (T 215) is a 150 m long strip of high tide boulders and sand fronted by a 30 m wide low tide terrace. It is bordered and backed by steep vegetated

slopes rising to 40 m at the highway and over 200 m 1 km inland. The small steep Constable Creek drains across the southern boundary supplying cobbles and boulders to the beach. There is a steep foot track from the highway down to the beach.

De Gillern Beach (T 216) occupies the next small valley 500 m to the southwest. It is a 300 m long sandy beach with a narrow low tide terrace. It is bordered by steeply rising slopes, with the highway cutting along the backing slopes 30 m above the beach. The steep Clements Creek reaches the rocky shore immediately north of the beach.

Beach **T 217** is located on a rocky point immediately to the south and consists of an 80 m long mixture of sand and rocks, backed by 30 m high eroding bluffs, with the highway running above the beach. The beach comes and goes between major wave events.

Beach **T 218** is located 100 m to the south at the mouth of a small steep gully. Steep vegetated slopes border the beach with a small rock reef extending off the northern end. The beach ranges from reflective to a narrow low tide terrace with high tide boulders to either end and a small grassy foredune. A rip runs out against the northern reef when waves exceed 1 m. The highway runs around the rear of the beach, with access down the slopes to the shore.

Brickfield Beach (T 219) is a 500 m long sandy beach that occupies the northern end of Mayfield Bay and is the site of a camping area. It is bordered by steep vegetated slopes rising to the Rocky Hills in the north and a small rocky point to the south. The beach receives waves averaging less than 1 m, which maintain a reflective to narrow low tide terrace system. It is backed by the narrow camping reserve, with the highway descending the backing slopes and Old Man Creek crossing the southern end of the beach.

Mayfield Beach (T 220) is the main bay beach. It commences on the southern side of the small boundary point and curves to the south and finally southeast to terminate in lee of cleared 15 m high Mayfield Point. The beach is composed of fine sand with a low gradient reflective high tide beach and 20-30 m wide low tide terrace, with wave height decreasing to the south. It is backed by a low vegetated foredune, with three houses on the foredune south of the boundary of the coastal reserve. The small Sandy Creek backs the centre of the beach. The highway clips the northern end of the beach then tends inland towards the Buxton River, with access to the southern end of the beach along the Mayfield Jetty Road.

Beach **T 221** is located between Mayfield Point and Little Christmas Island. The 800 m long beach faces northeast protecting it from waves but exposing it to northerly winds. The low waves maintain a reflective to low tide terrace beach, with central shallow rock flats and seagrass meadows off the beach. As a result it is often covered in seagrass debris. The northerly winds have blown out the centre of the low foredune to maintain a series of small active blowouts, which are encroaching on the backing

grazing land. Little Christmas Island is connected by sand and boulder flats to the mainland, and there is a right-hand point break over the rocks along the northern side of the 8 m high island. It requires high outside swell to work and is also called *Buxton Point* after the point 500 m to the south.

T 222-226 BUXTON-BOAGS POINTS

No.	Beach	Rating HT LT		Type	Length
T222	Front Beach	5	5	TBR	1 km
T223	Buxton R mouth	4	4	LTT	350 m
T224	Penquite Pt (S)	4	5	LTT/TBR	150 m
T225	Boags Pt (N2)	4	5	LTT/TBR	150 m
T226	Boags Pt (N1)	4	5	LTT/TBR	250 m
Spring & neap tidal range = 1.1 & 0.2 m					

Buxton Point is a 17 m high grassy granite headland with 12m high Boags Point 2.5 km to the south. In between is the mouth of the Buxton River and five moderately exposed headland-bound beaches (T 222-226) (Fig. 4.38). All the beaches are backed by low undulating cleared farmland, with the highway 1 km to the west, and no public access to the shore.

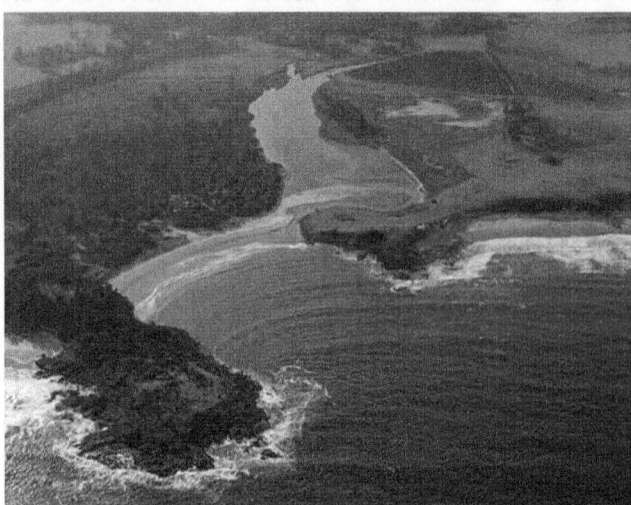

Figure 4.38 The Buxton River mouth flows out on the southern side of Buxton Point (right), and adjacent to beach T 223 (photo W. Hennecke).

Front Beach (T 222) extends southwest of Buxton Point for 1 km to the smaller Horrels Point which also forms the northern head of the Buxton River mouth. The beach is exposed to southerly waves which average just over 1 m and maintain a low tide terrace to transverse bar and rip system, with normally two central beach rips and rips to each end. It is backed by a 50-100 m wide foredune containing several vegetated blowouts, then the farmland.

Beach **T 223** is located at the mouth of the small Buxton River. The 350 m long beach is attached to the base of Penquite Point in the south, the northern end extending to the lee of Horrels Point as a tidal spit. The beach itself is backed by a 1 km wide series of up to 30 low foredunes that extend back into the river mouth. Sediments

delivered by the river and waves have prograded the foredune ridge plain to its present location. The inner ridges are cleared, with the outer ridges covered in trees. Waves are reduced slightly refracting around Penquite Point and average about 1 m at the beach where they usually maintain a low tide terrace.

Beach **T 224** is located on the southern side of the 100 m wide, 16 m high tree-covered rocky point. The 150 m long pocket beach faces southeast and receives higher waves, which maintain a 50 m wide bar, with a rip usually flowing out against the northern point. It is backed by vegetated slopes, with farm buildings above the southern end of the beach.

Beaches T 225 and 226 occupy the next small embayment 400 m to the south. Beach **T 225** is a 150 m long pocket of sand located at the mouth of a small valley and bordered by 10-25 m high rocky points. It receives waves averaging about 1 m, which maintain a 50 m wide bar, with a rip against the northern rocks. Beach **T 226** is a similar 250 m long beach, with wave height and the bar width decreasing down the beach, owing to increasing protection from the southern Boags Point. Both beaches are backed by small hummocky foredunes and cleared sloping farmland. Part of the slopes behind the southern beach has been quarried.

T 227-232 LISDILLON-SALTWORKS BEACHES

No.	Beach	Rating HT LT		Type	Length
T227	Lisdillon Beach	4	5	LTT/TBR	800 m
T228	Mitchells Reef (S1)	4	5	LTT/TBR	700 m
T229	Mitchells Reef (S2)	3	4	LTT	200 m
T230	Saltworks Beach (N2)	4	4	LTT+rocks	200 m
T231	Saltworks Beach (N1)	4	4	LTT+rocks	700 m
T232	Saltworks Beach	4	4	LTT+rocks	300 m
Spring & neap tidal range = 1.1 & 0.2 m					

To the south of Boags Point is a 3 km section of headland-bound beaches (T 227-232) terminating at the 150 wide mouth of Little Swanport estuary. The highway parallels the coats just over 1 km inland with public access in the south to the Saltworks subdivision and adjacent beach and estuary mouth.

Lisdillon Beach (T 227) is a curving, southeast-facing 800 m long moderately exposed beach located between the southern side of Boags Point and the wave-washed Mitchells Reef, which marks the shifting mouth of the Lisdillon Lagoon (Fig. 4.39). The beach usually has a continuous bar with wave height, bar width and the chance of rips increasing to the north. It is backed by an unstable foredune, then a 500 m wide series of 5-6 hummocky foredunes, which have prograded parallel to the inlet, resulting in an elongate lagoon. The lagoon has an area of 100 ha, and its mouth variously shifts to either side of Mitchell Reef, which it ties to the shore with a sandy tombolo.

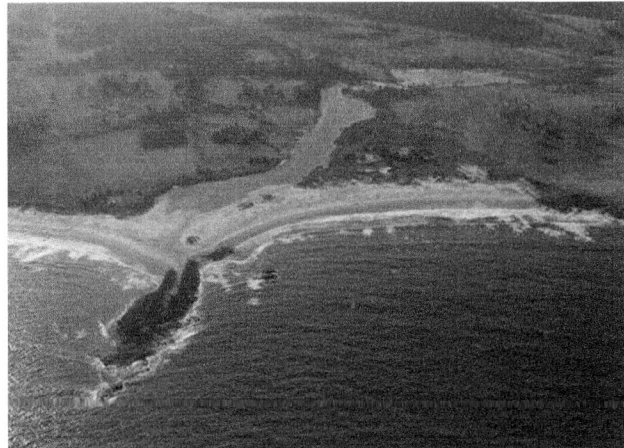

Figure 4.39 Mitchells Reef with Lisdillon Beach (T 227) to the right and Lisdillon Lagoon behind.

Beach **T 228** commences on the southern side of the boulder-strewn reef and curves to the southeast, then south for 700 m terminating against a low rocky shore. The beach receives moderate waves, which maintain a narrow bar, usually cut by a northern rip against the reef and at times a central beach rip. It is backed by a small foredune then cleared farmland with some farm buildings behind the northern end of the beach, adjacent the lagoon mouth. A fence line crosses the northern end of the beach.

Beach **T 229** occupies the next small embayment 200 m to the south. Low rocky points border the 150 m wide bay, which is filled with a curving 200 m long beach backed by a small usually blocked creek. Waves are lowered by the boundary rocks and points and average less than 1 m at the shore to maintain reflective to low tide terrace conditions.

Beaches T 230-232 are part of a near continuous 1 km long section of east-facing sand that terminates at Saltworks Beach. Waves decrease to the south as the beaches become increasingly protected by Seaford Point. Beach **T 230** commences on the southern side of a 100 m wide low grassy point and trends south for 200 m to a small foreland formed in lee of rock reef located 100-300 m offshore. Waves average about 1 m and maintain a 30 m wide low tide terrace, with rocks scattered along the beach and to either end. Beach **T 231** continues south of the foreland for another 700 m to a low grassy point. Waves decrease slightly, with the bar narrowing to the south. Both beaches are backed by a low grassy foredune and cleared farmland.

Saltworks Beach (T 232) is a 300 m long pocket of sand located between low grassy headlands, with a few rock outcrops along the beach and boulders strewn to each end. Waves averaging less than 1 m usually break across a narrow attached bar and the rocks. The beach and headland are backed by a 100 m wide coastal reserve, then the Saltworks subdivision, with a scattering of houses and the remains of the old Saltworks located on the grassy bluff behind the centre of the beach. The Little Swanport estuary mouth lies 300 m south of the beach.

T 233-234 LITTLE SWANPORT

No.	Beach	Rating HT LT		Type	Length
T233	Limekiln Pt	2	3	R+tidal shoals	500 m
T234	Seaford Pt (W)	2	3	R+rocks	500 m
Spring & neap tidal range = 1.1 & 0.1 m					

Little Swanport is a 7 km long 500 m wide drowned valley containing the estuary that enters the sea between Saltworks Beach and Limekiln Point. Between Limekiln Point and Seaford Point 1.7 km to the east are 2 km of north-facing sheltered shoreline containing two beaches (T 233 & 234). Both beaches are backed by cleared farmland with no public access.

Beach **T 233** is a sandy spit named Limekiln Point that forms the southern entrance to the port. The 500 m long northeast-facing beach is sheltered from waves by Seaford Point with extensive tidal sand shoals extending up to 1 km to the east. Reflective conditions usually prevail at the shore with larger waves breaking over the river mouth shoals to provide a long left-hand break, known as *Little Swanport*. The northern end of the spit contains up to five foredunes that have prograded the northern end of the spit up to 400 m east.

Beach **T 234** is located 1 km to the east in lee of 12 m high Seaford Point. The beach faces north and receives low refracted waves with reflective conditions prevailing. It has rocks scattered along the western half, with the eastern half blocking a small 100 m wide, 200 m long valley, which it has partially filled with sand, and a small patch of wetland at the rear. Cleared farmland surrounds the valley and point.

T 235-237 DRAKEYS BAY

No.	Beach	Rating HT LT		Type	Length
T235	Drakeys Bay (N)	5	7	Boulder	60 m
T236	Drakeys Bay	5	7	Boulder	80 m
T237	Drakeys Bay (S)	5	7	Boulder	50 m
Spring & neap tidal range = 1.1 & 0.1 m					

Drakeys Bay is a 300 m wide east-facing rocky bay located 700 m south of Seaford Point. The bay, and two smaller bays to either side, contain three exposed cobble-boulder beaches (T 235-237) all backed by 10-15 km high bluffs and cleared farmland. Beach **T 235** is a curving 60 m long high tide cobble beach, with intertidal to low tide boulders partly filling the small bay and rocks points to either side.

Drakeys Bay (**T 236**) is a deeper bay with a curving 80 m long high tide cobble beach and low tide boulders, with the rocky sides of the bay extending 150 m seaward. Beach **T 237** lies 500 m to the south and is a curving

50 m long cobble beach, slightly sheltered by a protruding northern point and southern rock reefs. All three beaches are difficult to access and unsuitable for swimming.

T 238-239 **MADDONS COVE**

No.	Beach	Rating HT LT		Type	Length
T238	Maddons Cove	3	3	Cobble+LTT	150 m
T239	Pt Bailly (S)	4	5	Boulder	100 m
Spring & neap tidal range = 1.1 & 0.1 m					

Maddons Cove is located 4 km south of Seaford Point and on the northern side of 500 m long Point Bailly. Beach **T 238** is located at the apex of the 500 m wide cove and faces east, and is protected from southerly waves by the point. The 150 m long beach consists of a steep high tide cobble beach fronted by a narrow inter- to subtidal sandy beach, with waves averaging less than 1 m. It is bordered by the rocky shores of the cove and backed by cleared farmland.

Beach **T 239** is located on the southern side of 200 m wide Point Bailly. It is a steep curving 100 m long cobble-boulder beach, with a deeper sandy bay floor. It faces east exposing it to southerly waves, which break over the bay floor and up the steep beach. The grassy point and farmland back the beach.

T 240-244 **SQUARE BAY-BECKLES HILL**

No.	Beach	Rating HT LT		Type	Length
T240	Square Bay	4	5	LTT/TBR	300 m
T241	Banwell Beach	4	5	LTT/TBR	1.3 km
T242	Beckles Hill (1)	5	6	Boulder	100 m
T243	Beckles Hill (2)	5	6	Boulder	80 m
T244	Beckles Hill (3)	5	6	Boulder+LTT	100 m
Spring & neap tidal range = 1.1 & 0.1 m					

Square Bay is a 300 m long southeast-facing embayment located 1 km southwest of Point Bailly and bordered in the south by the small Fish Point. Between the two low grassy headlands is an exposed 300 m long beach (**T 240**). Waves average about 1 m, which maintain a 40 m wide bar usually drained by a rip against the southern rocks. A low grassy foredune and farmland back the beach, with a small creek cutting through the dune to drain across the southern end of the beach.

Banwell Beach (T 241) is located immediately to the south between Fish Point and the slopes of Beckles Hill. The beach is 1.3 km long, faces east-southeast and is exposed to waves averaging about 1 m. These maintain a continuous low tide terrace usually cut by a few rips during higher waves (Fig. 4.40). The beach is backed by a narrow scarped grassy foredune, which increases in height to the south, with the usually blocked mouth of

Seabyrne Creek crossing the centre of the beach. A coastal reserve extends from north of the creek to Fish Point, while sloping farmland backs the reserve and beach restricting public access to along the shore.

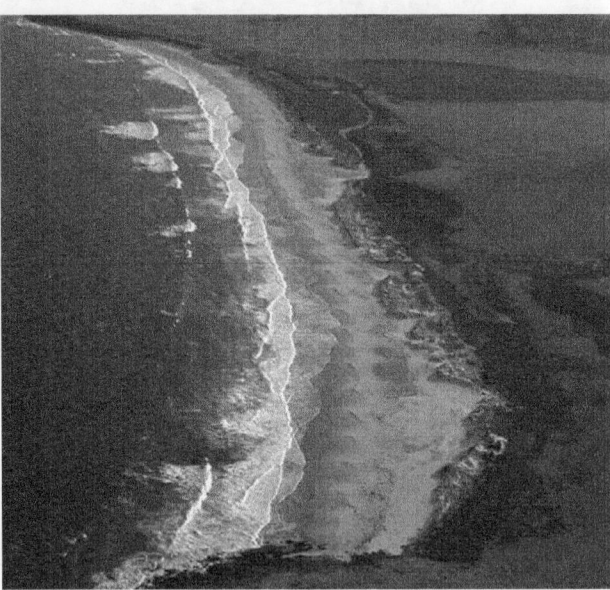

Figure 4.40 Banwell Beach (T 241) showing typical wave and beach conditions.

Beckles Hill is a cleared conical 7 m high granite headland around the eastern base of which are 1.5 km of protruding rocky shore containing three small boulder beaches (T 242-244). Beach **T 242** is a curving east-facing high tide boulder beach bordered by a low rocky northern point and a grassy headland to the south. Beach **T 243** lies 300 m southeast of the headland. It is an exposed 80 m long boulder beach with rocks running out either side. Beach **T 244** lies 500 m to the southwest in a small 100 m wide gap on the rocky shore. It consists of a steep cobble beach, fronted at times by a sandy low tide bar. Boulders dominate the northern side of the bay, with exposed granite rocks on the south side, and a right-hand surf break, known as the *Beckles*, running off the southern point into the small beach. All three beaches are backed by the narrow Boltons Beach Coastal Reserve and cleared farmland. The Banwell Road terminates 1 km due west of the hill.

Boltons Beach Coastal Reserve

Established:	1980	
Area:	46 ha	
Coast length:	7 km	(348-355 km)
Beaches:	5	(T 243-247)

Boltons Beach Coastal Reserve is a narrow 7 km long strip of rocky and sandy shore between Beckles Hill and Low Bay and centred on the longer Boltons Beach. The reserve is accessible via the Hermitage Road.

T 245-249 BOLTONS BEACH-GRINDSTONE BAY

No.	Beach	Rating HT LT		Type	Length
T245	Boltons Beach	4	5	LTT/TBR	4.2 km
T246	Rough Hill (N)	4	5	LTT+rocks	250 m
T247	Low Bay	5	5	Boulder+LTT	80m
T248	Grindstone Bay (N)	3	3	R/LTT	150 m
T249	Grindstone Beach	3	4	R/LTT	600 m
Spring & neap tidal range = 1.1 & 0.1 m					

Boltons Beach is one of the longer beaches on this section of coast. It is followed by predominantly rocky coast extending for 4 km south to Grindstone Point, with four smaller beaches (T 246-249) occupying parts of the shore. The only public access is via the Hermitage Road to the southern end of Boltons Beach.

Boltons Beach (T 245) extends for 4.2 km between the southern slopes of 70 m high Beckles Hill and the northern slopes of 140 m high Rough Hill. In between the beach faces east-southeast exposing it to waves averaging just over 1 m. These maintain a low tide terrace, with conditions ranging from reflective to rips during higher waves, when up to 16 rips form along the beach. A low narrow foredune backs the beach, breached in the centre by a usually blocked creek, and in the south by the small mouth of Hermitage Lagoon. A cluster of shallow reefs is located just north of the lagoon entrance. The road terminates at the northern side of the lagoon, where there is a car park but no facilities. It is backed by a row of holiday cottages with private land backing the remainder of the beach and reserve.

The slopes of **Rough Hill** dominate the landscape and rocky shore for the next 3 km, with the narrow reserve hugging the shoreline. Beach **T 246** is located 1 km south of the lagoon and consists of a discontinuous 250 m long series of three sand patches, backed by high tide cobble beaches and bordered and interrupted by protruding granite rocks. Steep vegetated bluffs rise 20 m behind the beach grading to partially cleared slopes of the hill.

Low Bay is a small open rocky bay located immediately south of Boltons Bluff. At the southern end of the bay is an 80 m long high tide boulder beach (**T 247**) fronted by a sandy low tide bar, together with rocks on and just off the beach. It is backed by cleared grassy slopes rising to 60 m.

Grindstone Bay is a U-shaped 700 m wide rocky bay bordered by the southern slopes of Rough Hill to the north and protruding 74 m high Grindstone Point to the south. The point and degree of embaymentisation afford moderate protection to the bay, which contains two beaches (T 248 and 249) (Fig. 4.41). The north beach **T 248** is a curving 150 m long pocket of sand bordered by extensive cleared slopes to the north and rear and a low rocky point to the south. The beach curves round within the small embayment with usually low wave to calm conditions and a lower gradient reflective to low tide

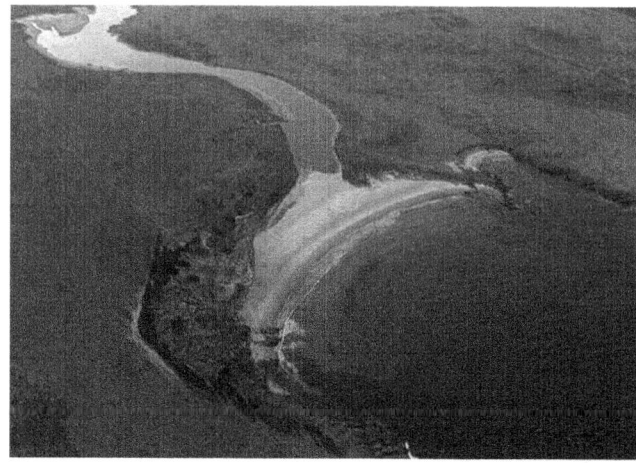

Figure 4.41 . Grindstone Bay, beach (T 248) and the blocked mouth of Eighty Mile Creek.

terrace beach. It is backed by a small foredune, which increases in size and instability to the south.

Grindstone Beach (T 249) is a curving 600 m long fine white sand beach which receives waves averaging up to 1 m that maintain a lower gradient reflective to low tide terrace beach usually free of rips. The beach is occasionally breached by the backing Eighty Mile Creek and small lagoon. As a consequence it is bare of vegetation apart from some unstable dunes to either side against the boundary slopes. In the 1990s the southern dune was transgressing up 200 m inland at the southern end. By 2000 revegetation had largely stabilised this system. Private farmland backs the two beaches with no public access.

T 250-255 PLAIN PLACE BEACH

No.	Beach	Rating HT LT		Type	Length
T250	Middle Bluff (S1)	5	6	Boulder+rocks	200 m
T251	Middle Bluff (S2)	4	5	LTT+rocks	60 m
T252	Middle Bluff (S3)	4	5	LTT+rocks	100 m
T253	Plain Place Beach	4	5	LTT/TBR	2.6 km
T254	Plain Place (S1)	4	6	LTT/TBR	60 m
T255	Plain Place (S2)	4	5	LTT/TBR	120 m
Spring & neap tidal range = 1.1 & 0.1 m					

Between Middle Bluff and Cape Bougainville is an open 5 km wide embayment containing the long Plain Place Beach (T 253) and small rock-bound beaches to either side (T 250-252 and T 254-255). All the beaches are backed by rising partly cleared slopes and private land with no public access.

Middle Bluff is a protruding steep dolerite point backed by slopes rising to 79 m. To the south is 1.5 km of steep rocky shoreline, backed by cleared slopes and containing beaches T 250-252. Beach **T 250** is a curving 200 m long cobble-boulder beach located at the mouth of a small grassy valley. The steep beach is bordered by rocky shore and has some rocks just off the beach, with sandy seabed further out.

Beach **T 251** is located 500 m to the south in the next small embayment. It consists of a 60 m long pocket of intertidal to high tide sand backed by steep vegetated bluff rising to 20 m, with some lines of rocks crossing the small beach. Beach **T 252** lies another 300 m to the south and is a similar 100 m long strip of sand at the base of 10 m high rocky bluffs, with numerous rocks along the beach and surf zone. A steep descent is required to reach both beaches.

Plain Place Beach (**T 253**) is a 2.6 km long east-facing sandy beach, bordered by steeply sloping grassy headlands. It is backed by a continuous foredune, containing many small blowouts and an area of now stabilising dune transgression in the south. The dune is breached by two creeks and backed by a cleared infilled wetland along the northern-central section, which grades into shallow 20 ha Okehampton Lagoon in the south. The beach receives waves averaging about 1 m, which usually maintain a low tide terrace, with up to 12 rips forming during periods of higher waves.

Beach **T 254** lies immediately south of the main beach and consists of a 60 m long pocket of sand wedged in between 15-20 m high steep lines of rocks, with some of the rocks continuing across the beach and surf zone. It shares its surf zone with the main beach and is unsuitable for swimming. Beach **T 255** lies 500 m to the southeast in the next small gap. It consists of a curving 120 m long high tide cobble beach, fronted by inter- to subtidal sandy bay floor, with low rocky points to either side and some rocks on the floor of the small bay. It is backed by steep 15 m high bluffs then cleared farmland. The high Cape Bougainville lies 1 km to the southeast.

T 256-257 OKEHAMPTON-REIDS BEACHES

No.	Beach	Rating HT LT		Type	Length
T256	Okehampton Beach	3	4	R/LTT	700 m
T257	Reids Beach	3	4	R/LTT	400 m
Spring & neap tidal range = 1.1 & 0.1 m					

Cape Bougainville forms the eastern extremity of a 184 m high double-peaked headland with Lords Bluff forming its southern boundary 2 km to the southwest. The headland forms the eastern boundary of the 1.5 km wide south-facing Okehampton Bay, with Flensers Point forming the western boundary. Steep slopes surround the small bay, which contains two beaches (T 256 and 257).

Okehampton Beach (**T 256**) is located along the northern shore of the bay. It is a 700 m long slightly curving south-facing beach. It faces into Mercury Passage and is afforded moderate protection by Maria Island. Waves average less than 1 m and maintain a low gradient reflective to low tide terrace beach (Fig. 4.42). The beach is backed by a continuous grassy 10 m high 50 m wide foredune containing several stable blowouts, which increase in size towards the eastern end. A 200 m wide wetland backs the dune and drains out across the western

corner of the beach. The beach is backed by private land with public access permitted to a small informal camping area behind the eastern end of the beach.

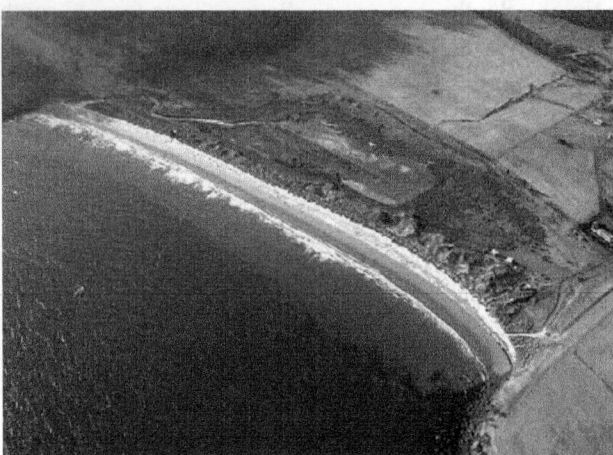

Figure 4.42 Okehampton Beach (T 256) with typical low waves and a continuous low tide terrace.

Reids Beach (**T 257**) is a 400 m long east-facing beach located on the western shore of the bay. It looks east across the 2 km wide bay to Lords Bluff. The beach is moderately sheltered with usually low waves and reflective to low tide terrace beach conditions. It is bordered and backed by partly vegetated slopes, with a private vehicle track and several small holiday cottages backing the northern half of the beach.

T 258-261 SPRING BAY

No.	Beach	Rating HT LT		Type	Length
T258	Windlass Bay	2	1	R+sand flats	400 m
T259	Freestone Cove	1	2	R	50 m
T260	Paddys Point	1	1	R+sand flats	500 m
T261	Alginate Bay	1	1	R	80 m
Spring & neap tidal range = 1.1 & 0.1 m					

Spring Bay is a north arm of 2 km wide Prosser Bay, which in turn opens into Mercury Passage, with Maria Island forming the eastern side of the 5-10 km wide passage. Both bays are relatively low energy, receiving only very low refracted swell and predominantly local wind waves. Because of the low energy and relatively protected shoreline a number of jetties and boating facilities are located either side of the mouth of Spring Bay at Freestone Point, Paddys Point and in Alginate Bay. Beaches T 258-261 are four low energy beaches located either side of the entrance to the bay.

Windlass Bay beach (**T 258**) is a low energy 400 m long south-facing strip of high tide sand and cobbles, fronted by shallow seagrass-covered sand flats, with a widening patch of clear intertidal sand towards the western end. Cleared low gradient slopes back the beach, with a small creek crossing the eastern end and a woodchip mill and some holding ponds on the western Freestone Point.

Freestone Cove is a small west-facing cove containing a 50 m long pocket of dark sand and gravel (beach **T 259**), located to the lee of the woodchip jetty. The deep water of the bay lies a few tens of metres off the beach, which is backed by wooded bluffs, then the woodchip mill. The water intake for the mill is located on the northern end of the beach.

Beach **T 260** is located 500 m to the north and curves to the northwest for 500 m to the lee of Paddys Point. This is a low energy beach dominated by wind waves with patchy seagrass growing to the shore. It is backed by a low continuous foredune, and then cleared slopes, with sloping rocky points to either end.

Alginate Bay is located on the western side of Spring Bay entrance, 1 km west of Paddys Point. The small bay and backing valley houses the Louisville Resort, which includes accommodation, pool, jetty and an attached breakwater to shelter the jetty. The Maria Island passenger ferry leaves from the jetty. The jetty is located at the southern end of the 80 m long pocket of sand and gravel that makes up the beach (**T 261**). A boat ramp crosses the northern end of the small beach, which is backed by a road then cabins.

T 262-267 **ORFORD**

No.	Beach	Rating HT LT	Type	Length
T262	Raspins Beach	3 3	R/LTT	900 m
T263	Orford Beach	2 3	R/LTT	1.2 km
T264	Orford Beach (1)	2 3	R/LTT	400 m
T265	Orford Beach (2)	2 3	R+sand flats	150 m
T266	Shelly Beach (1)	2 3	R+sand flats	400 m
T267	Shelly Beach (2)	2 3	R+ sand flats	300 m
	Raspins Beach Coastal Reserve		*4 ha*	
	Millingtons Beach Coastal Reserve		*18 ha*	
Spring & neap tidal range = 1.1 & 0.1 m				

Orford is a small town located on the southern banks of the Prosser River where it enters Prosser Bay (Fig. 4.43). When driving from Hobart the Tasman Highway winds down the deep, narrow Prosser River valley, suddenly opening up to reveal Orford and provide views of the sea for the first time since Hobart. The bay is set in lee of Maria Island and its beaches are protected from most swell, with only large outside swell reaching the shore. The bay is 2 km wide at its entrance between Meredith and Luther points, with 8 km of shoreline containing six sandy beaches (T 262-267) and the river mouth (Fig.4.44). The Tasman Highway provides good access to the northern Raspins Beach with residential development backing the southern Orford and Shelly beaches.

Raspins Beach (**T 262**) extends north from the shifting Prosser River mouth to the northern bedrock boundary where the small Sheas Creek crosses the beach. The 900 m long beach faces east-southeast towards the bay entrance and usually receives low refracted swell and wind waves, with calms common and waves usually less

Figure 4.43 Orford is located at the mouth of the Prosser River, with beaches occupying much of the shore of Prosser Bay.

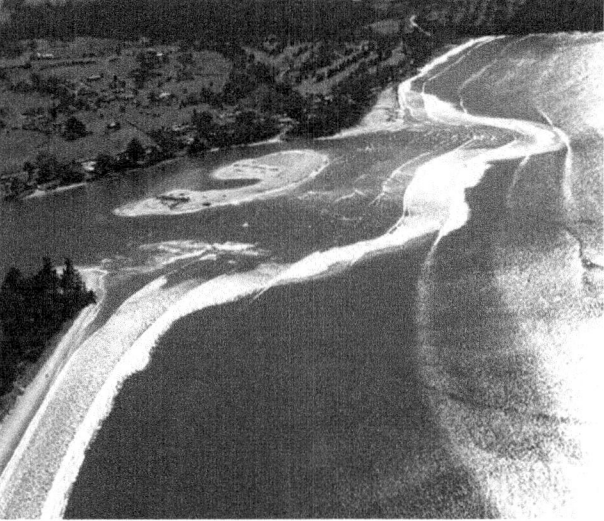

Figure 4.44 The Prosser River mouth at Orford, with Raspins Beach (T 262 top) and Orford Beach (T 263 lower). The river mouth bar produces a left and right-hand surf break (photo W. Hennecke).

than 1 m. They maintain a narrow low tide terrace to reflective conditions. The beach is backed by the narrow Raspins Beach Coastal Reserve, which contains car parking, picnic and camping areas. The highway parallels the rear of the beach with the Orford golf course occupying some of the inner foredunes to the west. The river mouth shoals vary considerably over time changing the length and width of the beach. In response a crude seawall has been dumped on the beach to protect the reserve.

Orford Beach lies on the south side of the Prosser River mouth. It curves round to the south than southeast for a total of 1.8 km and is separated into three sections (T 263-275) by small rock outcrops. The entire beach is backed by Millingtons Beach Coastal Reserve, which includes the 500 m long inlet beach (Millingtons Beach), on the western side of the Orford Beach sand spit. The main beach **T 263** extends from the dynamic river mouth spit for 1.2 km to the south to a low rock outcrop adjacent to the mouth of Orford Rivulet. This beach receives low swell and wind waves and usually has a narrow low tide terrace and low gradient high tide beach. It is backed by a partially vegetated reserve, then houses. Beach **T 264** curves to the southeast for another 400 m to the next rock outcrop which forms a rock platform. Wave height decreases along the beach with seagrass growing 50 m offshore. A low grassy reserve then houses back the beach. Beach **T 265** continues for another 150 m from the rocks to a low developed headland. It consists of a narrow north-facing low energy beach fronted by rocks and seagrass-covered sand flats. Dinghies are pulled up on the beach and there is a small boat shed behind the eastern end of the beach.

Shelly Beach lies to the lee of Luther Point and occupies the southern corner of the bay. It is 900 m long, faces north, curves to both ends and consists of two parts (T 266 and 267). Waves are usually less than 0.5 m and calms are common resulting in a narrow sandy beach occasionally broken by rocks and reefs. The western half (beach **T 266**) is a curving north-facing 400 m long narrow strip of high tide sand fronted by intertidal sand flats with seagrass 50 m offshore. A small rock-tied sandy foreland separates it from the eastern beach **T 267**, which curves to the east for another 300 m with seagrass growing almost to the shore. Beachfront houses back both beaches, with beach access via side streets and a public jetty in the centre of the eastern beach. The low rocky Luther Point borders it to the east. Boats, small jetties and boat sheds line the eastern end of the beach with boats moored between the beach and point.

Swimming: The six Prosser Bay beaches are all relatively safe for swimming with usually calm to low wave conditions and shallow bars. Care must be taken near the river mouth, as there are deep tidal channels and strong tidal currents.

Surfing: Usually none. However when there is a big outside swell there are good lefts at the *Orford (Prosser) River Mouth*, and a right-hander at *Shelly (Luther) Point*.

T 268-269 SPRING & STAPLETON BEACHES

No.	Beach	Rating HT	LT	Type	Length
T268	Spring Beach	4	5	LTT/TBR	1 km
T269	Stapleton Beach	4	5	LTT/TBR	400 m
Spring & neap tidal range = 1.1 & 0.1 m					

Spring Beach (**T 268**) is located 3 km southeast of Orford and to the south of 10 m high Quarry Point. The straight 1 km long beach faces east across Mercury Passage to Maria Island 11 km to the east, and receives southerly waves moving up the passage. The waves average about 1 m and maintain a moderate gradient beach and low tide terrace, with rips forming during periods of higher waves. A narrow foredune and coastal reserve back the beach with a cluster of houses behind the centre and the Rheban Road running behind the southern half of the beach. Two Mile Creek crosses towards the southern end of the beach, with a 30 m high headland to the south covered with several houses.

Stapleton Beach (**T 269**) is located in the next open embayment 1 km to the south. The 400 m long beach faces east and is bordered by a 30 m high sedimentary headland to the north, with the bedrock slopes decreasing towards the southern end, where the small Dead Horse Creek crosses the beach. A few houses are located on the backing tree-dotted slopes, which rise in the south to a 90 m high headland. The Rheban Road runs 100-200 m inland and provides good views of the beach from the northern headland. The moderately steep beach receives wave averaging 1 m, which maintain a low tide terrace, with occasional rips during higher waves.

T 270-275 SOUTH EAST CORNER-CARRICKFERGUS BAY

No.	Beach	Rating HT	LT	Type	Length
T270	South East Corner	2	3	Cobble+rocks	70 m
T271	Stapleton Pt (S)	3	3	Cobble+LTT	50 m
T272	Emerald Bay	3	3	Boulder/cobble	150 m
T273	Carrickfergus Bay (N)	4	4	Cobble	150 m
T274	Carrickfergus Bay (1)	4	4	Cobble+LTT	100 m
T275	Carrickfergus Bay (2)	4	4	Cobble	100 m
Spring & neap tidal range = 1.1 & 0.1 m					

To the south of Stapleton Beach are 5 km of deeply dissected dolerite slopes and shoreline containing six small cobble and boulder beaches (T 270-275) none of which are easily accessible. The Rheban Road winds south 0.5-1 km inland reaching the shore at Rheban farm adjacent to the southern two beaches.

Beach **T 270** is located in **South East Corner** and north-facing 500 m wide rocky embayment to the lee of Stapleton Point. The beach is located at the southern apex of the bay and consists of a narrow 70 m long boulder and cobble beach fronted by some rocks. Step slopes rise to the north, with wooded slopes behind then farmland, and the road 400 m to the west.

Beach **T 271** is located in a small embayment 700 m south of Stapleton Point. It consists of a 50 m long high tide cobble beach fronted by a small sandy low tide terrace and a sand covered bay floor. Low rocks border the southern side of the beach, which is part of a narrow

coastal reserve. Steep slopes back the bay and grade inland into gently sloping farmland.

Emerald Bay is located 1 km southwest of the prominent 101 m high Johnsons Point. The western end of the small 200 m wide bay contains a curving 150 m long cobble beach (**T 272**), fronted by rocks along its southern half. Rising tree-covered slopes back it to the north and lower cleared slopes to the south.

Beach **T 273** is located 600 m to the south in the next small open east-facing embayment. The beach is 150 m long, faces east and is composed of a steep, narrow band of cobble and boulders. It is backed by cleared gently sloping farmland, with a row of trees along the rear of the beach.

Beach T 274 and 275 are located adjacent to the Rheban farmhouse in an open southeast-facing embayment called Carrickfergus Bay. Beach **T 274** is a straight 100 m long cobble beach with a sand and cobble terrace, while beach **T 275**, located 200 m to the south, is a 100 m long cobble beach, with some rocks along the southern half and a rock reef off the northern half. The farmhouse and buildings are located on the gentle slopes behind the beaches, with the road 200 m to the west of the shore.

T 276-277 RHEBAN BEACH-SPIT

No.	Beach	Rating HT LT		Type	Length
T276	Rheban Beach	3	4	R/LTT	3.5 km
T277	Sandspit Pt	3	4	R/LTT	1.1 km
	Sandspit River Wildlife Sanctuary				*550 ha*
Spring & neap tidal range = 1.1 & 0.1 m					

Rheban Beach and Spit is one of the more dramatic coastal depositional features on the Tasmanian coast. The 3.5 km long spit widens to the east and is composed of up to 20 low foredune ridges, which record the evolution of the spit as it prograded up to 700 m seaward. The spit is backed by the shallow 200 ha Earlham Lagoon, which together with the eastern half of the spit is incorporated in the 550 ha Sandspit River Wildlife Sanctuary, a privately owned sanctuary. Two beaches (T 276 and 277) rim the spit.

Rheban Beach (**T 276**) is a curving, then convex 3.5 km long sandy beach. It commences at the base of the gently sloping farmland adjacent to Rheban farm and trends to the southeast, before curving round at Sandspit Point and trending south to terminate at the dynamic mouth of Earlham Lagoon (Fig. 4.45). Sand has been moving onto and along the beach for several thousand years slowly building out the barrier-spit system, which is largely in a natural state. The beach receives lower refracted waves, which maintain a reflective to low tide terrace system, with rips usually absent. It is backed by the foredune ridges, which widen from 300 m in the north to 700 m at the point, then the shallow lagoon. There is public access at the northern end of the beach adjacent to the farm.

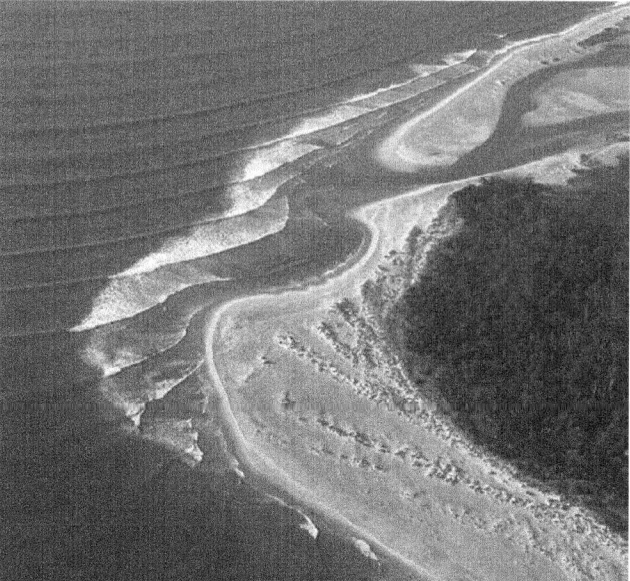

Figure 4.45 Wave breaking across the deflected mouth of Earlham Lagoon, with Rheban Beach (T 276) foreground.

Beach **T 277** commences on the southern side of the sandy lagoon mouth and shoals and curves to the south for 1.1 km attaching to the bedrock slopes on the southern side. This is an east-facing slightly more exposed beach which usually has a reflective to low tide terrace system, with rips forming during periods of higher waves. It is backed by a low foredune and overwash flats towards the lagoon mouth. About 20 holiday and fishing cottages are located on the slopes bordering the southern end of the beach.

Depending on the shape of the lagoon mouth shoals the point can produce an excellent long right-hand wave running across the lagoon mouth shoals and along the point. Best access is along the beach, with permission, from Rheban farm.

T 278-284 POINT DES GALETS-COCKLE BAY

No.	Beach	Rating HT LT		Type	Length
T278	Earlham (S)	2	3	R+rocks	200 m
T279	Pt des Galets (N)	3	4	Cobble+LTT	80 m
T280	Pt des Galets (S)	3	4	Cobble+LTT	100 m
T281	Boot Bay (N)	3	4	R/LTT	100 m
T282	Boot Bay	3	4	R/LTT	200 m
T283	Cockle Bay	4	4	LTT	1 km
T284	Cockle Bay (S)	3	4	Cobble	600 m
Spring & neap tidal range = 1.1 & 0.2 m					

To the south of Earlham Lagoon are 17 km of generally high steep rocky shore reaching 315 km at the sheer Hellfire Bluffs. Along the northern 6 km of shore are seven generally small beaches (T 278-284). All are bordered by rocky shore and backed by densely vegetated slopes rising to 309 m at Earlham Hill. There is no vehicle access to any of the shore.

Beach **T 278** is a narrow low energy northeast-facing strip of high tide sand located 500 m southeast of the Earlham cottages. The beach is backed by cleared farmland that descends almost to the shoreline, with rocky shore to either side as well as rock outcrops scattered along and off the beach. During higher swell a right-hand break runs along the side of the sand and rocks towards Earlham.

Point des Galets is a sloping 40 m high dolerite point located 1.5 km to the south, with two small beaches (T 279 and 280) to either side. Beach **T 279** is an east-facing 80 m long pocket of high tide cobbles fronted by a sandy low tide terrace located at the mouth of a small creek that descends the backing cleared slopes. Rocky shore extends to either side. Beach **T 280** lies 500 m to the south on the southern side of the point and is a similar 100 m long high tide cobble beach with a sand and rocky seafloor. It faces southeast and receives slightly higher waves which break over the rocks and sand. A small creek descends to the southern end of the beach and a few tall gum trees back the beach, and then cleared slopes.

Beach **T 281** lies 1 km to the southwest on the north side of Boot Bay. It is a 100 m long sandy east-facing beach, which ranges from reflective to narrow low tide terrace. It

is bordered by 20 m high eroding cliffs and backed by steep vegetated slopes. A 100 m wide cleared headland separates it from Boot Bay, a curving 30 m wide southeast-facing embayment, with beach **T 282** located at the rear of the small bay. The beach is 200 m long, backed by steep vegetated slopes, with waves averaging 1 m breaking across a 50 m wide bar.

Cockle Bay occupies the next larger embayment which extends for 1.3 km down to the southern boundary of 120 m high Pebbly Point. Two beaches (T 283 and 284) occupy most of the bay shore. Beach **T 283** is a curving, east-facing, 1 km long narrow beach located at the base of densely vegetated moderate slopes, with trees growing right down to the shore. A low gradient 50 m wide low tide terrace fronts the narrow high tide beach. It terminates in the south at a cobble foreland, which forms the northern side of the entrance to Cockle Bay Lagoon. Beach **T 284** curves south of the foreland then east across the small lagoon mouth for 600 m terminating at the beginning of the steep slopes of Pebbly Point. The steep beach is composed entirely of cobbles and backed by a cobble ridge then the 25 ha shallow lagoon (Fig. 4.46) with 120 m high Whalers Lookout dominating the rear of the beach. There are two surf breaks at the southern end of the bay, a point break off the boundary foreland and a fast right running along the side of the cobble beach.

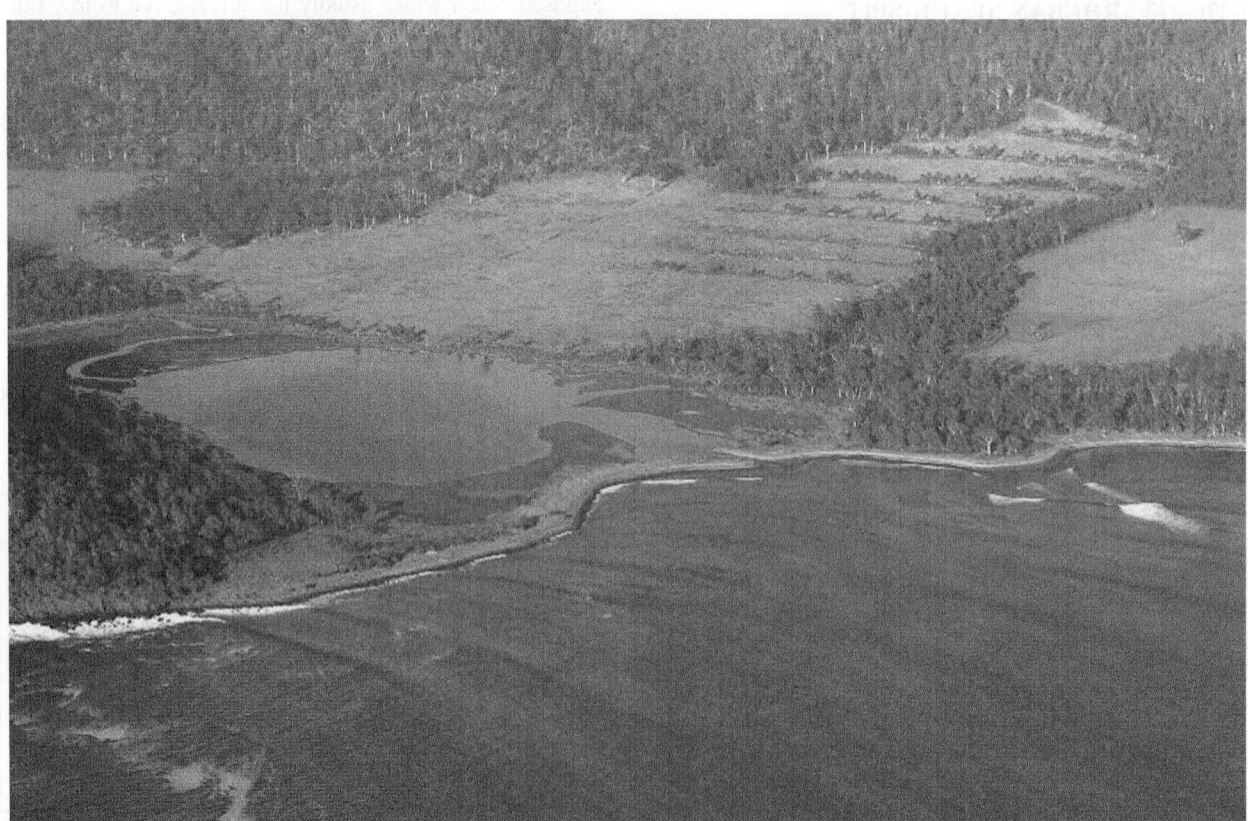

Figure 4.46 Cockle Lagoon is impounded behind the crenulate cobble beach T 284.

MARIA ISLAND

Maria Island is an 11 500 ha island located 5-10 km off the southeast coast between Cape Bougainville and Cape Bernier. The island consists of two bedrock highs linked by the low 2 km long McRaes Isthmus (Fig. 4.47). The larger 7800 ha northern part of the island rises to 711 m at Mount Maria, while the smaller 2400 ha southern part rises to 324 m at Middle Hill. The 65 km of island shoreline is dominated by steeply sloping rocky terrain including the Glenloth Cliffs which rise to 300 m. There are 19 beaches (MI 1-19) located around the island, principally either side of the isthmus and along the more protected northwest coast. They occupy only 17 km (26%) of the island shore, with no beaches on the southern rocky part of the island. The only public access to the island is by ferry from Louisville (Alginate Bay) to the landing at Darlington Cove.

Maria Island National Park

Established:　　1972
Area:　　　　　11 500 ha
Coast length:　65 km
Beaches　　　　19　(MI 1-19)

Regional map 3
Maria Island

Figure 4.47　Maria Island.

MI 1-2　BEACHING COVE

No.	Beach	Rating HT LT	Type	Length
MI 1	Beaching Cove	4　6	Boulder	150 m
MI 2	Red Rock Pt (E)	6　10	LTT+rocks	80 m
Spring & neap tidal range = 1.1 & 0.1 m				

The rocky eastern side of the northern part of the island extends for 22 km and contains only two small beaches (MI 1 and 2), the remainder dominated by steep granite slopes and shore.

Beaching Cove (MI 1) is the only beach on the rocky northeast side of the island. The small 150 m long beach is located 1 km east of Mount Maria, the island peak, and is backed by steep gullies that rise towards the 711 m high peak. The beach is composed of boulders, backed by steep vegetated slopes rising into three gullies and bordered by 50 m high granite cliffs and backing slopes that extend 100-200 m seaward to form the small cove (Fig. 4.48). There is no land access to the beach.

Figure 4.48 The remote Beaching Cove contains the only beach (M 1) on the northeastern side of Maria Island.

Beach **MI 2** is located on the rocky northern shore of Riedle Bay 500 m east of Red Rock Point. The 80 m long pocket of sand is located at the mouth of a steep narrow gully, with massive granite rocks bordering each side, together with a ridge of granite extending across the mouth of the 100 m wide 80 m deep bay. The sandy beach is located to the rear of the rocks at the mouth of the gully. Waves break over the rocks and roll into the bay, with a permanent rip flowing out through a narrow gap in the rocks.

MI 3-4 RIEDLE & SHOAL BAYS

No.	Beach	Rating HT LT	Type	Length
MI 3	Riedle Bay	6→4→6→4	TBR→LTT	3.8 km
MI 4	Shoal Bay	2 1	R+sand flats	5.5 km
Spring & neap tidal range = 1.1 & 0.1 m				

Riedle and Shoal bays lie to either side of the low sandy McRaes Isthmus, which links the two parts of the island. **Riedle Bay** faces east into the high waves of the Tasman Sea and is bordered by moderate to steep bedrock slopes reaching 344 m at Perpendicular Mountain. Moderate easterly waves refract into the bay with highest waves along the northern shore decreasing into the southern corner. The Riedle Bay beach (**MI 3**) forms the eastern side of the isthmus. It faces east and curves round between the two sides of the island for 3.8 km. The northern end at Elephant Bight receives waves averaging over 1 m, which maintain a low gradient rip-dominated 50-100 m wide surf zone (Fig 4.49). Wave height decreases slowly down the beach reducing to about 0.5 m in the southern north-facing Trigonia Corner, where the beach maintains a lower energy low tide terrace. This is the only beach on the island offering any surf. The beach is backed by well-vegetated dunes averaging 10 m in height and extending 100-200 m inland. They are linked in the centre with the dunes originating from Shoal Bay beach.

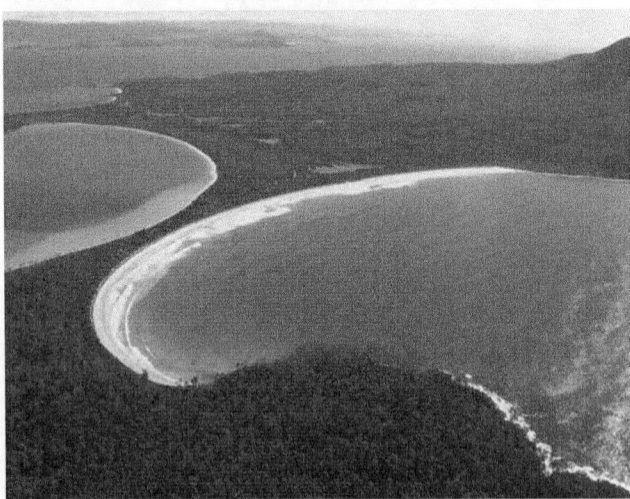

Figure 4.49 Riedle Bay and its curving beach (MI 3), with the lower energy Shoal Bay beach (MI 4) to the left.

Between Trigonia Corner and the beginning of Shoal Bay are 18 km of rocky shore which surrounds the southern half of the island and includes cliffs rising to 200-300 m along the Glenloth Cliffs.

Shoal Bay lies to the west of the isthmus. The bay faces west into Mercury Passage and is further protected by Point Lesueur in the north and Point Mauge to the south, with only very low reflected waves reaching the low energy shore. The beach (**MI 4**) commences in lee of Point Lesueur at Chinamans Bay, where it faces south. It

trends east, then curves to the southeast, south and finally southwest for 5.5 km, terminating in lee of Point Mauge. As the name of the bay suggests the beach is fronted by extensive sand flats, particularly in the south. Sand has been moving into the bay during the Holocene and the northern half of the beach has prograded up to 500 m into the bay, as a series of up to 15 low foredune ridges. In the north the Crooked McGuiness Lagoon wetland separates the Riedle Bay dunes from the Shoal Bay foredunes. The dunes do link in the centre where the isthmus narrows to 150 m. The main vehicle and walking track runs parallel to the dunes 100 m in from the shore.

MI 5-8 ENCAMPMENT COVE-POINT LESUEUR

No.	Beach	Rating HT LT	Type	Length
MI 5	Encampment Cove	1 1	R+sand flats	250 m
MI 6	Goldings Reef	1 1	R	200 m
MI 7	Guards Lagoon	2 3	R	350 m
MI 8	Pt Lesueur	2 3	R	300 m
Spring & neap tidal range = 1.1 & 0.1 m				

Point Lesueur forms the northwest boundary of Shoal Bay, with 4 km of rocky shoreline between the point and start of the main bay beach (MI 4). Spread along the south-facing shoreline are four small rock-bound beaches (MI 5-8).

Encampment Cove is a very low energy 300 m long cove that faces into the bay and towards the main Shoal Bay beach, 2 km to the east. It receives only low wind waves and very low swell and is usually calm. Within the cove is a 250 m long east-facing beach (**MI 5**), backed by a small well vegetated foredune and backing 50 m wide wetland. A camping site is located at the southern end of the beach.

Goldings Reef is a shore-attached rock reef located 500 m to the south. Immediately west of the reef is a 200 m long south-facing low energy beach (**MI 6**). The beach receives low waves and is often calm. It is backed by a low vegetated foredune, then 50-100 m wide wetlands.

Beaches MI 7 and 8 are two adjoining beaches located to the east of Point Lesueur. Beach **MI 7** is located 1 km to the east and consists of a 350 m long south-southwest-facing reflective beach bordered by a cleared 20 m high headland and backed by 1 ha Guards Lagoon, an infilled wetland. The beach receives waves averaging less than 1 m, which maintain a steep reflective beach. It is backed by a 50-100 m wide, 10-15 m high vegetated foredune and former blowouts then the lagoon. Beach **MI 8** is located 500 m to the west and extends for 300 m to the lee of 7 m high Point Lesueur. Its western end is tied to the point by a cobble-boulder isthmus, which narrows to 50 m at the point of attachment. Low waves and reflective conditions usually prevail along the beach, which is backed by hummocky dune-draped bedrock slopes, with one area of active blowouts.

MI 9-14 BLOOMING BAY

No.	Beach	Rating HT	LT	Type	Length
MI 9	Goodstone Pt (W)	2	2	R	300 m
MI 10	Goodstone Pt	2	2	R	350 m
MI 11	Bloodstone Beach	2	3	R	2.4 km
MI 12	Soldiers Beach	3	4	R	800 m
MI 13	Return Pt (S)	2	3	R	50 m
MI 14	Return Pt (W)	3	4	R/LTT	100 m
Spring & neap tidal range = 1.1 & 0.1 m					

Blooming Bay is a curving 3 km wide, west-facing bay bordered by Point Lesueur in the south and the smaller Return Point in the north. In between the points are 6 km of lower energy shoreline containing five beaches (MI 9-14).

Beaches MI 9 and 10 are two adjoining low energy northwest-facing beaches located immediately west of **Goodstone Point**, a small dolerite point with cobble deposits to either side. The point is largely composed of gravel and has been quarried in the past. Beach **MI 9** is a narrow 300 m long low energy reflective beach, with seagrass growing to within 20 m of the shore. It is backed by a narrow scarped grassy foredune, then an infilled lagoon that extends east to the lee of beach MI 10. A small rocky point separates the two beaches, with beach **MI 10** trending to the northeast for 350 m to the rocky Goodstone Point. This is a similar narrow low energy beach, with seagrass right offshore and shallow sand and rock flats surrounding the point. A low grassy terrain backs it, with the gravel quarry excavated in the foredune towards the point.

Bloodstone Beach (**MI 11**) commences on the northern side of Goodstone Point and curves to the northeast, then north for 2.4 km to the small protruding Gulls Nest Point. The beach receives low refracted waves, which increase slightly in height up the beach. Reflective conditions prevail with seagrass growing to within 50 m of the shore (Fig. 4.50). It is backed by a narrow well vegetated foredune, which increases in height towards the north with a small blowout at the northern end. An elongate infilled wetland backs most of the foredune.

Soldiers Beach (**MI 12**) is an 800 m long reflective beach that extends from Gulls Nest Point to Return Point. It faces southwest and receives waves averaging up to 1 m, which maintain a more energetic reflective beach, with the seagrass more than 50 m offshore. It usually has well developed cusps and waves surging up the moderately steep beach. It is backed by a continuous 50 m wide 10 m high foredune, then a 50 m wide elongate wetland.

Figure 4.50 Bloodstone Beach (MI 11) with Goodstone Point in the background.

Return Point is a 15 m high rounded grass-covered dolerite point that extends 400 m west of the northern end of Soldiers Beach. Beaches MI 13 and 14 are located in two small embayments on the point. Beach **MI 13** is a 50 m long pocket of sand located in a small indentation on the south side of the point. It is bordered and backed by the grassy slopes rising to 10 m. It receives low waves, which surge up the small reflective beach, with a white sandy seafloor extending offshore into the bay. Beach **MI 14** is located in a slightly larger, deeper bay at the western tip of the point. The 100 m long beach is located at the rear of the small bay and is partly sheltered by headlands that extend 100 m to either side. It is bordered and backed by grassy slopes. Waves are usually low to calm and break across the narrow low gradient white sandy beach.

Maria Island Marine Reserve

Coast length: 12 km (58-65-5 km)
Beaches: 5 (MI 15-19)

Maria Island Marine Reserve extends for 12 km along the northwest side of the island between Return Point and the northern Cape Boullanger and across Fossil Bay to the base of Bishop and Clerk Hill. The reserve encompasses the shoreline and the seabed extending 1 km seaward.

MI 15-19 FOUR MILE BEACH-DARLINGTON BAY

No.	Beach	Rating HT	LT	Type	Length
MI 15	Return Pt (N)	3	4	Cobble+rock flats	100 m
MI 16	Four Mile Beach	3	3	R	400 m
MI 17	Howells Pt	3	4	R+rock flats	200 m
MI 18	Hopground Beach	3	3	R	700 m
MI 19	Darlington Bay	3	3	R	750 m
Spring & neap tidal range = 1.1 & 0.1 m					

At Return Point the rocky island shoreline turns and trends to the north-northeast for 7 km to the northern tip of the island at Cape Boullanger. In between are five small beaches (MI 15-19) including the main island settlement at Darlington Bay. The main vehicle track runs south from Darlington along the shore providing access to all but the southernmost beach.

Beach **MI 15** is located 1 km north of Return Point and consists of a 100 m long pocket of west-facing cobbles, fronted by a 50 m wide band of intertidal rocks. It is bordered by low grassy points and backed by moderate gradient densely vegetated slopes.

Four Mile Beach (**MI 16**) lies 4 miles (6.4 km) southwest of Darlington, and consists of a curving 400 m long northwest-facing reflective beach, bordered by sloping vegetated headlands to either side. Four Mile Creek and its narrow 500 m long lagoon drain across the northern end of the beach. The low energy beach and its backing foredune have partly filled the small valley. The main vehicle track crosses the lagoon 500 m inland.

Howells Point lies 2.5 km to the north with beach **MI 17** located on the northern side of the small point. The beach is 200 m long, faces northwest and consists of a sandy high tide reflective beach fronted by 50 m wide intertidal rock flats. It is backed by cleared sloping land, with the main vehicle track located immediately east of the beach.

Hopground Beach (**MI 18**) is a curving 700 m long west-facing beach bordered by Magistrates Point to the north and the Painted Cliffs to the south. The beach is low energy reflective with seagrass growing 50 m offshore. Counsel Creek drains across the northern end of the beach, with the main track crossing the creek and running along the low foredune. A cottage is located behind the centre of the beach.

Darlington Bay is located at the northeastern tip of the island and is the site of Darlington the only settlement on the island and site of the national park ranger station. Beach **MI 19** is a curving 750 m long west- to northwest-facing reflective beach that occupies the shore of the bay, with the sole island jetty extending 100 m seaward at the northern end. The beach has seagrass growing to within 50 m of the shore. It is backed by a low grassy foredune with Bernacchis Creek and small lagoon draining out at the northern end of the beach, next to the jetty. The Darlington settlement is located on the cleared grassy slopes that extend east of the beach. This area includes a camping area and ruins of earlier settlements, which date back to the 1850's.

T 285-288 BLOWHOLE POINT-PINE CREEK BEACH

No.	Beach	Rating HT LT		Type	Length
T285	Blowhole Pt (E2)	5	7	Cobble	80 m
T286	Blowhole Pt (E1)	5	7	Cobble	50 m
T287	Bluff Beach	4	5	LTT/TBR	800 m
T288	Pine Ck Beach	4	5	LTT/TBR	400 m
Spring & neap tidal range = 1.1 & 0.1 m					

Blowhole Point is an irregular 20 m high dolerite headland located at the western end of the 375 m high Hellfire Bluff, a 3 km long section of high cliffs between Cape Bernier and the point, and is one of the highest sections of coastal cliffs in Australia. The blowholes are related to wave erosion along joint lines in the rocks. Immediately east of the point are two gaps in the 100 m high bluffs containing beaches T 285 and 286. There is no formal land access to either beach.

Beach **T 285** is an 80 m long pocket of sand and cobbles located at the base of steep densely vegetated slopes. Waves averaging over 1 m surge up the steep beach face, with a 100 m long dolerite point forming its western boundary. Beach **T 286** is located immediately to the west in a 60 m wide gap between two dolerite points backed by a steep densely vegetated narrow V-shaped valley. Waves breaking into the gap form a permanent rip in front of the steep 50 m long sand and cobble beach.

Bluff Beach (T 287) commences 50 m to the southwest on the southern side of Blowhole Point and is bordered to the south by a 200 m wide 20 m high tree-covered point. It is a slightly curving 800 m long low gradient exposed beach, with waves averaging over 1 m. These maintain a 50-100 m wide surf zone, with usually a rip against Blowhole Point and one to two central beach rips. Steep tree-covered slopes descend to the rear of the sand, with three small creeks reaching the beach (Fig. 4.51). A vehicle track terminates at the centre of the beach.

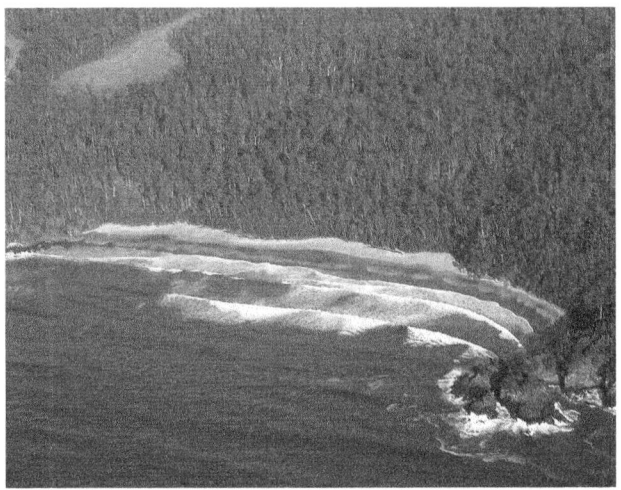

Figure 4.51 Bluff Beach (T 287) with typical wave conditions and the dense forest growing to the rear.

Pine Creek Beach (T 288) is located between the boundary point and the lower Point du Ressac 400 m to the south. This is a low gradient beach with a 50-100 m wide surf zone and rips usually flowing out against the boundary headlands. It is backed by partly-cleared moderate slopes, with tall trees backing the beach. Three small creeks also reach the beach, together with the steep Pine Creek draining across the northern end of the beach.

T 289-294 POINT DU RESSAC-EAGLE BEACH

No	Beach	Rating HT LT		Type	Length
T289	Pt du Ressac (S)	4	5	LTT/TBR	300 m
T290	Pt du Ressac (S1)	4	5	LTT/TBR	50 m
T291	Pt du Ressac (S2)	4	5	LTT/TBR	70 m
T292	Eagle Beach	4	5	LTT/TBR	800 m
T293	Eagle Beach (S1)	4	5	LTT/TBR	40 m
T294	Eagle Beach (S2)	4	5	LTT/TBR	300 m
Spring & neap tidal range = 1.1 & 0.1 m					

Point du Ressac is a sloping partly cleared 500 m long rocky section of shore to the south of which is a series of six east-facing exposed beaches (T 289-294) which occupy most of the next 2 km of shore. The Cockle Bay vehicle track runs along the slopes 200-300 m in from the beaches.

Beach **T 289** commences on the southern side of the point and trends to the south for 300 m. It is a low gradient beach, which usually has a 50 m wide bar, which is cut by rips at either end during higher waves. Partly cleared tree-dotted slopes descend to the rear of the beach.

Beaches T 290 and 291 are two pockets of sand located on the southern 300 m wide boundary headland. Beach **T 290** is a V-shaped 50 m wide pocket of wave-washed sand that occupies the mouth of a small creek, with low cleared rocky points to either side. The beach narrows into the gully, with a rip usually running out against the southern rocks. Beach **T 291** is located 50 m to the south and is a 70 m long pocket of high tide cobbles and intertidal sand, with rocks strewn across the beach and the 50 m wide surf zone. It is bordered by low rocky shore and backed by cleared slopes.

Eagle Beach (T 292) commences 150 m to the south with low rocky points bordering each end of the 800 m long beach. The beach receives waves averaging about 1 m which maintain a 50 m wide bar usually cut by two rips, with rips forming against the boundary rocks during higher waves. Partly cleared slopes back the beach, with two small creeks descending to either end of the beach from the 190 m high Eagles Sugarloaf, located 1 km west of the beach. The Cockle Bay track passes 100 m in from the beach.

Beach **T 293** is a 40 m long pocket of sand located on the 100 m wide cleared southern headland. The beach is wedged in a gap in the rocky shore, with the 50 m wide

surf zone continuing along past the rocks and beach to the southernmost Eagle Beach (T 294).

Beach **T 294** continues south of the point for 300 m to a sloping 50 m wide cleared rocky point that separates it from the long Marion Beach (T 295). The low gradient beach has a 50 m wide usually continuous surf zone, with rips only forming during periods of higher waves. Partly cleared slopes descend to the rear of the beach.

T 295 MARION BEACH

No.	Beach	Rating HT LT		Type	Length
T295	Marion Beach	4	5	LTT/TBR	8.2 km
Spring & neap tidal range = 1.1 & 0.1 m					

Marion Beach (T 295) is an east-facing slightly curving 8.2 km long beach that occupies most of the western shore of Marion Bay. It extends from the southern rocks of Eagle Sugarloaf in the north, which separate it from Eagle Beach, to the Marion Narrows inlet in the south, which connect to the large Blackman Bay (Fig. 4.52). The beach is exposed to waves averaging about 1 m, which decrease to the south where the 500 m wide inlet mouth and associated tidal currents and shoals dominate. Waves break out over the shoals producing some long right-hand waves during periods of higher swell. The waves maintain a 50 m wide low tide terrace for most of the length of the beach, with numerous rips, spaced about every 200 m, cutting the bar during periods of higher waves. The low gradient beach is backed by a continuous 10 m high 50-100 m wide foredune, with some small blowouts increasing towards the south. It is backed for most of its length by Bream Creek, which is deflected 5 km to the south and reaches the beach at a usually blocked mouth. The creek is backed by farmland with the only public access along the Marion Bay Road, which reaches the beach just south of the creek mouth. There are a few holiday cottages, a small car park, beach access but no facilities. The southern 3 km of the beach-barrier is backed by Porpoise Hole, an arm of Blackman Bay.

Figure 4.52 The Marion Narrows at the end of Marion Beach (T 295) are part of the tidal delta for the large Blackman Bay.

T 296-298 CAPE PAUL LAMANON

No.	Beach	Rating HT LT		Type	Length
T296	Gardiners Cove	3	3	R/LTT	100 m
T297	Watsons Bay	3	4	Cobble	600 m
T298	Tasman Bay	2	3	Cobble	200 m
Spring & neap tidal range = 1.1 & 0.0 m					

Cape Paul Lamanon forms the southern boundary of Marion Bay and marks the beginning of the rugged Forestier Peninsula. The 31 m high cape is bordered by steep densely vegetated rocky shore to either side, with beaches T 296-298 located in three small bays to either side of the cape. There is no land access to any of the beaches.

Gardiners Cove is a semicircular 200 m wide north-facing rocky bay located 2 km east of the Marion Narrows and 1.5 km west of the cape. Beach **T 296** is a narrow low energy 100 m long sandy beach and bar located at the base of the cove. It is bordered by rocky shore and densely vegetated slopes rising to 70 m and backed by a steep V-shaped valley.

Watsons Bay is a 500 m wide north-facing rocky bay located immediately west of the cape. It faces north and is backed in the west and south by slopes rising to 100 m. Beach **T 297** is a steep, narrow cobble beach that extends for 600 m along the base of the bay. It is fronted by a sandy bay floor, with low waves usually surging up the cobble beach face.

Tasman Bay is located immediately south of the cape, and is a 500 m wide east-facing rocky bay that narrows to 200 m at its base, where 200 m long beach **T 298** is located. It is a steep, narrow cobble beach, backed by moderately sloping tree-covered terrain. The beach is fronted by a shallow sand and rocky bay floor, with two mid-bay cobble spits extending part way across the bay, further reducing waves at the shore. The spits could produce a left- and right-hand surf break during period of higher swell. There is a monument to Abel Tasman located at the rear of the beach.

T 299 TWO MILE BEACH

No.	Beach	Rating HT LT		Type	Length
T299	Two Mile Beach	4	5	LTT/TBR	3 km
Spring & neap tidal range = 1.1 & 0.0 m					

Two Mile Beach (T 299) is a gently curving 3 km long northeast-facing sandy beach located in 3 km wide North Bay (Fig. 4.53). The bay is bordered by the prominent Cape Paul Lamanon and Monument Point in the north and 138 m high Cape Frederick Hendrick to the east. The beach receives refracted waves which average about 1 m at the shore and maintain a 50 m wide low tide terrace,

cut by up to 12 rips during periods of higher waves. It is backed by a continuous foredune, which has a series of blowouts along the northern and central sections, some extending 200 m inland. The dunes are backed by 200 ha Top and Swan lagoons and associated partly drained wetlands, with Swan Lagoon draining out via a small creek at the southeastern end of the beach. Farmland borders and backs the lagoon, with vehicle access to Parrot Point at the southeastern end of the beach.

Figure 4.53 Two Mile Beach (T 299) with a series of inactive rip channels on the bar and the backing unstable foredune and Swan Lagoon.

T 300-303 LAGOON BAY

No.	Beach	Rating HT LT		Type	Length
T300	Lagoon Bay	4	4	LTT	1 km
T301	Lagoon Bay (S)	3	4	Cobble	100 m
T302	Hyatts Beach	3	4	R	100 m
T303	Goat Hill Ck	3	4	Cobble	50 m
Spring & neap tidal range = 1.1 & 0.0 m					

Lagoon Bay is a 1.5 km deep, 700 m wide, east-facing U-shaped bay located to the south of Cape Frederick Hendrick, with rocky shore and the three small Kelly Islands forming the southern boundary. Deep within the bay is beach **T 300**, a curving, 1 km long sandy beach that faces east out the bay mouth. The beach receives lowered refracted waves that average less than 1 m and maintain a low gradient reflective to low tide terrace beach, with cusps usually present on the beach face. It is backed by a low 50 m wide foredune then cleared farmland with some farm buildings behind the centre of the beach and vehicle access to either end. A drainage ditch crosses the southern end of the beach.

Beach **T 301** is a 100 m long steep cobble beach located at the end of a 100 m long low rocky-boulder point that extends northeast from the southern end of the main

beach. Rocks litter the intertidal zone, while cleared farmland backs the beach.

Hyatts Beach (T 302) lies 1 km east of the main beach in lee of the Kelly Islands. It consists of a 100 m long pocket of north-facing sand. The islands shelter it with waves averaging less than 1 m at the shore and reflective conditions prevailing. It is bordered by straight steep 20 m high rock points that extend 100 m seaward and backed by bluffs then partly cleared slopes, that rise to 193 m at Goat Hill. The vehicle track from Lagoon Bay terminates on the bluff behind the beach.

Beach **T 303** lies 500 m to the south. It is a 50 m long cobble beach located in a steep, rocky gap in the shoreline. The indented location of the beach, plus a rock islet just off the northern side of the beach, lower waves to less than 1 m at the shore. The small Goat Hill Creek descends steeply to reach the beach.

T 304-308 PIRATES BAY

No.	Beach	Rating HT LT		Type	Length
T304	Lufra Cove	4	4	R	100 m
T305	Eaglehawk Neck	5	6	TBR	1.8 km
T306	Quarry Beach	5	7	TBR+rock flats	200 m
T307	Egg Beach	4	5	LTT/TBR	500 m
T308	Doo Beach	4	4	LTT	1.2 km
Pirates Bay State Reserve				*28 ha*	
Eaglehawk Bay State Reserve				*16.5 ha*	
Eaglehawk Neck Historic Site				*8 ha*	
Tessellated Pavement State Reserve				*3.9 ha*	
Spring & neap tidal range = 1.1 & 0.0 m					

Pirates Bay is an open east-facing bay, bordered by the prominent Osprey Head and Clydes Island in the north and Fossil Island and the Tasman Blowhole in the south, and linked by the infamous Eaglehawk Neck. The bay is 2.7 km wide at the entrance, 1.5 km deep and has 6 km of shoreline which includes five beaches (T 304-308) that range from protected to moderately exposed (Fig. 4.54).

The Arthur Highway winds down the Eaglehawk spur on the northern approaches providing views of the bay and Neck. The highway reaches the coast at the Tessellated Pavement State Reserve, an area of tessellate rock platform. It then crosses Eaglehawk Neck, where during the convict era a continuous chain of dogs were kept to deter escaping convicts. The Highway then turns inland along Eaglehawk Bay, while the Blowhole Road follows the bay shoreline running along the bluffs backing Egg Beach to reach Doo Beach and the quaint settlement of Doo Town, where every house name incorporates the letters 'doo'.

The scenic and historic significance of the bay is indicated by the fact it hosts four reserves - Pirates Bay, Eaglehawk Neck and Tessellated Pavement state reserves and Eaglehawk Neck Historic Site. The Eaglehawk reserve incorporates the famous Tasman Arch, Tasman

Figure 4.54 Pirates Bay contains higher energy rip-dominated central beaches (Eaglehawk, Quarry & Egg), with lower energy Lufra Cove and Doo Beach to either end.

Blowhole and Devils Kitchen along the exposed rocky eastern shore.

Lufra Cove (T 304) is the smallest and least accessible of the beaches. It is located deep inside the northern side of the bay, faces south and is sheltered by Osprey Head and the Clydes Island and reef, with waves usually less than 1 m at the shore. The 100 m long beach is used by locals to store and launch small boats across the narrow reflective beach. It can be reached on foot from the Tessellated Pavement.

Eaglehawk Neck is a low sand beach **(T 305)** and backing dune that connects the Tasman Peninsula to the mainland. There is good access off the Arthur Highway with two car parks and toilet facilities at the Neck. The Neck is only 200 m wide, while the beach is 1.8 km long and faces east directly into the bay mouth. As a result it receives moderately high waves averaging 1-1.5 m. These produce a continuous bar cut by several strong rips. The smaller beach T 306 is located on the low energy bay side of the Neck.

Quarry Beach (T 306) is a 200 m long continuation of Eaglehawk Neck beach, with 20 m high cliffs and rocks separating it from Eaglehawk and the adjoining Egg beaches. The beach can be accessed from the Blowhole Road, which runs along the bluffs behind the beach. It faces east toward the bay mouth and receives 1 m high waves which usually maintain a strong rip against the northern rocks.

Egg Beach (T 307) begins past the southern rocks of Quarry Beach and runs to the southeast for 500 m, with a central rock outcrop and rock platforms to either end. Waves begin to decrease in height down the beach, however they are large enough to maintain a continuous 50 m wide bar, with rips against the rocks particularly toward the northern end. The beach is backed by densely vegetated bluffs, with the Blowhole Road running above the beach to provide access.

Doo Beach (T 308) lies in the more protected southern corner of the bay and faces due north to northeast. Waves decrease from west to east along the beach, with a jetty, boat sheds, boat ramp and moored boats at the eastern end (Fig. 4.55). The Blowhole Road parallels the back of the beach with a car park and facilities at the jetty. The beach has a shallow continuous bar, with rips only forming toward the western end during periods of higher waves.

Figure 4.55 Doo Beach (T 308) is sheltered by the Blowhole headland, resulting in usually low waves and a safe anchorage off the beach.

Swimming: The safest swimming in the bay is on Doo Beach toward the jetty. Be very careful on Eaglehawk, Quarry and Egg beaches as waves are larger and rips common, particularly near the rocks. Lufra Cove is usually quiet, but more difficult to access.

Surfing: The best surfing is at the Neck car parks with a wide beach break along Eagleneck (T 305). There are also breaks off the *Tessellated Pavement,* further round at *Eaglehawk Reef,* as well as reef breaks around Quarry and Egg beaches.

T 309 **FORTESCUE BAY**

No.	Beach	Rating HT LT		Type	Length
T309	Fortescue Bay	3	4	R/LTT	700 m
Spring & neap tidal range = 1.1 & 0.0 m					

Fortescue Bay is a remote 4 km deep bedrock embayment located to the lee of 134 m high Cape Hauy. The bay has a 1 km wide entrance widening into the northern small Canoe Bay, a popular anchorage, and the larger main Fortescue Bay. Beach **T 309** is located at the southwestern base of the main bay. The entire bay shore is surrounded by steep, densely wooded slopes rising 100-200 m and all are part of the Fortescue Forest Reserve (Fig. 4.56). The 12 km long Fortescue Road winds in from the highway to the southern end of the beach, where there are camping and boat launching facilities.

The beach is 700 m long and faces northeast towards the bay entrance. Lower refracted waves reach the shore averaging about 0.5 m, where they maintain a lower gradient reflective to low tide terrace beach. The beach and low backing foredune form a barrier across the mouth of Agnes Creek, which is impounded behind the centre of the beach as the small Fortescue Lagoon. The lagoon occasionally breaks out across the beach, causing a slight protrusion in the centre of the beach, with some rocks deposited on the seafloor off the mouth.

Figure 4.56 The sheltered Fortescue Bay beach (T 309) is backed by densely vegetated slopes, with Agnes Creek in the centre depositing a small gravel delta off the beach.

SOUTH COAST

Region 2 Cape Pillar-South East Cape

Coast length	585 km	(512-1097 km)
Beaches:	256	(T 310-565)
Regional maps:	Figure 4.58	p. 111
	Figure 4.84	p. 132
	Figure 4.98	p. 144 (Bruny Island)

The south coast of Tasmania is a highly irregular indented rocky shore that commences at the southern tip of the Tasman Peninsula at Cape Pillar (Fig. 4.57) and winds its way west and finally south for 585 km to South East Cape. The coast includes the western half of the Tasman Peninsula, Norfolk and Frederick Henry bays, South Arm, the lower Derwent River, Bruny Island and the D'Entrecasteaux Channel (Fig. 4.58). In all there are 256 beaches that occupy only 99 km or 22% of the shore, the remainder dominated by rocky shore. Bruny Island contains an additional 232 km of shoreline and 95 beaches.

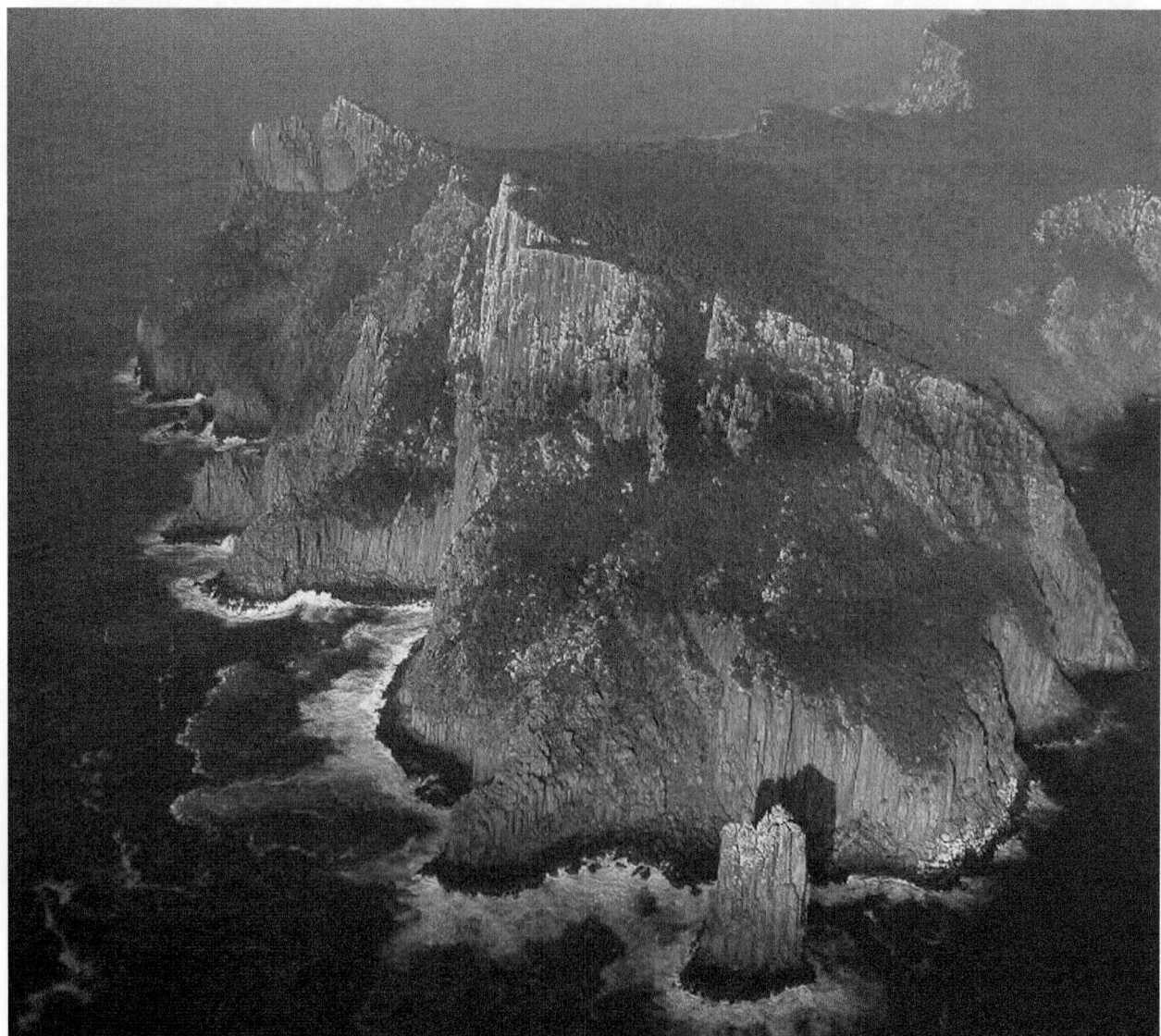

Figure 4.57 Cape Pillar is composed of columnar Jurassic dolerite, which dominates much of the east and south coast.

Regional map 4 South East Coast: Cape Pillar to D'Entrecasteaux Channel

Figure 4.58 Region 2: The South East Coast between Cape Pillar and the D'Entrecasteaux Channel

T 310-312 **PORT ARTHUR (E)**

No.	Beach	Rating HT LT	Type	Length
T310	Surveyors Cove	2 2	R	150 m
T311	Denmans Cove	1 1	R+sand flats	100 m
T312	Stinking Cove	2 2	R	300 m
Spring & neap tidal range = 1.2 & 0.3 m				

Port Arthur is a large 2,000 ha drowned valley that extends 10 km north of the entrance between Budget and West Arthur heads. The eastern shore runs almost due north from Budget Head to Stinking Cove, with three beaches (T 310-312) located at the mouths of three small valleys. Two are only accessible by boat across the bay. The western shore of the bay is occupied by the famous Port Arthur ruins and a number of small communities.

Surveyors Cove is a small 100 m wide valley mouth located 4 km north of Budget Head. Beach **T 310** occupies the mouth of the steep, V-shaped valley. It is 100 m long, faces west across the 2 km wide bay, and consists of a low energy sand and cobble reflective beach, backed by the densely vegetated valley.

Denmans Cove lies 1.5 km further north in an elongate, narrow V-shaped valley, with the 100 m long beach (**T 311**) located 500 m inside the 200 m wide entrance. The beach consists of a low narrow reflective beach, backed by bare overwash flats with Denmans Creek flowing along the northern side, while it is fronted by a shallow sandy bay floor.

Stinking Cove lies in the northwestern corner of the bay at the mouth of Gathercoles Creek. This is a 300 m long low energy reflective beach (**T 312**) that faces south-southwest down the bay towards the entrance, 10 km to the south. The creek crosses towards the western end of the beach, with a forestry track off the Fortescue Road, terminating at the western end of the beach.

T 313-320 **PORT ARTHUR (W)**

No.	Beach	Rating HT LT	Type	Length
T313	Stewarts Bay	1 1	R+sand flats	500 m
T314	Ladies Bay	1 1	R+sand flats	100 m
T315	Big Possum Beach	1 1	R+sand flats	900 m
T316	Little Possum Beach	1 1	R+sand flats	150 m
T317	Briar Paddock Beach	1 1	R+sand flats	200 m
T318	Puer Road	1 1	R+sand flats	200 m
T319	Old Station Beach	1 1	R+sand flats	200 m
T320	Pt Puer Beach	1 1	R+sand flats	150 m
	Stewarts Bay State Reserve		*78 ha*	
	Port Arthur Historic Site		*125.6 ha*	
Spring & neap tidal range = 1.2 & 0.3 m				

The historic Port Arthur prison and the small settlement of Carnarvon Bay are located along the western shore of Port Arthur, centred on Stewarts and Carnarvon bays. Within the two bays are eight very low energy beaches exposed only to wind waves and all fronted by sand flats and seagrass meadows. The Arthur Highway runs close to the two bays with access roads to all the beaches.

Stewarts and Ladies bays are located in a 500 m wide southeast-facing bay located between Garden and Fryingpan points. Beach **T 313** occupies the western shore of **Stewarts Bay**. It is a narrow curving 500 m long, high tide reflective beach fronted by 200 m wide sand flats then patchy seagrass. Alberry Creek drains out at the southern end of the beach shoaling the sand flats. A few dinghies are usually stored on the beach, which has a boat ramp towards the creek mouth. A cluster of houses back the southern half of the bay, while the north half is backed by the tree-covered Stewarts Bay State Reserve.

Ladies Bay is located in the southern part of the bay in lee of Fryingpan Point. Beach **T 314** is a 100 m long strip of north-facing sand, fronted by 50 m wide sand flats then the deeper water of the outer bay. Boats are usually moored off the beach in lee of the point. The beach is located within the Port Arthur Historic Site and backed by tree-covered slopes rising to 30 m.

Carnarvon Bay is a 1 km wide bay, bordered by Commandants Point and Point Puer, which widens to 2 km along its southwestern shore. Beaches T 315-320 occupy the southwestern and eastern shore of the bay, which is also the site of the Carnarvon Bay settlement. **Big Possum Beach (T 315)** extends for 900 m along the western shore of the bay between the base of Commandants Point and the smaller Brick Point, with the settlement backing the northern half of the beach. It is a narrow high tide beach fronted by 50-100 m wide sand flats then seagrass meadows. The Safety Cove Road runs along the rear of the beach with houses on the western side of the road. Boats are stored on the beach with two small jetties crossing the beach to deeper water.

Little Possum beach (**T 316**) is located immediately east of Brick Point. It is a 150 m long, narrow strip of high tide sand, backed by the road then houses. It is bordered to the south by the low rocky Tramway Point, with a small jetty on the point. **Briar Paddock Beach (T 317)** lies to the east of Tramway Point. It is a narrow north-facing 200 m long very low energy shelly beach fronted by 200 m wide sand flats. The Puer Road runs along the rear of the beach and towards the point.

Beaches 318-320 are located in three indentations along the eastern shore of the bay and are all accessible along the 1 km long Puer Point Road. Beach **T 318** is a curving 200 m long narrow beach located in the first indentation and backed by the road. It is fronted by 50 m wide sand flats then seagrass meadows. **Old Station Beach (T 319)** lies in the next indentation. The road terminates at the southern end of the beach, with the northernmost beach located in the eastern part of the Port Arthur Historic Site. The beach is 200 m long, faces west across the bay and has seagrass growing to within 10 m off the shore. Densely vegetated slopes rising to 20 m back the beach.

Point Puer Beach (T 320) is located 200 m to the north in the final indentation in lee of 10 m high Point Puer. The curving low energy beach is 200 m long, fronted by 50 m wide sand flats then seagrass meadows.

T 321-323 SAFETY COVE-BLANKET BAY

No.	Beach	Rating HT LT		Type	Length
T321	Safety Cove	3	3	R	1.6 km
T322	Crescent Bay	4	5	LTT	900 m
T323	Basket Bay	6	8	TBR+rocks	100 m
	Safety Cove State Reserve			*16 ha*	
	Pt Puer Crescent Bay State Reserve				
Spring & neap tidal range = 1.2 & 0.3 m					

The Safety Cove Road leads to the moderately sheltered Safety Cove and onto the exposed Basket Bay, 5 km south of Port Arthur. Between the two bays is a 3 km long headland that extends southeast to 173 m high West Arthur Head. Crescent Bay is located on the northern side of the head.

Safety Cove beach **(T 321)** is a curving east- to northeast-facing sandy beach sheltered by Briggs Point, with waves averaging 1 m at the northern end next to Rileys Reef and decreasing into the southern corner. It is dominated by a moderately steep, cusped reflective beach, with bigger waves producing a heavy shorebreak. A low foredune and the road run along the rear of the beach with a car park and toilets at the northern end.

Crescent Bay is located 1 km to the south between Standup Point and Briggs Head. The two headlands form a 700 m wide, 1 km deep bay with the beach **(T 322)** curving for 900 m from the northern end of the bay and facing southeast out between the heads. The beach receives refracted waves averaging about 1 m (Fig 4.59), which combine with the medium sand to maintain a moderately steep beach, which can range from reflective to transverse bar and rips, depending on wave conditions. During bigger waves there are usually two beach rips, as well as rips against the boundary headlands. A 30 m high scarped foredune backs the northern half of the beach, with a heath-covered headland behind. The beach can only be accessed on foot along a 1.5 km track, from the southern end of Safety Cove.

Basket Bay is an exposed south-facing 700 m wide bay located at the end of the Safety Cove Road, with the clifftop car park providing views of the rugged 150 m high cliffs, as well as the patch of boulders and occasional sand at the base of the cliffs, which is beach **T 323**. The Remarkable Caves are located in the linear rocks that border the beach. At its widest the beach is sand with waves breaking over a rip-dominated surf. However during high waves the sand is stripped off to reveal a steep boulder beach. It is a steep walk down to the beach and caves, which are used by fishers and the occasional surfers, who surf peaky waves off the beach.

Figure 4.59 The curving Crescent Bay beach (T 322) usually has lower waves and a low tide terrace surf zone, with a high scarped foredune behind.

Be careful as a strong rip flows out of the small bay during higher waves.

T 324-327 TUNNEL BAY-RUSH LAGOON

No.	Beach	Rating HT LT		Type	Length
T324	Tunnel Bay	4	6	Boulder	150 m
T325	Salters Bay	4	6	Boulder	200 m
T326	Rush Lagoon	4	6	Boulder	200 m
T327	Quoin Channel	4	4	R	200 m
	Cape Raoul State Reserve				
Spring & neap tidal range = 1.2 & 0.3 m					

To the west of Basket Bay are 32 m of generally steep, high rocky shoreline, including 230 m high Cape Raoul, the southernmost tip of the Tasman Peninsula. The entire shoreline is part of the Cape Raoul State Reserve. There are only three small boulders beaches (T 324-326) and one sand beach (T 327) within the reserve.

Tunnel Bay is located 8 km west of Basket By and can be assessed along the Tunnel Bay walking track off the Stormlea Road. The 700 m deep funnel-shaped bay narrows from 600 m to 100 m with a curving 150 m long west-facing boulder beach **(T 324)** at the base of the bay. Waves are lowered to about 1 m at the beach where they surge up the steep boulder beach face. Tunnel Bay Creek crosses the northern end of the beach. The famous, or infamous, *Shipstern Bluff* point break is located 1 km southeast of the bay, and can be reached along a walking track off the Tunnel Bay track.

Salters Bay lies 2 km west of Tunnel Bay and in lee of 73 m high Salters Point. The U-shaped bay faces south with refracted waves averaging over 1 m at the base of the bay. Beach **T 325** is a curving 200 m long boulder beach located at the base of steep vegetated slopes with two steep creeks draining to either end of the beach.

Rush Lagoon is located at the northern end of west-facing Crooked Billet Bay, 1 km south of Low Point. The

small 2 ha lagoon is fed by Rat Creek and impounded in lee of a curving 200 m long southwest-facing boulder beach (**T 326**), set at the apex of the small V-shaped bay. A left-hand surf break, known as *Kelpies*, runs along the southern point. Waves average over 1 m with higher waves required to produce a good break. The beach can only be accessed on foot across farmland from the end of the Noyes Road.

Beach **T 327** is located 1 km north of Low Point in a slight indentation in the sloping rocky shoreline. It consists of a 200 m long strip of high tide sand grading into the deeper waters of the Quoin Channel. The beach is sheltered by Wedge Island with waves usually less than 1 m. It can only be accessed on foot.

T 328-330 WHITE BEACH

No.	Beach	Rating HT LT		Type	Length
T328	Wades Corner	1	1	R+sand flats	150 m
T329	White Beach	2	2	R	2.1 km
T330	White Beach (N)	1	1	R+sand flats	50 m
Spring & neap tidal range = 1.2 & 0.3 m					

Wedge Bay is a 2.5 km wide, 5 km deep bay that splits into two eastern arms. White Beach occupies the eastern shore of the southern arm while the small town of Nubeena is located at the base of the northern Parsons Bay arm. Three beaches are located in the White Beach embayment (T 328-330).

Wades Corner occupies the more sheltered southern corner of White Beach at the mouth of Cripps Creek. Beach **T 328** is located 200 m west of the creek mouth past a 100 m long section of low rocky shore. It is backed by a road and moderate slopes covered with houses. This is a very low energy north-facing beach with usually calm conditions. It is fronted by 50 m wide seagrass-covered sand flats, which widen past the rocks and towards the creek mouth. Dinghies are stored on the beach, with several boats moored just offshore.

White Beach (**T 329**) is a curving 2.1 km long west-facing sandy beach, which forms the eastern shore of the bay. It is backed by a low foredune, the White Beach Road and a scattering of houses. The beach receives very low refracted swell, which usually laps against the narrow low gradient reflective beach. It is bordered to the south by the mouth of Cripps Creek and its sand shoals, and a low rocky point at the northern end.

Beach **T 330** is a 50 m long pocket of south-facing sand located at the northern end of White Beach. It is separated from the main beach by a low rocky point and a boat ramp and seawall partly built across the western half of the beach. The small usually calm beach is fronted by 50 m wide sand flats.

T 331-334 PARSONS BAY-NUBEENA

No.	Beach	Rating HT LT		Type	Length
T331	Parsons Bay (S)	1	1	R+sand flats	500 m
T332	Nubeena	1	1	R+sand flats	600 m
T333	Nubeena (N)	1	1	R+sand flats	200 m
T334	Creeses Mistake	3	4	Cobble	50 m
Spring & neap tidal range = 1.2 & 0.3 m					

Parsons Bay is an L-shaped 3 km long bay that narrows towards the mouth of Parsons Creek. Three beaches occupy parts of the sheltered low energy bay, with the town of Nubeena backing the eastern shore of the bay.

Beach **T 331** is located on the southern shore of the bay, extending for 500 m west of a small rocky outcrop called Flax Island. The low narrow beach is usually calm and fronted by 50 m wide sand flats, with dinghies stored on the beach. A jetty is located on the western point in lee of the island and the Parsons Bay road runs along the rear of the low beach.

Nubeena beach (**T 332**) fronts the township, with a narrow foreshore reserve between the beach and the Nubeena Road and houses on the backing slopes. It is a narrow low energy west-facing beach, fronted by small sand flats then the deeper water of the bay. There is a small jetty at the southern end, while small boats are pulled up on the beach. Sandstone bluffs rising to 15 m back and border the northern end of the beach.

Beach **T 333** is located on the northern side of the boundary bluffs and is spread across the mouth of Sucklings Creek. The beach is 200 m long and faces west across 200 m wide sand flats, with the creek flowing out along the northern side of the beach. It is backed by a storage pond and the Nubeena hospital.

Creeses Mistake is an indentation in the rocky northern shore of Wedge Bay, immediately west of North Passage Point and just outside the entrance to Parsons Bay. Wedged in the corner of the indentation is a 50 m long southwest-facing cobble beach (**T 334**). The beach is backed by densely vegetated slopes rising to 190 m high Blueys Hill and is only accessible by boat.

T 335 ROARING BEACH

No.	Beach	Rating HT LT		Type	Length
T335	Roaring Beach	6	7	TBR	900 m
	Roaring Beach Coastal Reserve				*109 ha*
Spring & neap tidal range = 1.2 & 0.3 m					

Roaring Beach (**T 335**) is the only surfing beach on the western side of Tasman Peninsula. The 900 m long southwest-facing beach is located on the more exposed

western coast 5 km west of Nubeena, with access to a high car park via the Roaring Bay Road. The beach receives waves averaging up to 1.5 m increasing in height up the beach. They break across a 100 m wide rip-dominated surf zone (Fig. 4.60). There are usually two beach rips with permanent rips flowing out against the boundary headlands, which extend 300 m to the southwest. The strongest rip is usually against the northern headland. There are beach breaks along the beach, with the best surf usually towards the southern end of the beach. A transgressive dune field fills the small valley backing the northern half of the beach, with the now vegetated dunes extending up to 600 m inland and to 30 m in height. Only one large blowout remains active. A small creek meanders through the dunes and occasionally breaks out across the centre of the beach. The beach, dunes and adjacent shoreline are located in the Roaring Beach Coastal Reserve.

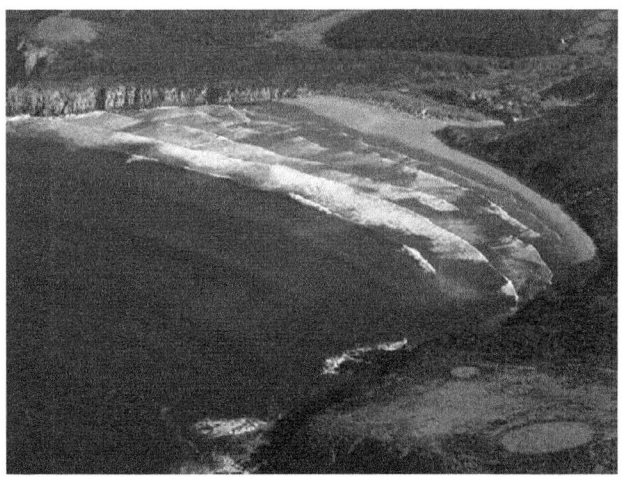

Figure 4.60 Roaring Beach (T 335) is one of the more exposed surfing beaches on the Tasman Peninsula and a popular surfing spot, though hazardous for swimming.

T 336 BLACK JACK BIGHT

No.	Beach	Rating HT LT	Type	Length
T336	Black Jack Bight	3 4	R/LTT	300 m
Spring & neap tidal range = 1.2 & 0.3 m				

Black Jack Bight is a 250 m wide southeast-facing rocky bay located 1.5 km south of North West Head. The isolated bay is backed by slopes rising steeply to 200 m high Black Jack Hill and Mount Wilmot, with a steep V-shaped valley descending to the rear of the bay. Beach **T 336** is a narrow curving 300 m long sand and cobble beach located along the eastern base of the bay, with steep slopes rising behind. The cobbles form a steep high tide beach, fronted by a sandy low tide terrace. Waves average above 1 m increasing slightly in height up the beach. The beach is only accessible by boat.

T 337-339 BLACK JACK POINT

No.	Beach	Rating HT LT	Type	Length
T337	Black Jack Pt (W)	3 3	Cobble	200 m
T338	Black Jack Pt (E1)	2 3	Cobble	200 m
T339	Black Jack Pt (E2)	2 3	Cobble	200 m
Spring & neap tidal range = 1.2 & 0.2 m				

Black Jack Point is a low cleared headland, to either side of which is a rocky shoreline dominated by low energy cobble beaches. The cobbles have been supplied by erosion of the Triassic sandstone that forms the shoreline of the point.

Beach **T 337** is a 200 m long double crenulate, steep narrow cobble beach that is located 500 m west of the point. It faces north and receives only low refracted waves. It is backed by cleared farmland and a farmhouse.

Beach **T 338** lies to the eastern side of the point. It is a curving, protruding cobble beach that has built out along its eastern end to form a cobble point. Cleared farmland and a house back the western end of the beach, with dense tree growth along the eastern end. Beach **T 339** is located 100 m further on and consists of a narrow curving northwest-facing cobble beach, with tall trees extending right to the shore. A boat shed is located on the crest of the beach, with a house behind, and a boat usually moored just offshore.

T 340 SLOPING MAIN

No.	Beach	Rating HT LT	Type	Length
T340	Sloping Main	2 2	R	3.5 km
Spring & neap tidal range = 1.2 & 0.3 m				

Sloping Main beach (**T 340**) is a curving 3.5 km long low energy west-facing beach located in the 3 km wide bay bounded by Black Jack Point and the northern Lobster Point. The beach receives low refracted waves, which average about 0.5 m at the shore and maintain a white sand reflective beach, usually lined with cusps. The beach is backed by a series of low foredune ridges which widen to 200 m in the north then the 200 ha Burdens Marshes, a partly drained wetland, which drains out at the very northern end of the beach. The small Gwandalan settlement is located at the very southern end of the beach, with a road and beachfront houses also backing the first 1 km of the beach.

T 341-348 LOBSTER POINT-GREEN HEAD

No.	Beach	Rating HT LT	Type	Length
T341	Lobster Pt (S2)	2　3	R	200 m
T342	Lobster Pt (S1)	2　4	R+rock flats	80 m
T343	Lagoon Beach	2　3	R→LTT	1.6 km
T344	Lagoon Beach (N1)	2　3	R+rock flats	400 m
T345	Lagoon Beach (N2)	2　3	R+rock flats	100 m
T346	Green Hd (W3)	2　3	R+rocks	70 m
T347	Green Hd (W2)	2　3	R+rocks	50 m
T348	Green Hd (W1)	2　3	R+rocks	40 m
	Lime Bay Nature Reserve		*1310 ha*	
Spring & neap tidal range = 1.2 & 0.3 m				

Green Head is the northernmost point of the Tasman Peninsula and forms the boundary between the large Frederick Henry Bay that opens in the south to the sea, and the sheltered Norfolk Bay that extends to the east and south and separates Tasman from Forestier peninsulas. Between Green Head and Sloping Main beach are 5 km of west-facing shore, containing eight low energy reflective beaches (T 341-348), which are partly sheltered by Sloping Island. All the beaches are located within the Lime Bay Nature Reserve.

Beaches T 341 and 342 are located on the rocky shore that extends for 1.5 km southeast of Lobster Point to Sloping Main beach. Beach **T 341** is a 200 m long west-facing reflective beach bordered by sloping sandstone points and backed by partly vegetated 10 m high bluffs, then densely vegetated slopes. Patchy seagrass and some rocky seafloor lie off the beach. Beach **T 342** lies 100 m to the north and is an 80 m long strip of high tide sand located at the base of 5-10 m high sandstone bluffs and fronted by 80 m wide intertidal rock flats. The beaches are only accessible along a foot track that follows the crest of the bluffs.

Lobster Point is a sloping densely vegetated headland, which forms the southern boundary of 1.6 km long **Lagoon Beach (T 343)**. The beach trends to the northwest and lies 2 km to the lee of 1.5 km long Sloping Island. The beach receives waves averaging about 0.5 m, which pick up a little towards the northern end, with the beach also grading from reflective in the south to low tide terrace in the north. The beach is backed by a 10-15 m high foredune, which has been breached by several blowouts, which are actively transgressing 50-100 m inland. This is backed by the 1.5 km wide 50 ha Sloping Lagoon, which links with the rear of the western Lime Bay beach (T 349). A smaller lagoon backs the northern end of the beach and a vehicle track accesses the southern and central section between the lagoons.

A small rocky point forms the northern boundary of Lagoon Beach on the north side of which is 400 m long beach **T 344**. Several low rock outcrops front the beach with sandy patches in between. Beach **T 345** lies immediately to the north and is a similar 100 m long strip of high tide sand, fronted by continuous 50 m wide

intertidal rock flats, with only a small sandy opening at the southern end. Dense vegetation grows right to the sand behind both beaches, which have no formal access.

Beach **T 346** is a narrow isolated 70 m long pocket of sand and rocks located 700 m west of Green Head. It is bordered and backed by 20 m high eroding bluffs, whose debris litters the small low energy beach.

Beaches T 347 and 348 are two adjoining pockets of sand located immediately west of the tip of Green Head. Beach **T 347** is a curving 50 m long pocket of sand almost encased by the bordering and backing 10-20 m high sandstone bluffs. Beach **T 348** lies 100 m to the east and is a similar 40 m long pocket of sand with rock debris from the backing 20 m high bluffs littering the beach. Both beaches open onto the sand seafloor, which surrounds the tip of the headland. They are only accessible by boat.

T 349-350 LIME BAY

No.	Beach	Rating HT LT	Type	Length
T349	Lime Bay (W)	1　1	R+ridged sand flats	400 m
T350	Lime Bay (E)	1　1	R+ridged sand flats	700 m
Spring & neap tidal range = 1.3 & 0.3 m				

Lime Bay is a north-facing 1 km wide bay located at the northern end of the Tasman Peninsula to the west of Whitehouse Point. Only low wind waves usually enter the bay, which is largely filled with 500 m wide intertidal ridged sand flats backed by two very low energy shell-rich beaches (T 349 and 350). Beach **T 349** extends for 400 m from the western boundary slopes of 100 m high Black Rock Hill to a central 150 m wide low rock outcrop (Fig. 4.61). Low densely vegetated flats back the beach extending 500 m west to the eastern end of Sloping Lagoon. Beach **T 350** continues on the eastern side of the rocks for another 700 m to the western rocks of Whitehouse Point. A gravel road reaches the centre of the beaches, with an extensive camping area under the trees behind the western end of beach T 350. Small boats can be launched across the beach.

T 351-356 MONK & IRONSTONE BAYS

No.	Beach	Rating HT LT	Type	Length
T351	Monk Bay (N)	1　1	R+ridged sand flats	100 m
T352	Monk Bay (S)	1　1	R+ridged sand flats	350 m
T353	Ironstone Pt	1　2	Cobble	70 m
T354	Ironstone Bay	1　1	R+sand flats	150 m
T355	Ironstone Bay (S1)	1　1	R+rocks	70 m
T356	Ironstone Bay (S2)	1　1	R+sand flats	30 m
	Coal Mines Historic Site		*217 ha*	
Spring & neap tidal range = 1.3 & 0.3 m				

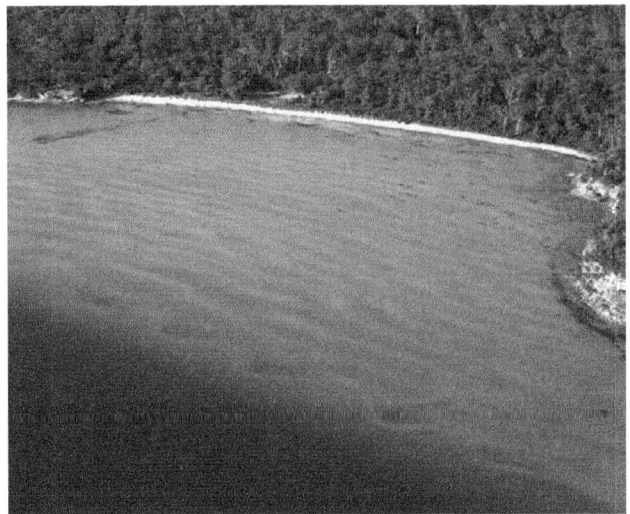

Figure 4.61 The western Lime Bay beach (T 349) is fronted by 500 m wide ridged sand flats.

At **Whitehouse Point** the rocky shoreline turns and trends to the south for 5 km to Salem Bay then southeast for 17 km to Cascades Bay at the base of Norfolk Bay. The entire shoreline is dominated by the horizontally bedded sandstone and claystones, with a few very low energy beaches and sand flats located in some of the bays. Along the first 3 km are six beaches adjacent to Monk and Ironstone bays. All are located within Lime Bay Nature Reserve, with access only to the southernmost beach (T 356).

Monk Bay is an open 1 km wide northeast-facing bay bordered in the east by 15 m high Ironstone Point. Two beaches occupy the bay shore. Beach **T 351** is a 100 m long strip of narrow high tide sand bordered to the east by a 50 m wide clump of rocks. Beach **T 352** continues on the other side of the rocks for another 350 m to the base of Ironstone Point. Both beaches are fronted by continuous 250 m wide ridged sand flats that fill much of the bay floor. The beach is backed by eroding 5-10 m high bluffs, then densely wooded slopes that rise to 50 m.

Beach **T 353** is located 300 m to the east in a small indentation on the northern side of Ironstone Point. The 70 m long beach is composed of steeply sloping cobbles that are fronted by the eastern extension of the sand flats, which narrow to 100 m off the beach. It is backed by moderately steep partly vegetated slopes that rise to 15 m.

Ironstone Bay is located on the southern side of the point. It is a small southeast-facing 500 m wide embayment, with beach **T 354** occupying 150 m of the bay shore. It is a narrow low energy sandy high tide beach fronted by 150 m wide sand flats. Tree-covered slopes rising to 20 m back the beach.

Beaches T 355 and 356 are located 800 m to the south at the boundary between the reserve and the 217 ha Coal Mines Historic Site. Beach **T 355** is a 70 m long strip of sand with a rock outcrop causing a slight foreland towards the southern end. It is fronted by a 100 m wide mixture of sand and rock flats, and backed by rising tree-

covered slopes. Beach **T 356** lies 200 m to the south and is a 30 m long pocket of sand located at the end of a vehicle track that defines the boundary between the reserve and historic site. The sand and rocks narrow to 50 m off the beach.

T 357-359 TURNER POINT-SALEM BAY

No.	Beach	Rating HT LT		Type	Length
T357	Turner Pt (N)	1	1	R+ridged sand flats	100 m
T358	Salem Bay (N)	1	1	R+ridged sand flats	100 m
T359	Salem Bay	1	1	R+ridged sand flats	700 m
Spring & neap tidal range = 1.3 & 0.3 m					

The southern shores of **Norfolk Bay** consist of a series of north-trending ridges of sedimentary rocks separated by several very low energy embayments, some of which contain small beaches and extensive tidal flats. The beaches in the area are only exposed to wind waves generated within the 10 km wide, 15 km deep bay. Much of the southern shoreline is accessible along the Coal Mine, Saltwater and Nubeena roads. Beaches T 357-359 are located between Turner Point and Salem Bay in the southwestern corner of the bay.

Beach **T 357** is a 100 m long strip of east-facing sand located 500 m north of Turner Point. It faces east across ridged 200 m wide sand flats, with moderately sloping tree-covered bluffs behind and rocky shore to either side. A few houses are located on the slopes behind the bluffs and to either side of the beach.

Salem Bay is a 1.5 km wide east-facing embayment bordered by the low Turner Point to the north and Salem Point to the south. Ridged sand flats link the two points and widen to 600 m in the centre of the bay. Beach **T 358** is located on the southern side of Turner Point and faces south across the sand flats. It is 100 m long and backed by moderately sloping tree-covered terrain, then the houses of Turner Point. A boat ramp is located at the eastern end of the beach.

Beach **T 359** occupies the 700 m long base of the bay and faces northeast across the widest section of sand flats. It consists of a steep, narrow shell-rich high tide beach fronted by the sand flats, with salt marsh growing behind the low beach crest (Fig. 4.62). Garnetts Creek drains out across the centre of the beach and continues across the inner sand flats. The Saltwater Road runs along the rear of the beach, which is used for launching small boats.

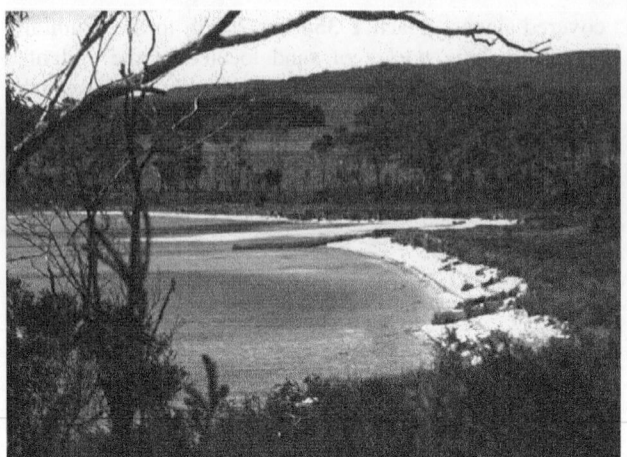

Figure 4.62 Salem Bay beach (T 359) is a low energy high tide beach fronted by sand flats and backed by salt marsh.

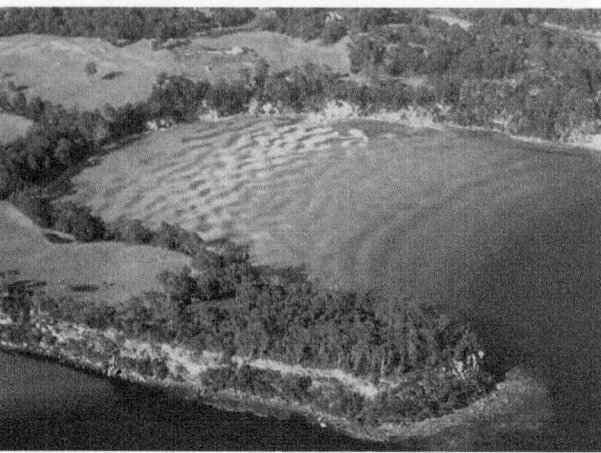

Figure 4.63 Parkers Beach (T 361) is a narrow sheltered beach fronted by 250 m wide ridged intertidal sand flats.

T 360-365 PRICES BAY-NEWMANS BEACH

No.	Beach	Rating HT LT	Type	Length
T360	Prices Bay	1 1	R+ridged sand flats	700 m
T361	Parkers Beach	1 1	R+ridged sand flats	300 m
T362	Eli Pt (E)	1 1	R+ridged sand flats	100 m
T363	Parkinsons Pt (W)	1 1	R+ridged sand flats	100 m
T364	Shelly Beach	1 1	R+ridged sand flats	200 m
T365	Newmans Beach	1 1	R+ridged sand flats	300 m
Spring & neap tidal range = 1.3 & 0.3 m				

The southernmost section of Norfolk Bay between Deer and Sympathy points is an 8 km wide north-facing sheltered embayment, containing seven small bays each bordered by north-trending sandstone ridges. Within the small bays are six low energy beaches and their associated sand flats (T360-365). Most are accessible from the Nubeena Road.

Prices Bay is a 1.5 km wide north-facing U-shaped bay bordered to the east by 1.5 km long Halfway Bluff. Beach **T 360** is located along the southeastern base of the bay. It is a low narrow low energy high tide beach fronted by 500 m wide ridged sand flats. The Saltwater Road runs along the rear of the beach, with farmland extending to the south.

Parkers Beach (T 361) occupies a 500 m wide U-shaped bay bordered by Glenila and Eli points. The low energy 3 m wide high tide beach is 300 m long, faces north-northwest and extends along the base of the bay, with eroding 10 m high bluffs bordering the western end. A short road off the Nubeena Road leads to the eastern end of the small beach where there is a small park and toilet. Ridged sand flats extend 250 m offshore half filling the bay (Fig. 4.63).

Beaches **T 362** and **T 363** are located in a more open 700 m wide embayment bordered by the 30 m high Eli and Parkinsons points, with 50 m long, 30 m high bluffs separating the two 100 m long beaches. The slightly more exposed beaches consist of a 5 m wide high tide beach fronted by 100 m wide ridged sand flats. They are backed by farmland with no direct public access.

Shelly Beach (T 364) is located on a 500 m wide headland in the centre of Cascades Bay. The 200 m long beach faces north across 100 m wide sand flats. It is backed and bordered by tree-covered bluffs, and accessible along a 700 m long gravel road off the Nubeena Road. The 10 m wide beach is rich with mollusc shells and is backed by a storm boulder beach, then the small car park and toilets.

Newmans Beach (T 365) is located in the southeastern corner of Cascades Bay and faces northwest out into Norfolk Bay. The very low energy 300 m long beach is fronted by 400 m wide sand flats and backed by tree-covered slopes, which rise gradually to the Nubeena Road, located 200 m to the east.

T 366 EAGLEHAWK NECK (W)

No.	Beach	Rating HT LT	Type	Length
T366	Eaglehawk Neck (W)	1 1	R+sand flats	400 m
Spring & neap tidal range = 1.3 & 0.3 m				

Eaglehawk Neck connects the Tasman Peninsula to the mainland. The high energy ocean beach (T 305) occupies the eastern side of the neck, with the smaller very low energy beach **T 366** on the western side. The 10 m wide beach faces west across 200 m wide ridged sand flats, then down the 500 m wide, 5 km long Eaglehawk Bay, with moderately steep wooded slopes rising to either side. The Tasman Highway runs along the rear of the beach then along the southern side of the bay.

T 367-368 FLINDERS & SOMMERS BAYS

No.	Beach	Rating HT LT	Type	Length
T367	Flinders Bay	1 1	R+ridged sand flats	100m
T368	Sommers Bay	1 1	R+ridged sand flats	200 m
	Eaglehawk Bay-Flinders Bay Conservation Area 455 ha			
Spring & neap tidal range = 1.3 & 0.3 m				

The northeast shores of Norfolk Bay consist of a few deeply incised drowned valleys that trend east into the tree-covered slopes of the Forestier Peninsula. Several very low energy beaches and sand flats are located in some of the more exposed small bays with beaches T 367 and T 368 located in Flinders and Sommers bays respectively.

Flinders Bay is a V-shaped bay that narrows to the mouth of Flinders Creek. Westerly wind waves blowing into the creek mouth have produced a 100 m long high tide beach (**T 367**) immediately south of the creek mouth, fronted by ridged sand flats that widen to 300 m at the creek mouth. The entire bay is bordered by tree-covered slopes that rise steeply to over 100 m. A vehicle track from the highway terminates at the beach where there are some buildings associated an oyster farm in the bay.

Sommers Bay occupies a small valley that links Conical Hill and Point to the peninsula. At the base of the 1 km wide U-shaped bay is a narrow 200 m long south-facing shelly high tide beach (**T 368**), fronted by 200 m wide ridged sand flats. The Sommers Bay Road terminates behind the centre of the beach, which is backed by a 50 m wide tree-filled reserve, with cleared land and several houses behind and on the slopes that rise to either side of the beach.

T 369-373 DUCK CREEK-BELLETTES BAY

No.	Beach	Rating HT LT	Type	Length
T369	Duck Ck	1 1	R+ridged sand flats	200 m
T370	Bellettes Pt (S)	1 1	R+ridged sand flats	150 m
T371	Bellettes Bay	1 1	R+ridged sand flats	800 m
T372	Daltons Beach	1 1	R+ridged sand flats	300 m
T373	Dunbabin Pt (E)	1 1	R+ridged sand flats	100 m
Spring & neap tidal range = 1.3 & 0.3 m				

Duck Creek and Bellettes Bay are located either side of 500 m wide King George Sound. Bellettes Bay is a 1.2 km wide southwest-facing low energy embayment, bordered by Bellettes Point to the southeast and Dunbabin Point in the west. Beach T 369 is located on the southern side of Bellettes Point, while beaches T 370-373 occupy three smaller curving embayments within Bellettes Bay.

Duck Creek flows into a U-shaped 500 m wide northwest-facing low energy bay with beach **T 369** located along the base of the bay on the north side of the creek mouth. The narrow 200 m long shell-rich beach faces northwest across 400 m wide ridged sand flats. The Sommers Bay Road runs around the bay and across the rear of the beach.

Bellettes Point is a 200 m wide, 15 m high tree-covered headland, with beach **T 370** located immediately to the west in a small south-facing 300 m wide embayment. The narrow 150 m long beach is fronted by 100 m wide sand flats, with rocks littering the beach and inner flats. A vehicle track reaches the rear of the beach.

Beach **T 371** occupies the southern half of **Bellettes Bay**. It extends for 800 m along the eastern shore of the west-facing bay, from the northern side of Bellettes Point to a small creek, which forms its northern boundary. Densely wooded slopes rise to 100 m behind the beach, with a slight bedrock induced protrusion in the centre of the beach. It is fronted by ridged sand flats, which widen from 200 m in the south to 400 m in the north. A vehicle track reaches the northern end of the beach where there is a solitary house.

Daltons Beach (**T 372**) is located in the northern corner of Bellettes Bay. It faces south-southwest out of the bay and consists of a narrow 300 m long high tide beach fronted by 300 m wide ridged sand flats (Fig. 4.64). It is bordered by rising tree-covered slopes and backed by low ground with a few houses and a central 2 ha pond. Beach **T 373** is located 200 m to the west in lee of 40 m high Dunbabin Point. The narrow 100 mm long beach lies at the base of bluffs rising to 10 m with a farmhouse and orchards on the slopes behind. It faces south across the sand flats it shares with Daltons Beach.

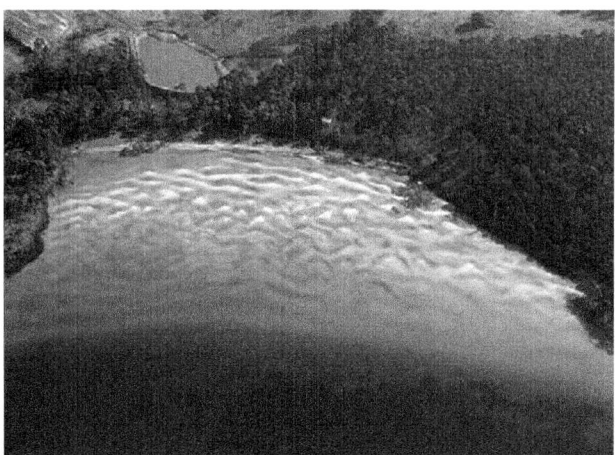

Figure 4.64 Daltons Beach (T 372) and multiple intertidal sand ridges.

T 374-379 WIGGINS POINT-DUNALLEY BEACH

No.	Beach	Rating HT LT	Type	Length
T374	Wiggins Pt (E1)	1 1	R+sand flats	100 m
T375	Wiggins Pt (E2)	1 1	R+sand flats	100 m
T376	Carlisle Beach	1 1	R+ridged sand flats	600 m
T377	Dunalley Beach	1 1	R+ridged sand flats	1.1 km
T378	Dunalley Beach (N)	1 1	R+ridged sand flats	250 m
T379	Dunalley Bay (N)	1 1	R+ridged sand flats	800 m
Spring & neap tidal range = 1.3 & 0.3 m				

Dunalley Bay is a curving 2.5 km wide southwest-facing bay bordered by Wiggins Point in the south and Stroud Point to the north. In between the shoreline curves round for 7 km and contains six low energy beaches (T 375-379), all fronted by extensive sand flats. The small town of Dunalley is located at the top of the bay adjacent to the Denison boat canal, which connects Blackmans Bay to Norfolk Bay.

Wiggins Point is a 15 m high dolerite point to the east of which the shoreline curves to the northeast. Beach **T 374** lies in a 300 m wide north-facing embayment immediately east of the point. The beach is 100 m long and fronted by 150 m wide sand flats, with rocky shore to either side and cleared farmland behind. Beach **T 375** lies 500 m to the north and is a similar 100 m long west-facing pocket of high tide sand fronted by 100 m wide sand flats, with a cleared 200 m long, 15 m high headland separating it from Carlisle Beach. Cleared land and a farmhouse back the beach.

Carlisle Beach (**T 376**) is a 600 m long beach that faces west out of the bay. It receives low westerly wind waves which break across a 150 m wide ridged sand flats (Fig. 4.65), with a narrow high tide beach backed by sloping cleared land, then the Tasman Highway 100 m behind. A few houses are located between the highway and beach.

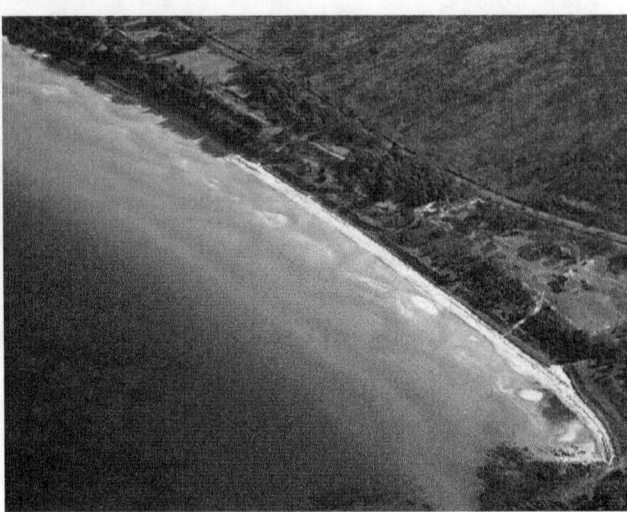

Figure 4.65 Carlisle Beach (T 376) has a 150 m wide mixture of inner rhythmic ridges grading into shore-parallel outer ridges.

Dunalley Beach (**T 377**) commences 500 m further north and is a 1.1 km long slightly curving west-southwest-facing shelly high tide beach fronted by 500 m wide ridged sand flats, with up to 30 m subdued ridges. These are the best developed ridges in Norfolk Bay. The highway runs along the rear of the beach with cleared farmland to the eastern side. A low 300 m wide wooded point separates it from beach **T 378**, which trends to the northwest for another 250 m, terminating against the beginning of the training wall for the canal. The narrow high tide beach is fronted by 300 m wide ridged sand flats, and backed by 300 m of timbered private land and a solitary house between the shore and highway.

Beach **T 379** occupies the northern section of Dunalley Bay. It commences west of the canal entrance and curves round the top of the bay for 800 m, facing south down the bay and across 300-400 m wide sand flats. Oyster racks are located across the western section of the sand flats. The narrow high tide beach is backed by the Fulham Road and cleared farmland, with the cleared slopes of 30 m high Stroud Point forming the western boundary.

T 380-382 BREAKNOCK BAY-FULHAM POINT

No.	Beach	Rating HT LT	Type	Length
T380	Breaknock Bay (E)	1 1	R+sand flats	100 m
T381	Breaknock Bay (W)	1 1	R+sand flats	100 m
T382	Fulham Pt (W)	1 1	R+sand flats	150 m
Spring & neap tidal range = 1.3 & 0.3 m				

The northern shore of Norfolk Bay commences at Stroud Point and trends west for 10 km to Renard Point. In between are a series of south-trending headlands forming several small embayments, some of which are occupied by low energy beaches. **Breaknock Bay** lies 1 km west of Stroud Point and contains two small beaches (T 380 and 381). Beach **T 380** is a narrow 100 m long strip of high tide sand fronted by 100 m wide sand flats. Beach **T 381** lies 100 m to the west, with a low bluff in between. It is a similar 100 m long strip of sand and fronted by the same continuous sand flats. They are backed by low grassy bluffs, cleared farmland with the Fulham Road 200 m to the north. Oyster racks are located on the sand flats.

Beach **T 382** is located in the next embayment 500 m northwest of the cleared 50 m high Fulham Point. The beach occupies the first indentation in the bay and is a curving 150 m long sand and cobble beach, fronted by 100 m wide sand flats. Cleared land and fishponds back the beach, with the road 200 m inland.

T 383-390 **WYKEHOLM-PRIMROSE POINTS**

No.	Beach	Rating HT	LT	Type	Length
T383	Wykeholm Pt (W)	1	1	R+ridged sand flats	200 m
T384	Dorman Pt (E)	1	1	R+sand flats	150 m
T385	Dorman Pt (W)	1	1	R+ridged sand flats	100 m
T386	Connellys Bay	1	1	R+ridged sand flats	950 m
T387	Susan Bay (E)	1	1	R+ridged sand flats	250 m
T388	Susan Bay (W)	1	1	R+sand flats	100 m
T389	Gypsy Bay	1	1	R+sand flats	100 m
T390	Primrose Pt (W)	1	1	R	150 m
Spring & neap tidal range − 1.3 & 0.3 m					

Wykeholm Point is a sloping 15 m high grassy dolerite headland to the west of which is a series of five small south-facing embayments that extend for 5.5 m km to Primrose Point which marks the northern entrance to Norfolk Bay. Eight low energy beaches (T 383-390) and sand flats are located between the two points.

Beach **T 383** is located 300 m northwest of Wykeholm Point and consists of a southwest-facing 200 m long high tide beach fronted by 100 m wide sand flats with subdued ridges (Fig. 4.66). A small creek crosses the centre of the beach, which is backed by a grassy verge then cleared farmland, with the Fulham Road 150 m to the north. Vegetated 5-10 m high rocky bluffs border the beach.

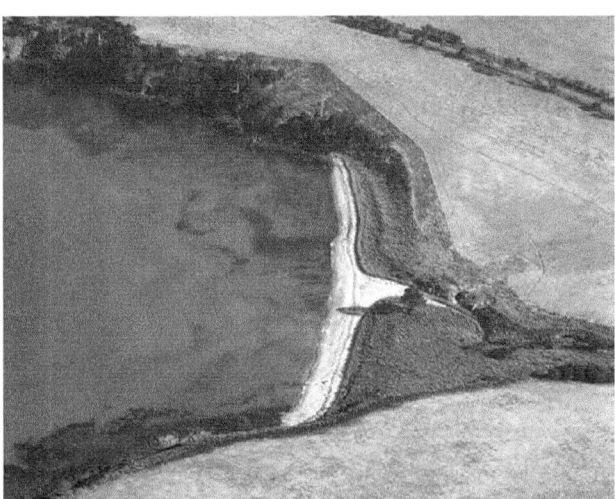

Figure 4.66 Beach T 383 is a sheltered beach backed by a low grassy foredune, and then cleared farmland.

Beach **T 384** is located 1 km to the west at the eastern base of 19 m high Dorman Point. It is a sheltered 150 m long south-facing beach backed by 10 m high vegetated rocky bluffs, and then cleared farmland. The narrow 150 m long beach is fronted by a 100 m wide mixture of sand and rock flats. A solitary boat shed is located at the base of the western bluffs, with a farm track running along the top of the bluffs and the road 200 m to the north.

Beach **T 385** is a 100 m long pocket of west-facing sand located on the western side of Dorman Point. The beach is bordered by low dolerite boulders and rocks, which form a small 100 m wide embayment, filled with 100 m

wide sand flats. Cleared farmland backs the beach and covers the point.

Connellys Bay is a 1 km wide southwest-facing bay bordered by Dorman Point in the west and the lower slopes of 180 m high Thornes Hills to the west. Beach **T 386** faces southwest out of the bay and extends for 950 m between the two bedrock highs. This is a more exposed beach with a 15 m wide high tide beach and 200 m wide ridged sand flats backed by a 5 m high foredune. A row of beachfront homes back the small foredune and occupy the 100 m wide barrier. The barrier is backed by Connellys Marsh, which feeds into Connellys Creek and drains across the southern end of the beach. Houses also spread for 1 km along the western slopes of the bay.

Susan Bay is a curving 700 m wide south-facing bay located at the eastern end of the Primrose Sands settlement. The low energy bay is backed by the cleared northern slopes of the Thornes Hills. Two beaches (T 387 & 388) occupy parts of the bay shore. Beach **T 387** is a 250 m long narrow strip of high tide sand, fronted by 50 m wide sand flats, and backed by a row of trees, then the rising cleared farmland. Beach **T 388** lies 500 m to the west, tucked in the western corner of the bay, and is a 5 m wide 100 m long high tide beach located at the base of the slopes and fronted by ridged sand flats which widen to 250 m. The easternmost houses of Primrose Sands are located behind the bluffs at the western end of the beach.

Gypsy Bay is located 1 km to the southwest and lies to the lee of Primrose Point. It is an open southeast-facing bay and contains one small beach (**T 389**). The beach is a sheltered southeast-facing 100 m long steep cobble beach, backed by 5 m high bluffs then houses. A boat ramp and protecting groyne cross the centre of the beach, with the groyne extending 50 m out to the edge of the sand flats. Several boat sheds and jetties lie at the base of the bluffs to either side of the beach.

Beach **T 390** is located 100 m to the west and on the western side of Primrose Point. It is a moderately steep 150 m long pocket of sand and cobbles, backed by 10 m high bluffs and blufftop houses, with a track cutting diagonally across the bluffs to reach the small beach and a boat ramp at the northern end.

T 391 **PRIMROSE BEACH**

No.	Beach	Rating HT	LT	Type	Length
T391	Primrose Beach	3	3	LTT	1.8 km
Spring & neap tidal range = 1.2 & 0.3 m					

Primrose Beach (**T 391**) is a slightly curving 1.8 km long southwest-facing beach located between Renard Point in the east and 100 m high Carlton Bluff in the west. The moderately exposed beach faces down Frederick Henry Bay and receives low refracted swell averaging about 0.5 m. The waves combine with the fine

sand to maintain a low gradient usually cusped beach and 50 m wide low tide terrace, with rips usually absent. The beach is backed by a 10 m high marram covered foredune, then the houses of Primrose Sands, which parallel the beach. The houses sit atop a 200 m wide barrier backed in the centre by a shallow 10 ha lake. There is beach access towards the southern end where there is a small reserve and toilets and in the more sheltered northern corner where boats are launched across the beach.

T 392 CARLTON BEACH (SLSC)

No.	Beach	Rating HT LT	Type	Length
T392	Carlton Beach	5 5	TBR	2.7 km

CARLTON PARK SLSC
Patrols:
December–March (weekends & public holidays)
Spring & neap tidal range = 1.2 & 0.3 m

Carlton Beach (T 392) is a popular summer surfing beach located 40 km east of Hobart. The Carlton Beach Road runs off the Carlton Road and provides good access to the beach. The beach is 2.7 km long and faces south-southwest towards the entrance to Frederick Henry Bay 15 km to the south. The Carlton River mouth, its deep inlet and neighbouring Carlton Bluff form the eastern boundary with 20 m high Spectacle Head to the west (Fig. 4.67). The entire beach is backed by a coastal reserve containing a 10-15 m high foredune, then houses straddling each side of the Carlton Beach Road. Several walking tracks cross the dune to the beach. The Carlton Park Surf Life Saving Club (CPBSLSC), founded in 1975, is located in a recreation reserve toward the eastern end of the beach (Fig. 4.68).

Figure 4.67 Carlton Beach is located deep inside Fredrick Henry Bay adjacent to the Carlton River mouth.

While the beach is set deep within Frederick Henry Bay, owing to its southerly orientation it receives most southerly swell entering the bay, with waves averaging about 1 m and occasionally higher. These interact with the fine beach sand to maintain a low gradient beach and surf zone, with a 50-100 m wide bar often cut by rips

spaced about every 200 m along the beach. In addition there is a permanent rip against Spectacle Head, and strong tidal currents flowing off the eastern end of the beach out of the 100 m wide Carlton River mouth.

Figure 4.68 Carlton Beach (T 392) and the Carlton Park Beach Surf Life Saving Club.

Swimming: Carlton Beach is a potentially hazardous beach, particularly if waves exceed 1 m and rips intensify. The best swimming is at the surf life saving club in the patrolled area. Watch out for rips and stay close inshore on the attached portions of the bars. The Carlton River mouth is particularly dangerous for swimming with a strong rip present especially on outgoing tides. It accounts for 90% of the CPBSLSC rescues.

Surfing: Carlton usually offers beach breaks, however in a big south swell the *Carlton River mouth* bars can produce good lefts, with rights off the *Spectacle Head* end.

T 393-396 RED OCHRE-OKINES BEACHES

No.	Beach	Rating HT LT	Type	Length
T393	Red Ochre Beach (1)	3 4	R+sand/rock flats	300 m
T394	Red Ochre Beach (2)	3 3	R+sand flats	400 m
T395	Tiger Head Beach	1 2	R+sand flats	800 m
T396	Okines Beach	3 4	R+sand flats	1 km

Spring & neap tidal range = 1.2 & 0.3 m

At Spectacle Head the shoreline turns and trends north for 3 km into Pitt Water, a 3 km wide coastal lagoon. Four increasingly protected and low energy beaches (T 393-396) occupy parts of the west-facing shoreline. All are backed by housing associated with Park Beach, Bally Park and Dodges Ferry.

Red Ochre Beach is a protected west-facing beach located on the north side of Spectacle Head and is divided into two sections (T 393 and 394) by a 50 m long central outcrop of low rocks and boulders. The southern half (**T 393**) consists of a steep, narrow 300 m long west-facing sand and gravel beach and is backed by several boat sheds and fronted by shallow rock- and seagrass-covered seabed. The northern half (**T 394**) is 400 m long

consisting of a wider sandy high tide beach and low hummocky foredune, with a narrow shallow bar and the Blue Lagoon Reserve backing the northern end.

Tiger Head Bay is an open bay in lee of Tiger Head, with an 800 m long low energy, northwest facing beach (**T 395**) running from the head to low rocks at Dodges Ferry. The beach is low and narrow, usually calm, and backed by numerous boat sheds, together with a boat ramp, two jetties and several boats usually moored off the beach. Sand flats with patchy seagrass extend 300 m west of the southern end of the beach narrowing to the north, with the deep 300 m wide Pitt Water entrance channel, and strong tidal currents flowing past the flats.

Okines Beach (**T 396**) is located immediately north of Dodges Ferry and runs north for 1 km forming the eastern shore of the inner entrance to Pitt Water. The beach is sheltered by the entrance tidal shoals and its estuarine location with usually calm conditions at the shore. The low narrow high tide beach, with a central seawall, is fronted by 300 m wide sand flats then the 400 m wide entrance channel with its strong tidal flows. Beachfront houses back most of the beach, which is also crossed by two small creeks.

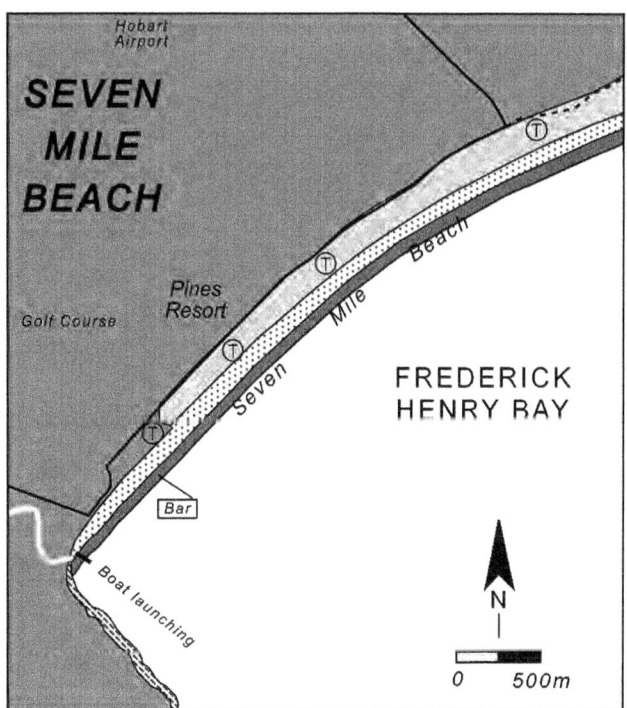

Figure 4.69 The western end of Seven Mile Beach is a popular recreational beach for Hobart.

T 397 SEVEN MILE BEACH

No.	Beach	Rating Type	Length
		HT LT	
T397	Seven Mile Beach	4 4 LTT	10.3 km
Spring & neap tidal range = 1.2 & 0.3 m			

Seven Mile Beach (**T 397**) is the closest surfing beach to Hobart. It is located 15 km east of the city on the northern shores of Frederick Henry Bay. The Seven Mile Beach road reaches the western end of the beach and parallels the back of the beach for 3 km. Between the road and the beach is a forested beach reserve and the Tingarra horse-riding trail. The best access and facilities are at the western end where there is a store and beach boat launching next to small Acton Creek, which drains across the beach. East along the beach are also four day area reserves with picnic and toilet facilities, including one with camping facilities (Fig. 4.69).

The beach is 10.3 km (7 miles) long and essentially faces southeast, curving round to face south to southwest at the eastern Sandy Point end. Sandy Point forms the western entrance to Pitt Water, a 3,500 ha barrier estuary, which backs the barrier system. The entire beach system has in fact built out 1 to 2 km seaward, as a series of more than 50 low foredune ridges, which have subsequently been transgressed by dune activity that increases to the east. Part of the barrier is used to house Hobart's Cambridge airport, while pine plantations cover much of the remaining area. The only settlement, called Seven Mile Beach, is toward the western end.

The beach receives usually low to moderate waves, 0.5 to 1 m high, that have to travel 20 km into Frederick Henry Bay. The waves arrive as low crests paralleling the beach (Fig. 4.70). The beach usually has a narrow dry high tide beach, commonly containing cusps, with a wider shallow low tide beach. Rips only occur when waves exceed 1 m.

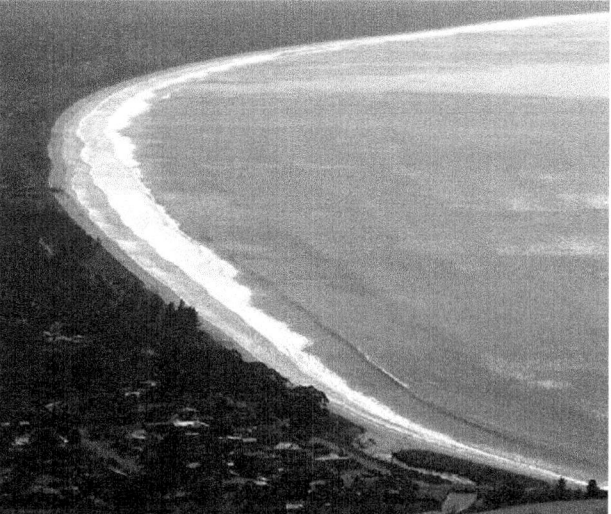

Figure 4.70 Low refracted waves break along the low tide terrace of Seven Mile Beach (T 397).

Swimming: The western end of Seven Mile and its day reserves are popular in summer. They provide good access to a low hazard beach under normal low waves. Bigger swell can however induce rips across the bar.

Surfing: Seven Mile usually has low spilling beach breaks. Big south swell produces a right-hand break along the point. However it is a bit of a walk to the break, which can also be very popular when working.

T 398-402 ROCHES BEACH

No.	Beach	Rating HT LT		Type	Length
T398	Roches Beach (N4)	4	5	LTT+rocks	50 m
T399	Roches Beach (N3)	4	5	LTT+rocks	50 m
T400	Roches Beach (N2)	4	5	LTT+rocks	300 m
T401	Roches Beach (N1)	4	5	LTT	800 m
T402	Roches Beach	4	5	R/LTT	3.5 km
Spring & neap tidal range = 1.2 & 0.3 m					

Roches Beach is a 5 km long series of increasing larger beaches (T 398-402) that emerge from the base of 200 m high Single Hill and trend to the south to finally curve to the east in lee of Mays Point.

The northernmost beach (**T 398**) is a 50 m long pocket of sand and rocks at the base of steep slopes, fronted by a narrow low tide terrace. It is backed by a tree-covered gully, then the cleared slopes of the hill. Beach **T 399** lies 200 m to the south at the northern edge of the blufftop houses of Roches Beach. The beach is a 50 m long pocket of sand and narrow low tide terrace, located in a slight indentation in the bluffs, with some rocks scattered on the beach. It is backed by tree-covered 15 m high bluffs, then the housing estate.

Beach **T 400** commences 50 m to the south and is a 300 m long high tide beach and 30 m wide low tide terrace that has rocks outcropping along the centre and forming the southern boundary. It is backed by sloping tree-covered 15 m high bluffs, then houses, with the bluff decreasing to 5 m in height at the southern end of the beach. Beach **T 401** continues on the south side of the rocks for 800 m to a slight reef-tied foreland, with waves breaking over the shallow reef. The beach has a continuous low tide terrace, with waves decreasing slightly to the lee of the reef. The Lauderdale Yacht Club is located towards the northern end of the beach, with a drainage reserve for a small creek in the centre and a Girl Guides camp behind the southern end and beachfront houses in lee of the foreland.

The main **Roches Beach** (**T 402**) commences at the foreland and trends south finally curving round to the east in lee of Mays Point, with a total length of 3.5 km. The sandy beach is initially a low tide terrace, which narrows to the south as wave height decreases to less than 0.5 m, switching to reflective conditions in the southern corner. During larger swell there is a right-hand break out on the southern Mays Point, called *Lauderdale Point*. The Lauderdale beachfront houses back most of the beach, with beach access at Epping Park reserve in the north, the boat ramp in the centre and Bayview and Lauderdale parks in the south. There are a few groynes across the southern section of the beach, with dinghies stored on the beach. A 1 km long disused boat canal lies behind the boat ramp area and was used to link Frederick Henry Bay with Ralphs Bay providing a shortcut to Hobart.

T 403 MAYS BEACH

No.	Beach	Rating HT LT		Type	Length
T403	Mays Beach	3	3	R/LTT	1 km
Spring & neap tidal range = 1.2 & 0.3 m					

Mays Beach (**T 403**) is a curving 1 km long east-facing beach located immediately south of May Point, with 79 m high Richardson Hill rising behind the northern half of the beach. The beach is moderately sheltered from the southerly waves by rocky coast that protrudes 1.5 km to the east and rises to 138 m high Calverts Hill. The beach receives waves averaging about 0.5 m, which maintain a reflective to narrow low tide terrace beach. It is backed by farmland in the north and a few private houses in the south, with no public access to the shore. During higher waves there is a right-hand break along the southern point, called *Mays Point* or *Maze*.

T 404-407 CREMORNE BEACH

No.	Beach	Rating HT LT		Type	Length
T404	Cremorne Beach (N)	4	5	Cobble+LTT	50 m
T405	Cremorne Beach	3	3	R/LTT	1.3 km
T406	Pipe Clay Hd	4	5	Cobble+LTT	100 m
T407	Cape Deslacs	4	5	Cobble	100 m
	Cape Deslacs Nature Reserve			*83 ha*	
Spring & neap tidal range = 1.2 & 0.3 m					

Cremorne is a small township located to the lee of Cremorne Beach (T 405) and at the mouth of Pipe Clay Lagoon. Rocky coast extends to either side of the beach, with rock-bound beach T 404 to the north and beaches T 406 and 407 to the south.

Beach **T 404** lies 200 m north of the main beach and is a 50 m long pocket of steep cobbles, located at the base of 30 m high cliffs, backed by steep slopes. At times the small, largely inaccessible beach fills with sand forming a low tide terrace.

Cremorne Beach (**T 405**) is a curving, 1.3 km long east-facing lower energy beach bounded by the steep slopes of Calverts Hill to the north and 100 m wide entrance to Pipe Clay Lagoon to the south (Fig. 4.71), with rising terrain forming the southern side of the entrance. The beach receives waves averaging about 0.5 m, which decrease towards the more sheltered lagoon mouth. The northern-central section of beach is reflective to low tide terrace, with tidal sand shoals extending 100 m out to a 50 m wide tidal channel. During higher waves there is a right-hand surf break across the tidal shoals known as *Cremorne Point*. The beach is backed by a low 100 m wide barrier, which is covered with beachfront houses, apart from a central public park and access.

South of the lagoon entrance are 2 km of 50-60 m high cliffed coast extending from Pipe Clay Point to Cape Deslacs. Beach **T 406** is located 500 m south of Pipe

Clay Point and consists of a curving east-facing 100 m long high tide cobble beach, fronted by a sandy low tide terrace. It is backed by steep bluffs rising to 30 m then cleared sloping farmland. Beach **T 407** lies 2 km to the south and 500 m north of Cape Deslacs. It is a similar 100 m long high tide cobble beach sloping into deeper water. Steep 50 m high bluffs back the beach. The cape is part of an 80 ha nature reserve, which includes a mutton bird nesting area. It is accessible along a track from the rear of Clifton Beach.

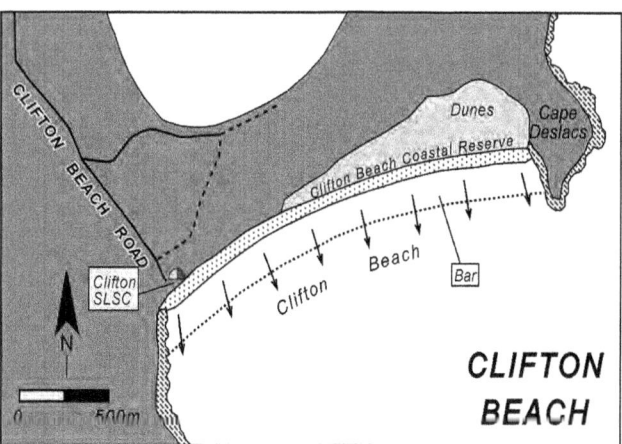

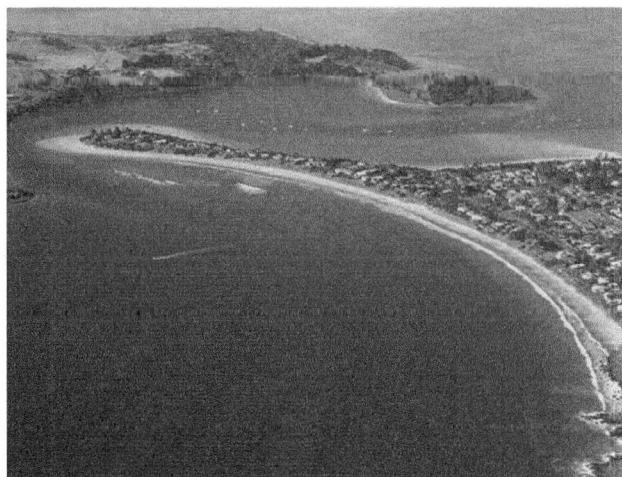

Figure 4.71 Cremorne Beach (T 405) and Pipe Clay Lagoon and inlet.

Figure 4.72 Clifton Beach is moderately well exposed and usually dominated by several beach rips.

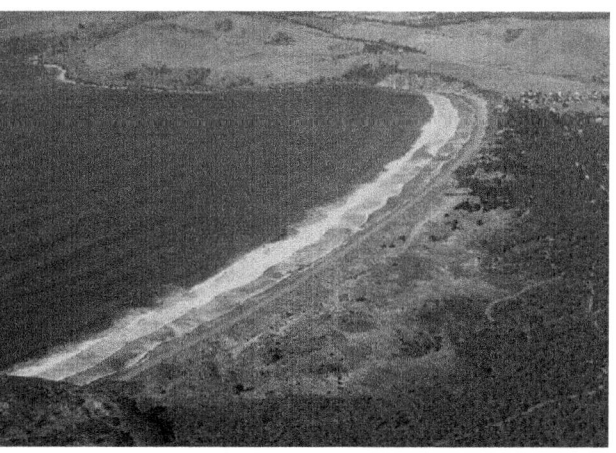

Figure 4.73 Clifton Beach (T 408) with a moderate swell running and rips dominating the surf zone.

T 408 CLIFTON BEACH (SLSC)

No.	Beach	Rating HT LT	Type	Length
T408	Clifton Beach	5 6	TBR	2.1 km
	CLIFTON BEACH (SLSC)			
	Patrols:			
	December-March: Weekends & public holidays			
Spring & neap tidal range = 1.2 & 0.3 m				

Clifton Beach (T 408) is a popular surfing beach located about 25 km southeast of Hobart. The Clifton Beach Road runs to the western end of the beach, providing access to the growing community and the Clifton Beach Surf Life Saving Club, which was established in 1963. The entire beach is backed by a coastal reserve, which incorporates coastal dunes behind the central and eastern part of the beach (Fig. 4.72). The now vegetated dunes have transgressed up to 300 m inland rising to more than 20 m, with dense vegetation behind, then the shallow southern shores of circular Pipe Clay Lagoon. The beach is bordered by 54 m high Cape Deslacs in the east and 50 m high rocky cliffs in the west that run south for 3.5 km rising to 100 m high at Cape Contrariety.

The beach is 2.1 km long and faces south-southeast into Storm Bay exposing it to all southerly swell (Fig. 4.73). Waves average 1-1.5 m and maintain a moderately steep beach fronted by a continuous bar which is cut by rips every 200 m during and following high waves, with permanent rips against the rocks at each end.

Swimming: Clifton can be a hazardous beach, particularly when waves exceed 1 m and rips are present. The safest swimming is toward the western end in the patrolled area. Stay clear of the rocks and avoid the rips.

Surfing: Clifton picks up any south swell and will always produce a series of beach breaks, which work best up to 2 m. The southern breaks are accessible from the surf life saving club car park, while to access the northern end of the beach requires a trek over the dunes.

T 409-413 CALVERTS & HOPE BEACHES

No.	Beach	Rating HT LT	Type	Length
T409	Smugglers Cove	4 5	Cobble +LTT	150 m
T410	Cape Contrariety(W)	6 7	TBR+rocks	200 m
T411	Goat Bluff	6 7	TBR+rocks	2.3 km
T412	Calverts Beach	6 6	TBR	60 m
T413	Hope Beach	6 6	TBR	5 km
	Cape Contrariety Wildlife Sanctuary		*4 ha*	
	South Arm State Recreation Area		*67.5 ha*	
Spring & neap tidal range = 1.2 & 0.3 m				

Cape Contrariety and Cape Direction mark the southern boundaries of the South Arm peninsula, which separates Frederick Henry Bay from the entrance to the Derwent

River. The 10 km of predominantly sandy shoreline between the two capes face south into Storm Bay and are the highest energy section of coast within the bay. Five moderate energy beaches (T 409-413) are located between the two capes.

Smugglers Cove is a 400 m wide east-facing embayment located on the northern side of Cape Contrariety. The cove is surrounded by steep grassy dolerite slopes rising to over 100 m. Beach **T 409** is a 150 m long high tide cobble beach located along the western end of the cove, with a sand and rock low tide terrace. Waves averaging about 1 m break across the 50 m wide bar and surge up the cobbles, with the steep slopes right behind. The 4 ha tip of the cape is a private wildlife sanctuary.

Beach **T 410** is a pocket of sand located on the western side of the cape, with a grassy 20 m high 100 m wide headland to the west. The 200 m long beach occupies the base of the small embayment, and is backed by a foredune climbing part way up the backing 50 m high slopes. The beach receives waves averaging 1.5 m, which break across a 100 m wide surf zone with a permanent rip running out against the western headland. It is backed by cleared sloping farmland with no public access.

Calverts Beach (T 411) commences on the western side of the small headland and trends west-southwest for 2.3 km to the sedimentary rocks of 30 m high Goat Bluff. The beach is exposed to moderate to occasionally high waves and usually has ten or more rips along the beach, together with rips against either headland. The beach is backed by now vegetated transgressive dunes extending between 300 and 400 m inland, then the 30 ha Calverts Lagoon, a landlocked dry lake. Most of beach, dune and all the lake is part of the 67 ha South Arm State Recreation Area. There is vehicle access off the South Arm Road through the dunes to the beach.

Goat Bluff is an irregular 500 m long section of 30 m high cliffed sandstone rocks that separates Calverts from Hope Beach. There is a lookout on the crest of the bluff with views south to Black Jack Rocks and the larger Betsey Island. Beach **T 412** is a 60 m long pocket of rocks and sand set in a gap in the centre of the bluffs and immediately below the lookout. The beach consists of high tide cobbles and boulders against the base of the cliffs, then a sandy 100 m wide bar with rock outcrops that fill the gap. Waves are lowered to 1 m at the bluff owing to sheltering by the island and rocks and break across the bar with a weak rip usually flowing out against the western rocks. There is no safe access to this hazardous beach. Surfers head to the lookout to check the surf to either side. To the east close to the bluffs is *Rebound*, while to the west along Hope Beach are *Goats* and the *Wedge*.

Hope Beach (T 413) commences on the western side of the bluffs and initially protrudes seaward as a sandy foreland in lee of Betsey Island, then curves to the west and west-southwest for 5 km to the base of Cape Direction. Wave height is 1 m in lee of the island, quickly picking up to average 1.5 m along the rest of the beach which usually has a 100 m wide rip-dominated surf zone,

with up to 25 rips cutting across the bar and a strong permanent rip against the cape. The beach is backed by 10-20 m high dunes extending up to 200 m inland, with the South Arm Road behind, then the large Ralphs Bay. A part of South Arm State Recreation Area is located in the centre of the beach with a car park and beach access across the dunes. Parts of the dunes are also mined for sand.

T 414-416 POT & SEACROFT BAYS

No.	Beach	Rating HT LT		Type	Length
T414	Fort Beach	4	5	LTT+rocks	80 m
T415	Pot Bay	4	4	LTT	400 m
T416	Seacroft Bay	3	3	R/LTT	800 m
	Cape Direction Wildlife Sanctuary				*5 ha*
Spring & neap tidal range = 1.3 & 0.3 m					

Cape Direction marks the southwestern tip of South West peninsula and the 4 km wide southeast entrance to the Derwent River estuary. The cape is partly protected by Iron Pot islet 1 km to the south and backed by 110 m high Fort Hill, both prominent markers to the river mouth. From the cape the shoreline trends to the northwest with Pot and Seacroft bays behind the Derwent River shoreline. Much of the cape and hill are a part of the Commonwealth Fort Direction military reserve.

Fort Beach T 414 is an 80 m long pocket of south-facing sand located on the western side of the 20 m high tip of the cape, with 20 m high bluffs backing and bordering the small beach. The cleared slopes of the cape back the bluffs and rise towards 110 m high Fort Hill. The beach faces south towards the small Iron Pot islet and its lighthouse with a series of rock reefs extending off the eastern end of the beach south to the Pot, which reduces waves to less than 1 m. They break across a moderately steep reflective to narrow low tide terrace beach.

Pot Bay lies immediately to the west and is a curving 500 m wide south-facing bay bordered in the west by 18 m high Cape Deliverance. The bay contains a 400 m long beach (**T 415**), which is also partly sheltered by the reefs and receives waves averaging about 1 m which break across a reflective to low tide terrace beach (Fig. 4.74). There are two outcrops of sandstone along the beach, and rocky points to either end. It is backed by 10 m high vegetated bluffs then cleared blufftop slopes.

Seacroft Bay is located on the northern side of Cape Deliverance. It is a 700 m long west-facing bay with 10 m high Johns Point forming the northern headland. Wave height decreases north of the cape and averages less than 1 m inside the small bay, increasing slightly towards the northern point. Fort Beach (**T 416**) occupies the western shore of the bay consisting of an 800 m long southwest-facing reflective to low tide terrace beach, with two central rock outcrops. A low grassy foredune backs the beach, with the southern half backed by Fort Direction Commonwealth land, while houses back the northern half.

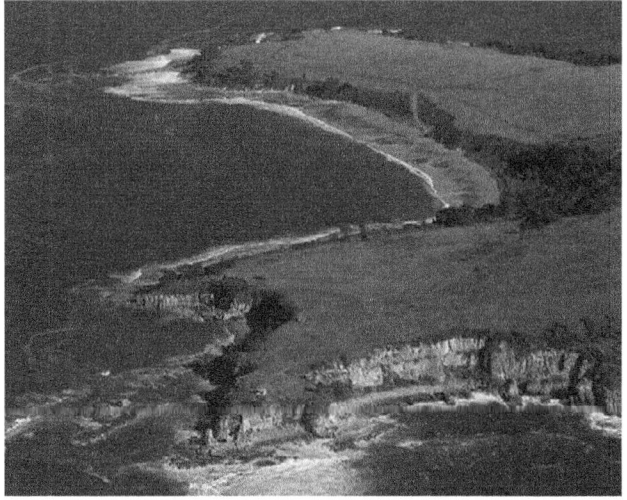

Figure 4.74 Cape Deliverance in foreground with beach T 414 at its base and reflective Pot Bay beach (T 415) behind.

T 417-419 HALFMOON BAY

No.	Beach	Rating HT LT		Type	Length
T417	Johns Pt (N)	3	3	R	150 m
T418	South Arm Beach	3	4	R/LTT	2.3 km
T419	Pigeon Holes	3	4	R/LTT	150 m
Spring & neap tidal range = 1.3 & 0.3 m					

Halfmoon Bay is an open 3 km wide bay that faces west across the 6 km wide Derwent River estuary. The bay receives lowered refracted waves that travel up Storm Bay to enter the Derwent. Three beaches (T 417-419) occupy most of the bay shore, with the small township of South Arm located in the southern corner of the bay.

Beach **T 417** is a 150 m long west-facing reflective beach, which is partly protected by Johns Point. The narrow beach is backed by 20 m high vegetated bluffs, with houses sitting atop the bluffs continuing to either side where they are fronted by the bluffs and low rocky shore.

South Arm Beach (T 418) extends for 2.3 km along the eastern shore of Halfmoon Bay. The curving beach faces west across the Derwent and receives waves averaging less than 1 m which maintain a reflective to low tide terrace beach composed of fine sand. It is backed by a low grassy foredune with some beachfront houses and boat sheds in the south, centre and north, with a narrow coastal reserve in between and low rocky shore to either end. There is a boat ramp and jetty on the rocks at the southern end of the beach, while the South Arm Road parallels the beach 200 m inland.

Pigeon Holes is a cleared sloping point that forms the northern boundary of Halfmoon Bay. Beach **T 419** is located on the southern side of the point and looks south down the bay. It is separated from South Arm beach and the northern cluster of houses by a 100 m long low rocky point and platform. The beach is 150 m long and straight,

with a narrow low tide terrace. It is backed by a row of trees on a low bluff then cleared farmland, with the South Arm Road 300 m to the north.

T 420-422 OPOSSUM BAY

No.	Beach	Rating HT LT		Type	Length
T420	Glenvar Beach	3	3	R/LTT	250 m
T421	Opossum Bay	3	3	R/LTT	600 m
T422	Mitchells Beach	3	3	R/LTT	850 m
Spring & neap tidal range = 1.3 & 0.3 m					

Opossum Bay is a 1.5 km wide west- to southwest-facing bay bordered by a low rocky point in the south and 30 m high White Rock Point to the north. The small town of Opossum Bay occupies the southern corner and spreads south around the point to Glenvar Beach (T 420). Two beaches (T 421 and 422) occupy most of the bay shore and all three beaches receive low waves that have to travel from Storm Bay several kilometres up the Derwent to the bay.

Glenvar Beach (T 419) is a 250 m long west-facing headland-bound beach located on the southern side of Opossum Bay. The beach receives waves averaging about 0.4 m, which usually surge up a moderately steep reflective beach (Fig. 4.75). It is backed by a row of beachfront houses with boat sheds, some boat ramps and seawalls spread along the beach. The houses continue along the boundary 10 m high bluffs and around the northern point into Opossum Bay.

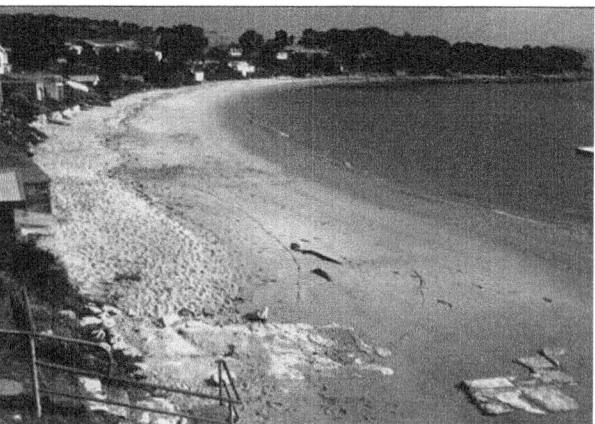

Figure 4.75 The low energy reflective Glenvar Beach (T 419) with houses and boat sheds right behind.

Opossum Bay beach **(T 421)** is a curving 600 m long west-facing beach, sheltered in the south by a 200 m long headland, with waves increasing slightly up the beach to maintain a low gradient reflective to low tide terrace beach. Beachfront houses and several boat sheds line the back of the beach, the houses sitting atop 10 m high bluffs, with the road behind. The only public access is at the southern end where there is a jetty, small car park and reserve.

Mitchells Beach (T 422) occupies the northern half of the bay commencing 200 m north of Opossum Bay beach. It is a curving 850 m long beach that receives slightly higher waves which maintain a reflective to narrow low tide terrace beach backed by a low grassy foredune. The South Arm Road terminates just south of the beach at a locked gate, with access to the beach only on foot along the shore from Opossum Bay.

T 423-427 GELLIBRAND POINT

No.	Beach	Rating HT LT	Type	Length
T423	Mary Ann Bay	3 3	R/LTT	250 m
T424	Gellibrand Pt (W)	3 3	R/LTT	150 m
T425	The Spit (N)	2 1	Cobble+sand flats	300 m
T426	The Spit (S)	2 1	Cobble+sand flats	250 m
T427	Shelly Beach	1 1	R+sand flats	1.9 km
Spring & neap tidal range = 1.3 & 0.3 m				

Gellibrand Point is located at the northern tip of South Arm and forms the southern entrance to Ralphs Bay. The 20 m high grassy dolerite point lies at the tip of a 300-500 m wide, 2 km long finger of private farmland with rocky shore and beaches to either side.

Mary Ann Bay is located 1 km southwest of the point and contains a 250 m long northwest-facing reflective beach (**T 423**). The narrow beach is backed by sloping 20 m high grassy bluffs in the south and a patch of grassy foredune in the north with vegetated rocky bluffs to either end.

Beach T 424 lies 500 m south of the western tip of the point and consists of a 150 m long strip of high tide sand interrupted by rock outcrops and backed by steep 10-20 m high bluffs. It faces west across the Derwent and usually receives very low swell to calm conditions.

The Spit is a 300 m long east-trending cobble ridge located 500 m south of the eastern side of the point inside Ralphs Bay. Two beaches are located either side of the spit and converge at its tip (Fig. 4.76). Beach **T 425** occupies the northern side and is a curving 300 m long northeast-facing high tide sand and cobble beach fronted by 50 m wide sand flats. It links at the tip of the cobble spit to beach **T 426**, which trends to the southwest, facing southeast down the bay. It is 250 m long and composed of high tide sand and cobble with sand flats extending 100 m into the bay. Both beaches are backed by a low barrier, which is tied to the backing cleared slopes of the point.

Shelly Beach (T 427) commences 1.5 km south of the point and curves for 1.9 km to the southeast terminating against the cleared slopes of Icehouse Bluff. The beach faces northeast into the bay and receives only low wind waves. It consists of a narrow high tide beach fronted by sand flats, which widen from 100 m in the south to 500 m in the north. Mitchells Beach (T 422) is located 500 m to the west on the Derwent side of South Arm.

Figure 4.76 The Spit is a sheltered salient inside Ralphs Bay bordered by beaches T 425 & 426.

T 428-432 RALPHS BAY (S)

No.	Beach	Rating HT LT	Type	Length
T428	Musks Beach	1 1	R+sand flats	600 m
T429	South Arm Neck (N)	1 1	R+sand flats	2.3 km
T430	Collins Springs Hill (1)	1 1	R+sand flats	250 m
T431	Collins Springs Hill (2)	1 1	R+sand flats	150 m
T432	Collins Springs Hill (3)	1 1	R+sand flats	300 m
Spring & neap tidal range = 1.3 & 0.3 m				

Ralphs Bay is a 50-km^2 low energy embayment located on the eastern side of the Derwent River estuary. The bay has a 2.5 km wide entrance between Gellibrand and Droughty points and 43 km of very low energy shoreline containing 18 beaches (T 425-443) all fronted by sand flats. Beaches T 425-427 lie to the lee of Gellibrand Point, the southern entrance to the bay, while beaches T 428-432 are located around the southern half of the bay shore.

Musks Beach (T 428) is located halfway down the western shore of Ralphs Bay and 1 km east of Halfmoon Bay. It is a very low narrow 600 m long northeast-facing shell-rich beach, fronted by 300 m wide sand flats. It can be accessed along the Bezzants Road.

Beach T 429 lies at the base of the bay on the northern side of South Arm Neck, with the higher energy Hope Beach (T 413) to the south. The beach faces north to northwest up the bay and receives only low wind waves sufficient however to have prograded the eastern end of the beach 200 m into the bay as a series of low beach ridges. The beach extends for 2.3 km from an area of salt marsh to the southern slopes of Collins Springs Hill. It consists of a narrow high tide beach fronted by 1 km wide sand flats, with the South Arm Road running along the rear of the beach.

Beaches T 430-432 occupy three small west-facing embayments located along the base of the western slopes of 112 m high Collins Springs Hill. The slopes of the hill have been subdivided with access to the land and slopes above the beaches along two service roads. Beach **T 430** is a 250 m long west-northwest-facing strip of high tide sand fronted by 700 m wide sand flats, with a 50 m wide

series of beach ridges then wooded slopes rising to 100 m behind. Beach **T 431** lies 100 m to the north and is a similar 150 m long west-facing beach with 500 m wide sand flats, located at the base of a small valley with densely wooded slopes backing the small beach. Beach **T 432** occupies the next small valley 500 m to the north. It is a west-facing 300 m long high tide beach with 200 m wide sand flats. Steeply wooded slopes rise to 100 m behind the beach.

T 433-435 MORTIMER BAY

No.	Beach	Rating HT LT	Type	Length
T433	Gorringes Beach	1 1	R+sand flats	2.6 km
T434	Mortimer Bay (N)	1 1	R+sand flats	300 m
T435	Maria Pt	1 1	R+sand flats	100 m
Spring & neap tidal range = 1.3 & 0.3 m				

Mortimer Bay is a 2.5 km long east- to southeast-facing embayment located midway up the eastern side of Ralphs Bay. One kilometre long Maria Point shelters the northern half of the low energy bay which is filled with extensive sand flats. Three beaches (T 433-435) occupy much of the bay shore.

Gorringes Beach (T 433) curves along the eastern side of the bay for 2.6 km swinging round to face south along its northern end. The narrow high tide beach is fronted by 800 m wide sand flats which half fill the bay. A narrow reserve backs the beach, which is then backed by a 100 m wide area of prograded shoreline, then subdivided slopes, which rise behind the centre of the beach to 170 m at Mount Augustus. Two valleys lie to either side of the slopes with their small creeks reaching the beach. The Rifle Range Road provides access to the northern end of the beach.

Beach **T 434** is located at the northern end of the bay in lee of Maria Point. It is a very low energy south-facing 300 m long strip of high tide sand fronted by 400 m wide sand flats. The road terminates at the eastern end of the beach. Beach **T 435** is located at the tip of Maria Point just inside the bay. It is a 100 m long strip of south-facing sand with 50 m wide sand flats. It is backed by cleared farmland on the 30 m high 200 m wide point.

T 436-438 HUXLEYS-RICHARDSONS BEACHES

No.	Beach	Rating HT LT	Type	Length
T436	Maria Pt (N)	1 1	R	1 km
T437	Huxleys Beach	1 1	R+sand flats	1 km
T438	Richardsons Beach	1 1	R+sand flats	800 m
Spring & neap tidal range = 1.3 & 0.3 m				

At **Maria Point** the shoreline turns and trends north for 6 km to Haynes Point. A mixture of tree-covered and cleared slopes descend to the low energy west-facing shoreline. Three beaches (T 436-438) are located along

the southern part of the shore. They face west across the 4 km wide Ralphs Bay to the entrance.

Beach **T 436** commences at the southern tip of Maria Point and follows the bedrock point north for 1 km. It is a narrow high tide beach backed by 10-20 m high bluffs and fronted by the deeper water of the bay. It is backed by private land with no public access.

Huxleys Beach (T 437) extends for 1 km between two 20 m high headlands with Dixon Point forming the northern boundary. The beach faces west across 200 m wide sand flats. It is backed by a row of trees then a mix of cleared and vegetated slopes rising to 100 m. The beach can be accessed along the Dixon Point road, which terminates at a small coastal reserve in the centre of the beach.

Richardsons Beach (T 438) extends north of Dixon Point for 800 m. It is a narrow high tide beach with 200 m wide sand flats. It backed by a row of trees then cleared slopes gradually rising to 160 m. Private land surrounds the beach with no public access.

T 439-441 RALPHS BAY (N)

No.	Beach	Rating HT LT	Type	Length
T439	Lauderdale (W1)	1 1	R+sand flats	400 m
T440	Lauderdale (W2)	1 1	R+sand flats	730 m
T441	Rokeby Beach	1 1	R+sand flats	2.3 km
Spring & neap tidal range = 1.3 & 0.3 m				

The northern end of Ralphs Bay is a relatively sheltered 2-3 km wide rectangular shaped bay bordered by rising ground on three sides and open to the south facing into the main part of the bay. The bay shore receives no ocean swell only wind waves generated within the bay. Three low energy beach and sand flats (T 439-441) are located at the northern end.

Beach **T 439** is a 400 m long west-facing beach located in the northeastern corner of the bay and on the western side of Lauderdale, with the old boating canal forming the northern boundary and bisecting what was once a continuous beach. The beach consists of a narrow high tide beach backed by a low grassy ridge, which protrudes in two places across the northern end of the beach. Flat featureless sand flats extend 700 m into the bay. The South Arm Road runs along the rear of the beach to the bridge across the canal. Beach **T 440** continues on the northern side of the bridge curving to the northwest. It is bordered in the south by a grassy bank formed from dredge spoil from the canal, with the road running right behind the narrow beach while sand flats extend into the bay (Fig. 4.77).

Rokeby Beach (T 441) is located in the northwestern corner of the bay. It is a curving south-facing 2.3 km long low energy beach fronted by narrow sand flats. It is bordered to the east by the low Mill Point which is

backed by the police academy, with Clarence Creek draining out across the western end of the beach below the rising slopes of the 100 m high Rokeby Hills. The beach continues for 200 m south of the creek mouth with tidal shoals extending off the mouth. In between the high ground is low flat land occupied in the west by a sewage treatment works. The Clarence Road crosses the creek at the western end of the beach, where a boat ramp is located.

Figure 4.77 The Lauderdale canal separates the two very low energy beaches and wide sand flats of T 439 & 440.

T 442-443 TRYWORK & DROUGHTY POINTS

No.	Beach	Rating HT LT	Type	Length
T442	Droughty Pt (W)	2 2	R	100 m
T443	Trywork Pt (E)	2 2	R	150 m
Spring & neap tidal range = 1.3 & 0.3 m				

Droughty and Trywork points are located at the southern base of Droughty Hill and form the northern entrance to Ralphs Bay, with Gellibrand Point 2.5 km to the south. The two points are 700 m apart with two small south-facing embayments in between occupied by beaches T 442 and 443. The Droughty Point track runs along the western slopes of the hill to reach the slopes above both beaches.

Beach **T 442** is a 100 m long pocket of sand with a small creek draining across the centre of the beach. Cleared grassy slopes border and back the beach, with Droughty Point forming the eastern boundary. Beach **T 443** is a 150 m long strip of sand with small creeks draining to either end, and sloping Trywork Point forming its western boundary. Both beaches receive low refracted swell and wind waves.

T 442-450 TRANMERE-HOWRAH-BELLERIVE

No.	Beach	Rating HT LT	Type	Length
T444	Tranmere Pt (S)	2 2	R	100 m
T445	Tranmere Pt (N1)	2 2	R	50 m
T446	Tranmere Pt (N2)	2 2	R	100 m
T447	Tranmere	2 2	R	2.5 km
T448	Little Howrah Beach	2 2	R	200 m
T449	Howrah Beach	2 2	R	1.2 km
T450	Bellerive Beach	2 2	R	1.2 km
Spring & neap tidal range = 1.3 & 0.3 m				

Tranmere, Howrah and Bellerive are three bayfront suburbs located directly across the Derwent from Hobart. They are fronted by seven low energy beaches (T 444-450), which are the northernmost beaches in the Derwent estuary and face down the estuary towards Storm Bay. They receive only very low swell and southerly wind waves, which maintain low energy reflective beaches.

The three southernmost beaches (T 444-446) occupy small embayments either side of the sloping Tranmere **Point** at the southern end of the development. Beach **T 444** is a 100 m long strip of reflective high tide sand backed and bordered by grassy slopes rising to 152 m high Droughty Hill. Beach **445** is located on the northern side of the 200 m wide point and is a 50 m long pocket of sand and rocks backed by cleared slopes then the southern end of the houses. Beach **T 446** lies 100 m further north and is a similar 100 m long strip of reflective sand with numerous rocks along the beach and a small creek draining across the centre of the beach and houses on the slopes to either side.

Tranmere beach (**T 447**) extends along the base of the sloping Tranmere shoreline, from the northern base of the grassy Rokeby Hills along to and around Punchs Reef and on to the southern side of Howrah Point. The entire 2.5 km long narrow beach is backed by beachfront houses and Tranmere Road. The beach usually receives low wind waves generated across the bay and very low swell travelling up the estuary.

Howrah Beach consists of two sections. Little Howrah Beach (**T 448**) is located at the eastern end of the main beach and consists of a curving 200 m long low energy, low gradient beach, that looks west to Hobart 5 km across the Derwent. The beach is sheltered by Howrah Point, which forms its southern boundary, and receives only low wind waves with calms common. The Tranmere Road runs along the rear of the beach, which is backed by a low seawall and grassy reserve, then the road, with some low rocks and a boat ramp at the northern end and houses behind. The main Howrah beach (**T 449**) commences on the other side of the rocks and trends to the west-northwest for 1.2 km to 20 m high Second Bluff. The beach receives slightly higher waves including occasional low swell and is reflective. It is backed by grassy slopes and part of a school and sport grounds.

Bellerive Beach (**T 450**) extends for 1.2 km between Second and Kangaroo bluffs. It faces due south down the Derwent and receives very low swell, which maintains a moderate gradient often cusped reflective beach. It is backed by a narrow tree-lined reserve then houses with the Bellerive Oval behind the western end.

T 451-455 SANDY BAY

No.	Beach	Rating HT LT		Type	Length
T451	Short Beach	1	2	R+sand flats	150 m
T452	Lords Beach	2	2	R	70 m
T453	Manning Reef	2	2	R	150 m
T454	Nutgrove Beach	2	2	R	700 m
T455	Little Sandy Bay	2	2	R	150 m
Spring & neap tidal range = 1.3 & 0.3 m					

Sandy Bay is a popular riverside suburb that extends from 1-4 km southeast of Hobart. The Sandy Bay Road follows much of the foreshore, together with rowing and yacht clubs, the Wrest Point Casino and bayside houses out on Sandy Bay Point. The shoreline has been heavily modified by reclamation, seawalls, the road and general housing, recreational and commercial development. Today five modified beaches (T 451-455) are located between Sandy Bay and its point 3 km to the south.

Short Beach (T 451) is a 150 m long sandy beach located at the channelised mouth of Sandy Bay Rivulet. The beach extends south of the mouth to a seawall that protrudes 100 m into the bay and surrounds a hectare of reclaimed land occupied by rowing clubs, a Sea Scout hall and boat storage sheds (Fig. 4.78). The beach is backed by a low grassy park and car parking at the end of Marieville Esplanade, then the houses of Sandy Bay. The shallow bay floor extends out in line with the seawall, with boats moored further out.

Figure 4.78 Short Beach (T 451) in Sandy Bay has been modified by foreshore development and is the northernmost beach in the Derwent.

Lords Beach (T 452) is the next segment of the once continuous beach. It lies immediately south of the Wrest Point seawall and today consists of a 70 m long wedge of sand located between the casino seawall and the seawall for the Channel Highway, which runs right past the beach, with houses rising on the slopes to the west. A covered jetty is located immediately south of the beach and boats are moored in the deepwater within 50 m of the shore.

Red Chapel Beach (T 453) lies 500 m to the south in a slight indentation in the sloping shore, with bayfront houses lining the slopes to the rear of the beach as well as the slight protrusions to either side. The narrow 150 m long beach is bordered by intertidal rocks, with rocks also outcropping along the shore. It is backed by a seawall and some boatsheds with trees overhanging the beach. It can only be accessed on foot from a small grassy reserve at the southern end.

Nutgrove Beach (T 454) commences 100 m future south and extends 700 m east to the rounded tip of the low Sandy Bay Point (Fig. 4.79), a 300 m wide sandy foreland that is now heavily developed. The beach faces north up the Derwent and consists of a steep narrow high tide beach, with deep water and boats moored 50 m offshore. It is backed initially by bayfront houses, then a yacht club and Sundown Park and Long Beach Reserve, the latter protected by a basalt seawall.

Figure 4.79 Nutgrove Beach (T 454) forms the northern part of Sandy Bay Point.

Long Beach (T 455) once connected with Nutgrove Beach and is now separated by the seawall. The narrow 150 m long beach occupies the rear of 400 m wide Little Sandy Bay, an east-facing embayment formed between the once sandy foreland (Sandy Bay Point) and the rocks of Blinking Billy Point. Today the narrow beach is backed by a seawall, hotel, parking and park facilities, with the Sandy Bay Road clipping the southern corner of the beach. The small reflective beach receives low refracted swell, which surges up the narrow beach.

T 456-458 BLINKING BILLY POINT

No.	Beach	Rating HT LT	Type	Length
T456	Blinking Billy Pt (S)	2 2	R	150 m
T457	Blinking Billy Pt (S1)	2 2	R+rocks	100 m
T458	Blinking Billy Pt (S2)	2 2	R+rocks	200 m
Spring & neap tidal range = 1.3 & 0.3 m				

Blinking Billy Point marks the beginning of a relatively straight south-trending 4 km of shoreline that extend down to Crayfish Point, all backed by bayfront houses, the Sandy Bay Road and the rising slopes of 349 m high Albion Heights. Three beaches (T 456-458) are located in slight indentations in the first 1 km south of the point.

Beach **T 456** is a 150 m long narrow strip of high tide cobbles and sand that extends due south of Blinking Billy Point and is backed by 10 m high bluffs then blufftop houses between the beach and highway. There is public access from the point area and a boat shed at the southern end. Beach **T 457** lies 100 m to the south around a bluff-backed rocky point. The beach trends to the south for 100 m as a discontinuous narrow strip of high tide sand and rocks, backed by vegetated bluffs rising steeply to 30 m, then blufftop houses and the Sandy Bay Road. Three boat sheds are located along the southern half of the beach with small Folder Creek draining across the southern end. Beach **T 458** occupies the next indentation 200 m to the south and is similar narrow reflective sand and rocky beach that extends along the base of 20-30 m high bluffs for 200 m. The Sandy Bay Road parallels the shore 200 m inland with blufftop houses between the road and shore, together with a few boat sheds at the base of the bluffs.

T 459-464 CARTWRIGHT POINT-TAROONA-HINSBY BEACH

No.	Beach	Rating HT LT	Type	Length
T459	Cartwright Pt (S)	2 3	R+cobble+rocks	200 m
T460	Dixons Beach	2 3	R+rocks	200 m
T461	Taroona HS (S1)	2 3	R+rocks	70 m
T462	Taroona HS (S2)	2 2	R	60 m
T463	Taroona Beach	2 3	R+rocks	500 m
T464	Hinsby Beach	2 3	R+rocks	250 m
Spring & neap tidal range = 1.3 & 0.3 m				

Cartwright Point is a protruding rocky point located immediately south of Cartwright Creek. Beach **T 459** extends south of the sloping 20 m high point as a 200 m long strip of high tide sand and rocks. The narrow eroding beach is backed by vegetated bluffs that rise to 20 m in the south, with blufftop houses behind. There is public access via some steps at the northern end of the beach.

The suburb of Taroona lies 1 km south of Cartwright Point and has 2 km of bluff-backed shoreline containing five narrow generally rock-dominated beaches. Beaches T 460-462 are located either side of Taroona High School (Fig 4.80). **Dixons Beach (T 460)** lies on the northern side of the high school. It is a curving 200 m long east- to northeast-facing strip of high tide sand and rocks, with clusters of rocks crossing and scattered just off the beach. Tall trees back the northern end of the beach with a central boat shed, then the school playing fields on the low southern rocky point. Beach **T 461** lies immediately south of the point, with the playing field behind. It is a 70 m long strip of sand and rocks, with a drainage ditch reaching the southern end. Tall trees border each end of the beach. **T 462** lies 50 m to the south and is a 60 m long sandy high tide beach backed by a row of several boat sheds and a few dinghies, with rocks dominating the southern end of the beach. A grassy reserve and road back the beach and provide public access.

Figure 4.80 Taroona High School is bordered by Dixons Beach to the north and beaches T 461 & 462 to the south.

Taroona Beach (T 463) is located 1 km to the south on the southern side of rocky Crayfish Point, site of both marine and wildlife research centres and a sewage treatment plant. The 500 m long beach faces southeast down the Derwent estuary exposing it to waves averaging up to 0.5 m. These surge up a steep reflective beach with numerous rocks scattered along and off the beach. It is backed by the tree-dotted Taroona Park, then playing fields with a boat ramp at the northern end of the beach. A 50 m long cluster of rocks separates it from **Hinsby Beach (T 464)**, which continues southwest for 250 m to the beginning of a higher cliffed section of shore. The beach is steep and narrow with numerous rocks along the shore. It is backed by houses in the north and steep tree-covered bluffs to the south, with public access in the centre at the end of Jenkins and Hinsby streets. The Alum Cliffs walking track commences on the top of the bluffs above the southern end of the beach and runs along the top of the 50-100 m high Alum Cliffs for 2 km to Tyndall Beach.

T 465-466 TYNDALL-KINGSTON BEACHES

No.	Beach	Rating HT LT		Type	Length
T465	Tyndall Beach	3	4	R/LTT	300 m
T466	Kingston Beach	3	4	R/LTT	1 km
KINGSTON BEACH SLSC					
Spring & neap tidal range = 1.3 & 0.3 m					

Tyndall and Kingston beaches are located to either side of the sandy mouth of Browns River (Figs. 4.81 & 4.82), with the centre of Kingston located 1.5 km to the west. The northern **Tyndall Beach (T 465)** is a southeast-facing 300 m long sandy beach that extends from the southern rocks of 40 m high Bonnet Point to the usually narrow sandy river mouth and associated sand shoals. Waves averaging about 0.5 m maintain a reflective to low tide terrace beach. It is backed by a small grassy foredune and densely vegetated bluffs rising to 40 m in the north and a small reserve with a Sea Scout hall in the south, with a footbridge across the river to Kingston Beach.

Figure 4.81 Kingston Beach is one of Hobart's southern suburbs and is fronted by the popular usually lower energy beach.

Kingston is a southern suburb located 15 km south of the city, and the first main swimming beach southwest of Hobart. The beach is patrolled by the new Kingston Beach SLSC, a branch of Clifton Beach SLSC. The area surrounding the beach is highly developed with Kingston Beach shopping area and housing behind the beach, and residential development on the southern slopes overlooking the beach. **Kingston Beach (T 466)** commences at the river mouth and curves to the south for 1 km to the first rocks of Boronia Point. The beach faces east-southeast receiving waves travelling up the Derwent estuary and averaging about 0.5 m, which break across a 30-50 m wide low tide terrace. A seawall, narrow reserve, picnic area and playground back the beach. Towards the south there is a boat ramp across the beach and the

Kingston Beach Sailing Club in the southern corner, with a hotel behind. The beach is backed by Osborne Esplanade, then four rows of houses, which completely occupy the low 250 m wide barrier system, with the river behind.

Swimming: This is a relatively safe beach with usually low wave to calm conditions. Stay clear of boating activity in the southern corner and watch for deep water off the beach.

Figure 4.82 Tyndall and Kingston beaches (T 465 & 466) lie either side of the small mouth of Browns River.

T 467-468 BLACKMANS BAY

No.	Beach	Rating HT LT		Type	Length
T467	Blackmans Bay Beach	3	3	R	900 m
T468	Flowerpot Pt (S)	3	4	Cobble	200 m
Spring & neap tidal range = 1. & 0.3 m					

Blackmans Bay is a 700 m wide east-facing semi-circular bay backed by the small township of Blackmans Bay and containing Blackmans Bay Beach (**T 467**). The beach curves between bordering sandstone points and rock platforms. It is sheltered by its orientation and the southern Flowerpot Point from direct swell, with waves averaging under 0.5 m and decreasing into the southern corner. The low waves maintain a steep reflective beach, which during higher waves grades to a low tide terrace along the northern end. The beach is backed by a low grassy foredune, then Ocean Esplanade together with a large northern car park, a central sailing club and boat ramp and several boat sheds towards the southern end, with the houses of Blackmans Bay rising behind.

Flowerpot Point extends 200 m east at the southern end of the bay, with beach **T 468** located immediately south of the point in a small rocky embayment. The beach is 200 m long and consists of a steep cobble and boulder beach bordered by the point and rock platforms, together with a central rocky bluff and outcrop. Steep vegetated bluffs rising to 40 m in the south back the beach, with blufftop houses behind.

T 469-475 SOLDIERS POINT-TINDERBOX BAY

No.	Beach	Rating HT LT	Type	Length
T469	Soldiers Pt (S1)	3 5	Cobble+rocks	150 m
T470	Soldiers Pt (S2)	3 5	Cobble+rocks	100 m
T471	Fishermans Haul	3 4	Cobble	100 m
T472	Fishermans Haul (S)	3 4	Cobble	200 m
T473	Piersons Pt (S1)	3 4	Cobble	100 m
T474	Piersons Pt (S2)	3 4	Cobble	100 m
T475	Tinderbox Bay	3 4	R	100 m
Spring & neap tidal range = 1.3 & 0.3 m				

To the south of Blackmans Bay is a 5.5 km long, 2.5 km wide peninsula, with the 200-300 m high Tinderbox Hill forming a central ridge. The ridge slopes to the shore, in places forming sandstone cliffs. The eastern side of the peninsula extends for 5 km between Soldiers Rocks and Tinderbox Bay and contains seven small cobble beaches (T 469-475). The Tinderbox Bay road makes a circuitous route around the peninsula providing access to some of the beaches.

Beach **T 469** lies 500 m south of Soldiers Rocks and is a curving 150 m long cobble beach located at the base of 30 m high sandstone cliffs, with rock platforms to either end and rock reefs off the beach. The cliffs are backed by cleared slopes containing a few clifftop houses, with no safe access to the rocky beach. Beach **T 470** lies 700 m further south along the cliffed coast. It is a 100 m long cobble beach located in a small rocky embayment, with 20 m high steep vegetated bluffs behind and rock reefs filling much of the 100 m deep embayment. A house is located on the cleared slopes behind the bluffs.

Fishermans Haul is a small curving cobble beach (**T 471**) located to the lee of 40 m high Lucas Point. Steep vegetated bluffs rise to 50 m behind the small beach, which is partly sheltered by the point and rock reefs resulting in low waves at the shore. The road runs along the top of the bluff 100 m west of the beach with access via a steep descent. Beach **T 472** commences 100 m south of the Haul, and is a 200 m long east- to northeast-facing narrow high tide cobble beach located at the base of 50 m high cliffs, with a steep gully descending to the centre of the beach.

Beach **T 473** is located 500 m southeast of Piersons Point just inside the D'Entrecasteaux Channel and partly sheltered by Bruny Island 1.5 km to the east. The beach is a slightly curving east-facing 100 m long cobble beach backed by vegetated bluffs rising to 50 m. Beach **T 474** lies 200 m to the west and is a similar 100 m long south-facing cobble beach, backed by 30 m high bluffs with the road running 150 m in from both beaches.

Tinderbox Bay lies at the base of the peninsula. It contains a 100 m long sheltered south-facing reflective beach (**T 475**) backed by a car park, together with toilets and a boat ramp (Fig. 4.83). It faces south across the channel to Bruny Island.

Figure 4.83 The small Tinderbox Bay beach (T475).

D'Entrecasteaux Channel

The D'Entrecasteaux Channel is a 50 km long north-south waterway that separates Bruny Island from the mainland. It ranges in width from 1.5 km at its northern entrance between Piersons and Kellys points, widening in places to 10 km. The channel is bordered by 157 km of mainland shoreline along its western side, and 120 km of Bruny Island shoreline to the east. Most of the shoreline is protected from ocean swell receiving only wind waves generated within the channel. There is a total of 144 generally low to very low energy beach systems in the channel, 89 along the mainland shore (T 476-564) and 55 along the western shore of Bruny Island (BI 39-94).

T 476-481 NORTH WEST BAY

No.	Beach	Rating HT LT	Type	Length
T476	Peggys Beach	1 1	R+sand flats	250 m
T477	Snug Beach	1 2	R	500 m
T478	Snug Bay (S)	1 2	R	150 m
T479	Little Coningham	1 2	R	200 m
T480	Coningham Beach	2 3	R/LTT	500 m
T481	Legacy Beach	2 3	R+rocks	300 m
	Coningham State Recreation Area			*487 ha*
Spring & neap tidal range = 1.3 & 0.3 m				

North West Bay is a 2,000 ha low energy embayment located on the northwest side of the D'Entrecasteaux Channel. The bay has 16 km of generally low to very low energy shoreline, with beaches beginning to form along the slightly more exposed southern shore of the bay.

Peggys Beach (**T 476**) is a 250 m long beach that faces east towards the entrance of the bay, the D'Entrecasteaux Channel and Bruny Island. The beach is bordered by low rocky points and consists of a narrow high tide beach fronted by 150 m wide sand flats that fill the small embayment between the points. A small lagoon backs the beach with a few houses on its northern side, while a factory is located on the southern headland and a sewage treatment plant on the northern head.

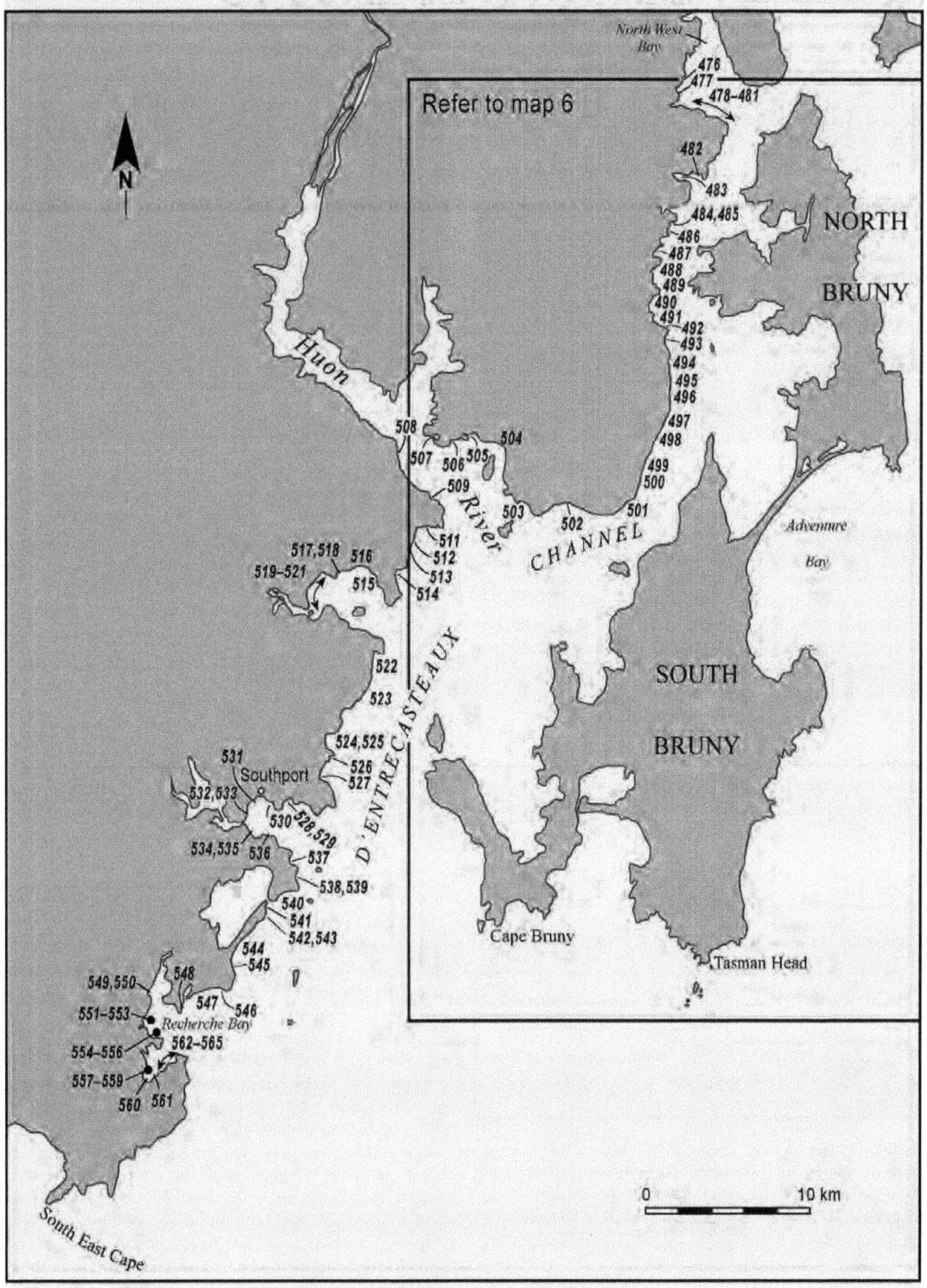

Figure 4.84 Region 2 South East Coast: D'Entrecasteaux Channel to South East Cape

Australian Beach Safety and Management Program

Snug Beach (T 477) is located 500 m to the south and fronts the small town of Snug. The beach faces east-northeast across the bay curving slightly for 500 m. The small Snug River runs out at the northern end of the beach against a 10 m high headland, with 600 m wide Snug Bay on the southern side of the beach. The narrow reflective beach is backed by a 100 m wide recreation reserve, then the township occupying gently rising slopes. A boat ramp is located at the river mouth, next to a footbridge across the mouth.

To the east of Snug Bay are 3.5 km of increasingly steep north-facing shoreline that extends to Snug Point, where it turns and trends south. Most of the shore is backed by Coningham State Recreation Area, with a narrow strip of houses behind the first 2 km of shore. Beach **T 478** is a curving 150 m long north-facing strip of sand tied to 10 m high sandstone points. It is fronted by 100 m wide sand and rock flats, with partly cleared slopes and a few houses. **Little Coningham Beach (T 479)** occupies the next small embayment 200 m to the east and is a curving 200 m long reflective beach, with some rock flats off the eastern end and boats moored off the beach. A few boat sheds and dinghies line the beach, which is backed by sloping land containing a youth camp and a few houses.

Coningham Beach (T 480) lies 300 m to the east on the eastern side of 20 m high Hurst Point. The 500 m long beach faces northeast across the bay entrance and receives waves averaging up to 0.5 m, which maintain a reflective to occasionally low tide terrace beach. A row of ten boat sheds line the western end of the each, with six along the eastern end as well as a small area of reserve, picnic area and toilets. Two rows of houses occupy the backing slopes, with the reserve dominating the higher slopes that rise to 240 m at Sheppards Hill.

Legacy Beach (T 481) is located 500 m to the east at the end of the access road and 500 m west of Snug Point. The 300 m long beach is backed by moderately steep wooded slopes, with Coningham Camp above the western end of the beach. The beach is reflective with patches of rock flats bordering and fronting parts of the beach.

T 482-483 OYSTER COVE

No.	Beach	Rating HT LT		Type	Length
T482	Oyster Cove (N)	1	1	R+sand flats	150 m
T483	Oyster Cove	1	1	R+sand flats	300 m
	Oyster Cove Historic Site				
Spring & neap tidal range = 1.3 & 0.3 m					

Oyster Cove is an irregular V-shaped east-facing embayment located between the northern Simmonds Point and Oyster Cove Point. Much of the western shore of the bay is fronted by sand flats, with only two low energy beaches (T 482 and 483) along the otherwise rocky shore.

Beach **T 482** is a 150 m long strip of high tide sand and cobbles located in a 200 m wide embayment at the northern apex of the bay. It faces southeast out of the bay across 300 m wide sand flats, which fill the small bay between its boundary rocky shore (Fig. 4.85). It is bordered and backed by partly cleared sloping farmland with buildings behind the eastern end of the beach and a small creek draining across the centre of the beach.

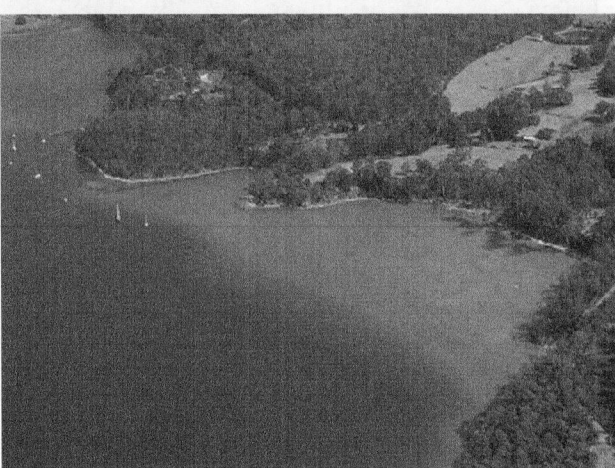

Figure 4.85 Narrow, low energy beach T 482 is located in Oyster Cove in lee of 300 m wide sand flats.

Beach **T 483** is located at the western end of the 1.5 km deep bay and is within the Oyster Bay Historic Site. The 300 m long beach commences at the mouth of Oyster Cove Rivulet and trends southeast to the rocky slopes of the 120 m high ridge that extends 1 km east to Oyster Cove Point. It is a narrow high tide beach fronted by 300 m wide sand flats, with boats moored off its southern half.

T 484-486 TRIAL & PERCH BAYS

No.	Beach	Rating HT LT		Type	Length
T484	Trial Bay (N)	1	1	Cobble+sand flats	200 m
T485	Trial Bay (S)	1	1	Cobble+sand flats	300 m
T486	Perch Bay	1	1	R+sand flats	250 m
Spring & neap tidal range = 1.2 & 0.3 m					

Trial and Perch bays are two curving east-facing embayments located on the southern side of Kettering and Deadmans points respectively. They contain three low energy beaches (T 484-486).

Trial Bay is a curving 600 m wide embayment bordered by Kettering and Deadmans points. Beach **T 484** occupies the northwestern shore of the bay and consists of a high tide cobble beach fronted by sand flats that widen to 300 m in the centre of the bay. A picnic area, toilets and boat ramp occupy the small reserve behind the beach, with the Channel Highway clipping the western end. Flights Creek separates the two beaches, with beach **T 485** trending to the south for another 300 m to the inner slopes of Deadmans Point. It is a similar low, narrow cobble beach located to the rear of the sand flats, with salt marsh growing towards the southern end of the beach. The highway then sloping cleared farmland back the beach.

Perch Bay is located to the west of Deadmans Point. It is a curving east-facing 400 m wide embayment, with beach **T 486** curving for 250 m around the western shore of the small bay. The beach is composed of cobbles and fronted by a 50 m wide sand flats then the deeper bay with boats moored just off the flats. A boat ramp, large shed and slipway cross the northern end of the beach, with cleared farmland behind the centre and a house on the southern point.

T 487-492 PERIWINKLE-BIRCHS BAYS

No.	Beach	Rating HT LT	Type	Length
T487	Little Periwinkle Bay	1 2	R+sand/rock flats	500 m
T488	Periwinkle Bay (N)	1 2	R+sand/rock flats	100 m
T489	Periwinkle Bay (S)	1 1	R+sand flats	250 m
T490	Birchs Bay (N)	1 2	R+sand/rock flats	200 m
T491	Yellow Pt (S)	1 1	R+sand flats	300 m
T492	Fleurtys Pt (N)	1 1	R+sand flats	500 m
Spring & neap tidal range = 1.3 & 0.3 m				

Little Periwinkle, Periwinkle and Birchs bays are a series of small east-facing embayments each bordered by resilient dolerite points, with valleys carved in softer Permian sandstones. They are located either side of the small town of Woodbridge and occupy 6 km of shore. Six small low energy beaches and sand flats (T 487-492) are located in the bays. The Channel Highway hugs the coast and provides direct access to most of the beaches.

Beach **T 487** extends for 500 m along the northern shore of 700 m wide Little Periwinkle Bay. It is a discontinuous narrow high tide sand and cobble beach, which terminates at the small mouth of Bates Creek in the southern corner of the bay. One hundred metre wide sand and rock flats parallel the beach, which is backed by tree-covered bluffs rising to 20 m then cleared farmland.

Helliwells Point protrudes 500 m into the channel and separates the Periwinkle bays. Periwinkle Bay lies to the south and is a 1.5 km wide east-facing bay bordered to the south by Birchs Point. Woodbridge is located in the centre of the bay to the lee of a small central headland. Beach **T 488** is a 100 m long strip of high tide sand and 150 m wide sand flats located in the northern half of the bay. It faces southeast down the bay receiving only low wind waves. It is backed by three houses then the highway, with a few dinghies usually pulled up on the beach. Beach **T 489** is located in the southern half of the bay. It commences at the mouth of Masons Creek and trends to the south-southeast for 250 m. It faces northeast across 200 m wide sand flats. It is backed by generally cleared slopes with the Woodbridge high school between the beach and highway.

The southern Birchs Point forms the northern boundary of 2.5 km wide **Birchs Bay**, an open east-facing embayment, divided into two by the central Yellow Point. Beach **T 490** occupies 300 m of the northern half of the bay. It is a 200 m long southeast-facing narrow high tide

sand and cobble beach with 100 m wide sand and rock flats. The highway runs right along the rear of the beach. Beach **T 491** commences at the mouth of Birchs Bay Creek, on the southern side of Yellow Point, and trends to the southeast for 300 m to a small rocky point. It is paralleled by 300 m wide sand flats that fill much of the southern half of the bay. Beach **T 492** continues on the southern side of the small point for another 500 m to the inner rocks of Fleurtys Point. Both beaches are backed by gently sloping farmland with the highway 200 to 400 m inland.

T 493-500 FLEURTYS-THREE HUT POINTS

No.	Beach	Rating HT<	Type	Length
T493	Fleurtys Pt (S)	1	R+sand flats	200 m
T494	Flowerpot Rock (S)	1	R+sand flats	100 m
T495	Dripstone Pt (N)	1	R+rock/ridged sand flats	150 m
T496	Whaleboat Rock (N)	1	R+ridged sand flats	200 m
T497	Middleton	1	R+sand flats	100 m
T498	McDowall Rivulet	1	R+sand flats	200 m
T499	Webster Rd	1	R+sand flats	300 m
T500	Three Hut Pt	1	Cobble+ridged sand flats	200 m
Spring & neap tidal range = 1.3 & 0.3 m				

To the south of **Fleurtys Point** the shoreline trends to the south for 9 km to Three Hut Point. The highway parallels the shore between 50 and 600 m inland, running along the base of slopes that rise 300-400 m to the west. The shoreline is backed by generally cleared farmland. Eight small generally east-facing lower energy beaches and sand flats (T 493-500) occupy several slight indentations in the shoreline

Beach **T 493** is located on the southern side of the narrow Fleurtys Point. It consists of a narrow 200 m long strip of high tide sand and cobbles fronted by 300 m wide sand flats, with oyster racks covering parts of the flats (Fig. 4.86). A landing for the oyster farm is located towards the southern end of the beach, with a belt of trees then orchards on the slopes behind, and the highway 400 m inland.

Figure 4.86 The narrow high beach T 493 is fronted by 300 m wide sand flats containing oyster racks.

Beach **T 494** is located 1 km to the south on the southern side of a slightly protruding point to the lee of **Flowerpot Rock**. The 100 m long beach faces south across 200 m wide sand flats with subdued ridges. It is backed by a 50 m wide band of tall trees then farmland on the backing slopes. Beach **T 495** is located in the next slight embayment 700 m to the south and on the northern side of the slight **Dripstone Point**. The 150 m long beach is located at the base of a small creek and consists of a narrow strip of high tide cobbles fronted by 50 m wide linear rock flats, then ridged sand flats extending another 300 m into the channel. It is backed by trees, cleared sloping farmland and some houses, with the highway 150 m inland.

Beach **T 496** lies 1.5 km further south on the northern side of the slightly protruding **Whaleboat Rocks**. The 200 m long beach extends to either side of a small creek and consists of a cobble high tide beach fronted by a narrow band of rock flats then ridged sand flats extending 400 m offshore. A band of tall trees, then sloping farmland and some houses back the beach, with the highway paralleling the shore 300 m inland.

Middleton beach (**T 497**) is located on the Esplanade between Oates and McDowall roads. It is a 100 m long sandy beach that has accumulated in a slight indentation in the shore, with the road and cleared farmland rising behind. Ridged sand flats extend 100 m off the beach gradually sloping into deeper water. There is a small reserve with toilets and a playground between the beach and road (Fig. 4.87).

Figure 4.87　　The sheltered Middleton Beach (T 497) is backed by a grassy reserve.

The **McDowall Rivulet** reaches the shore 1 km to the south forming a small cobble delta that extends 100 m out across the sand flats. Beach **T 498** extends south of the creek mouth for 200 m as a narrow high tide cobble beach. A few small buildings and a jetty are located immediately south of the creek mouth. They service the oyster racks located 200 m offshore.

Beach **T 499** is located at the base of the Webster Road, which descends from the 100 m high backing slopes. The beach extends to the south for 300 m as a narrow high tide cobble beach, backed by partly tree-covered slopes, some cleared farmland and houses, with the highway 100 m inland. It is fronted by 300 m wide sand flats containing numerous oyster racks.

Three Hut Point is a low cobble recurved spit located at the base of slopes that rise 340 m to Mount Royal. Beach **T 500** commences on the northern side of the spit and curves to the north for 200 m as a narrow high tide cobble beach, with the highway running right along the rear of the northern half of the beach. Ridged sand flats extend out to the point with a boat ramp located on the point.

T 501-503　PENSIONERS BAY-PICKUP BEACH

No.	Beach	Rating HT LT		Type	Length
T501	Pensioners Bay	2	3	Boulder	300 m
T502	Well Rd	2	3	Cobble	50 m
T503	Pickup Beach	2	3	R/LTT	800 m
Spring & neap tidal range = 1.3 & 0.3 m					

At Three Hut Point the shoreline turns and trends to the west for 7 km to Ninepin Point, where it turns slightly to the northwest and continues for another 2 km to Garden Island Point. The Channel Highway runs along beside the shore at the base of densely wooded slopes rising 200-300 m. Most of the shore is dominated by dolerite rocks and boulders, with only three beaches (T 501-503). Beach **T 501** is located 500 m southwest of the point in the open southeast-facing Pensioners Bay. It consists of a slightly curving 300 m long cobble and boulder beach with the highway running 30 m in from the shore.

Beach **T 502** is located 100 m east of where Wells Road joins the highway. It is a 50 m long pocket of cobbles located between two low rocky points with the highway right behind. A small car park is located at the eastern end of the beach.

Pickup Beach (**T 503**) is a straight 800 m long south-southwest-facing beach backed by three rows of houses, which make up the small Verona Sands subdivision (Fig. 4.88). The beach occupies an open embayment fed by Lasts Creek, which crosses the western end of the beach and is bordered by Ninepin Point to the east and a smaller headland to the west. Low wind waves generated in the channel reach the sandy beach and maintain an often cusped reflective to narrow low tide terrace beach. It is backed by a low well vegetated tree-lined foredune then the houses, with the highway 200 m to the rear. There is a store in the settlement and a boat ramp and picnic area at the western end of the beach by the small usually blocked creek mouth.

Figure 4.88 Pickup Beach (T 503) is a usually low energy reflective strip of sand.

T 504-507 GARDEN ISLAND BAY

No.	Beach	Rating HT	LT	Type	Length
T504	Garden Island Sands	1	1	R+sand flats	400 m
T505	Randalls Bay	1	1	R+sand flats	750 m
T506	Cray Pt (N)	1	1	R+sand flats	150 m
T507	Eggs & Bacon Bay	1	1	R+sand flats	400 m
Spring & neap tidal range = 1.3 & 0.3 m					

Garden Island Bay is a 3 km wide irregular embayment that faces south past Garden Island into the D'Entrecasteaux Channel. Three beaches (T 504-506) are located in the relatively sheltered bay, with one (T 507) immediately to the west.

Garden Island Sands beach (**T 504**) is located at the mouth of Garden Island Creek. The 400 m long beach is bordered by the creek at its eastern end and steep wooded slopes rising to 200 m on either side. The beach consists of a 5 m wide strip of high tide sands fronted by 100 m wide sand flats. Two rows of houses back the beach, with the Lowes Road connecting to the highway, which parallels the creek and crosses it 1 km north of the beach.

Randalls Bay lies 1 km to the west in the centre of Garden Island Bay. The 600 m wide bay faces south-southeast and contains a 750 m long low energy beach (**T 505**) along its northern shore. An elongate 300 m long point provides additional shelter for the bay, which is largely filled with sand flats and seagrass meadows. Houses are located along the base of Echo Sugarloaf at the eastern end of the bay with Williams Road running along the rear of the small beach to link with Randalls Bay Road. A camping and picnic area and toilets are located at the western end of the beach adjacent to the deflected mouth of Randalls Creek.

Beach **T 506** is located on the western side of Garden Island Bay to the lee of Cray Point. It is a 150 m long east-facing narrow high tide beach, backed by densely vegetated bluffs rising to 20 m with a few houses to either side.

Eggs and Bacon Bay is located on the western side of Cray Point. It is a 300 m wide west-facing bay bordered by Eggs and Bacon Reef to the south and the larger Cygnet Point to the north. Beach **T 507** is a curving 400 m long west-facing beach located along its eastern shore. The low, narrow low energy beach is fronted by sand flats and backed by partly cleared slopes and scattered houses.

Huon River

The Huon River flows into a 20 km long drowned river valley, also called the Huon River. The valley widens gradually from 1 km at the river to 3 km at its mouth between Garden Island Point and Huon Point. The estuary has 60 km of generally steep wooded shoreline, with most of the shoreline accessible along roads that follow the shore. The towns of Cygnet and South Franklin are located on the shores of the estuary. The only beaches inside the estuary are the northern Garden Island Bay beaches (T 504-507) and beaches T 508 and 509 located towards the southern entrance to the estuary.

T 508-509 BARRETTS & SURVEYORS BAYS

No.	Beach	Rating HT	LT	Type	Length
T508	Barretts Bay	2	2	R	200 m
T509	Surveyors Bay	2	2	R	350 m
Spring & neap tidal range = 1.3 & 0.3 m					

Barretts and Surveyors bays are two small east-facing embayments located on the southern side of the entrance to the Huon River estuary. **Barretts Bay** is 200 m wide and contains a 200 m long narrow reflective beach (**T 508**), which faces east out of the estuary. It is backed by wooded slopes then farmland and bordered by low rocky tree-covered points. The Esperance Coast Road clips the southern end of the beach, with a small car park and reserve behind the beach.

Surveyors Bay lies 3 km to the southeast and 1.5 km north of Huon Point, the entrance to the estuary, with Surveyors Point forming the northern boundary. The curving 600 m wide bay is bordered and backed by partly cleared slopes rising to 200 m at Camden Hill to the rear. The 350 m long beach (**T 509**) receives waves averaging up to 0.5 m, which maintain a usually cusped reflective beach, backed by a row of holiday cottages.

T 510-514 ROARING BAY

No.	Beach	Rating HT	LT	Type	Length
T510	Roaring Bay Beach	4	4	LTT	1.4 km
T511	Little Roaring Bay	3	3	R	250 m
T512	Roaring Bay (S1)	3	4	R+rocks	70 m
T513	Roaring Bay (S2)	3	3	R	80 m
T514	Esperance Pt (N)	3	4	R/LTT	200 m
Spring & neap tidal range = 1.3 & 0.3 m					

Roaring Bay is an open south-facing embayment located immediately west of Huon Point, with the western shoreline trending south for 5 km to Esperance Point. The name derives from the low swell that regularly arrives at the main beach (T 510) to break and roar across the bar. Four smaller and more sheltered beaches occupy small gaps in the rocky shore that makes up the western shore of the bay. The Esperance Coast Road provides access to the northern two of the five beaches.

Roaring Bay Beach (**T 510**) is a 1.4 km long south-facing moderately exposed beach, which receives south swell averaging about 1 m. This maintains a 30-50 m wide low tide terrace (Fig. 4.89). Forty metre high Huon Point borders the eastern end of the beach, with the steep wooded slopes rising behind the western end. The first 1 km of the beach is backed by a 5-8 m high foredune, then a row of beachfront houses, with a small creek crossing towards the western end and another 200 m of the more sheltered beach extending west of the creek out along the base of the steep slopes, with the road running along the slopes above this end of the beach.

Figure 4.89 Roaring Bay Beach (T 510) receives low refracted swell which usually breaks across a narrow attached bar.

Little Roaring Bay (**T 511**) lies 500 m to the south and is a more sheltered east-facing reflective beach located at the mouth of a 250 m wide valley. Kubes Creek drains the valley and crosses the centre of the beach. A rock outcrop cuts the beach in two with a 50 m long section north of the rocks. The 250 m long main section of beach is backed by a narrow cleared valley with a few houses and the Esperance Road widening around the valley sides. A few boat sheds are located behind the centre of the beach with several dinghies usually pulled up on the beach.

Beach **T 512** is located at the base of steep wooded slopes 600 m to the south. It consists of a 70 m long high tide reflective sand beach largely fronted by 50 m wide rocks and rock flats. There is a steep vehicle track down to the beach to a boat shed and the remains of a slipway on the northern rocks.

Beach **T 513** lies 300 m further south along the steep rocky shore. It is an 80 m long reflective sandy beach, with a cluster of rock reefs off the south end and rocky shore to either side. Steep wooded slopes rise to 100 m behind the beach with the road at that level.

Beach **T 514** is a further 1 km to the south and 2 km north of Esperance Point. It is a slightly more exposed southeast-facing 200 m long sandy beach, bordered by rocky shore to either side. Waves averaging about 0.5 m maintain a reflective to occasionally low tide terrace beach. There is no formal access to the beach.

T 515-521 PORT ESPERANCE

No.	Beach	Rating HT LT	Type	Length
T515	Blubber Hd Rd	1 1	R+sand flats	150 m
T516	Kents Beach	2 2	R	800 m
T517	Kents Beach (W)	2 2	R	200 m
T518	Dover Beach	2 2	R+sand flats	500 m
T519	Brick Kiln	2 2	R+sand flats	300 m
T520	Hopetoun Beach	1 1	R+sand flats	850 m
T521	Slacks Pt	1 1	R+sand flats	200 m
Spring & neap tidal range = 1.3 & 0.3 m				

Port Esperance is a 1200 ha embayment with a 2 km wide mouth between Esperance and Lomas points, and Hope Island located in the entrance. The shoreline curves around for 15 km inside the sheltered bay, with seven beaches (T 515-521) located along the northern and western shore, while steep wooded slopes back the entrance points and southern shore. Low reflected swell and wind waves dominate the generally low energy bay shoreline. The small town of Dover is located on the northwest shore of the bay.

Beach **T 515** is located at the junction where the Esperance Coast Road reaches the bay shore and links with the Blubber Head Road. It is a narrow 150 m long low energy beach that faces west into the bay across 100 m wide sand flats. A boat shed is located behind the centre of the beach, with the road behind then a few houses on the backing wooded slopes.

Kents Beach (**T 516**) is the highest energy beach in the bay and receives some low swell, as well as wind waves. It is an 800 m long south-facing narrow reflective beach grading into the shallow bay floor. The road runs along the rear of the beach with the small Glenbervie Rivulet at the eastern end, a small creek and wetland at the western end, and a row of houses in between. It terminates at a cluster of rocks and a slipway, with beach **T 517**

continuing on the other side for another 200 m to low Knobbys Point. The road follows the rear of the beach with a small tree-filled reserve between the road and low energy reflective beach.

Dover Beach (T 518) extends from the western base of Knobbys Point for 400 m to the small mouth of Dover Rivulet then another 100 m to the Dover jetty and slipway. The sandy beach faces southeast toward the bay mouth and consists of a reflective high tide beach fronted by 100-200 m wide sand flats with some boats moored off the western end near the jetty (Fig. 4.90). A low vegetated foredune and small reserve runs between the road and beach with a picnic area and toilets at the eastern end. Across the road are a row of houses, caravan park and the small township extending to the north.

Figure 4.90　　Dover Beach (T 518) fronts the small Dover township and faces into the sheltered waters of Port Esperance.

Beach **T 519** is located 1 km southwest of Dover and fronts the Huon Highway and Dover Hotel. It is a narrow, low energy 300 m long strip of sand with narrow sand flats, backed by low vegetated bluffs, then the highway, with a 50 m long jetty crossing the sand flats in the centre of the beach.

Hopetoun Beach (T 520) occupies the centre of the western shore of the bay. The narrow low energy west-facing beach is fronted by 100 m wide sand flats and backed by several beachfront houses. It is bordered in the north by the small mouth of Bates Creek and a cluster of low rocks to the south. Several boats are usually moored off the beach. Beach **T 521** extends south of the rocks for 200 m to the low rocky Slacks Point, which forms the northern entrance to the Esperance Narrows, a 500 m wide arm of the bay. The beach faces northeast across the bay and is fronted by the continuous 100 m wide sand flats, with the deeper narrow channel to the south. A vehicle track runs along the rear of the narrow beach.

T 522-527　GARRETTS BIGHT-LADY & SISTERS BAYS

No.	Beach	Rating HT LT		Type	Length
T522	Garretts Bight	3	6	Boulder+LT	150 m
T523	Little Garretts Bight	3	6	Boulder+rocks	40 m
T524	Lady Bay (N)	3	6	Boulder+rocks	600 m
T525	Lady Bay (S)	3	6	Boulder+rocks	300 m
T526	Browns Pt	3	6	Boulder	50 m
T527	Sisters Bay	3	6	Boulder	600 m
Spring & neap tidal range = 1.3 & 0.3 m					

At Lomas Point the coast trends south for 10 km to Rossel Point at the entrance to Southport. In between are 16 km of generally steep, densely wooded slopes and rocky shoreline, with vehicle access only in the south at Lady and Sisters bays. In amongst the rocky coast are six boulder beaches (T 522-527).

Garretts Bight is located 500 m south of Lomas Point and immediately west of Scott Point. The bight is a 150 m wide south-facing rocky embayment bordered and backed by densely wooded slopes rising to 50 m. Beach **T 522** curves for 150 m along the northern shore of the bay and consists of a steep boulder beach with some sandy seafloor off its eastern half. Waves averaging about 1 m break over the sand and surge up the steep beach. There is a vehicle track to Scott Point with a steep climb down to the beach.

Little Garretts Bight lies 2 km due south of Scott Point and is a small V-shaped rocky bay at the mouth of a narrow V-shaped densely vegetated valley. Beach **T 523** is a 40 m long steep boulder beach wedged in the apex of the bay, with steep rocky slopes extending to either side and the backing slopes rising to 400 m.

Lady Bay is a curving 1 km wide east-facing bay located 4 km north of Rossel Point. The bay is backed by freehold land with the Lady Bay Road running along the southern side of the bay. Beach **T 524** occupies 600 m of the northern side of the bay. It is a curving southeast- to east-facing boulder beach, with a mixture of rock and sand seafloor backed by densely wooded slopes rising to 400 m. It is bordered by steep rocky slopes to the north and a 100 m long rocky point to the south. Selfs Rivulet crosses the centre of the beach. Beach **T 525** occupies the southern half of the bay and is a more sheltered northeast-facing 300 m long boulder beach, backed by a 50 m wide band of trees, then partly cleared slopes with a few houses and the road.

Browns Point protrudes 500 m to the southeast, terminating as a narrow 20 m high finger of dolerite, and forms the southern boundary of Lady Bay. Beach **T 526** is a southeast-facing 50 m long pocket of boulders wedged in a narrow gully on the south side of the point. Cleared farmland backs the 20 m high slopes, with the road 400 m to the west.

Sisters Bay is located 1 km south of Browns Point and is a curving 700 m wide east-facing rocky embayment, with Lady Bay Road running along its northern shore. Beach **T 527** occupies the centre of the bay and is a curving, east-facing 600 m long boulder beach. The road clips its northern end, with both wooded and cleared slopes rising behind the beach and a few houses in the cleared areas.

T 528-533 SOUTHPORT (N)

No.	Beach	Rating HT LT		Type	Length
T528	Roaring Beach (E)	4	4	LTT	150 m
T529	Roaring Beach (W)	5	6	TBR	250 m
T530	Walpoles Ck	3	3	R	300 m
T531	Southport	3	3	R	400 m
T532	Kingfish Beach	3	3	R	800 m
T533	Southport Narrows	3	3	R+tidal channel	100 m
Spring & neap tidal range = 1.3 & 0.3 m					

Southport is a 2.5 km wide, 4 km deep drowned bedrock valley that faces east between the northern Rossel Point and the southern rocky shore. The bay continues west through the 100 m wide Southport Narrows into the 5 km long Hastings Bay, with several creeks and the Lune River draining into the bays. The Southport embayment has 14 km of sloping generally rocky shoreline, with nine partly sheltered beaches located around the bay shore. Beaches T 528-533 are located on the northern shore of the bay.

Roaring Beach is located on the more exposed northeastern shore of the bay 1.5 km inside Rossel Point. The beach contains two southeast-facing sections, which receive moderate ocean swell. The eastern section (**T 528**) is a 150 m long white sand beach, which receives waves averaging about 1 m which break across a 30 m wide low tide terrace (Fig. 4.91). It is backed by a low narrow grassy foredune, and then cleared farmland. A small creek drains across the centre of the beach, with a house next to the creek mouth. A small clump of rocks separates it from the main beach **T 529** that continues west for 250 m to the base of Burying Ground Point, which extends 500 m to the south. The western section of the beach receives waves up to 1.5 m, which maintain a 50 m wide surf zone, with a rip usually flowing out against the western rocks and an occasional central beach rip. The beach offers one of the few readily accessible beach breaks south of Hobart. It is backed by a low foredune, then cleared farmland and some scattered buildings.

Beach **T 530** is located on the western side of Burying Ground Point, with Walpoles Creek draining across the centre of the beach. It is a 300 m long curving sheltered narrow low energy reflective beach that faces southwest into the bay and receives very low refracted swell. The Lady Bay Road runs along the rear of the beach, with a camping area on the western 100 m wide grassy point. Cleared sloping land and a few houses back the beach, with a few boats usually moored off the shore.

Figure 4.91 Roaring Beach consists of two sections (T 528 & 529) linked by a continuous narrow surf zone.

Southport beach (**T 531**) is located at the northern extremity of the bay. It is a curving 400 m long south-facing reflective beach, which receives only very low swell waves. The 100 m long Southport jetty crosses the eastern end at the junction of the Huon Highway and Lady Bay Road with Kingfish Road continuing along the rear of the remainder of the beach. Settlement Creek crosses the beach just west of the jetty, with a small park and toilets next to the creek. A few houses back the jetty with cleared farmland behind the remainder of the beach. Several boats are usually moored off the jetty.

Kingfish Beach (**T 532**) is a narrow 800 m long low energy reflective beach that faces east towards the bay entrance. The beach is backed by gently sloping cleared land containing beachfront houses, the road then a few rows of houses and holiday cabins behind the centre of the beach. Beach **T 533** is located at the end of Kingfish Road on the northern side of the Narrows. It is a transient 100 m long wedge of sand that faces south across the 100 m wide deep tidal channel and has a boat ramp at its western end. It is backed by low vegetated bluffs, the road and a few houses.

T 534-536 SOUTHPORT (S)

No.	Beach	Rating HT LT		Type	Length
T534	Elliott Beach (W)	3	4	R+tidal shoals	1 km
T535	Elliott Beach (E)	3	4	R+tidal shoals	500 m
T536	Deephole Bay	4	5	Boulder+LTT	50 m
Ida Bay State Reserve					
Spring & neap tidal range = 1.3 & 0.3 m					

The southern shores of Southport Bay consist of the sweeping 1.5 km long Elliott Beach that extends east of the Southport Narrows, to the beginning of the higher rocky shore that dominates the outer bay. The shore is now part of the Ida Bay State Reserve, but in the past had a jetty serviced by the Ida Bay railway. The jetty remains as does the disused railway line.

Elliott Beach (T 534) commences on the south side of the Southport Narrows where it faces north across the deep 100 m wide channel to beach T 533. The 1 km long beach curves round to trend southeast terminating at the old jetty, only the base of which remains. The beach is fronted by the sandy tidal shoals of the narrows, which extend up to 1 km into the bay to reach the lee of Pelican Island. Low swell breaks across the shoals producing surf during periods of higher swell. The shoals narrow to the southern end of the beach where there is a deepwater at the site of the jetty in Deephole Bay. The beach is backed by 300 m wide low wooded foredune ridges that abut wooded slopes rising to 80 m.

The eastern half of the beach (**T 535**) continues east of the jetty for 500 m as a curving north-facing low energy reflective beach that has a deeper hole in the eastern corner, with shallow sandy bay floor extending 200 m offshore then the deepwater of the bay (Fig. 4.92). It is backed by a low foredune, and then low wooded terrain, and is bordered in the east by a small dolerite point on the eastern side of which is the pocket beach **T 536**. This is a 50 m long east-facing boulder beach fronted by a sandy low tide terrace. It is more exposed and receives waves averaging up to 1 m, which break over the rocks off the northern point and across the 50 m wide sandy terrace producing a right-hand break during higher swell.

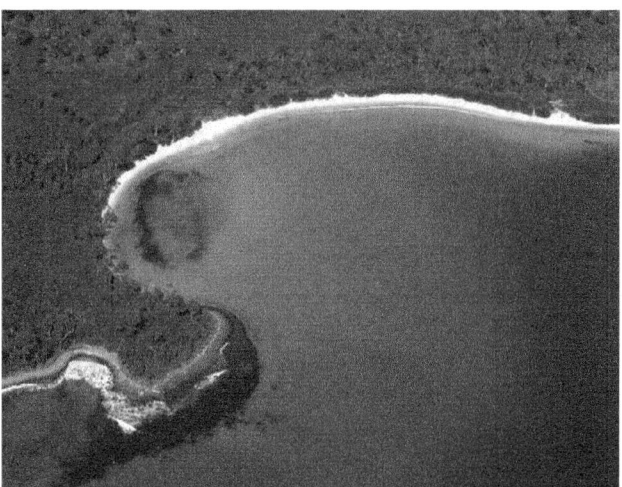

Figure 4.92 The eastern half of Elliott Beach (T 535) curves round in lee of a low dolerite point.

T 537-540 SOUTHPORT BLUFF

No.	Beach	Rating HT LT		Type	Length
T537	Southport Bluff (N3)	5	6	TBR	500 m
T538	Southport Bluff (N2)	5	5	LTT/TBR	300 m
T539	Southport Bluff (N1)	4	4	LTT	60 m
T540	Southport Bluff (S)	5	5	TBR	700 m
	George III Monument Historic Site				*14.4 ha*
Spring & neap tidal range = 1.3 & 0.3 m					

Southport Bluff is a 20 m high dolerite headland, which forms the western entrance to the D'Entrecasteaux Channel. The bluff area is incorporated in the George III Monument Historic Site, which commemorates the wreck of the George III in 1835 with the loss of 133 convicts. The bluff is backed by densely vegetated heathland then state forest, with a vehicle track winding out through the forest from Elliott Beach to the bluff and providing vehicle access to the bluff and southern beach. Three beaches (T 537-539) are located within 1 km north of the bluff and one on its southern side (T 540).

Beach **T 537** is an east-facing 500 m long beach, bordered by 20 m high vegetated headlands, that extends 200 m seaward. The beach receives long south swells averaging up to 1.5 m, which maintain a transverse bar and rip system, with rips usually against the boundary rocky headland, and one to two central beach rips. It is backed by a low foredune with wooded slopes to the north and a wetland that extends around the rear of the southern headland.

Beaches T 538 and 539 occupy the next open embayment 300 m to the south. Beach **T 538** is a straight 300 m long east-facing beach partly sheltered by Southport Island and a reef, which lie 500 m off the southern headland. The beach receives waves averaging about 1 m, which usually maintain a 50 m wide low tide terrace (Fig. 4.93), with a rip forming against the northern rocks during higher waves. Boulder beaches lie to either side, while a heath-covered Pleistocene sand dune and the wetland back the beach. The dune and others extending south behind the bluff have originated from the exposed sandy bed of Southport Lagoon during periods of low sea level probably during the glacial maxima about 20,000 years ago.

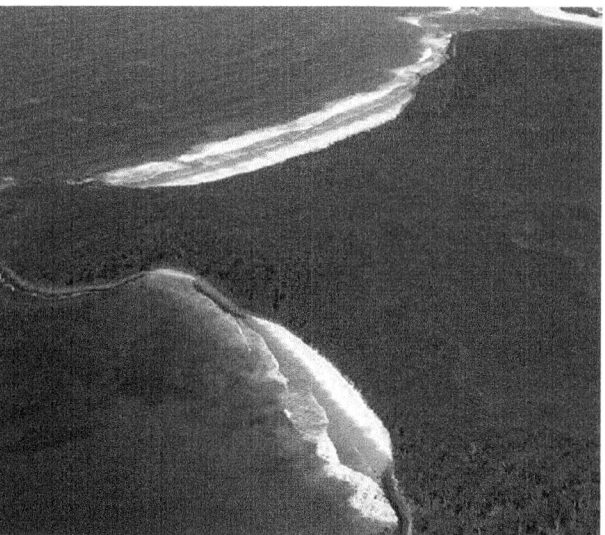

Figure 4.93 Beach T 538 (foreground) and beach T 539 (rear), lie either side of Southport Bluff.

Beach **T 539** is located 100 m to the south at the end of a boulder beach that separates the two. It is a 60 m long pocket of northeast-facing sand with bordering boulders, then Southport Bluff extending 150 m to the east and the island and reefs further out. Waves are lowered to less than 1 m and maintain a 30 m wide sandy low tide

terrace. Trees then heath-covered bluffs back the small beach. A vehicle track runs across the bluff to the George III monument, 200 m to the south.

Beach **T 540** commences on the southern side of the bluff and trends to the southwest for 700 m terminating against the 500 m wide headland that forms the northern boundary of Southport Lagoon and inlet. The beach faces southeast into the prevailing southerly swell and receives waves averaging about 1.5 m which maintain a transverse bar and rip systems, with usually a rip against the northern rocks and one to two beach rips. It is backed by a few trees to either end and heath-covered Pleistocene 'glacial' dunes from the lagoon.

T 541-545 SOUTHPORT LAGOON

No.	Beach	Rating HT LT	Type	Length
T541	Southport Lagoon	6 8	TBR+inlet channel	400 m
T542	Southport Lagoon (S1)	6 7	Boulder +LTT	50 m
T543	Southport Lagoon (S2)	6 7	Boulder +LTT	100 m
T544	Big Lagoon Beach	6 6	TBR	2.5 km
T545	Big Lagoon Beach (S)	6 6	LTT+rocks	80 m
	Southport Lagoon Wildlife Sanctuary			*4150 ha*
Spring & neap tidal range = 1.3 & 0.3 m				

Southport Lagoon is a pristine 1,000 ha coastal lagoon located to the lee of Southport Bluff. It is surrounded by undulating cleared and timbered terrain, with several small creeks draining into the lagoon. It has an exposed 200 m wide opening to the sea through which the wave and tides have deposited a 300 ha flood tidal delta (Fig. 4.94). Big Lagoon Beach extends for 2.5 km southwest of the entrance to enclose the southeastern side of the lagoon, with four other smaller beaches (T 541-543, 545) to either side. All are located within the Southport Lagoon Wildlife Sanctuary.

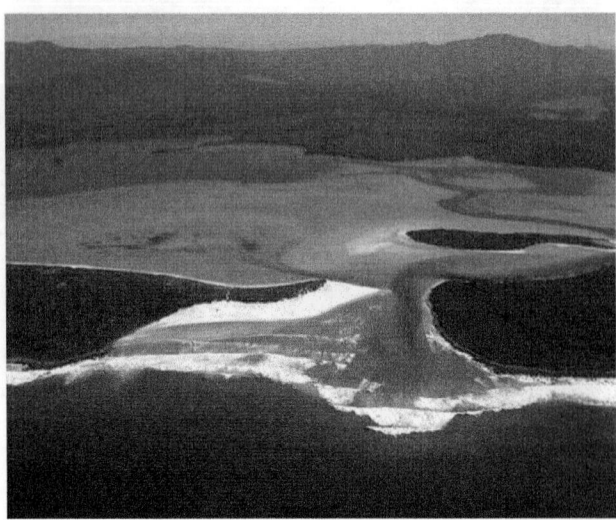

Figure 4.94 Southport Lagoon has a dynamic inlet with exposed beaches (T 540 & 541) to either side.

Beach **T 541** occupies the southern entrance to the lagoon. It is an exposed curving east- to north-facing 400 m long beach, fronted by a 100 m wide bar with the deep 100 m wide tidal channel running off the northern end of the beach while it is attached to a low bedrock high in the south. Waves average over 1.5 m and usually produce a strong rip draining out against the southern rocks, which combines with the tidal flow through the inlet to produce hazardous surf conditions. A 50 m wide foredune, then the lagoon backs the beach. There is a walking track across the foredune used by people landing on the lagoon shore.

Beaches T 542 and 543 are two small boulder beaches located on the 500 m long bedrock high. Beach **T 542** is a curving 50 m long boulder beach fronted by a patch of low tide sand, while beach **T 543** lies 100 m to the south and is a similar though 100 m long beach. Both beaches are exposed to moderate swell, which generates a 50-100 m wide surf zone breaking over the bars, with strong rips flowing out of each system. They are backed by a belt of heathland then 200 m of trees with the lagoon shore behind.

Big Lagoon Beach (T 544) is a southeast-facing 2.5 km long exposed beach that extends from the southern side of the bedrock to the southern bedrock boundary of the lagoon. The beach receives waves averaging about 1.5 m, which maintain a rip-dominated 50-100 m wide surf zone, with up to 10 rips along the beach, as well as a permanent rip against the northern rocks. Wave height decreases slightly towards the southern end. The beach is backed by a 200 m wide foredune, which narrows to 50 m in the south and is crossed by two walking tracks from the lagoon shore. A rough, boggy vehicle track reaches the southern end of the beach.

Beach **T 545** is located on the low rocky shore 500 m to the south. It is an 80 m long sandy beach and bar, bordered by dolerite boulders and rocks, which also extend 50 m offshore. Waves averaging about 1 m break across the 50 m wide bar. It is backed by tree- and heath-covered slopes rising to 35 m.

T 546-548 LITTLE LAGOON BEACH

No.	Beach	Rating HT LT	Type	Length
T546	Bowdens Mistake (W)	6 7	Boulder +TBR	80 m
T547	Little Lagoon Beach	6 7	TBR	2.3 km
T548	Little Lagoon (W)	5 6	LTT/TBR	500 m
Spring & neap tidal range = 1.3 & 0.3 m				

Eliza Point and Bowdens Mistake form the southeast tip of a 1.5 km wide, 60 m high bedrock high that separates Southport Lagoon and beach from the smaller Blackswan Lagoon and Little Lagoon Beach. The coast curves away to the southwest from the point and contains three beaches (T 546-548). The lagoon and beaches are all included in the Southport Lagoon Wildlife Sanctuary.

Beach **T 546** is located 600 m west of the point in a 100 m wide gap in the bedrock shore. It is an 80 m long

curving high tide boulder beach at the base of 10 m high bluffs, with a sand bar filling the bay. Waves averaging over 1.5 m break outside the bay and roll across the 100 m wide surf zone, with a permanent rip draining the small embayment. Heath-covered slopes back the bluffs reaching 60 m in height, with a vehicle track 100 m in from the bluffs.

Little Lagoon Beach (T 547) begins 150 m to the west at the end of the dolerite rocks. It curves gently to the southwest for 2.3 m to a cuspate foreland formed in lee of The Images, a cluster of dolerite rocks, reefs and islets that extend 700 m off the end of the beach (Fig. 4.95). The beach receives waves averaging over 1.5 m at the eastern end, which decrease slightly to the lee of the reefs. The waves maintain a rip-dominated 100 m wide surf zone, with a strong permanent rip against the eastern rocks and usually several beach rips. A 10-15 m high foredune runs the length of the beach, with rising heath-covered slopes behind the central-northern end of the beach, and the usually blocked mouth of Blackswan Lagoon towards the southern end. A vehicle track also reaches the northern end of the beach.

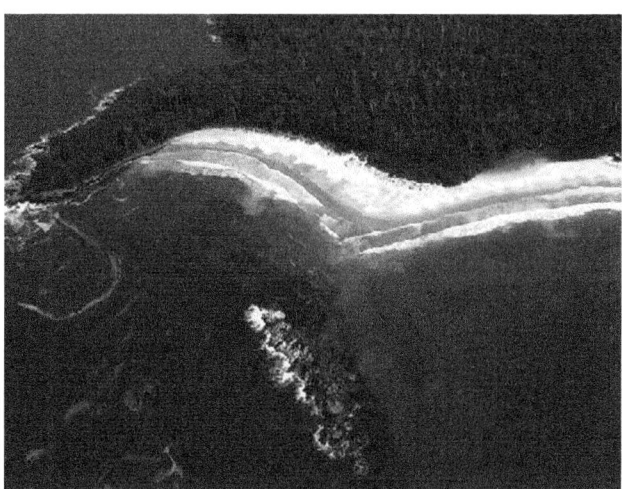

Figure 4.95 The Images are a cluster of rocks and reefs, whose backing cuspate foreland contains the southern end of Little Lagoon Beach (T 547) and beach T 548.

Beach **T 548** forms the western side of the foreland. It curves to the west for 500 m and faces southeast between The Images and 15 m high Sullivan Point. Waves are lowered to between 1 m and 1.5 m and maintain an energetic low tide terrace to occasionally rip-dominated 50 m wide surf zone, with rips forming against the Sullivan Point and at times in the centre of the beach. It is backed by wooded slopes rising to 20 m.

T 549-556 RECHERCHE BAY

No.	Beach	Rating HT	LT	Type	Length
T549	Moss Glen	2	3	R+sand/rock flats	300 m
T550	Moss Glen (S)	2	3	R+rock flats	80 m
T551	Gillams Beach	3	3	R	250 m
T552	Gillams Beach (S)	3	3	R	100 m
T532	Finns Beach	3	3	R+LTT	250 m
T554	Catamaran (1)	3	4	R+rocks	250 m
T555	Catamaran (2)	3	4	R	100 m
T556	Mary Ann Pt	3	4	R+rocks	70 m
Recherche Bay State Recreation Area					
Spring & neap tidal range = 1.3 & 0.3 m					

Recherche Bay is the northern arm of a 2.5 km wide bay mouth that opens between Sullivan and Fishers points. The southern arm is occupied by Rocky Bay with the Kelly Rocks separating the two. Both bays are drowned valleys surrounded by moderate to in places steep wooded slopes. Recherche Bay has a 2 km wide mouth at Kelly Rocks and trends to the north for 5 km gradually narrowing from 2 km at the mouth to 700 m at Pigsties Bay. Eight moderately sheltered beaches are located along the southwestern shore of the bay and receive lowered refracted swell. The Coles Bay Road runs along the shore providing direct or close access to all the beaches. Apart from a few houses and cabins there is little development.

Moss Glen is a small collection of houses just inside Pigsties Bay, with two low energy beaches (T 549 and 550) occupying its southwestern shore. They receive either very low swell or have calm conditions. Beach **T 549** is a curving east-facing narrow high tide beach fronted by shallow sand and rock flats, with the road running right along the rear of the beach, and several houses in a clearing on the other side. A 50 m wide low rocky point and platform separate it from beach **T 550** which curves to the south for 80 m backed by low grassy bluffs and cleared land between the shore and road. It is bordered by the rock platforms and fronted by shallow rock flats. Small waves break along the southwest-trending rock flats that extend 300 m south to Ryans Point and can provide a right-hand break during bigger swell.

Gillams and Finns beaches (T 551-553) are three adjoining beaches on the southern side of Ryans Point. They face east out towards the wide bay entrance and receive low refracted swell averaging about 0.5 m. They are also located within the Recherche Bay State Recreation Area, with the road running right along the rear of the beaches. **Gillams Beach (T 551)** is a straight 250 m long usually cusped reflective beach bordered by low rocky points, with a small foredune, then road behind. Across the road is a clearing with a camping area and toilets. Beach **T 552** lies on the southern side of a 100 m long tree-covered rocky point and is a similar 100 m long cusped reflective beach, with the road and a few houses right behind.

Finns Beach (T 553) lies 100 m further south and is a straight 250 m long beach bordered by the low rocky point. It receives slightly higher waves and usually has a narrow low tide terrace. The road runs along the back of the beach and across a small creek. A house is located on the partly cleared southern point.

The **Catamaran River** flows out between two low rocky tree-covered points 500 m south of Finns Beach. To the south of the 70 m wide river mouth the shoreline trends southeast in a series of small embayments for 1.5 km to Needle Point located to the lee of Kelly Rocks, which extends 1 km east into the central bay mouth. Three small embayed beaches (T 554-556) are located along the shore with beaches T 554 and 555 sharing a 300 m wide northeast-facing bay. Beach **T 554** is a curving 250 m long reflective beach bordered by a wooded rocky point to the north and small rock outcrop to the south. Beach **T 555** continues south of the rock outcrop for another 100 m to the southern tree-covered Mary Ann Point. The beaches are backed by partly cleared land and private houses with the road 100 m to the west and no direct public access.

Beach **T 556** occupies the next small bay to the east with Mary Ann Point forming its western boundary and tree-covered slopes rising to 40 m high Needle Point 500 m to the east. The 70 m long northeast-facing reflective beach has a few rocks towards its northern end and is backed by a private house with the road 400 m to the west.

T 557-565 **ROCKY BAY**

No.	Beach	Rating HT	LT	Type	Length
T557	Ramsgate (N2)	2	2	R	100 m
T558	Ramsgate (N1)	2	2	R	30 m
T559	Ramsgate	2	2	R	200 m
T560	Cockle Creek	2	2	R	500 m
T561	Fords Green	2	2	R	800 m
T562	Snake Pt (W2)	2	2	R	500 m
T563	Snake Pt (W1)	2	2	R	250 m
T564	Planter Beach	2	2	R	500 m
T565	Planter Beach (E)	2	2	R	150 m
Recherche Bay State Recreation Area 280 ha					
Spring & neap tidal range = 1.3 & 0.3 m					

Rocky Bay is located 10 km north of South East Cape, the southernmost point in Tasmania. The bay forms the southern arm of Recherche Bay, with Gagens and Fishers points bordering its 1 km wide entrance. The 2.5 km deep bay faces northeast towards the large bay entrance and is sheltered from direct southerly swell by its orientation, Fishers Point and reefs within the bay, with only low refracted waves reaching the nine low energy bay beaches (T 557-565) which are spread along the southern shores of the bay. All the beaches are located within the Recherche Bay State Recreation Area, the reserve fringing the bay shore and providing several beachfront camping sites and facilities (Fig. 4.96). A ranger station is located at Fords Green, with the station also the

beginning of the South Coast Walking Track which heads south along Cockle Creek. The beaches are the southernmost in Australia accessible by road. The Cockle Creek Road terminates at Fords Green with no vehicle access to the south.

Beaches T 557 and 558 are adjoining pockets of sand on the northern side of Cockle Creek beach. Beach **T 557** is a 100 m long pocket reflective beach facing southeast across the 700 m wide southern end of the bay. It is bordered by a tree-covered 10 m high rocky point, with a few shacks behind the beach and the road 100 m to the west. Beach **T 558** lies 100 to the west and is a 30 m pocket of reflective sand bordered by small tree-covered points. Both beaches receive only low refracted swell.

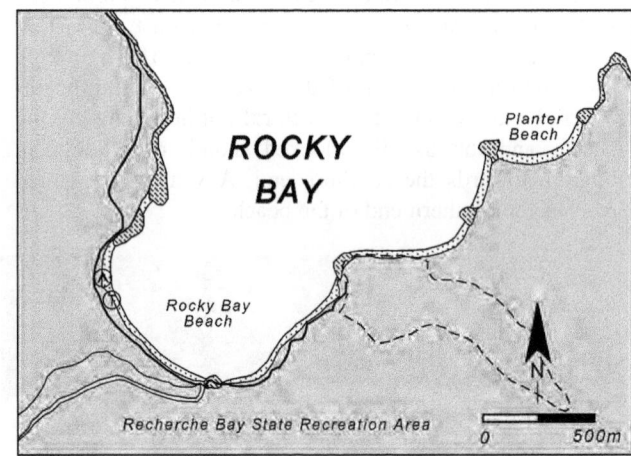

Figure 4.96 Rocky Bay is the southernmost bay and beach accessible by vehicle in Tasmania.

Ramsgate beach **(T 559)** commences at the end of the northern rocky shore and curves to the south for 200 m to a small sandy foreland formed in lee of a rock reef 100 m offshore. The beach is reflective with calm to low swell conditions usually prevailing. Beach **T 560** continues southeast of the foreland for another 500 m to the mouth of Cockle Creek (Fig. 4.97). The road runs along the rear of the beach and across the bridge at the creek mouth. The backing low hummocky foredunes have been partly cleared and there is a camping area in the north, together with several holiday shacks in the centre and toilets and an historic cemetery. The creek backs the southern half of the 100-200 m wide low barrier. This is the main bay beach and has usually calm conditions with only occasional low swell. A few boats are usually moored in the bay just off the beach.

The road crosses the small bridge to **Fords Green**, a cleared strip of coastal land where the National Park ranger station is located. Fords Green beach **(T 561)** commences on the eastern side of the creek mouth and trends to the northeast for 800 m to a low rocky point. This is a low energy northwest-facing beach, backed by a low hummocky foredune and cleared low ground, which is also used for camping and has toilet facilities. The gravel road terminates at a gate at the northern end of the beach with a jetty located on the point.

Beaches T 562-565 occupy four small embayments located along the southwestern arm of the bay and are only accessible on foot or by boat. Beach **T 562** is a relatively straight north-facing 500 m long reflective beach that looks north to Gagens Point. It is a low energy reflective beach with low rocky points to either end and a walking track behind. Beach **T 563** commences 50 m to the east and curves to the northeast for 250 m to Snake Point and faces west into the bay. It is a low energy reflective beach with rocks scattered off either end.

Planter Beach (T 564) extends east of the low Snake Point for 500 m curving to the north against its boundary

rocks. Waves average about 0.5 m at its western end decreasing to the east. Rocks border each end with a rock reef in the eastern corner of the beach. Beach **T 565** lies immediately to the north and is a curving west-facing 150 m long beach located to the lee of Fishers Point. It receives only low refracted swell with often calm conditions. Both beaches are backed by vegetated slopes that rise to 100 m to the south.

Summary: These are Tasmania's and Australia's southernmost accessible beaches. There is a lovely camping area fronted by the quiet beaches and backed by the wilderness of the South Coast.

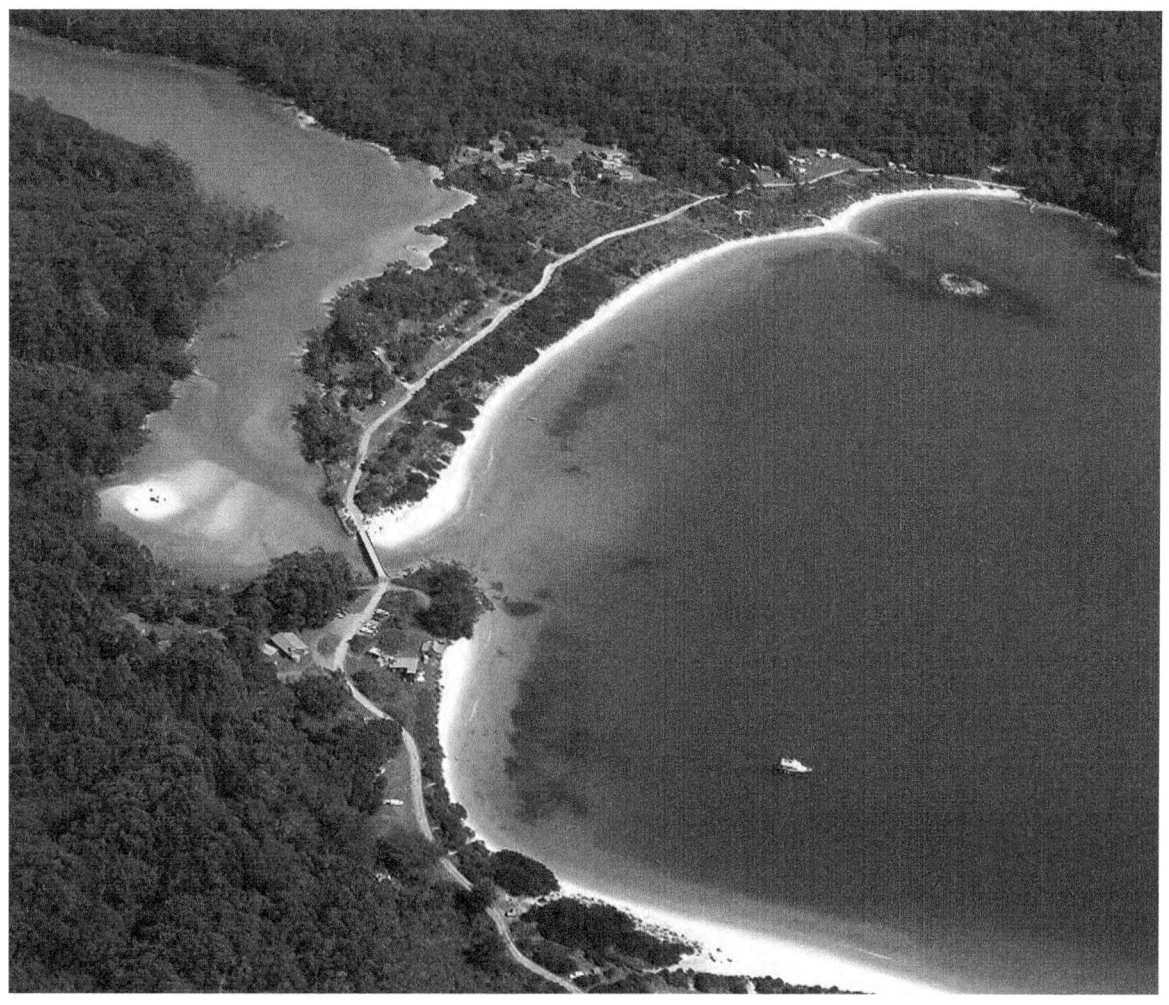

Figure 4.97 Ramsgate Beach (T 559) is located deep in Rocky Bay and is backed by Cockle Creek. The road in view terminates here, the southernmost in Australia.

BRUNY ISLAND

Bruny Island is a 50 km long irregularly shaped island that parallels the coast southwest of Hobart. The exposed eastern side of the island forms the western boundary of Storm Bay and in the south faces into the Tasman Sea. The sheltered western side forms the outer boundary of the 50 km long D'Entrecasteaux Channel. The island consists of two bedrock highs - North Bruny and South Bruny - connected by low sandy 6 km long Neck Isthmus, that narrows to 100 m in the centre (Fig. 4.98). The island can only be accessed by vehicle ferry from Kettering. All North Bruny and most of western South Bruny is freehold and used for farming. The rugged central-eastern South Bruny is incorporated in South Bruny National Park.

The island has 234 km of shoreline ranging from high to very low energy with a predominantly rocky coast. In amongst the rocks are 20 boulder and 74 sandy beach systems (BI 1-94), which occupy 57 km (24%) of the island shore.

Area:		38 000 ha	
Coast length:		234 km	
Beaches:	North Bruny	32	(BI 1-11, 74-94)
	Isthmus	2	(BI 12 & 73)
	South Bruny	60	(BI 13-72)

Regional map 6 Bruny Island

Figure 4.98 Bruny Island has a total of 94 beaches.

BI 1-3　BULL BAY

No.	Beach	Rating HT LT	Type	Length
BI 1	Bull Bay (1)	4　6	Boulder	50 m
BI 2	Bull Bay (2)	4　6	Boulder	50 m
BI 3	Bull Bay (3)	4　6	Boulder	600 m
Spring & neap tidal range = 1.3 & 0.3 m				

Bull Bay is an east-facing rocky bay located 2 km south of Kellys Point, the northern tip of the island. The bay curves to the southeast then east in lee of Bull Bay Point. Steep cleared slopes and farmland back the bay rising to 210 m at Dennes Hill, while three boulder beaches (BI 1-3) occupy its southern shore. Beach **BI 1** is a 50 m long boulder beach at the base of 30 m high vegetated bluffs. A large rock outcrop separates it from beach **BI 2**, a similar 50 m long steep boulder beach. Beach **BI 3** occupies the southern half of the bay curving round in the south to the lee of the point. It is a continuous boulder beach backed by sloping cleared farmland, with three small creeks converging on the centre. The beaches are sheltered by the point with waves averaging less than 1 m and decreasing to the southern corner.

BI 4-6　PATRICKS BIGHT

No.	Beach	Rating HT LT	Type	Length
BI 4	Patricks Bight	4　5	Cobble+LTT	150 m
BI 5	Mother Hayles Beach	4　5	Cobble+LTT	100 m
BI 6	One Tree Pt (N)	4　5	Cobble+LTT	150 m
Spring & neap tidal range = 1.3 & 0.3 m				

Patricks Bight is a 2 km wide northeast-facing bedrock embayment located between Bull Bay and One Tree points. Cleared farmland slopes steeply down to the shore where three small beaches (BI 4-6) are located.

Beach **BI 4** is an east-facing 150 m long high tide cobble beach fronted by a 30 m wide sandy low tide terrace. Rocky shore borders either end, with cleared land descending to the rear of the centre of the beach. A farmhouse is located on the 20 m high southern point. **Mother Hayles Beach** (**BI 5**) is located on the southern side of the 100 m wide point. It is a 100 m long strip of high tide cobbles and boulders backed by partly cleared 10 m high bluffs then the sloping farmland.

Beach **BI 6** lies 500 m to the east in lee of 20 m high One Tree Point. The 150 m long cobble beach faces northeast with steep partly tree-covered slopes rising to 40 m on three sides (Fig. 4.99). Waves average about 0.5 m breaking across a narrow sandy low tide terrace backed by the narrow high tide cobble beach, then the slopes.

Figure 4.99　　Beach BI 6 is a cobble beach located in lee of One Tree Point (left).

BI 7-9　TRUMPETER BAY

No.	Beach	Rating HT LT	Type	Length
BI 7	Trumpeter Bay (1)	4　5	Cobble+LTT	250 m
BI 8	Trumpeter Bay (2)	4　5	Cobble+LTT	150 m
BI 9	Lookout Pt	4　6	Boulder	150 m
Spring & neap tidal range = 1.3 & 0.3 m				

Trumpeter Bay is an open east-facing bay bordered in the south by 60 m high Trumpeter Point. The point partly shelters the shore with waves averaging less than 1 m. Cleared gently rising farmland backs the bay with a farm occupying the slopes behind the centre of the bay. Two small beaches (BI 7 and 8) are located in the centre of the bay below the farm buildings, with beach BI 9 located on the southern side of Trumpeter Point.

The northern beach (**BI 7**) is a 250 m long high tide cobble beach fronted by a narrow sandy low tide terrace, with steep 10 m high bluffs behind, and eroding rocky points to either end. Beach **BI 8** lies 100 m to the south and is a 150 m long sand and cobble beach fronted by narrow low tide terrace extending into sandy bay floor. The beach is backed by a small foredune then farmland, with a farm building on the southern point.

Trumpeter Point is a cliffed 60 m high dolerite point. Steep 50 m high cliffs line its southern side extending into the small rocky Lookout Bay. The bay contains a curving 150 m long boulder beach (**BI 9**). The beach faces southeast out of the little bay receiving waves averaging about 1 m. These surge up the steep beach and reach the backing cliffs during high seas. The only access to the beach is down the steep slopes of the point.

BI 10-12 ADVENTURE BAY (N)

No.	Beach	Rating HT LT	Type inner outer bar	Length
BI 10	Miles Beach	5 →6	LTT→TBR	700 m
BI 11	Mars Bluff	6 6	TBR	100 m
BI 12	Neck Beach	6 6	TBR LBT	10.3 km
	Bruny Island Neck Reserv e			*1450 ha*
Spring & neap tidal range = 1.3 & 0.3 m				

Cape Queen Elizabeth is a 150 m high dolerite headland that marks the southeastern tip of North Bruny and the northern boundary of 11 km wide Adventure Bay. The bay curves round for 23 km to the southern headland at Grass Point. In between are eight beaches (BI 10-17) (Fig. 4.100) including the 10 km long Neck Beach which forms the eastern side of the Isthmus which links North and South Bruny. The northern half of the bay contains three exposed moderate to high energy beaches (BI 10-12). The beaches and backing dunes, heathland and wetlands are part of the 1,450 ha Bruny Island Neck Game Reserve.

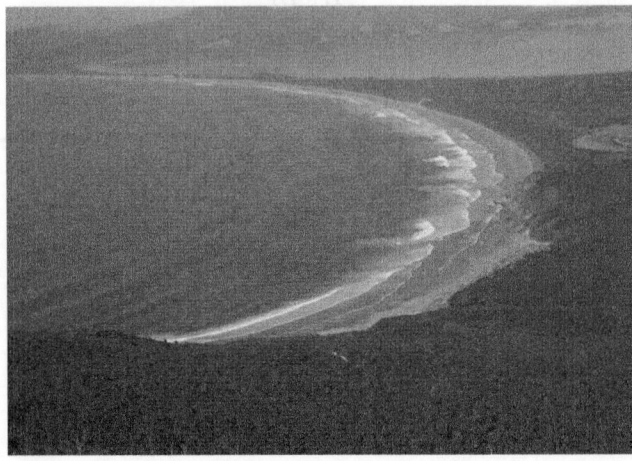

Figure 4.100 Miles Beach and Mars Bluff (BI 10 & 11 foreground) and the northern half of the long Neck Beach (BI 12).

Miles Beach (BI 10) commences 1 km inside the tip of the cape and trends to the west for 700 m terminating at the cliffed 50 m high Mars Bluffs. The eastern end is partly sheltered by the cape with waves averaging about 1 m and breaking across a 50 m wide low tide terrace. Wave height increases to about 1.5 m at the western end of the beach, as the surf zone widens to 100 m and rips begin to form. The beach is backed by a grassy foredune and well vegetated dunes that extend up to 1.5 km inland reaching 30-50 m in height and partly blocking the backing valley. Miles Creek drains through the dunes to reach the eastern section of the beach, while three smaller creeks are blocked by the dunes forming small perched lakes. The beach is accessible from the west via a 4WD track from the main road, which runs along the top of Mars Bluffs and in the east via the longer Rookery Track, which follows the cliff line and continues to Cape Queen Elizabeth.

Beach **BI 11** is located in a 100 m long gap in the bluffs and shares the surf zone with Miles Beach to the east and Neck Beach to the south. The beach is bordered and backed by a small foredune and scrubby slopes rising to 50 m. Waves average 1.5 m and usually one strong rip drains the beach. The bluffs continue for another 200 m to the beginning of Neck Beach with patches of sand along their base and the surf and rips continuing to the main beach.

Neck Beach (BI 12) is the longest and one of the most exposed beaches on the island. It commences at the bluffs and curves to the southeast for 10.3 km to the beginning of Blighs Rocks. Wave energy remains moderate for most of its length averaging 1.5 m, and maintaining a rip-dominated inner transverse bar and rip system with up to 50 rips forming along the beach, and an outer shore-parallel bar, which only breaks during periods of higher waves. There are usually a series of beach breaks right along the beach. The beach is backed by a continuous foredune, which decreases in height and size from 30 m in the north to a few metres in the south. The foredune is backed by Big and Gibbs lagoons in the north then it narrows to 200 m and less along the 4 km long central isthmus section before widening in the south where it is backed by a wetland. Isthmus Bay beach (BI 73) forms the low energy western side of the isthmus. The Bruny Island Main Road runs down the centre of the isthmus providing good access to the beach.

BI 13-17 ADVENTURE BAY (S)

No.	Beach	Rating HT LT	Type	Length
BI 13	Dunckels Beach	3 3	R	500 m
BI 14	Dunckels Beach (S)	3 3	R	100 m
BI 15	Two Tree Pt	3 3	R	700 m
BI 16	Adventure Bay Beach	3 3	R	3 km
BI 17	East Cove	3 3	R	500 m
Spring & neap tidal range = 1.3 & 0.3 m				

The southern half of Adventure Bay begins at the 3 km long sandstone Bligh Cliffs at the southern end of which begin a series of five lower energy reflective beaches that occupy the southern 5 km of the bay. The Adventure Bay Road follows the cliff line and runs behind the beaches providing good access to the beaches and the several small communities scattered along the southern shores of the bay. Behind the shore area steep wooded slopes rise on three sides to the 400-500 m high South Bruny Range and the 200-250 m high ground behind Fluted Cape.

Dunckels Beach (BI 13) is the first of the beaches viewed from the road and commences immediately south of 20 m high Cemetery Point. The beach trends south for 500 m to a cluster of rocks that separates it from the southern 100 m section (beach **BI 14**). Both beaches receive low refracted swell averaging about 0.5 m and are usually cusped and reflective. They are backed by a small cleared reserve with a creek deflected to the south and draining out against the rocks that separate the two

beaches. The road runs along the rear of the reserve, while low rocky Two Tree Point forms the southern boundary.

During big outside swell there are a number of reef and point breaks north of Cemetery Point, the best being *Coal Point*, located 500 m north of Cemetery Point. It produces a heavy left-hand break over a rocky seabed on the south side of the point.

Beach **BI 15** commences on the southern side of Two Tree Point and trends to the southeast for 700 m to the northern side of a 20 m high 100 m wide headland. The beach is reflective and usually cusped. A vegetated reserve backs the beach with the road running 50 m inland.

Adventure Bay Beach (BI 16) commences on the southern side of the head in a sheltered corner called Quiet Corner and curves to the southeast, then east for 3 km to the eastern Kadens Corner against Blackfellows Point. The beach is reflective its entire length with wave height gradually decreasing to the east. The road parallels the rear of the beach, with a narrow reserve between the road and beach. Captain Cook Creek is deflected to the east behind the beach crossing it a few hundred metres west of Kadens Corner, forming a small tidal delta. Houses back either end of the beach, with a central caravan park and boat ramp in Kadens Corner. The historic beach has a museum to Captain Bligh, Captain Cook and Captain Foveaux all of whom anchored in the bay to replenish their water supplies.

East Cove is a 600 m wide north-facing slight embayment between Blackfellows Point and the rear of Grass Point (Fig. 4.101). Beach **BI 17** extends for 500 m along the shore of the cove. It is a reflective low energy beach backed by a narrow reserve, then a caravan park and a cleared 200 m wide valley, with several houses in the small Cooksville settlement located on the slopes above the western end of the beach. Dorloff Creek drains the valley and flows to the rear of the centre of the beach where it is deflected to the eastern end.

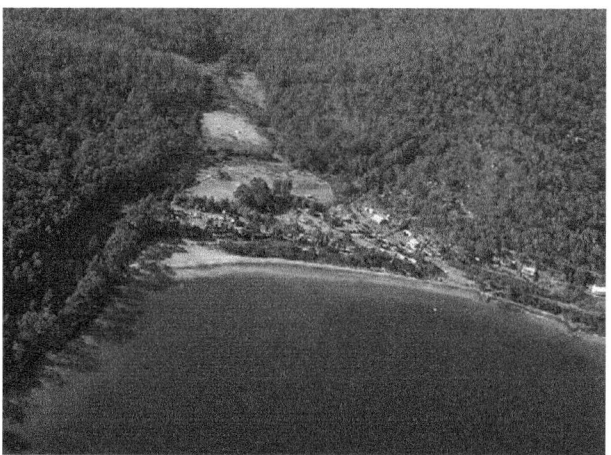

Figure 4.101 East Cove is a sheltered cove and beach tucked into the southeast corner of Adventure Bay.

<table>
<tr><th colspan="6">South Bruny National Park</th></tr>
<tr><td>Established:</td><td colspan="5">1997</td></tr>
<tr><td>Area:</td><td colspan="5">5059 ha</td></tr>
<tr><td>Coast length:</td><td colspan="5">74 km (49-123 km)</td></tr>
<tr><td>Beaches:</td><td colspan="5">29 (BI 18-46)</td></tr>
</table>

South Bruny National Park encompasses three land areas at Fluted Cape, Tasman Head and the Labillardiere Peninsula, lined by narrow coastal strips. It totals 5059 ha, and has 74 km of coast incorporating 29 beaches. The park is dominated by high steep relief, spectacular cliffs and capes, and both exposed boulder and sand beaches, as well as the sheltered waters and beaches of Great Taylors Bay.

Camping areas are located at Cloudy Bay, Neck Beach and Jetty Beach.

BI 18-25 BAY OF ISLANDS

No.	Beach	Rating HT LT		Type	Length
BI 18	Bay of Islands (1)	3	4	R	150 m
BI 19	Bay of Islands (2)	3	4	R	100 m
BI 20	Bay of Islands (3)	6	8	TBR+rocks	150 m
BI 21	Bay of Islands (4)	6	8	TBR+rocks	100 m
BI 22	Haulage Bay (N)	6	8	Cobble+TBR	50 m
BI 23	Haulage Bay (S)	6	8	Cobble+TBR	150 m
BI 24	Arched Is (1)	6	8	Cobble	150 m
BI 25	Arched Is (2)	6	8	Cobble+TBR	150 m
Spring & neap tidal range = 1.3 & 0.3					

The **Bay of Islands** is an open east- to southeast-facing 5 km wide embayment located immediately south of the 250 m high cliffs of Fluted Cape-Cape Connella, with the 80 m high Mangana Bluff forming the southern boundary. In between are 6 km of steeply sloping, often cliffed dolerite and sandstone rocks, backed by densely wooded slopes rising to 459 m at Mount Cook and 412 m at Daveys Hill. There are eight small beaches located in gaps and indentations at the base of the slopes. They are exposed to high waves and none readily accessible.

Beaches BI 18 and 19 lie either side of a sandy tombolo located to the lee of a small 60 m high rocky islet 1.5 km southeast of Cape Connella. Beach **BI 18** is located to the lee of the islet and faces east out of a 100 m wide rocky bay. The curving 150 m long beach forms the northern side of the tombolo and is moderately sheltered by the islet, reefs and its orientation, with usually lower swell and reflective conditions prevailing. Beach **BI 19** faces south and forms the southern side of the tombolo. It is 100 m long and curves between the islet and steep rocks of the mainland. It is also moderately sheltered by the islet and reefs with reflective conditions at the shore. Both beaches are backed by vegetated slopes rising steeply to 100 m.

Beach **BI 20** lies 300 m to the west and is a curving 150 m long sandy beach backed by a steep V-shaped valley rising to 150 m and bordered by 100 m high steep headlands. It faces southeast into the prevailing waves which average over 1.5 m and maintain a 100 m wide surf zone with a strong rip usually running out against the eastern headland. Beach **BI 21** is located 100 m to the southwest in the next small embayment. It is a 100 m long high tide cobble beach fronted by a 50 m wide sandy surf zone, with a strong rip usually flowing out past the southern boundary rocks. A steep valley rising to 250 m backs the beach, with the old railway track located at 200 m elevation on the backing slopes.

Beaches BI 22 and 23 are east-facing beaches located in two adjoining indentations in Haulage Bay, a 1 km wide embayment located in the southern half of the Bay of Islands and bordered by Grays and Mangana bluffs. Beach **BI 22** lies at the base of 400 m high Daveys Hill, with the old railway line halfway up the hill. The beach is 50 m long with high tide cobbles grading into boundary rocks and boulders. It has an 80 m wide sand and rocky surf zone with a rip usually forming against the northern rocks. Beach **BI 23** lies 200 m to the south and is a similar 150 m long high tide cobble beach and 50 m wide sand and rock-strewn surf zone. It is backed by steep densely vegetated slopes with a bare 100 m high cliff at the southern end.

Beaches BI 24 and 25 are located either side of **Arched Island** on the southern side of Mangana Bluff (Fig. 4.102). The linear rocky 30 m high island is linked to the shore by a lower wave-washed rock ridge with beach **BI 24** extending for 150 m either side of the ridge. It is a high tide cobble beach backed by a steep V-shaped valley, with waves averaging 1 m on the more sheltered northern side of the island and over 1.5 m on the exposed southern side. Rocks also lie off the beach. Beach **BI 25** lies 100 m to the south and shares the 100 m wide surf zone that continues south of the island. The beach is 150 m long and composed of a strip of high tide cobbles at the base of densely vegetated 50 m high slopes. Waves break across the sand and rock-dotted surf zone with a rip usually running out between the two beaches.

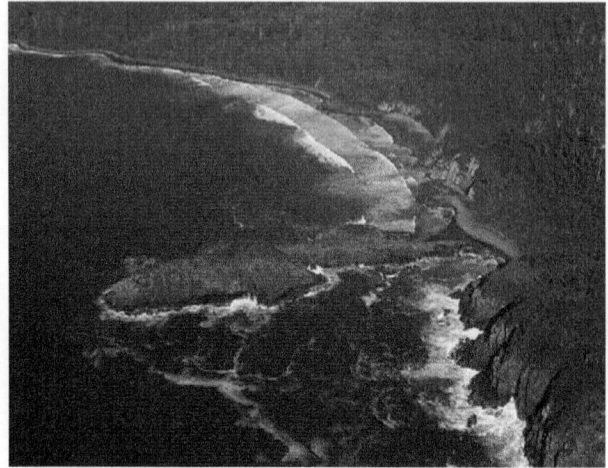

Figure 4.102 Arched Island is actually attached to the mainland and separates beaches BI 24 & 25.

BI 26-28 PINE LOG & BEAUFORT BAYS

No.	Beach	Rating HT LT		Type	Length
BI 26	Pine Log Bay (1)	6	9	Boulder+TBR	80 m
BI 27	Pine Log Bay (2)	6	9	Boulder+TBR	100 m
BI 28	Beaufort Bay	4	6	Boulder	100 m
Spring & neap tidal range = 1.3 & 0.3 m					

Tasman Head is a 74 m high dolerite headland that forms the southern tip of Bruny Island with high rocky coast to either side. To the east and north are 12 km of steep dolerite shoreline with cliffs rising to 350 m high that continue to Arched Island and on up to Fluted Cape. To the northwest are 5 km of more irregular south-facing rocky shoreline climbing more gradually to 504 m at Mount Bruny. At 292 m high East Cloudy Head the shoreline turns and trends north for 3 km to the beginning of the Cloudy Bay beaches. In between Arched Island and Cloudy Bay are 23 km of high rocky shoreline containing only three small boulder beaches. Two are located in Pine Log Bay (BI 26 and 27) and one in Beaufort Bay (BI 28).

Pine Log Bay is a 500 m wide south-facing rocky bay located 1 km northwest of Tasman Head. The bay contains three small rocky gullies, two of which house beaches (BI 26 and 27). Beach **BI 26** is located at the mouth of the central gully, which is fed by the steep Little Friars Creek. The beach consists of an 80 m long high tide boulder beach fronted by a 50 m wide sand and rock surf zone, with waves averaging about 1.5 m. A narrow finger of 30 m high dolerite separates it from beach **BI 27**, which trends to the southwest for 100 m as a high tide boulder beach. It has some sand off its northern corner against the dividing rock, with deeper water off the southern half of the beach. The beach is backed by steep slopes rising to 274 m, with a 4WD track terminating on the slopes 150 m above the beach.

Beaufort Bay is located 2 km north of East Cloudy Head and is a 600 m wide west-facing rocky bay backed by slopes rising to 200 m. Beach **BI 28** is located in the northern corner of the bay and is moderately sheltered from the swell with waves averaging less than 1 m. They surge up the 100 m long south-facing steep boulder beach, which is backed by a sloping heath-covered valley with a small central creek. A 4WD track from Cloudy Bay provides access to the beach.

BI 29-34 CLOUDY BAY

No.	Beach	Rating HT LT		Type inner	outer	Length
BI 29	Cloudy Beach (E)	4→	6	LTT→TBR		3.5 km
BI 30	Cloudy Beach	6	7	TBR+rocks		200 m
BI 31	Cloudy Beach (W)	6	6	TBR	RBB	2.4 km
BI 32	Inlet Beach	4	5	LTT+tidal channel		400 m
BI 33	Mabel Cove (N)	6	7	Cobble+TBR		80 m
BI 34	Mabel Cove	5	6	LTT/TBR		700 m
Spring & neap tidal range = 1.3 & 0.3 m						

Cloudy Bay is a U-shaped south-facing 3-4 km wide bay bordered by East and West Cloudy heads. The bay has 16 km of shoreline, with four sandy beaches (BI 29-32) occupying the northern 7 km of shore, and two located on Mabel Cove (BI 33 and 34) on the western shore. The top of the bay is accessible along the Cloudy Bay Road.

Beach **BI 29** is the longest of the Cloudy Bay beaches. It commences 3 km north of East Cloudy Head in lee of Cloudy Reef. The beach trends to the north, then curves slightly to the northwest for 3.5 km terminating at the mouth of Sheepwash Creek. The southern corner of the beach, called Cloudy Corner, is sheltered from waves by the reef and its orientation and usually receives very low swell with reflective to low tide terrace conditions prevailing. It is backed by vegetated slopes rising to over 200 m with the small Imlays Creek draining across the southern end of the beach where a vehicle track reaches the beach. Wave height increases gradually up the beach averaging 1.5 m by the northern end. The surf zone widens to 100 m in the north and rips begin to dominate along the northern 1 km of shore. Sheepwash Creek maintains an area of unstable sand either side of its shifting mouth, which can reach as far as the northern boundary, a 20 m high grassy headland. The beach is backed by two to three grassy foredunes, then an area of earlier vegetated parabolic dunes that extend up to 1 km inland and reach 30 m in height, with the creek running between the ridges and dunes. The Cloudy Bay Road terminates at the northern headland where there is a car park, camping area and toilets.

Beach **BI 30** is a 200 m long pocket of sand located between two cleared 20 m high dune-draped dolerite headlands, the western extending 300 m into the bay (Fig. 4.103). Waves average over 1.5 m and break across a 200 m wide surf zone, with a strong permanent rip running out against the western head. The beach is backed by grassy 10 m high bluffs rising to the vegetated dunes. The dunes have blown diagonally across the headlands and appear to have originated during the sea level transgression when sea level was lower and may be contemporary with the Sheepwash Creek dunes.

Figure 4.103 The Cloudy Bay access road reaches the western end of beach BI 29 (right) with the small beach BI 30 (centre) and longer Cloudy Beach beginning to left.

Beach **BI 31** extends as a 300 m wide barrier for 2.4 km from the western 150 m wide headland to the mouth of 600 ha Cloudy Bay Lagoon, where it recurves 700 m into the bay. It is also exposed to moderately high waves which combine with fine beach sand to maintain a 300-400 m wide double bar surf zone. The inner bar usually has several well developed rips, with more widely spaced rips along the outer bar. Like the eastern beach this beach is backed by a 200 m wide band of well developed low grassy foredunes then inner parabolic dunes extending up to 500 m inland. At the 50 m wide inlet, the tidal channel and shoals extend 300-500 m into the bay along the western rocky shoreline. The shoals can produce a long right-hand break running in towards the beach called *Lagoons* (Fig. 4.104).

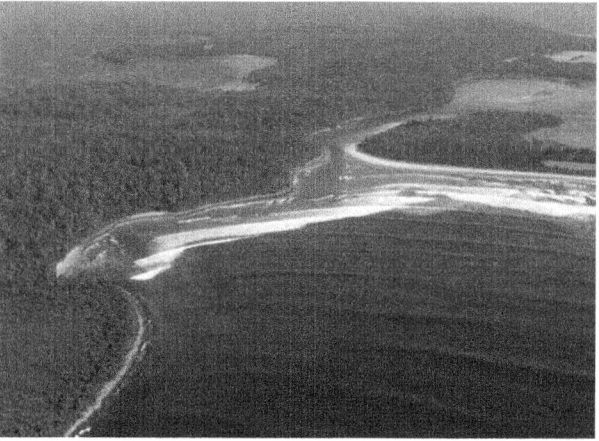

Figure 4.104 The Cloudy Bay Lagoon inlet with Cloudy Bay beach to the right and the smaller Inlet beaches to the left, and surf break across the inlet's ebb-tide delta (photo W. Hennecke).

Inlet Beach (BI 32) is located on the western side of the bayshore, 500 m south of the inlet. The 400 m long beach faces east across the bay and is bordered and backed by densely wooded slopes, with rocks bordering either end and outcropping in the centre. A vehicle track terminates at the northern end of the beach. The beach is moderately sheltered, with waves averaging just over 1 m. These maintain a low tide terrace, however the tidal channel and shoals from the inlet can flow past the beach causing both major changes in the size and width of the beach as well as bar and wave conditions off the beach. The inlet channel sometimes runs along the beach eroding the beach back to the rocks and forming a strong tidal rip. During these conditions it can also produce a long right-hand break over the tidal shoals off the beach.

Mabel Cove is a 1 km wide southeast-facing embayment bordered and backed by steep vegetated slopes rising to 150 m. It receives waves averaging about 1.5 m in the north decreasing to the south. Beach **BI 33** is located in its northern corner. It is an 80 m long high tide cobble beach fronted by a 50 m wide sandy surf zone, together with a few large rocks at the base of the slopes. Steep slopes border the northern side and rear of the beach with a steep 100 m wide headland separating it from the main beach. A strong rip usually flows out against the northern slopes. The main cove beach (**BI 34**) extends south of the

dividing headland for 700 m grading into rocky shore in the south. It is a narrow sandy beach backed by the steep slopes with wave height decreasing down the beach. The surf varies from a low tide terrace to transverse bar and rip as wave height increases. The Lighthouse Road runs along the top of the backing slopes 150 m above the beaches, with a gravel quarry above the centre of the beach.

BI 35-38 LIGHTHOUSE BAY

No.	Beach	Rating HT	LT	Type	Length
BI 35	West Cloudy Hd (1)	8	10	Boulder	100 m
BI 36	West Cloudy Hd (2)	8	10	Boulder	100 m
BI 37	Lighthouse Bay (E)	8	10	Cobble+TBR	150 m
BI 38	Lighthouse Bay	6	6	TBR	1 km
Spring & neap tidal range = 1.3 & 0.3 m					

Lighthouse Bay is a 1.5 km wide south-facing embayment located at the southwestern tip of Bruny Island between West Cloudy Head and Cape Bruny. Two beaches (BI 35 and 36) are located just to the west of West Cloudy Head, while beaches BI 37 and 38 occupy the exposed northern shore of the bay.

Beaches BI 35 and 36 are two boulder beaches located immediately west of West Cloudy Head. Beach **BI 35** is a curving southwest-facing 100 m long strip of boulders backed by steep slopes rising to 180 m with the West Cloudy Head forming its eastern headland. Beach **BI 36** lies 400 m to the west and is a similar 100 m long south-facing boulder beach bordered by 120 m high steep slopes and boundary cliffs.

Beach **BI 37** lies in the northeastern corner of Lighthouse Bay. It is a crenulate 150 m long high tide cobble beach backed by slopes rising to 100 m with a 100 m high headland to the east and rocks extending 100 m offshore to the west. Three small creeks flow down the slopes to the beach. In between is an 80 m wide surf zone breaking over sand and rocks, with a strong rip against the eastern head. The main beach (**BI 38**) commences on the western side of the rocks and curves to the west, then southwest for 1 km, terminating at the north side of 100 m high Cape Bruny. Wave height averages over 1.5 m in the east, decreasing slowly to the west, with two to three rips dominating the eastern half of the beach, grading to a narrow low tide terrace in the west (Fig. 4.105). Some vegetated east-trending transgressive dunes have climbed part way up the eastern slopes behind both beaches. A vehicle track descends from the Cape Bruny ridge to the western end of the beach.

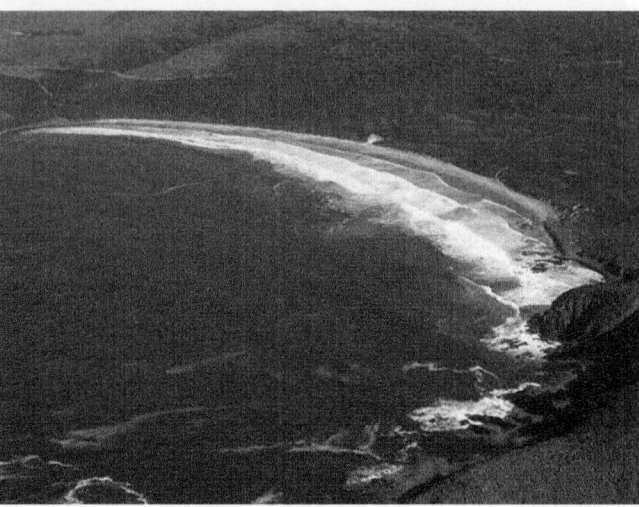

Figure 4.105 Lighthouse Bay contains the smaller cobble beach BI 37 (right) and the longer main beach BI 38.

BI 39-42 PARTRIDGE NARROWS

No.	Beach	Rating HT	LT	Type	Length
BI 39	Hopwood Beach	3	3	R	300 m
BI 40	Hopwood (N)	3	4	R+rock flats	300 m
BI 41	Partridge Narrows	1	2	R+sand shoals	450 m
BI 42	Butlers Beach	1	1	R+sand flats	700 m
Spring & neap tidal range = 1.3 & 0.3 m					

Partridge Narrows is located 10 km north of Cape Bruny at the top of the rocky western shore of Labillardiere Peninsula. The narrows is a 200 m wide channel between Partridge Island and the northern tip of the peninsula. Sand has accumulated in and either side of the narrows to form four low energy beaches (BI 39-42). There is no vehicle access to the beaches, which are only accessible on foot along the Pineapple Rocks Track or by boat.

Beaches BI 39 and 40 are located on the western side of the narrows and face into D'Entrecasteaux Channel, receiving only low refracted swell travelling up the channel and westerly wind waves. They occupy a 500 m wide west-facing bay called Southerly Bight. **Hopwood Beach** (**BI 39**) is a curving 300 m long west-facing sandy reflective beach bordered by rocky shores rising to 40 m Hopwood Point in the south, and low rocks in the north. It is backed by a small area of vegetated dunes behind the northern end of the beach. Beach **BI 40** commences on the northern side of the rocks and curves to the north as a double crenulate recurved spit, sitting on a rock base, with rocks located to the south and off the centre of the beach. The beach is fronted by a narrow band of rock flats and backed by a 20 ha wetland, which has been partly impounded by the spit. The northern rock-tied tip of the beach forms the southern side of the narrows.

Beaches BI 41 and 42 extend 1 km west of the narrows to Butlers Point, linked by a central sandy foreland. Beach **BI 41** is a curving, north-facing 450 m long sandy beach

fronted by the tidal channel and shoals of the narrows, which attach to the island 300 m to the north. The beach is sheltered by the narrows and island and receives only very low swell and easterly wind waves. **Butlers Beach (BI 42)** extends east of the boundary foreland for 700 m to the lee of 10 m high Butlers Point. It is a low energy sandy beach fronted by sand flats, which narrow to 50 m against the point. The two beaches are backed by a 50-100 m wide zone of low beach ridges, then the wetland.

BI 43-49 GREAT TAYLORS BAY

No.	Beach	HT	LT	Type	Length
BI 43	Taylors Reef (1)	1	1	R+sand flats	100m
BI 44	Taylors Reef (2)	1	1	R+sand flats	150 m
BI 45	Lighthouse Jetty Beach	1	1	R+sand flats	700 m
BI 46	Kingfisher Beach	1	1	R+sand flats	1.4 km
BI 47	Kingfisher Beach (E)	1	1	R+sand flats	400 m
BI 48	Stinking Beach (S)	1	1	R+sand flats+rocks	50 m
BI 49	Stinking Beach	1	1	R+ridged sand flats	500 m
Spring & neap tidal range = 1.3 & 0.3 m					

Great Taylors Bay is a sheltered 4 km wide north-facing bay that lies to the lee of the Labillardiere Peninsula and Partridge Island. The bay extends for 8 km to the south and is bordered by two 100 m high densely vegetated dolerite ridges. Beaches BI 43-49 all lie more than 5 km into the bay and occupy the southernmost shores of the bay. They are all low energy beaches and only exposed to wind waves generated within the bay and no ocean swell. The only vehicle access to the southern bay shore is along the Old Jetty Road to the Old Lighthouse jetty.

Beaches BI 43 and 44 lie to the lee of Taylors Reef, a small rock outcrop located 400 m offshore. Beach **BI 43** is a 100 m long pocket of northeast-facing sand fronted by narrow sand flats. It is located at the mouth of a small valley and bordered by rocky dolerite shore, which rises moderately inland as partly tree-covered slopes. Beach **BI 44** lies 200 m to the east and is a similar 150 m long beach and 50 m wide sand flats backed and bordered by slopes rising to 40 m. A walking track from Lighthouse Jetty Beach runs along the eastern shore of the peninsula and past both beaches.

Lighthouse Jetty Beach (BI 45) is the site of the now disued jetty for the Cape Bruny lighthouse located 4 km to the south. The ruins of the jetty are located at the western end of the beach against the boundary rocks. The beach curves to the east for 700 m to 29 m high Wares Point. It is a low energy north-facing reflective beach fronted by 100 m wide sand flats. It is backed by a low narrow foredune then a 150 m wide 4 ha wetland (Figure 4.106). There is vehicle access to the old jetty with a camping area and toilets at the western end of the beach.

Kingfisher Beach (BI 46) occupies the southernmost shore of the bay and is the lowest energy beach in the system. It commences in lee of Wares Point and curves to the northeast for 1.4 m to a section of rocky shore. This

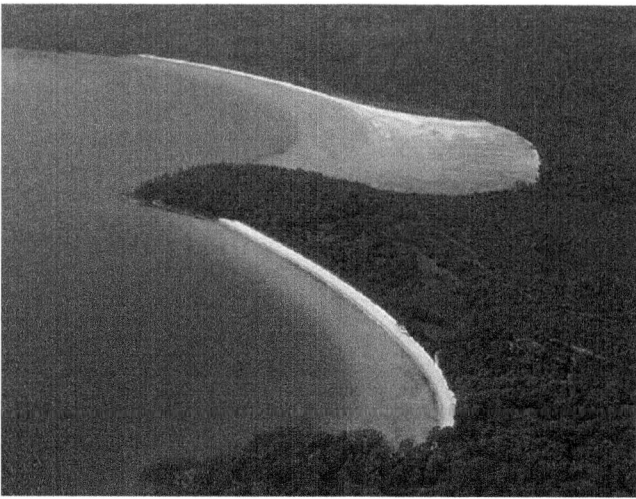

Figure 4.106 Lighthouse Jetty Beach (BI 45 foreground) and Kingfisher Beach (BI 46) are located in the sheltered Great Taylors Bay.

is a very low energy, narrow strip of high tide sand fronted by 300 m wide sand flats that fill the southwestern corner of the bay, narrowing to 100 m in the east where the beach has prograded slightly into the bay. It is backed by gently sloping terrain with Hawkins Creek and a second small creek draining to the beach. A 4WD track reaches the western end of the beach in lee of Wares Point.

Beach **BI 47** commences on the eastern side of the 400 m long boundary rocks and curves to the north for 400 m to the beginning of the rocks of Oak Point. The low energy beach faces west across the 1.5 km wide southern section of the bay. It consists of a very low energy 400 m long narrow high tide beach backed and bordered by densely vegetated slopes rising gradually to 100 m. A 4WD track runs down the slopes to reach the western end of the beach.

Stinking Beach extends northeast along the rocky shore from Oak Point. Beach **BI 48** is a 50 m long pocket of sand and rocks located in a 50 m wide gap in the rocks. The beach curves for 80 m inside the bay with the whole small embayment filled with sand flats and backed by moderate densely vegetated slopes. Beach **BI 49** commences 100 m to the north and occupies the eastern end of a 500 m wide west-facing embayment. It is a low, narrow 500 m long high tide beach fronted by 500 m wide sand flats, which are ridged close to shore. It is backed by both heath- and tree-covered slopes rising gradually to the Lighthouse Road 1 km to the east.

BI 50-53 MICKEYS & TINPOT BAYS

No.	Beach	HT	LT	Type	Length
BI 50	Mickeys Bay (S)	1	1	R+sand flats	400 m
BI 51	Mickeys Bay (N)	1	1	R+ridged sand flats	350 m
BI 52	Tinpot Bay	1	1	R+sand flats	300 m
BI 53	North Tinpot	1	2	R+sand flats	150 m
Spring & neap tidal range = 1.3 & 0.3 m					

Mickeys and Tinpot bays are two west-facing embayments located on the northeastern side of Great Taylors Bay. Both face west across the 4 km wide bay and receive only wind wave generated by westerly winds across the bay. Four beaches (BI 50-53) are located in the two bays.

Mickeys Bay is a 1 km wide bedrock embayment bordered by 18 m high Mickeys Point to the north, with slopes rising to 108 m behind and 78 m to the south. Two beaches are located in the bay (BI 50 and 51). Beach **BI 50** is a 400 m long low energy narrow beach that faces west out of the bay mouth across 200 m wide sand flats, with Seagull Rock and Curlew Island located 600 m and 1.5 km offshore respectively. There is an access track to the centre of the beach and three holiday cabins located to either side and one behind the centre of the beach. Beach **BI 51** occupies the northern end of the bay and faces south down the bay between Mickeys Point and the eastern boundary ridges. The beach is 350 m long and fronted by 400 m wide ridged sand flats, which partly fill the northern end of the bay. A house is located in a clearing on the western side of the beach, with a small creek draining into the western corner.

Tinpot Bay is located on the northern side of Mickeys Point and is a 500 m wide west-facing bay, surrounded by moderately steep vegetated slopes, with beach **BI 52** located in the northern corner (Fig. 4.107). This is a 300 m long south-facing beach, which has a narrow high tide strip of sand and 100 m wide sand flats. It is bordered by rocky shore and backed by partly cleared slopes and a vehicle track. **North Tinpot** beach (**BI 53**) is located on the northern side of 200 m wide Tinpot Point, with a 150 m long ridge of bare dolerite forming its western boundary. The 150 m long reflective beach faces north across 50 m wide sand flats. It is backed by partly cleared slopes and a solitary house.

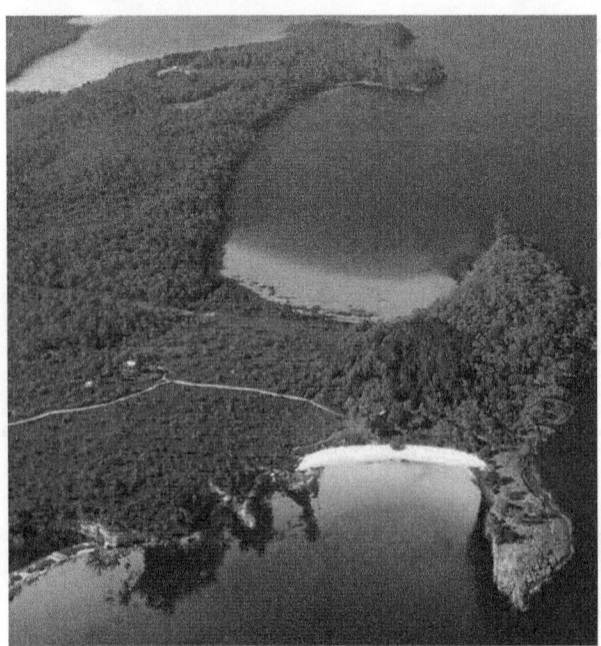

Figure 4.107 Tinpot Bay and beach (BI 52 upper) and North Tinpot beach (BI 53 foreground) lie either side of Mickeys Point (photo W. Hennecke).

BI 54-55 CONLEYS BEACH-VENTENAT POINT

No.	Beach	Rating HT LT		Type	Length
BI 54	Conleys Beach	2	3	R	1.2 km
BI 55	Ventenat Pt	2	3	R+rock flats	250 m
Spring & neap tidal range = 1.3 & 0.3 m					

Conleys Beach (BI 54) is a curving 1.2 km long east-facing beach located 1.5 km north of Tinpot Point. The beach is exposed to a 10 km wide westerly fetch and receives higher wind waves resulting in low energy reflective beach. It is bordered by rocky shore and is backed by partly cleared slopes, with several holiday cabins along the centre of the beach.

West-facing rocky shore dominates the next 3 km of shore to 15 m high Ventenat Point. Beach **BI 55** is located in a 500 m wide north-facing embayment immediately west of the point. It is a 250 m long north-facing beach consisting of a high tide reflective beach fringed by low tide rocks. A vehicle track runs up the ridge of the backing 3 km long peninsula to reach the point and beach.

BI 56-59 QUARRIES BAY

No.	Beach	Rating HT LT		Type	Length
BI 56	Quarries Bay	1	1	R+ridged sand flats	600 m
BI 57	Quarries Bay (S1)	1	1	R+ridged sand flats	50 m
BI 58	Quarries Bay (S2)	1	1	R+ridged sand flats	100 m
BI 59	Quarries Bay (S3)	1	1	R+ridged sand flats	150 m
Spring & neap tidal range = 1.3 & 0.3 m					

Quarries Bay is a sheltered 500 m wide bay located on the south side of Ventenat Point. It faces east across the entrance to a 2 km wide bay that extends 3 km south to Little Taylors Bay. The bay contains one main beach (BI 56) and a series of three smaller beaches (BI 57-59) along the southern rocky boundary that extends for 700 m to Swifts Point. There is vehicle access to the point and tracks to most of the beaches.

Quarries Bay beach (**BI 56**) is a curving 600 m long high tide sandy beach fronted by 200 m wide ridged sand flats, as well as a few small rock outcrops on the flats, with Ventenat and Swifts points extending several hundred metres to either side. It receives only low and refracted wind waves and is often calm. The beach is backed by several holiday cabins in the centre and southern corner.

Beaches **BI 57, 58** and **59** are located in amongst the eroding low cliffed sandstone shore that extends out to 10 m high Swifts Point. They are three adjoining beaches 50, 100 and 150 m long respectively, each separated by a narrow ridge of protruding sandstone and rock flats, with Swifts Point forming the eastern boundary of beach BI 59. They share a continuous 100 m wide ridged sand flat and face northeast towards the bay entrance. Each has a narrow high tide beach backed by partly vegetated 10 m

high bluffs then moderately wooded land. A vehicle track runs out to a house at the point.

BI 60-64 SWIFTS POINT (S)

No.	Beach	Rating HT LT	Type	Length
BI 60	Swifts Pt (S1)	1 2	R+sand/rock flats	40 m
BI 61	Swifts Pt (S2)	1 2	R+sand/rock flats	50 m
BI 62	Swifts Pt (S3)	1 2	R+sand/rock flats	100 m
BI 63	Swifts Pt (S4)	1 2	R+sand/rock flats	100 m
BI 64	Swifts Pt (S5)	1 2	R+sand/rock flats	60 m
Spring & neap tidal range = 1.3 & 0.3 m				

Swifts Point is a 10 m high sandstone point covered with scattered trees surrounding a clifftop house serviced by an access track from the south. Beaches BI 60-64 are five pockets of sand and sand and rock flats located along the gradually rising tree-covered sandstone coast that extends for 1 km south of the point.

Beach **BI 60** is a 40 m long pocket of sand located below the tip of the point. It faces east across 50 m wide rock flats then 100 m of sand flats, with low rocky shore to either side. Beach **BI 61** lies 150 m to the south and is a 50 m long strip of high tide sand bordered by rocky shore and fronted by 100 m wide sand and rock flats that continue south in front of beaches BI 62 and 63. Beach **BI 62** lies 50 m to the south and extends for 100 m to the next 150 m long rocky section, with beach **BI 63** continuing for another 100 m to a low rocky point. The sand flats narrow to 50 m off the beach. A house is located on the 20 m high point that separates beaches BI 63 and 64. Beach **BI 64** lies 100 m south of the point and is a 50 m long pocket of high tide sand fronted by 50 m wide sand and rock flats, with tree-covered slopes gradually rising to 101 m high Ventenat Hill 1 km to the south.

BI 65-66 LITTLE TAYLORS & DANIELS BAYS

No.	Beach	Rating HT LT	Type	Length
BI 65	Little Taylors Bay	1 1	R+ridged sand flats	1 km
BI 66	Daniels Bay	1 1	R+ridged sand flats	600 m
Spring & neap tidal range = 1.3 & 0.3 m				

Little Taylors Bay is a 1.5 km wide semi-circular bay located at the base of the larger bay bordered by Ventenat and Winifred points. The little bay is bounded by Swifts and Grundys points and extends 2 km to the south. Beach **BI 65** is located along the southern base of the bay and faces north across 600 m wide ridged sand flats. The low narrow high tide beach extends for 1 km along the southern shore backed by Sharps Road and cleared low farmland, with Fitchetts Creek draining towards the centre. The road links with Lighthouse Road at the eastern end of the beach.

Lighthouse Road runs north for 2 km to the lee of Grundys Point before turning into **Daniels Bay** and the junction with the Main Road at the settlement of Lunawanna. Point Winifred forms the northern boundary of the bay. This is a 1 km wide V-shaped west-facing bay containing a very low energy beach (**BI 66**) at its eastern end. The beach trends north for 600 m as a low narrow strip of high tide sand, facing west across 600 m wide plain inner flats and outer ridged sand flats (Fig. 4.108). Cockerills Creek drains to the centre of the beach. The Bruny Island Main Road runs along the rear of the beach, with a few houses and cleared sloping farmland behind.

Figure 4.108 Daniels Bay beach is fronted by inner flats and outer ridged sand flat (photo W. Hennecke).

BI 67-69 CEMETERY BEACH

No.	Beach	Rating HT LT	Type	Length
BI 67	Cemetery Beach	1 1	R+sand flats	300 m
BI 68	Little Reef	2 2	R+sand/rock flats	150 m
BI 69	Big Reef	2 2	R+rock/sand flats	200 m
Spring & neap tidal range = 1.3 & 0.3 m				

Point Winifred marks the northeast side of the 2 km wide bay that extends across to Ventenat Point. To the north the coast is more exposed to westerly wind waves generated across the 10-15 km wide D'Entrecasteaux Channel. As wave energy increases the beaches respond with wider beaches and narrow sand flats. Three beaches (BI 67-69) extend 1.5 km north of the point.

Cemetery Beach (BI 67) is located 200 m north of Point Winifred. It is a slightly curving 300 m long west-facing beach exposed to a greater fetch across the 12 km wide channel. The higher wind waves maintain a high tide reflective beach fronted by 50 m wide sand flats. It is bordered by low rocky shoreline and backed by a narrow tree-filled reserve, gravel road and two rows of houses behind the southern end of the beach. A sand mine is located at the northern end of the beach, with rocky shore continuing for another 300 m past Vaughans Landing to Little Reef, a low rocky point and reef.

Beach **BI 68** is located in an open 400 m long embayment between Little and Big reefs. The beach is 150 m long and faces east into the channel. It consists of a high tide beach fronted by 50 m wide sand flats crossed by intertidal rock ridges and backed by a small foredune then tree-covered slopes. Beach **BI 69** is located immediately to the north on the other side of Big Reef. It is a similar 200 m long high tide beach backed by tree-covered slopes descending to the back of the beach. It is fronted by an irregular zone of rock flats then 50 m wide sand flats and deeper rock reefs.

BI 70-72 ALONNAH

No.	Beach	Rating HT LT		Type	Length
BI 70	Sunset Bay	2	2	R+sand flats	150 m
BI 71	Alonnah	2	2	R+sand flats	1.1 km
BI 72	Alonnah jetty	1	2	R+harbour	50 m
Spring & neap tidal range = 1.3 & 0.3 m					

Alonnah is the largest community on the island consisting of one to two rows of houses extending 2 km along the shore. The island council, district school, health centre and only hotel, the southernmost in Australia, are all located in the small settlement. Three beaches (BI 70-72) are located in and adjacent to the settlement.

Sunset Bay is located at the southern end of Alonnah and is an open west-facing 700 m, long slight embayment, bordered to the north by the Mills Reef. Beach **BI 70** extends for 150 m along the centre of the bay, from the small mouth of Murphys Creek to the beginning of the low rocky shore that extends to the reef. It is backed by gently sloping partly cleared land, with houses backing the rocky shore to either side.

Alonnah beach (**BI 71**) commences on the northern side of Mills Reef, which extends 300 m seaward. Satellite Island lies 1 km offshore partly sheltering the beach from westerly wind waves. The beach extends north of the low reef-tipped point for 1.1 km to the rock walls of the boat harbour (Fig. 4.109). Wind waves average up to 0.5 m and maintain a 20 m wide high tide beach with 50 m wide sand flats widening to 150 m in the north against the harbour wall, the wider flats due to increasing protection afforded by the island. The main road runs along the rear of the beach, with the hotel located towards the southern end, Barnes Creek crossing the centre and the council office and school behind the northern end.

The small Alonnah boat harbour consists of a 50 m long groyne and a 100 m long attached breakwater with the boats moored inside the breakwater. Beach **BI 72** is a 50 m long pocket of sand located in the southeast corner of the harbour. It is used as a boat launching area, with a second gravel boat ramp at the entrance. The beach is backed by a large cleared area for car and trailer parking, then the main road. Houses extend to the rear and north of the harbour.

Figure 4.109 The small community of Alonnah and its equally small boat harbour with Alonnah Beach (BI 71) to the right and the jetty beach (BI 72) in foreground.

BI 73 ISTHMUS BAY

No.	Beach	Rating HT LT		Type	Length
BI 73	Isthmus Bay	1	1	R+sand flats	8 km
Spring & neap tidal range = 1.3 & 0.3 m					

Isthmus Bay is a 5 km wide U-shaped north-facing bay located between Simpsons Point and Porpoise Head. It western shore is formed by a 2.5 km long dolerite peninsula that terminates at Simpsons Point, while its eastern shore is the low energy rear of Neck Beach (BI 12). The two beaches BI 73 and 12 form either side of the sandy isthmus (Fig. 4.110), which links North and South Bruny. The eastern isthmus beach (**B 73**) commences in the southern area called Simpsons Bay, 500 m east of the mouth and wetlands of Simpsons Creek. At this point the isthmus is 1 km wide, with a wetland between the two beaches. The beach curves for 8 km to the northeast where the isthmus narrows to 100 m, then north and finally east in lee of the northern boundary 15 m high Porpoise Head. At this point the isthmus widens to 1 km, with Gibbs Lagoon and associated wetland separating the two beaches.

Figure 4.110 The low energy sand flats of Isthmus Bay beach (BI 73) contrast with the higher energy Neck Beach (BI 12) shown here at the narrowest part of the isthmus (photo W. Hennecke).

The beach is a very low energy narrow high tide beach, fronted by 1 km wide sand flats, which are covered with a complex arrangement of outer shore-parallel sand ridges and inner transverse ridges, the latter inducing slight crenulations in the sandy shore. The main road runs down the centre of the isthmus providing good access at the narrowest section of the two beaches.

BI 74-76 FANCY BAYS

No.	Beach	Rating HT LT		Type	Length
DI 74	Porpoise Bay	1	1	R+ridged sand flats	250 m
BI 75	Fancy Bay	1	1	R+ridged sand flats	1.3 km
BI 76	Little Fancy Bay	1	1	R+ridged sand flats	400 m
Spring & neap tidal range = 1.3 & 0.3 m					

To the north of Porpoise Head lie the two Fancy bays separated by 30m high Chuckle Head. Two beaches are located in the bays (BI 75 and 76) and one on Porpoise Head (BI 74). All three face west across the 6-7 km wide D'Entrecasteaux Channel and receive only westerly wind waves.

Beach **BI 74** is located at the western end of **Porpoise Head** and extends for 250 m between 10-15 m high diverging sandstone points. The beach faces due west and is fronted by 400 m wide sand flats covered by 15 subdued sand ridges. Two vehicle tracks reach the rear of the beach where two small fishing shacks are located.

Fancy Bay is a curving 1 km wide bay located on the northern side of Porpoise Head. Within the bay beach **BI 75** curves for 1.3 km as a semi-circular west-facing beach. Sand flats fill the bay extending beyond the head to link with the Porpoise Head sand flats. They are covered by up to 20 well developed sand ridges. The beach is backed by a low 100-200 m wide foredune area, with a central 5 ha wetland and rising ground behind. A vehicle track runs along the rear of the beach.

Little Fancy Bay is located between Chuckle Head and the northern Fancy Point. The bay is 700 m wide between the heads narrowing into the 600 m deep bay to a 400 m long west-northwest-facing low energy beach (**BI 76**). Two hundred metre wide ridged sand flats front the beach and partly fill the bay (Fig. 4.111). It is backed by a 50 m wide beach ridge area and a central 3 ha wetland fed by three small creeks. A vehicle track reaches the centre of the beach, with rising densely vegetated ground surrounding the bay.

BI 77-83 GREAT BAY

No.	Beach	Rating HT LT		Type	Length
BI 77	Ford Bay	1	1	R+sand flats	500 m
BI 78	Sadgrove Pt (N)	1	1	R+ridged sand flats	700 m
BI 79	Smoothys Pt (S)	1	1	R+ridged sand flats	500 m
BI 80	Great Bay (1)	1	1	R+ridged sand flats	600 m
BI 81	Great Bay (2)	1	1	R+ridged sand flats	400 m
BI 82	Great Bay (3)	1	1	R+ridged sand flats	900 m
BI 83	Adams Bay	1	1	R+ridged sand flats	500 m
Spring & neap tidal range = 1.3 & 0.3 m					

Figure 4.111 Little Fancy Bay is partly filled with 200 m wide ridged sand flats of beach BI 76.

Great Bay has a 3.5 km wide entrance between Chevertons and Stallards points, widening to 4.5 km inside and with a shoreline length of 9 km. The bay faces west out across the 9-10 km wide D'Entrecasteaux Channel and receives only westerly wind waves, which are further lowered by refraction within the bay and the extensive sand flats that dominate much of the bay shore. Most of the shoreline is dominated by seven low energy beaches and their ridged sand flats (BI 77-83), with generally rising ground behind. All but Adams Bay are located on the main road and readily accessible.

Ford Bay is located in the southern corner of the bay. It has a 900 m wide entrance between Chevertons and Sadgrove points and faces north up the bay. Beach **BI 77** is located along the southern shore of the U-shaped 700 m deep bay, the north-facing beach extending for 500 m along the shore linking the base of the two points. It is a narrow high tide beach fronted by 400 m wide sand flats, with oyster racks extending right across the outer flats. It is backed by 150 m wide low grassy barrier flats, then a series of wetlands associated with the Bains Lagoons which link 3 km to the south with the rear of Big Lagoon and the northern end of Neck Beach (BI 12). The wetland drains across the eastern end of the beach with the main road 100 m to the east.

Beach **BI 78** is located on the northern side of Sadgrove Point, commencing at the base of the 300 m long point. The narrow high tide beach trends northeast for 700 m to the next small headland. It faces northwest towards the bay mouth and is fronted by 150 m wide ridged sand flats. A small jetty is located out on the point past the sand flats and the main road runs along the rear of the beach, with beachfront houses along the southern half of the beach and Lawrence Creek draining across the centre.

A densely vegetated 100 m wide headland separates beaches BI 78 and 79. Beach **BI 79** extends north of the headland for 500 m to the small Smoothys Point, which

protrudes 100 m into the bay. The low narrow beach is fronted by 200 m wide ridged sand flats that extend out to just past the northern point. A few rocks outcrop on the northern end of the flats. The beach is backed by dense vegetation in the south and a house and cleared land to the north, with the main road paralleling the shore 100 m inland, then slopes rising to over 100 m. This is the narrowest bedrock section of the island with the exposed cliffed east coast located less than 2 km to the east.

North of **Smoothys Point** is a series of three near continuous beaches (BI 80-82) which share continuous well developed ridged sand flats which widen to 600 m in the north. Beach **BI 80** commences on the northern side of Smoothys Point and trends north for 600 m to a 150 m long section of low rocky shore, with rock flats extending out onto the flats. The beach is fronted by 300 m wide ridged sand flats and backed by the main road then densely vegetated slopes rising to 100 m. Beach **BI 81** continues on the northern side of the rocks for another 400 m to the next 200 m long section of low rocks. The sand flats widen to 500 m with some oyster racks on the outer edge of the flats. The road and partly cleared slopes back the low narrow high tide beach.

Beach **BI 82** is the largest beach in the bay. It faces west-southwest towards the bay entrance and extends for 900 m between the southern boundary rocks and the mouth of Saltwater Creek. The narrow beach is fronted by 700 m wide ridged sand flats. It is backed by a low barrier, a deflected creek and wetlands, with the main road running along the rear of the southern half of the beach then skirting 100-200 m inland around the wetlands. The backing cleared slopes rise to 116 km at Big Lookout, 2 km to the east on the rugged east coast of the island.

At Saltwater Creek the shoreline turns and trends west to **Adams Bay**. This is the northernmost bay in the Great Bay and consists of a south-facing 500 m long low energy beach (**BI 83**) fronted by 300 m wide inner transverse and outer ridged sand flats which face due south towards Ford Bay 4 km to the south. The beach is backed by gently sloping partly cleared farmland, with an oyster works on the western point and oyster racks spread across the outer flats (Figure 4.112). At the western end of the beach the shoreline turns south for 1 km to Stallards Point and is backed by densely vegetated slopes rising to 80 m.

BI 84-86 **MISSIONARY BAY**

No.	Beach	Rating HTLT	Type	Length
BI 84	Black Rock Pt	1 2	R+sand/rock flats	300 m
BI 85	Cockleshell Beach (S)	1 1	R+ridged sand flats	200 m
BI 86	Cockleshell Beach (N)	1 1	R+ridged sand flats	100 m
Spring & neap tidal range = 1.3 & 0.3 m				

Missionary Bay is a 1 km wide southwest-facing U-shaped bay located between Black Rock and Soldiers

points. The bay is surrounded by sloping terrain rising in the north to 206 m at Roberts Hill. Three small beaches are located in the area, one on Black Rock Point (BI 84) and two at the eastern end of the 2 km deep bay (BI 85 and 86).

Figure 4.112 Adams Bay contains a narrow high tide beach, with 300 m wide ridged sand flats used to support oyster racks.

Beach **BI 84** is a curving west-facing 300 m long beach bordered by 10 m high Black Rock Point to the south and Stockyard Point to the north, both of which protrude about 100 m west of the beach. Densely vegetated 10 m high slopes surround the beach rising to cleared farmland, with a road running round the top of the slopes and some houses on the southern point. The beach consists of a narrow high tide beach facing west across 50 m wide sand and some rock flats.

The **Cockleshell** beaches are located in a 400 m wide embayment at the eastern end of the large bay either side of the mouth of small Missionary Creek. Beach **BI 85** is a curving 200 m long northwest-facing low energy beach fronted by 400 m wide ridged sand flats that fill the bay. The creek flows out between low bedrock points immediately north of the beach. A low tree-covered 100 m wide point borders the northern side of the creek, with beach **BI 86** then extending north for 100 m. It faces west across the continuous sand flats. Both beaches are backed by generally cleared moderately sloping farmland.

BI 87-88 **RAT & KILLORA BAYS**

No.	Beach	Rating HTLT	Type	Length
BI 87	Rat Bay	1 2	R+rock/sand flats	60 m
BI 88	Longfords Beach	1 2	R+rock/sand flats	700 m
Spring & neap tidal range = 1.3 & 0.3 m				

Rat and Killora bays are two adjoining bedrock embayments located south of Bligh Point. They both face east across a narrow 1.5 km wide section of the D'Entrecasteaux Channel and receive low westerly wind waves.

Rat Bay is a small rocky bay with a gap in the centre containing 60 m long beach **BI 87**. The beach is located at the mouth of a small creek that descends from the backing 200 m high slopes. It consists of a mixture of sand and rocks, with rocky shore extending out 50 m on either side, with sand flats in between. Sloping tree-covered bluffs back the beach with the Killora Road running around the top of the bluffs and a few houses on the backing slopes.

Killora Bay is located 1 km to the north and extends for 700 m between Longfords Point and the protruding Bligh Point. In between is the curving, west-facing 700 m long **Longfords Beach** (**BI 88**). The beach is bordered and backed by vegetated bluffs rising to 40 m where the road runs and then rising up to 200 m. The beach consists of a narrow high tide sand and rocky shore fronted by a 50 m wide mixture of sand and rock flats, the sand flats widening slightly to the northern end. A few houses on Longfords Point overlook the southern end of the beach.

BI 89-92 **NEBRASKA BEACHES**

No.	Beach	Rating HT LT		Type	Length
BI 89	Bligh Pt (E1)	2	2	R+sand flats+rocks	150 m
BI 90	Bligh Pt (E2)	2	2	R+sand flats+rocks	100 m
BI 91	Bligh Pt (E3)	2	2	R+sand flats+rocks	80 m
BI 92	Nebraska Beach	2	3	R	1.2 km
Spring & neap tidal range = 1.3 & 0.3 m					

Bligh Point is a 500 m long 100 m wide sandstone point that separates Killora Bay from Nebraska Beach. The 20 m high point is backed by cleared slopes rising to 200 m at Dennes Hill. The Killora Road runs along the slopes about 30 m above the shore descending to the shore along Nebraska Beach. Three small rock-bound beaches (BI 89-91) are located east of the point grading into the longer Nebraska Beach (BI 92).

Beach **BI 89** is a 150 m long strip of high tide sand bordered by boulders and rocky sandstone shore and backed by the cleared 20 m high point. Sand flats extend about 50 m off the beach. The sand flats continue along past the rocks for 200 m to beach **BI 90**, a similar 100 m long high tide beach bordered by the rocks and fronted by the sand flats which widen to about 100 m. Beach **BI 91** lies another 300 m to the east and consists of a small curving 80 m long beach at the base of a small gully. Rocks line either side and the flats extend about 50 m offshore. All three beaches are backed by a fringe of trees then cleared steeply rising slopes.

Nebraska Beach (**BI 92**) commences 100 m to the north and curves slightly to the northeast for 1.2 km past the small Stiffys Creek mouth to the rocky mouth of Norlin Creek. The beach faces across channel into North West Bay with a fetch of 7 km, resulting in slightly higher waves. These maintain a high tide reflective, at times

cusped, beach, with deeper water offshore. The beach is backed by beachfront houses, then the main road, which backs the northern end of the beach.

BI 93-94 **JETTY BEACH**

No.	Beach	Rating HT LT		Type	Length
BI 93	Boulder Pt (N)	2	3	R+LTT	400 m
BI 94	Jetty Beach	2	3	R	300 m
Spring & neap tidal range = 1.3 & 0.3 m					

The small **Dennes Point** settlement is located at the northwestern tip of the island and just 1.5 km from the mainland at Tinderbox Bay. The Killora Road terminates at the settlement, which is fronted by two beaches (BI 93 and 94) separated by Boulder Point.

Beach **BI 93** extends for 400 m south of Boulder Point and consists of a curving northwest-facing reflective to low tide terrace beach bordered by rocky shore to each end. It receives low wind waves as well as some low refracted swell around the northern tip of the island. The beach is backed by a narrow grassy reserve and a row of trees, with a small car park and toilets towards the northern end. The road parallels the rear of the beach, with a row of houses on the eastern side then cleared slopes rising to 126 m high Sheep Hill.

Jetty Beach (**BI 94**) is located on the northern side of 100 m wide Boulder Point and curves to the north for 300 m terminating at the low Dennes Point, which is surrounded by a boulder beach (Fig. 4.113). The Jetty beach is reflective dropping off into deeper water and receives low refracted swell as well as wind waves travelling across the channel. The jetty is located at the southern end of the beach, with a low 50 m wide foredune, two houses and cleared sloping land backing the beach.

Figure 4.113 The sheltered Jetty Beach (BI 94) is the northernmost on Bruny Island.

WEST COAST

Region 3A South East Cape - Cape Sorell

Coast length:	448 km	(1097-1545 km)
Beaches	306	(T 566-791)
Regional maps:	Figure 4.114	Page 164
	Figure 4.125	Page 174
	Figure 4.140	Page 188

The west coast of Tasmania extends for 692 km from South East Cape, the southern tip of Tasmania and Australia (43°39'S), to Cape Grim on the northwestern tip of the island. The coast can be divided into two, a southern and a northern section. The undeveloped 448 km long southern half extends from South East Cape to Cape Sorell at the entrance to Macquarie Harbour (Figs. 4.114, 4.125 & 4.140)) and includes 319 km of rocky coast and 306 beach systems totalling 129 km in length. This is a rugged coast exposed to some of the highest waves in the world and buffeted by strong westerly winds and accompanying high rainfall. The result is a rugged and wild coast the southern half of which is contained entirely in the Southwest Conservation Area and Southwest National Park. The only formal access to limited areas of the park and coast is by foot, with a few landing strips and essentially no vehicle access to any of the southwest coast.

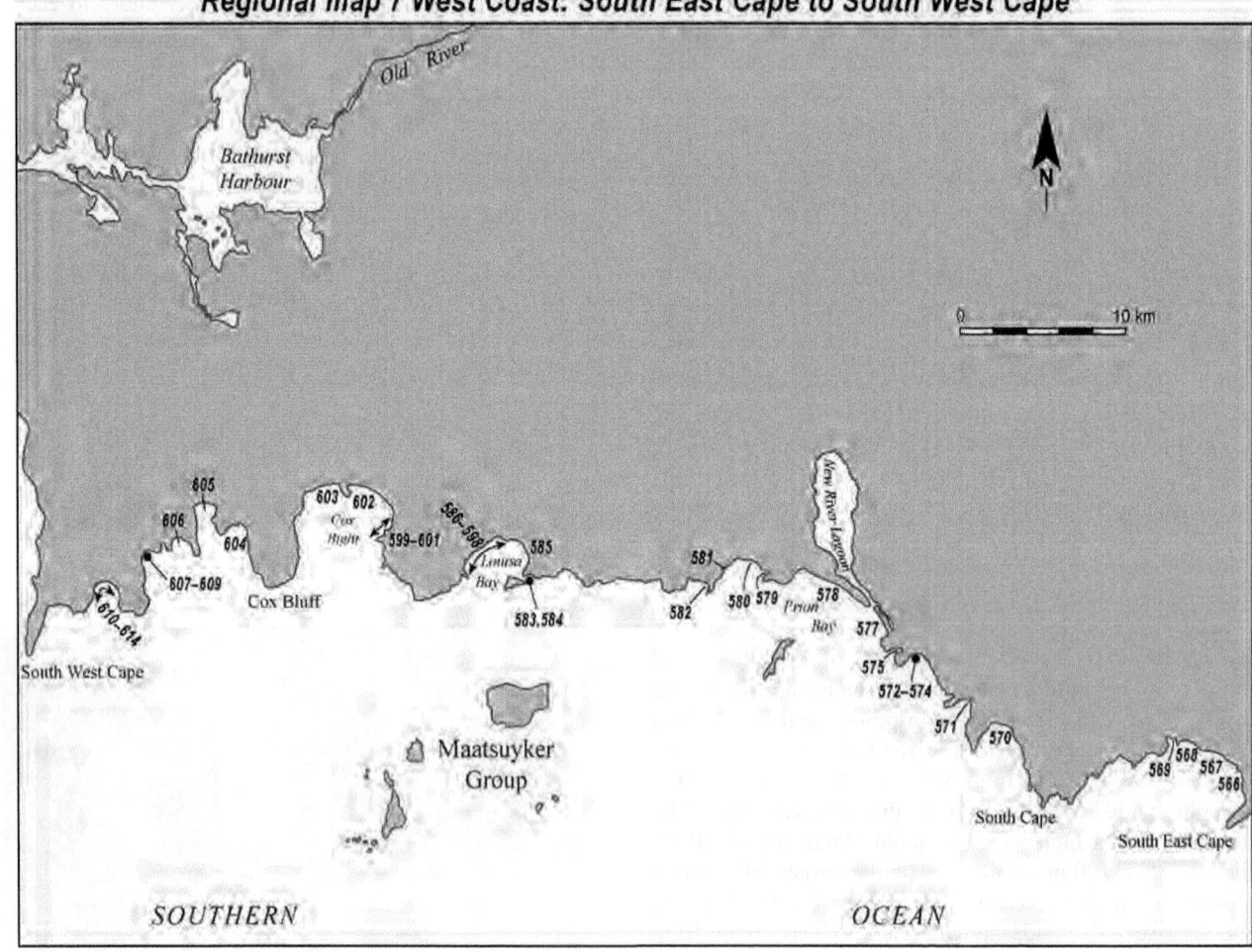

Figure 4.114 The West Coast region between South East Cape and South West Cape.

Southwest National Park

Established: 1951
Area: 618 190 ha
Coast length: 300 km (1083-1383 km)
Beaches: 127 (T 566-693)

The Southwest National Park is the largest park in Tasmania and includes most of the rugged southwest of the state. At the coast it commences at First Lookout Point, 11 km northeast of South East Cape, the southernmost point in the state. It then follows the coast west and north for 300 km to Elliott Bay. The predominantly high rocky coast is exposed to some of the highest waves in the world, together with strong onshore winds and high rainfall. A total of 127 beaches occupy 62 km (50%) of the coast. The coast is only accessible on foot, or by boat and in some locations by light plane. Most is a true wilderness area and is located within the Tasmanian Wilderness World Heritage Area. Most of the beaches and surf are little if ever used, apart from as a hiking track.

T 566-569 SOUTH CAPE BAY

No.	Beach	Rating		Type		Length
		HT	LT	inner	outer	
T566	South Cape Bay (1)	8	10	R+rock flats	TBR	250 m
T567	South Cape Bay (2)	7	9	TBR	RBB	850 m
T568	South Cape Bay (3)	7	9	TBR+rocks		650 m
T569	South Cape Rivulet	6	7	TBR		600 m
Spring & neap tidal range = 1.2 & 0.2 m						

South Cape Bay is the southernmost embayment in Australia. The 10 km wide south-facing rocky bay is bordered by 169 m high South East Cape in the east and 122 m high South Cape to the west. In between are 13 km of predominantly rocky shoreline backed by steep slopes rising 100 to 200 m (Fig. 4.115). The bay is exposed to some of the highest waves in the world averaging 3 m in height together with strong westerly winds. Five exposed beaches (T 566-570) are located towards the centre of the bay.

Figure 4.115 South Cape Bay is exposed to the full force of the southerly winds and swell and contains several high energy beaches.

Beach **T 566** is the most southern beach in Australia and lies 2.5 km north of South East Cape. It consists of an irregular 250 m long, southwest-facing strip of high tide sand fronted by 50 m wide rock platform, then a 100 m wide rip- and rock-dominated surf zone. It is backed by

50 m high cliffs capped by vegetated clifftop dunes extending up to 1 km inland. The dunes continue south to the cape area, where they extend up to 2 km inland. The South Coast walking track reaches the shore 1 km northwest of the beach.

Beach **T 567** commences where the walking track reaches the shore and trends to the northwest for 850 m. It faces straight into the high waves and winds and consists of a sandy beach fronted by a 100 m wide surf zone usually drained by two boundary rips and one central rip, the western rip flowing out against Lion Rock which extends 300 m due south. A small creek drains across the centre of the beach and densely vegetated dunes climb the backing slopes reaching 70 m in height and extending 500 m inland to link with the cape dunes to the east. The walking track follows the beach to a camping site by the creek mouth. It then continues around the rocky shore to beach T 568.

Beach **T 568** lies 1 km to the west on the other side of a steep 100 m high headland called Coal Bluff, the track following the base of the headland. The beach is relatively straight, faces due south and is 650 m in length, with a cluster of rocks in the inner surf zone along the eastern end of the beach. Waves average about 2 m and maintain a 150 m wide surf zone usually drained by two large rips. A 20 m high rocky point extends 400 m south to form the western boundary, with the track crossing the base of the point. The beach is backed by densely vegetated dune-draped slopes rising steeply to over 100 m.

Beach **T 569** commences on the western side of the 300 m wide point. It continues west for 600 m to the mouth of South East Cape Rivulet and the beginning of a section of densely vegetated high rocky shore that initially trends 1 km to the south. This headland partly protects the western end of the beach lowering waves to less than 1.5 m. The surf zone narrows to 50 m with rips to either end, the western rip incorporating flow from the creek. A reef off the eastern headland causes waves to break and run in towards the beach resulting in seaward flow of return water outside the surf zone (Fig. 4.116). The track follows the beach to a campsite at the creek

mouth, and then heads up the steep western slopes to follow the 100-200 m high ridgeline.

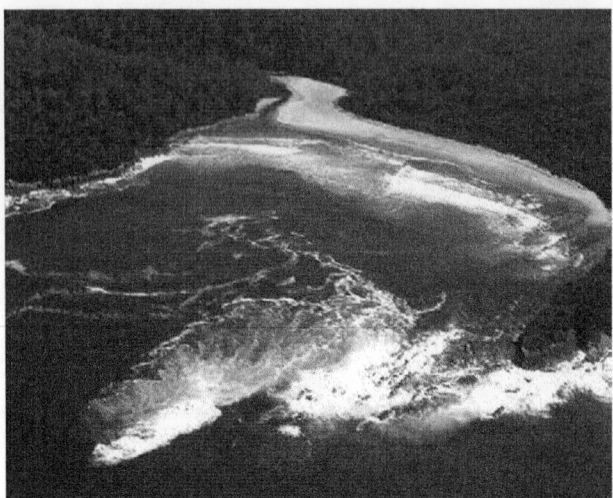

Figure 4.116 Beach T 569 and the mouth of South East Cape Rivulet.

T 570-575 SOUTH CAPE-POINT CECIL

No.	Beach	Rating HT	LT	Type	Length
T570	Granite Beach	7	8	TBR	1.4 km
T571	Surprise Bay	7	8	TBR	900 m
T572	Osmiridium Beach (E)	7	8	TBR	300 m
T573	Osmiridium Beach (W)	7	8	TBR	400 m
T574	Rocky Plains Bay	3	5	R/LTT	150 m
T575	Rocky Boat Inlet	3	4	Cobble	150 m
Spring & neap tidal range = 1.2 & 0.2 m					

Between South Cape and Cecil Point are 12 km of rugged southwest-facing coast dominated by high rocky points and cliffs and intervening bays and rocky inlets. The bays and inlets contain six beaches (T 570-575). The South Coast walking track runs along the two eastern beaches (T 570 and 571) passing inland of the western beaches.

South Cape is a 122 km high cliffed dolerite point, to the northwest of which the sheer 300 m high Fluted Cliffs extend for 4 km into Shoemaker Bay. At the north end of the 2 km wide bay is south-facing **Granite Beach (T 570)**. The 1.4 km long sandy beach is backed by densely vegetated slopes, which commence at the rear of the beach and gradually rise to over 500 m along the South Cape Range, with three creeks including Sandstone Creek draining down the backing slopes to the beach. The beach is bordered by the 200-300 m high Fluted Cliffs to the east and 100 m high Shoemaker Point extending 1.5 km south on the west. Waves averaging over 2 m maintain a rip-dominated 200 m wide surf zone with usually strong rips to either end and 2 to 3 beach rips in between. The walking track descends to the beach from the South Coast Range, follows the beach and then climbs the rear of Shoemaker Point, with a camping site located at the eastern end of the beach.

Surprise Bay is located on the western side of 1 km wide Shoemaker Point. The 1.3 km wide bay faces southwest and is bordered to the west by the narrow 107 m high Prettys Point and its reefs. Beach **T 571** occupies the northern base of the bay, which it has partly filled with a 30 m high, 500 m wide now densely vegetated dune system. The dunes have deflected the Surprise Rivulet to the eastern end of the beach where it maintains a wide sandy entrance between the boundary headland and some shore-perpendicular rocks that extend 500 m into the surf. The beach receives waves averaging 2-3 m which maintain a 200 m wide surf zone with normally a large central rip and smaller rips against the boundary rocks and reefs. The walking track descends to a campsite at the eastern end of the bay, then crosses the usually shallow creek mouth and follows the beach before heading inland for 5 km in lee of Prettys Point.

Rocky Plains Bay lies 2.5 km west of Prettys Point with rugged rocky coast in between. The bay is bordered to the west by 60 m high Point Vivian which extends due southwest for 1 km with Chicken Island and reefs continuing south for another 700 m. Tylers Creek drains the valley at the rear of the bay which is partly filled by the **Osmiridium** beaches (T 572 and 573), the creek mouth and a central rock outcrop separating the two beaches. The eastern side of Osmiridium beach (**T 572**) extends west for 300 m to the central outcrop, while the western side (**T 573**) continues on the other side past the small creek mouth for another 400 m to the 60 m high inner slopes of Point Vivian. Both beaches are fronted by a continuous 200 m wide surf zone usually containing a strong central rip off the creek mouth and small rips to either end. A high foredune and now vegetated climbing dunes back the eastern section, while a 25 m high, 200 m wide foredune backs the western side. A campsite is located 500 m inland where the track crosses Tylers Creek.

Beach **T 574** is located on the side of Point Vivian inside a 20 m wide gap in the rocks 150 m south of the western end of the beach. The gap opens into a 100 m wide cove with the beach curving round the rocky shore for 150 m and facing east out of the gap. Large waves flow through the gap and break over the 100 m long ridge of metasedimentary rocks and spread out around the curving beach to maintain a sloping reflective to low tide terrace beach and a central surging 30 m wide tidal pool. The beach is backed by densely vegetated slopes rising to 60 m and can only be reached with difficulty along the rocks.

Rocky Boat Inlet is located on the western side of Point Vivian and forms a 300 m wide U-shaped southwest-facing bay, bordered by 140 m high Point Cecil and Wierah Hill to the west, and with numerous rocks and reefs filling the small bay. The reefs together with Hen Island located 1.5 km offshore lower waves at the shore to less than 1 m as they spread out around the northern shore of the rocky bay. Beach **T 575** is a sheltered curving 150 m long high tide cobble and sand beach located in the northern corner of the bay at the mouth of

Lithograph Creek. It faces southwest across the reefs of the bay toward the mouth.

T 576-578 **PRION BEACH**

No.	Beach	Rating HT LT		Type	Length
T576	Wierah Hill	7	8	TBR	150 m
T577	Prion Beach (E)	7	8	TBR	1 km
T578	Prion Beach	7	7	TBR/RBB	5 km
Spring & neap tidal range = 1.2 & 0.2 m					

Prion Beach is the longest beach in the southwest extending for 6 km between Point Cecil and Menzies Bluff. The beach is divided into two sections (T 576 and 577) by the shifting mouth of New River Lagoon. The walking track descends from the rear of Wierah Hill to the lagoon shore where there is a campsite and a rowing boat for crossing the inlet. On the other side the track follows the full length of the beach passing to the rear of Menzies Bluff.

Beach **T 576** is located at the base of 136 m high Wierah Hill and faces west along the main beach. It is a 150 m long pocket of sand fronted by a 100 m wide surf zone which links with the Prion Beach surf zone immediately to the east. The beach is bounded by 100 m long rocky points and backed by the steep slopes with a strong rip usually flowing out against the northern rocks.

The eastern section of Prion Beach (**T 577**) commences against the inner 130 m high slopes of Point Cecil and trends west to the lagoon mouth, which is usually a few tens of metres wide as it cuts across the beach. The mouth can shift from against the eastern rock, where it links with Milford Creek, to as far as 1 km west along the beach. In between the shifting entrance maintains a 1 km long, 200-300 m wide zone of bare beach backed by the active or inactive channel (Fig. 4.117), with a well vegetated foredune on the northern side of the inlet. The walking track follows the crest of this dune to the crossing located 2.5 km along the inlet. The inlet extends west for a total of 4 km before opening into 1,200 ha New Lagoon. It extends north for 6.5 km to the New River delta and averages 2 km in width. The lagoon occupies a fault with steep slopes rising to 850 m on the west and more gently sloping terrain to the east.

The main Prion Beach (**T 578**) continues west of the shifting inlet for another 5 km with a total beach length of 6 km, with the walking track running the length of the beach. The entire system faces south-southeast into the 3 m high average swell. The waves break across a 300 m wide rip-dominated surf zone, with usually large rips spaced about every 400-500 m. The main beach is backed by a 4.5 km long vegetated foredune which rises to 25 m and ranges from 100-200 m in width. This is backed by extensive vegetated overwash flats and the flood tide delta, all of which extend up to 1.5 km into the southern end of the lagoon.

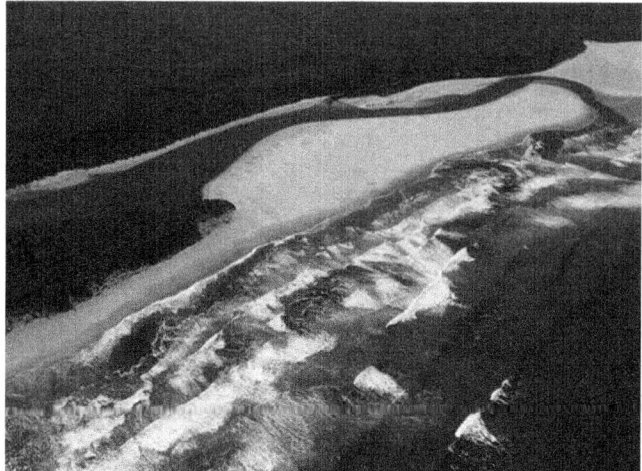

Figure 4.117 The usually small shifting mouth of New River Lagoon divides Prion Beach in two and maintains a long section of bare sand beach.

T 579-580 **DEADMANS BAY**

No.	Beach	Rating HT LT		Type	Length
T579	Turua Beach (E)	6	7	TBR	250 m
T580	Turua Beach	6	7	TBR	800 m
Spring & neap tidal range = 1.2 & 0.3 m					

Deadmans Bay is located on the western side of 1.5 km wide Menzies Bluff with Purrar Point extending 2.5 km to the southwest and forming the western boundary. Turua Beach curves around the top of the bay for a total of 1 km with a protruding rock outcrop dividing it into two sections (T 579 and 580).

The eastern section (**T 579**) commences against the western slopes of Menzies Bluff and curves to the northwest for 250 m, to 100 m long densely vegetated protruding slopes, which are fronted by a linear rock platform. The beach has a 100 m wide surf zone with waves breaking over the bar and rocks and forming a strong permanent rip against the eastern rocks. The main **Turua Beach** (**T 580**) curves west of the rocks for 800 m to the inner slopes of Purrar Point. Waves averaging over 1.5 m break across a 100 m wide surf zone, usually drained by a large central rip and smaller western boundary rip, as waves decrease into the western corner. Both beaches are backed by a vegetated foredune then slopes that steepen and rise to 300 m. Deadmans Creek drains across the centre of the main beach, with a smaller creek at the western end of the eastern beach. The walking track runs around the back of Menzies Bluff to reach the eastern beach and then follows the shoreline to the western end. A campsite is located at the western end before the track climbs the rear of Purrar Point.

T 581-582 LOUSY BAY

No.	Beach	Rating HT LT	Type	Length
T581	Purrar Pt	3 4	Cobble+rocks	150 m
T582	Lousy Bay	7 10	TBR+rocks	200 m
Spring & neap tidal range = 1.2 & 0.2 m				

To the west of Deadmans Bay are 11 km of exposed rugged south-facing rocky shore, rising steeply in places to 600 m and dissected by steep creeks. The entire coast is rocky apart from two small beaches (T 581 and 582).

Beach **T 581** is located in a small rocky bay 1.5 km northeast of Purrar Point. The beach is a curving 150 m long cobble beach bordered by low intertidal rock platforms together with some rocks and reefs off the beach. It is sheltered and receives low refracted swell. Trees line the shoreline and centre of the backing valley with heathland to either side. The track from Turua Beach follows the rocky shore to the small bay where there is a campsite.

Lousy Bay extends for 1.5 km west of Purrar Point, with 343 m high Havelock Bluff forming its western boundary. The rugged 1 km deep rocky bay has a 200 m long patch of sand located in its northern corner at the base of steep densely vegetated slopes. The beach (**T 582**) is awash at high tide and fronted by a 150 m wide bay that occupies the area between the boundary steep rocky points, with surf filling the bay and feeding a strong rip against the western rocks. A steep valley rises behind the beach with a creek descending onto the sand.

T 583-585 LOUISA RIVER

No.	Beach	Rating HT LT	Type	Length
T583	Louisa Pt (E)	4 5	LTT+reef	200 m
T584	Louisa Pt (W)	4 5	LTT+reef	500 m
T585	Louisa River	4→6	LTT→TBR	2.3 km
Spring & neap tidal range = 1.2 & 0.2 m				

The Louisa River is a medium sized river that makes a dramatic entrance to the sea between lee of Louisa Point and Louisa Island. The river has been deflected to the south behind a 2 km long vegetated, then bare, sand barrier (beach T 585), entering the sea between beaches T 583 and 584, which are sheltered in lee of a 300 m wide gap between the point and 80 m high Louisa Island (Fig. 4.118).

Beaches T 583 and 584 share the 500 m wide embayment in lee of the gap, the two beaches linking to form the curving northern shore of the small bay. Beach **T 583** curves to the northwest for approximately 200 m to the small river mouth, while beach **T 584** continues on the other side to curve to the west, then southwest for 500 m to link to the island where it forms one side of a low sandy tombolo. Both beaches are very dynamic and bare

of vegetation, owing to the mobility of the river mouth. They are fronted by a shallow sand- and reef-filled bay with waves averaging about 1 m at the shore and breaking across a low gradient surf zone with the small river mouth in the centre. The brown tannin water of the river flows into the bay, staining the seawater.

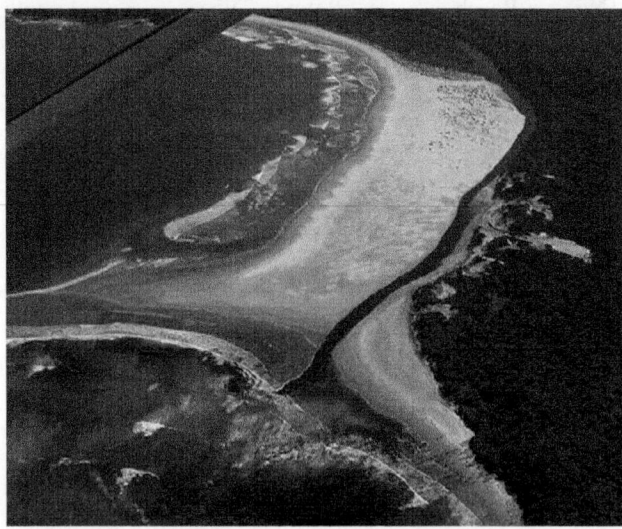

Figure 4.118 The Louisa River enters the sea in lee of the low bare Louisa beach and Louisa Point.

The main beach (**T 585**) forms the western side of the tombolo, commencing in the south where it attaches to the island. It then curves to the north and finally northwest for 2.3 km linking to a densely vegetated headland in the north. Wave height increases northwards along the beach from about 1 m in lee of the island to over 2 m in the north. The beach responds with a continuous low tide terrace in the south, while rips begin to develop about halfway up the beach, as the surf zone widens to 80 m. The backbeach is initially low and overwashed along the tombolo, which then widens to 200 m wide overwash flats covered with low active dunes. The northern 1 km is vegetated, with the deflected 50 m wide river backing the entire system. Towards the southern end of the beach there are several climbing parabolic dunes on the eastern side of the river.

T 586-590 LOUISA BAY (N)

No.	Beach	Rating HT LT	Type	Length
T586	Louisa Bay (1)	6 7	TBR+rocks	40 m
T587	Louisa Bay (2)	6 7	TBR+reef	60 m
T588	Louisa Bay (3)	6 7	LTT+reef	150 m
T589	Louisa Ck	6 6	LTT/TBR	200 m
T590	Louisa Bay (4)	6 7	LTT+rocks	200 m
Spring & neap tidal range = 1.2 & 0.2 m				

Louisa Bay has a 2.5 km wide entrance between Louisa Island and Anchorage Cove. In between it curves round for 9 km and contains 15 beaches (T 585-599). The long main beach (T 585) forms the western shore of the bay with the remainder of the beaches dominated by the rocky shore and backed by slopes gradually rising to the 200 m high Red Point Hills. Beaches T 586-590 are located in

the centre of the northern shore of the bay either side of Louisa Creek.

Beach **T 586** is a 40 m long pocket of sand wedged in between south-trending ridges of 20 m high metamorphic rocks, 50 m west of beach T 585. The little beach faces due south between the rocks and receives waves averaging about 1.5 m, which break across an 80 m wide sand and rocky surf zone wedged between the rock ridges.

Beach **T 587** lies 400 m to the west past a series of south-trending rocky points. It is a similar 60 m long beach bordered and backed by densely vegetated 20 m high ridges, with rock reefs and platform almost enclosing the small beach. Waves break over sand and reef in line with the boundary point and run 100 m into the small beach.

Beach **T 588** is located 200 m to the west and is a 150 m long sandy beach located at the base of a 20 m high vegetated bluff, which protrudes in the centre and continues as a narrow band of rocks into the surf, almost cutting the beach in two. It is partly sheltered by a small islet off its eastern end with waves averaging less than 1.5 m and breaking across a 30 m wide sand and rocky surf zone.

Beach **T 589** lies immediately to the west and is located at the mouth of **Louisa Creek** (Fig. 4.119). The 200 m long beach fills the small valley mouth and deflects the creek to its western end where it flows out against the boundary 20 m high headland. The beach receives waves averaging less than 1.5 m, which break across a 40 m wide low tide terrace, with rips only forming during higher waves. The creek meanders inland behind the beach for 2 km.

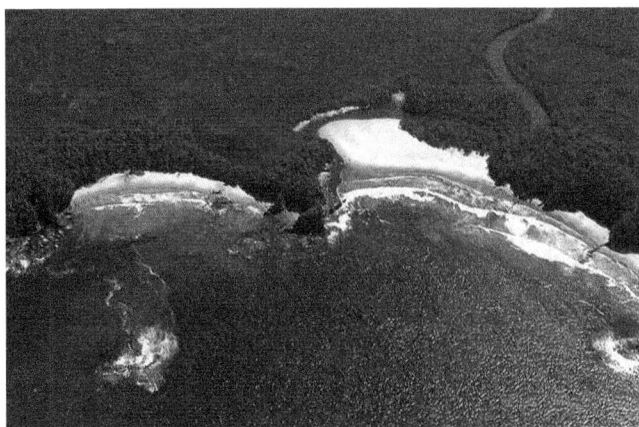

Figure 4.119 The small Louisa Creek enters the sea adjacent to beach T 589, with beach T 590 to the left.

A 50 m wide headland separates the creek from beach **T 590** that continues west for 200 m to the beginning of a 20 m high rocky section of shore. The beach is partly sheltered by a reef 200 m offshore with waves averaging just over 1 m and breaking across a 30 m wide low tide terrace, with some rocks in the surf towards the eastern end.

T 591-595 LOUISA BAY (NW)

No.	Beach	Rating HT LT	Type	Length
T591	Louisa Bay (5)	2 3	R+rocks/reef	60 m
T592	Louisa Bay (6)	2 3	R+rocks/reef	60 m
T593	Louisa Bay (7)	2 3	R	50 m
T594	Swallow Ck (E)	4 5	LTT/TBR+rocks	60 m
T595	Swallow Ck	4 5	LTT/TBR+rocks	150 m
Spring & neap tidal range = 1.2 & 0.2 m				

To the west of beach T 590 is a 2 km long section of indented 20 m high rocky shore extending west to Swallow Creek mouth and containing five small beaches (T 591-595). Beaches T 591 and 592 share a 200 m wide rocky bay largely filled with rock reef. Beach **T 591** occupies party of the northern side of the bay extending for 60 m between two tree-covered 20 m high points, with heath-covered slopes behind. The narrow high tide reflective beach is largely fronted by scattered rock reefs resulting in low waves at the shore. A 50 m wide tree-covered knoll separates it from beach **T 592** that continues to the southwest for another 60 m. It is a similar beach backed by 10 m wide tree-covered bluffs, with more open water off the beach and reef further out in the small bay.

Beach **T 593** occupies the western end of the next small embayment. It is a 50 m long east-facing reflective beach, bordered and backed by steep 20-30 m high tree-covered bluffs. Reefs and small islets lie off the beach with waves averaging less than 0.5 m at the shore.

Swallow Creek drains the eastern slopes of the 250 m high Red Point Hills and reaches the coast at a small V-shaped sand-filled valley containing beach T 595 (Fig. 4.120). Beach **T 594** is located 50 m to the east on the other side of a 20 m high tree-covered headland. The beach is a 60 m long pocket of sand backed and bordered by 20 m high bluffs, with rocks outcropping on and off the beach. It faces south out of a 300 m wide embayment containing scattered reefs and receives waves averaging over 1 m, which break across a 40 m wide bar drained via a rip against the western point. The surf zone continues past the point to 150 m long beach **T 595**, with the creek draining along the western side of the beach against the densely vegetated valley sides. The beach fills the mouth of the valley and extends 150 m inland as a plug of bare sand. Waves average just over 1 m and break across a 40 m wide surf zone, with a rip combining with the creek flow and usually running out against the western rocky point.

T 596-598 **ANCHORAGE BAY**

No.	Beach	Rating HT LT	Type	Length
T596	Anchorage Bay	4→3	LTT→R	500 m
T597	Anchorage Bay (S1)	3 4	R+rocks/reef	150 m
T598	Anchorage Bay (S2)	3 4	R+rocks/reef	150 m
Spring & neap tidal range = 1.2 & 0.2 m				

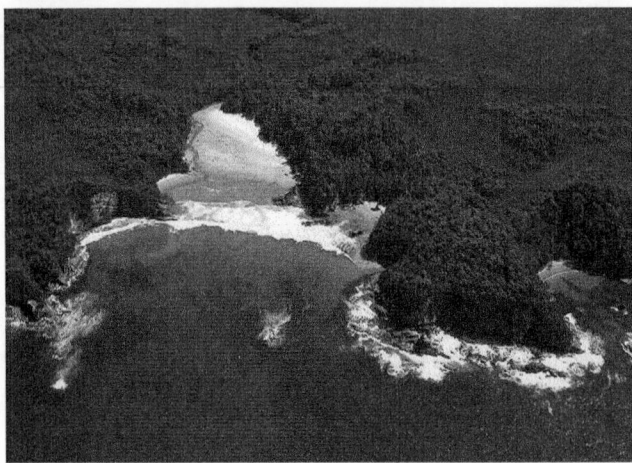

Figure 4.120 Beach T 595 is located at the mouth of the small Swallow Creek, whose flow and floods maintain a bare back beach.

Anchorage Cove commences 200 m south of Swallow Creek and is a curving 500 m wide southeast-facing slight embayment located on the western side of Louisa Bay. Beach **T 596** extends for 500 m along the shore of the cove, with wave height decreasing to the south in lee of a small island and reefs. The northern end of the beach receives waves over 1 m high, which maintain a 30 m wide low tide terrace and usually a rip against the northern rocks. As waves decrease down the beach the bar narrows with reflective cusped conditions in the south and a small creek draining across the southern end. The beach is backed by densely vegetated bluffs rising from 10 m in the south to 20 m in the north then gently sloping heathland.

Beaches T 597 and 598 occupy the next small 250 m wide embayment located between the island at the southern end of Anchorage Cove and a headland consisting of a cluster of rocks and islet extending 300 m to the southeast. Beach **T 597** extends for 150 m along the base of 20 m high densely vegetated bluffs. It receives waves averaging about 0.5 m which surge up a steep reflective cusped beach, bordered by steep rocky shore to either end, with a reef attached at the northern end and rocks along the southern section. Beach **T 598** occupies the southern section of the small bay and is a 150 m long reflective beach, located at the base of 10 m high vegetated bluffs. It terminates in the sheltered lee of the southern headland, with extensive rocks and reefs filling the southern half of the bay off the beach.

T 599-600 **ZEBRA BAY**

No.	Beach	Rating HT LT	Type	Length
T599	Zebra Bay	3 4	R+rock flats	200 m
T600	Zebra Bay (N)	3 4	R	250 m
Spring & neap tidal range = 1.2 & 0.2 m				

The western shores of Louisa Bay are bordered by a 4-5 km wide headland, dominated by the 200 m high central Red Point Hills, which terminate in the south at Red Point. The headland is surrounded by 10 km of steeply sloping, rugged exposed rocky shore. To the west of Red Point it trends northwest to Bridge Point, then north into Cox Bight. **Zebra Bay** is a 150 m wide west-facing rocky bay located on the eastern side of Cox Bight 2 km north of the boundary Bridge Point. Beach **T 599** is located along the sheltered eastern shore of the small bay. It is a curving 200 m long beach that consists of high tide sand and cobbles fronted by 50-100 m wide intertidal rock flats that almost fill the small bay and lower waves to less than 0.5 m at the shore. Steep densely vegetated slopes back the beach.

Beach **T 600** is located midway between Zebra Bay and Landing Point and consists of a sheltered 250 m long beach. It faces west across the bight and is bordered and backed by steep vegetated 20 m high bluffs. It is moderately sheltered by rocks and reefs extending to the southwest with waves averaging less than 1 m at the shore and reflective conditions prevailing.

T 601-603 **COX BIGHT**

No.	Beach	Rating HT LT	Type	Length
T601	Cox Bight (1)	6 7	TBR	1.3 km
T602	Cox Bight (2)	7 7	TBR	1.7 km
T603	Cox Bight (3)	7 7	TBR/RBB	1.9 km
Southwest Conservation Area				*184 770 ha*
Spring & neap tidal range = 1.2 & 0.2 m				

Cox Bight is a 4.5 km wide, 5 km deep U-shaped south-facing bay located between Bridge Point and Cox Bluff. Three high energy beaches occupy the 5 km long northern shore of the bight and are well exposed to the prevailing southerly waves. The bight is bordered by the 250 m high Red Point Hills to the east and the 500 m high New Harbour Range in the west, with the valleys of Buoy, Cox and Breakspeare creeks backing the three beaches. Point Eric and the backing 300 m high Moinee Ridge separate the beach systems and backing valleys. The South Coast walking track descends the Red Point Hills and reaches the coast at the small mouth of Buoy Creek and then follows the three beaches to the western side of the bight with camping areas on the central Point Eric and behind the western bight beach. Most of the beaches and backing valleys through to Melaleuca are part of the Southwest Conservation Area.

Beach **T 601** commences on the northern side of Landing Point and curves slightly to the northwest for 1.3 km to a small headland that separates it from beach T 602. The beach receives waves averaging over 1.5 m which break across a lower gradient 100 m wide surf zone, with rips against the boundary rocks and usually 2 to 3 central rips. Waves decrease close to Landing Point, which may have permitted the area to be used as an occasional landing site. The beach is backed by a well vegetated 10 m high foredune with gently sloping heathland behind converging on the central Buoy Creek, which maintains a gap through the dunes as it drains across the centre of the beach. Beach **T 602** commences on the western side of the protruding bluff, which just reaches the shoreline, while the surf zone continues past the rocks. The beach curves to the west for 1.7 km to the base of 50 m high Point Eric which extends 500 m due south. Waves average over 1.5m and break across a 100 m wide surf zone with usually a smaller rip against Point Eric, two to three central rips and a rip amongst the eastern rocks. Cox Creek drains across the centre of the beach with the smaller Goring Creek to the west. Between the creeks is a 25 m high well vegetated foredune, then gently sloping heathland.

Beach **T 603** occupies the western half of the bight. It is a 1.9 km long gently curving south-facing high energy beach exposed to waves averaging up to 3 m. They break across a 150-200 m wide surf zone (Fig. 4.121), with a strong rip against Point Eric and smaller rips against the western rocks, with 3-4 beach rips in between. The beach is backed by a 10 m high well vegetated foredune, with the Freney Lagoon inlet draining across the centre of the beach. The 70 ha lagoon backs the western half of the beach and is fed by Breakspeare Creek, while the smaller 10 ha Miller Lagoon, fed by Dutchman Creek, backs part of the eastern half of the beach, with a broad valley extending to the northwest to link with Moth Creek which flows into Melaleuca Lagoon and Bathurst Harbour. The walking track follows this valley for 10 km to Melaleuca where there is a landing strip. The beach is also used to land light planes.

Figure 4.121 The western side of Cox Bight beach (T 603) showing typical high waves and a wide surf zone (photo W. Hennecke).

T 604-609 NEW HARBOUR-KETCHEM BAY

No.	Beach	Rating HT	LT	Type	Length
T604	Abeona Hd	7	8	RBB	250 m
T605	New Harbour	5	6	LTT/TBR	1.4 km
T606	Hidden Bay	6	6	TBR	800 m
T607	Ketchem Bay (1)	6	7	TBR+rocks	150 m
T608	Ketchem Bay (2)	6	7	TBR+rocks	60 m
T609	Ketchem Bay (3)	6	7	TBR+rocks	60 m
Spring & neap tidal range = 1.2 & 0.2 m					

To the west of 470 m high Cox Bluff is a 6 km wide south-facing embayment bordered in the west by the 290 m high Amy Range that terminates at Telopea Head. In between are five smaller rocky embayments, separated by high rocky ridges, four of which contain six sandy beaches (T 604-609). The Wilson Bight walking track roughly follows the shore and provides access to five of the beaches.

Beach **T 604** is a 250 m long south-facing high energy beach located at the base of a 1 km wide bay located immediately east of Abeona Head. The beach is backed by steep vegetated slopes rising to the 490 m high New Harbour Range to the east and 270 m high Smoke Signal Hill in the west. A small creek descends the steep valley behind the beach to cross in the western corner. Southerly waves averaging up to 2 m travel straight up the bay to the beach where they break over the boundary rocks and reefs and across a 200-300 m wide surf zone, which is usually drained by a large central rip. This is an inaccessible very hazardous beach.

New Harbour is located on the western side of Abeona Head, with New Harbour Point forming its western entrance. The 1 km wide harbour extends 2.5 km north of the point with beach **T 605** extending 1.4 km across the northern shore of the bay. The beach faces south down the harbour and is moderately protected by its boundary points and the inner entrance rocks, with waves averaging just over 1 m at the shore. These break across a fine sand low gradient 50 m wide low tide terrace, with 3-4 rips occurring during periods of higher waves. In addition New Falls Creek drains permanently across the eastern end of the beach. The beach is backed by a 100 m wide well vegetated foredune, then a 300 m wide wetland with the creek deflected along its northern side. The walking track reaches the beach at the creek mouth, where there is a camp site, and follows it to the base of New Harbour Point, which it then crosses to Hidden Bay.

Hidden Bay is located between New Harbour Point and Middle Bluff. The 1 km wide bay has an 800 m long beach (**T 606**) occupying the western side of its northern shore, with Middle Head extending 500 m to the south. The beach is moderately well exposed to the southerly waves, which average over 1.5 m and break across a 50-100 m wide surf zone, which increases in energy east along the beach (Fig. 4.122). A permanent rip runs out against the eastern rocks, with usually a central beach rip

and smaller rip against the western rocks. The beach is backed by a 100 m wide foredune cut by a creek in the centre and a 40 m high blowout in the east. The dune is backed by an 800 m wide wetland with the creek flowing through the centre, then valley sides rising to 200 m. The walking track runs along the beach, with a campsite at the western end, before climbing the rear of Middle Bluff.

Figure 4.122 Hidden Bay beach (T 606) has a typical rip-dominated high energy surf zone.

Ketchem Bay is a small 500 m wide rocky bay located 1 km west of Middle Bluff. The bay is located in amongst a series of north-south-trending rocky ridges, which continue off the eastern side of the bay as Ketchem Island. Set in the rear of the bay are three rock-divided small beaches (T 607-609), the easternmost at the mouth of Ketchem Creek. Southerly waves travel into the small bay averaging over 1.5 m and break across a continuous 100 m wide surf zone, with the three beaches behind. Beach **T 607** occupies the creek mouth and is a 150 m long area of bare sand, destabilised by the creek flow. It is backed by a 14 m high foredune, then a 350 m wide wetland, with the creek flowing through the centre. Waves break across the bar and flow west along the beach existing via a rip it shares with the neighbouring beach which flows out against a series of linear rocks and reefs that separates the two beaches. Beach **T 608** is a 60 m long pocket of sand backed by a densely vegetated 15 m high bluff, tied to rocky points at either end, that protrudes slightly to define the beach and extends into the surf as rock reefs.

Beach **T 609** lies immediately to the west and occupies a small valley fed by a creek, which maintains a 60 m wide bare sand beach, the creek flowing along its eastern boundary with the rocks. The three beaches are usually drained by the large central reef-dotted rip and a secondary rip against the western boundary rocks. The walking track runs along the three beaches with a campsite on the slopes at the western end of the bay. None of the surf beaches are safe for swimming. There is however a more protected rocky bay immediately west of beach T 609 which normally has low waves and is relatively safe close to shore.

T 610-614 **WILSON BIGHT**

No.	Beach	Rating HT LT	Type	Length
T610	Wilson Bight (E2)	6 8	TBR+rocks/reefs	300 m
T611	Wilson Bight (E1)	6 8	TBR+rocks/reefs	50 m
T612	Wilson Bight (W1)	6 8	TBR+rocks/reefs	200 m
T613	Wilson Bight (W2)	6 8	TBR+rock platform	100 m
T614	Wilson Bight (W3)	6 8	TBR+rocks/reefs	150 m
Spring & neap tidal range = 1.2 & 0.2 m				

Wilson Bight is a 1.5 km wide, 1.5 km deep U-shaped south-facing rocky bay bordered by steep slopes rising to the 250 m high Amy Range in the east, over 300 m high ridges to the west, with five steep incised valleys to the rear. Spread along the 1.2 km northern shore of the bight and occupying some of the valley mouths are five exposed beaches, separated by rocks and reefs, but sharing a continuous partly reef-dominated surf zone (Fig. 4.123). The walking track descends the Amy Range to the eastern end of the beach and follows the beaches terminating at the western end. A campsite is located behind the easternmost beach (T 610).

Beach **T 610** commences at the base of the steep slopes descending from the Amy Range and occupies the mouth of a small valley with a creek draining across the centre of the beach and well vegetated foredunes to either side. The beach trends west for 300 m to a small protruding bluff fronted by a series of rock reefs which extend 100 m into the surf, with a rock islet located 600 m off the centre of the beach. Waves average 1.5-2 m and break across a 150 m wide surf zone, with a strong rip against the eastern rocks and a second towards the western reefs. Beach **T 611** lies in lee of the boundary bluff, in a 50 m wide gap, with the western bluff also extending seawards as a small headland attached to the reef which continues into the surf. The reef-studded surf zone continues outside the bluffs linking to the beaches either side.

Figure 4.123 The high energy reef-strewn beaches and surf zone of Wilson Bight (T 610-614).

Beach **T 612** commences on the western side of the 50 m wide headland and trends to the west for 200 m, initially as a narrow bluff-backed beach, then as a wider beach as the bluff retreats slightly, with dense tree-covered bluffs backing and bordering the beach and a small creek in the corner. It faces south across a 150 m wide surf zone with a large central rip controlled by the reef to the east and a rock point, platform and reefs to the west. Beach **T 613** continues immediately west for 100 m along the base of the western bluffs, as a narrow high tide beach fronted by a 50 m wide rock platform then the surf zone extending another 50 m. The bluffs trend to the south forming a headland that separates it from beach T 614.

Beach **T 614** is located in the northwestern corner of the bight on the western side of the 50 m wide headland and platform. It curves to the southwest for 150 m, to a small creek where the shoreline turns and trends south as a narrow cobble and boulder beach that continues into the bight. The narrow high tide beach is fronted by a mixture of sand and reefs, with waves breaking along the boundary reefs 300 m off the beach to produce a right-hand break.

To the south and west of Wilson Bight are 6 km of high rocky shore that terminate at 171 m high South West Cape, the southwestern tip of Tasmania, and the boundary between the south and west coasts. At the cape the shoreline turns and trends due north for 11 km to Window Pane Bay.

T 615 MCKAYS GULCH

No.	Beach	Rating HT LT	Type	Length
T615	McKays Gulch	2 3	R	50 m
Spring & neap tidal range = 0.6 & 0.4 m				

McKays Gulch is a narrow rocky gulch located 3.5 km north of South West Cape. It occupies a steep V-shaped valley with slopes rising to 50 m and more on each side. It has a 250 m wide rocky entrance that narrows for 500 m to the southeast to a 20 m wide bedrock lined valley. A creek descends from the backing 441 m high Mount Karamu to the gulch, with a 50 m sheltered low energy wide sandy beach (**T 615**) at the creek mouth. The entrance area is used by fishing boats to anchor out of the heavy south swell.

T 616-617 WINDOW PANE BAY

No.	Beach	Rating HT LT	Type	Length
T616	Window Pane Bay	6 7	TBR/RBB	1.5 km
T617	Window Pane Bay (E)	3 5	R	100 m
Spring & neap tidal range = 0.6 & 0.4 m				

Window Pane Bay is a 1.5 km wide southwest-facing exposed bay located 11 km north of South West Cape. The steep rocky slopes of the 500 m high South West Cape Range descend along the eastern shore, while 1 km long Flying Cloud Point forms the western boundary. The 1.5 km long beach (**T 616**) commences against the eastern slopes as a boulder beach grading into a sandy beach as it leaves the slopes and curves to the northeast, then east to the lee of a collection of rock reefs and islets, where it forms a tombolo. The beach faces into the high swell and strong winds, receiving waves averaging over 2.5 m which break across a 100 m wide surf zone usually dominated by 4 to 5 beach rips (Fig. 4.124) and shallow rips to each end against the rocks. The beach is backed by steep scarped 50 m high foredune and vegetated transgressive dunes, with an active blowout in the east and a second blowout at the mouth of the Window Pane Creek, which drains across the centre of the beach. Earlier transgressive dunes have been blown up the eastern slopes to a height of 250 m and include a small blowout at that elevation. The dunes cover an area of approximately 150 ha.

Figure 4.124 Well developed beach rips along Window Pane Bay beach (photo W. Hennecke).

Beach **T 617** is a curving 100 m long reflective beach located on the western side of the tombolo, with the inner slopes of Flying Cloud Point forming its long western boundary and shielding it from waves. The tombolo varies in length, sometimes being eroded back to a cuspate foreland. The beach receives waves averaging about 0.5 m, which also break across some shallow reefs off the beach.

Regional map 8 West Coast: South West Cape to Low Rocky Point

Figure 4.125 West Coast between South West Cape and Low Rocky Point.

T 618-619 ISLAND BAY

No.	Beach	Rating HT LT		Type	Length
T618	Island Bay (1)	2	4	R+rock flats	150 m
T619	Island Bay (2)	2	4	R+rock flats	100 m
Spring & neap tidal range = 0.6 & 0.2 m					

Island Bay is located on the northern side of Flying Cloud Point. The 700 m wide bay faces northwest between a collection of six 50 m high small islands on the west and 100 m high cliffs to the east. The southern shore of the bay consists of northwest-trending 20-50 m high rock ridges. Beaches T 618 and 619 occupy the base of two small embayments between the densely vegetated sand-draped ridges.

Beach **T 618** is a curving 150 m long cobble beach bordered and backed by 30 m high cliffs. The steep, narrow 10 m wide beach is fronted by an irregular 50 m wide intertidal rock platform that extends along the side of the bay, then the deeper water of the small bay. Beach **T 619** is located 200 m to the east in the next similar embayment. It is a 100 m long narrow high tide cobble beach backed by steep cliffs and fronted by 60 m wide

rock flats cut by a narrow central gutter, which continues into the small bay.

T 620-622 FAULTS BAY

No.	Beach	Rating HT LT		Type	Length
T620	Faults Bay (S2)	2	3	R+rocks	30 m
T621	Faults Bay (S1)	2	3	Cobble+rocks	30 m
T622	Faults Bay	2	3	Cobble	80 m
Spring & neap tidal range = 0.6 & 0.4 m					

To the north of Island Bay are 5 km of steep irregular rocky shore, with numerous rocks, reefs and islets spread along the coast. Midway up the shore is Faults Bay, a 600 m wide southwest-facing irregular rocky embayment. Beaches T 620 and 621 are located in the next embayment to the south and beach T 622 at the northern extremity of Faults Bay.

Beach **T 620** is a 30 m long pocket of sand located at the southern end of a 200 m wide bay that is sheltered in lee of four rocky islets. The beach is bordered by bare sloping rocky points and backed by dense heathland. It faces north into a usually calm embayment receiving very low attenuated swell. Beach **T 621** is located 300 m to the north at the northern end of the small bay. It lies at the mouth of a narrow rock-bound creek that descends from the South West Cape Range. The beach consists of a mixture of boulders, cobbles and sand, and curves round in the narrow bedrock valley to face south at the creek mouth into the small bay.

Beach **T 622** is located in Faults Bay at the northern end of the 800 m long bay. The beach consists of a curving 80 m long cobble beach backed and bordered by steep 20 m high densely vegetated bluffs. It faces south down the bay, with a western headland, rock platforms and rocky islets to the east. Its protected location lowers waves to less than 0.5 m.

T 623-624 NOYHENER BEACH

No.	Beach	Rating HT LT		Type inner bar	outer	Length
T623	Noyhener Beach	6	7	TBR	RBB	2 km
T624	Chatfield Pt (S)	4	5	R+rocks/reefs		200 m
Spring & neap tidal range = 0.6 & 0.4 m						

Noyhener Beach (**T 623**) is a 2 km long beach located between the base of the 200-300 m high South West Cape Range and Chatfield Point. The beach begins in the east against the base of the range and initially trends north before curving to the east and facing south into the high swell. Murgab Creek descends from the ranges and is deflected south along the eastern side of the beach to cross in the southern corner. In the west Mutton Bird Island extends from 1-3 km south of the point and

provides some protection from southwesterly waves. The beach still receives persistent high swells averaging 1.5-2.5 m which maintain a double bar system, with a 100 m wide inner bar usually cut by 7 strong rips and a more subdued outer bar which breaks during periods of higher swell (Fig. 4.126). Wave height decreases slightly towards the point owing to reefs at and off the point and the Wendar, East Pyramids and Sugarloaf Rock islands and islets extending 3 km to the west. High dunes rising to 50 m back the beach. The dunes have largely originated from Stephens Bay beach (T 626) and blown across the rear of Chatfield Point, thereby supplying fine sand to Noyhener Beach. Southerly winds have destabilised the dunes towards the eastern end of the beach, with active dunes extending up to 400 m inland.

Figure 4.126 The exposed Noyhener Beach is dominated by several strong rips and an unstable foredune (photo W. Hennecke).

Beach **T 624** is located 100 m to the west on Chatfield Point in the lee of and between the bare metamorphic rocks that form the point. The offshore rocks and reef decrease the high swell to about 1 m at the beach where they maintain a reflective sand and cobble beach surrounded by the rocks of the point. The 10-20 m high heath-covered point backs the beach.

T 625-630 STEPHENS BAY

No.	Beach	Rating HT LT		Type	Length
T625	Chatfield Pt (N)	4	6	R+rocks/reef	300 m
T626	Stephens Bay	7	8	TBR/RBB	2.4 km
T627	Stephens Bay (N1)	5	7	LTT+rocks/reef	100 m
T628	Stephens Bay (N2)	5	7	LTT+rocks/reef	200 m
T629	Stephens Bay (N3)	4	6	R+rocks/reef	60 m
T630	Stephens Bay (N4)	4	6	R+rocks/reef	100 m
Spring & neap tidal range = 0.6 & 0.4 m					

Stephens Bay is a semi-circular 2.5 km wide bay located between Chatfield Point and the base of the northern 213 m high Going Hill. It faces west to southwest into the prevailing swell, with a high energy southern shoreline, and the northern shore more sheltered by Hilliard Head and numerous reefs. The long beach T 626 dominates the eastern bay shore, with six smaller beaches tucked in

amongst the rocky shore to the south (T 625) and north (T 627-630).

Beach **T 625** is located on the northern side of Chatfield Point. It is a curving 300 m long high tide sand and cobble beach that faces northwest across the bay. It is fronted by an irregular intertidal rock platform, with considerable rocks and reef extending 100 m off the beach. It is backed by the densely vegetated dune-draped point.

Stephens Bay beach (**T 626**) is a curving 2.4 km long beach that faces west to southwest out of the bay. It is exposed to persistent 1.5-2.5 m westerly waves, which maintain a 200 m wide surf zone usually dominated by several strong rips, with wave height decreasing slightly towards either end. The beach is backed by a well vegetated 20 m high foredune in the north grading into a scarped 50 m high foredune in the south, together with three large areas of active dunes extending 200-300 m inland (Fig. 4.127). The dunes transgress over earlier well vegetated transgressive dunes that extend up to 2 km to the east across to Noyhener Beach and part way up the lower slopes of the range. The entire dune system covers an area of approximately 250 ha. The northern end of the beach terminates at the beginning of a 1.5 km long series of south-trending ridges of rocks, with four small beaches located amongst the ridges.

Beach **T 627** is separated from the main beach by a 50 m long finger of rock that crosses the beach and continues 100 m offshore as a wave-washed ridge. The beach trends to the west for 100 m along the base of 15 m high densely vegetated bluffs, with heathland behind. Rock ridges extend off the centre and mark the western boundary of the beach with waves averaging about 1 m breaking over the rocks, reefs and a 50 m wide sand and rocky surf zone.

Figure 4.127 Stephens Bay beach is backed by a high scarped foredune and transgressive dunes.

Beach **T 628** is located 200 m to the west past a densely vegetated headland fronted by rock platform and reefs. The beach is 200 m long, fringed by rock reefs to either end with a central sandy section and narrow low tide terrace. The beach faces due south into the prevailing

swell, with waves breaking across the reef that extends 200 m seaward, lowering the waves to about 1 m at the shore. During higher waves a rip flows out towards the western side of the bay. It is backed by a scarped 10 m high foredune, which abuts against vegetated bluffs rising to 20 m.

Beach **T 629** occupies the next small bay 150 m to the west. It is a curving 60 m long narrow high tide cobble beach that faces south out of the narrow rocky bay that widens to 100 m at its entrance. Waves break over reefs to either side of the entrance, which lower waves to less than 1 m at the shore. It is bordered and backed by densely vegetated slopes rising to 20 m. Beach **T 630** is located 100 m to the west in the next bay, and is a similar 100 m long narrow cobble beach, fronted by a relatively shallow rock- and reef-filled bay floor, with breaking waves filling much of the bay.

Port Davey

Area:	approx. 10 000 ha
Coast length:	57 km (1265-1322 km) (excluding Hannant Inlet, Bathurst Harbour, Kelly Basin)
Beaches:	36 (T 631-666)

Port Davey is part of a large drowned valley system that links to Bathurst Harbour, Payne Bay and Kelly Basin. The port is 8 km wide at its entrance between Hilliard Head and North Head, with 57 km of shoreline, excluding the sheltered Bathurst Harbour, Kelly Basin and Hannant Inlet. The main port area has an area of approximately 100 km^2 and contains 36 beach systems. Apart from a landing strip at the bottom of Melaleuca Inlet off Bathurst Harbour, there is development in the port area, all of which is located within the Southwest National Park.

T 631-636 NORMAN COVE-SPAIN BAY

No.	Beach	Rating HT LT		Type	Length
T631	Norman Cove	4	4	LTT	400 m
T632	Spain Bay (1)	3	3	R	200 m
T633	Spain Bay (2)	3	3	R	300 m
T634	Spain Bay (3)	3	3	R	1 km
T635	Hannant Pt (E)	4	4	R/LTT	200 m
T636	Hannant Inlet	1	1	R+sand flats	1.3 km
Spring & neap tidal range = 0.6 & 0.4 m					

The southeastern shore of Port Davey extends east of the entrance of Hilliard Head for 8 km to Turnbull Head at the entrance to Bathurst Harbour. It consists of an irregular rocky shore rising in places to more than 100 m and interrupted by Norman Cove, Spain Bay and Hannant Inlet. The three embayments contain six increasingly lower energy beaches (T 631-636), all used as anchorage for fishing boats.

Norman Cove is a 300 m wide northwest-facing U-shaped bay on the northern side of Hilliard Head, with 1 km long Forbes Point forming its southern boundary and a small cluster of rocks off its northern entrance. It

faces northwest across the port entrance with Swainson Island and Big Caroline Rock partly protecting it from ocean swell. Waves enter the 500 m deep cove and average about 1 m at the shore. Beach **T 631** extends along the eastern shore of the cove for 400 m as a slightly curving 50 m wide low tide terrace that faces northwest out of the cove. The waves break across the terrace (Fig. 4.128), with a rip or two forming during higher waves, particularly towards the northern end of the beach. The beach is backed by a low well vegetated 50 m wide foredune, cut by a small central creek, then gradually rising densely vegetated slopes.

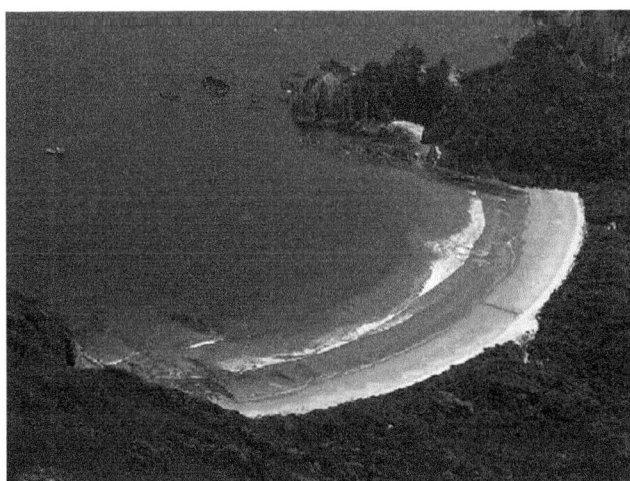

Figure 4.128 The sheltered Norman Cove receives lowered waves, which usually break across a continuous low tide terrace.

Spain Bay is a semi-circular 1 km wide bay that narrows to 500 m at its entrance between Knapp and Hannant points and faces northwest across the port entrance. Waves moving into the port and refracting into the bay are lowered to less than 1 m as they spread out around the shoreline of the bay. Three near-continuous beaches (T 632-634) are located along the southwest shore of the bay. Beach **T 632** is a 200 m long north-facing reflective beach located at the base of the bay and is the most sheltered, receiving waves averaging about 0.5 m. A small cluster of rocks just off the beach form a sand foreland and separate it from beach **T 633** which continues to curve to the east for 300 m to a 100 m wide headland. Waves average just over 0.5 m and maintain a reflective beach. Beach **T 634** commences on the eastern side of the head and curves to the northeast and finally north for 1 km terminating against the northern rocky boundary. Wave height peaks at just over 0.5 m along the middle of the beach, which is usually reflective with well developed cusps. It is backed by a low well vegetated foredune, with small creeks crossing in the south and centre of the beach.

One kilometre east of Hannant Point, and just inside the 300 m wide entrance to Hannant Inlet, is a 200 m wide north-facing embayment containing beach **T 635**. The beach faces due north between a 200 m long western headland and low 80 m long eastern rocky point. Waves average just over 0.5 m and maintain a reflective to

narrow low tide terrace beach, backed by densely vegetated slopes (Fig. 4.129).

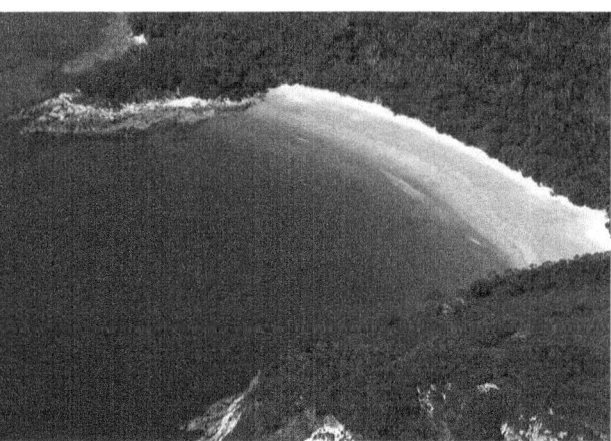

Figure 4.129 Beach T 635 is a sheltered reflective beach located inside Hannant Inlet.

Beach **T 636** is located inside **Hannant Inlet** to the lee of Lourah Island. The 1.3 km long beach faces west towards the 600 m long island and 300 m wide inlet entrance on the western side. As a consequence ocean swell is all but precluded from the inner inlet and beach. The beach consists of a high tide reflective beach fronted by a shallow sandy bay floor, with some rocks to either end. A small central creek crosses the centre of the beach and has deposited a protruding sandy delta. A well vegetated low foredune backs the beach, with sloping heathland behind.

T 637-641 BRAMBLE COVE

No.	Beach	Rating HT LT		Type	Length
T637	Bramble Cove	2	2	R	350 m
T638	Bramble Cove (N1)	2	2	R	80 m
T639	Bramble Cove (N2)	2	2	R	40 m
T640	Bramble Cove (N3)	2	2	R	60 m
T641	Bramble Cove (N4)	1	1	R+sand flats	200 m
Spring & neap tidal range = 0.6 & 0.4 m					

Bramble Cove is a 1 km wide semi-enclosed bay with a 500 m wide entrance facing out into the mouth of Bathurst Passage. The small cove is partly surrounded by slopes rising over 200 m in the north to Mount Milner and Mount Greer and in the east to 400 m at Mount Stokes and 280 m at Mount Parry. Nestled along the northern shore of the cove are five small low energy beaches (T 637-641), which receive much reduced swell through South Passage together with local wind waves.

Beach **T 637** is the main beach. It is 350 m long and located at the northeast end of the cove, facing southwest towards the entrance. The beach usually has calm to low wind wave conditions with a reflective beach face. The remains of a rough rock jetty crosses the northern end of the beach, the jetty left over from when a whaling station operated out of the cove in the 1850s. Rocky shore borders each end and a fringe of trees then steep grassy

slopes rise behind, with a small grassy headland at the northern end.

Beach **T 638** is located 200 m to the west on the western side of the headland. It is an 80 m long west-facing strip of high tide sand wedged between the boundary headland and the base of the slopes that rise to the north. A low tree-covered point and rock platform lie at the southern end of the beach and rocky shore to the north.

Beach **T 639** lies 200 m to the west at the narrow mouth of a creek that descends from Mount Greer. The 40 m long V-shaped wedge of sand occupies the creek mouth with vegetated rocky slopes to either side. Beach **T 640** is located on the western side of the 50 m wide boundary point. It is a 60 m long strip of high tide sand that faces south across the cove. Grassy slopes border and descend to the rear of the beach. Beach **T 641** occupies the northwestern corner of the cove. It is a 200 m long east-facing beach bisected by a creek that descends from Mount Milner. The creek has delivered sand to the beach and built sand flats 200 m into the cove to reach the edge of beach T 640.

T 642-648 TOOGELOW BEACH-WALLABY BAY

No.	Beach	Rating HT LT	Type	Length
T642	Toogelow Beach	6 6	TBR	1 km
T643	Mavourneen Rocks (S)	3 3	R	50 m
T644	Mavourneen Rocks (N)	3 3	R	40 m
T645	Ashley Pt (S 2)	3 5	R+rock flats	200 m
T646	Ashley Pt (S 1)	3 5	R+rock flats	200 m
T647	Wallaby Bay	4 4	LTT	950 m
T648	Wallaby Bay (N)	3 3	R	100 m
Spring & neap tidal range = 0.6 & 0.4 m				

Payne Bay extends for 12 km north of the entrance to Bathurst Harbour at Milner Head. Wave energy decreases northward into the bay with only the lower beaches receiving regular swell through the port entrance. Between Milner Head and Berry Head 5 km to the north are seven beaches (T 642-648).

Toogelow Beach (T 642) is located on the northern side of Milner Point at the base of the slopes of Mount Milner between two densely vegetated steeply rising headlands. The 1 km long beach faces west-southwest towards the port entrance 8 km to the southwest. It still receives moderately high swell averaging up to 1.5 m, which has to pass between Boil Rock and Kathleen Island to reach the shore. The waves maintain a well developed transverse bar and rip system containing 4 to 5 beach rips. The bar and surf zone is a mixture of sand and some scattered rocky seafloor (Fig. 130). It is backed by a scarped 20 m high foredune, which extends 50-100 m inland to the base of the slopes of Mount Greer. A creek drains through the dune and across the centre of the beach.

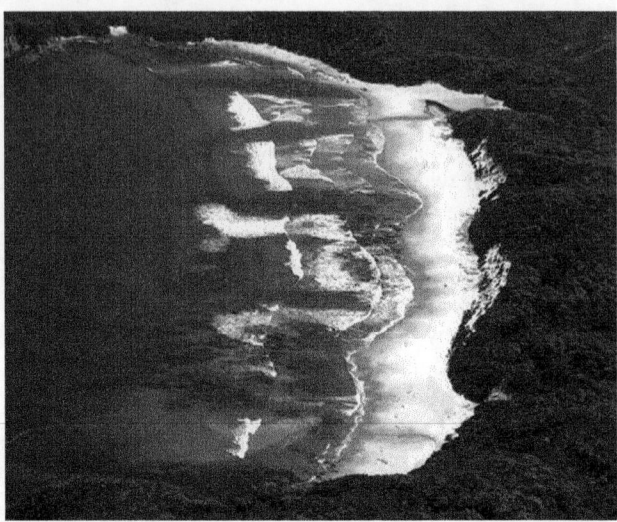

Figure 4.130 Toogelow Beach has an exposed rip- and rock-dominated surf zone.

Beaches T 643 and 644 are two pockets of sand that form a small tombolo to link one of the inner Mavourneen Rocks to the shore. Beach **T 643** is a curving 50 m long south-facing reflective beach, with steep slopes to the east, the pyramid-shaped 30 m high rock to the west, and a series of similar rocks extending southwest for 500 m to Kathleen Island. Beach **T 644** is located on the northern side and faces northwest. The 40 m long reflective beach is backed by a vegetated 50 m wide ridge of sand that is the core of the tombolo.

Beaches T 645 and 646 lie 300 m to the north past a section of 50 m high cliffs. Beach **T 645** is a curving 200 m long sand and cobble beach fronted by irregular 20-60 m wide intertidal rock flats and backed by densely vegetated slopes rising to 80 m. Beach **T 646** commences immediately to the north and is a similar 200 m long sand and cobble high tide beach, that curves around the next small embayment with a protruding bluff cutting it in two. It is also fronted by a 30 m rock flats and backed by 40 m high vegetated bluffs.

Wallaby Bay is a semi-circular 700 m wide bay located between Ashley Point and Berry Head. Beach **T 647** occupies much of the bay shore. It commences in the south in lee of Ashley Point and curves to the north for 950 m, past four rock outcrops to a northern 50 m wide headland. Waves averaging up to 1 m reach the northern end of the beach, decreasing to the south. They maintain a low gradient low tide terrace that increases to 50 m in width to the north, together with crenulations induced by the rocks. During higher waves one to two rips form along the northern end of the beach and cross the terrace. It is backed by a low foredune then tree-covered slopes rising to 20 m. Beach **T 648** is a 100 m long pocket beach between the northern 50 m wide headland and the base of Berry Head. Rock platforms surround the boundary points and front the beach, with waves lowered to less than 1 m at the shore. Densely vegetated slopes rise to the 80 m high ridge of Berry Head.

T 649-653 COFFIN BAY-WOODY POINT

No.	Beach	Rating HT LT	Type	Length
T649	Coffin Ck	1 2	R+sand flats	250 m
T650	Schooner Pt (S)	1 2	R+rock flats	200 m
T651	Schooner Pt (N1)	1 2	R+rock flats	300 m
T652	Schooner Pt (N2)	1 2	R+rock flats	150 m
T653	Woody Pt (S)	1 2	R+rock flats	350 m
Spring & neap tidal range = 0.6 & 0.4 m				

Payne Bay extends a further 7 km north of Berry Head as a 2-4 km wide sheltered embayment with 13 low energy beaches (T 649-661) around its eastern, northern and western shores. Some swell travels into the port and part way up the bay to reach some of the beaches, however wind waves provide most of the energy. Between Berry Head and Woody Point 4 km to the north are 5 km of crenulate rocky west-facing shoreline containing five beaches (T 649-653). The shore is backed by slopes that gradually steepen and rise to 200 m.

Beach **T 649** is located at the mouth of Coffin Creek, a small tannin-stained creek that enters the southern end of 1.2 km wide Coffin Bay in lee of three small vegetated islets and rock reefs (Fig. 4.131). The beach occupies the creek mouth and curves to the northeast for 250 m. Sand flats extend 200 m out of the creek mouth to link the islets and part way along the beach. A fringe of trees then thinly vegetated slopes back the beach.

Beach **T 650** is located just north of Coffin Bay on the southern side of 30 m high Schooner Point. The beach faces west across the bay and curves around the base of a small valley for 200 m with rock reef fringing both sides and extending up to 100 m off either end. There is a patch of sand in the centre of the beach, which is backed by dense tree-covered slopes.

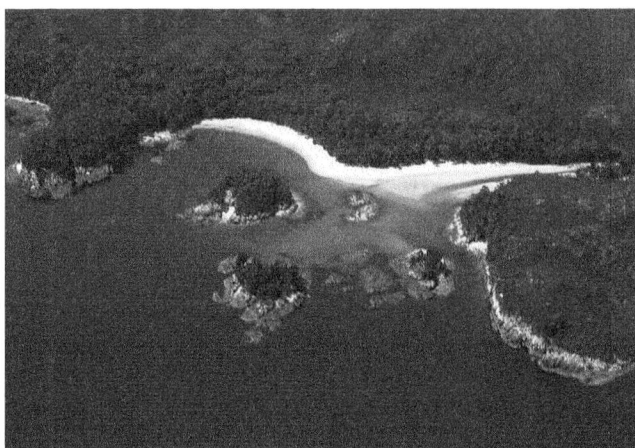

Figure 4.131 Beach T 649 is located in lee of three small islets at the mouth of Coffin Creek.

Beach **T 651** is located on the northern side of the point and on the northern side of the rock reefs that extend 400 m west of the point. The narrow high tide beach extends for 300 m north of the main reef, between steep tree-covered slopes and a narrow rock reef. It terminates at a small vegetated bluff with beach **T 652** continuing north on the other side for another 150 m to the next reef-fringed point. Both beaches receive low wind waves generated across the 5 km wide bay.

Beach **T 653** commences on the northern side of the 100 m wide point and continues north for 350 m, terminating on the southern side of Woody Point. It is initially fronted by 50 m wide intertidal reef which extends sub-tidally further out causing low waves to break offshore. The northern 100 m of the beach are free of reef permitting very low swell to reach the shore and maintain a reflective beach. Steep tree-covered slopes rising 20-30 m back the beach.

T 654-657 WOODY POINT-FITZROY POINT

No.	Beach	Rating HT LT	Type	Length
T654	Woody Pt (N)	1 2	R	250 m
T655	Heather Bay	1 1	R+sand flats	1.2 km
T656	Fitzroy Pt (E)	1 2	R+sand/rock flats	250 m
T657	Fitzroy Pt (N)	1 2	R+sand/rock flats	800 m
Spring & neap tidal range = 0.6 & 0.4 m				

At the northeast end of **Payne Bay** the shore extends for 4 km from Woody Point past Heather Bay to the 1 km wide bay bordered by Fitzroy Point into which flows the Davey River. Between Woody Point and the bay are four low energy beaches (T 654-657). The beaches are located up to 15 km inside the entrance to Port Davey and receive only very low swell and wind waves generated within the bay.

Beach **T 654** is a slightly curving 250 m long west-facing reflective beach, fringed by low rock reefs, with reefs extending 300 m off the northern point. It is backed by a fringe of dense trees, and then low vegetated slopes.

Heather Bay is a 1.5 km wide semi-circular bay into which flows Kellatie Creek. Beach **T 655** commences at the creek mouth and curves to the northwest, then west for 1.2 km, generally facing southwest down the bay. The beach consists of a narrow high tide beach fronted by continuous 100 m wide sand flats which merge with the creek flats in the south. It is backed by a low densely vegetated foredune.

Beach **T 656** is located 500 m to the west and curves slightly for 250 m between two low rocky points and associated rock reefs, with the low Fitzroy Point located 400 m further west. It faces due south down the bay and receives some very low swell. It is backed by a 50 m wide band of dense trees, then barer slopes.

At **Fitzroy Point** the shore turns and trends north towards the mouth of the Davey River. Beach **T 657** commences on the northern side of the point and curves to the north for 800 m. The beach is sheltered by the point, the small Fitzroy Islands and scattered rocks and reefs and usually

receives only low wind waves. It consists of a high tide beach with a scattering of rocks and reefs along the shore, and a small creek reaching the southern section of the beach.

T 658-661 BOND BAY

No.	Beach	Rating HT LT		Type	Length
T658	Curtis Pt	1	3	R+rock flats	150 m
T659	Curtis Pt (W)	1	3	R	100 m
T660	Bond Bay	1	3	R	2.4 km
T661	Garden Pt	1	3	R+rock flats	2 km
Spring & neap tidal range = 0.6 & 0.4 m					

Bond Bay is a 2 km wide east-facing side arm of Payne Bay that extends 2 km west to the narrow entrance to Kelly Basin. It is bordered to the north by the low Curtis Point, with Garden and Eagle points defining either end of the southern shoreline. Four low energy beaches are located around the bay (T 658-661).

Beach **T 658** is a 150 m long east-facing pocket of sand located on the tip of the low rocky Curtis Point. The reflective high tide beach is backed and bordered by tree-covered slopes rising to 20 m, with 100 m wide rock flats filling the small bay off the beach and linking the boundary rocky points. Because of its more exposed location the beach and point does intercept some low swell moving up the bay.

Beach **T 659** lies 1 km to the west inside Bond Bay. It is a 100 m long reflective beach backed by tree-covered 20 m high bluffs, and bordered by subdued points fronted by 100 m wide intertidal rock flats that continue into the bay as subtidal reefs. The beach is often calm only receiving occasional low swell.

Beach **T 660** commences 100 m to the west and curves to the southwest, then south for 2.4 km to Larsens Rocks on the northern side of the entrance to Kelly Basin. The beach faces due east-southeast towards the bay mouth and for most of its length is a low energy reflective high tide beach, grading into scattered rocks to the south (Fig. 4.132). It is backed by a fringe of trees and low terrain that increases to 10-20 m in the south. A walking track parallels the rear of the beach down to Larsens Rocks.

Larsens Rocks and Garden Point are located either side of the 200 m wide entrance to the shallow sheltered Kelly Basin. Beach **T 661** commences at the low Garden Point and trends east for 2 km to the low rocky Eagle Point, facing north across the 2 km wide bay. The beach has a crenulate alongshore owing to the outcrops of rocks and rock flats and is backed by a generally densely vegetated low undulating terrain.

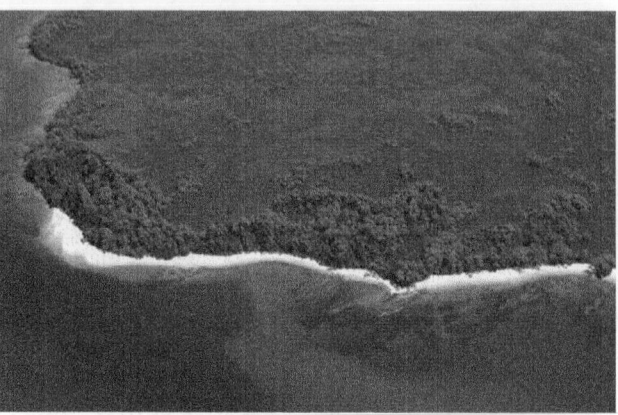

Figure 4.132 Beach T 660 is typical of the low energy beaches that occupy the sheltered shores of Bond Bay.

T 662-665 EAGLE-WHALERS POINTS

No.	Beach	Rating HT LT		Type	Length
T662	Eagle Pt (S1)	3	3	R/LTT	350 m
T663	Eagle Pt (S2)	3	3	R/LTT	300 m
T664	Whalers Pt (N2)	3	3	R/LTT	300 m
T665	Whalers Pt (N1)	3	3	R/LTT	150 m
Spring & neap tidal range = 0.6 & 0.4 m					

Eagle Point forms the southern entrance to Bond Bay. At the point the shoreline turns and trends south for 4 km to Whalers Point. Four moderately sheltered east-facing beaches (T 662-665) are located between the two points. All are fringed by low rocky shore and are backed and bordered by densely vegetated sloping terrain.

Beach **T 662** is a slightly curving 350 m long southeast-facing sandy beach located between low rock flats to the north and a densely vegetated point to the south that extends 150 m to the east. The beach receives low refracted swell averaging less than 1 m which breaks across a 40 m wide low tide terrace, bordered by rocks to either end.

Beach **T 663** lies 800 m to the south and is a 300 m long southeast-facing beach with a small protruding section of bluff dividing it into two sections with a continuous 30 m wide low tide terrace. Waves average just over 0.5 m and break across the low bar and some rocks off the southern end.

Beach **T 664** is located 100 m to the south and is a 300 m long east-facing low tide terrace, which commences amongst some rocks in the north then narrows to the south as waves drop slightly to the lee of a bordering small southern islet. Beach **T 665** is located on the southern side of the islet, with a narrow gulch separating the islet from the point. The beach is 150 m long, with a small central bar and rocks to either end. Whalers Point lies 1 km to the south.

T 666 SADDLE BIGHT

No.	Beach	Rating HT LT	Type	Length
T666	Saddle Bight	6 8	TBR+rocks	200 m
Spring & neap tidal range = 0.6 & 0.4 m				

Saddle Bight is a curving 2 km wide southeast-facing rocky embayment located in the northern entrance to Port Davey between Whalers Point and Point Lucy. In the northern corner of the bight is a 200 m long pocket of sand (beach **T 666**). The beach faces due south into the slightly reduced southerly waves, which average about 1.5-2 m. They break across an 80 m wide surf zone, with a large rock located in the centre. The beach is sandwiched between protruding joint-aligned rocky points, with a backing vegetated bluff, that protrudes part way across the western end of the beach. A strong rip drains out the eastern end against the rocks with irregular rocky shore extending to either side.

T 667-672 SOUTH EAST BIGHT

No.	Beach	Rating HT LT	Type	Length
T667	South East Bight (S4)	3 5	R+rock flats	100 m
T668	South East Bight (S3)	3 5	R+rocks	80 m
T669	South East Bight (S2)	4 7	LTT+rocks	100 m
T670	South East Bight (S1)	5 9	LTT/TBR+rocks	150 m
T671	South East Bight (N1)	5 10	R+rock flats	150 m
T672	South East Bight (N2)	5 9	R+rock flats	100 m
Spring & neap tidal range = 0.8 & 0.4 m				

South East Bight is located on the northern side of North Head, the northern entrance to Port Davey. While the bight is outside the port on the open coast it receives some shelter from The Coffee Pot and West Pyramid, two collections of rocks and reefs located 2-3 km due west of the bight. Within the 1 km wide bight entrance is a curving rocky shore containing six small rock-dominated beaches (T 667-672).

Beaches T 667 and 668 are adjoining pockets of sand located in the more sheltered southern corner of the bight. They face northwest across the bight and receive waves averaging less than 1 m. Beach **T 667** is a 100 m long high tide reflective beach bordered and backed by 20 m high rocky slopes, with irregular rock flats and reef extending 50 m off the beach. Beach **T 668** lies immediately to the northeast and is an 80 m long pocket of high tide sand fronted by a fringe of low rocks, then deeper sandy floor of the bight. Both beaches are backed by vegetated slopes that rise to 345 m at Davey Head.

Beaches T 669 and 670 are located 400 m to the north and are adjoining rock-dominated beaches. They are located more towards the centre of the bight, face west out the entrance and receive waves averaging 1-1.5 m. Beach **T 669** is a 100 m long pocket of sand fronted by a 50 m wide bar with scattered rocks, with a rip usually

flowing out against the northern rocks. Beach **T 670** lies immediately to the north and is 150 m long, partly shielded by a ridge of rock that widens from 50 m in the south to 100 m in the north, across which the waves break heavily, resulting in relative low wave to calm conditions at the shore. Both beaches are backed by some active and vegetated climbing transgressive dunes.

Beaches T 671 and 672 are two adjoining rock-controlled beaches located in the northern corner of the bight. Beach **T 671** is a 150 m long high tide reflective beach fronted by a 150 m wide surf zone dominated by linear rock reefs, with waves averaging over 1.5 m. A strong rip flows out against the southern boundary headland. The beach is backed and bordered by steep vegetated 30-40 m high slopes. Beach **T 672** lies 100 m to the northwest and consists of two pockets of high tide sand that share an irregular 150 m wide inter- and subtidal rock-filled bay, bordered by steep vegetated slopes. It faces south with waves usually less than 1.5 m.

T 673 QUAIL FLAT

No.	Beach	Rating HT LT	Type	Length
T673	Quail Flat	6 7	TRB	250 m
Spring & neap tidal range = 0.6 & 0.4 m				

Beach **T 673** is located at the mouth of a 1 km wide valley called Quail Flat that narrows to reach the shore at the 250 m long beach. The beach is bordered by rocky points extending 100 m seaward to the south and 1 km west towards the Trumpeter Islets. Within the small embayment the beach faces southwest and receives waves reduced to 1-1.5 m. These maintain a 50 m wide bar with small rips to each end. The beach is backed by two climbing blowouts and older vegetated transgressive dunes that fill the valley mouth (Fig. 4.133). A small creek meanders through the southern end of the dunes inducing further dune instability and crossing the beach.

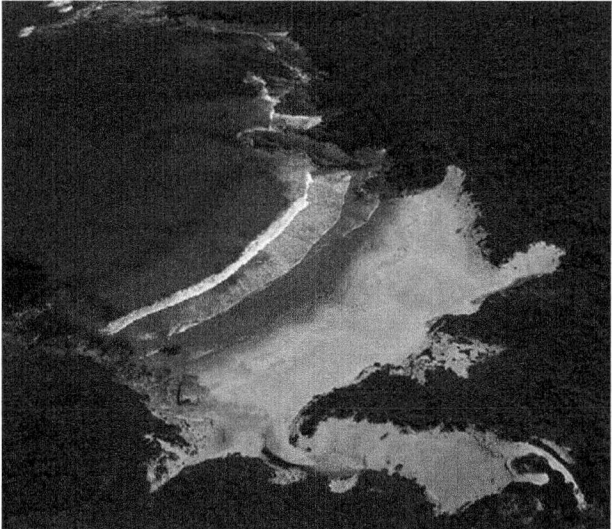

Figure 4.133 Quail Flat beach is a moderate energy pocket beach exposed to the strong westerly winds that maintain an active foredune.

T 674 GULCHES REEF

No.	Beach	Rating HT LT	Type	Length
T674	Gulches Reef	4 5	R+rock platform	900 m
Spring & neap tidal range = 0.6 & 0.4 m				

Gulches Reef is a 1.5 km long string of shore-parallel reefs that extend north of Trumpeter Rock and lie 500-600 m offshore. They are backed by a north-trending section of rocky coast containing 900 m long beach **T 674**. The beach is a crenulate sand and cobble high tide beach, located to the rear of an irregular 50-100 m wide intertidal rock platform. Waves are lowered initially by the outer reef averaging 1-1.5 m at the end of the platform, with waves only reaching the beach at high tide. The beach is backed by low wind-blasted scrubs that thicken as the slopes rise to 160 m high Toogee Hill.

T 675-677 SANDBLOW BAY

No.	Beach	Rating HT LT	Type	Length
T675	Sandblow Bay (1)	6 8	TBR+rocks/reef	100 m
T676	Sandblow Bay (2)	6 8	TBR+rocks/reef	50 m
T677	Sandblow Bay (3)	5 7	TBR+rocks/reef	50 m
Spring & neap tidal range = 0.6 & 0.4 m				

Sandblow Bay is a 1 km wide southwest-facing rocky bay located 7 km north of North Head. Beaches T 675-677 are wedged in amongst the rocks at the rear of the small bay that narrows into a V-shaped drowned creek mouth occupied by beach T 675 (Fig. 4.134).

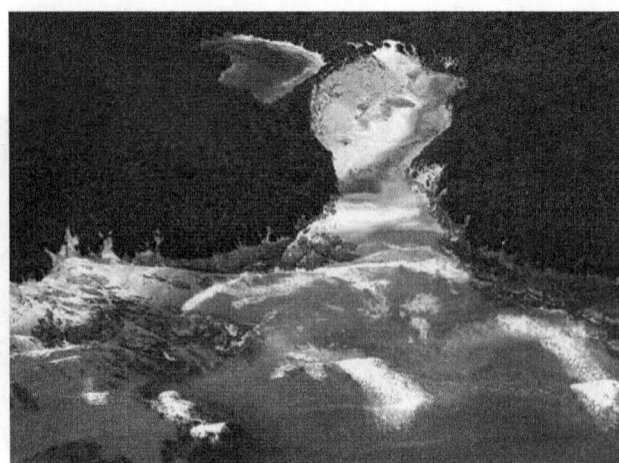

Figure 4.134 The exposed Sandblow Bay with beach T 675 destabilised by high waves, the creek and strong westerly winds.

Beach **T 675** is a 100 m long sandy beach bordered by sloping wave-washed metamorphic rocks, then densely vegetated slopes rising to either side. Waves averaging over 1.5 m break 100 m offshore over a mixture of sand, rocks and reefs, with a strong rip usually flowing out

against the rocks on the northern side of the beach. The creek drains to the back of and across the beach destabilising the northern backshore, resulting in a narrow scarped 200 m long 30 m high dune, backed by the small Paradise Lagoon, then rising terrain.

Beach **T 676** lies 100 m to the north and shares the same surf zone. It is a 50 m long pocket of sand wedged between low rock outcrops and facing south across the surf. The main rip runs off and parallel to the beach. Several large rocks outcrop on the beach which links around the rear of the northern rocks to beach **T 677**. This is another 50 m long pocket of sand, which is afforded a little more shelter by offshore reefs, with waves averaging just over 1 m. They break across a series of scattered rocks and a 50 m wide bar, with a rip running out against the southern rocks. Both beaches are deposited amongst ridges of rocks, with a semi-stable climbing foredune behind.

T 678-683 DENNIS GULCH-ALFHILD BIGHT

No.	Beach	Rating HT LT	Type	Length
T678	Sandblow Bay (N)	4 5	R+rock platform	150 m
T679	Dennis Gulch	3 5	Cobble+rock flats	300 m
T680	Alfhild Bight (1)	3 5	R+rock flats	200 m
T681	Alfhild Bight (2)	3 5	R+rock flats	150 m
T682	Alfhild Bight (3)	3 5	R+rock flats	300 m
T683	Alfhild Bight (N)	4 6	LTT+rocks/reefs	300 m
Spring & neap tidal range = 0.6 & 0.4 m				

To the north of Sandblow Bay up to the lee of Hobbs Island are 3 km of irregular, rocky west-facing shore containing six beaches (T 678-683) all located in amongst the rocks resulting in a more sheltered shoreline.

Beach **T 678** occupied the rear of a small 300 m wide rock- and reef-filled rocky embayment immediately north of Sandblow Bay. The 150 m long beach faces due west out across the 250 m wide rocks and reefs, which lower waves to less than 0.5 m at the edge of the rocky shore and result in an inner collection of tidal pools. The beach is perched at the rear of an irregular 50 m wide rock platform and consists of a mixture of sand and cobbles grading into vegetated bluffs rising to 20 m.

Dennis Gulch is the name of the next small rocky embayment located 400 m to the north. Beach **T 679** is a curving crenulate 300 m long high tide sand and cobble beach located along the southern and eastern shore of the 200 m wide V-shaped bay. It is sheltered by its orientation and protected location, together with intertidal rock platforms extending up to 100 m off the western end of the beach. The reef narrows to provide a small sandy central access point to the beach. The beach is backed by higher wave-deposited boulders and rocky slopes, grading into initially sparsely vegetated slopes.

Alfhild Bight commences 800 m to the north and is a curving 700 m wide west-facing rocky bay containing three beaches (T 680-682). The beaches are sheltered by reefs within the bay as well as Hobbs Island and the Alfhild and Horseshoe reefs, all of which extend between 1 and 3 km west of the bight. Beach **T 680** is located in the southern corner and faces north up the bay. It is sheltered from direct swell with waves averaging less than 0.5 m at the shore. The 200 m long sandy beach is fronted by shore-perpendicular rock ridges that also form the bay floor. Beach **T 681** lies 100 m to the northeast and is a more irregular sand and cobble beach disrupted by rocks and reefs that extend into the bay with higher waves breaking over the reefs and a quieter tidal pool between the reefs and beach. It faces northwest towards the bay entrance with low waves at the shore. Beach **T 682** lies 200 m to the north and is a 300 m long west-facing beach, which faces out the bay entrance, but receives only low attenuated swell at the shore. The waves are further reduced by several narrow shore-parallel rock ridges, which emerge at low tide forming an inner tidal pool. Densely vegetated slopes back all three beaches.

Beach **T 683** lies 500 m north of Alfhild Bight to the lee of Hobbs Island. It is a 300 m long high tide beach set amongst a rocky shore, with intertidal rocks and reefs dominating the low energy surf zone. There is only one area of intertidal sand towards the northern end, where waves averaging about 1 m break across a 50 m wide sand and rocky bar. It is backed by a generally well vegetated foredune, then densely vegetated slopes.

T 684-685 TOWTERER BEACH

No.	Beach	Rating HT LT	Type inner	outer bar	Length
T684	Towterer Beach	7 8	TBR	RBB	1.5 km
T685	Towterer Beach (N)	6 7	TBR	-	150 m
Spring & neap tidal range = 0.6 & 0.4 m					

Towterer Beach occupies an open 1.5 km long west-facing embayment, with low densely vegetated rocky points to either side. The main beach **T 684** curves to the north for 1.5 km and is exposed to the full force of the westerly waves and winds. The waves maintain a 300 m wide double bar system, with an inner transverse bar usually cut by four rips, including a rip against the northern rocks. The outer bar only breaks when waves exceed 2 m and is drained by two large rips. The beach is backed by a 20 m high unstable foredune breached by several blowouts including a large southern blowout extending 400 m inland (Fig. 4.135). In addition older well vegetated transgressive dunes extend up to 6 km to the southeast reaching up to 120 m in height. They are part of an 800 ha now largely well vegetated transgressive dune system. To the east of the dunes the De Witt Range rises to over 400 m. The Towterer Creek runs along the northern side of the dunes to reach the northern end of the beach where it forms a small lagoon. It is then deflected down the beach sometimes exiting

half way down the beach and inducing further beach and foredune instability.

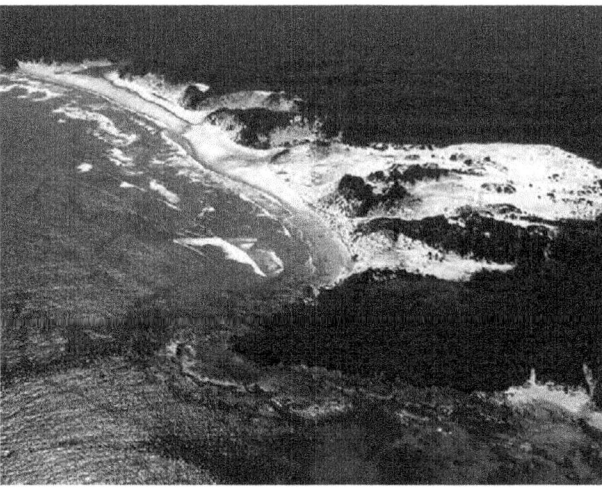

Figure 4.135 The exposed high energy Towterer Beach and active dune system.

Beach **T 685** is a curving southwest-facing 150 m long beach located between rocks at the northern end of the main beach. The boundary rocks and reefs in the surf zone lower waves to produce a sheltered 'lagoon' between the reefs and beach. However high waves break over the reefs and merge with the main wide energetic surf zone. It is backed by a semi-stable foredune and a small creek flowing out of a backing valley in the northern corner.

T 686-688 WRECK BAY

No.	Beach	Rating HT LT	Type inner	outer bar	Length
T686	Wreck Bay (1)	7 8	TBR	RBB	700 m
T687	Wreck Bay (2)	7 8	TBR	RBB	1 km
T688	Svenor Pt (E)	5 6	LTT/TBR	-	100 m
Spring & neap tidal range = 0.6 & 0.4 m					

Wreck Bay is a 1.8 km wide south-facing bay located to the lee of Svenor Point, named after the *Svenor,* which was wrecked on the beach in 1914. The eastern half of the beach contains two high energy beaches (T 686 and 687), while beach T 688 is located in a moderately sheltered embayment closer to the point.

Beach **T 686** is a curving 700 m long south-facing high energy beach that extends north from the southern rocky shore, past the still visible wreck to a small rocky point and platform that separate it from the northern beach (**T 687**). This beach continues to curve to the northwest for 1 km to the jagged western boundary point. Both beaches share a 250 m wide double bar surf zone, with an inner bar containing rips against the eastern and central rocks, and usually a large central rip along the western section of beach, with waves decreasing slightly into the western corner as rocks and reefs increase in the surf (Fig. 4.136). Waves break on the outer bar and in higher swell the bar is cut by two large central rips. The beaches are backed

by a moderately stable foredune, with Trepanner Creek draining across the southern end of beach T686, and two small creeks across each beach. The creek drains from the western slopes of 747 m high Mount Hean located 4 km inland.

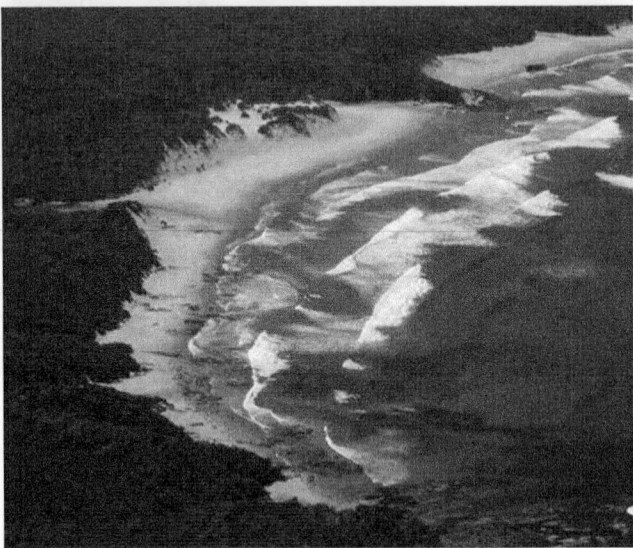

Figure 4.136 Wreck Bay northern beach (T 687) has a wide rip-dominated surf zone with rocks increasing towards the northern point (photo W. Hennecke).

Beach **T 688** is a 100 m long beach wedged in a narrow V-shaped south-facing valley 1 km east of Svenor Point. A small creek drains out of the densely vegetated valley and across the beach maintaining a low bare back beach. Reefs fringe either side of the small beach, with waves averaging over 1 m breaking across a 50 m wide low gradient bar, with a rip usually flowing out against the western rocks. The surf zone widens to 100 m during higher waves.

T 689 SVENOR PT (N)

No.	Beach	Rating HT LT	Type	Length
T689	Svenor Pt (N)	3 5	R+rock flats	80 m
Spring & neap tidal range = 0.6 & 0.4 m				

To the north of Svenor Point are 8 km of dissected rocky shore containing numerous gullies. The only beach along this section lies 2.5 km north of the point in a small narrow northwest-facing gully (**T 689**). The beach consists of an 80 m long high tide wedge of sand and cobbles located at the base of the small 100 m wide embayment, which narrows to 50 m at its entrance. Only low refracted waves reach the beach, which is fronted by a 50 m wide rock platform, which narrows to the south.

T 690-692 MULCAHY BAY

No.	Beach	Rating HT LT	Type	Length
T690	Mulcahy Bay (S)	4 5	R+rock flats	300 m
T691	Mulcahy Bay	6 7	TBR/RBB	1.8 km
T692	Mulcahy River	5 6	R+river mouth	100 m
Spring & neap tidal range = 0.6 & 0.4 m				

Mulcahy Bay is a 1.5 km wide southwest-facing bay, bordered by Brier Holme Head to the south with the Mulcahy River entering though a narrow gully in the north. One main beach (T 691) occupies the northern shore of the bay, with smaller beaches (T 690 and 692) to either end.

Beach **T 690** is located inside the southern boundary point of the bay. It is an irregular, discontinuous narrow high tide strip of sand, fronted by irregular 50 m wide rock flats and a bar off the rocks. It faces north across the bay and receives lower refracted waves averaging about 1 m, with only higher waves breaking on the bar.

Beach **T 691** is the main beach and commences on the northern side of the boundary rocks and curves to the northwest and west for 1.8 km, to terminate in lee of a collection of rocks along the northern 100 m. It is well exposed to southwest waves which average over 1.5-2 m and maintain a well developed 100 m wide transverse bar and rip system, with a 100 m wide surf zone. There are usually strong rips against the boundary rocks and 2 to 3 rips along the beach. The Alec Rivulet crosses the very southern end of the beach against the rocks and flows into the boundary rip. The beach is backed by a semi-stable 20 m high foredune, which increases in width to the south, extending 300-400 m inland as a densely vegetated dune system. A few scattered lakes back the dunes.

The **Mulcahy River** enters the northern side of the bay through a narrow bedrock valley, with densely vegetated 20 m high sides. Beach **T 692** is located at the mouth of the river, 300 m inside the valley, and faces south out of the bay. The river flow maintains a low bare unstable beach, which grades into a low gradient bar, with waves breaking heavily across a bar 100 m off the beach at the rock-bordered mouth of the valley. The beach and surf are often stained with the tannin river flow.

T 693 NYE BAY

No.	Beach	Rating HT LT	Type	Length
T693	Nye Bay	6 8	TBR	2.1 km
Spring & neap tidal range = 0.6 & 0.4 m				

Nye Bay is a 1.5 km wide west-facing bay located at the mouth of the Giblin River. Beach **T 693** occupies the eastern shore of the bay and curves round between the boundary rocky points for 2.1 km, with the river entering

the sea at the southern end through a 50 m wide permanent entrance, where the tannin water discolours the sea. It then meanders inland as an elongate lagoon for 2 km. The beach and bay are bordered by irregular rock platforms and densely vegetated 10-20 m high headlands. The beach faces west straight out the bay into the prevailing westerly swell, which averages 2-3 m at the beach. The waves and medium sand maintain an 80 m wide rip-dominated surf zone with up to eight rips along the beach (Fig. 4.137), and usually a steeper cusped beach face. The smaller Nomeme Creek crosses the northern corner of the beach, with the beach continuing west in lee of some inshore reef for 100 m before grading into a rock platform.

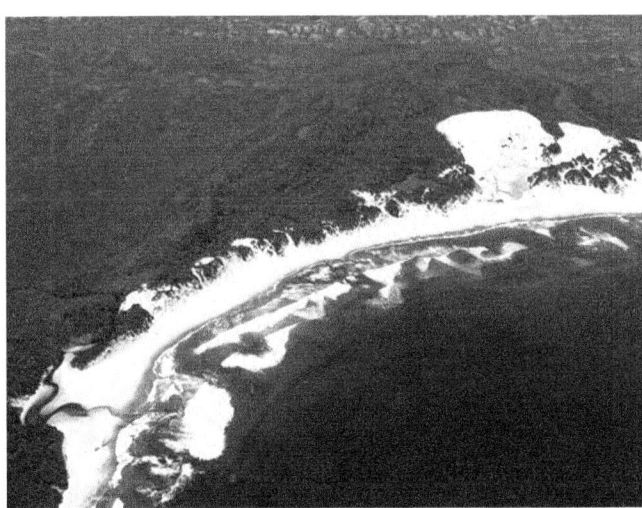

Figure 4.137 Nye Bay beach is a typical higher energy west coast beach, crossed by a creek, backed by active dunes and containing several well developed rips (photo W. Hennecke).

Behind the beach the westerly winds have built a steep, semi-stable 20-30 m high foredune which increases in height and instability to the south, with the dunes reaching 40-50 m in height and transgressing up to 2 km east to the river. They contain 3-4 active blowouts some of which extend 500 m inland to reach the southern end of the river. However the majority of the 200 ha dunes are densely vegetated.

Southwest Conservation Area

Established: 1966
Area: 185 770 ha
Coast length: 148 km (1383-1531 km)
Beaches: 91 (T 694-784)

The central section of the Southwest Conservation Area covers a 148 km long section of open coast between Nye Bay and Cape Sorell, as well as the western shore of Macquarie Harbour, and extends up to 25 km inland. The shoreline is dominated by exposed rocky coast and scattered beaches of varying exposure.

T 694-697 MIDDLE ROCK

No.	Beach	Rating HT LT	Type	Length
T694	Middle Rock (E3)	3 5	Cobble+rocks/reef	100 m
T695	Middle Rock (E2)	3 5	Cobble+rocks/reef	150 m
T696	Middle Rock (E1)	3 5	Cobble+rocks/reef	150 m
T697	Middle Rock	3 5	R+rocks/reef	200 m
Spring & neap tidal range = 0.6 & 0.4 m				

Middle Rock is a rocky headland located 3 km northwest of Nye Bay. In between is sloping rocky shoreline dominated by north-south trending ridges of metamorphic rocks. The waves have carved gullies and small embayments into the ridges, with beaches T 694-697 deposited at the northern end of the some of the small rocky, reef-filled bays. All the shore is backed by gently sloping densely vegetated terrain.

Beach **T 694** is a 100 m long high tide sand and cobble beach, backed by densely vegetated slopes, and bordered by ridges of rock extending 200-300 m to the south. It faces south across rocks and reefs and receives waves at the shore averaging less than 1 m. Beach **T 695** is located in the next small bay 100 m to the west and is a similar 150 m long sand and cobble high tide beach, with a boundary 200 m long eastern rock ridge and rocky shore extending for 600 m south of the west end of the beach.

Beach **T 696** is located 1 km to the southwest and is a 150 m long beach consisting of two adjoining sections cut by a central rock ridge. The beach is fronted by a near continuous ridged rock platform and bordered by rocky points extending 200-300 m to the south. Waves break over the rocks and reefs and average less than 1 m at the shore.

Beach **T 697** is located immediately east of Middle Rocks. It is a curving 200 m long high tide beach that faces south paralleled by rocky shore and rock ridges that extend 200 m on the west and 600 m on the east. High waves break heavily over the rocks and reefs at the mouth of the small bay with lower waves reaching the shore where they maintain a reflective beach.

T 698 BIG BEACH

No.	Beach	Rating HT LT	Type inner	outer bar	Length
T698	Big Beach	7 8	TBR	RBB	700 m
Spring & neap tidal range = 0.6 & 0.4 m					

Big Beach (T 698) is located in the northeastern corner of the open Elliott Bay, at the mouth of the Little Rocky River. The bay marks a major inflection as the north-trending coast turns and trends west for 8 km to Low Rocky Point. The beach is located right at the junction of the inflection and extends for 700 m between south-trending rocky coast to the south and west-trending rocky shore to the north. The river reaches the rear of the centre

of the beach and is deflected south to exit over the beach and against the southern rocks (Fig. 4.138). The beach faces into the prevailing waves and winds and has an exposed 300 m wide double bar system. The inner bar usually has rips running out against the rocks at either end, while the outer bar tends to be drained by one large southern rip. The river flow destabilises the southern half of the beach which consists of 200 m of bare sand and creek flats extending back to the river, while the northern half is backed by a climbing foredune extending 150 m inland in the centre and decreasing in width to the north. Older well vegetated dunes extend 1.5 km south of the beach behind the neighbouring rocky shore and blanket the backing rocky slopes up to 500 m inland.

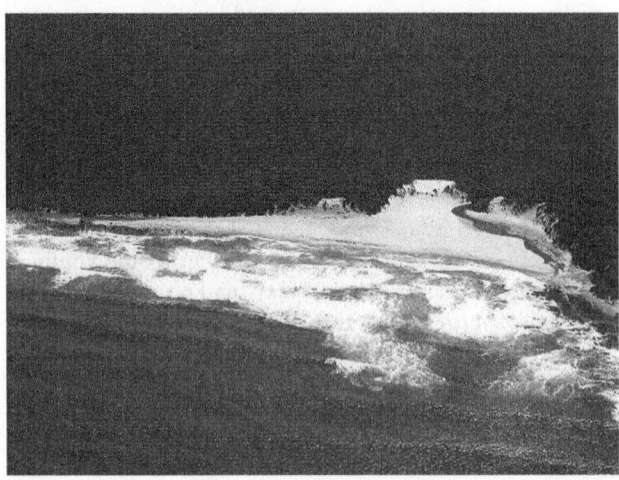

Figure 4.138 Big Beach with Little Rocky River crossing its eastern corner and flowing into the energetic surf zone.

T 699-705 ELLIOTT BAY-LOW ROCKY POINT

No.	Beach	Rating HT LT	Type	Length
T699	Barrel Ck	5 7	Cobble+rock flats	400 m
T700	Elliott Bay (2)	5 7	Cobble+rock/reef	700 m
T701	Cowrie Beach	5 7	Cobble+rock/reef	200 m
T702	Elliott Bay (4)	5 7	Cobble+rock flats	250 m
T703	Elliott Bay (5)	5 7	Cobble+rock flats	200 m
T704	Drake Ck	5 7	Cobble+rock flats	150 m
T705	Granite Pt (W)	5 7	Cobble+rock flats	800 m
Spring & neap tidal range = 0.6 & 0.4 m				

Elliott Bay is an open south- to southwest-facing bay bordered by rocky shores trending south and west. Big Beach (T698) occupies the apex of the bay, while beaches T 699-705 are located along the south-facing western arm of the bay that extends 8 km west of the beach to Low Rocky Point. All the beaches are dominated by rocks, rock flats and rock reefs. The only access to the coast is via the walking track to Low Rocky Point with sidetracks off to some of the beaches.

Beach **T 699** is a crenulate 400 m long high tide cobble and boulder beach fronted by irregular rock flats ranging from 10-50 m in width, with scattered reef extending 200 m offshore. Waves break across the rocks and reefs

with usually low wave at the shore. The small Barrel Creek drains across the rocks in the centre of the beach, which is backed by a cluster of trees and low vegetation on the rising terrain. A walking track reaches the centre of the beach.

Beach **T 700** is located immediately to the east and is a crenulate 700 m long sand and cobble high tide beach, fronted by a 50-100 m wide rock-studded surf zone, with waves averaging about 1.5 m in the outer surf and decreasing towards the shore and to the west. The very western end of the beach has a small cove, which is relatively free of rocks and provides access to the sea. Most of the beach is backed by low stunted vegetation, with a tree-covered hill rising to 70 m west of the western cove.

Cowrie Beach (T 701) is located on the western side of the 70 m high tree-covered hill in a 200 m wide south-facing bay with trees continuing around the sloping shores of the bay. The beach extends for 200 m along the northern shore of the bay and terminates at the mouth of a small creek in the northern corner. It is a high tide cobble beach, free of rocks in the northern corner, but with rock flats increasing in width from 50 to 100 m to the west. Most waves break over reefs outside the bay with usually low waves at the shore. A side walking track reaches the rear of the beach.

Beach **T 702** commences 300 m to the west of Cowrie Beach. It is a 250 m long series of three strips of high tide cobbles, separated and fronted by irregular rock outcrops and rock reef extending 50-100 m offshore where waves average over 1 m at the outer rocks. Beach **T 703** continues 100 m to the west and is a sand and cobble high tide beach that extends west in two sections for 200 m, both fronted by rocks and intertidal rocks flats that narrow to the west. In addition reefs extend up to 200 m offshore lowering waves at the shore to less than 0.5 m. Both beaches are backed by low stunted vegetation and gently rising slopes.

Beach **T 704** occupies a 150 m wide rocky bay at the mouth of the small Drake Creek, which enters the northern corner of the bay. The beach is a curving 150 m long sand and cobble beach, with rocky shore to either side and a deeper rocky bay floor. Scattered reef extends up to 500 m south of the beach resulting in low wave conditions at the shore. It is backed by a 300 m wide cluster of trees, which appear to be covering an older dune, the tree-lined creek and generally low vegetated terrain.

Beach **T 705** occupies a gently curving south-facing embayment 2 km east of Low Rocky Point. The discontinuous 800 m long beach extends around the embayment in a series of curving sections of high tide cobbles, fronted by irregular rocks and rock reefs extending from 10 m to more than 100 m seaward. Waves break irregularly over the rocks and reefs with variable wave height along the shore. Generally low trees and heathland back the beach.

T 706-710 SASSY CREEK

No.	Beach	Rating HT LT	Type	Length
T706	Black Is	3 5	Cobble+rock flats	80 m
T707	Sassy Ck (S2)	3 5	R+rocks & reef	40 m
T708	Sassy Ck (S1)	4 6	R+rocks & reef	40 m
T709	Sassy Ck	6 8	TBR+rocks & reef	200 m
T710	Sassy Ck (W)	6 7	LTT+rocks & reef	80 m
Spring & neap tidal range = 0.9 & 0.5 m				

At **Low Rocky Point** the shore turns and trends north for 10 km to the next westerly inflection at The Shank. Most of the coast in between is irregular, joint-controlled Cambrian metasedimentary rocks, backed by densely vegetated moderate slopes. The Lewis River flows through a 2 km long narrow drowned valley to reach the shore 4 km north of the point. A few beaches are located at creek mouths and suitable protected sites along the shore. In the 7 km of shoreline between the point and Sassy Creek there are five small beaches, one in lee of Black Island (T 706) and four clustered around the creek mouths (T 707-710).

Beach **T 706** is located 700 m northwest of the small **Black Island**. It is an 80 m long strip of high tide sand and cobbles fronted by 50-80 m wide rock flats, which only receives waves at high tide and is backed by a small foredune. The sheltered area behind the island is used as a boat anchorage.

Sassy Creek reaches the coast 500 m east of 30 m high Veridian Point. Four small beaches are located around the creek mouth (Fig. 4.139). Beaches **T 707** and **708** are two 40 m long pockets of sand located in amongst ridges of rock 100-200 m south of the creek. The ridges extend 100 m seawards with narrow gullies in between. Waves break over the outer rocks with low waves at the shore and reflective pocket beaches. Both are bordered by rocks and backed by a low foredune, with a walking track terminating on the slopes above the beaches.

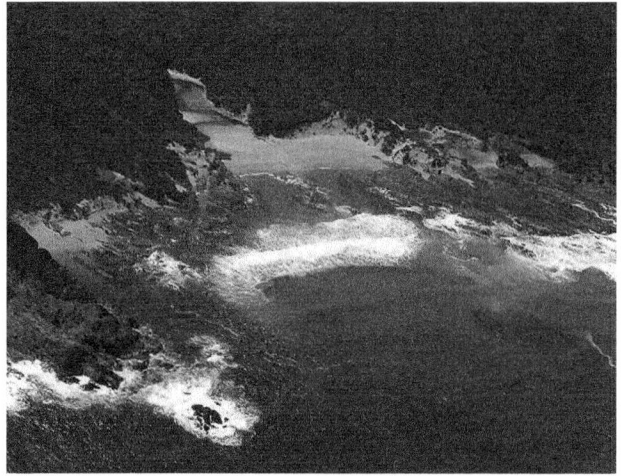

Figure 4.139 Sassy Creek reaches the sea in lee of beach T 709 with small rock-bound beaches located to either side.

Beach **T 710** lies 100 m to the west past an irregular section of rocky shore. It is an 80 m long pocket of sand, bordered and partly fronted by rock ridges extending up to 100 m offshore with a 150 m long vegetated point forming its western boundary. Waves break over the outer rocks and reefs with low wave conditions at the shore.

T 711-713 COOPERS CREEK

No.	Beach	Rating HT LT	Type	Length
T711	Coopers Ck (S)	3 4	R+reefs/rocks	100 m
T712	Coopers Ck	4 5	LTT+reefs/rocks	150 m
T713	Diorite Pt (E)	3 4	R+reefs/rocks	300 m
Spring & neap tidal range = 0.9 & 0.5 m				

Coopers Creek is a deeply incised creek that emerges from its narrow 80 m deep valley 600 m east of Diorite Point. Between the two is a small southwest-facing 700 m wide bay containing three small sheltered beaches (T 711-713). Scattered rocks and reefs extend up to 500 m off the beaches and fill much of the bay, resulting in waves averaging 1 m and less at the shore.

Beach **T 711** lies 200 m south of the creek. It is a 100 m long northwest-facing high tide reflective beach bordered by rock platforms and encircled in inner and outer reefs, the latter extending 500 m offshore. Waves break over the reefs and are reduced to about 0.5 m at the shore. It is backed by well vegetated dunes extending 200 m inland to a small lake.

Beach **T 712** occupies Coopers Creek mouth. It is a 150 m long west-facing beach that is bordered by rocks and rock platforms to either end, with scattered rocks off the southern half of the beach and the creek flowing across the northern end against the point. It is backed by a 10 m high vegetated foredune, which links with the dunes behind the southern beach. Waves break over the inner and outer reefs averaging less than 1 m at the shore. A track terminates at the creek mouth and links to a landing ground located 1 km inland.

Beach **T 713** commences 100 m to the north past a rocky point and continues to trend west for 300 m to the lee of 10 m high Diorite Point. The reflective beach faces south and is sheltered by the rocks and reefs, with waves averaging about 0.5 m at the beach. It is backed by a low vegetated foredune with a small creek draining across the western end of the beach.

Regional map 9 West Coast: Low Rocky Point to Cape Sorell

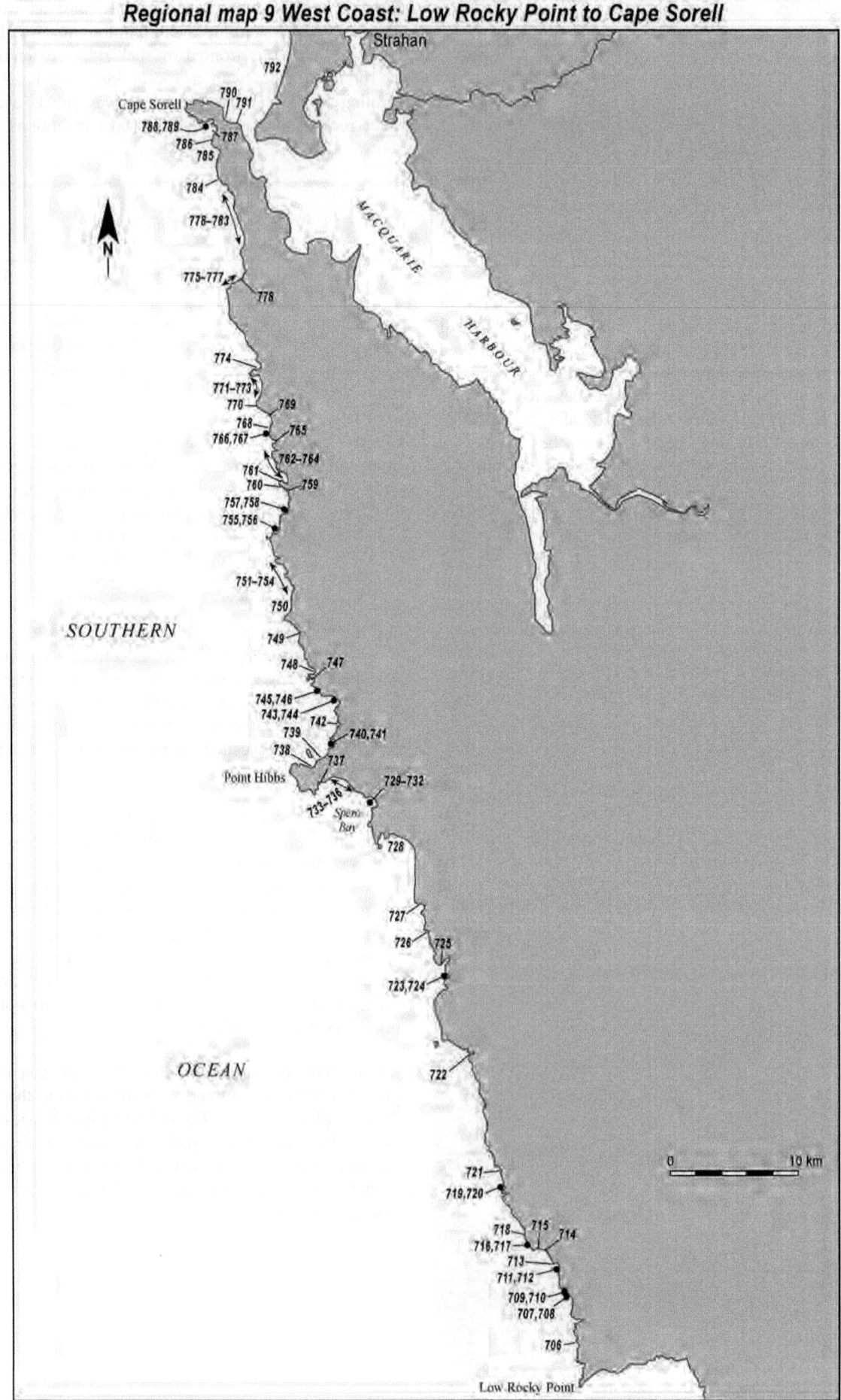

T 714-718 THE SHANK

No.	Beach	Rating HT LT	Type	Length
T714	Abo Creek	3 4	R+rocks/reefs	250 m
T715	The Shank	3 4	R+rocks/reefs	900 m
T716	The Shank (N1)	3 4	R+rocks/reefs	300 m
T717	The Shank (N2)	3 4	R+rocks/reefs	200 m
T718	The Shank (N3)	3 4	R+rocks/reefs	200 m
Spring & neap tidal range = 0.9 & 0.5 m				

The Shank is a collection of rock reefs that extends 3 km west of Diorite Point and follows the coast for 2 km to the north around a low dune-covered point. To the west of Abo Creek and located 1 km north of Diorite Point are four continuous beaches (T 714-717), with beach T 718 located 1 km further north. All are sheltered by the numerous reefs along and off the coast, with low waves and reflective conditions prevailing (Fig. 4.141).

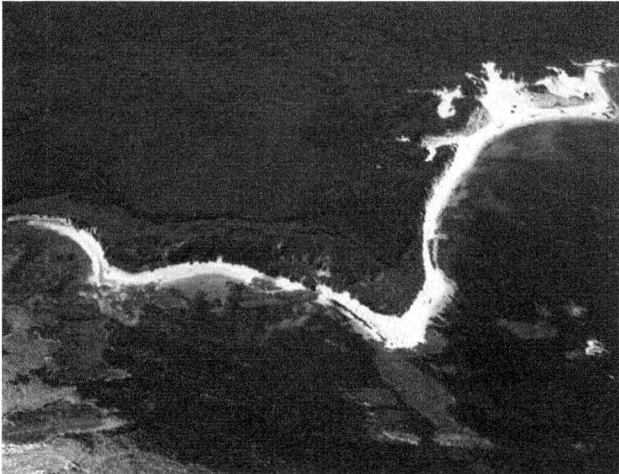

Figure 4.141 Beaches T 714-717 are all sheltered in lee of rock reefs, with some active dunes behind T 714.

Beach **T 714** commences at the mouth of the small Abo Creek, with rocky shore to the east. It curves to the west for 250 m to a sandy foreland in lee of a rock reef located 100 m offshore. The beach is reflective and faces south across a rocky seafloor. Beach **T 715** commences at the foreland and curves to the west for 900 m to the next sandy foreland, that is tied to rock reef extending 100 m offshore. It faces south across reefs that extend up to 1.5 km offshore, lowering waves to about 0.5 m at the shore. Both beaches are backed by semi-stable dunes including two east-trending blowouts that extend up to 100 m to the east.

Beach **T 716** commences on the northern side of the foreland and curves to the north for 300 m to the next reef-tied sandy foreland. The beach is sheltered by the rocks and reef, as well as a central rock outcrop on the beach, with waves only reaching the shore at high tide. Beach **T 717** continues north for 200 m, the entire way fronted by 50-100 m wide intertidal rock flats. The two beaches are backed by a continuous foredune that

increases in size and height to the south, where it merges with the 50 m wide dunes of beach T 715.

Beach **T 718** is located 1 km to the north past a section of irregular rocky coast fronted by 100 m wide rock platforms. It is a 200 m long northwest-facing strip of high tide sand, located between low north-trending rock ridges that continue 200-300 m north of the beach, with shallow reefs in between. The rocks, ridges and reefs lower waves to about 0.5 m at the shore, with reflective conditions prevailing. A steep, 10-15 m high, 50 m wide foredune backs the beach.

T 719-721 MAINWARING INLET

No.	Beach	Rating HT LT	Type	Length
T719	Mainwaring Inlet	3 4	R+rocks	80 m
T720	Mainwaring Inlet (N1)	3 4	R+rock flats	100 m
T721	Mainwaring Inlet (N2)	3 4	R+rocks	150 m
Spring & neap tidal range = 0.9 & 0.5 m				

Mainwaring Inlet is a narrow drowned bedrock valley located at the mouth of the small Mainwaring River. The inlet meanders inland as an estuary through 20-40 m high bedrock valley sides for 2 km to the head of river. At the shore the inlet is 100 m wide with rocks and reefs continuing offshore for another 500 m. Two small beaches are located on the northern side of the inlet (T 719 and 720) and one 1.5 km to the north (T 721) on an otherwise rocky coast.

Beach **T 719** is an 80 m long pocket of sand located on the northern side of the inlet. It faces southwest out the 150 m wide, 500 m deep bedrock mouth. Waves are greatly reduced by the rocks and reefs averaging about 0.5 m at the shore. The beach is fringed by low rocks, with a central rock outcrop on the beach. Low grassy sand-draped rocks back the beach, while the tannin water of the river stains the inlet.

Beach **T 720** is located 100 m to the north on the northern side of the bedrock entrance. It faces northwest up the rocky shore, is sheltered by a rocky point to the west, and is fronted by 100 m wide intertidal rock flats with reefs extending another 200-300 m offshore. As a consequence it only receives low waves at high tide. It shares the grassy low dunes with the inlet beach (T 719).

Beach **T 721** occupies the next small rocky embayment 1.5 km north of the inlet. It is a curving 150 m long northwest-facing high tide beach bordered by low rocks and intertidal rock flats extending most of the way across the beach, with only a small central sandy access to the sea. The beach is also sheltered by its orientation, a low western point and scattered reefs extending 200-300 m offshore. It is backed by low scrubby foredune, a narrow strip of low grassy dunes, and then densely vegetated slopes.

T 722-727 URQUHART RIVER-HARTWELL & CHRISTMAS COVES

No.	Beach	Rating HT LT	Type	Length
T722	Urquhart R	2 4	R+creek mouth	50 m
T723	Hartwell Cove	2 3	R+rocks	80 m
T724	Hartwell Cove	2 3	R+sand/rock flats	250 m
T725	Christmas Cove	5 6	LTT/TBR	350 m
T726	Christmas Cove (N1)	3 5	Boulder+rocks	60 m
T727	Christmas Cove (N2)	3 5	Cobble+rocks	300 m
Spring & neap tidal range = 0.9 & 0.5 m				

Between Mainwaring Inlet and Endeavour Bay are 23 km of rugged west-facing rocky shore, generally backed by moderate to steep densely vegetated slopes rising to over 100 m. The slopes are dissected by the Urquhart and Wanderer rivers and several smaller creeks and gullies. Seven small moderate to well protected beaches (T 722-727) are located at the mouths of the rivers and some of the creeks.

The **Urquhart River** is a small river draining through a narrow V-shaped valley that reaches the coast 2 km east of 79 m high High Rocky Point. The river emerges into a 700 m long narrow estuary with densely vegetated slopes rising to 80 m on either side. Beach **T 722** is located on the north side of the estuary 300 m inside the 100 m wide rock- and reef-strewn mouth, at the mouth of a small tributary creek. The low gradient 50 m wide beach consists of a V-shaped creek delta, with only minor wave reworking owing to its protected location. It is backed and bordered by the densely vegetated slopes, with the main river delta 200 m further to the east.

Hartwell Cove is located 4 km north of High Rocky Point. The 100-200 m wide, 700 m deep cove contains two sheltered beaches in two small adjacent embayments in the southeast corner of the cove. Beach **T 723** is an 80 m long pocket of north-facing sand backed and bordered by steep vegetated slopes, rising to 100 m to the south. The curving pocket of sand is fringed by some intertidal rocks and faces out towards the entrance of the cove. Beach **T 724** curves for 250 m around the eastern end of the cove. It occupies the mouth of Dale Creek entering steeply from the north and Pegg Creek from the south. The two creeks have deposited the sand and cobble sediment which have been reworked to form the high tide beach fronted by 50-100 m wide sand flats, with some rocks outcropping between the two creeks.

Christmas Cove is a 350 m wide south-facing bedrock embayment located at the mouth of the Wanderer River (Fig. 4.142). Beach **T 725** is located on the northern shore of the cove and extends for 350 m west of the 50 m wide rock-fringed river mouth. It faces due south down the cove and receives waves averaging 1-1.5 m which maintain a 50 m wide low tide terrace cut by one to two rips during higher wave conditions. The beach is bordered by steep, densely vegetated slopes rising to 100 m. A low densely vegetated 200 m wide barrier

backs the beach, with the estuary meandering a few kilometres upstream in a deeply incised V-shaped valley. Beach **T 726** is located at the mouth of a small creek that descends steeply from the backing 120 m high slopes, 2 km north of Christmas Cove. The beach consists of a 60 m wide collection of boulders and poorly sorted creek debris, located inside a 100 m deep 50 m wide bedrock gully. Waves average about 0.5 m at the shore and wash over the backing creek deposits during high wave conditions.

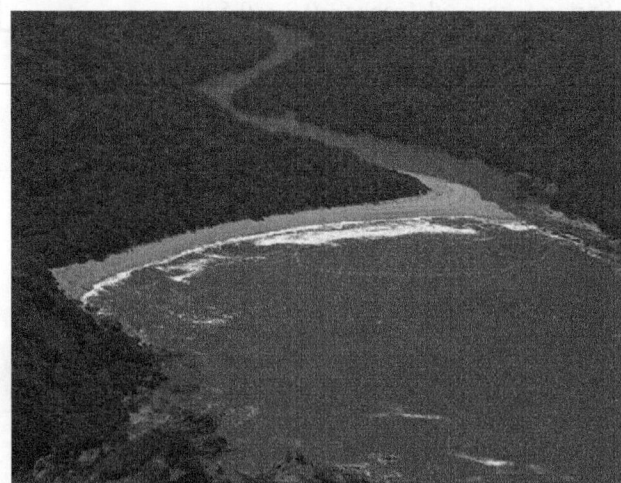

Figure 4.142 The Wanderer River entering the sea at Christmas Cove at the eastern end of beach T 725.

Beach **T 727** is located another 2 km to the north in a west-facing 500 m wide semi-circular rocky embayment. The cobble and boulder beach occupies the northern shore of the bay and faces southwest across a series of scattered inner rocks and outer reefs, which lower waves to less than 1 m at the shore. It is backed by densely vegetated slopes rising to 120 m.

T 728 ENDEAVOUR BAY

No.	Beach	Rating HT LT	Type	Length
T728	Endeavour Bay	7 8	TBR/RBB	2.1 km
Spring & neap tidal range = 0.9 & 0.5 m				

Endeavour Bay is an exposed 2.7 m wide south-facing bay located between 40 m high protruding Conder Point to the west and a north-south section of straight rocky coast to the east that rises steeply to 150 m. Beach **T 728** occupies the northern shore of the bay, extending for 2.1 km from the eastern slopes to the lee of the point. It faces due south into the persistent high swell averaging over 2 m. The waves maintain a 300-400 m wide low gradient double-bar surf zone. The inner bar usually has 5-6 strong rips, while the outer bar has two to three large rips (Fig. 4.143). The beach is backed by a scarped 10-20 m high foredune, with small creeks draining across the ends of the beach. Several foredune ridges extend 500-700 m inland decreasing in height to a higher inner ridge and abutting the backing steep slopes of the 120 m high Lowren Hill.

T 729-732 **SPERO RIVER**

No.	Beach	Rating HT LT	Type	Length
T729	Spero R (1)	4 6	LTT/TBR	450 m
T730	Spero R (2)	5 7	TBR+rocks	150 m
T731	Spero R (3)	5 7	TBR+rocks	200 m
T732	Spero R (4)	4 5	Cobble+LTT	400 m
Spring & neap tidal range = 0.9 & 0.5 m				

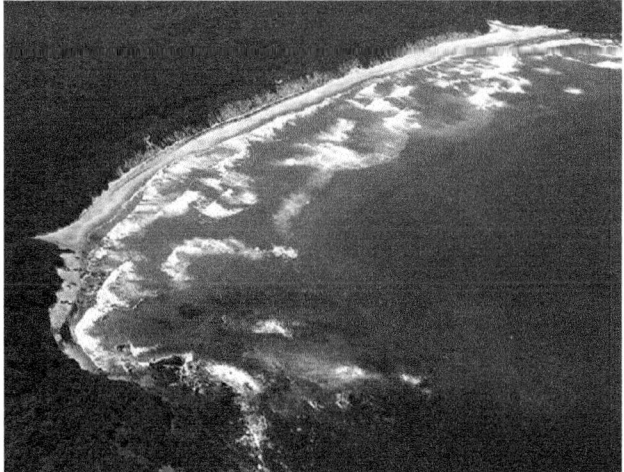

Figure 4.143 The exposed high energy double barred rip-dominated beach at Endeavour Bay.

The **Spero River** meanders through steeply dissected hills to reach the coast on the northern side of Lowren Hill and the eastern side of Spero Bay, a 3.5 km wide south-facing exposed bay located between Leelinger Island and Conder Point. The river flows into the southern side of a 1 km wide semi-circular shaped rocky embayment on the eastern side of the bay. Beaches T 729-732 occupy the shore of the bay curving north and west from the river mouth.

Beach **T 729** commences at the narrow, sometimes blocked Spero River mouth, against the southern rocks of the bay. It curves to the north for 450 m to a cluster of rocks (Fig. 4.144). Waves refract round into the small bay, averaging about 1 m at the river mouth and increase up to 1.5 m at the northern end of the beach. These maintain a 50 m wide low tide terrace in the south, widening slightly to the north, with usually one central beach rip and one against the northern rocks. It is backed by a 200 m wide densely vegetated foredune, then the river.

Beach **T 730** is located on the northern side of the 50 m wide low rocky point and curves for 150 m to a similar northern point. Both points are surrounded by 50 m wide rock platforms, which converge towards the centre of the beach leaving a 50 m wide gap in the centre. Waves averaging up to 1.5 m break over the rocks and exit via a permanent rip through the narrow gap. Beach **T 731** continues on the other side of the rocks for another 200 m to the next set of rocks, with several rocks outcropping along the southern section of the beach and in the surf.

The waves break across the rocks and a 50 m wide bar, with two permanent rips draining the surf, one through the rocks and one towards the northern point.

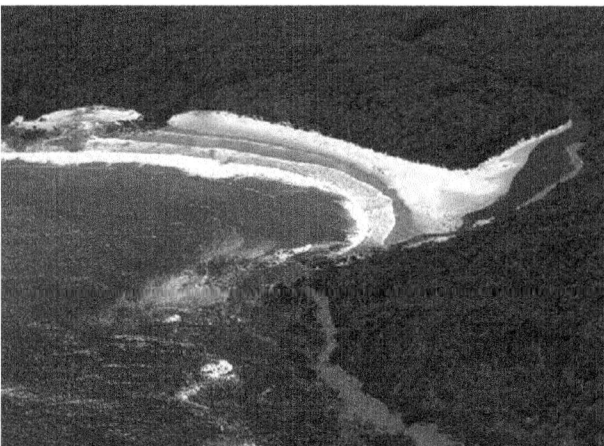

Figure 4.144 The Spero River mouth reaches the sea at the moderately sheltered beach T 729.

Beach **T 732** commences on the western side of the northern rocks and trends to the west for 400 m. It is a high tide cobble beach with a sandy low tide terrace. Wave height decreases into the northwestern corner of the bay in lee of the boundary point and its 50 m wide rock platform. The waves average about 1-1.5 m along the beach and break over some outer reefs and a low gradient bar. The three northern beaches are all backed by densely vegetated slopes rising 70-100 m. All four beaches have a potential for moderate sized beach breaks, together with a right break over the north point and a left off the southern point.

T 733-737 **WHITEHORSES BEACH**

No.	Beach	Rating HT LT	Type	Length
T733	Whitehorses Beach (E2)	5 7	Cobble+rocks/reef	500 m
T734	Whitehorses Beach (E1)	5 7	Cobble+rocks/reef	250 m
T735	Whitehorses Beach (1)	6 8	TBR+rocks/reef	700 m
T736	Whitehorses Beach (2)	6 8	TBR+rocks/reef	800 m
T737	Red Reef Cliff	5 7	LTT/TBR	350 m
Spring & neap tidal range = 0.9 & 0.5 m				

The **Whitehorses beaches** (T 733-736) occupy 2.5 km of the northern section of Spero Bay. Together with beach T 737 they face south out of the open bay and into the prevailing high southerly swell. The waves are however reduced slightly by the western headland that terminates at Leelinger Island and reefs that continue a few hundred metres to the south. The five near continuous beaches are all bordered by low rocky points, with numerous rocks and reefs dominating the beach and surf zone.

Beach **T 733** is a slightly curving 500 m long southwest-facing high tide cobble beach, fronted by scattered rocks and reefs up to 100 m wide then sandy bay floor. Waves averaging about 1.5 m break over the outer rocks and reefs, with low waves at the shore. Beach **T 734** is located immediately to the west and is a similar curving

250 m long high tide cobble beach, with rocks and reefs extending up to 200 m off either side of the small bay and with deeper water in the centre which permits lowered waves to reach the steep beach. Rocks are scattered along the beach and the returning water flows out through a permanent rip between the boundary rocks and reefs. Densely vegetated slopes back the two beaches.

The main Whitehorses Beach consists of two parts separated by a small central sandy foreland tied to an intertidal reef (Fig. 4.145). Beach **T 735** occupies the eastern side of the beach. It is 700 m long and faces due south. It has rocks along each end and a central outcrop in the surf, with a detached bar in between. Waves break up to 200 m offshore over the bar and reefs and feed a strong eastern and central reef-controlled rip. Oxley Creek emerges from a steep narrow valley to drain across the rocks at the eastern end of the beach. Beach **T 736** continues west of the foreland for another 800 m. Rocks dominate the surf zone as wave height decreases to about 1 m at the western end. They break across a mixture of sand and reefs with a permanent rip against the foreland reef. Parpeder Creek drains across the centre of the beach, with densely vegetated slopes rising to 60 m behind.

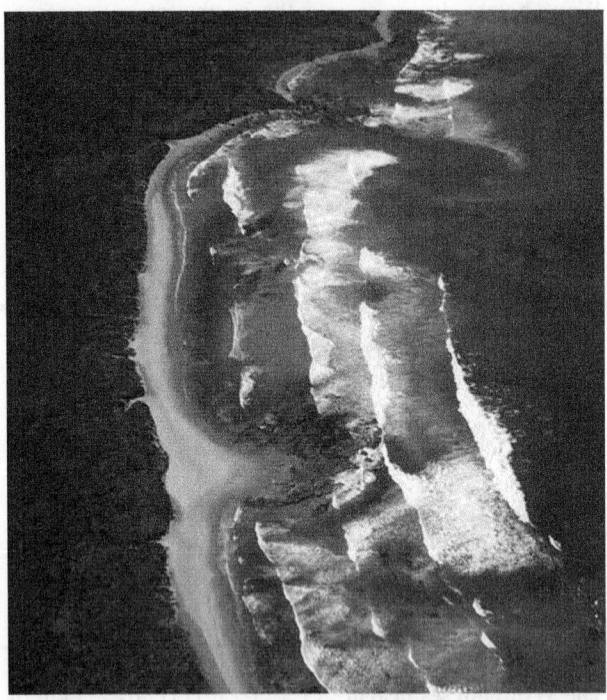

Figure 4.145 The main Whitehorses beaches (T 735 & 736) showing the high energy sand and rock-dominated surf zone, with strong permanent rips against the rocks (photo W. Hennecke).

Beach **T 737** is located 200 m to the west. It is a curving 350 m long southeast-facing beach, that is moderately sheltered by both Red and Hayes reefs, as well as the headland and reefs that extend for 1.5 km south to Leelinger Island and reefs. Waves average about 1 m and maintain a 50 m wide low gradient low tide terrace, with some scattered reefs, only cut by rips during periods of higher waves. Densely vegetated slopes rise gradually to 50 m behind the beach and several small creeks flow down to cross the sand.

T 738-742 MEERIM BEACH

No.	Beach	Rating HT LT		Type	Length
T738	Sanctuary Bay	3	3	R	200 m
T739	Meerim Beach	4	5	LTT/TBR	1.2 km
T740	Meerim Beach (N1)	4	5	LTT/TBR	300 m
T741	Meerim Beach (N2)	4	5	LTT/TBR	250 m
T742	Hibbs Bay (S)	4	5	Cobble+rocks/reef	600 m
Spring & neap tidal range = 0.9 & 0.5 m					

Hibbs Bay is a 5 km wide west-facing rocky bay bordered to the south by 35 m high Point Hibbs and Clydies Corner in the north, where the coast turns and trends west. In between are 10 km of rocky shoreline with numerous inshore reefs and 73 m high Hibbs Pyramid in the south. The shore is backed by deeply incised densely vegetated slopes rising to 150 m, with Hibbs Lagoon fed by the Hibbs River in the centre. Nine beaches (T 738-746) occupy parts of the bay shore.

Sanctuary Bay is a small semi-circular shaped bay located 1.5 km east of Hibbs Point. The bay has a 100 m wide west-facing entrance with reefs also cluttering the opening. Inside is a curving 200 m long reflective beach (**T 738**) which receives waves averaging about 0.5 m. The low energy beach is backed by windswept heathland gradually rising to 60 m.

Meerim Beach (**T 739**) commences on the northern side of Sanctuary Bay and trends to the northeast as a crenulate 1.2 km long moderately exposed beach that blankets the rocky shore and curves to the northwest in lee of the northern 100 m wide rocky point. It faces northwest and is sheltered from southerly waves in the south by rocks and reefs, including Hibbs Pyramid. Wave height increases along the northern half of the beach with rocks outcropping along the central-northern surf zone. The beach grades from a 50 m wide low tide terrace in the south, to a 100 m wide surf zone drained by two to three rips controlled by the central rocks and northern point. A crenulate semi-stable foredune backs the beach, with a small creek cutting through the dune and flowing across the northern end of the beach.

Beaches T 740 and 741 occupy a small 500 m wide embayment on the northern side of Meerim Beach. It is bordered by 10-20 m high rocky headlands with rocks and reefs extending out across the bay floor and forming exposed reefs off the northern half of the bay (Fig. 4.146). Beach **T 740** extends northwards for 300 m from the southern boundary point to a central rock outcrop. It is initially sheltered by the point as it curves round in its lee and continues past some rock outcrops to the central bluff. Evans Creek cuts through the backing foredune and across the centre of the beach. Beach **T 741** continues on the northern side of the rocks for another 250 m to the northern rocky point, which extends 300 m seaward. Both beaches receive waves averaging 1-1.5 m which maintain a 50 m wide northern surf zone widening to

100 m in the south, with a strong permanent rip exiting against the southern point.

Beach **T 742** is located 1.5 km to the north, past a section of rocks and reef-dominated shore, including the 150 m wide Clearwater Bay. The beach curves slightly to the north for 600 m as a high tide cobble beach cut by southwest-trending rock ridges, which continue 100-300 m offshore as exposed rocks and reefs. These lower waves at the shore to less than 1 m. Dense vegetation rising to an 88 m high hill backs the beach.

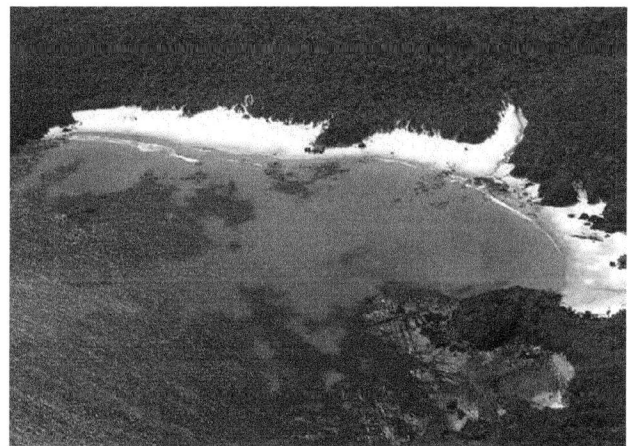

Figure 4.146 The two northern Meerim beaches (T 740 & 741) are moderately sheltered by Hibbs Point and inshore reefs.

T 743-744 **HIBBS LAGOON**

No.	Beach	Rating HT LT		Type	Length
T743	Hibbs Lagoon (1)	7	8	TBR+rocks	650 m
T744	Hibbs Lagoon (2)	7	8	TBR+rocks	550 m
Spring & neap tidal range = 0.9 & 0.5 m					

Hibbs Lagoon is a 60 ha coastal lagoon, fed by the Hibbs River and bordered by slopes rising to 100 m. It enters the sea through a narrow 300 m long inlet at the eastern end of beach T 743. Beaches T 743 and 744 share a 1.2 km wide southwest-facing rocky bay between the lagoon mouth and Clydies Corner (Fig. 4.147).

Beach **T 743** commences in lee of a small rocky point that protrudes 50 m to the north. The beach curves round in lee of the point for 200 m to the inlet, then trends to the northwest for a total of 650 m to a 50 m wide central bluff-topped rock outcrop, with a small creek on its eastern side. Beach **T 744** continues on past the outcrop for another 550 m to Clydies Corner past scattered rocks and reef in the surf and one large rock outcrop to the densely vegetated western headland. Waves average over 1.5 m high in the east decreasing slightly towards the western corner in lee of reefs that extend 500 m south of the corner. They maintain a 50 m wide surf zone in the corner increasing to 100 m at the lagoon inlet, with usually a rip against the central rocks and a strong rip exiting along the southern point, which includes flow

from the inlet. The beach is backed by a well vegetated foredune and densely vegetated slopes, together with the 300 m wide, 20 m high plug of sand that blocks the lagoon.

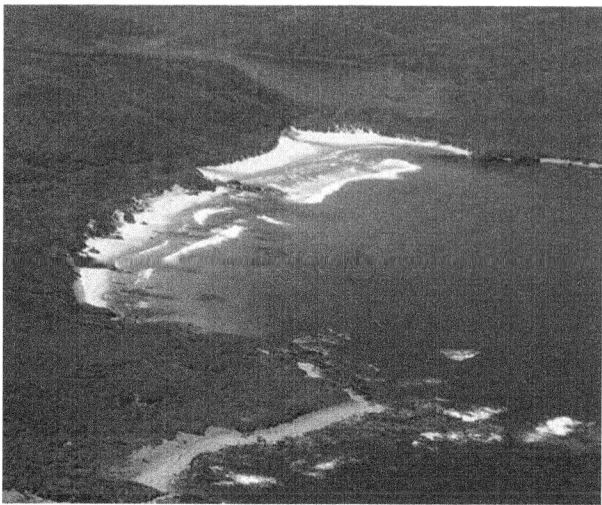

Figure 4.147 Hibbs Lagoon and beaches T 743 & 744 (photo W. Hennecke).

T 745-749 **HIBBS BAY-PENNEROWNE POINT**

No.	Beach	Rating HT LT		Type	Length
T745	Hibbs Bay (N1)	4	8	Cobble+rock platform	200 m
T746	Hibbs Bay (N2)	3	5	Cobble+reef	250 m
T747	Hibbs Bay (N3)	3	5	Cobble+rocks/reef	200 m
T748	Jones Ck	3	5	Cobble+rocks/reef	300 m
T749	Pennerowne Pt (S)	4	7	Cobble+rocks/reef	400 m
Spring & neap tidal range = 0.9 & 0.5 m					

On the northern side of **Hibbs Bay** the shoreline continues to the north for 6 km to Pennerowne Point. In between is a rocky reef-fronted irregular section of shore backed by densely vegetated slopes rising to 100 m and cut by several deeply incised small creeks. Six rock- and reef-dominated beaches (T 745-749) are located along the shore.

Beach **T 745** is located on the western side of the point that borders Clydies Corner. It is a 200 m straight then curving high tide sand and cobble beach, fronted by an irregular rock platform that narrows from 150 m in the south to a 50 m wide collection of rocks in the north. Waves averaging 1-1.5 m break over the outer rocks. It is backed by some supratidal cobble deposits, then low heathland. Beach **T 746** occupies a 300 m wide south-facing U-shaped rocky bay immediately to the north, with two small creeks draining to either end of the beach. The 250 m long cobble beach curves around the northern shore of the bay, facing out across a shallow reef-filled bay floor. Irregular rock flats extend from beach T 745 to the eastern end of the beach, with a vegetated cobble ridge behind the beach and an active ridge extending along the western side of the small bay to a cobble mound

at the western entrance. The reefs lower waves to about 0.5 m at the shore.

Beach **T 747** occupies the next small south-facing bay 700 m to the northwest. The 200 m long beach runs around the northern shore of the 200 m wide rocky bay. It consists of a mixture of sand, cobbles and boulders fronted by intertidal rock platforms that fill much of the bay sides, with just one narrow sandy approach to the beach in its northeast corner. A small island lies off the western side of the bay with a narrow gully between the island and bayshore. Waves break over the entrance reefs and platform to lower waves to about 0.5 m at the shore. It is backed by low gradient densely vegetated terrain.

Beach **T 748** occupies the next bay 300 m to the north. The rocky bay has a 250 m wide opening widening to 350 m inside. The beach extends for 300 m in a disjointed fashion around the eastern and northern shore cut into eight sections by rock ridges and outcrops. The beach is a mixture of high tide sand, cobbles and boulders, with a sandier beach at the mouth of Jones Creek, which enters in the northeast corner. The bay is surrounded by low health-covered terrain. The narrow entrance, orientation and reefs lower waves to about 0.5 m at the shore, with no wave reaching the beaches at low tide.

Beach **T 749** lies 2 km to the north and 1 km southeast of Pennerowne Point. It consists of a 400 m long crenulate high tide sandy beach that towards its northern end grades into a cobble beach at a small creek mouth. The beach is fronted by 200 m wide rock platforms and reefs in the south that diminish into the creek mouth. Waves break over the rock and reefs with low waves only reaching the shore at high tide. A low grassy foredune backs the sandy section backed by densely vegetated slopes rising to 70 m.

T 750-754 VARNA BAY

No.	Beach	Rating		Type	Length
		HT	LT		
T750	Varna Bay (1)	3	4	R+reef	1.7 km
T751	Varna Bay (2)	3	4	R+reef	450 m
T752	Varna Bay (3)	4	6	R+rock flats	400 m
T753	Varna Bay (4)	4	5	R+rocks/reefs	800 m
T754	Varna Bay (5)	3	4	R+rocks/reef	300 m
Spring & neap tidal range = 0.9 & 0.5 m					

Varna Bay is an open 3.5 km wide west-facing bay located to the north of Pennerowne Point. While it faces straight into the prevailing waves and winds, a 0.5-1.5 km wide shore-continuous section of reefs lowers waves at the shore. Most of the bay shore is occupied by five beaches (T 750-754), which are backed by slopes rising to 120 m, and dissected by three large and several smaller deeply incised creeks.

Beach **T 750** is the main beach. It commences in lee of Pennerowne Point and initially curves to the east to the mouth of Griffiths Creek, before trending north for a total of 1.7 km, past a smaller creek mouth to the mouth of

Modder River. Rock reefs and islets extend up to 1 km offshore lowering waves to about 0.5 m at the shore which maintains a crenulate reflective beach, cut by the three creeks, with a 20-30 m high foredune in between breached by a few small blowouts, and with a circular 2 ha lake behind (Fig. 4.148). Beach **T 751** commences on the northern side of the small Modder River mouth and curves slightly to the northwest for another 450 m to a low rocky point. Rocks line the creek mouth and southern end of the beach, with the offshore reefs lowering waves to about 0.5 m and maintaining an often calm reflective beach, backed by a 10-20 m high foredune with several small blowouts.

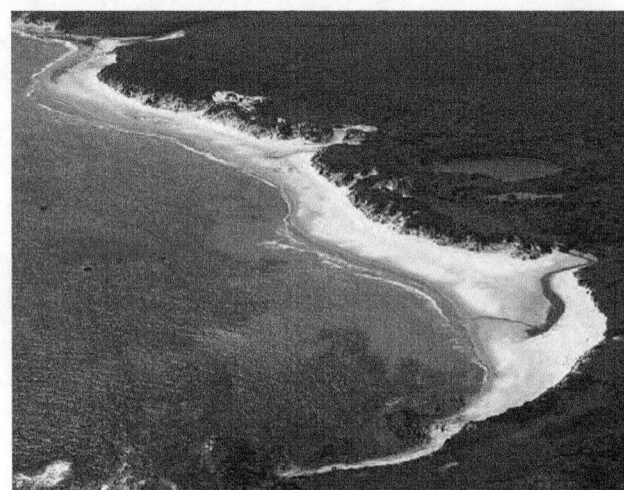

Figure 4.148 Beach T 750 at the southern end of Varna Bay is typical of the crenulate reef-sheltered reflective beaches within the bay.

Beach **T 752** commences at the low rocky point and continues north for 400 m with intertidal rock flats then reef continuing the length of the beach and lowering waves to less than 0.5 m at the shore. A 10 m high foredune breached by a small central creek backs the beach.

Beach **T 753** occupies a 700 m wide rocky embayment 300 m to the north. The 800 m long beach continues around the shore of the open west-facing bay, as a mixture of sand and cobbles interrupted by numerous rocks and reefs, with reefs extending 500 m offshore. Wave are very low along the southern section reaching up to 1 m along the northern section. The entire beach is backed by an irregular 5-10 m high semi-stable foredune, cut by three small creeks, including the central Timms Creek.

Beach **T 754** occupies the north side of the 100 m wide V-shaped bedrock mouth of a small creek. The sand and rocky beach commences in the rock-filled creek mouth and continues to the west for 300 m amongst numerous rock outcrops lining both sides of the small bay. Waves are lowered by outer reefs and its sheltered location with calm conditions common at the shore. Densely vegetated slopes gradually rising to 70 m back the beach.

T 755-758 BIRTHDAY BAY

No.	Beach	Rating HT LT		Type	Length
T755	Birthday Bay (S2)	3	4	Cobble+rocks	100 m
T756	Birthday Bay (S1)	3	4	Cobble+rocks	80 m
T757	Birthday Ck (1)	5	7	TBR+rocks	200 m
T758	Birthday Ck (2)	6	7	TBR+rocks	200 m
Spring & neap tidal range = 0.9 & 0.5 m					

Birthday Bay is on open, west-facing 3 km wide bay located between a rocky 20 m high point in the south and a low rocky point and rock reefs extending 1 km offshore in the north. It has a rocky 4 km long shoreline backed by densely vegetated slopes rising to 90 m, which are deeply dissected by Birthday, Iron and a central creek, together with several small creeks descending the outer slopes. Six rock-dominated beaches (T 755-760) are located along the bay shore.

Beach **T 755** is a curving 100 m long cobble beach that faces northwest out of a reef-bound 150 m wide embayment. Beach **T 756** lies immediately to the north in a similar smaller bay and is 80 m long. Both beaches have rocks and intertidal rock flats, grading into reefs to either side and a rocky bay floor. Waves are lowered to less than 0.5 m at the shore. A storm cobble and boulder ridge backs the beach then densely vegetated slopes rising to 90 m.

Beaches T 757 and 758 are located at the mouth of Birthday Creek, which emerges from a narrow 80 m deep, V-shaped valley. Beach **T 757** occupies the rock-bound 100 m wide creek mouth and extends south amongst the rocks for 100 m. Beach **T 758** commences on the north side of the 50 m wide northern rock boundary of the creek and continues north amongst numerous rocks for 200 m. Both the rock-dominated beaches share an inner surf zone underlain by a rock and sandy seafloor, then a sandy bar located 100 m offshore, with permanent rips draining to either end. Steep densely vegetated slopes back the beaches.

T 759-760 NIELSEN RIVER

No.	Beach	Rating HT LT		Type	Length
T759	Nielsen R (1)	6	8	TBR	200 m
T760	Nielsen R (2)	6	10	TBR+rocks	600 m
Spring & neap tidal range = 0.9 & 0.5 m					

The **Nielsen River** emerges from a deeply incised V-shaped meandering valley to reach the coast at the northern end of Birthday Bay. The last kilometre curves behind a large dunes system that originated from beach T 762. The creek enters the sea behind 200 m long beach **T 759**. The beach occupies a small bay at the mouth of the creek, with a 25 m high headland and rock platform to the south and rock ridges extending into the surf in the north.

The beach blocks the creek entrance, causing it to drain out against the northern rocks. A bare berm and overwash flats and small lagoon back the beach, however during floods the low bare sand beach can be washed over and away by the flooding creek. It faces southwest into the prevailing waves which average up to 2 m and maintain a 200 m wide surf zone with a large permanent rip running out against the southern rocks (Fig. 4.149).

Beach **T 760** commences at the rock ridge and continues behind the rocks and ridges for 600 m to an irregular low rocky point. Waves break heavily over the southern rocks and reefs that extend 200 m offshore, with a permanent rip against the southern rocks and a secondary northern rip operating during higher waves. The waves decrease to the north as the reefs extend up to 1 km offshore. It is backed by a semi-stable foredune, then 500 m of vegetated dunes which originated from beach T 561, and which merge with the active dunes migrating southeast from beach T 762.

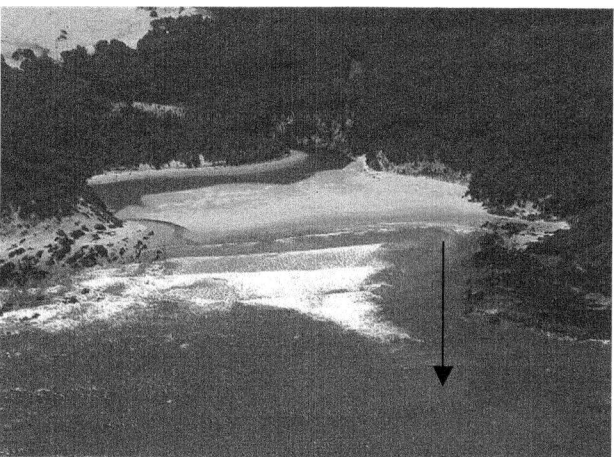

Figure 4.149 The Nielsen River mouth and beach T 759, with a deep permanent rip channel (arrow) against its southern rocks.

T 761-764 ALBINA ROCK (S)

No.	Beach	Rating HT LT		Type inner	outer bar	Length
T761	Albina Rock (S4)	3	5	R+rocks/reefs	-	200 m
T762	Albina Rock (S3)	7	8	TBR	RBB	650 m
T763	Albina Rock (S2)	7	8	TBR+rocks/reefs	-	200 m
T764	Albina Rock (S1)	7	8	TBR+rocks	RBB	500 m
Spring & neap tidal range = 0.9 & 0.5 m						

Albina Rock is a 14 m high islet located 1 km off a protruding low rocky point, with a string of reefs between the point and rock. Beaches T 761-764 extend for 2 km south to the northern boundary of Birthday Bay. The beaches all face west-southwest directly into the prevailing high swell and westerly winds.

Beach **T 761** is located to the lee of rocks and rock reefs extending from the shoreline up to 1 km offshore, which lower waves at the shore to less than 1 m and maintain a

reflective beach face. It is bordered by low rocky point and platforms, with a central rock outcrop on the beach as well as the extensive reefs. Well vegetated dunes rising to 15 m back the beach.

Beach **T 762** commences on the northern side of the rocks and trends to the north for 650 m to the next rocky point and reefs, with a small creek draining across the northern end of the beach. The beach is exposed to the full force of the waves and has a 300 m wide double barred surf zone, with usually two to three inner rips and two outer rips, including one against the northern rocks. It is bordered by rock reefs extending up to 1 km seaward and backed by an active dune system that has migrated 700 m to the east and more than 1 km to the southeast to the Nielsen River. The largely bare active dunes rise to 30 m.

Beach **T 763** is located amongst the northern boundary rocks. It extends for 200 m to the lee of the rocks, with waves breaking 100-200 m offshore on the outer rocks and reefs, reducing them to less than 1 m at the shore. The irregular rock-studded beach is backed by a vegetated foredune.

Beach **T 764** commences on the northern side of the rocks and continues north for 500 m to the next rocky point with the reefs extending 1.5 km offshore to Albina Rock. The beach is exposed to the prevailing high waves and has a double bar system, with the inner surf zone containing a mixture of sand and rocks and reefs, drained by rips to each end of the beach, while the outer surf zone has a sandy bar drained by rips to each side. Active sand dunes commence right at the beach and extend up to 400 m inland reaching 50 m in height. A small creek drains across the southern end of the beach.

T 765-768 WALLER & ALBINA CREEKS

No.	Beach	Rating		Type		Length
		HT	LT	inner	outer bar	
T765	Waller Ck	7	8	TBR	RBB	250 m
T766	Albina Ck	7	8	TBR	RBB	550 m
T767	Albina Ck (N1)	4	5	LTT+rocks/reef		200 m
T768	Albina Ck (N2)	4	5	LTT+rocks/reef		200 m
Spring & neap tidal range = 0.9 & 0.5 m						

To the north of the Albina Rock reefs the rocky coast continues to trend north with beaches T 765-768 set in amongst the rocks and reefs along the next 2 km of shore. Beach **T 765** occupies the 200 m wide bedrock mouth of Waller Creek. The beach extends between the two sand-draped bedrock sides, with rock and reefs extending 100 m into the surf zone. It receives waves averaging 2-3 m, which maintain an inner bar drained by a deep rip against the southern rocks, and an outer bar, which breaks during high seas. The creek maintains an area of unstable bare sand behind the beach, with a blowout climbing the southern boundary rocks.

Beach **T 766** is located 300 m to the north at the mouth of Albina Creek. The creek emerges from a narrow 100 m deep V-shaped valley to flow though an elongate 300 m long lagoon and then across the southern end of the 550 m long beach (Fig. 4.150). Densely vegetated dune-draped slopes border the beach, with rocky points and reefs to either side. The beach has an inner bar, which at times merges with a tidal delta, an inner rip draining out through the boundary rocks and an outer bar which links in the south with the Waller Creek bar. A vegetated dune-draped point forms the northern boundary with beach **T 767** occupying a 200 m long section of shore dominated by rock outcrops and reefs extending 200 m offshore, and lowering waves to about 0.5 m at the shore. It is backed by vegetated dunes then slopes that rise to 90 m. A walking track reaches the northern end of the beach.

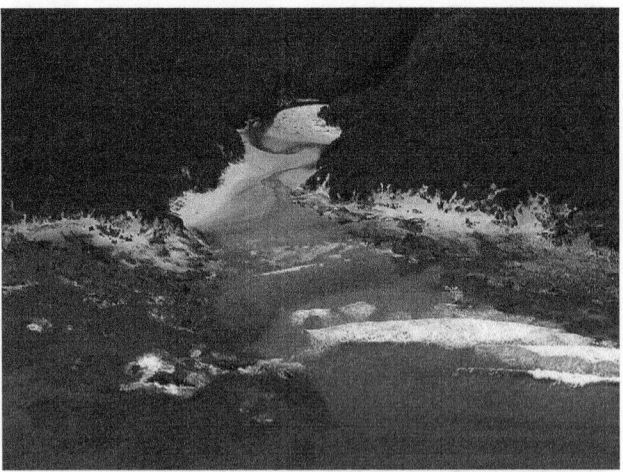

Figure 4.150 Albina Creek flows across the rear of beach T 766 to reach a reef-dominated surf zone.

Beach **T 768** is located 300 m north along the rocky shore. It is a curving 200 m long southwest-facing wide sandy beach backed by a storm boulder ridge. The beach is bordered and crossed by rocks, with a mixture of rock and sand off the beach and a series of reefs extending 500 m offshore. Behind the boulder ridge is a strip of grass then heath-covered slopes rising to 70 m. A walking track emerges from the heath to reach the southern end of the beach and continue south to beach T 767.

T 769-770 DISCOVERY BEACH

No.	Beach	Rating		Type		Length
		HT	LT	inner	outer bar	
T769	Discovery Beach	7	8	TBR+reef	RBB	900 m
T770	Discovery Beach (N)	6	7	TBR+reef	-	250 m
Spring & neap tidal range = 0.9 & 0.5 m						

Discovery Beach (T 769) extends across the mouth of Lagoon Creek, deflecting it 500 m south to the southern rocks. The 900 m long beach is bordered by rocks to either end and faces southwest into the prevailing waves. A low gradient inner bar and rock reefs extend 100 m off the southern half of the beach, with a sandy outer bar just beyond the reefs producing a 300 m wide surf zone.

Small rips drain the inner surf zone, with a permanent rip against the southern rocks and a large rip draining across the centre of the surf. The beach is backed by a high hummocky unstable foredune in the north with some small lakes behind. The creek destabilises the southern half of the beach resulting in a wide southern berm-overwash area in front of the narrow creek.

Beach **T 770** is located 100 m to the south in a 200 m wide southwest-facing embayment bordered by rock platforms and 10 m high vegetated rocky points with reefs filling the southern half of the small bay. Waves lowered by the outer reefs break 100 m offshore over the reefs and sand with a rip flowing out across the sandy central-north section of the beach. The 250 m long beach is backed by a scarped 15 m high foredune, then patches of grass and heath-covered undulating terrain. A walking track follows the rear of the foredune.

T 771-773 GEORGE POINT (S)

No.	Beach	Rating HT LT		Type	Length
T771	George Pt (S 3)	3	5	R+rock flats	500 m
T772	George Pt (S 2)	3	5	R+rock flats	800 m
T773	George Pt (S 1)	4	5	R+rocks/reef	500 m
Spring & neap tidal range = 0.9 & 0.5 m					

George Point is a 30 m high, 500 m wide point composed of Precambrian metamorphic rocks and surrounded by irregular rock reefs. To the south of the point is a 1.5 km wide roughly curving rocky bay containing three near continuous cobble beaches (T 771-773). A 10 km long walking track from Macquarie Harbour reaches the rear of beach T 772 and continues south along the shore.

Beach **T 771** is a crenulate 500 m long north-trending high tide cobble beach fronted by continuous 40-80 m wide intertidal rock flats, together with some scattered reefs extending 200 m offshore. It terminates at a protruding 50 m wide reef-fronted low rocky point. The reefs lower waves to less than 1 m with waves only reaching the beach at high tide. The walking track follows the rear of the beach, with grass- and heath-covered slopes rising in steps to 150 m. Beach **T 772** continues as a crenulate high tide cobble beach on the northern side of the point for another 800 m to a slightly protruding 30 m high grassy bluff. The beach is fronted by a 10-40 m wide rock flats and scattered reefs extending 500 m offshore, with low waves at the shore. Grassy bluffs increase in height northward behind the beach reaching 30 m at the northern end, with the walking track running along the top.

Beach **T 773** occupies a 450 m wide south-facing bay at the north end of the embayment and immediately to the west of George Point. The high tide cobble beach is bordered by rocky shore, with a central rock outcrop and reefs extending up to 1 km to the south, which lower waves to less than 1 m at the shore.

T 774 GEORGE POINT (N)

No.	Beach	Rating HT LT		Type	Length
T774	George Pt (N)	6	7	RBB	800 m
Spring & neap tidal range = 0.9 & 0.5 m					

On the northern side of George Point is a 1.2 km wide west-facing embayment, with beach **T 774** extending from the rear of the point for 800 m to the north. A small creek crosses the southern end of the beach, with George Creek crossing the north end, both emerging from steep V-shaped gorges eroded into the backing slopes that rise to 150 m. The southern end of the beach is sheltered by rocks and reef extending 100 m north of the point, with the creek crossing the beach in lee of two inshore reefs. Wave height increases rapidly up the beach averaging over 1.5 m and maintaining a continuous longshore trough to the mouth of George Creek, with a bar onshore and rips draining to each end. A partly active dune climbs the slopes between the two creeks reaching 40 m in height and extending up to 700 m inland to the southern incised creek.

T 775-778 SLOOP POINT-DUNES CREEK

No.	Beach	Rating HT LT		Type	Length
T775	Sloop Pt (N1)	3	5	R+rocks & reefs	300 m
T776	Sloop Pt (N2)	3	5	R+rocks & reefs	200 m
T777	Sloop Pt (N3)	3	5	R+rocks & reefs	500 m
T778	Dunes Ck	6	7	TBR	1 km
Spring & neap tidal range = 0.9 & 0.5 m					

Sloop Point is an irregular 15 m high point composed of metamorphic rocks and surrounded by rocks and reefs extending up to 500 m offshore. The rocky shore extends for 1.2 km northeast of the point to Dunes Creek and contains three rock-dominated beaches (T 775-777), with a sandy beach (T 778) beyond (Fig. 4.151). The point is accessible via the walking track, which crosses from Betsys Bay on Macquarie Harbour to Dunes Creek.

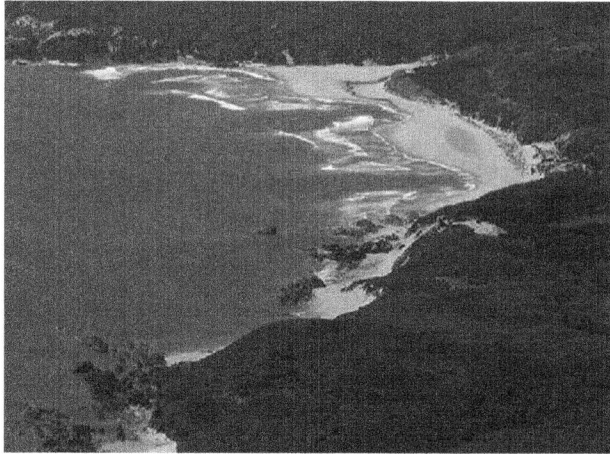

Figure 4.151 Dunes Creek (top) crosses the northern end of the rip-dominated beach T 778.

Beach **T 775** commences in lee of the rocky point and consists of a crenulate high tide sand cobble beach that trends to the northeast for 300 m past a small creek mouth to a vegetated sand foreland attached to a 100 m long rocky islet. The beach is backed by gently sloping heathland and fringed and fronted by rocks and reefs extending up to 600 m offshore, which reduce waves to less than 0.5 m at the shore. Beach **T 776** continues on the northern side of the foreland for another 200 m to a jagged rocky point backed by slopes rising to 35 m. Large rock outcrops dominate the lower beach and inshore forming three tidal pools, with very low waves at the shore.

Beach **T 777** trends northeast from the point for 500 m to the southern side of Dunes Creek. Rocks continue to outcrop along the crenulate beach, with open water in between. Waves are reduced by the outer reefs with waves averaging less than 1 m. It is backed by heath-covered slopes rising to 20-30 m, with a blowout climbing the northern slopes and two 5 ha lakes behind.

Dunes Creek is a larger creek draining an area of backing terrain that rises to 200 m. The last 1.5 km of the creek flow between the bedrock slopes to the south and well vegetated dunes to the north, finally forming a narrow lagoon to reach the shore at the southern end of beach **T 778**. At times the creek is deflected northwards behind the berm to drain across the centre of the beach. The beach trends north-northeast for 1 km to the beginning of the next section of sloping rocky shore. Waves averaging 1.5 to 2 m maintain a well developed transverse bar and rip system usually maintaining three beach rips and a highly crenulate rip-induced shoreline. A second creek drains out across the northern end of the beach. Well vegetated transgressive dunes extend up to 2 km southeast of the beach rising to 60 m in the centre. The 4 km long walking track for Betsys Bay reaches the northern end of the beach and follows the beach to the track out to Sloop Point.

T 779-784 **DUNES CREEK (N)**

No.	Beach	Rating HT LT	Type	Length
T779	Dunes Ck (N1)	6 8	TBR+rocks/reef	350 m
T780	Dunes Ck (N2)	6 8	TBR+rocks/reef	300 m
T781	Dunes Ck (N3)	6 8	TBR+rocks/reef	300 m
T782	Dunes Ck (N4)	3 3	R/LTT	50 m
T783	Dunes Ck (N5)	6 8	TBR+rocks/reef	350 m
T784	Dunes Ck (N6)	3 5	R+rocks/reef	100 m
Spring & neap tidal range = 0.9 & 0.5 m				

North of the point where the Betsys Bay track reaches the coast are 6 km of west-facing exposed rocky shore dominated by scattered rocks and reef extending up to 500 m offshore. In amongst the rocks are six beaches (T 779-784) all dominated by the bordering and fronting rocky shore and reefs.

Beach **T 779** is located 1.5 km north of the track and consists of a 350 m long sandy beach, bordered by rock platforms with rocks outcropping along the beach together with a prominent central reef and foreland. A small creek drains across the southern half of the beach. The 100 m wide surf zone contains both a sand bar and the reefs, with permanent rips located either side of the central reef. Beach **T 780** lies 200 m further north and is a similar 300 m long rock-bordered beach, with rocky shore dominating the southern half of the beach and a creek draining across the northern end of the rocks. Reefs lie up to 200 m offshore of the northern half, with a bar between the reefs and shore (Fig. 4.152). Waves average over 1.5 m on the outer reefs, with variable wave height along the shore. Both beaches are backed by a climbing partly unstable foredune, with three climbing blowouts along beach T 779 and a large blowout at the creek on the northern beach. Older well vegetated dunes extend up to 1 km inland and reach 90 m in height.

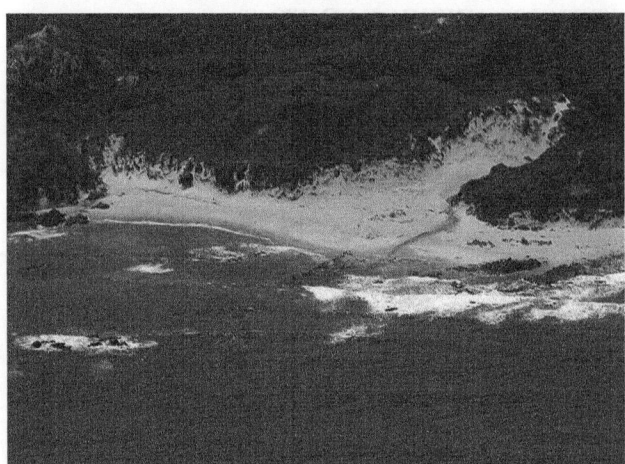

Figure 4.152 Beach T 780 is crossed by a small creek and partly sheltered by inshore reefs.

Beach **T 781** is located 200 m to the north and is a similar 300 m long west-facing sand beach bordered by jagged rock platforms and with rock outcrops and reefs extending the length of the beach, including a large central collection of rocks and reefs. The reefs lower waves to about 1 m at the shore. However strong rips are generated amongst the reefs during higher waves. It is backed by a 20 m high hummocky foreland.

Beach **T 782** is a 50 m long pocket of sand located in a small gap in the rocks. It is bordered by wide irregular rock platforms and backed by a storm cobble to boulder beach. The beach is sheltered by reefs extending up to 500 m offshore, with usually low to calm conditions at the shore. During high waves the surf extends 500 m seaward with a rip running out of the small embayment.

Beach **T 783** lies 500 m further north and is a 300 m long section of near continuous sandy shore dominated by bordering rock platforms and four ridges of rocks that extend from the beach 50 m into the surf, with reefs extending up to 500 m offshore. Waves average 1 to 1.5 m close to shore and maintain three permanent rips between the rock ridges. A 15-20 m high hummocky

foredune backs the beach, with a small creek draining across the centre of the beach.

Beach **T 784** is located at the mouth of a small creek 1 km to the north. The creek flows into a curving, south-facing rocky bay that narrows to 50 m at its entrance. The beach is located at the head of the bay and consists of a discontinuous 100 m long strip of high tide sand, with scattered rocks to either end, a sandy central section, with a prominent rock located just off the centre of the beach. A bare rock islet protects the western side of the bay with usually low waves at the shore.

T 785-789 EDWARDS BAY

No.	Beach	Rating HT LT		Type	Length
T785	Grandfathers Beach	3	5	R+rock flats	600 m
T786	Charleys Beach	4	5	R/LTT+rocks/reef	350 m
T787	Tiddys Beach	6	6	TBR	700 m
T788	Pebbly Beach	3	5	R+rock flats	150 m
T789	Pebbly Beach (W)	3	5	R+rock flats	100 m
Spring & neap tidal range = 0.9 & 0.5 m					

Edwards Bay is a 1.5 km wide southwest-facing rocky bay bordered by Trumpeter Point to the west and the Bird Islets to the south. Cape Sorell lies 1.5 km to the northwest. Four beaches (T 786-789) occupy parts of the bay shore, while beach T 785 lies south of the islets.

Grandfathers Beach (**T 785**) is located at the base of irregular rocky slopes that rise to 60 m to a collection of rocks called The Grandfathers. The beach curves to the north for 600 m as a narrow high tide sand and cobble beach fronted by continuous, irregular inter- to supratidal rock flats, ranging in width from 50-100 m and cut by several gutters. Two small creeks descend the backing slopes to cross the southern end and centre of the beach. It is moderately sheltered by the platforms and rocks and reefs extending up to 1 km offshore with waves averaging less than 1 m at the shore and only reaching the beach at high tide.

Charleys Beach (**T 786**) is located to the lee of the Bird Islets and protrudes westward in lee of inshore rocks and reefs. The 350 m long beach has white sand grading into a sand and rocky seafloor. It is has a well vegetated foredune and older dunes extending 250 m inland impounding a small lake. A 4WD track from Pilot Bay reaches the centre of the beach.

Tiddys Beach (**T 787**) occupies the eastern shore of Edwards Bay and is bordered by 10 m high Split Rock to the north and a dune-capped rocky point to the south. It is a curving 700 m long beach that faces west towards the bay entrance and receives waves averaging 1-1.5 m. These maintain a 50 m wide bar usually cut by three central beach rips. The outer seafloor has rock reefs, with higher waves breaking over the reefs. The beach is

backed by a scarped 10-20 m high foredune, then older vegetated dunes and lakes extending 500 m inland to Teal Pond, a small dune-dammed lake. The vehicle track runs around the rear of the dunes.

Pebbly Beach (**T 788**) is located in a 150 m wide rocky bay on the northern side of Split Rock. The beach consists of a narrow 150 m long strip of sand and cobbles fronted by continuous 50 m wide intertidal rock flats that slope into a rocky bay floor. Waves average 0.5 m and less at the shore with higher waves breaking over midbay rocks and reefs. The 4WD track provides access to the slopes above the southern end of the beach.

Beach **T 789** is a 100 m long pocket beach located 500 m west of Pebbly Beach. The beach faces south out of a small rocky bay and consists of a strip of high tide sand and cobble fronted by irregular intertidal rock flats up to 50 m wide, then irregular rock reefs extending 300 m into Edwards Bay. The reefs lower waves to less than 0.5 m at the shore.

T 790-791 PILOT BEACH

No.	Beach	Rating HT LT		Type	Length
T790	Pilot Beach	3	3	R+tidal creek	1.1 km
T791	Macquarie Heads (W)	3	3	R	100 m
Spring & neap tidal range = 0.9 & 0.5 m					

Pilot Beach (**T 790**) is located adjacent to Hells Gate, the mouth of Macquarie Harbour. The 1.1 km long north-facing beach has developed since a 1.2 km long rock breakwater was constructed in the 1900's to channelise the flow through Hells Gate (Fig. 4.153). The beach now extends from the side of the breakwater west to Wooding Point, which rises to 50 m high Watts Hill. The beach is sheltered by the 1 km long north-trending western rock shore and the breakwater, with waves usually averaging about 0.5 m at the western end of the beach increasing to 1 m at the breakwater. A small creek flows across the western end of the beach maintaining a shallow tidal delta, while the central-eastern section of beach tends to be reflective, to low tide terrace during higher waves. The entire beach has prograded 300 m northwards against the breakwater decreasing to the west. It is now backed by a low hummocky area of progradation, then the vehicle track from Macquarie Heads.

Beach **T 791** is located between the breakwater and Macquarie Heads. It is a 100 m long north-facing reflective beach that is sheltered by the breakwater and the Kawatiri Shoal. These are tidal sand shoals that extend 1 km north of Hells Gate and dominate the shallow 500 m wide entrance to the harbour. The beach is bordered by the sloping rocks of Macquarie Heads, with a vehicle track running across the slopes to the harbour entrance.

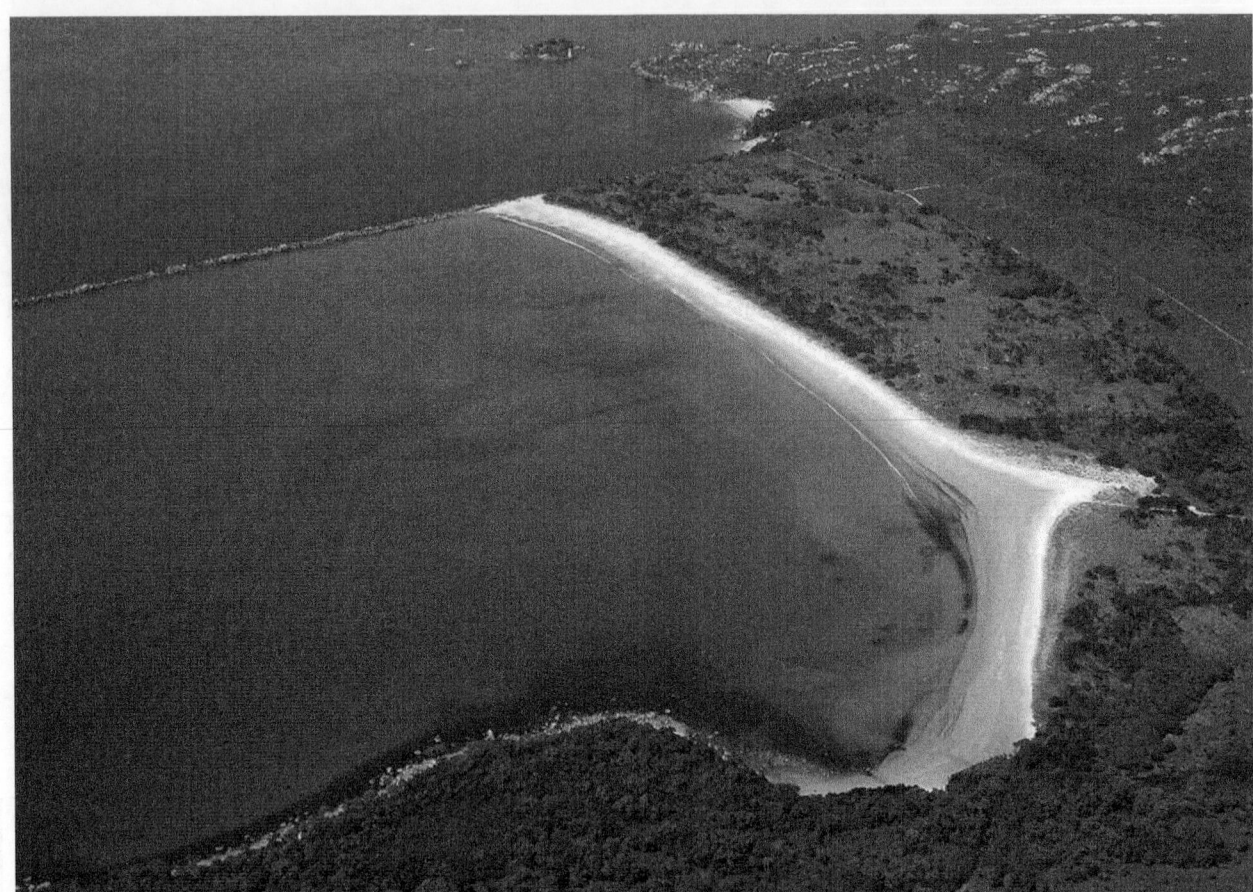

Figure 4.153	Pilot Beach has built seaward since the construction of the boundary Hells Gate training wall.

WEST COAST: NORTHERN SECTION

Region 3B Macquarie Harbour-Woolnorth Point

Coast length:	244 km	(1545-1789 km)
Beaches	173	(T 792-964)
Regional maps	Figure 4.154	Page 201
	Figure 4.160	Page 204
	Figure 4.170	Page 213

The northwest coast of Tasmania extends for 244 km from the entrance to Macquarie Harbour at Hells Gate, north to Woolnorth Point on the northwestern tip of the island. This section contains 173 beach systems including several of the highest energy beaches in Australia, and probably some of the highest energy in the world. Most of the higher energy beaches are backed by extensive active and vegetated transgressive dune systems. The whole coast is sparsely populated with small communities at Trial Harbour-Remine, Granville Harbour, Pieman River, Temma and Arthur River, and the town of Strahan located 5 km inland in the south. Thirty-four of the northern beaches are accessible by road, 126 by 4WD tracks and 11 only on foot. Beaches occupy 122 km (50%) of the coast.

Figure 4.154 The northern half of the West Coast between Cape Sorell and Trial Harbour is dominated by the long, high energy Ocean Beach (T 792 & 793).

T 792-795 OCEAN BEACH

No.	Beach	Rating HT LT	Type inner	outer bar	Length
T792	Ocean Beach (S)	8 9	TBR/RBB	RBB/LBT	20.5 km
T793	Ocean Beach (mid)	8 9	TBR/RBB	RBB/LBT	7.8 km
T794	Ocean Beach (N)	8 9	TBR/RBB	RBB/LBT	3.9 km
T795	Ocean Beach (N1)	8 9	TBR+reefs	TBB/LBT	300 m
Spring & neap tidal range = 0.9 & 0.5 m					

Ocean Beach is one of the great beaches of the world. It is the longest beach on the Tasmanian west coast and faces west into the full force of the Southern Ocean, exposing it to one of the highest energy wave climates in the world (Fig. 4.155). On average waves are 3 m in height and reach 5 m every day, occasionally reaching as high as 18 m. In addition westerly gales regularly sweep across the coast leading to the development of the largest sand dune system on the west coast. The beach is further destabilised by the Henty and Little Henty rivers, which divide the 32 km long beach into three. The river mouths have to fight against the persistent high waves and are usually deflected up to a few kilometres to the south thereby causing the actual individual beach lengths to vary by a few kilometres, as well as destabilising the shoreline and backing dunes. The surf zone is dominated by a continuous double bar to in places a triple bar system between 500 and 600 m in width, with a rip-dominated inner bar cut by the largest rips in Australia averaging 450-650 m in spacing, with larger rips crossing the outer bar. Apart from car access via Strahan the beach is undeveloped and difficult to access.

Figure 4.155 Ocean Beach under typical 3-5 m wave conditions with waves breaking across a 500 m wide triple bar surf zone.

The southern part of the beach (**T 792**) commences at Braddon Point on the northern side of the entrance to 500 m wide Macquarie Harbour and opposite Hells Gate. The extensive ebb tidal Kawatiri Shoal and Cape Sorell afford some protection to the first 3-5 km of the beach, with a single rip-dominated bar and waves increasing from 1 to 1.5 m, while the beaches are backed by a few foredunes and low hummocky dunes. The remainder of the beach however receives the full force of the 3 m high waves, and contains a double to triple bar system, with

usually 35 large inner bar rips extending up to the Henty River mouth. The beach is backed by an irregular 10-30 m high often scarped foredune then largely well vegetated transgressive dunes that extend 0.5-7 km inland and to heights of 50 m. These become more unstable to the north and include the bare 400 ha Henty Dunes, which border the northern 3 km of beach and the river mouth. The dunes receive a high rainfall and have numerous lakes and wet deflation hollows, which feed small creeks draining to the beach. In all, the southern dunes cover more than 6,000 ha. The only public access to the beach is along the Ocean Beach Road from Strahan, 5 km to the east, which leads to a beachfront car park next to a small creek (Figs. 4.156 & 4.157). The northern end of the beach is accessible via the Sand Dunes Picnic ground in lee of the Henty Dunes, which requires a 2 km walk across the dunes to the shore.

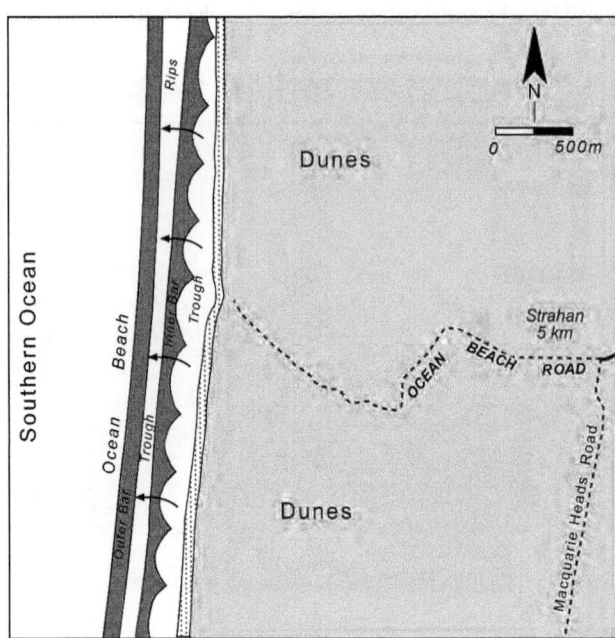

Figure 4.156 Ocean Beach is located west of Strahan and has a high energy multibar surf zone.

Figure 4.157 Ocean Beach on a relatively calm day, with the road from Strahan and car park shown in centre.

The central section of Ocean Beach (**T 793**) commences at the shifting Henty River mouth (Fig. 4.158) and

continues for roughly 7.8 km to the equally shifting mouth of the Little Henty River. Wave height, surf zone width and bar, rip and beach conditions remain the same along this section. Most of the beach is backed by the northern Henty Dunes, a 500 ha predominantly active dune sheet, which extends up to 1.5 km inland. There is no formal access to this beach.

Figure 4.158 The shifting mouth of the Henty River separates beaches T 793 & 794.

The northern section (**T 794**) extends north of the shifting Little Henty River for approximately 3.9 km to the base of a 120 m high well vegetated hill. The waves, wide surf zone and rips continue right to the rocky boundary. The entire beach is destabilised by the river mouth which can shift as much as 3 km along the shore, with the beach consisting of a low bare beach ridge, backed by the active or inactive 100-200 m wide river channel. The only access route is via a rough 2 km long vehicle track that follows the shore south from Trial Harbour.

Beach **T 795** is located at the northern end of Ocean Beach and consists of a curving 300 m long beach wedged between low rocks. It faces southwest across an inner surf zone and shoreline dominated by several rocks and rock reefs. Waves break over the northern end of the outer bar and then break heavily on the reefs, which result in lower waves at the shore. The beach is backed by vegetated slopes rising to 50 m and cut by the 4WD track from Trial Harbour.

Swimming: This is a very hazardous beach. It is remote and usually deserted, has usually high waves, a very wide surf zone, and strong rips in the inner surf zone. In addition the periodic water set up and set down, every 1 to 2 minutes, produces strong uprush and backwash on the beach, which can knock people over and drag then into the rips. Best to stay on the shore unless conditions are calm, when rips however will still be present.

Surfing: Surfers do try their luck here, usually surfing the rebroken waves in the inner surf zone. Its a long way out to the outer breakers.

T 796-799 **TRIAL HARBOUR**

No.	Beach	Rating HT	LT	Type	Length
T796	Trial Harbour (S2)	3	5	R+reefs	50 m
T797	Trial Harbour (S1)	4	6	R+rocks/reef	450 m
T798	Trial Harbour (S)	3	4	R+reefs	200 m
T799	Trial Harbour	3	4	R+reefs	300 m
Spring & neap tidal range = 0.9 & 0.5 m					

Trial Harbour is an exposed west-facing 500 m wide embayment, backed by the small settlement of Remine. The small community was gazetted as a town site, but today consists of a collection of fishing shacks occupying some of the sites. The bay was used as a makeshift harbour commencing in 1881, but today is only used to launch small fishing boats off the beach through the numerous reefs, which extend 500 m offshore. Waves average over 3 m on the outer reefs making this a very hazardous section of coast. Four beaches (T 796-799) are located in and just south of the harbour, all protected to varying degrees by the extensive reefs (Fig. 4.159). All are accessible via the Trial Harbour Road and the vehicle track that runs south to Ocean Beach.

Figure 4.159 The small community of Remine at Trial Harbour with the anchorage to the left adjacent to beach T 799.

Beach **T 796** is a curving 50 m long pocket of sand that faces northwest between encircling irregular rock platforms. Waves break over the outer reefs and average less than 1 m at the reflective sandy shoreline. A rip runs out against the southern rocks.

Beach **T 797** is the longest beach in the harbour area. It extends for 450 m along the southern side of Remine. It curves slightly between boundary rocks, with a prominent central reef and foreland dividing the beach in two, with shallow reefs to the south and deeper reefs to the north. Waves break over the reefs and average about 1 m at the shore. The waves and reefs generate two permanent rips in the southern reef-dominated 'bay' and two rips at the end of the northern 'bay'. A few shacks back the northern end of the beach, with the track running along the rear of

Regional map 11 West Coast: Trial Harbour to Sandy Cape

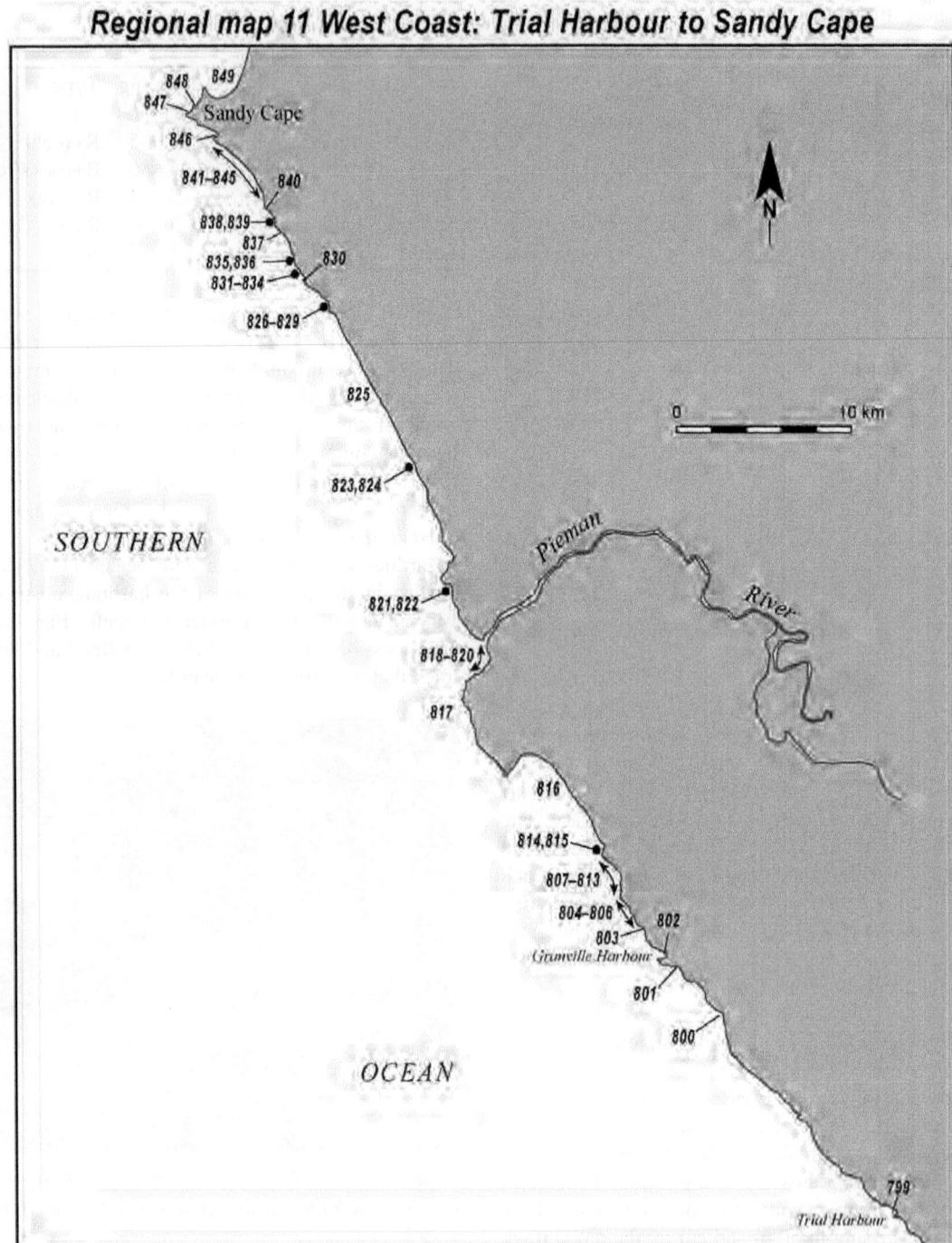

Figure 4.160 The north West Coast between Trial Harbour and Sandy Cape

the remainder and a small creek draining to the lee of the central foreland. A 10-15 m high foredune backs the beach with an elongated wetland behind which is drained by the creek.

Beach **T 798** lies to the southern side of a sandy foreland that is located in front of the main area of shacks between a small southern boundary reef-tied foreland and the main sandy foreland. The 200 m long beach faces southwest and is sheltered sufficiently by the reefs and a shallow platform that they form a 'lagoon' between the reefs and shore with waves usually less than 0.5 m at the shore and calm conditions common. Out on the outer reef is one of the biggest rideable waves in Tasmania with a steep take

off and low hollow left. A right-hand bommie is located on the northern side of the harbour. This is a wild danger location for experienced surfers only.

Beach **T 799** is the main **Trial Harbour** beach and site of the 'harbour' and backed by the main area of shacks. It commences at the tip of the sandy foreland and curves to the north for 300 m narrowing and terminating against the northern rocky shore. Extensive rock reefs lie off the southern half of the foreland, with several rocks and shallow reef off the northern half, and only a 50 m wide central sandy section into which drains Wakefield Creek. This area was called 'a hole in the rock' and a 'miserable apology for a port' when used as a commercial harbour,

when cargo was transferred from steamers by lighters to the shore and periodic large seas ran into the harbour. Today it is used by smaller fishing boats and during high seas is the site of a rip draining the harbour area.

To the north of Trial Harbour is 10 km of northwest-trending steep, rocky coast rising sharply to 50 m then gradually too as high as 400 m. The slopes are incised by numerous small streams and the larger Packers, South Gap, Granite, St Clair, Amy and Foster creeks. The 4WD Granville Harbour track follows the slopes to the Tasman River where it joins a spur off the Granville Harbour Road.

T 800 TASMAN RIVER

No.	Beach	Rating HT LT		Type	Length
T800	Tasman R	7	9	TBR+rocks/reef	300 m
Spring & neap tidal range = 0.9 & 0.5 m					

The **Tasman River** is the first section of coast accessible by car north of Trial Bay. At the mouth of the steep, deeply incised small river is beach **T 800**. The gravely river bed drains out amongst rocks at the southern end of the beach, which curves for 300 m to the north and is bordered by low irregular rock platforms together with a central outcrop of rocks. Waves averaging 3 m break over an outer bar and boundary reefs converging on the beach, with a strong permanent rip flowing out towards the northern end of the beach. The steep yellow beach is bare of vegetation and grades into an unstable foredune and partly exposed white Pleistocene dunes, which have climbed part way up the backing slopes.

T 801-802 GRANVILLE HARBOUR

No.	Beach	Rating HT LT		Type	Length
T801	Cannonball Bay	5	9	Cobble+rocks	50 m
T802	Granville Hbr	3	5	Cobble+rocks/reef	200 m
Spring & neap tidal range = 0.9 & 0.5 m					

Granville Harbour is a 500 m wide semicircular-shaped, protected shallow rocky bay located 4 km north of the Tasman River and accessible via the gravel Granville Harbour Road. A collection of fishing shacks lines each side of the end of the road and forms the small community of Granville Harbour. A second collection of houses is located in the southern corner of the bay. There is one beach in the harbour area (T 802) and one just to the south (T 801).

Cannonball Bay is a narrow V-shaped south-facing rocky bay with beach **T 801** located in a 50 m wide gap at the northern end of the 300 m wide bay. The beach lies across a small creek and is composed of cobble and boulders presenting a steep beach face to the persistent waves that roll into the narrow bay. It is bordered by the

exposed irregular rocky shore of the bay with larger waves breaking outside and running into the bay. The Granville Harbour road runs 200 m east of the bay.

Inside Granville Harbour is 1.5 km of generally low gradient rocky shore sheltered by outer reef and refraction into the bay with usually low wave to calm conditions along the inner shore. Most of the shoreline is composed of rocks, reefs and boulders. Beach **T 802** is located along the southern side of the bay and consists of a curving 200 m long high tide sand and boulder beach grading into an intertidal area of cobbles, boulders and rock flats, with deeper water of the bay further out. The centre of the beach has been partly cleared of boulders and is used as the main boat launching area, with a car and trailer parking area to the rear (Fig. 4.161).

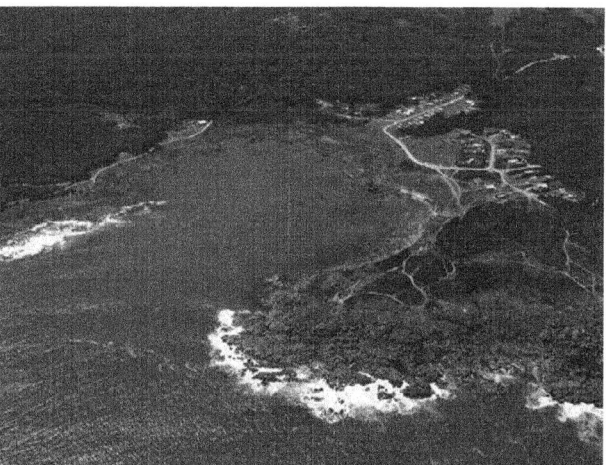

Figure 4.161 The small community of Granville Harbour is located adjacent to the natural anchorage on an otherwise exposed coastline.

T 803-809 STINGRAY BAY-DUCK CREEK

No.	Beach	Rating HT LT		Type	Length
T803	Stingray Bay	3	4	R/LTT+rocks/reef	200 m
T804	McGuinness Gut	3	4	R+platforms	60 m
T805	McGuinness Gut(N)	3	4	R+rocks/reef	150 m
T806	Duck Ck (S4)	3	4	R+rocks/reef	500 m
T807	Duck Ck (S3)	3	4	R+rocks/reef	100 m
T808	Duck Ck (S2)	3	4	TBR+rocks/reef	300 m
T809	Duck Ck (S1)	3	4	TBR+rocks/reef	600 m
Spring & neap tidal range = 0.9 & 0.5 m					

To the north of Granville Harbour is a 6 km long section of low gradient rocky shore up to Hoyle Creek at the southern end of Four Mile Beach. The entire shoreline is highly irregular and paralleled by numerous rocks and reefs extending 500 m offshore, resulting in lower and variable wave conditions along the shore. The Top Farm vehicle track follows the shoreline up to Duck Creek, with a second track between Duck and Hoyle creeks. Beaches T 803-809 occupy parts of the 4.5 km of shoreline between the harbour and Duck Creek.

Stingray Bay is a 300 m wide semicircular shaped, low rocky bay located 1 km north of the harbour. The bay faces west but is protected by a ridge of rock that almost encloses the bay with a central 50 m wide gap for waves and outer reefs extending a further 400 m offshore. Beach **T 803** is located in the southeast corner of the bay and consists of a low energy 200 m long reflective beach fronted by a shallow sand and rock bay floor. It is backed by a low grassy foredune and the track. The dune is crossed by vehicle tracks, which are used to access the beach to launch small fishing boats, with some boats occasionally moored in the sheltered bay. The vehicle track continues around the perimeter and to the north.

McGuinness Gut is located 1 km to the north and consists of a 60 m long pocket of sand (beach **T 804**) located at the end of a 200 m long 50 m wide gutter between intertidal rock platforms, with reefs continuing another 300 m offshore. The protected location results in low wave to calm conditions at the shore, where the small beach is used to launch boats. The vehicle track runs past the rear of the beach, with a fishing shack 100 m to the northeast.

Beach **T 805** lies 500 m northwest of the Gut and is a 150 m long patch of sand bordered by converging irregular rocks and reefs, with two large rock outcrops on the beach which is backed by a storm boulder beach, then vegetated slopes. Dense subtidal reefs front the beach and continue 500 m offshore, resulting in low waves at the shore. The vehicle track winds through the backing vegetated hummocky dune-draped slopes, to a cleared area overlooking the northern end of the beach.

Beach **T 806** commences 200 m to the north where the track descends off the dune ridge and runs along lower land behind the 500 m long sandy beach. The beach trends north but is highly irregular owing to several rock ridges cutting across the shore and continuing 500 m seaward as rocks and reefs. Waves break over the reefs with usually low waves at the shore. A 5-10 m high hummocky semi-stable foredune backs the beach with the track behind.

Beach **T 807** continues immediately north as a 100 m long high tide sandy beach bordered by two shore-perpendicular 100 m long ridges of rocks, with small ridges filling much of the seabed in between and reefs continuing 500 m offshore resulting in low wave to calm conditions at the shore. An unstable 10-20 m high hummocky foredune backs the beach. Beach **T 808** extends past the boundary rocks for another 300 m to a straight 300 m long west-trending rock ridge that forms its northern boundary. Sand fills most of the area between the boundary rocks, with waves averaging 1-1.5 m maintaining a low gradient 100 m wide surf zone drained by a rip that exits towards the northern end of the beach. A small creek drains across the southern end of the beach, while hummocky semi-stable dune ridges rise to over 20 m behind the central-northern part of the beach, with the track deflected 200 m inland around the dunes.

Beach **T 809** is the longest and most exposed beach along this section. The 600 m long beach commences at the base of the long rock boundary ridge and curves to the north to a series of linear west-trending ridges on the south side of Duck Creek. The southern half of the beach is fronted by a 150 m wide bar drained by a permanent rip against the southern ridge, while the northern half has subtidal rock ridges, with a second rip flowing out over the rocky seafloor (Fig. 4.162). A continuous 20 m high vegetated foredune backs the beach, with an active blowout behind the southern end. The track runs around the rear of the dunes to reach the northern end.

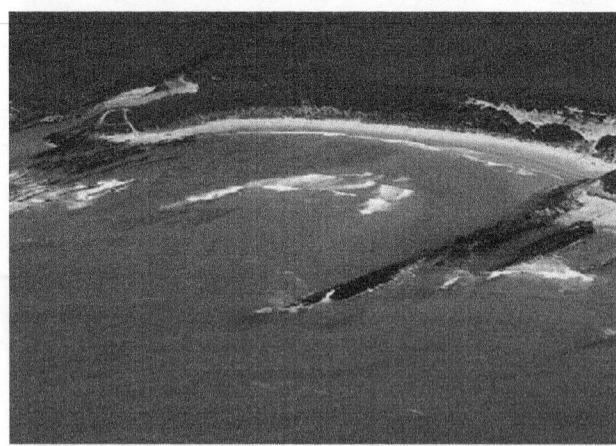

Figure 4.162 Beach T 809 is located just south of Duck Creek, with its surf zone dominated by the linear rock reefs.

T 810-815 DUCK-HOYLE CREEKS

No.	Beach	Rating HT	LT	Type	Length
T810	Duck Ck	2	3	R+tidal creek	40 m
T811	Duck Ck (N1)	4	5	LTT+rocks/reef	150 m
T812	Duck Ck (N2)	3	4	R+rocks/reef	300 m
T813	Duck Ck (N3)	3	5	R+rocks/reef	100 m
T814	Hoyle Ck (S)	3	5	R+rocks/reef	250 m
T815	Hoyle Ck	4	6	R+rocks/reef	250 m
Spring & neap tidal range = 0.9 & 0.5 m					

Duck Creek emerges from a narrow V-shaped valley, which drains the backing 100 m high plateau to reach the shore 4.5 km north of Granville Harbour in the centre of a rock-dominated section of coast. The rocky shore continues for another 1.5 km north to Hoyle Creek, which drains similar terrain. In between the two creek mouths are six rock-dominated beaches (T 810-815) all bordered and fronted by rocks and reefs extending 500-700 m offshore. The northern section of the Top Farm track follows the coast to Hoyle Creek and provides access to the beaches and shore.

Beach **T 810** is located at the mouth of Duck Creek, which reaches the sea at the end of a 50 m wide gap between 100-200 m long linear ridges of west-trending rocks. The 40 m long sandy beach is reworked by the creek flow, with the tannin from the creek staining the water of the small embayment. Waves are lowered to

0.5 m and less at the shore, with higher waves breaking outside the rocky boundaries. The vehicle track crosses the creek about 100 m upstream of the beach.

Beach **T 811** is located on the northern side of the boundary rocks and consists of a 150 m long crescent of west-facing sand bordered by rock ridges, the northern ridges curving as they trend west into the surf forming a 100 m wide opening to the 'bay'. The southern half of the bay has a sandy seafloor occupied by a low tide terrace, together with a pocket of sand in the southern corner. Waves break over a low gradient sandy floor between the rock ridges, with higher waves producing a strong rip flowing out of the narrow bay.

Beaches T 812 and 813 are adjoining high tide sand beaches dominated by a rock-filled shoreline. Beach **T 812** extends north for 300 m as a discontinuous irregular strip of white high tide sand and cobbles, with rocks outcropping the length of the beach and dominating the inner 200 m of the surf zone, with most waves breaking offshore and low waves at the shore. Beach **T 813** is a similar 100 m long curving pocket of high tide sand located 50 m to the north. It also faces west across dense inner reefs and rocks with most waves breaking 200 m and more offshore and low waves at the shore. The vehicle track runs right along the crest of both beaches.

Beach **T 814** is located 100 m to the north and is a curving 250 m long west-facing yellow sand beach that consists of a well developed inter- to high tide beach, bordered by 5-10 m high rocky points, and fronted by a reef-filled seabed and some large outcrops, with waves breaking up to 200 m offshore over the rocks and reefs. Waves average less than 1 m at the shore and surge up a steep reflective beach backed by a continuous well vegetated 10-20 m high foredune, with the track running behind.

Beach **T 815** continues immediately to the north and is a 250 m long high tide beach fronted by near continuous rocks and reefs, which terminate as Hoyle Creek drains across the southern end of Four Mile Beach. Waves break heavily on the outer rocks and reefs with two sheltered tidal pools amongst the rocks at the shore. A 4WD track crosses the backing foredune to the southern end of the beach, which is the main access point to the longer Four Mile Beach. There is a clearing behind the foredune, which is used as a campsite.

T 816 **FOUR MILE BEACH**

No.	Beach	Rating HT LT	Type inner	outer bar	Length
T816	Four Mile Beach	8 9	TBR	RBB	6.2 km
Spring & neap tidal range = 0.9 & 0.4 m					

Four Mile Beach (T 816) is an exposed 6.2 km long southwest-facing high wave and wind energy beach dominated by a wide surf zone and backed by active dunes. The beach commences in the south at the mouth of Hoyle Creek, which drains out against the southern rocky

section of shore and beach T 815 (Fig. 4.163). It trends to the northwest for 5 km curving round the west into Ahrberg Bay, in the lee of a lower rocky section of shore that trends 1 km southwest of the northern end of the beach. The entire beach receives waves averaging 3 m, which break across a 300 m wide double bar surf zone. The outer bar is usually rhythmic with widely spaced rips, while the inner bar varies from transverse to rhythmic bar and beach with usually 15 beach rips spaced about every 400 m dominating the inner surf. The northern corner of the beach is slightly sheltered by the northern point with usually cleaner and slightly reduced waves.

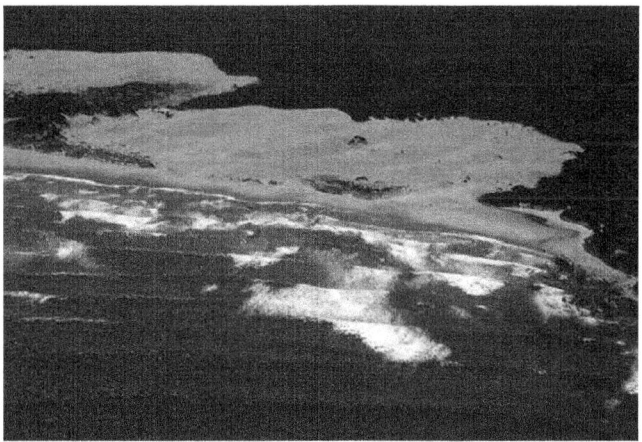

Figure 4.163 The southern end of Four Mile Beach is crossed by the small Hoyles Creek with extensive transgressive dunes extending to the north.

In addition to the high surf there is a 1 km long section of reefs off the centre of the beach, and seven creeks draining the hinterland and dunes to cross the beach including Hoyle, George Town Packet, Newdegate and Surprise creeks. The result is a very unstable foredune and backbeach with active dunes transgressing up to 1 km inland and older vegetated dunes up to 2 km inland rising to 40 m. The active dunes are extensively deflated down to the water table with numerous small lakes and wet areas linked to the beach drainage system, as well as feeding groundwater seepage across the beach. Only the northern south-facing section of beach has a well developed and vegetated 20-30 m high foredune. The southern Top Farm, central Wilson Road and a northern 4WD track reach the dunes and beach area, with the northern track continuing out to and around the northern headland.

In summary this is an exposed high energy rip-dominated beach backed by some of the most active dunes on the west coast.

T 817 **CONICAL HARBOUR**

No.	Beach	Rating HT LT	Type	Length
T817	Conical Harbour	2 3	R+rocks/reef	60 m
Spring & neap tidal range = 0.9 & 0.4 m				

Conical Harbour is a small sheltered rocky embayment located midway along the 8 km of rocky shoreline and reefs between Four Mile Beach and Hardwicke Bay. The small 200 m wide bay is named after rounded conical granite outcrops that extend inland from the shoreline, with the most prominent rocks adjacent to the small beach. Beach **T 817** is located in the southern corner of the bay, at the mouth of a small creek. It is 60 m long and faces north into a 50 m wide arm of the bay with rock reefs and platforms to either side, which together with outer rocks and reefs lower waves to less than 0.5 m at the shore (Fig. 4.164). A vehicle track reaches the bay where there are three fishing shacks located amongst the rocks. The beach is used to launch small boats, with boats occasionally moored in the gutter off the beach.

Figure 4.164 The small fishing community at Conical Harbour with beach T 817 tucked deep in lee of the rocks.

T 818-820 PIEMAN RIVER

No. Beach	Rating HT LT	Type inner	outer bar	Length
T818 Hardwicke Bay (S2)	2 3	R+rocks/reef	-	50 m
T819 Hardwicke Bay (S1)	3 4	R+rocks/reef	-	300 m
T820 Pieman River	7 8	TBR+river	D	1 km
Spring & neap tidal range = 0.9 & 0.4 m				

Hardwicke Bay is a 1.5 km wide southwest-facing bay located at the mouth of the Pieman River, the largest river on the northwest coast. The lower reaches of the river flow through a 15 km long, 100 m deep incised valley, which enters the sea in lee of the low rocky Pieman Head. Beaches T 818 and 819 are located along the rocky southern shore of the bay, while beach T 820 extends south of the river mouth.

Beach **T 818** is a 50 m long pocket of sand bordered by 50-100 m wide supra-tidal ridged rock platforms. It faces north into a 50 m wide rock-floored gutter between the platforms, with some rocks reaching the surface, and a sandy bay floor beyond the platforms. Beach **T 819** commences 50 m to the north and is a crenulate 300 m long high tide sand and cobble beach that varies in width as near continuous 50 m wide rock platforms impinge

upon the beach. There is an open sandy area at the southern end of the beach. A vehicle track backs both beaches and connects with two fishing shacks located in from the northern beach.

Beach **T 820** commences at the end of the rocks where the Violet Rivulet crosses the shore and tends due north for 1 km to the 100 m wide mouth of the Pieman River. The wide low gradient sandy beach is crossed by another central creek and backed by low heathland. It faces due west and receives waves averaging over 2 m, which break across a low gradient 500 m wide surf zone, with a dissipative outer bar that links the side of the bay. There is usually a well developed transverse bar and rip inner bar cut by a southern boundary rip, a central beach rip, and the deep river channel to the north which runs along the northern Pieman Head. The dark tannin water from the river usually stains the waters of the bay (Fig. 4.165). There is vehicle access to the river mouth and a collection of about 20 fishing shacks and two small jetties located 1 km inside the mouth.

Figure 4.165 The dark tannin-stained waters of the Pieman River flow into Hardwicke Bay past the northern end of beach T 820.

T 821-822 RUPERT POINT

No. Beach	Rating HT LT	Type inner	outer bar	Length
T821 Foam Ck (S)	4 6	R+rocks/reef	RBB	500 m
T822 Foam Ck	3 4	R+rocks/reef	RBB	50 m
Spring & neap tidal range = 0.9 & 0.4 m				

Rupert Point is a 10 m high rocky point that protrudes 500 m west of the run of north-trending section of rocky shore. The point is located 3 km north of Pieman Head with continuous irregular rocky coast and reefs in between. In amongst the northern sections of rocks are two rock-dominated beaches (T 821 and 822) fronted by a continuous outer bar which links with the high energy beaches to the north of the point.

Beach **T 821** is an irregular, discontinuous collection of sand patches set amongst shore-perpendicular rocks, ridges and reefs, fronted by continuous rocky seafloor

and backed by an irregular hummock 10-20 m high foredune with slopes rising inland to 50 m. Waves are lowered by a continuous outer bar and rocks and reefs to less than 1 m at the shore. Two small creeks drain to the beach and a vehicle track from the head runs along the rear of the beach.

Beach **T 822** is located 500 m south of the point at the mouth of the small Foam Creek. The 50 m long beach is wedged in at the base of a 40 m wide, 100 m deep rocky bay, with the creek flowing across the bare sand into the bay. Waves break over the outer bar and rocks and are lowered to less than 0.5 m at the shore. The vehicle track crosses the creek at the beach.

T 823-825 INTERVIEW-LAGOON RIVERS

No.	Beach	Rating		Type			Length
		HT	LT	inner	mid	outer bar	
T823	Lanes Tor	8	9	TBR	RBB	RBB	200 m
T824	Interview R	8	9	TBR	RBB	RBB	300 m
T825	Lagoon R	8	9	TBR	RBB	LBT	9.6 km
Spring & neap tidal range = 0.9 & 0.4 m							

The 25 km long section of coast between Rupert Point and Sandy Cape contains some of the highest energy beaches in Tasmania and the world, most being fully exposed to the persistent high southwesterly swell averaging 3 m and commonly reaching several metres, and maintains one of the few triple bar systems in Australia. The first three beaches (T 823-825) occupy 10 km of shore between the Interview and Lagoon rivers and share a continuous surf zone. There is vehicle access to the southern end of these beaches from the Pieman Head track.

Beach **T 823** is located at the base of Lanes Tor, a prominent 40 m high granite outcrop, 300 m in from the shore. The 200 m long beach is bordered by large rounded granite outcrops, which form protruding wave-washed points, together with some rocks on the beach and in the inner surf. Waves averaging 3 m break across the outer bar over 600 m offshore, then on the inner two bars. Close to shore there is usually a partly attached bar and deeper water around the rocks and a single rip draining the inner surf, usually against the northern rocks. The beach is destabilised by drainage from two small creeks with a bare back beach grading into an unstable 20 m high hummocky foredune.

Beach **T 824** is located on the northern side of the granite rocks that protrude 100 m seaward at the base of the tor. It continues north for 300 m across the sandy mouth of the Interview River to a cluster of large granite outcrops on the beach and inner surf zone, with the river dominating the southern half of the beach and the rocks the northern. Sand from the beach drapes the rocky southern point, a small lagoon backs the river, and active sand dunes extend 400 m in behind the rocks to reach a bend in the deeply incised river. Rips drain out either end

of the beach against the rocks, with the outer bars extending 600 m offshore.

Beach **T 825** commences on the northern side of the rocks and trends to the west-northwest for 9.6 km to the sandy mouth and backing elongate lagoon of the Lagoon River. The beach is exposed to the full forces of the westerly waves and winds and is one of the most dynamic and possibly the highest energy beach on the Australian coast. In addition it is crossed by more than 10 smaller creeks, including Monster, Chimney and Hunters creeks, flowing down the densely vegetated granite slopes, which rise inland to 150-200 m. The creeks tend to be deflected to the south along the beach up to 100-200 m. The result is a very high energy triple bar surf zone and an active, though often saturated, dune field extending 1-2 km up the slopes to heights of 100 m (Fig. 4.166). Finally granite boulders and outcrops are scattered along the shoreline. The surf zone consists of a 100 m wide inner bar cut by rips every 400-600 m, which induce a highly rhythmic shoreline. The second bar lies 300 m offshore and has rips spaced roughly every 750 m, while the outer bar is located 600-800 m offshore with rips up to 1,000 m apart, some of the largest rips in the world. This is one of the few open coast beaches in the world where persistent high swell can generate and maintain such a wide rip-dominated surf zone.

Figure 4.166 Part of the massive transgressive dunes in lee of beach T 825.

The waves, rips, creeks and rocks destabilised the back beach, with no foredune along most of the beach permitting the sand to blow straight into a climbing transgressive dune systems between each of the creeks, and in some cases smothering the smaller creeks. The active dunes extend up to 2 km inland with some of the older vegetated dunes reaching 2.5 km. The lower reaches and deflation hollows are saturated by the creeks and groundwater seepage, with the higher dunes climbing to over 100 m. The dunes consist of climbing transverse dunes of varying size, together with wet deflection hollows, and deflated older dune surfaces and paleosols, with each major unit separated by the incised creeks and the boundary rivers.

T 826-829 **LAGOON RIVER (N 1)**

T 826-829 LAGOON RIVER (N 1)

No.	Beach	Rating		Type		Length
		HT	LT	inner	outer bar	
T826	Lagoon R (N1)	6	8	LTT+rocks	RBB	50 m
T827	Lagoon R (N2)	6	8	LTT+rocks	RBB	60 m
T828	Lagoon R (N3)	6	8	TBR+rocks	RBB	70 m
T829	Lagoon R (N4)	4	8	R+rocks	RBB	40 m
Spring & neap tidal range = 0.9 & 0.4 m						

The **Lagoon River** emerges from its meandering deeply incised 15 km long valley to reach the sea at the northern end of the long beach T 825, the beach finally terminating at the beginning of a 3 km long section of shoreline dominated by granite rocks, boulders and outcrops. Located in amongst the rocks are 10 small rock-dominated beaches located to the lee of the continuous double bar surf zone. The first four beaches (T 826-829) are located in the first 600 m of rocky shore. A vehicle track runs along the rear of the dune-draped rocks behind the beaches providing access to each.

Beach **T 826** is a 50 m long pocket of sand bordered by wave-washed rocks extending 70 m seaward into the inner reaches of the 500 m wide surf zone. Waves averaging over 1 m break at the outer end of the rocks and roll into the beach, with a narrow rip draining out the small gap. A small blowout then vegetated dune-draped rocks back the beach. Beach **T 827** is located 100 m to the north and is a 60 m long pocket of sand bordered by broken rocks extending 50 m into the surf and continuing as a reef 150 m into the wide surf zone. The reef lowers waves slightly at the beach, with usually reflective to low tide terrace at the shore. It is backed by an active 100 m wide sheet of sand, which links behind the rocks to the rear of beach **T 828**. This beach is located 50 m to the north and has a 70 m long shoreline bordered and interrupted by rocks both on and off the beach. Waves break heavily over the outer rocks, with the surf zone continuing 500 m offshore. A single rip drains the rock-dominated small embayment. The backing dunes extend up to 100 m inland almost reaching the vehicle track.

Beach **T 829** is located 200 m to the north at the base of a 40 m wide, 150 m deep rocky gutter. The 40 m long beach faces southwest down the gutter, with low waves at the shore, but a 500 m wide surf zone beyond the rocks. It is backed by vegetated dune-draped rocks and then the vehicle track 200 m further up the slopes.

T 830-836 LAGOON RIVER (N 2)

No.	Beach	Rating		Type		Length
		HT	LT	inner	outer bar	
T830	Lagoon R (N5)	4	8	R+rocks	RBB	50 m
T831	Lagoon R (N6)	4	8	R+rocks	RBB	40 m
T832	Lagoon R (N7)	6	8	TBR+rocks	RBB	100 m
T833	Lagoon R (N8)	5	8	LTT+rocks	RBB	50 m
T834	Lagoon R (N9)	5	8	LTT+rocks	RBB	60 m
T835	Lagoon R (N10)	5	8	LTT+rocks	RBB	40 m
T836	Lagoon R (N11)	4	8	R+rocks	RBB	40 m
Spring & neap tidal range = 0.9 & 0.4 m						

The second section of rocky shoreline north of the Lagoon River continues for another 1.5 km to the southern end of the next longer sandy beach (T 837). This section like the first is dominated by dissected granite rocks and ridges which contain seven small rock-bound beaches (T 830-836), all bordered and fronted by rocks and reefs, and then the outer bar continuing up to 400-500 m offshore. The beaches are all backed by stable and some unstable dune-draped rocky slopes (Fig. 4.167), with the vehicle track running 100-300 m inland.

Figure 4.167 Beaches T 830-834, while dominated by rocks and reefs, maintain an outer bar and backing active dunes (photo W. Hennecke).

Beach **T 830** is a 50 m long pocket of sand bordered by diverging rocky shore extending 200 m seaward, with a large rock outcrop dominating the centre of the small embayment. Waves break over the outer bar and then the rocks and reefs, with lower waves at the shore. The broken waves tend to flow into the northern side of the bay with a rip running out the southern side. An area of bare sand extends 50 m inland to reach the vehicle track.

Beach **T 831** lies 200 m further north past an irregular sand-draped rocky section of shore. The beach is 40 m long and located between rock points and reefs that extend 200 m into the inner surf zone. The high waves are lowered to less than 1 m at the shore with a quieter 'tidal pool' at the shore. A rip drains the 'pool' usually running against the southern rocks. A small foredune, then the vehicle track, back the beach.

Beach **T 832** lies 200 m to the north and is the longest beach in this section, extending for 100 m between rocky points that extend 100 m into the inner surf, together with rocks and reefs off the northern half of the beach. Waves break over these reefs and flow toward the beach with the water exiting via a permanent rip off the southern half of the beach. It is backed by an active area of sand extending 150-200 m inland and linking around the boundary 50 m wide rocks with beach **T 833**. This beach is a 50 m pocket of sand wedged between the rocks and

10 m high rock ridge that extends 150 m seaward. Waves break over the reef between the outer boundary rocks and flow into the small embayment. The backing dunes run along the side of the northern vegetated ridge, with a vehicle track down the ridge to the beach.

Beach **T 834** is located on the northern side of the 200 m wide vegetated ridge. It is a 60 m long beach that faces southwest between two parallel ridges of rock extending 150 m seaward. Reefs at the end of the rocks and the outer bar lower waves to less than 1 m at the shore, resulting in a quieter channel between the rocks. An extensive area of active sand extending up to 250 m inland backs the beach and continues north to the rear of beach **T 835**. This beach lies 200 m to the north past a section of seaward-trending rock ridges. The beach is 40 m long and bordered by ridges extending 200-300 m seaward resulting in low waves at the shore. The bare sand behind the beach continues to the north to link with a 200 m wide deflation area beyond which are the larger sand dunes behind beach T 837.

Beach **T 836** is the northernmost pocket of sand before the longer beaches. It is separated from beach T 835 by a 60 m long section of rock ridges. The 40 m long beach faces northwest across the 500 m wide surf zone, with boundary rocks and reefs extending 200 m into the surf to lower waves to less than 1 m at the shore, where they maintain a steep reflective beach. The beach is backed by the active sand sheet that links to the neighbouring beaches.

T 837-840 ITALIAN RIVER-JOHNSONS HEAD

No.	Beach	Rating		Type		Length
		HT	LT	inner	outer bar	
T837	Italian R	6	8	TBR	RBB	1 km
T838	Italian R (N)	6	8	TBR+rocks	RBB	400 m
T839	Johnsons Bay	4	5	LTT	RBB	300 m
T840	Johnsons Hd	5	6	LTT+rocks/reef	-	50 m
Spring & neap tidal range = 0.9 & 0.4 m						

The **Italian River** emerges from a deeply incised valley cut through the 40-100 m high densely vegetated granite slopes to reach the coast 4 km north of the Lagoon River mouth, with 3 km of rocky shore separating the two rivers. To the north of the Italian River the shoreline trends to the northwest for 8 km to the prominent Sandy Cape. In between the river and the cape are 10 exposed high energy beaches (T 837-846) together with sections of rocky shore. The first four beaches occupy much of the 2.5 km of shore between the river and the low dune-capped Johnsons Head.

Beach **T 837** commences on the northern side of the southern rocks and where the Italian River usually reaches the shore after it is deflected 500 m to the south. It trends to the northwest for 1 km to a 200 m long section of rocks and inner reefs. The beach is exposed to the full force of the waves and winds and usually has an inner bay dominated by 2 to 3 large rips and an outer bar

lying up to 500 m offshore. Active dunes rising to 40 m and deflated surfaces extend up to 1 km inland, where they impound a wetland at the base of the vegetated slopes that rise to 60 m. Beach **T 838** continues on the northern side of the rocks for another 400 m to the lee of a low reef-tied sandy foreland that is awash during high waves and forms the southern boundary of Johnsons Bay. The beach is fronted by the continuous surf zone from the Italian River, with rocks and reefs dominant to either end. It shares the active dunes with beach T 837.

Johnsons Bay is a curving 300 m long semi-circular shaped sandy bay occupied by beach **T 839**. The beach faces west and curves for 300 m between the southern foreland and the beginning of a 1 km long section of low rocky shore. Waves break over the outer bar and reefs off the entrance to the bay to average about 1 m at the shore where they surge up a steep reflective to low tide terrace beach (Fig. 4.168). Skull Creek drains across the northern corner of the beach, with active dunes extending south to the Italian River and following the southern side of the creek for 800 m inland.

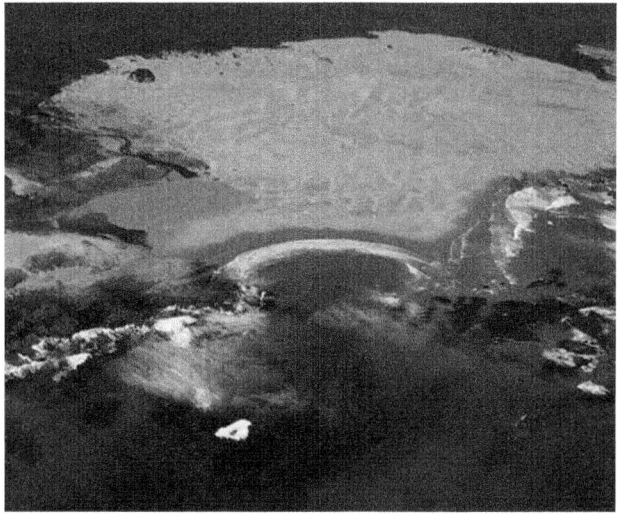

Figure 4.168 The curving beach of Johnsons Bay (T 839) is partly sheltered by rocky points and reefs, while massive active dunes back it and the adjoining beach (T 838).

Johnsons Head is a 10 m high sand-draped granite rock, which forms the northern boundary of the bay. The sand-covered rocks continue north for 1 km with the outer bar located offshore and waves breaking across the reef-dominated inner bar to usually reach a rocky shore, backed by active and vegetated dunes extending up to 250 m inland, with a vehicle track through the dunes. Beach **T 840** is located towards the northern end of the rocks and is the only sandy section of the shore. It is a 50 m long pocket of sand located between irregular low rocky points extending up to 100 m seaward, with reefs continuing for another 100 m then the outer bar. Waves break heavily off the entrance to the small embayment, with lower waves inside. The 4WD track crosses the dune to the rear of the beach.

T 841-846 JOHNSONS HEAD-NATIVE WELL BAY

No.	Beach	Rating		Type		Length
		HT	LT	inner	outer bar	
T841	Johnsons Hd (N)	6	7	LTT+rocks	RBB	200 m
T842	Sea Devil Rivulet (S)	6	8	TBR	RBB	700 m
T843	Sea Devil Rivulet (N)	6	8	TBR	RBB	1.2 km
T844	Blue Lagoon	6	8	TBR	RBB	1.6 km
T845	Native Well Bay (S)	3	4	R+rocks/reef	-	300 m
T846	Native Well Bay	3	4	R+reef	-	500 m
Spring & neap tidal range = 0.9 & 0.4 m						

To the north of **Johnsons Head** the shoreline trends northwest for 6 km to Sandy Cape. The first 4.5 km are dominated by seven near continuous sandy beaches (T 841-847), with rocky shoreline dominating the remainder out to the low rocky cape. All the beaches face into the southwest waves and wind, with a near continuous double bar beach and backing active and older inner vegetated dunes (Fig. 4.169).

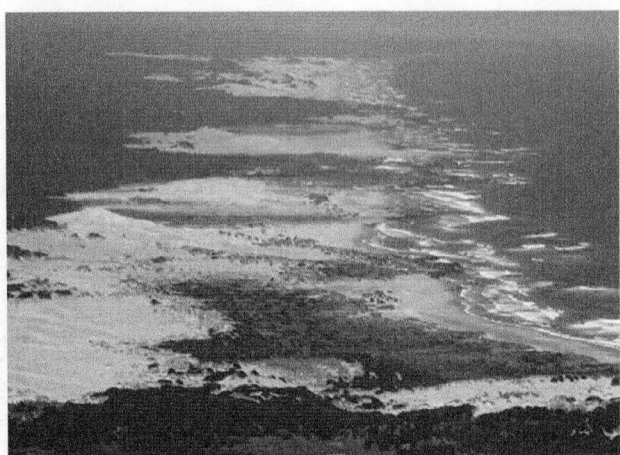

Figure 4.169 The exposed high energy coast, beaches and dunes south from beach T 844.

Beach **T 841** commences on the northern side of the rocky section of shore and consists of a 200 m long sand beach bordered by low rocky points, with two central rock outcrops on the beach and a near continuous shore-parallel reef 50 m offshore. Waves break over the outer rocks, bar and reef, with a permanent rip running northward and exiting into the surf at the northern end of the beach. Vegetated dunes back the southern end of the beach destabilising into active dunes at the northern end, with the vehicle track reaching the dune field.

Beach **T 842** continues on immediately to the north and extends for 700 m to a 200 m long section of scattered rocks on and off the beach, with Sea Devil Rivulet draining through the dunes and to the lee of the rocks. Waves break across a 400 m wide double bar system, with usually a central beach rip, as well as boundary rips adjacent to the rocks. Active dunes extend up to 700 m inland, rising to more than 20 m in the south, where they impound a small lake.

Beach **T 843** commences on the northern side of the rocks and rivulet and continues to the northwest for another 1.2 km to the next 300 m long section of boundary rocks and reefs. The outer bar continues well seaward of the rocks with waves breaking up to 500 m offshore, and reforming to break across the inner bar which is usually drained by a north-trending central rip, together with a rip against the southern rocks. Active dunes extend inland north of the rivulet reaching up to 1.2 km inland with older vegetated parabolic dunes extending up to 2.5 km inland. Beach **T 844** continues for 1.6 km north of the rocks trending to the northwest and then curving to west in lee of the of the Sandy Cape rocks. The wide high energy surf zone continues with waves breaking up to 500 m offshore, decreasing slightly into the northern end. A large rip usually drains out against the southern rocks, with a smaller rip towards the northern end. The dunes continue along the beach with some stability amongst the modern dunes, and older vegetated dunes continuing up to 3 km inland. Blue Lagoon wetland lies 1 km inland impounded at the rear of the active dunes.

Beach **T 845** commences 2 km southeast of Sandy Cape in lee of a 500 m wide band of rocks and reefs that form the northern boundary to beach T 844. The beach is sheltered by the reefs with waves averaging only about 0.5 m at the shore where they maintain a sandy reflective 'lagoon'. This is a relatively popular destination for beach fishers, with vehicle tracks crossing the backing dunes to the 100 m wide sandy area behind the beach. A 200 m long rocky point borders the northern end and separates it from Native Well Bay, with the sand continuing behind the rocks.

Native Well Bay is a protected semi-circular rock-bordered sand bay, with a 200 m wide gap between the boundary rocks opening into a curving 500 m long reflective beach (**T 846**). Waves average only about 0.5 m at the shore, lowered by the 500 m wide outer reef, narrow entrance and rocky floor of the bay. The beach is backed by a 10 m high hummocky foredune that has stabilised over the past 40 years and is now crossed by several 4WD tracks, with the beach and backing dunes used as informal campsites.

This is the final destination of the 31 km long winding sandy Sandy Cape track, which commences at Trial Harbour and passes along 24 beaches and crosses 10 creeks to reach the Cape.

Regional map 12 West Coast: Sandy Point to Woolnorth Point

Figure 4.170 *The northern section of the West Coast between Sandy Cape and Woolnorth Point.*

T 847-848 SANDY CAPE

No.	Beach	Rating HT LT		Type	Length
T847	Sandy Cape (1)	4	6	LTT	60 m
T848	Sandy Cape (2)	3	5	R+reef	60 m
Spring & neap tidal range = 0.9 & 0.4 m					

Sandy Cape stands at the tip of a protruding section of low sand-draped granite, with rocky shore extending for 1 km southwest to Native Well Bay and 1 km northeast to Bare Rock and the southern corner of Kenneth Bay at Venables Corner. The exposed cape has an irregular shoreline with rocks and reefs extending up to 500 m offshore. The northern side of the cape contains three small rocky bays, linked by continuous sand-draped rocks. The first bay, Koonya Inlet, has a rocky shore, while beaches T 847 and 848 occupy the next two.

Beach **T 847** is a 60 m long pocket of sand dotted with rocks located at the base of a rocky bay. The beach is sheltered by rocks and reefs that extend 600 m offshore, with waves averaging about 1 m and breaking across a 50 m wide low tide terrace. Beach **T 848** lies 200 m to the north with a low rocky point separating the two. It is a more sheltered northwest-facing 60 m long pocket of sand, with the small bay floor dominated by rocks. A patch of sand fronts the beach, which is usually reflective. Vehicle tracks link the two beaches to the cape and the northern longer beaches.

T 849-854 KENNETH BAY

No.	Beach	Rating HT LT		Type inner	outer bar	Length
T849	Sandy Cape Beach (1)	6	8	TBR	RBB	3.7 km
T850	Sandy Cape Beach (2)	6	8	TBR	RBB	8 km
T851	Sandy Cape Beach (3)	6	8	TBR	RBB	750 m
T852	Sandy Cape Beach (N1)	7	8	TBR+rocks	RBB	250 m
T853	Sandy Cape Beach (N2)	6	8	TBR+rocks	RBB	60 m
T854	Sandy Cape Beach (N3)	6	8	TBR+rocks	RBB	80 m
Spring & neap tidal range = 0.9 & 0.4 m						

Kenneth Bay is a 9 km wide zeta-curved bay that spirals east in lee of Sandy Cape before curving to the north to terminate amongst the rocks of Greenes Point. In between the two low rocky boundaries are 14 km of predominantly exposed high energy sandy beaches, with a continuous double bar system backed by active dunes extending up to 1 km inland. Four rivers drain into the bay emerging from incised valleys in the backing 100-150 m high granite hinterland. They are deflected by the high waves to form elongate lagoons amongst the dunes which destabilise the beach and dunes. Most of the bay is dominated by Sandy Cape Beach, which consists of three near continuous beaches (T 850-852) each separated by the rivers and linked by the continuous bars and surf. The beaches can only be accessed by vehicle along the beach.

The southern end of **Sandy Cape Beach (T 849)** commences in lee of Sandy Cape and Bare Rock, in a moderately sheltered north-facing section of beach called Venables Corner where waves average about 1-1.5 m and maintain a single transverse bar with rips spaced about every 400 m inducing a highly rhythmic shoreline. The 3.7 km long beach curves to the northeast and finally north to terminate at the shifting mouth of the **North Pedder River**. The beach is backed initially by vegetated dunes, then a 1.5 km area of active transverse dunes backed by vegetated dunes then a 20 ha wetland that links with the river. The river is deflected 800 m to the north of the wetland to finally enter the sea on the northern side of a 500 m long vegetated foredune. The beach in the vicinity of the mouth varies considerably owing to the deflection of the mouth and the stage of river flow. When blocked it forms a shallow lagoon, which banks upstream for a few hundred metres. There are vehicle tracks to the beach and a fishing shack on the south side of the river mouth.

The central section of Sandy Cape Beach (**T 850**) commences at the river mouth and continues north past the smaller Wild Wave and Daisy river mouth to terminate at the larger shifting Thornton River mouth. The 8 km long beach faces west into the high waves and has a 500 m wide double bar surf zone with large inner rips averaging 600-700 m in spacing and inducing a highly rhythmic shoreline. The beach is backed by active dunes blowing straight off the beach as transverse dune sheet extending up to 1 km inland and includes extensive wet deflated areas (Fig. 4.171). Older vegetated dunes extend up to 1.5 km inland and to heights of 50 m.

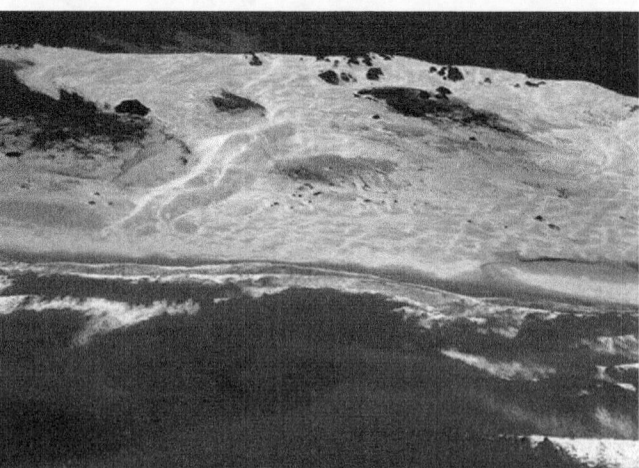

Figure 4.171 The massive dunes and deflation surfaces in lee of central Sandy Cape Beach (T 850).

The northern section of the beach (**T 851**) commences at the **Thornton River** mouth and continues northwest for 750 m to the beginning of the rock-dominated section of shore. The high waves and double bar continue with usually two large rips draining the inner surf zone while active dunes extend up to 600 m inland. The final section of beach (**T 852**) continues on past the first 200 m long section of rock outcrops for another 250 m to the next rock outcrop. Waves begin to decrease owing to offshore reefs with a single rip draining the beach and the outer bar moving closer to shore. The dunes continue north

along the rear of the beach where much of the dune surface has been deflated to the underlying rocks (Fig. 4.172).

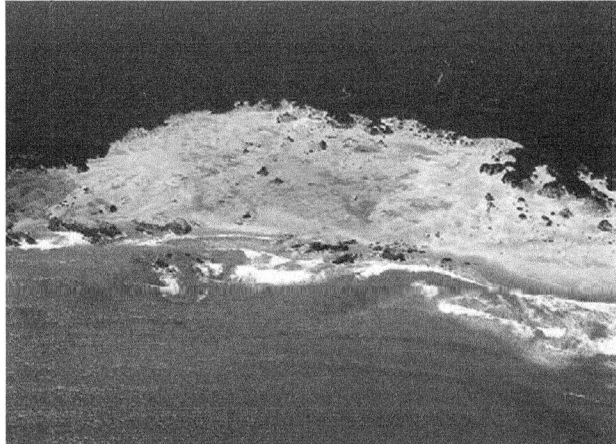

Figure 4.172 The extensive dunes and deflation surfaces in lee of beaches T 851 and 852.

Beach **T 853** lies 100 m to the north and is wedged between two rock outcrops that extend 50 m into the surf, with a cluster of rocks just off the beach. Waves break over the reefs and outer bar with the inner bar located just outside the rocks and a deep channel draining the small embayment. Beach **T 854** is located another 100 m further north and is a similar 80 m long pocket of sand wedged between two protruding 50 m long arms of rocks, with the inner bar linking the rocky points. The dunes diminish to the lee of these two beaches with the north beach backed by a bare 200 m wide deflated surface.

T 855-858 GREENES POINT

No.	Beach	Rating HT LT		Type	Length
T855	Greenes Pt (S3)	3	4	R+rocks/reef	50 m
T856	Greenes Pt (S2)	3	4	R+rocks/reef	250 m
T857	Greenes Pt (S1)	3	4	R+rocks/reef	200 m
T858	Greenes Pt (N)	3	4	R+rocks/reef	250 m
Spring & neap tidal range = 0.9 & 0.4 m					

Greenes Point is a low, sand-capped sandstone point located 500 m northwest of the small mouth of Greenes Creek. Four small rock- and reef-bound beaches (T 855-858) occupy the 1 km of shoreline to either side of the point. The Sandy Cape Beach outer bar continues off the rocks as far as the point. The bar, rocks and reefs lower the high outside waves to less than 1 m at the shore resulting in lower energy beaches. All are accessible along the Sandy Cape track, which runs south along the shoreline, with sidetracks out to the beaches and boundary points.

Beach **T 855** is a 50 m long pocket of sand wedged between two 150 m long ridges of southwest-trending rocks, with reefs extending another 250 m offshore and the remnants of the Sandy Cape Beach outer bar at the

outer end. Waves are lowered to less than 1 m at the shore. A 5 ha patch of bare sand backs the beach with the track on the eastern side of the sand and Greenes Creek draining out onto the rocks on the northern side of the sand. Beach **T 856** commences 200 m to the north amongst a collection of large rocks and reefs that dominate each end of the 250 m long beach and extend up to 200 m offshore, with a more open reef-free central area. The beach faces west with waves lowered by the outer bar and reefs to less than 1 m at the shore.

Beach **T 857** commences 100 m to the north and curves to the north for 200 m to the low vegetated Greenes Point. The entire beach is fronted by a near continuous 100 m wide band of intertidal rocks, apart from a narrow rocky channel in the centre. The rocks lower waves and form a tidal pool between the rocks and shoreline. The beach is backed by a 100 m wide area of bare sand towards the north then a low foredune, with vehicle tracks entering each end.

Beach **T 858** is located on the northern side of Greenes Point. It consists of a 250 m long west-facing sandy beach bordered by extensive rock platforms, with a small central sandy foreland tied to a large rock outcrop. It is backed by a foredune, then the vehicle track. The outer reefs lower waves with often calm conditions at the shore.

T 859-862 ORDNANCE POINT

No.	Beach	Rating HT LT		Type	Length
T859	Ordnance Pt (S3)	3	4	R+rocks/reef	150 m
T860	Ordnance Pt (S2)	3	4	R+rocks/reef	100 m
T861	Ordnance Pt (S1)	3	4	R+rocks/reef	600 m
T862	Ordnance Pt (N)	3	4	LTT/TBR	1 km
Spring & neap tidal range = 0.9 & 0.4 m					

Ordnance Point is a reef-tied sandy tombolo located to the lee of a cluster of outer reefs, which continue 200 m further seaward. The tombolo forms the boundary of two small embayments, with beaches T 859-861 occupying the southern bay and beach T 862 in the northern bay.

Beach **T 859** is located 800 m southeast of the point in the southern corner of the southern bay. It is a 150 m long sandy reflective beach bordered by a low rocky point with a central rock outcrop forming a sandy foreland and two small sand and rock tidal pools to either side, both with narrow entrances to the outer reef-dominated area. Waves are lowered to about 0.5 m at the shore. It is backed by an 80 m wide foredune backed and crossed by vehicle tracks. Beach **T 860** commences 50 m to the north and is a straight 100 m long strip of sand with a 200 m long rock reef off the southern end, reefs off the centre and a smaller northern point. Deeper reefs extend 400 m offshore and lower waves to about 0.5 m at the shore. The Sandy Cape track runs along the beach in front of the small backing foredune.

Beach **T 861** commences immediately north of beach T 860 amongst a 500 m long series of rock outcrops and inner reefs, which divide the beach into several smaller pockets of sand linked by the continuous upper beach and backing dunes with the Sandy Cape track behind. The beach curves to the northwest for 600 m and forms the southern side of the tombolo. The foredune destabilises towards the tombolo, which consists of a low narrow berm overwashed during higher waves. A mixture of sand and rock seafloor fronts the beach.

Beach **T 862** forms the northern side of the tombolo. It commences at the reef and curves to the northeast and then north for 1 km. It faces northwest into the more open bay that fronts Brooks Creek, permitting waves averaging over 1 m to reach the shore where they maintain a 50 m wide bar along the central section, with reflective conditions in lee of the reef and rocks, and reefs dominating the northern end, and a rip usually running out against the northern rocks. The beach is backed by 10-20 m high 200 m wide semi-stable dunes, including a northeast-trending blowout, which originates from the foreland. The Sandy Cape track runs along the eastern side of the dunes.

T 863-865 BROOKS CREEK

No.	Beach	Rating HT LT		Type	Length
T863	Brooks Ck	5	6	LTT/TBR	200 m
T864	Smiths Gulch (W)	3	4	R+rocks/reef	300 m
T865	Gannet Gulch (E)	3	4	LTT	80 m
Spring & neap tidal range = 0.9 & 0.4 m					

Brooks Creek emerges from a narrow incised valley cut into the backing slopes that rise to 150 m, to flow into the apex of a curving 1 km wide embayment, bordered by Ordnance Point to the south and Parallel Reef to the north. Three small beaches (T 863-865) occupy parts of the 2 km long rocky shore between the creek mouth and the reef.

Beach **T 863** occupies the mouth of the creek. It is 200 m long and faces west out of the more open bay exposing it to waves averaging 1-1.5 m which maintain a low gradient 50 m wide surf zone with higher waves breaking further out into the bay. Rocky points border either side of the beach with small rips against the rocks. The creek tends to flow out against the southern rocks with a small lagoon behind, while a low foredune has formed on the northern side of the creek. The Sandy Cape track reaches the northern side of the creek and crosses the beach and creek to continue on to the south.

Beach **T 864** is located 1 km northwest of the creek mouth in a rocky area known as Smiths Gulch. It is a low energy 300 m long beach located to the lee of shore-parallel rock ridges, which extend 250 m offshore. The rocks lower and refract the waves to form a sandy foreland. The beach is fronted by shallow sand and scattered rocks with a deeper drainage channel against the

inside reef. Several fishing shacks occupy a clearing in the centre of the foreland (Fig. 4.173).

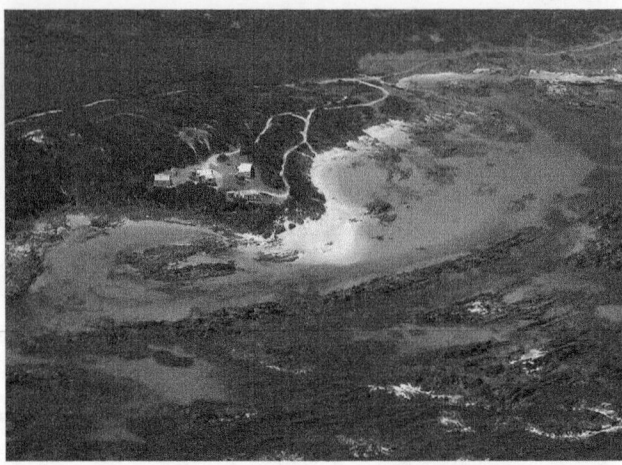

Figure 4.173 Beach T 864 in the Smiths Gulch area, where the reefs shelter the beach and provide a launching site for small fishing boats.

Beach **T 865** lies another 500 m to the northeast in a small west-facing rocky embayment, midway to Gannet Gulch. The 80 m long beach faces west out of the rocky 150 m wide bay and receives waves averaging about 1 m which maintain a 50 m wide bar with rocks and reefs to either side and a sandy channel winding out though the rocky bay floor. The beach is backed by a low foredune then the Sandy Cape track, with a solitary fishing shack located amongst the rocky shore 200 m west of the beach.

T 866-867 DAWSON BAY

No.	Beach	Rating HT LT		Type	Length
T866	Dawson River	4	5	R/LTT	200 m
T867	Dawson Bay (N)	3	4	R+rocks	50 m
Spring & neap tidal range = 0.9 & 0.4 m					

Dawson Bay is a 400 m wide rocky bay fed by the small Dawson River. The bay faces west-southwest across scattered outer reefs, which lower waves within the small bay. Two small beaches (T 866 and 867) occupy part of the rocky bay shore.

Beach **T 866** is located in the eastern apex of the bay across the mouth of the small Dawson River and its backing small lagoon. The beach extends for 200 m between boundary rocky slopes with a central rock outcrop. The creek flows out against the southern rocks, and when flooding it destabilises the southern half of the beach. North of the central rock outcrop is a more stable beach backed by a vegetated 20 m high climbing foredune. The beach faces west and receives waves reduced to about 1 m at the shore which maintain a narrow bar to reflective conditions, with a sandy bay floor extending seaward between the bordering reefs and rocks. The main Sandy Cape track crosses the creek 500 m inland, with a secondary track running behind the northern foredune to cross at the creek mouth (Fig. 4.174).

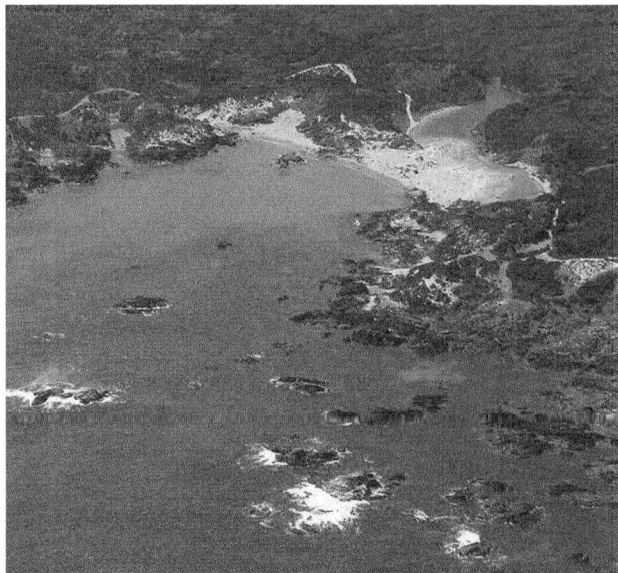

Figure 4.174 The Dawson River flows across the southern end of the sheltered beach T 866, which is also crossed by the Sandy Cape track.

Beach **T 867** is a 50 m long wedge of sand at the base of a south-facing 150 m long, 50 m wide gutter located 300 m northwest of the creek mouth. Waves are low to calm at the shore. The beach is bordered by the elongate rock reefs and backed by a vegetated foredune then older grass-covered dunes rising to 20 m with the secondary track running along their crest.

T 868 INGRAM BAY

No.	Beach	Rating HT LT		Type	Length
T868	Ingram Bay	4	5	LTT+reefs	600 m
Spring & neap tidal range = 0.9 & 0.4 m					

Ingram Bay is a 700 m wide bay bordered by low sand-capped rocky points and reefs, with beach **T 868** curving for 600 m between the two sides of the bay. Symes Creek drains across the southern end of the beach into the small rocky Driftwood Cove. The beach faces west out of the open bay, however rock reefs dot the bay and extend up to 1 km seaward of the beach lowering waves to about 1 m at the shore. The waves break across the inner reefs and a low gradient 50 m wide bar, with higher waves breaking over the numerous outer rocks and reefs. The beach is backed by a steep vegetated foredune rising to 30 m in places, with a wetland behind. The Sandy Cape track runs 1 km inland with a sidetrack out to the creek mouth.

T 869-870 HAZARD BAY

No.	Beach	Rating HT LT		Type	Length
T869	Hazard Bay (S)	6	6	LTT/TBR	700 m
T870	Hazard Bay	6	6	TBR+reefs	1.6 km
Spring & neap tidal range = 0.9 & 0.4 m					

Hazard Bay is located immediately north of Ingram Bay and is an open west-southwest-facing 2 km long slight embayment bordered by sand-covered Eva Point to the north and rocks and reefs extending 800 m seaward in the south. Two near continuous beaches (T 869 and 870) occupy the shore of the bay. The beaches are backed by both a modern foredune and older parabolic dunes, possibly Pleistocene, which in the north extend up to 3.5 km inland climbing the backing slopes to a height of 85 m.

Beach **T 869** is a 700 m long southwest-facing beach bordered by low rocks to the south and a small linear 100 m long islet to the north that forms a sandy foreland to their lee. The beach is partly sheltered by the extensive outer reefs with waves averaging 1-1.5 m and breaking across a 50 m wide continuous bar drained by rips to each end and occasionally a central rip. The beach widens to the foreland in front of a grassy foredune. The Possum and No Mans creek converge to drain across the beach in lee of the foreland helping to maintain the wide sandy back beach. The foredune is backed in turn by older vegetated transgressive dunes, with the Sandy Cape track located 1 km to the east, while a sidetrack follows an older dune ridge to overlook the junction of the two creeks.

Beach **T 870** commences at the islet and curves to the north, then north-northwest for 1.6 km to the lee of the small Eva Point. While there are scattered reefs off the beach and in the northern surf zone it receives waves averaging over 1.5 m which break across a 50-100 m wide bar, drained by permanent boundary rips against the rocks and two to three beach rips. The beach is backed by a grassy foredune, then the older vegetated transgressive dunes that extend up to 800 m inland. In addition to the southern No Mans Creek, Pardoe and a second small creek parallel the older dune ridges to drain across the centre of the beach.

T 871 DARTYS CORNER

No.	Beach	Rating HT LT		Type	Length
T871	Dartys Corner	3	4	R+rocks/reef	400 m
Spring & neap tidal range = 0.9 & 0.4 m					

Dartys Corner is the name of the next small embayment located 1 km north of Eva Point. The corner is located on the southern side of a 250 m long rocky point that continues seaward for another 500 m as rocks and reefs. Beach **T 871** extends south of the corner for 400 m to the irregular section of rocky shore that continues to Eva Point. The beach faces southwest but is sheltered by the outer and inner reefs with low waves at the shore and reflective beach conditions. The shoreline protrudes slightly in the centre in lee of a large rock located 200 m offshore, with some waves usually breaking across the reefs off the southern end. It is backed by a 100 m wide area of low grassy foredune, then the older vegetated parabolic dunes that extend up to 3 km inland to an

elevation of 50 m. The older dunes have aligned the drainage parallel to the ridges, with the small Little Eel Creek draining to the northern end of the beach. Two fishing shacks are located on the low northern point, which is accessible via a 1 km sidetrack off the main Sandy Cape track. The beach is also used for launching small fishing boats.

T 872-874 TEMMA HARBOUR

No.	Beach	Rating HT LT		Type	Length
T872	Richardson Pt (S)	4	5	Cobble+rocks	80 m
T873	Temma Harbour	4	4	R+reef	150 m
T874	Gaffney Pt (N)	4	5	R+rocks/reef	1.1 km
Spring & neap tidal range = 0.9 & 0.4 m					

Temma Harbour is located at the end of the Temma Road, with only the sandy 4WD Sandy Cape track continuing to the south. It is the first community north of the Pieman River, 50 km to the south, and consists of about 20 houses and fishing shacks and two slipways for the fishing boats that operate out of the small bay. Beside the harbour beach (T 873) two beaches (T 872 and 874) are located to either side of the harbour (Fig. 4.175).

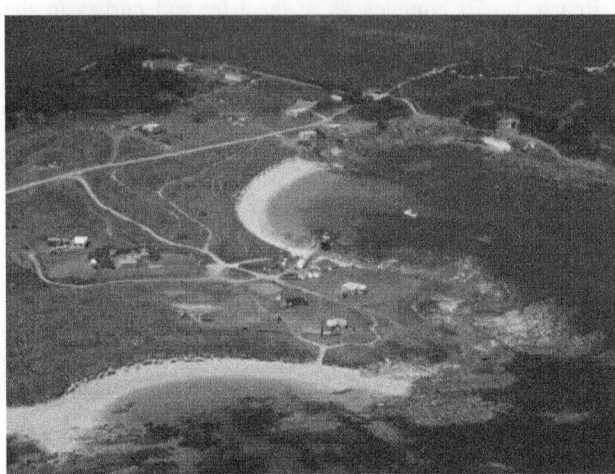

Figure 4.175 Temma Harbour is a small but growing community based around the sheltered waters of the natural harbour.

Beach **T 872** is located 500 m south of **Richardson Point** in a small west-facing rocky bay. The 80 m long beach is composed of high tide cobbles, with a rock- and boulder-dominated inter- to low tide zone. It is sheltered by inner rocks and reefs with low waves at the shore, particularly at low tide. A 4WD track runs along the crest of the cobble ridge.

Temma Harbour occupies the base of a 250 m wide low rocky bay that faces west-southwest between 700 m long Richardson Point and 300 m long Gaffney Point, which extends another 300 m seaward as reefs. The beach (**T 873**) is located at the northern end of the beach with rock platforms to either side. It is sheltered by its embayed location, three reefs just off the beach and the boundary points and reefs which result in usually low waves at the

shore and reflective conditions. Slipways are located to either side of the beach with the larger boats slipped because of the reefs in the bay. The few houses back the west and north side of the harbour with about 10 foredune ridges extending 200 m inland to the edge of Poppys Lagoon.

Beach **T 874** commences at **Gaffney Point** and trends to the north for 1.1 km as a series of five cuspate sandy bays between reef-tied forelands. The rocks and reefs continue up to 800 m offshore lowering waves to less than 1 m at the shore, where reflective conditions usually prevail. A few houses back the first bay, with a continuous crescentic foredune extending to Poppys Lagoon creek at the northern end. Between the beach and xx ha wetland is a 300-500 m wide series of about 12 crescentic foredune ridges, the ridges shaped by wave refraction around the rocks and reefs.

T 875-879 POLLYS BAY

No.	Beach	Rating HT LT		Type	Length
T875	Poppys Lagoon (N)	3	4	R/LTT+reef	1.2 km
T876	Barney Creek	5	6	LTT/TBR+reef	1.6 km
T877	Pollys Bay	3	4	R+reef	400 m
T878	Lady Kathleen Beach	4	5	LTT+reef	750 m
T879	Rebecca Pt (S)	5	6	LTT/TBR+reef	700 m
Spring & neap tidal range = 0.9 & 0.4 m					

Between the northern end of beach T 875 and Rebecca Point is a 4 km wide open embayment containing five near continuous crenulate sandy beach systems (T 875-879). All three beaches are bordered by low rocks and fronted by scattered reefs extending up to 500 m offshore, which result in lower and variable wave conditions along the shore. They are backed by a near continuous hummocky foredune, cut by several small creeks, then the Temma Road and gradually rising cleared slopes, the most southerly farmland on the West Coast.

Beach **T 875** commences at the sandy foreland in lee of the extensive reefs at the northern end of beach T 874 and the end of Poppys Lagoon. It initially curves to the east before turning and trending north for 1.2 m to terminate at the next sandy foreland located to the lee of a prominent reef lying 300 m offshore. Waves are lowered to less than 1 m at the shore where they maintain a reflective to narrow low tide terrace. Several beachfront shacks and the road back the southern corner of the beach, with a grassy foredune widening to 500 in lee of the foreland and reaching 25 m in height. A small creek cuts through the foredune to reach the centre of the beach.

Beach **T 876** is the longest of the beaches extending from the foreland for 1.6 km past the mouth of Barney and Templars creeks and a few rock outcrops along the centre of the shore to the next major foreland. The curving beach faces west and receives waves averaging 1-1.5 m which maintain a low tide terrace cut by two to three central reef-controlled rips during periods of higher

waves. The grassy foredune narrows to 100 m in the centre creek area, widening to 600 m behind the northern foreland, with the road running behind and some tracks across to the beach.

Pollys Bay beach (T 877) is located in the small bay between the next two small sandy reef-tied forelands (Fig. 4.176). The 400 m long beach curves between the forelands and faces west across a nearshore dominated by shallow reefs, which lower waves to less than 1 m at the shore and usually maintain a steep reflective beach. Higher waves break over the continuous reefs with a 'lagoon' between the reefs and shore. The foredune widens from 600 to 800 m by the northern end of the beach. There are some blowouts in the outer foredune with older ridges to the rear.

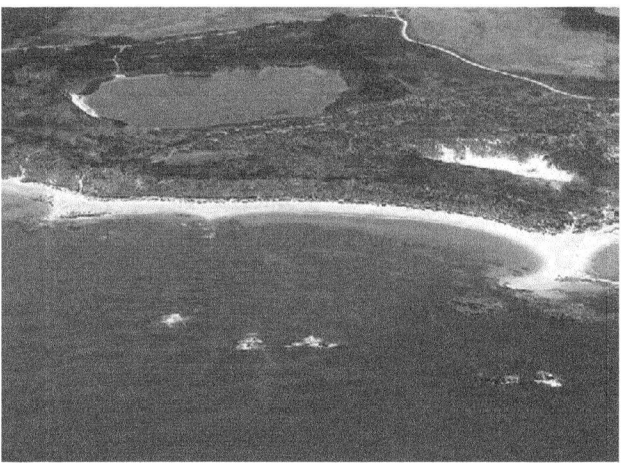

Figure 4.176 The reef-sheltered Pollys Bay with Rebecca Lagoon to the rear.

Lady Kathleen Beach (T 878) curves to the north for 750 m across the mouth of Rebecca Creek to the next reef-tied foreland. Waves are lowered by the reefs, which extend up to 700 m offshore and are usually less than 1 m at the shore, maintaining a reflective to low tide terrace conditions. The wide foredune continues along the southern half, with 10 ha Rebecca Lagoon behind, then the creek mouth, which destabilises the northern half of the beach. The 200 m wide foredune continues on the north side with a small backing creek.

Beach **T 879** commences at the northern foreland and curves to the northwest and finally west for 700 m to terminate in lee of the low rocky **Rebecca Point**. The beach faces southwest across scattered reefs, which permit waves averaging 1-1.5 m to reach the shore where they maintain a 50 m wide surf zone with a central rocky outcrop. Usually small rips form against the boundary rocks as well as either side of the outcrop. The hummocky foredune narrows to 100 m at the point and rises to 20 m behind the centre of the beach. A vehicle track runs around the rear of the dune to reach the point.

T 880-884 COUTA ROCKS

No.	Beach	Rating HT LT	Type	Length
T880	Rebecca Pt (N)	3 4	R+rocks/reef	300 m
T881	Couta Rocks (S)	3 4	R+rocks/reef	300 m
T882	Couta Rocks (1)	4 5	LTT+rocks	150 m
T833	Couta Rocks (2)	3 4	R+rocks/reef	100 m
T884	Couta Rocks (N)	4 5	LTT+rocks	300 m
Spring & neap tidal range = 0.9 & 0.4 m				

To the north of Rebecca Point is a 3 km section of north-northwest-trending low rocky shoreline continuing to Sarah Anne Rocks. The irregular coast has rocks and reefs extending several hundred metres offshore resulting in lower waves along the shore. In amongst the rocks are five small sandy beaches (T 880-884).

Beaches T 880 and 881 are located to the lee of a 1 km long north-south-trending shore-parallel rock reef, which shelters the backing shoreline and in the centre is located just 50 m off the shore, with sand occasionally forming a foreland linking the reef to the shore. Beach **T 880** is located to the southern side of the foreland and consists of three patches of sand bordered and separated by low rocky shore and with patchy sand and rock seafloor extending out to the reef, which lies 150 m off the southern end of the beach. Waves are usually less than 0.5 m at the shore, with calm conditions at low tide. The beach is backed by low vegetated terrain, with a small wetland in the south and vehicle tracks to the northern end. Beach **T 881** extends north of the foreland for 300 m into a small rock- and reef-bound bay. The beach is 300 m long, faces west toward the reef and is sheltered from most waves with low wave to calm conditions at the shore. Rocks outcrop along and off the beach, while fishing shacks are located to either end of the beach with a slipway built on the rocks at the northern end.

Couta Rocks is the name of a small fishing settlement consisting of about 10 shacks and the slipway on the northern side of the small bay. Beach **T 882** is the main beach occupying the northern corner of the bay and receives waves averaging about 1 m, which break across a narrow low tide terrace. Low rocky points border the 150 m long beach, with scattered rocks and reefs extending into the bay. A vehicle track runs around the rear linking the two collections of shacks.

Beach **T 883** is a collection of three small pockets of reflective sand, totalling 100 m in length, set amongst the 5 m high rock bluffs on the northern side of the bay below the main collection of shacks. The pockets are linked by inter- to subtidal sand, with rocks, reefs and a shore-parallel islet located 50 m offshore, which lower waves at the shore to less than 1 m.

Beach **T 884** is located 300 m north of the settlement in the next small 200 m wide rocky embayment. The bay is bordered by rocky points with west-trending ridges of rock grading into reefs, which continue 500 m offshore.

The beach curves around the shore of the bay in a semi-circular fashion for 300 m with four rock outcrops along the beach and a large rock in the centre of the 100 m wide entrance to the inner bay. The rocks and reefs lower waves to about 1 m at the shore where they maintain reflective to narrow low tide terrace conditions. A low hummocky foredune backs the beach with a blowout on the northern point and a small creek in the southern corner linking to a 5 ha lake. A vehicle track follows the rear of the foredune.

T 885-887 NELSON BAY

No.	Beach	Rating HT LT	Type	Length
T885	Sarah Anne Rocks	3 4	R/LTT	250 m
T886	Sardine Ck	6 7	TBR+rocks	900 m
T887	Nelson Bay	6 6	TBR	800 m
T888	Nelson Bay (N1)	4 5	R/LTT+rocks/reef	650 m
Spring & neap tidal range = 0.9 & 0.4 m				

Sarah Anne Rocks are a collection of rock reefs extending 500 m seaward of a 20 m high rocky point, which also forms the southern boundary of 2 km wide Nelson Bay, an open west-facing embayment at the mouth of the Nelson Bay River. Four beaches (T 885-889) occupy most of the bay shoreline.

Beach **T 885** is located in a 150 m wide rock-bordered little bay in lee of Sarah Anne Rocks, with a 50 m wide sandy channel between the boundary points and reefs. The beach curves for 250 m between the boundary rocks with waves lowered to about 1 m at the shore where they usually break across a narrow low tide bar. The beach is backed by a low foredune then a cleared area containing about eight fishing shacks spread along the rear of the beach (Fig. 4.177), linked by a vehicle track to the Temma Road 1 km to the east. Small fishing boats are launched off the beach.

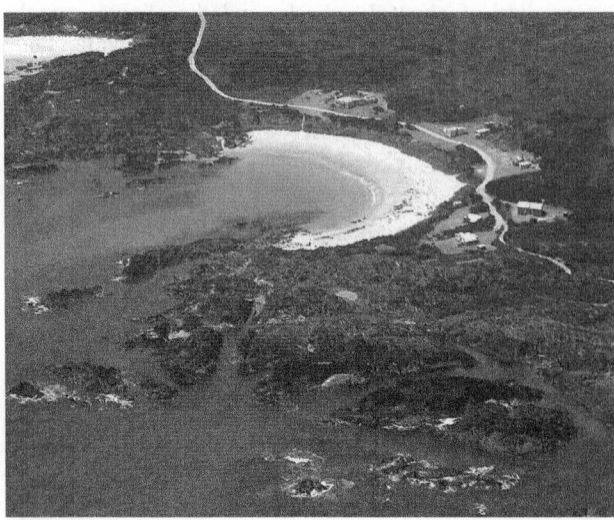

Figure 4.177 Sarah Anne Rocks provide shelter to the curving beach T 885, which hosts a small fishing community.

Beach **T 886** commences 200 m to the north, past the boundary rocks, and trends almost due north for 900 m to the mouth of Sardine Creek which crosses the beach in lee of a 10 m high vegetated rocky point. There are four rock outcrops on the beach and in the surf, linked by a continuous bar that increases in width to 100 m in the north and is cut by three rock-controlled rips, the largest amongst the northern reefs. Most of the beach receives waves averaging 1.5 m and more, with only the southern corner relatively sheltered with lower waves. The beach is backed by vegetated dune-draped bluffs rising to 30 m and extending 200-300 m inland. It can be accessed in the south off the Sarah Anne Rocks road.

Beach **T 887** extends north of the boundary rocks for 800 m to the mouth of Nelson Bay River, which crosses the northern end of the beach and bay in lee of a northern sand-draped rocky point and a reef in front of the river mouth. The beach faces due west with waves averaging over 1.5 m, which maintain a 100 m wide low gradient bar usually drained by rips to either end. It is backed by largely vegetated dunes which have spread over backing bedrock slopes to a height of 40 m and extending 700 m to the northeast, with the creek and river to either side, both forming elongate narrow lagoons. The dunes have stabilised substantially in the last few decades.

Beach **T 888** forms the northern boundary of the bay shoreline. It is a protruding 650 m long beach that wraps around the sand-draped point between four major reefs which form cuspate bays and forelands along the sandy beach. The southern end receives waves up to 1 m and more, which maintain a low tide terrace and a rip against the rocks near the river mouth. In the north the reefs extend 500 m offshore and lower the waves to less than 1 m with usually reflective conditions at the shore.

T 889-891 NELSON BAY (N)

No.	Beach	Rating HT LT	Type	Length
T889	Nelson Bay (N2)	3 4	R+rocks/reef	300 m
T890	Sundown Pt (S2)	4 5	LTT+rocks/reef	250 m
T891	Sundown Pt (S1)	4 4	LTT	400 m
Spring & neap tidal range = 0.9 & 0.4 m				

To the north of Nelson Bay and beach T 888 is 1 km of reef-fringed shore containing three near continuous lower energy sandy beaches (T 889-891) all backed by a string of fishing shacks.

Beach **T 889** commences on the north side of a reef-tied sandy foreland and curves to the north for 300 m to the next low rocky point. Rocks outcrop along the southern half of the beach and reefs extending up to 500 m offshore lower waves to less than 1 m at the shore with usually reflective beach conditions. A 20 m high vegetated foredune backs the foreland, with two fishing shacks located in a clearing behind, while the northern half of the beach is low and cleared and occupied by six shacks. A vehicle track backs the beach with an access

track down to the beach, which is used to launch small boats.

Beach **T 890** commences on the north side of the 100 m long low rocky point, with the sand continuing behind and along the 250 m long beach. The beach is bordered by west-trending rock ridges extending 200 m off the boundaries, with four smaller ridges extending from the beach into the low surf. Waves average about 1 m at the shore and maintain a narrow low tide terrace, with higher waves generating a rip flowing out of the small embayment. A low foredune, track and several shacks back the beach.

Beach **T 891** continues to the north for another 400 m, curving around to terminate against the beginning of an 800 m long section of rocky shore that continues to the low rocky Sundown Point. The beach faces west-southwest with waves lowered by the outer reefs to about 1 m at the shore where they break across a continuous narrow low tide terrace, bordered by platforms and reefs to either end, which converge offshore. The vehicle track runs the length of the beach and north to the point, with a handful of shacks to either end of the beach.

T 892-893 SUNDOWN POINT (N)

No.	Beach	Rating		Type	Length
		HT	LT		
T892	Sundown Pt (N1)	3	5	R+rock flats	200 m
T893	Sundown Pt (N2)	4	4	R/LTT	150 m
Spring & neap tidal range = 0.9 & 0.4 m					

Sundown Point is an irregular 10 m high dune-draped sandstone headland that forms the southern boundary of the 6 km long Arthur Beach system. The point and shoreline for 2 km to the north are included in the Sundown Point Aboriginal Site, in recognition of the ancient rock carvings located on rocks around the point. There is a gravel access road to the point area and Sundown Creek mouth, with a campsite near the creek. Two small beaches (T 892 and 893) are located on the northern side of the point (Fig. 4.178).

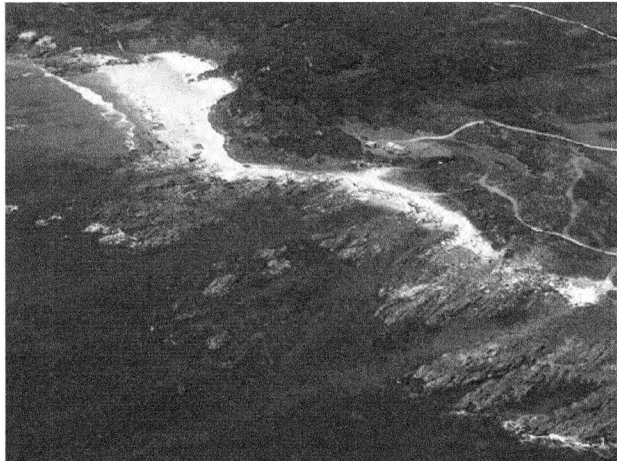

Figure 4.178 Sundown Point (right) and the rock-dominated beaches T 892 and 893.

Beach **T 892** is a 200 m long strip of high tide sand and cobbles located at the rear of 200 m wide rock ridges and gutters, which lower waves to less than 1 m at high tide. An older vegetated dune and deflation hollow back the beach with a fishing shack in the hollow. One of the gutters is used to launch small fishing boats.

Beach **T 893** is located immediately to the north and is a wide sandy 150 m long beach, with low waves reaching the shore and usually reflective to low tide terrace conditions. Higher waves break over the reefs which commence 50 m offshore and ring the point. It is backed by vegetated older dunes, with the campsite to the rear.

T 894-897 ARTHUR BEACH

No.	Beach	Rating		Type			Length
		HT	LT	inner	second	third bar	
T894	Sundown Ck	7	7	TBR	RBB	-	1 km
T895	Bottle Ck	7	8	TBR+reef	-	-	250 m
T896	Arthur Beach	8	9	TBR	RBB	LBT	4.5 km
T897	Arthur Beach (N)	8	9	TBR	RBB	LBT	400 m
Spring & neap tidal range = 0.9 & 0.4 m							

Arthur Beach is a 6 km long exposed high energy west-facing beach system composed of four sections (T 894-897). It is bordered to the south by the low Sundown Point and in the north by the sand-covered Gardiner Point at the 200 m wide entrance to the Arthur River. In between is one of the higher energy beaches on the west coast, which is dominated by a wide three bar surf zone backed by some extensive transgressive dunes. The beach is accessible in the south at Sundown Point and by 4WD in the north and centre.

The beach commences in the south at the mouth of the small Sundown Creek, which flows out against the northern rocks of the point. Beach **T 894** trends due north from the creek mouth for 1 km to a linear rock ridge which extends off the beach and marks the beginning of a 500 m long section of rock reefs. Waves are lower in the southern corner where they maintain a single transverse bar and rip system, then rapidly rise to the north with as well a double bar at the northern end. The inner 80 m wide surf zone is usually cut by three rips, which increase in size to the north. Vegetated transgressive dunes widen from 100 to 500 m at the north end.

Beach **T 895** is a 250 m long section of sand located between two rock outcrops and to the lee of the reef-dominated section of surf. The reef disrupts the bars and produces a curving shoreline, with a rip usually draining the inner surf zone against the northern rocks. The dunes continue behind the beach widening to 600 m.

The main section of **Arthur Beach (T 896)** commences on the north side of the rocks whose reefs continue for another 500 m offshore, while Bottle Creek crosses the beach 300 m north of the rocks. Once past the small creek mouth the beach continues north for a total of 4.5 km as an open exposed sandy beach and wide surf zone. Waves

average 3 m and break across a three bar 400-500 m wide surf. The inner bar is dominated by usually eight large rips, with more widely spaced rips along the second bar, while the third bar only breaks during higher seas. The strong westerly winds have blown sand inland to form a series of transgressive dunes which widen to 3.5 km in the north, rising as high as 65 m. Drainage is deflected down the dune ridges with Tiger and Alert creeks crossing the central section of the beach. The beach is open for use by recreational vehicles with access points at each end as well as two central tracks across the dunes, while the Temma Road runs across the inner edge of the dunes.

Beach **T 897** forms the northern 400 m of the beach. It commences past a 100 m long section of scattered rocks and continues to the more continuous rocks that dominate the final 1 km to Gardiner Point. The inner rips and outer bars continue the length of the beach and on towards the point with a large rip exiting against the northern rocks. The beach is backed by a wide grassy foredune, with a vehicle track down the centre, then stabilising transgressive dunes, including a large blowout behind the southern end.

T 898-902 GARDINER POINT-ARTHUR RIVER

No.	Beach	Rating		Type			Length
		HT	LT	inner	second	third bar	
T898	Gardiner Pt (S3)	8	9	TBR+rocks	RBB	LBT	100 m
T899	Gardiner Pt (S)	8	9	TBR+rocks	RBB	LBT	100 m
T900	Gardiner Pt (S)	8	9	TBR+rocks	RBB	LBT	200 m
T901	Gardiner Pt (E)	3	5	LTT+river			50 m
T902	Arthur R (S)	2	4	R+river			250 m
Spring & neap tidal range = 0.9 & 0.4 m							

Gardiner Point is a low sandstone point backed by vegetated transgressive dunes, which form the southern head to the 200 m wide Arthur River. The river occupies a drowned incised valley and meanders upstream between the 50-100 m high valley sides for several kilometres. The Arthur Bridge crosses the river 700 m west of the point, with the small settlement of Arthur River on the southern side of the bridge. Five beaches are located either side of the point, three to the south (T 898-900) and two just inside the river mouth (T 901 and 902) (Fig. 4.179).

Beaches T 898, 899 and 900 are three pockets of sand that occupy part of a 600 m long section of rocky shore that extends south of the point to link with the Arthur Beach system (beaches T 887-894). A 4WD track from Arthur River runs along the foredune at the rear of the beach to link with the main beach. The high waves of the main beach and 400 m wide surf zone continue along the rocky section with the rock disrupting the inner bar and in places the second bar, while the third bar continues essentially undisturbed, widening in the north as it links with the wide river mouth shoals. Beach **T 898** is an open 100 m long pocket of sand that commences 200 m north of beach T 897 and is wedged between rock platforms, with a discontinuous southern rock ridge extending out to

the second bar. Waves break across the bars and reefs with a permanent rip flowing along the inside of the reef.

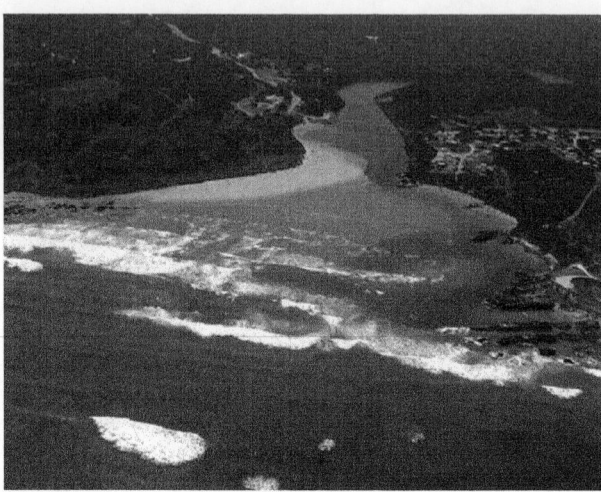

Figure 4.179 The Arthur River mouth and its sheltered river mouth beaches (T 901-903).

Beach **T 899** is located 100 m further north and consists of a 100 m long strip of sand largely fronted by a rock platform, with only a small open sandy section towards the northern end and scattered reefs extending to the second bar. Beach **T 900** lies another 100 m to the north and is a 200 m long strip of sand interrupted by several rock outcrops and reefs that extend 50 m into the surf, with the bars beyond.

Gardiner Point is marked by two 200 m long ridges of rock that trend to the northwest across the outer river mouth. Beach **T 901** is located at the base of the ridges, with another 100 m long ridge forming its eastern boundary. The 50 m long pocket beach is sheltered from direct wave attack, with a small bar filling the inner area between the ridges, and the deep water of the river channel running just outside the end of the ridges. Two car parks are located immediately east of the beach.

Beach **T 902** lies 200 m further into the river and consists of a curving 250 m long low wave energy beach sheltered by the extensive bars and river mouth shoals that extend 1 km to the west. Low wave to calm conditions usually prevail along the narrow beach, which is backed by a high tide boulder beach then slopes rising to the edge of the Arthur River houses. While waves are usually low at the beach the deep river channel and strong tidal flow run just off the shore and present a hazardous location for swimming.

T 903-904 ARTHUR RIVER (N)

No.	Beach	Rating		Type		Length
		HT	LT	inner	outer bar	
T903	Arthur R (N)	8	9	TBR+river mouth		500 m
T904	Australia Pt (E)	6	7	TBR+reefs	RBB	600 m
Spring & neap tidal range = 0.9 & 0.4 m						

The north side of the Arthur River is dominated by low dune-capped rocky shore that extends west for 2 km to Australia Point. Between the river and point are three beaches (T 903-905).

Beach **T 903** is a dynamic shifting beach that partially blocked the river mouth. The protruding 500 m long beach begins in the river mouth and protrudes towards the entrance before curving round to the west to attach to the rocky shore at its western end. It is a wide beach backed by a low grassy foredune and fronted by shallow river mouth shoals that extend south to the channel and west 500 m into the high surf. The inner beach borders the deep river channel with its strong flows while the exposed outer beach faces into the high surf with rips, river flows and to the west scattered rocks in the inner surf. The beach is destabilised by the river flow, floods and the shifting river mouth bar.

Beach **T 904** is located 500 m to the west and consists of curving 600 m long south-facing moderately exposed sandy beach, bordered by low rocky points with a central rock outcrop (Fig. 4.180). It is partly sheltered by inner and outer reefs with waves averaging 1.5-2 m and breaking across an outer bar which links with the river mouth shoals 400-500 m offshore. The inner bar is usually drained by permanent rips to either end. It is backed by a grassy foredune and older vegetated dunes extending 2.5 km inland, while vehicle tracks reach both ends of the beach.

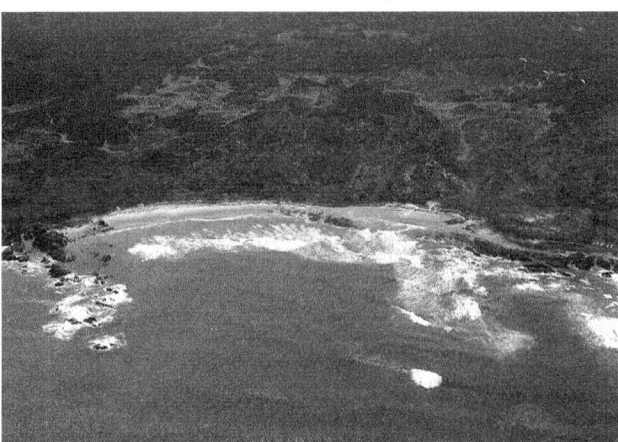

Figure 4.180 The moderately sheltered beach T 904 receives sufficient waves to maintain permanent rips to either end.

T 905-910 **AUSTRALIA POINT-BLUFF HILL**

No.	Beach	Rating HT	LT	Type	Length
T905	Australia Pt	3	4	R+rocks/reef	100 m
T906	Australia Pt (N)	3	5	R+rock platform	150 m
T907	Church Rock (S)	3	5	Cobble+rocks/reef	60 m
T908	Church Rock (N)	3	5	Cobble+rocks/reef	200 m
T909	Bluff Hill (1)	3	5	Cobble+rocks/reef	600 m
T910	Bluff Hill (2)	3	5	Cobble+rocks/reef	100 m
Spring & neap tidal range = 0.9 & 0.4 m					

At **Australia Point** the rocky shoreline turns and trends to the northwest for 5 km to Bluff Hill Point, a low vegetated sand-covered rocky point and one of the two most westerly points on the Tasmanian mainland at 144°36'E. The rocky shoreline in between is exposed to the full force of the southwest waves and winds, with the waves breaking over reefs that extend up to 1 km seaward resulting in low waves at the shore. A vehicle track runs the length of the irregular rocky shore and provides access to the six low energy rock-dominated beaches (T 905-910) that occupy parts of the shore.

Beach **T 905** is located in a 100 m wide rocky bay on the southern side of Australia Point. The sand and cobble beach faces south across 500 m of inner and outer reefs, with waves lowered to less than 1 m at the shore. It is backed by storm boulders and a small foredune with the vehicle track behind.

Beach **T 906** is located 200 m to the north on the northern side of the point. It is a crenulate high tide cobble beach, bordered by a 250 m long ridge of rock to the south and facing into a small bay filled with rocks and reefs, leading to outer reefs 800 m offshore. Waves are low at the shore and only reach the beach at high tide. The track runs along the rear of the beach.

Beach **T 907** lies on the southern side of the Church Rock, a series of five 16 m high bare rock ridges. The curving 60 m long beach faces south across 600 m of reefs, and consists of a curving high tide boulder beach, with an intertidal sand and cobble swash zone and then the low tide rock reefs. The southernmost ridge borders the western end of the little beach. Beach **T 908** commences on the northern side of the Rock and continues north along the rocky shore for 200 m as a discontinuous high tide cobble beach fronted by shore transverse rock ridges and reefs. Extensive cobble and shell deposits are located around the beach and in front of the Rock (Fig. 4.181). The vehicle track runs along the rear of both beaches and behind the Rock, with a solitary fishing shack located at the base of the Rock.

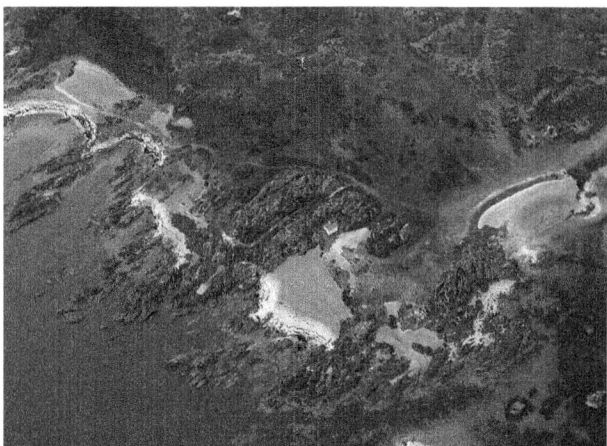

Figure 4.181 Beaches T 907 and 908 lie either side of the prominent Church Rock (right), with both beaches and backing beach ridges dominated by the rock reefs and composed of cobbles and boulders.

Beach **T 909** commences 300 m to the north and consists of a crenulate 600 m long southwest-facing high tide ridge of cobbles, fronted by irregular 50-80 m wide intertidal rock flats with deeper reefs extending 800 m offshore. Waves are low at the shore only reaching the beach at high tide. The track runs along the rear of the beach. Beach **T 910** is located 400 m to the north and 500 m south of 50 m high Bluff Hill. The 100 m long beach occupies a small southwest-facing embayment bordered by shore-perpendicular ridges of rock, the beach curving between the boundary rocks, with shallow reefs filling the small bay and continuing 500 m offshore.

T 911-914 BLUFF HILL POINT (E)

No.	Beach	Rating HT LT	Type	Length
T911	Bluff Hill Pt (E1)	3 4	R+reef	150 m
T912	Bluff Hill Pt (E2)	3 4	R+reef	50 m
T913	Bluff Hill Pt (E3)	3 4	R+rocks/reef	150 m
T914	Bluff Hill Pt (E4)	3 4	R/LTT+reef	250 m
Spring & neap tidal range = 0.9 & 0.4 m				

The low **Bluff Hill Point** forms the southern boundary of the open, 7 km wide, west-facing Mawson Bay with West Point forming the northern boundary. In between are 11 km of sand and some rocky shoreline containing 14 beaches (T 911-924) ranging from very sheltered in the south to high energy along the central-northern section, the latter backed by some transgressive dune systems. The first four beaches (T 911-914) are located between 1 and 2 km east of the point and are sheltered both by the point and extensive rocks and reefs that dominate the southern corner of the bay.

Beach **T 911** is a curving, northwest-facing 150 m long low energy sandy beach, tied to a low vegetated islet in the south and bordered by a low rocky point to the north, with reefs extending 400 m offshore. Beach **T 912** lies 50 m to the east on the other side of the small boundary point and is a 50 m long high tide cobble and boulder beach grading into intertidal sand then reef. Both beaches are well protected by their orientation, the point and reefs with waves averaging 0.5 m or less at the shore. They are backed by a cleared area containing about 12 fishing shacks. The centre of the main beach is used a slipway with fishing boats often pulled up onto the beach.

Beach **T 912** is located 200 m to the east, with a large fishing shack on the boundary point. It curves to the northeast for 150 m between shore-perpendicular low rocky points that grade into reefs and continues a few hundred metres offshore. Waves are lowered to less than 1 m with reflective conditions usually prevailing. A well vegetated 150 m wide hummocky foredune backs the beach. Beach **T 913** commences immediately to the north and curves to the northeast for another 250 m terminating at a protruding 200 m long section of low rock ridges. Waves average about 1 m and maintain a reflective to low tide terrace beach. A low foredune then cleared area with a few fishing shacks back the southern half of the beach, with the small Nimble Creek crossing in the

centre, and a grassy foredune area behind the northern end.

T 915-917 MAWSON BAY (S)

No.	Beach	Rating HT LT	Type inner	outer bar	Length
T915	Nimble Ck (N)	7 8	TBR	RBB	1.5 km
T916	Woodside Ck	7 8	TBR	RBB	1.1 km
T917	Black Rocks	4 5	R+reef/rocks		150 m
Spring & neap tidal range = 0.9 & 0.4 m					

The southern half of **Mawson Bay** consists of the 1.5 km of rock- and reef-dominated northwest-facing shore containing four lower energy beaches (T 911-914), beyond which the shoreline turns and trends north and becomes exposed to high wave conditions. Between the boundary rocks at the northern end of beach T 914 and the central Black Rocks reefs are three beaches (T 915-917) occupying 2.6 km of the bay shore.

Beach **T 915** commences as the shoreline turns at the low boundary rocks and trends to the north for 1.5 km to a series of inner reefs that terminate at a larger reef-tied sandy foreland. The beach faces due west and receives waves averaging 2 m and more which maintain a double bar system, with usually two large central beach rips and two rips against the boundary rocks, the larger at the higher energy northern end of the beach. The outer bar lies 300 m offshore linking to the tip of the southern rocks. It breaks during higher waves and is usually drained by two large rips.

Beach **T 916** commences at the foreland and continues to the north for 1.1 km to the southern side of Black Rocks. Several smaller rock outcrops and reefs are located the length of the beach and generate five small embayments each divided by the rocks and drained by reef-controlled rips, with a disrupted outer bar along the outer edge of the reefs.

Beach **T 917** is located to the lee of Black Rocks and consists of a series of scattered reefs and small islets extending 500 m offshore. It is a curving 150 m long low energy beach tied to low rocky points at either end. The reefs lower waves to less than 1 m at the shore with a high tide reflective beach fronted by shallow rocks and reefs.

The three beaches are backed by generally well vegetated transgressive dunes that widen from 600 m in the south to 1.5 km in the north, rising up to 55 m in elevation. The dunes have disrupted the backing drainage forming some small lakes, with only Woodside Creek reaching the shore in the centre of beach T 916. The beach is accessible by 4WD along the shore, with the track in some places using the grassy foredune.

T 918-923 MAWSON BAY (CENTRE)

No.	Beach	Rating		Type			Length
		HT	LT	inner	second	third bar	
T918	Black Rocks (N1)	7	8	TBR	RBB		300 m
T919	Black Rocks (N2)	7	8	TBR	RBB		200 m
T920	Mawson Bay (1)	7	8	TBR	RBB		400 m
T921	Mawson Bay (2)	7	8	TBR	RBB	RBB/LBT	1.4 km
T922	Doctors Ck	7	8	TBR	RBB		550 m
T923	Doctors Ck (N)	7	8	TBR	RBB		150 m
Spring & neap tidal range = 0.9 & 0.4 m							

The central 3 km of **Mawson Bay** is the most exposed section and contains six high energy beaches (T 918-923), each separated by rock outcrops and reefs and all backed by the vegetated transgressive dunes with Wells, Cuffys and Doctors creeks draining through the dunes to the beach. The northern part of the bay and the boundary West Point are located within the West Point Aboriginal Site.

Beaches T 918, 919 and 920 are three adjoining beaches that extend north of Black Rocks and are each separated by low rocky outcrops or small points. Beach **T 918** commences on the northern side of the low 50 m wide north Black Rocks and trends north for 300 m to the next irregular 50 m wide, 6 m high rock outcrop (Fig. 4.182). The Black Rocks reefs extend seaward of the southern end and these and the northern rocks form a reef-controlled rip that drains the inner surf zone, flowing out past the north rocks, with the outer bar beyond. Beach **T 919** continues for another 200 m up to the next irregular 10 m high rocky 100 m wide vegetated outcrop. The two outcrops converge towards the centre, with a small reef off the centre of the beach. Waves however remain high with the reef controlling the inner surf, which is drained by a solitary rip while the outer bar continues seaward. An access track follows a relatively straight 2 km long boundary to reach the shore at the point. Beach **T 920** extends due north of the point for 400 m to a small rock outcrop. It tends to have a large rip against the southern point, and a second rip towards the northern rocks. All three beaches are backed by 1 km wide transgressive dunes in the south, narrowing along beach T 920 towards the mouth of Wells Creek.

Beach **T 921** is the main bay beach and highest energy beach in the bay. It commences at a small southern rock outcrop and trends to the north-northwest, past Wells Creek for 1.4 km to a narrow rock ridge and reefs that extend into the surf. The beach receives waves averaging 3 m that maintain a 600 m wide three bar system. It consists of a rip-dominated inner bar normally drained by four large rips, including two against the boundary rocks. The second bar is highly rhythmic with usually two rips, while the outer bar is less well defined and only breaks during high seas. The small Wells Creek drains across the southern end of the beach, with Cuffys Creek towards the northern end and the vegetated dunes behind, widening to 2.5 km by the northern end of the beach

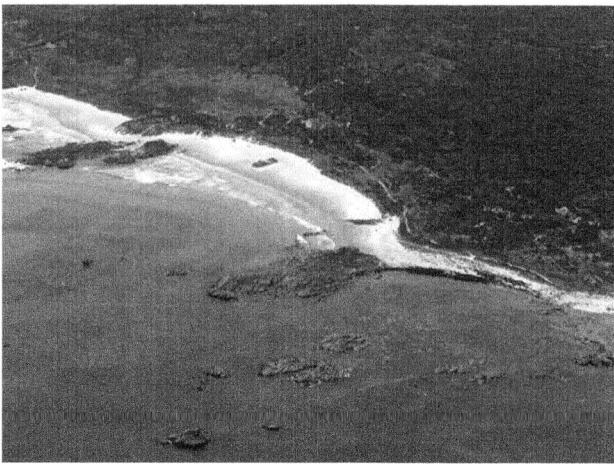

Figure 4.182 Beach T 918 is the southernmost of the Mawson Bay beaches.

Beaches T 922 and 923 occupy the northern end of the longer beach section. Beach **T 922** extends to the northwest for 550 m between the rock reefs and a 50 m wide low rocky point, with the small Doctors Creek crossing the centre of the beach. The two bars continue along the beach with the inner bar dominated by two rips against the boundary rocks and during lower waves a central beach rip. Beach **T 923** is located between the northern point and a 200 m wide 20 m high sand-draped rocky point. The beach is only 150 m long with the southern reefs and north point extending 300 m seaward and lowering waves slightly at the beach. During high waves a solitary large rip runs out against the northern rocks to reach the second bar. Both beaches are backed by the 2.5 km wide dunes on the south side of Doctors Creek, which narrow to several hundred metres on the north side.

T 924 LIGHTHOUSE BEACH

No.	Beach	Rating		Type	Length
		HT	LT		
T924	Lighthouse Beach	6	7	TBR/RBB	700 m
Spring & neap tidal range = 0.9 & 0.4 m					

Lighthouse Beach (**T 924**) occupies the northern corner of Mawson Bay. The curving 700 m long beach faces southwest and is bordered to the north by West Point that extends 500 m to the west with reefs continuing seaward for another 400 m, while a 200 m wide vegetated point separates it in the south from the southern beaches (Fig. 4.183). The beach is partly sheltered by reef off the southern point, and rocks along the northern end and West Point, all of which lower waves to each end with higher waves in the centre. The waves break across a wide low gradient bar drained by permanent rips to each end, which provide access to some good beach, breaks, known as *Lighthouse*. A grassy foredune crossed by several foot tracks backs the beach then 500 m of vegetated transgressive dunes rising to 20 m. The gravel West Point Road runs out to the point with a car park overlooking the northern end of the beach and a vehicle track winding down to the beach.

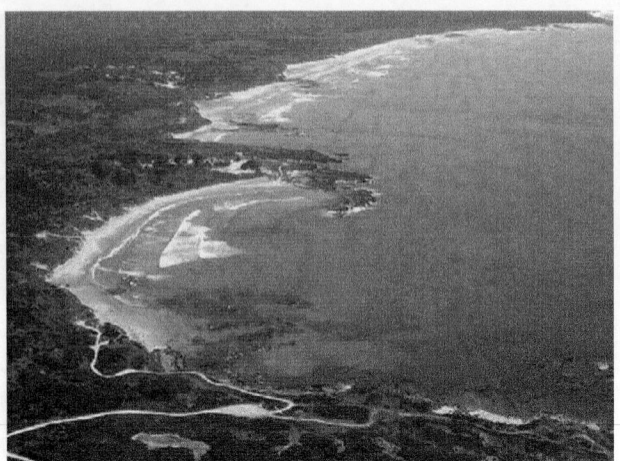

Figure 4.183 Lighthouse Beach (foreground) and the Mawson Bay beach extending to the south.

T 925-929 WEST-PAVEMENT POINTS

No.	Beach	Rating HT LT	Type	Length
T925	West Pt	4 4	LTT	60 m
T926	Gales Bay	3 4	Cobble+rock flats	150 m
T927	Nettley Bay	4 4	Cobble+rock flats	400 m
T928	Pavement Pt	4 4	R+rock flats	150 m
T929	Pavement Pt (E)	4 5	Boulder+rocks/reef	200 m
Spring & neap tidal range = 0.9 & 0.4 m				

West Point is the westernmost tip of the Tasmanian mainland coast at 144.5°E and consists of an irregular low rocky 1.2 km wide headland containing numerous low hummocky rock outcrops, with Mawson Bay to the south and a 5 km long section of lower energy rocky shore to the north terminating at Slaves Bay. Five small sheltered rock-dominated beaches (T 925-929) are located along the rocky section. All are accessible by vehicle tracks.

Beach **T 925** is located 700 m north of the western tip of the point, at the base of a 250 m deep 100 m wide rocky bay. The 60 m long beach curves around the eastern end of the beach facing west out towards the entrance. Waves are low at the shore, with rocks outcropping along the northern end of the beach. It is backed by a low grassy foredune and two fishing shacks.

Gales Bay is located 500 m to the northwest on the northern side of the point. It is a semi-circular 150 m wide, north-facing rocky bay, with beach **T 926** curving around the southern base for 150 m. It is a narrow high tide cobble beach fronted by intertidal rock flats that narrow to the east where a boat ramp crosses the beach.

Nettley Bay lies another 700 m to the northeast and is a 400 m long west-facing rocky bay with a highly irregular eastern shore containing seven pockets of high tide cobbles and boulders (beach **T 927**) separated by west-trending rock outcrops grading into intertidal and subtidal reefs, which fill the bay floor. Waves are lowered to 0.5 m and less at the shore, with the beaches only active

at high tide. Three fishing shacks are located along the northern end of the beach.

Pavement Point is a 200 m wide low sandstone point capped by bare rock ridges with vegetation in between. Beach **T 928** is located immediately east of the point and consists of a 150 m long north-facing low energy sandy beach fronted by shallow reefs. It is bordered by low rocky shore and backed by cleared farmland, the southernmost coastal farmland on the west coast.

Beach **T 929** lies 800 m to the east and is a straight 200 m long high tide boulder beach, bordered by low rocky shore and fronted by rocks, shallow reefs and patches of sand. It faces northwest with waves averaging less than 1 m. A patch of bare sand dune is located behind the western point, with cleared farmland extending in from the beach and point.

T 930-931 PERIWINKLE BEACH

No.	Beach	Rating HT LT	Type inner	outer bar	Length
T930	Periwinkle Beach	7 7	TBR	RBB	550 m
T931	Periwinkle Beach(N)	6 7	TBR+reef		150 m
Spring & neap tidal range = 0.9 & 0.4 m					

The two Periwinkle beaches (T 930 and 931) are located in Slaves Bay, a 2 km wide west-facing rock bay bordered by Pavement Point to the south and Green Point to the north (Figs. 4.184 &. 4.185). Most of the bay shore consists of low rock and backing farmland, with beaches T 928 and 929 occupying part of the southern shore. The Periwinkle beaches are located towards the northern end of the beach adjacent to the low Green Point, which protrudes 1 km to the northwest. The main beach is accessible by car along the Green Point Road.

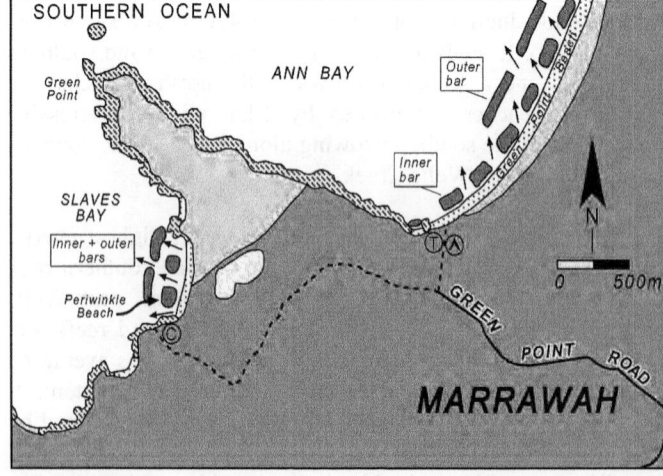

Figure 4.184 Marrawah is a popular surfing location with breaks at Periwinkle Beach and the main rip dominated Marrawah beach.

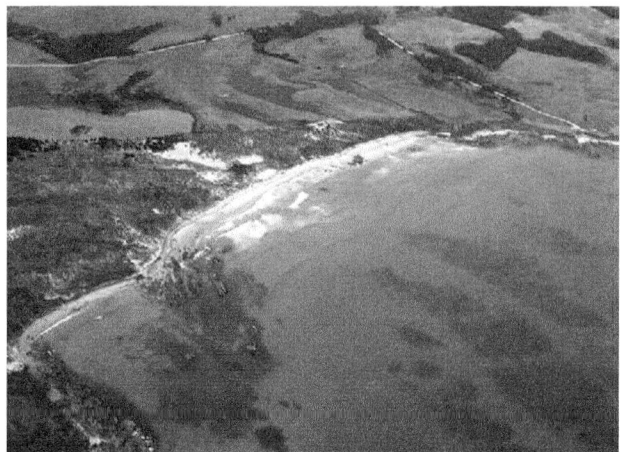

Figure 4.185 The Periwinkle beaches (T 930 & 931) during relatively calm conditions, which highlight the extensive rock reefs in the bay.

Periwinkle Beach (T 930) is a 550 m long slightly curving west-facing sandy beach bordered by low rocky shore to the south and a 100 m long ridged-reef to the north, together with a few rocks on the shore. It is exposed to waves averaging over 2 m, which maintain a well developed inner bar, usually drained by rips to either end, and at times a smaller central rip. Higher waves break across an outer bar and deeper reefs and feed a strong rip, which runs out against the northern rocks. The beach is backed by a high tide cobble beach, then vegetated dunes that extend to the northeast for up to 1 km and cross the rear of Green Point. The road terminates at the southern end of the beach, which is a popular surfing spot, also called *Nettley Beach* or *Nettley Bay*.

Beach **T 931** is located on the northern side of the boundary reef and consists of a 150 m long high tide boulder and intertidal sand beach which grades into a deeper reef with some rock outcrops off the southern half. Waves break over the rocks, reefs and sand and feed a permanent rip that exists along the northern rocks that continues for 800 m to Green Point.

T 932 MARRAWAH (THREE MILE, GREEN POINT) BEACH

No.	Beach	Rating		Type		Length
		HT	LT	inner	outer bar	
T932	Marrawah	6	7	TBR	RBB	5.7 km
Spring & neap tidal range = 0.9 & 0.4 m						

Marrawah is a small community located at the end of the Bass Highway 3 km in from the coast. A sealed road leads to the two main surfing beaches at Periwinkle (T 930) and Marrawah (T 932). There are limited facilities available at Marrawah, with a camping reserve and toilets at the beach and a car park at Periwinkle. The beaches lie either side of Green Point, with Periwinkle occupying the southern Slaves Bay, and Marrawah, also known as Three Mile and Green Point beach, the northern Ann Bay. Both

bays face west into the persistent high westerly swell and have energetic, hazardous surf zones.

Marrawah Beach begins at the base of Green Point and runs for 5.7 km (3.6 miles) up to Mount Cameron West, a steep 170 m high basalt headland. The beach faces west-northwest with the southern end receiving slight protection from Green Point, while the very southern corner contains a 100 m long section between the point and a small reef that usually has the lowest waves (Fig. 4.186). Wave height increases rapidly up the beach with a rip-dominated double bar dominating north of the reef. The inner bar has a combination of beach rips and rips against four areas of rocks and inner reefs, with up to 15 rips along the shore. The outer bar lies 200 m offshore with more widely spaced rips, while a third bar forms along the northern few hundred metres of beach terminating against Mount Cameron West.

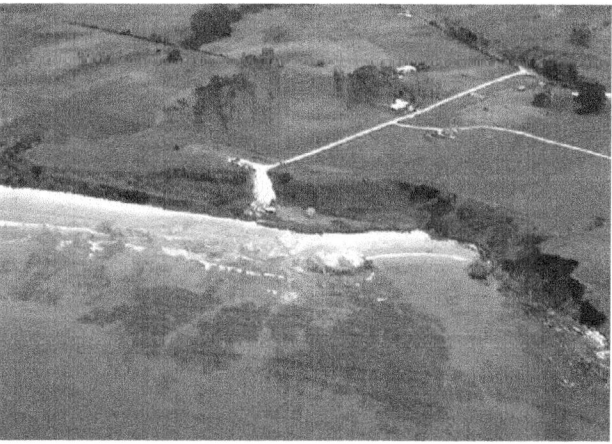

Figure 4.186 The southern corner of Marrawah Beach showing the main beach access point and adjacent reefs.

The beach is backed by vegetated transgressive dunes that increase in size to the north where they extend up to 2 km inland and to a height of 30 m. The drainage is orientated along the shore-perpendicular dune ridges with six small creeks, including Shell Creek draining onto the beach. The northern dunes are included in the Mount Cameron West Aboriginal Site. The best beach access is in the southern corner where there is a car park, picnic area, playground and a camping area, while a vehicle track also reaches the northern end of the beach at the southern base of Mount Cameron West.

Swimming: Be very careful if swimming as strong rips run out from the beach. Stay close inshore on the bar and well clear of any rip currents. Best in the southern corner, however if waves are breaking rips will be present.

Surfing: Both Periwinkle and Marrawah beaches are well known surfing and wind surfing locations, with waves breaking over both the wide surf zone and some of the reefs. The main breaks are *Green Point*, with a left along the point, Greens *Beach* (Marrawah Beach) and *Nettley* (Periwinkle). At the northern end of the surfable beach are beach and reefs at the base of *Mount Cameron*.

T 933-935 MOUNT CAMERON BEACH

No.	Beach	Rating Type				Length
		HT LT	inner	second	third bar	
T933	Mt Cameron Beach	7 8	TBR	RBB	RBB	3.2 km
T934	Mt Cameron (N1)	6 7	TBR+rocks/reef			250 m
T935	Mt Cameron (N2)	6 7	TBR+rocks/reef			250 m
Spring & neap tidal range = 0.9 & 0.4 m						

Mount Cameron West dominates the landscape rising steeply to 168 m (Fig. 4.187). The mount is located in the centre of Mount Cameron West Aboriginal Site, which includes significant rock engravings and middens. The site includes the north end of Marrawah Beach (T 932) and all the beaches up to Maxies Point (T 934-938), as well as much of the backing dunes and the mount. Six beaches (T 933-938) are located between the base of the northern side of the mount and the low rocky Maxies Point. Four-wheel drive tracks provide access to most of the beaches.

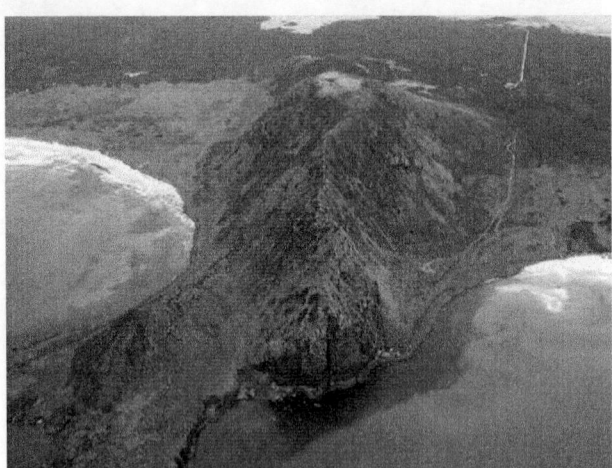

Figure 4.187 Mount Cameron West with Marrawah and Cameron beaches to either side (photo W. Hennecke).

Mount Cameron Beach (**T 933**) commences at the northern base of the basalt mount, as the basalt boulders that rim the base give way to the low gradient white sandy beach that trends to the north for 3.2 m to the beginning of the next rocky section of shore. The mount protrudes 1 km seaward in the south affording some protection to the southern corner of the beach. Wave height however increases rapidly up the beach, with one, then two and finally three bars dominating most of the surf zone, which widens to 400-500 m at the northern end. The inner bar is usually cut by five strong rips, with more widely spaced rips crossing the outer bars. The beach is backed by both vegetated and a 200 ha area of active dunes which form an active sand sheet of transverse dunes, and whose deflation basin has been partly stabilised in the past 20 years. The dunes extend up to 3 km inland rising to more than 50 m in places. Several small creeks run though the dunes to drain onto the beach.

Beaches T 934 and 935 are located amongst the rocks at the northern end of the main beach. Beach **T 934** is a 250 m long southwest-facing low gradient sandy beach, bordered by rock outcrops, which extend into the surf 50 m in the south and 200 m in the north, together with scattered reefs off the beach and in the surf. While the rocks and reefs lower waves at the shore they induce reef-controlled rips, with a mixture of sand, rocks and gutters dominating the surf zone. A small creek drains onto the centre of the beach, which is backed by vegetated transgressive dunes blanketing the backing low bedrock.

Beach **T 935** lies 100 m to the north with an irregular cluster of rock outcrops in between. The beach continues northwest for 250 m to the next largest outcrop which trends southwest into the surf for 300 m. The rocks and reefs to either side form a channel with the lower energy beach and bar at the base, however during high waves a rip exits between the reefs. An irregular foredune and densely vegetated transgressive dunes back the beach.

T 936-938 MAXIES POINT (S)

No.	Beach	Rating	Type	Length
		HT LT		
T936	Maxies Pt (S3)	6 7	TBR+rocks/reef	150 m
T937	Maxies Pt (S2)	6 7	TBR+rocks/reef	100 m
T938	Maxies Pt (S1)	4 5	LTT+rocks/reef	250 m
Spring & neap tidal range = 0.9 & 0.4 m				

Maxies Point is the southernmost point in a 5 km long section of irregular rocky shore that continues north to Dodgers Point. The point is a low dune-covered rocky headland composed of steeply dipping meta-sedimentary rocks, which form an irregular shoreline and numerous rocks, islets and reefs extending up to 1 km offshore. Small pockets of sand are located south (beaches T 936-938) and north (beaches T 939-943) of the point, with access via the boundary track, which descends to the rear of the point.

Beach **T 936** occupies the first gap in the southern rock reefs. It is a 150 m long west-facing beach bordered by the 300 m long reef to the south and a ridged-reef extending 200 m offshore to the north, with waves lowered to about 1.5 m between the two. The waves break over a usually attached bar with a deep channel and rip running out against the southern rocks. A semi-stable foredune, then vegetated slopes, back the beach.

Beach **T 937** is a 100 m long pocket of sand wedged between ridged rock outcrops, with rocks and reefs also dominated the surf zone., with larger rocks and refs further out. In amongst the rocks a bar extends 80 m offshore, with some small rip channels adjacent to the reefs.

Beach **T 938** commences 50 m to the north and occupies the southern side of the low rocky Maxies Point. The beach consists of a 250 m long collection of three pockets of sand divided by large rock outcrops off the beach,

together with rock ridges bordering each end and some in the centre. More extensive rocks and reefs extend up to 300 m offshore lowering waves to about 1 m at the shore. While waves are usually lower the reefs result in a number of deeper holes in the bar that links most of the inner reefs. A cleared boundary track runs down the rear of the point to provide access to the beach.

T 939-943 MAXIES POINT (N)

No.	Beach	Rating HT LT		Type	Length
T939	Maxies Pt (N1)	3	4	R+rocks/reef	100 m
T940	Maxies Pt (N2)	3	4	R+rocks/reef	200 m
T941	Maxies Pt (N3)	4	5	LTT+rocks/reef	60 m
T942	Maxies Pt (N4)	3	4	R+rocks/reef	60 m
T943	Maxies Pt (N5)	4	5	LTT	200 m
Spring & neap tidal range = 0.9 & 0.4 m					

The northern side of Maxies Point consists of a slight 1.5 km long rocky embayment ringed by reefs extending 500 m offshore. Five small partly sheltered beaches (T 939 943) occupy parts of the shore. The first 500 m north of the point consist of a 500 m long section of low rocky shore fringed by extensive reefs. The next 500 m long section is occupied by three sheltered beaches (T 939-941) (Fig. 4.188).

Figure 4.188 Beaches T 939-941 extend north of Maxies Point in lee of the reef-studded nearshore.

Beach **T 939** is a 100 m long reflective beach located to the lee of rocks and reefs extending up to 1 km offshore. The inner reefs form a small 'lagoon' off the beach, with waves usually less than 1 m at the shore. The northern end of the beach occasionally ties to a reef forming a small tombolo. Beach **T 940** commences on the northern side of the foreland-tombolo and curves to the northeast for 200 m to the next rock outcrop, with some rocks also along the shore. The reef extends the length of the beach with a partly sheltered 100-200 m wide sandy 'lagoon' between the rocks and shore. Waves are usually low with reflective conditions at the shore. Both beaches are

backed by a semi-stable foreland and now largely vegetated transgressive dunes, which as recently as 1970 where migrating up to 600 m inland.

Beach **T 941** is located 100 m to the north and is a curving 60 m long pocket of west-facing sand wedged between irregular rocky points extending 50 m seaward on either side, with more extensive reefs further out. Waves average about 1 m at the shore and maintain a small bar. Vegetated dune-covered low bedrock slopes back the beach.

Beach **T 942** is located another 300 m to the north, with vegetated dune-capped rocks in between. The beach is a 60 m long pocket of west-facing sand bordered by slightly converging low rocky points, which extend over 100 m to the west and form a shallow bay. The bay floor is rocky with the beach occupying the eastern end. The reefs and rocks lower waves to about 0.5 m at the shore where they surge up the small reflective beach. It is backed by a stabilised dune system, which contains an inner blowout.

Beach **T 943** is located 200 m to the north and is a 200 m long south-facing sandy beach, bordered by the rocky coast to the east and the southern end of a 500 m long ridge of north-south trending rock, which continues south as patchy reef. Waves are lowered to about 1 m where they maintain a reflective to low tide terrace beach, with sand extending 50-100 m offshore. A low grassy foredune, then densely vegetated transgressive dunes, back the beach.

T 944-949 CALM BAY

No.	Beach	Rating HT LT		Type	Length
T944	Calm Bay	4	5	R/LTT+reef	400 m
T945	Calm Bay (N1)	3	4	R+rocks/reef	100 m
T946	Calm Bay (N2)	3	4	R+reef	100 m
T947	Calm Bay (N3)	3	3	R	100 m
T948	Calm Bay (N4)	4	5	R+rocks/reef	200 m
T949	Calm Bay (N5)	4	5	R+rocks/reef	200 m
Spring & neap tidal range = 0.9 & 0.4 m					

Calm Bay is a sheltered 300 m wide semi-circular shaped rocky bay located to the lee of rocky points and reefs that extend up to 600 m offshore and permit only southerly waves to enter the embayment. Waves are normally reduced to less than 1 m within the bay, which is occasionally used by fishing boats to shelter from the swell. Three protected beaches (T 944-946) are located around the bay shore.

Beach **T 944** occupies the southeastern shore of the bay. It is a curving 400 m long northwest-facing reflective to low tide terrace sandy beach that faces across the bay towards the protecting rocks and reefs, with only low refracted waves reaching the shore. It is bordered by low rocky points with rocks outcropping on the southern half of the beach, and sand then rocky seafloor off the beach.

It is backed by a low grassy foredune then older vegetated transgressive dunes and a small wetland.

Beach **T 945** lies 100 m to the north on the northern side of the bay. It is a 100 m long west-facing high tide sandy beach, bordered by low rocky points and fronted by continuous rocks and rock reef, resulting in low waves at the shore. Beach **T 946** lies immediately to the north and is a similar 100 m long pocket of sand curving between low rocky points, with some sand off the beach and then the extensive reefs of the bay. Both beaches are backed by a densely vegetated foredune, then older vegetated dunes.

Beach **T 947** lies 50 m east of beach T 946, but on the outside and northern side of Calm Bay. A vehicle track crosses the low vegetated dunes that link the two beaches. The 100 m long beach faces north-northwest between two low rocky points, which form a 200 m long narrow bay resulting in low waves and often calms at the shore. A small creek drains onto the eastern end of the beach, the creek linked to a 10 ha wetland 300 m to the east.

Beaches T 948 and 949 are neighbouring northwest-facing beaches located 400 m to the north. Beach **T 948** is a curving 200 m long reflective beach tied to low rocky points and reefs at either end. The reefs converge with only a central patch of sandy sea floor. A sandy foreland forms the northern end, with beach **T 949** curving to the north of the foreland for another 200 m to terminate at the next low rocky point. It is a reflective high tide beach with a primarily rocky sea floor. Both beaches are backed by active blowouts that have transgressed up to 500 m inland climbing to 30 m (Fig. 4.189), with some older vegetated dunes behind, then some cleared farmland.

T 950-951 DODGERS POINT

No.	Beach	Rating HT LT	Type	Length
T950	Dodgers Pt (1)	4 5	LTT+rocks/reef	80 m
T951	Dodgers Pt (2)	4 5	R+rocks/reef	50 m
Spring & neap tidal range = 0.9 & 0.4 m				

Dodgers Point is a low irregular meta-sedimentary point fringed by reefs extending up to 1 km offshore. In amongst the rocks on the northern side of the point are two small sheltered beaches (T 950 and 951). Beach **T 950** is an 80 m long straight northwest-facing sandy beach fronted by a shallow bar and bordered by low rocky points that extend 200 m offshore converging to form a narrow channel. The rocks and outer reefs lower waves to less than 1 m at the shore and at low tide form a 'lagoon' off the beach. Beach **T 951** lies 200 m to the north and is a 50 m long pocket of sand completely encased in rocks and rock reefs, with only a 20 m wide sandy gap and tidal pool off the beach at low tide. Both beaches are backed by low foredunes, grassy deflated surfaces, and then older vegetated dunes. A vehicle track reaches the rear of beach T 950.

Figure 4.189 Climbing transgressive dunes back the two northern beaches in Calm Bay (T 948 & 949).

T 952 STUDLAND BAY

No.	Beach	Rating HT LT	Type inner outer bar		Length
T952	Studland Bay	7 9	LTT→TBR+reefs	RBB	3.7 km
Spring & neap tidal range = 0.9 & 0.4 m					

Studland Bay is an exposed 2.5 km wide west-facing, semi-circular shaped bay, bordered to the south by the low irregular Dodgers Point and to the north by the steep 72 m high basaltic Bluff Point. In addition to the points, reefs extend 1 km north of Dodgers Point and are scattered along parts of the southern-central shoreline and surf zone. Curving between the two points is 3.7 km long beach **T 952**.

The beach consists of three sections. In the south Dodgers Point and reefs lower waves to about 1 m where they maintain a low tide terrace along the first 1 km of shore. Waves then increase to over 1.5 m along the central 2 km where they interact with the rocks and reefs to maintain a 100 m wide inner bar cur by a series of six reef-controlled rips. The northern 1 km of the beach curves to the west and is relatively free of reefs, with an outer bar also forming and drained by large rips to each end. The vegetated slopes of Bluff Point rise steeply behind the northern corner of the beach, with reefs dominating the final 200 m of surf.

The beach is backed by a series of both active and older vegetated transgressive dunes. The active dunes form two sand sheets, a 20 ha southern sheet extending about 1 km inland to a height of 68 m and a 150 ha northern sheet which reaches 1.7 km inland and 84 m in height. A narrow parabolic dune also climbs the northern slopes to extend 800 m inland and reach 88 m in height. At least five small creeks drain from the dunes onto the beach.

T 953 **HIPPO POINT (N)**

No.	Beach	Rating HT LT	Type	Length
T953	Hippo Pt (N)	4 5	R/LTT+rocks/reef	100 m
T954	Valley Bay	6 7	TBR	800 m
T955	Victory Hill	4 6	R+rock platform	200 m
Spring & neap tidal range = 0.9 & 0.4 m				

To the north of Bluff Point are 10 km of high basaltic cliffs and bluffs rising to over 100 m along the sheer face of the Flat Topped Bluff and Prospect Hills, to 80 m at Cape Grim, and 65 m at the northern Victory Hill. Most of the shoreline is steep cliffs and rocky shore, with a few boulder beaches in the embayments and only three sandy beaches (T 953-955). Windmill farms are located along the crest of the Flat Topped Bluff.

Beach **T 953** is a 100 m long pocket of north-facing sand located 1 km north of Hippo Point. The beach is bordered by 20 m high vegetated basalt points, with slopes rising steeply to the 100 m high Prospect Hills behind. A foredune climbs about 20 m up the backing slopes. The beach is sheltered by its orientation, the points and reefs extending a few hundred metres off the beach, with usually low waves at the shore. The beach can only be reached on foot down the slopes.

Valley Bay is a 1.2 km wide west-facing bedrock bay surrounded by slopes rising to 80 m with Cape Grim forming the northern headland. Beach **T 954** is a narrow beach that curves around the north-central section of the bay for 800 m (Fig. 4.190). The beach faces due west and receives waves lowered by deeper reefs in the bay to about 1.5 m. They maintain a 50-80 m wide bar usually cut by three rips and backed by a narrow sandy beach, which is at times removed to expose a backing storm boulder beach. Moderate to steep vegetated dune-draped slopes back the beach with the climbing dunes reaching the 50 m high crest and extending up to 1.2 km inland. The dune area is surrounded by farmland, part of the historic Woolnorth station, which is located 2 km east of the beach. The northern Cape Grim is the site of a climate monitoring station and is located on a 50 ha area of Commonwealth land.

Beach **T 955** is located 1 km north of Cape Grim and at the base of 68 m high Victory Hill. The beach consists of a 200 m long strip of high tide sand fronted by an irregular rock platform up to 50 m wide, with scattered reefs beyond. It is backed by a grassy foredune then the grassy slopes rising to over 50 m and the hill.

Figure 4.190 Valley Bay beach is bordered by the northern Cape Grim and backed by steep dune-draped slopes.

T 956-962 **DAVISONS BAY**

No.	Beach	Rating HT LT	Type	Length
T956	Davisons Bay (1)	3 4	R+rocks	80 m
T957	Davisons Bay (2)	4 5	LTT+rocks	100 m
T958	Davisons Bay (3)	4 5	LTT	300 m
T959	Davisons Bay (4)	4 5	LTT+rocks	400 m
T960	Davisons Bay (5)	4 5	LTT+rocks	200 m
T961	Davisons Bay (6)	4 5	LTT+rocks/reef	400 m
T962	Davisons Bay (7)	4 5	LTT+rocks/reef	150 m
Spring & neap tidal range = 0.9 & 0.4 m				

Davisons Bay is located at the very northwest tip of Tasmania, with the low Woolnorth Point, the tip, bordering the northern end of the bay, while 11 m high Davisons Point forms the southern boundary. The sheltered bay is 1.5 km wide and faces northwest towards Trefoil Island. It is also partly sheltered by The Doughboys islets, Davisons Point and its orientation, which lower waves to about 1 m along the shore. The bay has 1.5 km of sandy shore divided into seven small beaches (T 956-962) by low outcrops of sedimentary rocks and reefs. Patches of cleared farmland back the bay and provide 4WD vehicle access to the beaches.

Beach **T 956** is located to the lee of Davisons Point and consists of a curving 80 m long patch of sand bordered by low rocky points, with only a narrow central sandy gap between. Waves average about 0.5 m maintaining a low gradient reflective beach, with low grassy terrain behind.

Beach **T 957** is located 50 m to the east and curves to the northeast for 100 m, with sand and scattered reefs off the beach. Waves average about 1 m and break across a narrow low tide terrace. A rock outcrop separates it from beach **T 958**, which continues northeast for 300 m to the next rock outcrop. Waves remain about 1 m and maintain a narrow low tide terrace. Low vegetated foredunes, then a 200 m wide band of scrub, back the beach, with cleared farmland behind.

Beach **T 959** continues northeast of the rocks for 400 m with two small outcrops on the beach, before terminating at a low protruding vegetated point with rocks and reef extending across the beach and into the low surf. The beach remains a narrow low tide terrace, while reefs increase off the beach. The low foredune, scrub and cleared land continue along the back of the beach. Beach **T 960** is a crenulate 200 m long beach with low rocky points and reefs to either end, as well as a small central reef forming a slight sandy foreland. Dense scrub backs the beach and extends for 900 m across the base of Woolnorth Point.

Beach **T 961** continues north for another 400 m as a double crenulate sandy beach containing three low rocky outcrops, which induce the small forelands, with the dense scrub continuing behind. The bar widens to 50 m as waves pick up to over 1 m. Beach **T 962** is the northernmost strip of the sand and consists of a 150 m long beach largely fronted by ridges of rocks and reefs, with only the northern 30 m open to the sea. A vehicle track from Woolnorth Point reaches the beach, with dense scrub extending for 800 m to the eastern side of the low point.

Woolnorth Point is located at the northwestern tip of the Tasmanian mainland. It is a low rock-tipped 500 m wide sand-covered point composed of Precambrian meta-sedimentary rocks. The rocks strike northeast and parallel the western side of the point. Three sheltered beaches (T 963-965) are located to either side of the point, which is accessible via a vehicle track from Woolnorth Station located 5 km to the south.

Beaches T 963 and 964 occupy the western side of the point. Beach **T 963** is a 300 m long reflective to low tide terrace beach located between a gap in the parallel rock ridges that border each end. The northern rocks form a sandy foreland to their lee (Fig. 4.191). The beach faces west towards Trefoil Island with scattered rocks and reefs located on and off the beach. These lower waves to usually less than 1 m with higher waves breaking over the outer rocks and reefs. A vehicle track crosses the point to reach the southern end of the beach. Beach **T 964** commences at the foreland and continues for 400 m to the low rock-tipped point. Rocks and reefs continue along and just off the beach with reflective beach conditions in between and small lagoons and tidal pools formed in lee of the rocks. Both beaches are backed by generally dense scrub.

T 963-964 WOOLNORTH POINT

No.	Beach	Rating HT LT	Type	Length
T963	Woolnorth Pt (W2)	4 5	R/LTT+rocks/reef	300 m
T964	Woolnorth Pt (W1)	4 5	R/LTT+rocks/reef	400 m
Spring & neap tidal range = 0.9 & 0.4 m				

Figure 4.191 The two northernmost beaches on the West Coast (T 963 & 964) occupy the western tip of Woolnorth Pt.

KING ISLAND

King Island is a 1100 km² island located 80 m northwest of Woolnorth. The island lies towards the centre of the 220 km wide western entrance to Bass Strait and together with Hunter Island to the south and a series of smaller rocks and reefs they effectively block much of the high westerly swell from entering the Strait and shelter the northern Tasmanian coast, resulting in a lower energy wind-waves-dominated shoreline. King Island extends for 65 km north-south (Fig. 4.192), with its western shoreline exposed to the full force of the westerly wind and waves, and generally consists of smaller beaches eroded back to the granite base and backed by extensive Pleistocene and Holocene dune transgression. The more sheltered east coast has acted as a sink for marine sediments with extensive Pleistocene and Holocene barrier regression and several long sandy moderate energy beaches. The island has a total shoreline length of 197 km, which includes 80 beaches, which occupy 90.5 km (46%) of the coast. The main settlement is at Currie on the southwest side of the island, with a small secondary community at the now defunct Grassy mine site on the southeast side of the island. This island has a population of about 1800, most of who live in Currie. The entire west coast of the island is dominated by Precambrian granite, while much of the island has been blanketed with Pleistocene, and to a lesser extend Holocene, transgressive dunes. Most of the island is low and undulating with the highest area reaching 140 m on the resilient granodiorite around Grassy.

Figure 4.192 King Island is bordered by the high energy Southern Ocean on the west coast, with the more sheltered Bass Strait on the east.

The island can be divided into the exposed west coast and more sheltered east coast, with Cape Wickham in the north and Stokes Point in the south forming the extremities of the coast. The only sealed roads on the island lead from Currie north to Cape Wickham and southeast to Grassy, with the remainder accessed on minor secondary roads and 4WD tracks.

KING ISLAND - EAST COAST

Cape Wickham - Stokes Point
Coast length: 96 km (0-96 km)
Beaches: 45 (KI 1-45)

The east coast of King Island faces predominantly east into Bass Strait and extends for 96 km from Cape Wickham to Stokes Point. In between are 45 sandy beaches totalling 64.5 km in length (67% of the coast). The coast is only accessible in the north at Lavinia Beach, in the centre at Fraser Beach and the small community of Naracoopa, and in the southeast at City of Melbourne Bay, Grassy and Colliers Beach.

KI 1-6 DISAPPOINTMENT BAY-WHITE BEACH

No.	Beach	Rating HT	LT	Type	Length
KI 1	Disappointment Bay	4	5	LTT/TBR	1.6 km
KI 2	Rocky Point (S 1)	4	5	LTT/TBR	300 m
KI 4	Rocky Point (S 2)	4	5	LTT/TBR	600 m
KI 4	White Beach	4	5	LTT/TBR	2.2 km
KI 5	White Beach (S)	3	4	R/LTT	750 m
KI 6	Boulder Point (N)	4	4	R+rock flats	1.2 km
Spring & neap tidal range = 1.4 & 0.1 m					

The northeast coast of King Island commences at 30 m high Cape Wickham and trends to the southeast for 18 km to the low sandy Lavinia Point. The first 11 km are occupied by Disappointment Bay and a total of six beaches (KI 1-6).

Disappointment Bay (KI 1) a curving 1.7 km wide north-facing bay, bordered by the eastern granite base of Cape Wickham in the west and the low granite Rocky Point to the east. The beach curves for 1.6 km along the base of the bay and faces due north, receiving refracted westerly swell around Cape Wickham, which averages over 1 m. This maintains a low tide terrace, which is cut by a few rips during periods of higher waves. The westerly winds have blown sand from the beach up to 1.3 km across the rear of Rocky Point reaching the shoreline to the south of the point. Most of the dunes are now well vegetated and stable and a small creek drains across the western end of the dunes and onto the beach, while a 4WD track reaches the western end of the beach.

Rocky Point is a sand-draped 20 m high rocky granite point that protrudes 500 m to the north, with Disappointment Bay to the west and a near continuous strip of five sandy beaches (KI 2-6) to the southeast. Beach **KI 2** commences in lee of the northern rocks of the point and curves to the south for 300 m to a small rock-tied sand foreland. It faces due east and receives low refracted westerly waves, with a low tide terrace usually dominating the narrow surf zone. Beach **KI 3** extends south of the foreland for another 600 m to a 200 m long section of 15 m high rocky shoreline. The beach faces northeast, with waves averaging 0.5-1 m, which maintain

a low tide terrace cut by one to two rips during periods of higher waves. Both beaches are backed by the dunes that have transgressed across the base of the point from Disappointment Bay.

White Beach (KI 4) commences on the southern side of the small section of rocky shore and trends to the southeast for 2.2 km to the next small rock-tied sandy foreland. The beach faces northeast with waves averaging up to 1 m, which maintain a more energetic low tide terrace, often cut by several rips during periods of higher waves. It is backed by a low continuous well vegetated foredune. Beach **KI 5** extends from the foreland for 750 m to the southeast to the beginning of a rocky section of shore that extends to Boulder Point. The beach is moderately sheltered by the northern rocks and tidally driven sand waves that extend up to 1 km offshore. The lower waves maintain a usually reflective to occasionally low tide terrace beach. Beach **KI 6** continues for 1.2 km from the beginning of the rocks to Boulder Point. It is a crenulate high tide reflective beach fronted by 200 m wide intertidal rock flats, with only a small pocket of sandy shoreline 200 m west of the point. The sand waves extend up to 1 km off the rocky section narrowing towards the point. A 4WD track from the south reaches the southern side of the 50 m high sand-draped granite slopes behind the beach.

KI 7-9 LAVINIA & NINE MILE BEACHES

No.	Beach	Rating HT	LT	Type	Length
KI 7	Boulder Pt (S)	4	5	R+rock flats	500 m
KI 8	Lavinia Beach	4	5	LTT/TBR	6.2 km
KI 9	Nine Mile Beach	5	6	TBR	17 km
Lavinia Nature Reserve					
Spring & neap tidal range = 1.4 & 0.1 m					

Boulder Point marks the beginning of a continuous 35 km long section of sandy coast that includes five beaches (KI 7-11) and the island's longest beach, 17 km long Nine Mile Beach (KI 9). Beaches KI 7-9 occupy the first 24 km of shoreline between Boulder and Cowper points, with most of the shoreline and backing dunes and wetlands part of Lavinia Nature Reserve.

Beach **KI 7** extends 500 m south of Boulder Point with the entire beach fronted by irregular rock flats that are 100 m wide in the north narrowing to the south. It is backed by dune-capped slopes rising to 40 m, with a 4WD track running along the base of the slopes to the point.

Lavinia Beach (KI 8) commences at the end of the rocks and trends relatively straight for 6.2 km to a major sandy foreland at Lavinia Point. The beach faces northeast and receives waves averaging over 1 m which maintain a relatively steep sandy beach fronted by a 50 m wide low tide terrace to occasional transverse bar and rips (Fig. 4.193). It is backed by a mixture of dunes, which are low and 500 m wide in the north, up to 45 m high along the centre where they are backed by Lake Martha Lavinia and Pennys Lagoon, and widen to 1.5 km in lee of Lavinia Point, where they are backed by 5 km of wetlands, all part of the nature reserve. The beach is accessible in the centre along the Martha Lavinia Road, which leads to a car park just behind the beach.

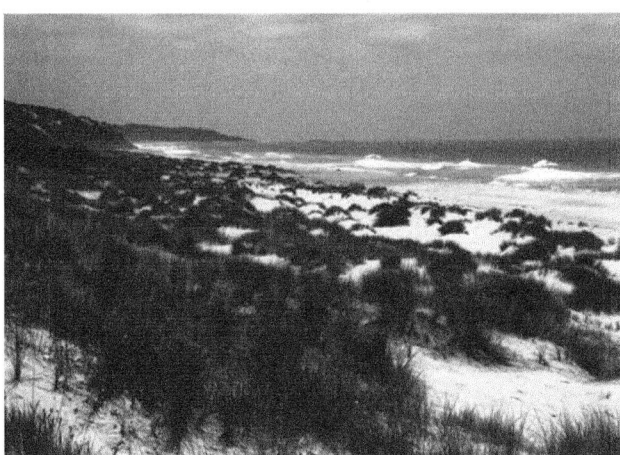

Figure 4.193 Lavinia Beach showing the moderate energy surf zone and well developed foredune.

Nine Mile Beach (KI 9) commences at Lavinia Point where the shoreline turns and trends due south for 17 km (10.5 miles), gently curving to the south-southeast along the southern half of the beach, to terminate at the low sandy Cowper Point, with the shallow, sandy Sea Elephant River crossing the beach 2 km north of Cowper Point. This is a more exposed beach with easterly wind waves averaging 1-1.5 m and maintaining a continuous transverse bar and rip system with rips spaced every 150-200 m and up to 80 rips flowing across the usually narrow bar. The beach is backed in the north by an 800 m wide series of 20 low foredune ridges. They are continuous to the river mouth, though they narrow to 200 m and decrease in number. The ridges are backed by the Nook Swamps which parallel the beach, with Saltwater Creek draining them to the river mouth, where it links with the Sea Elephant River, which also drains the backing 60-80 m high Sea Elephant Hills. The swamp is backed by a continuous inner barrier of apparently low Pleistocene beach-foredune ridges. The barrier extends the length of the swamp widening to 1.5 km in lee of the river mouth-point area. The only vehicle access is via

4WD in the north from Lavinia Beach and in the south to a small location called Sea Elephant, located 1.5 km inside the river mouth, with 4WD required to reach the beach.

KI 10-11 COWPER POINT-FRASER BEACH

No.	Beach	Rating HT LT		Type	Length
KI 10	Cowper Point (S)	4	4	R/LTT	4 km
KI 11	Fraser Beach	5	5	LTT/TBR	7 km
Spring & neap tidal range = 1.4 & 0.1 m					

Cowper Point is a prominent sand foreland formed by refraction of easterly waves around Councillor Island, a 1 km long 24 m high, 12 ha island located 2.7 km offshore. The low vegetated sand point has prograded 3 km to the east and is backed by an extensive Pleistocene and Holocene beach-foredune ridge plain and associated wetlands. Two beaches (KI 10 and 11) are located between the point and the mouth of the small Fraser River 11 km to the south.

Beach **KI 10** commences at Cowper Point and trends to the south then south-southwest for 4 km to a small reef-tied sandy foreland, 500 m north of Blowhole Creek mouth. The northern half of the beach is partly sheltered by Councillor Island, together with shallow tidally driven sand waves that extend between the point and island, while the southern half is fronted by some inner rock flats and shallow rocky seafloor. The result is waves averaging up to 1 m, which maintain a reflective to occasionally low tide terrace sandy beach. The beach is backed by an outer series of unstable foredune, blowouts and minor dune transgression up to 25 m high, then some inner Holocene foredunes, with a narrow wetland separating the outer barrier from an inner 1 km wide Pleistocene barrier consisting of up to 12 low beach ridges. The entire system is 2.5 km wide at the point narrowing south to 1 km at Blowhole Creek. Abeona Creek drains the interbarrier depression and crosses towards the southern end of the beach. There is a 4WD track across the dunes from the northern end of Sea Elephant Road, with the centre of the beach and barrier systems gazetted a recreation reserve.

Fraser Beach (KI 11) commences at the sandy foreland and curves slightly to the south for 7 km to the small mouth of the Fraser River at Naracoopa (Fig. 4.194). The beach faces due east and receives easterly wind waves averaging over 1 m which maintain a low tide terrace to transverse bar and rip, with numerous small rips cutting across the 50 m wide bar during periods of higher waves. The beach is backed by a 500 m wide regressive barrier consisting of several foredune ridges, backed by a discontinuous wetland and the Sea Elephant Road, and crossed by four small creeks including Eldorado and Rocky creeks, the latter deflected 1 km to the south. The Fraser River drains the rising Precambrian sedimentary slopes that dominate the southeast corner of the island. It enters the sea at the southern end of the beach against the

first outcrop of the rocks at the shore. The small community of Naracoopa backs the southern end of the beach and occupies the gently sloping bedrock immediately south of the river mouth. The Fraser River Road follows the lower section of the river to reach the river mouth and settlement, with 4WD beach access in the north off the Sea Elephant Road.

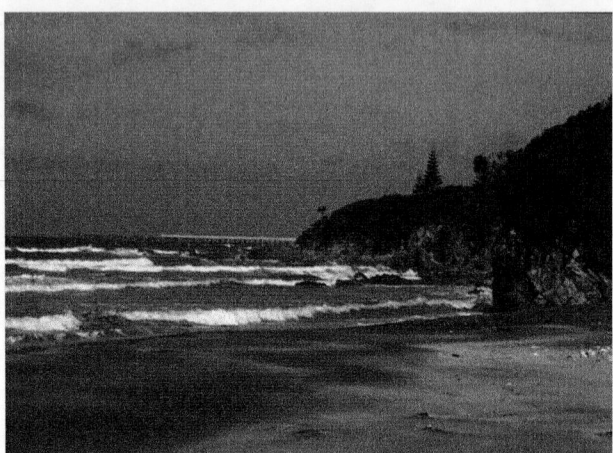

Figure 4.194 The southern end of Fraser Beach at Naracoopa.

KI 12-16 NARACOOPA-BARRIER CREEK

No.	Beach	Rating HT LT	Type	Length
KI 12	Naracoopa (W)	4 5	R+rock flats	1.4 km
KI 13	Naracoopa (E)	4 5	R+rock flats	900 m
KI 14	Fraser Bluff (S)	4 5	R+rock flats	800 m
KI 15	Forrests Creek	4 5	R+rock flats	700 m
KI 16	Barrier Creek	4 5	R/LTT	100 m
Spring & neap tidal range = 1.4 & 0.1 m				

Naracoopa is a small community located to the lee of the southern end of Fraser Beach on the site of a former rutile mine and spread along 1.5 km of rocky shoreline to the east of the small Fraser River mouth. To the north is the long Fraser Beach (KI 11), while to the east and south is the beginning of a rock-dominated section of coast that extends all the way south to Stokes Point, the southern tip of the island. Beaches KI 12-15 occupy a near continuous 4 km long section of rocky shore that extends to Denbys Creek, while beach KI 16 is an isolated small beach at the mouth of Barrier Creek.

Naracoopa beach consists of two parts (KI 12 and 13) located either side of the jetty. Beach **KI 12** extends from the Fraser River mouth east-southeast for 1.4 km to the jetty, which is located on a slightly protruding section of rocky shore. The beach consists of a steep narrow reflective high tide beach fronted by continuous 50-100 m wide rock flats, together with rocks outcropping on the beach and in the surf zone. It receives waves averaging up to 1 m, which break across the rock flats and reefs, with usually lower surging waves at the shore. The beach is backed by a narrow foreshore reserve then

the road and the few houses of Naracoopa on the backing slopes, with Rankins and Bronzewing creeks draining the slopes and crossing the beach. Beach **KI 13** continues east of the 200 m long jetty for 900 m to Fraser Bluff, which is composed of Cambrian greywacke and rises inland to 50 m. The beach is steep and reflective and fronted by continuous rock flats and reefs extending 100 m offshore. A vehicle track runs along the rear of the western half of the beach, with slopes rising behind to 50 m and a small creek draining across the centre of the beach.

Beach **KI 14** commences at Fraser Bluff and trends east-southeast for 800 m to the beginning of a 200 m long section of rocky shore. The narrow high tide reflective beach is fronted by continuous irregular 50-100 m wide rock flats and reefs. It is backed by a low narrow foredune which is part of a coastal reserve, then subdivided slopes rising to 50 m. Beach **KI 15** commences at the small mouth of Forrests Creek and trends to the south for 700 m to the deflected mouth of the small Denbys Creek. The beach is reflective to low tide terrace, with rocks and reefs to either end and a sandy central section. It is backed by a low 150 m wide foredune plain, then slopes rising to 60 m. Neither beach has public vehicle access.

Beach **KI 16** is located 2.5 km to the south and lies across the mouth of the small **Barrier Creek**. The curving 100 m long beach faces southeast and is bordered and backed by steep rocky slopes rising to 60-70 m with the creek emerging from a narrow V-shaped valley. The beach usually blocks the mouth of the creek damming a small lagoon behind, while it is breeched and partly eroded during heavy rain. Cleared farmland occupies the backing slopes.

KI 17-20 GRIMES CREEK-CITY OF MELBOURNE BAY

No.	Beach	Rating HT LT	Type	Length
KI 17	Grimes Creek	4 5	R/LTT	50 m
KI 18	Skipworths Creek	4 5	R+rocks flats	250 m
KI 19	City of Melbourne Bay	4 5	R+rocks flats	300 m
KI 20	City of Melbourne Bay(S)	4 5	R+rocks flats	80 m
Spring & neap tidal range = 1.4 & 0.1 m				

Grimes Creek is located 7 km south of Fraser Bluff and marks the beginning of a more irregular section of rocky shore that continues southwest to Stokes Point. Four beaches (KI 17-20) occupy parts of the first 3 km south of Grimes Creek.

Grimes Creek is a small creek draining slopes rising to 80 m. It emerges from a steep, narrow V-shaped valley 500 m south of Shower Droplet Rock. Beach **KI 17** occupies the creek mouth and is a 50 m long pocket of sand wedged in between rising rocky slopes. It faces east and receives waves averaging about 1 m, which maintain a small reflective to low tide terrace beach.

Skipworths Creek is located 1.7 km to the south. It is a small creek draining the backing cleared slopes that rise to 90 m and reaches the rocky shore at the northern end of beach **KI 18**, which extends for 250 m south of the creek mouth. The beach is a narrow reflective high tide beach fronted by irregular rock flats and reefs extending up to 150 m offshore. Cleared sloping farmland backs the beach.

City of Melbourne Bay contains two small curving embayments. Beach **KI 19** occupies the northern 250 m wide embayment located at the mouth of the larger Yarra Creek. The beach curves around the western side of the bay for 300 m as a moderately sheltered reflective beach, fronted by a shallow bay floor (Fig. 4.195) containing the gravel and sand deposits of the creek delta, which form intertidal flats. A scarped Pleistocene dune, that has transgressed 1 km from the Cottons Creek beach (KI 21), backs the northern side of the beach. Beach **KI 20** occupies the base of the southern 100 m wide embayment and consists of a curving 80 m long strip of high tide sand bordered by rock platforms, with a central sandy section. The main beach is accessible via Skipworths Road.

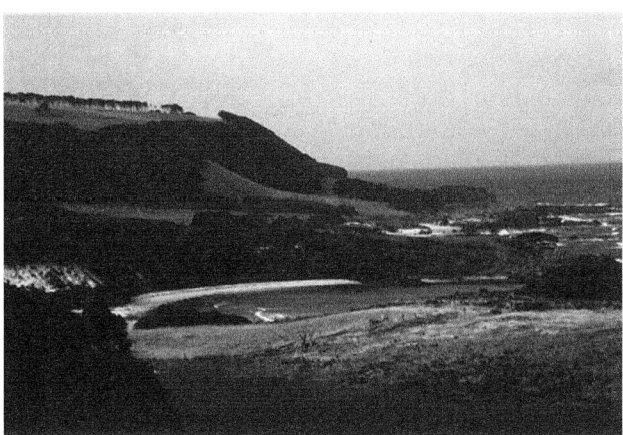

Figure 4.195 City of Melbourne Bay.

T 21-24 **COTTONS CREEK-BOLD HEAD (N)**

No.	Beach	Rating		Type	Length
		HT	LT		
KI 21	Cottons Creek	5	5	R+LTT/rock flats	1.1 km
KI 22	Cottons Creek (S)	4	5	R/LTT	400 m
KI 23	Bold Point (N2)	4	5	R/LTT	50 m
KI 24	Bold Point (N1)	4	5	R/LTT	40 m
Spring & neap tidal range = 1.4 & 0.1 m					

Cottons Creek is located 1 km south of City of Melbourne Bay and lies towards the northern end of an open east-facing 2.5 km wide rocky bay bordered to the south by 15 m high Bold Point. Four beaches (KI 21-24) occupy parts of the bay shoreline.

Beach **KI 21** is the longest beach and extends for 1.1 km along the northern shore of the bay, with Cottons Creek draining out across the centre of the beach and a second small creek to the south. The beach faces southeast and

is fronted by a discontinuous series of rock flats and reefs extending 50 m offshore, with sandy sections in between. It receives waves averaging over 1 m, which break across the rocks and maintain a few permanent rips. It is backed by 20 m high slopes draped by Pleistocene and smaller Holocene transgressive dunes, the Pleistocene dunes reaching as far as City of Melbourne Bay. A small rock outcrop and reef separate the main beach from beach **KI 22** that extends for another 400 m to the southwest across the mouths of two small creeks. This is a sandy beach with usually a reflective to narrow low tide terrace surf zone, backed by partly cleared farmland rising to 100 m.

Beach **KI 23** lies 500 m to the south and is a 50 m long pocket of sand wedged in at the base of moderately steep slopes rising to 120 m. Beach **KI 24** lies another 200 m further south and 700 m northwest of Bold Point. It is a similar 40 m long pocket of sand backed by a small creek and valley sides rising to 100 m. Both beaches are located in the narrow coastal reserve, which follows the coast, and are backed by densely vegetated slopes.

KI 25-26 **BOLD POINT**

No.	Beach	Rating		Type	Length
		HT	LT		
KI 25	Bold Point	4	5	R+LTT/rock flats	150 m
KI 26	Bold Point (S)	4	5	R+rock flats	300 m
Spring & neap tidal range = 1.4 & 0.1 m					

Bold Point is a 15 m high greywacke point surrounded by irregular rock platforms and backed by 93 m high Bold Head. Beach **KI 25** is located between the point and the base of the head and consists of a curving, south-facing 150 m long strip of sand bordered by low rock platforms extending 50 m seaward with a central sandy low tide terrace. Waves average about 1 m with a permanent rip draining out between the rocks.

Beach **KI 26** lies 700 m to the southwest and is a 300 m long strip of southeast-facing sand wedged in along the base of a low rocky point that extends 500 m to the south and forms the eastern boundary of Grassy Bay. The beach has been supplied with sand from a dune transgressing east from Grassy Bay. The dune drapes the backing slopes, with the beach a mixture of sand and rocks.

KI 27-32 **GRASSY BAY & HARBOUR**

No.	Beach	Rating		Type	Length
		HT	LT		
KI 27	Grassy Bay (1)	6	6	TBR	600 m
KI 28	Grassy Bay (2)	6	6	TBR	700 m
KI 29	Grassy Bay (3)	5	5	TBR	700 m
KI 30	Grassy tailings	6	6	Boulder	200 m
KI 31	Grassy Harbour	2	2	TBR	250 m
KI 32	Grassy Harbour(W)	3→4		R→LTT	1.5 km
Spring & neap tidal range = 1.4 & 0.1 m					

Grassy is the site of the former scheelite mine, which operated from 1917 to 1990. Today the small township is privately owned and sits atop the 130 m high slopes overlooking the deep abandoned open-cut mine, with Grassy Bay extending 2 km to the east, and the harbour occupying part of a 1.5 km wide embayment between Jetty and Sandblow points. Six beaches (KI 27-32) are associated with the bay and harbour (Fig. 4.196).

Figure 4.196 The eastern end of Grassy Bay with beaches KI 27-29.

Grassy Bay is a relatively open 2 km wide south-southeast-facing bay, bordered by low rocky points extending 500 m seaward. Three near continuous beaches occupy the bay shore (KI 27-29). Beach **KI 27** is a 600 m long south-facing more exposed beach that receives southwesterly waves refracting around Stokes Point and averaging up to 1.5 m. These maintain a 100 m wide transverse bar and rip surf zone, with usually two central beach rips and permanent rips against the rocks at each end. Beach **KI 28** commences 50 m to the east past the low boundary rocks and reef and is a 700 m long east-southeast-facing sandy beach, with some rocks outcropping off the eastern and a western boundary rock-reef. It usually has two beach rips and rips against the boundary rocks. Beach **KI 29** continues southeast for another 700 m to the side of the Grassy mine tailing slope, which extends up to 500 m across the original shoreline of the bay. Waves decrease to the east and average about 1 m, with two to three rips usually dominating the beach. The high tide beach transforms from sand in the east to cobble and boulders towards the tailings.

All three beaches are backed by well vegetated Holocene transgressive dunes that in lee of the eastern two beaches (KI 27-28) have migrated up to 1.6 km inland, up the 90 m high slopes of Bold Head and over to the northern side on Bold Point. Both dunes and the disused open cut mine back beach KI 29.

Beach **KI 30** is located on the southern side of the mine tailings. It consists of a curving 200 m long east-facing boulder beach, composed of partly rounded tailing debris. It is bordered by the main tailing slopes to the north and

the irregular rocks of Jetty Point to the south, with a mine access road clipping the southern corner of the beach.

Grassy Harbour consists of a 1 km long L-shaped attached breakwater that extends south from Jetty Point and encloses the 250 m wide harbour. Beach **KI 31** is located inside the harbour and occupies 250 m of the northern shoreline, with the breakwater forming its western boundary and a jetty and the old port facilities to the west. The sheltered sandy beach is bordered by rocks on and just off the beach, with a central reflective sandy section (Fig. 4.197).

Figure 4.197 Grassy Harbour beach is sheltered both by the breakwater and inshore rocks and reefs.

Beach **KI 32** extends west of the harbour facilities jetty for 1.5 km curving round past Grassy Creek to finally face east in lee of Sandblow Point. The beach receives refracted southwest swell, which averages over 1 m and increases in height towards the centre of the beach. In the centre the waves usually maintain a few rips, with a low tide terrace to either end of the beach. It is backed by climbing vegetated Holocene transgressive dunes that extend up to 1.5 km inland and to heights of 60 m and which are now occupied by the Grassy golf course. The beach is accessible at the eastern port area and at Grassy creek mouth.

KI 33-35 BROKEN ARM BEACH

No.	Beach	Rating HT LT		Type	Length
KI 33	Sandblow Pt (S)	4	4	R/LTT	300 m
KI 34	Broken Arm Beach	4	4	LTT	1.3 km
KI 35	Broken Arm (S)	4	4	LTT	200 m
Spring & neap tidal range = 1.4 & 0.1 m					

Sandblow Point marks the western boundary of Grassy Harbour embayment and the beginning of a 1.7 km wide open southeast-facing embayment containing three beaches (KI 33-35), all partly sheltered by scattered reefs that lie up to 700 m offshore.

Beach **KI 33** is located on the southern side of Sandblow Point, a low rocky point capped by 50 m high active and vegetated transgressive dunes. The beach is 300 m long

and curves to the southeast to a low reef-tied sandy foreland. It is exposed to southerly waves averaging 1 m. These maintain a reflective to low tide terrace beach, with rips only forming during periods of higher waves.

Broken Arm Beach (KI 34) commences at the foreland and curves to the southeast and finally south for 1.3 km terminating at a low rocky point. The beach is moderately sheltered by the southern point and reefs with waves averaging just over 1 m, which maintain a low tide terrace with rips occasionally forming along the centre of the beach, particularly against a central rock outcrop. A small creek reaches the beach in lee of the rocks, with a 4WD track reaching the creek mouth. To the east of the creek the beach is backed by northeast-trending transgressive dunes that have migrated up to 1 km and blanketed and crossed Sandblow Point, with a large active blowout presently blanketing the point. A second creek drains across the southern corner of the beach.

Beach **KI 35** is located on the southern side of the boundary rocks and curves for 200 m to the south to a 10 m high rocky point that forms the southern end of the embayment. The beach faces east and is moderately sheltered from southerly waves with usually a reflective to low tide terrace system. It is backed by active and vegetated transgressive dunes from beach KI 36.

KI 36-40 BROKEN ARM-RED HUT POINT

No.	Beach	Rating HT LT	Type	Length
KI 36	Broken Arm (S1)	5 6	TBR+rocks	350 m
KI 37	Broken Arm (S2)	4 4	LTT	200 m
KI 38	Crown Ck	4 5	R+rock flats	250 m
KI 39	Red Hut Pt (E2)	4 5	LTT+rocks	400 m
KI 40	Red Hut Pt (E1)	4 5	LTT+rocks	350 m
Spring & neap tidal range = 1.4 & 0.1 m				

Between the southern boundary point of the Broken Arm beaches and Red Hut Point is a 3 km long section of rock-dominated southeast-facing shoreline containing five small rock-bound beaches (KI 36-40). The beaches are all backed by well-vegetated dune-draped slopes, with 4WD access only to beach KI 39 and Red Hut Point.

Beach **KI 36** is an exposed curving 350 m long beach, bordered by a 300 m long low sand-draped point in the north and a small rocky point to the south. It receives waves averaging up to 1.5 m which maintain two permanent rips draining out across the sand and rock surf zone. Beach **KI 37** lies 500 m to the southeast and is a 200 m long southeast-facing beach moderately sheltered by a 400 m long southern point. It receives waves averaging about 1 m, which maintain a low tide terrace. Both beaches are backed by a continuous strip of vegetated Holocene transgressive dunes which trend northeast and parallel the shoreline.

Beaches KI 38-40 are located in a 1.5 km wide southeast-facing embayment that extends from the boundary point

to 20 m high Red Hut Point. Beach **KI 38** is a curving 250 m long south-facing beach consisting of a narrow high tide beach and continuous 50 m wide rock flats, together with reefs off the beach. A permanent rip drains the small beach embayment while the small Crown Creek drains across the centre of the beach. Beach **KI 39** occupies the centre of the embayment and is a 400 m long beach bordered by rocks to either end as well as rocks outcropping along the beach. It usually has a low tide terrace, with rips forming during periods of higher waves. Beach **KI 40** lies immediately east of Red Hut Point and is a 350 m long southeast-facing moderately sheltered sand beach with rocks outcropping to either end. All three beaches are backed by vegetated Holocene dunes that have transgressed east from Colliers Beach, with older Pleistocene dunes beyond.

KI 41-42 COLLIERS BEACH

No.	Beach	Rating HT LT	Type	Length
KI 41	Colliers Beach	6 6	TBR	2.3 km
KI 42	Seal Point	6 6	R+rock flats	400 m
Spring & neap tidal range = 1.4 & 0.1 m				

Colliers Beach (KI 41) is a curving southeast-facing 2.3 km long beach located between Red Hut and Seal points. The beach is moderately well exposed to refracted southerly waves along its entire length with waves averaging up to 1.5 m and maintaining a 100 m wide surf zone cut by 5-6 rips spaced every 200 m. It is backed by generally active dunes extending up to 500 m inland and climbing to 50 m, with older dunes from Surprise Bay behind, then the Colliers Swamp 700 m inland. There is 4WD access to the eastern end of the beach via the Red Hut Road.

Seal Point extends 700 m south of the southern end of the beach, with beach **KI 42** located on the south-facing 800 m long southern shore of the point. The point is composed of Carboniferous granodiorite capped by vegetated transgressive dunes reaching 33 m in height. The beach extends for 400 m along the eastern half of the point and faces due south into the southerly waves. The waves begin breaking over reefs that extend 500 m southeast of the tip of the point resulting in lower waves at the shore. The eastern half of the beach is fronted by narrow rock flats, with a more sandy western half, backed by a stable blowout. A 4WD track reaches the western tip of the point.

KI 43-45 SEAL BAY

No.	Beach	Rating HT LT	Type	Length
KI 43	Seal Bay (N)	5 6	TBR→LTT	3 km
KI 44	Seal Bay (S)	5 6	LTT	2.8 km
KI 45	Stokes Pt (E)	4 4	R	200 m
Spring & neap tidal range = 1.4 & 0.1 m				

Seal Bay is a 5 km wide southeast-facing bay located between Black and Stokes points, with Middle Point in the centre dividing the bay into two main beach systems (KI 43 and 44), while beach KI 45 is located on the southern Stokes Point. The only access to the bay shore is a 4WD track to the eastern Black Point.

Beach **KI 43** commences in lee of **Black Point** and curves to the east then southeast for 3 km to the sandy reef-tied Middle Point. The eastern half of the beach is moderately well exposed to southern waves and usually has a 70 m wide surf zone cut by four to five rips. The western half becomes increasingly sheltered by shallow reefs off Middle Point, which results in low waves and a gradation to low tide terrace conditions. The beach is backed by a foredune, then a 700 m wide band of Holocene transgressive dunes, which originated from Surprise Bay up to 5 km to the west. These are backed by an 800 m wide wetland partly occupied by Big Lake which links to the Colliers Swamp. The lake is drained by a 1.5 km long channel, which meanders through the dunes to drain across the western section of the beach.

Beach **KI 44** commences at sandy **Middle Point** and trends to the southeast and finally south for 2.8 km to the northern rocks of Stokes Point. The beach is sheltered from westerly waves by Stokes Point and the reef off Middle Point, which extends seaward of the northern half of the beach. As a result waves average less than 1 m and maintain a low tide terrace to occasionally reflective conditions. It is backed by a narrow foredune then the Surprise Bay dunes.

Beach **KI 45** is located 1 km to the southeast in a 250 m wide east-facing embayment on the eastern side of **Stokes Point**. The low energy beach faces due east and curves for 200 m along the base of the embayment. It is bordered by rocky shore and consists of a narrow high tide reflective beach. A vehicle track leads to the Stokes Point light located on a 46 m high crest, 200 m west of the beach. The dune-capped point is composed of Precambrian quartzite and extends for another 1.5 km south of the beach to the southern tip of the island.

KING ISLAND - WEST COAST

Stokes Point to Cape Wickham

Coast length: 101 km (96-197 km)
Beaches: 35 (KI 46-80)

The west coast of King Island faces into one of the world's highest energy wave climates, with deepwater wave height averaging 3 m. In addition strong onshore westerly winds prevail. The result has been the delivery of massive amounts of carbonate marine sand to the west coast which have formed beaches and supplied sand to the backing massive Pleistocene and later Holocene dune transgressions. The net result has been the blanketing of the entire west coast with Quaternary dune sands. Most of the beaches that supplied the Holocene sands have either been submerged and/or eroded, leaving a west coast shoreline that is predominantly rocky, particularly along the most exposed sections, with remnant beaches tucked in more protected locations. The legacy of the eroded beaches however remains in the often massive Holocene dune transgression that backs parts of the shoreline.

The west coast extends for 101 km from Stokes Point to Cape Wickham and includes 34 beaches, which occupy only 26 km (26 %) of the predominantly rocky shore.

KI 46-47 SURPRISE & DENBYS BAYS

No.	Beach	Rating HT LT	Type	Length
KI 46	Surprise Bay	4 5	LTT+rocks/reefs	750 m
KI 47	Denbys Bay	4 5	R+rocks/reefs	300 m
Spring & neap tidal range = 1.5 & 0.2 m				

Surprise and Denbys bays are two small adjoining bays located 4 km northwest of Stokes Point. The bays are bordered by resilient Precambrian quartzite, which forms the boundary headlands and also outcrops on both beaches and extends several hundred metres offshore as extensive reefs. While both beaches face west into the prevailing winds and waves, wave energy is lowered at the shore by the reefs and the embayed nature of the beaches. They are both accessible by vehicle tracks off the South Road.

Surprise Bay (**KI 46**) is a curving 750 m long sandy beach, bordered by low quartzite points, the southern rocks extending 1 km to the southwest, together with reefs extending 500 m off each point. The points and reefs lower waves to about 1 m at the shore where they maintain a low tide terrace bordered by cobble beaches and grading into a relatively shallow rocky bay floor. The beach is backed by extensive Holocene parabolic dunes, some of which are scarped at the beach and active (Fig. 4.198). **Denbys Bay** lies 200 m to the north and has a 300 m long curving reflective beach (**KI 47**) backed by a low foredune, with a 4WD track along the rear of the

dune, and cobble beaches against the boundary points. Rocks border each end and some outcrop across the southern section of the beach, while small reefs and rocky seafloor dominate the small bay. Both beaches are remnants of a more extensive sandy shoreline that in the early-mid Holocene supplied the massive parabolic dune field that extends 3 km south to Stokes Point and 2.5 km west to Surprise Point, and in lee of Surprise Bay extends up to 4 km northeast to Big Lake. The dune field blankets the entire southwest tip of the island covering about 700 ha.

Figure 4.198 Surprise Bay beach and backing dunes.

KI 48-49 **FITZMAURICE BAY**

No.	Beach	Rating HT LT	Type inner outer bar	Length
KI 48	Fitzmaurice Bay(S)	4 5	LTT+rocks/reef	300 m
KI 49	Fitzmaurice Bay	7 8	TBR RBB	1.2 km
Spring & neap tidal range = 1.5 & 0.2 m				

Fitzmaurice Bay is a 2.5 km wide northwest-facing bay bordered by 50 m high Cataraqui Point to the south. The point extends 1.5 km to the west and affords considerable protection to the southern corner of the bay. To the north resilient Precambrian granite dominates the shore with numerous rocks and reefs lining the coast including the site of the 1845 *Cataraqui* wreck, Australia's worst shipwreck, located 2.5 km north of the bay. The bay contains two adjoining beaches (KI 48 and 49). The point is accessible via the Attrills Road in the south and at the northern end of the bay via the Paddocks Road, both 4WD tracks.

Beach **KI 48** occupies 300 m of the southern corner of the bay and is moderately sheltered from the prevailing southwest swell by Cataraqui Point, with waves averaging about 1 m at the shore. They maintain a low tide terrace that grades into rocky seafloor along the southern half of the beach and is bordered by a small granite point and reefs to the north. During higher waves a rip runs out against the rocks.

The main beach (**KI 49**) receives considerably higher waves averaging 1.5-2.5 m which maintain an inner transverse bar and rip systems usually cut by two to three beach rips, as well as boundary rips against the points, and an outer bar located 200 m offshore and drained by a large rip against the northern rocks.

The beaches are backed by a massive Holocene parabolic dune field that reaches 96 m in height and extends up to 2.5 km inland to the South Road and where they have dammed the Attrills and Pearshape lagoons. The dunes are largely well vegetated and stable with only a few patches of instability.

KI 50-52 **ETTRICK BEACH-MILLERS BAY**

No.	Beach	Rating HT LT	Type	Length
KI 50	Ettrick Beach	3 3	R+sand/rock flats	200 m
KI 51	Millers Bay (S)	3 3	R+rocks	150 m
KI 52	Millers Bay (N)	3 3	R+rocks	100 m
Spring & neap tidal range = 1.5 & 0.2 m				

Ettrick River is one of the few rivers draining onto the west coast of the island. It drains a deeply incised area of Precambrian metamorphic rocks and has maintained a narrow valley through the bordering Pleistocene dune cover. It reaches the shore 6 km north of Fitzmaurice Bay, flowing into a 500 m wide V-shaped bay bordered by sand-draped metamorphic rocks, which form jagged intertidal rock flats and extend up to 500 m off either side of the bay as extensive rocks and reefs. The main South Road crosses the river at the mouth.

Ettrick Beach (**KI 50**) occupies 200 m of shoreline extending northwest from the river mouth. The beach is well protected by its embayed location and the bay mouth reefs, with usually low waves to calm conditions at the shore. It consists of a low gradient high tide beach, backed by storm cobbles, grading bayward into rocks and sand flats that have formed at the river mouth as part of the river delta.

Millers Bay is located 700 m north of the river and is a curving 400 m wide southwest-facing bay bordered and dominated by metamorphic rocks and reefs, which extend right across the bay mouth. Two low energy beaches are located inside the bay. The southern beach (**KI 51**) faces west and curves for 150 m to a central rock outcrop. It is a steep reflective beach backed by grass-covered older dunes and fronted by the usually calm waters of the bay. The northern beach (**KI 52**) continues north of the small boundary rocks for another 100 m to the lee of the northern point of the bay. It is a similar steep reflective beach, backed by the vegetated dune-covered slopes and facing southwest across the usually calm waters of the bay.

KI 53-58 SANDFLY BEACH-NETHERBY BAY

No.	Beach	Rating HT LT		Type	Length
KI 53	Sandfly Beach	6	7	TBR+rocks	900 m
KI 54	Badger Box Ck (S)	4	5	R+rock flats	350 m
KI 55	Badger Box Ck (N)	5	6	R+rocks/reefs	450 m
KI 56	British Admiral Beach	6	7	LTT/TBR+rocks	1.5 km
KI 57	Halfmoon Bay	2	3	R	300 m
KI 58	Netherby Bay	3	4	Cobble+rocks	150 m
Spring & neap tidal range = 1.5 & 0.2 m					

To the south of Currie is an exposed 6 km long section of southeast-trending coast containing six beaches (KI 53-58) all dominated to varying degrees by the continual outcrops of Precambrian granite rocks as points, rocks, islets and reefs. In addition considerable kelp grows on the reefs and washes onto the beaches (Fig. 4.199) and collects in the small bays.

Figure 4.199 Kelp washed up onto Sandfly Beach.

Sandfly Beach (KI 53) is located 5 km southeast of Currie and is a relatively straight 900 m long west-southwest-facing sandy beach, bordered by irregular granite rocks and reefs, with scattered reefs extending up to 500 m offshore. The beach receives waves reduced to about 1.5 m, which maintain a steep sandy beach and a transverse bar and rip system with usually two beach rips associated with rock outcrops. It is backed by well vegetated massive Holocene dunes extending up to 3.3 km inland and to 104 m in height. The beach can be accessed in the north off the Badger Box Creek track.

Beach **KI 54** is located in a curving 500 m wide southwest-facing rocky bay on the southern side of Badger Box Creek mouth. The beach faces southwest and curves round for 350 m as a narrow high tide reflective beach, fronted by continuous 50 m wide rock flats and a rocky bay floor. Waves average over 1 m and break across the rocks and reefs before reaching the sandy shoreline. Vegetated Holocene transgressive dunes extend for 2.5 km northeast along the southern side of the creek.

Beach **KI 55** is located on the northern side of Badger Box Creek. It is a relatively straight 450 m long

southwest-facing wide sand beach, fronted by a strip of sandy seafloor, then discontinuous rocks and reefs which extend up to 500 m offshore and lower waves at the shore. There is no vehicle access to the beach.

British Admiral Beach (KI 56) is named after the *British Admiral* shipwrecked in 1874 with heavy loss of life. The beach curves slightly for 1.5 km between two granite points that protrude 200 m seaward. It faces west-southwest, with waves reduced slightly by scattered inshore and outer reefs. They average about 1.5 m (Fig. 4.200) and maintain a 100 m wide transverse bar and rip surf zone with usually two to three beach rips along the northern half and rock-controlled rips in the south against Memorial Rock and against the boundary rocks. The beach is backed by well vegetated massive Holocene transgressive dunes that extend 3 km inland to the main road and reach 89 m at Huxley Hill and which extend north to the southern limits of Currie. The northern end of the beach is accessible along the Netherby Road and is the most popular surfing beach on the island.

Figure 4.200 Waves breaking across the northern end of British Admiral Beach.

Halfmoon Bay is a curving 200 m wide southwest-facing rock-bound bay, located immediately north of British Admiral Beach. The bay sides and mouth are sheltered by rocks and reefs, with only low waves reaching the bayshore where they maintain a 300 m long curving reflective beach (**KI 57**). The beach is backed by 20 m high scarped Pleistocene dunes, capped with vegetated Holocene dunes. The Netherby Road runs along the crest of the backing dunes.

Netherby Bay lies 500 m to the north and is a rock- and reef-bordered 300 m wide south-facing rocky bay. Beach **KI 58** is a cobble-boulder beach that curves around the northern end of the bay for 150 m. Waves average about 1 m and surge up the steep beach. The beach is backed by grassy dune-covered slopes, with the Netherby Road clipping the eastern end of the beach. The ship *Netherby* carrying 500 people was wrecked off the bay during calm conditions in 1866 with no loss of life.

KI 59-61 **CURRIE BEACHES**

No.	Beach	Rating HT LT	Type	Length
KI 59	Little Beach	2 2	R	200 m
KI 60	Big Beach	2 3	R+rocks	500 m
KI 61	Gull Rock	2 3	R+rocks	100 m
Spring & neap tidal range = 1.5 & 0.2 m				

Currie is the only town on King Island and is located to the lee of the small Currie harbour, a curving 600 m wide west-facing bay. Rocks and reefs extend out from either side of the entrance reducing waves inside the bay. In addition a 100 m long breakwater extends off the southern point and a breakwater-jetty forms the main landing site and boat ramp in the most protected southern corner of the bay. Three small low energy beaches (KI 59-61) are located inside the harbour.

Little Beach (KI 59) lies in the southern corner of the harbour and faces northwest across the bay. It is a curving 200 m long low gradient, low energy reflective beach composed of sand and cobbles. It is backed by a sloping grassy park, with the boat ramp, port jetty and facilities located at the eastern end of the beach. **Big Beach (KI 60)** occupies much of the eastern shore of the harbour. It extends for 500 m north of the port jetty curving to the north then northwest, crossing the small mouth of Camp Creek, to a small 20 m high northern boundary point. The beach is relatively steep and reflective with several jagged rock outcrops both on and off the beach. It is backed by grassy slopes rising to 20 m.

Beach **KI 61** is located in the northern corner of the bay and is a 100 m long south-facing pocket of sand, with rocks to either end as well as a few outcropping across and off the beach, including Gull Rock. It receives low refracted waves with a low gradient swash zone grading into a shallow bay floor (Fig. 4.201). It is backed by marram-covered older dunes.

Figure 4.201 The small pocket beach KI 61 located in lee of Gull Rock on the northern side of Currie Harbour.

KI 62-66 **WHALEBONE-LITTLE PORKY BEACHES**

No.	Beach	Rating HT LT	Type	Length
KI 62	Whalebone (S)	3 4	R+rocks/reefs	250 m
KI 63	Whalebone Beach	4 5	LTT+rocks/reefs	200 m
KI 64	Little Porky (S)	4 5	LTT	200 m
KI 65	Little Porky Beach	4 5	LTT+rocks/reefs	600 m
KI 66	Little Porky (N)	4 5	LTT+rocks/reefs	100 m
Spring & neap tidal range = 1.5 & 0.2 m				

Porky Creek reaches the shore in the centre of a 1 km wide west-facing rocky bay occupied by the three Little Porky beaches (KI 64-66), with Whalebone Beach (KI 63) located 700 m south of the creek mouth. The well known King Island Dairy is located beside the creek, 1 km in from the mouth, adjacent to the North Road.

Beach **KI 62** is located 1 km south of Whalebone Beach. It is a slightly curving, west-facing 250 m long strip of high tide sand, fronted by a continuous irregular 50 m wide band of rocks and reefs, then a sandy seafloor, with scattered reefs extending 500 m offshore. The reefs lower waves to about 1 m at the shore where they maintain the high tide reflective beach. It is backed by vegetated older Holocene dunes and is accessible along a 4WD track that follows the shoreline.

Whalebone Beach (KI 63) is a curving 200 m long west-facing beach bordered by low rocky points with reefs extending up to 700 m seaward off the points. Waves are lowered to about 1 m and maintain a low gradient fine sand beach, backed by a low foredune, then older grassy dunes. The 4WD track runs along the rear of the beach, with cleared farmland behind.

Beach **KI 64** is the southern of the Little Porky beaches and extends along the southern side of the bay and faces west. It is 200 m long, composed of fine sand, and receives waves lowered to about 1 m by rock reefs that extend up to 1 km west of the beach. These break across a narrow low tide terrace, with a low foredune, the older grassy dune behind.

Little Porky Beach (KI 65) occupies the centre of the bay and curves to either side of Porky Creek mouth and a central rock outcrop. The beach is 600 m long and receives waves averaging just over 1 m, which maintain a low gradient beach and low tide terrace. During higher waves rips form either side of the central rock outcrop. It is backed by three active blowouts which are climbing older vegetated dunes which rise to 34 m and extend 700 m inland (Fig. 4.202). There is vehicle access from the dairy turnoff that runs along the crest of the backing dunes to the northern end of the beach.

Figure 4.202 Little Porky Beach and its backing blowouts and Porky Creek mouth to the south.

Beach **KI 66** is a curving 100 m long south-facing pocket of sand located at the northern end of the embayment. It is separated from the main beach by a low rocky point with another point bordering its western end. It receives low refracted swell, which breaks across a low gradient low tide terrace and beach. The vehicle track from the North Road terminates in the grassy older dunes behind the beach.

KI 67-70 **PORKY BEACH-PASS RIVER**

No.	Beach	Rating HT LT	Type	Length
KI 67	Porky Beach	6 7	LTT/TBR+rocks/reefs	2.2 km
KI 68	Porky (N)	5 6	R+rocks flats	250 m
KI 69	Unlucky Bay	5 6	R+rocks/reefs	600 m
KI 70	Pass River Bay	5 6	R+rocks/reefs	200 m
Spring & neap tidal range = 1.5 & 0.2 m				

Between Porky Creek and Pass River is a 6 km long section of west-facing shoreline dominated by low points and reefs of Precambrian granite and containing the longer Porky Beach (KI 67) and three small beaches (KI 68-70). Massive, vegetated Holocene dunes extend 2-3.5 km inland to the North Road The dunes are now largely cleared for grazing and access to the beaches is only via vehicle tracks across the dunes.

Porky Beach (KI 67) is an exposed curving 2.2 km long west-facing beach, which receives moderate shelter from the extensive rocks and reefs that border both ends and outcrop along the beach and surf zone. Waves average about 1.5 m and maintain a series of rock- and reef-controlled rips along the beach. It is backed by the dunes rising to 60 m, which reach 3.5 km inland and cross the North Road. Vehicle tracks from the North Road reach both ends of the beach.

Beach **KI 68** is located immediately to the north and is a 250 m long rock-bordered and -bound high tide beach. Shallow rock reefs extend 200 m offshore and form a small cove towards the southern end of the beach. It is

backed by well vegetated 20 m high dunes that reach 80 m in height and extend 2 km inland.

Unlucky Bay lies 500 m to the north and is a curving 600 m wide west-facing rocky bay, with rock reefs extending across the bay mouth and up to 700 m seaward. Beach **KI 69** curves around the base of the bay for 600 m as a sloping beach that grades into the rocky bay floor. It is backed by a scarped 20 m high dune, then vegetated transgressive dunes extending 3.5 km inland, across the North Road, and reaching 75 m in height. Two vehicle tracks lead across the cleared farmland from the road to the bay.

The **Pass River** runs due west between dune fields for 6 km to reach the shore in a small curving 200 m wide embayment. Beach **KI 70** is located at the mouth of the river and curves for 200 m between the boundary granite points. The beach faces due west but is sheltered by reefs extending 500 m off either side, together with a fringe of reefs along the base of the beach, with a sandy seafloor in the centre of the bay. It is backed by a low foredune the northern side of the small river, then vegetated dunes extending 2.5 km inland.

KI 71-76 **PERCYS ROAD-DUCK BAY**

No.	Beach	Rating HT LT	Type	Length
KI 71	Percys Rd	5 6	R/LTT+rocks/reefs	500 m
KI 72	Bungaree Ck(S2)	5 6	R/LTT+rocks/reefs	1.25 km
KI 73	Bungaree Ck(S1)	5 6	R/LTT+rocks/reefs	150 m
KI 74	Eel Creek	5 6	R/LTT+rocks/reefs	500 m
KI 75	Duck Bay (S)	6 7	TBR	300 m
KI 76	Duck Bay	4 5	Cobbles	100 m
Spring & neap tidal range = 1.5 & 0.2 m				

To the north of the Pass River are 8 km of rocky west-facing shoreline that extends north to Whistler Point. In amongst the near continuous rocks and reefs are six beaches (KI 71-76) all backed by extensive vegetated Holocene transgressive dunes, now largely cleared for grazing. The North Road runs 3-7 km inland with only a few tracks across the dunes and farmland to the beaches and coast.

Beach **KI 71** is located at the end of Percys Road, a 3 km long track across the dunes. The beach faces west and extends for 500 m between a southern rocky point and a small rock outcrop. It is fronted by shallow reefs and rocks extending 400 m offshore, with the beach restricted to the rear of the rocks. Beach **KI 72** continues north of the boundary outcrop for 1.25 km to the next major rock outcrop. It consists of a continuous crenulate high tide beach with patches of sandbar in amongst the rocks and reefs, which dominate the beach and extend 400-500 m seaward. Waves break over the rocks and reefs, with several rips in amongst the reefs. Beach **KI 73** is a 150 m long curving pocket of sand located at the northern end of the main beach. It is tied to rock reefs, with a reef-filled seafloor extending 500 m offshore. The three beaches are exposed to waves averaging over 2 m on the outer reefs,

with lower waves at the shore. A wide reef-dominated surf zone persists, with several rips in amongst the reefs. The beaches are all backed by a continuous Holocene transgressive dune field that extends 2-3 km inland and reaches over 60 m in height. Bungaree Creek is located 500 m north of the beach system.

Beach **KI 74** lies 2 km north of the creek at the mouth of the small **Eel Creek**, which drains though the backing 1 km wide dune field. The narrow high tide beach curves for 500 m between dune-draped rocky points, with inshore rock flats and reefs extending up to 700 m seaward, and the creek crossing towards the southern end of the beach. The beach is backed by dunes, which widen to 3.5 km to the northwest, and one patch of active dune sand on the north side of the creek mouth.

Beach **KI 75** lies 1.5 km to the north and is a curving 300 m long sandy beach, bordered by sand-draped rocky points, with reefs extending 100-200 m off the points. The beach and small bay are relatively free of rocks, with a bar located 100 m offshore and a solitary rip draining the small embayment. A patch of active dune sand, then vegetated dunes, extend 3 km northwest of the beach.

Duck Bay lies 700 m to the northwest. It is a curving 150 m wide bay, with a narrow 100 m long cobble beach (**KI 76**) curving around the base. The bay floor is filled with reefs, which extend outside the bay and up to 600 m seaward. Transgressive dunes extend up to 3 km northwest of the bay and cover the entire backing terrain up to Whistler Point and the southern shore of Quarantine Bay.

KI 77-80 **PHOQUES BAY**

No.	Beach	Rating		Type		Length
		HT	LT	inner	outer bar	
KI 77	Quarantine Bay	4	4	LTT	-	2.9 km
KI 78	Yellow Rock Beach	6	6	TBR	RBB	8.7 km
KI 79	The Springs	4	5	R+rock flats	-	250 m
KI 80	Victoria Cove	4	5	LTT	-	200 m
Spring & neap tidal range = 1.5 & 0.2 m						

Phoques Bay occupies the northwest corner of King Island. It lies to the lee of New Year and Christmas islands, with the bay shoreline curving for 20 km between Whistler Point in the south and Cape Farewell to the north. The bay includes the small Quarantine Bay in the south and the west coast's longest beach, Yellow Rock Beach (KI 78). This is the only section of the west coast where substantial beach deposits exist, all backed by extensive Holocene transgressive dunes.

Quarantine Bay is located to the lee of Whistler Point and while it is exposed to westerly winds it is moderately sheltered from westerly waves by the reefs, which extend 2.5 km north of the point to Christmas and New Year islands lowering waves to about 1 m along the bay shore. The beach (**KI 77**) commences 1.5 km east of Whistler Point and curves to the northeast as a 200 m wide series

of foredune ridges backed by older transgressive dunes rising to 40 m. It then trends east as a protruding recurved spit capped by transgressive dunes rising to 34 m, that in the east deflects the shallow mouth of the Yellow Rock River. It has a total length of 2.9 km with shallow reefs off the western half and sandy bay floor off the spit section. The waves maintain a low gradient reflective to narrow low tide terrace beach. A vehicle track off the North Yellow Rock Road runs out to the slopes above the southern end of the beach.

Yellow Rock Beach (**KI 78**) commences at the shallow sandy river mouth and curves to the northeast, then north for 8.7 km, the longest beach on the west coast. The beach receives refracted westerly waves around the islands, which average about 1.5 m, increasing slightly up the beach. These maintain a continuous low gradient beach and inner transverse bar and rip system with up to 20 rips spaced approximately every 400 m, and a rhythmic outer bar located 200-300 m offshore, with more widely spaced rips. It terminates in the north against the metamorphic rocks that continue north for 4 km to Cape Farewell. The entire beach is backed by some active, though largely vegetated Holocene parabolic dunes that extend up to 2.5 km inland and rise to over 60 m in places. A track off the North Yellow Rock road runs out to a car park just inside the river mouth, with foot access to the beach.

Beach **KI 79** is located amongst the rocky shore 200 m north of Yellow Rock beach. It is a narrow 250 m long high tide beach, fronted by continuous 50 m wide intertidal rock flats, with deeper reefs extending up to 500 m offshore and low rocky points to either end. Older Holocene transgressive dunes back the beach and bordering rocky shore, with a small creek, The Springs, draining onto the northern point. The beach can be accessed along the Springs track.

Victoria Cove is located 2 km southwest of Cape Wickham and is the northernmost beach on the island. The 500 m wide northwest-facing cove is bordered by 16 m high Cape Farewell to the west and the rocky shore that trends northeast to Cape Wickham in the east. Beach **KI 80** curves around the base of the bay for 200 m with the rocky points bordering either end (Fig. 4.202). It receives westerly waves refracted around the point, which average less than 1 m at the shore where they maintain a reflective to low tide terrace beach. It is backed by marram-covered early Holocene dunes that extend 3 km to the east across the base of the cape almost reaching the east coast. The beach can be accessed via a vehicle track from Cape Wickham lighthouse, located 500 m east of the cove.

*Figure 4.203 The northernmost beach on King Island is the sheltered Victoria Cove beach, which is bordered by
steeply dipping metamorphic rocks and backed by grassy dune-draped slopes.*

NORTH COAST

Region 4 Woolnorth Point to Cape Portland

Coast length:	448 km	(1789-2237 km)
Beaches	305	(T 965-1269)
Robbins & Walker islands	68 km coast, 20 beaches	

The north coast of Tasmania extends for 448 km from Woolnorth Point (Fig. 4.204) to Cape Portland, the northern tip of Tasmania. The entire coast faces north into Bass Strait and is sheltered from the southern ocean swell by islands and orientation. In the absence of swell locally generated wind waves dominate the exposed beaches. Compared to the east, south and west coasts the north coast also has higher tide ranges, a product of the shallow Bass Strait, and generally lower wave conditions. Wave energy does however increase to the east as the fetch increases east of Devonport and the orientation of parts of the coast turns to the northeast to intercept the westerly waves and winds, resulting in higher energy beaches and extensive dune systems.

Regional map 14 North Coast: Woolnorth Point to Rocky Point

Figure 4.204 *The North Coast region between Woolnorth Point and Rocky Cape.*

NORTH COAST : WESTERN SECTION

Coast length:	222 km	(1789-2011 km)
Beaches	174	(T 965-1138)
Regional maps:	Figure 4.204	Page 247
	Figure 4.222	Page 262

The west north coast between Woolnorth Point and Devonport is 222 km in length containing 174 beach systems. This is the most densely populated section of the Tasmanian coast with a string of coastal towns commencing at Stanley and going onto Wynyard, Burnie, Ulverstone and Devonport, all located along a 100 km long section of coast. The beach systems are generally more sheltered on this section of coast owing to the protection of the Three Hummock, Hunter and Robbins islands in the west, the north-northeast orientation of much of the coast and the limited fetch for westerly waves, combined with the higher tides, which reach 3 m along most of the northwest coast.

T 965-970 WOOLNORTH POINT-SHOAL INLET

No.	Beach	Rating HT LT	Type	Length
T965	Colliboi Beach	2 3	R+sand flats/channel	150 m
T966	Woolnorth Anchorage	2 1	R+sand flats	450 m
T967	Woolnorth Anchorage(S1)	2 1	R+sand flats	250 m
T968	Woolnorth Anchorage(S2)	2 1	R+sand flats	2.2 km
T969	Annes Bay	2 1	R+sand flats	150 m
T970	Annes Bay (S)	2 1	R+ridged sand flats	2 km
Spring & neap tidal range = 2.0 & 1.5 m				

Woolnorth Point marks a dramatic change in the nature of the northwest coast. To the east of the point wave height decreases substantially, with all the high westerly swell blocked by the islands and the northerly orientation of the coast, and the shore dominated by low locally generated wind waves. Tide increases along the entire west north coast to 3 m, with spring tides up to 3.7 m. The beaches respond with substantial tide-dominated sand flats in the protected areas and tide-modified beaches on the more open coast. In addition to the beach and sand flats there are substantial tidal currents, inlets and channels in the area to either side and the lee of Robbins Island.

Colliboi Beach (T 965) lies on the eastern side of Woolnorth Point, commencing 200 m south of the low rocky point. The sandy beach widens to the south extending for 150 m to a low rock ledge, which marks the beginning of a cobble shoreline. A vehicle track off the main track reaches the shore at the rocks. Sand flats extend 100 m off the northern end of the beach narrowing to the south where a tidal channel between the point and the Harbour Islets impinges on the shore. While waves are usually low along the shore there are however strong tidal currents in the deep channel.

Woolnorth Anchorage is located in a slight east-facing embayment located 500 m south of the point. The anchorage consists of a curving 450 m long east-facing high tide cobble beach (**T 966**), fronted by sand flats, which widen from 50 m in the north to 200 m in the south, with the deeper channel beyond. The anchorage was located here to take advantage of the sheltered deep water close to shore. The vehicle track runs from the landing at the northern end of the beach along the rear and 4 km south to Woolnorth. Dense scrubby vegetation and a 20 m high ride of rocks occupy the base of the point, which extends west for 800 m to the Davisons Bay beaches.

Beach **T 967** is a curving 250 m long, east-facing continuation of the cobble beach tied to low rock outcrops at each end. The sand flats widen to 300 m and the track follows the rear of the beach. Beach **T 968** commences at the southern rock outcrop and trends to the southeast for 2.2 km to the northern rocks of Annes Bay. The beach consists of a narrow high tide cobble beach backed by dense scrubby vegetation, with a walking track running the length of the beach. The sand flats widen

from 250 m in the north to 500 m in the south and in the centre link with the Murky Islets, located up to 1 km offshore. The presence of the islets induces wave refraction, which has resulted in a slight protrusion in the backing cobble beach.

Annes Bay (T 969) is a 100 m wide curving embayment located amongst a section of low rocky shore. The narrow sand and cobble beach curves around the rear of the small bay for 150 m and faces northeast out of the bay across 600 m wide sand flats. The bay entrance is fringed by intertidal rock flats, then the sand flats. It is backed by vegetated bluffs rising to 5 m, with a vehicle track reaching the rear of the beach.

Beach **T 970** commences amongst rocks on the southern side of the bay and trends to the southeast for 2 km to the 500 m wide shallow entrance to Shoal Inlet (Fig. 4.205). Wave height decreases down the beach as the tidal flats widen to 1 km to reach the small Shell Islets, with the inner 300 m of flats containing up to 16 shore-parallel sand ridges. This is a very low energy beach and sand flats that have prograded south as a 300 m wide spit to form the northern side of the inlet. Intertidal vegetation grows across some of the flats and salt marsh grows along the shore in places. The beach is backed by a few low poorly defined vegetated beach ridges and recurved spits, then the 100 ha shallow inlet.

Figure 4.205 The very low energy Annes Bay beach, with tidal flats, which terminates at the entrance to Shoal Inlet.

T 971-973 SHOAL-WELCOME INLETS

No.	Beach	Rating HT LT	Type	Length
T971	Shoal Inlet (E)	2 1	R+tidal flats	1.5 km
T972	Welcome Inlet (W)	2 1	R+tidal flats	1.4 km
T973	Welcome Inlet (E)	2 1	R+tidal flats	2 km
Spring & neap tidal range = 2.0 & 1.5 m				

To the east of Shoal Inlet is the beginning of a 25 km long section of tide-dominated shoreline, culminating in the 15 km long Robbins Passage between Robbins Island

and the mainland. Most of the shore on both sides of the 1.5-3 km km wide Passage consists of very low wave energy tidal flats, grading into the deeper 100-200 m wide tidal channels with strong tidal currents. Beaches T 971-973 extend for 5 km from Shoal to Welcome inlets and on to Swan Bay at the entrance to the Passage. They represent a transition from low energy beaches and tidal flats to true tidal flats fringed by salt marshes.

Beach **T 971** commences on the southern side of Shoal Inlet entrance and trends to the east for 1.5 km finally curving to the northeast in lee of the small Clump Island. The narrow, crenulate high tide beach is fronted by both partly vegetated and clear sand tidal flats extending up to 2 km northward, with the inlet channel cutting across the western flats. Beach **T 972** commences in lee of Clump Island and trends to the southeast and then south into the 700 m wide shallow entrance to Welcome Inlet. This is a similar narrow crenulate, high tide beach fronted by the continuous 2 km wide flats, with the deep Welcome Inlet tidal channel located 300 m east of the end of the beach. Both beaches are backed by a 2 km wide beach ridge plain consisting of more than 20 low ridges, which splay to the east. The plain, called the Welcome Heath, was developed in the mid-Holocene and has since been stranded by a slight fall in relative sea level and the development of the sand flats. Most of the ridges have been cleared and the area drained for farming.

Beach **T 973** commences on the eastern side of the 700 m wide entrance to Welcome Inlet, a shallow funnel-shaped 300 ha inlet. It then trends to the east for 2 km to the entrance to the shallow 1 km wide Swan Bay. The beach is low and narrow and fronted by tidal flats that widen to 2.5 km with deeper tidal channels to either side. A 200 m wide fringe of scrub then low cleared and drained farmland, known as the Swan Bay Plain, back the beach

ROBBINS & WALKER ISLANDS

ROBBINS & WALKER ISLANDS

	Robbins Is	Walker Is
Area (approx.):	9700 ha	700 ha
Coast length:	54 km	14 km
Beaches	21 (RI 1-21)	10 (WI 1-10)

Robbins and Walker islands are two adjoining islands located in the northwest corner of Tasmania between Hunter Island and Stanley (Fig. 4.204). Robbins Island is separated from the mainland by the 15 km long Robbins Passage, a 1-4 km wide generally shallow tidal passage, with only the deeper central tidal channel separating the island from the mainland at low tide. Likewise Walker Island is located at the northern tip of Robbins Island and is separated by a 300 m wide tidal channel. In this description the two islands are treated as one, with the beaches described from the west to east around the top of the two islands.

Robbins Island consists of the central 50-60 m high White Rock Ridge composed of Precambrian mudstone, with extensive Pleistocene and Holocene coastal deposits to either side. Walker Island is a 20-30m high continuation of the ridge, with a smaller area of coastal deposits comprising the southern half of the island. Both islands are covered by low heath and cleared grazing land and used for grazing, with only one permanent farm and 4WD tracks.

The 21 island beaches are located along the very low energy west coast of Robbins Island, around the more exposed Walker Island and the more exposed northeast coast of Robbins Island with the final beach tucked into the eastern end of the Robbins Passage. The 25 km long southern shore of Robbins Island and the adjacent mainland (between beaches T 973 & 974) are dominated by tidal flats, with no beaches. The islands' shorelines therefore range from sheltered tide-dominated to exposed wave-dominated.

RI 1-3 LITTLE CREEK-BIRD POINT

No.	Beach	Rating HT LT		Type	Length
RI 1	Little Creek	1	1	R+tidal sand flats	4.7 km
RI 2	Bird Pt (S)	1	1	R+tidal sand flats	1.1 km
RI 3	Bird Pt (N)	1	1	R+tidal sand flats	2.1 km
Spring & neap tidal range = 2.0 & 1.5 m					

The western shore of Robbins Island extends for 16 km from the low Wallaby Islands at the western entrance to Robbins Passage, north to the northern tip of the island at Shooting Gallery. The entire western side faces west across tidal sand flats that extend into Walker Channel,

with Woolnorth Point and Hunter Island located approximately 12 km to the west. The point and island, together with several smaller islands, effectively block all westerly swell from entering the channel and reaching the island. Therefore only fetch-limited westerly wind waves impact the western shores of Robbins and Walker islands. These are further reduced by the tidal flats, which widen from 1 km in the north to 4 km in the south.

Beach **RI 1** commences at the meandering mouth of the Little Creek, a small tidal creek that drains some of the western slopes of White Rock Ridge. At the creek mouth the tidal flats extend 11 km due west to Woolnorth Point but narrow to 1 km by the northern end of the beach (Fig. 4.206). The low narrow high tide beach commences at the creek mouth and trends north before curving round to the northeast for 4.7 km, terminating at a low protruding rock outcrop, where a vehicle track reaches the shore. The beach is backed by a series of low beach ridges and south trending spits, which widen to 500 m at the creek mouth.

Figure 4.206 The very low energy beach and wide tidal flats extending north of Little Creek (centre) as beach RI 1.

Beach **RI 2** commences on the northern side of the 100 m wide outcrop and curves to the north for 1.1 km to the southern side of Bird Point, which extends 300 m to the east. The high tide beach is low and narrow and fronted by 1 km wide sand flats that contain some subdued transverse sand ridges. It is backed by a 100-200 m wide series of low beach ridges.

Beach **RI 3** extends from the north side of 100 m wide Bird Point, north for 2.1 km to the western side of the low bedrock that forms the 800 m wide northern tip of the island known as Shooting Gallery. The high tide beach is low, narrow and faces west across sand flats that widen from 1 km at Bird Point to 2 km in the north in response to tidal flows between Robbins and Walker islands. Partly vegetated mudstone slopes back the beach, rising to 20-30 m, while a vehicle track around the northern tip reaches the northern end of the beach.

WI 1-5 WALKER ISLAND (W)

No.	Beach	Rating HT LT		Type	Length
WI 1	Egging Pt	1	3	R+sand flats/channel	1.4 km
WI 2	Walker Is (W1)	1	1	R+sand flats	400 m
WI 3	Walker Is (W2)	1	1	R+sand flats	2 km
WI 4	Walker Is (W3)	1	1	R+sand flats	200 m
WI 5	Walker Is (W4)	1	1	R+sand flats	250 m
Spring & neap tidal range = 2.0 & 1.5 m					

Walker Island extends north of Robbins Island for 6 km, with a width between 1.5 and 1 km and narrowing to the northern Cape Buache. It is a low grass and heath-covered island with a central-northern mudstone ridge that rises to between 20 and 30 m. Beaches WI 1-5 occupy part of the sheltered western shore, while beaches WI 6-10 are located along the more exposed higher energy eastern shore. There is no permanent habitation on the island, which has a landing strip in the south and vehicle tracks running right around the island, which provide access to all the beaches. Two farm buildings are located on the northwestern tip of the island, 500 m south of Cape Buache, with a boat landing located 500 m further south.

Egging Point is a low sandy foreland that forms the southern tip of the island. Beach **WI 1** commences at the point and trends to the north, then northwest for 1.4 km to an 8 m high, 100 m long vegetated point. The beach faces west across the western side of Mosquito Inlet, a 500 m wide tidal channel that separates Robbins and Walker islands, and which narrows to 250 m at the northern tip of Robbins Island. The beach is sheltered by Robbins Island and the wide sands that extend to the west resulting in usually low wind waves to calm conditions at the shore. It is fronted by sand flats that widen from 100 m at the point to 250 m at the northern end, then a deep 100 m wide tidal channel. The entire beach forms the western side of a 1 km wide barrier bordered by the high energy Rookery Beach (WI 9) to the north and beach WI 10 along Mosquito Inlet. The landing ground is located to the lee of the centre of the beach and almost reaches the shore.

Beach **WI 2** is a curving 400 m long low energy beach wedged between the southern boundary point and a 16 m high northern point that protrudes slightly from the backing vegetated north-trending ridge. The beach faces south across the 700 m wide channel to the northern tip of Robbins Island. The channel is largely filled with sand flats that extend 2 km west into Walker Channel. A vehicle track from the landing ground runs along the low slopes that back the beach.

Beach **WI 3** commences on the western side of the slight point and trends to the northwest, then north for 2 km, finally terminating at a low 50 m long bedrock point. The convex beach initially faces southwest across 2 km wide sand flats, which narrow to 1 km at the northern point. Wave energy increases slightly up the beach with up to

10 low subdued sand ridges paralleling the northern end of the low, narrow high tide beach. It is backed by vegetated slopes to either end rising to 20 m, with a slight low sandy foreland in the curving apex of the beach.

Beach **WI 4** is located on the northern side of the 50 m wide boundary point and continues north for another 200 m to the beginning of a 300 m long section of rocky shore. The high tide beach remains low and narrow, while the 1 km wide flats and multiple sand ridges continues north. It is backed by vegetated slopes rising to 20 m.

Beach **WI 5** commences at the end of the rocky section that separates it from beach WI 4. It trends due north for 250 m to the next section of rocky shore that continues for 1.5 km north to Cape Buache. The beach receives slightly higher waves that refract around Cape Buache and maintain ridged sand flats along the beach, which narrow to 600 m. North-trending low rock ridges border either end of the beach, with a small outcrop in the centre. Grassy slopes rise to 15 m behind the beach with a vehicle track located on the slopes 200 m to the east.

WI 6-10 WALKER ISLAND (E)

No.	Beach	Rating		Type		Length
		HT	LT	inner	outer bar	
WI 6	Love Bay	6	7	TBR	-	500 m
WI 7	Cathedral Pt (S1)	6	7	TBR	-	150 m
WI 8	Cathedral Pt (S2)	6	7	TBR	LBT	350 m
WI 9	Rookery Beach	6	7	TBR	LBT	2.7 km
WI 10	Mosquito Inlet (W)	3	4	R+channel		1.5 km
Spring & neap tidal range = 2.0 & 1.5 m						

The eastern side of Walker Island commences at the rocky 17 m high Cape Buache and its associated islets and reefs, and trends roughly south for 6 km to Egging Point. This side is fully exposed to northerly through easterly waves (Fig. 4.207) generated within Bass Strait and responds with an energetic rip-dominated surf zone, widening to two bars along the longer Rookery Beach. A vehicle track follows the rear of the beaches providing access to the rear of slopes above all the beaches.

Figure 4.207 Cape Buache, the northern tip of Walker Island, with the exposed Love Bay to the left.

Love Bay is an east to northeast-facing 600 m wide bay located between the northern Cape Buache and 25 m high Cathedral Point. Beach **WI 6** occupies the southern 500 m of the bay shore and extends to the south before curving to the east in lee of the point. Rocky shore and a low reef border the northern end, while Cathedral Point juts 100 m to the north at the south end. The beach receives short wind waves averaging 1-1.5 m, which maintain a low gradient 100 m wide surf zone, drained by a permanent rip against Cathedral Point, with a second rip against the northern rocks. A small partly sheltered foreland lies in lee of the northern reef, while the beach is backed by a well vegetated 50 m wide, 10 m high foredune, then a narrow wetland, before the vegetated slopes rise to 30 m. A vehicle track reaches the small northern foreland.

Beach **WI 7** is located in the centre of a rocky section of 20-35 m high coast that extends for 1 km south of Cathedral Point. The beach is a curving 150 m long northeast-facing pocket of sand wedged between 30 m high rocky points and backed by vegetated slopes rising to 30 m. It has a 100-150 m wide surf zone drained by a strong rip against the northern rocks. The vehicle track runs along the crest of the backing slopes 200 m to the south, with only foot access down the slopes to the beach.

Beach **WI 8** is located 800 m further south towards the end of the rocky shore. It is a curving, east-facing 350 m long beach bordered by rocky shore to the north and a 30 m high, 200 m wide rocky point to the south. It is fully exposed to north through east wind waves which average up to 1.5 m and maintain a 100 m wide rip-dominated inner bar with an outer bar located 300 m offshore. The inner bar is drained by rips to each end, while a deep rip channel runs between the outer bar and the northern rocks. The beach has a central rock outcrop and is backed by a vegetated foredune, then rocky slopes rising to 30 m, with a vehicle track running down the slopes to the southern end of the beach.

Rookery Beach (WI 9) commences on the southern side of the point and gently curves to the south-southeast for 2.7 km terminating at the entrance to 800 m wide Mosquito Inlet (Fig. 4.208). The high wind waves continue the length of the beach, as do the rip-dominated inner bar and outer bar. The outer bar merges with the tidal shoals of the inlet, which extend 500 m off the southern end of the beach. The beach is backed by a continuous vegetated foredune then a 200-300 m wide band of older vegetated transgressive dunes which rise to 15-30 m, then a low 0.8-1 km wide vegetated sand plain, that is bordered by Mosquito Inlet and beach WI 10 to the southwest, and Egging Point and beach WI 1 to the southwest. The landing ground is located in the centre of this plain. The vehicle track runs along the rear of the transgressive dunes, with access to the northern end of the beach.

Mosquito Inlet separates Walker from Robbins Island and is dominated by a deep channel, strong tidal currents and extensive sand flats. Beach **WI 10** commences at the northern entrance to the inlet and trends to the southwest

for 1.5 km to Egging Point and the boundary with beach WI 1. The beach faces southeast across the inlet, which is 800 m wide at the entrance then opens into the 600 ha inlet, which backs the northern end of the long Back Banks beach on Robbins Island (RI 5). The beach is backed by 300 m wide transgressive dunes along its northern end then the low sand plain down to Egging Point. It receives low waves through the inlet, which maintain a reflective high tide beach and 50-100 m wide sand flats fronted by the 100 m wide deep tidal channel and its strong currents. The vehicle track runs along the rear of the central section of the beach.

barrier is backed by the inlet in the north and the Eel Creek wetland in the south. This outer barrier is in turn backed by the most extensive inner barrier beach-foredune ridge system in Australia, locally known as the **Remarkable Banks**. Commencing on the southern side of Eel Creek 120 ridges occupy 1,500 ha and extend for 7 km to the southwest, narrowing from 3 km in the north to 100 m in the south. The ridges fill a V-shaped valley bordered by 50 m high White Rock Ridge to the east and a low wetland to the east. They are probably Pleistocene in age and deposited at a slightly higher sea level.

Figure 4.208 The exposed Rookery Beach during high energy northerly conditions, with Mosquito Inlet in the distance.

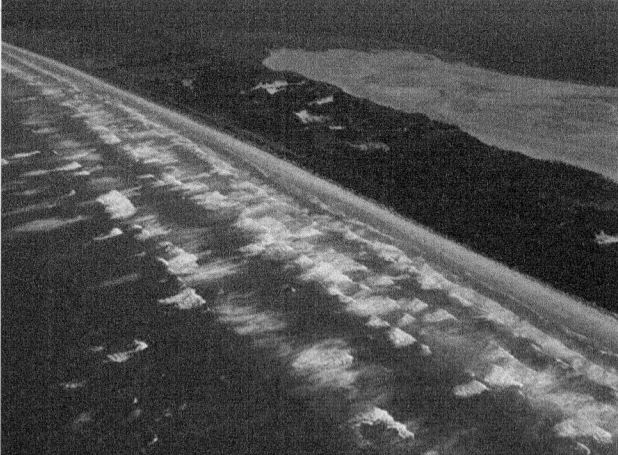

Figure 4.209 Back Banks beach maintains a double bar dissipative surf zone, seen here under northerly seas.

Beach **RI 5** commences at the base of Little Bluff and curves to the east-southeast for 2.3 km to the base of the 30 m high Big Bluff. A single bar dominates this final section of beach. It is usually cut by five rips as it gradually narrows from 150 to 50 m, in response to decreasing wave height in lee of the point. The beach is backed by a low foredune then grassy slopes gradually rising to 30-40 m. A farm is located on the cleared crest of Big Bluff above the eastern end of the beach.

RI 4-5 BACK BANKS

No.	Beach	Rating		Type		Length
		HT	LT	inner	outer bar	
RI 4	Back Banks	7	7	TBR/RBB	Diss	6.7 km
RI 5	Big Bluff	5	5	TBR	-	2.3 km
Spring & neap tidal range = 2.0 & 1.5 m						

The northeast coast of Robbins Island is dominated by the 9 km long **Back Banks** barrier and beaches (RI 4 and 5). The main beach (**RI 4**) commences on the southern side of Mosquito Inlet as a low bare sand spit fronted by the 600 m wide tidal sand shoals. It curves to the southeast for 6.7 km, terminating at the base of 40 m high Little Bluff, the sand continuing on to beach RI 5. The beach is one of the longest and most exposed on the west north coast and is backed by a large inner and outer barrier. It faces northeast exposing it to all north through easterly wind waves which average about 1.5 m and maintain a continuous double bar system (Fig. 4.209) for 7 km from the inlet to Little Bluff. The double bar consists of an inner bar usually crossed by westerly skewed rips spaced every few hundred metres and a dissipative outer bar located up to 400 m offshore.

The outer barrier consists of a 500 ha well developed transgressive dune system between the inlet and bluff, with 10-30 m high hummocky dunes extending up to 500 m inland and including some active blowouts. The

RI 6-8 GUYTON POINT-EAST BEACH

No.	Beach	Rating		Type	Length
		HT	LT		
RI 6	Guyton Pt (W)	4	6	Boulder+rocks	1 km
RI 7	Guyton Pt (E)	4	5	LTT/TBR	500 m
RI 8	East Beach	5	5	LTT/TBR	3.8 km
Spring & neap tidal range = 2.0 & 1.5 m					

Guyton Point is a low vegetated boulder point that forms the southern boundary of Ransonnet Bay. The point protrudes 1 km to the northeast, with basalt boulders eroded from the base of the Big Bluff forming the shoreline and beach **RI 6** (Fig. 4.210). The beach consists of a crenulate 1 km long high tide boulder shoreline which grades into a mixture of sand and rocks at low tide. Waves refract around the point and break along the narrow bar to produce a right-hand point break. The boulders extend high up onto the beach, which is backed by low vegetation.

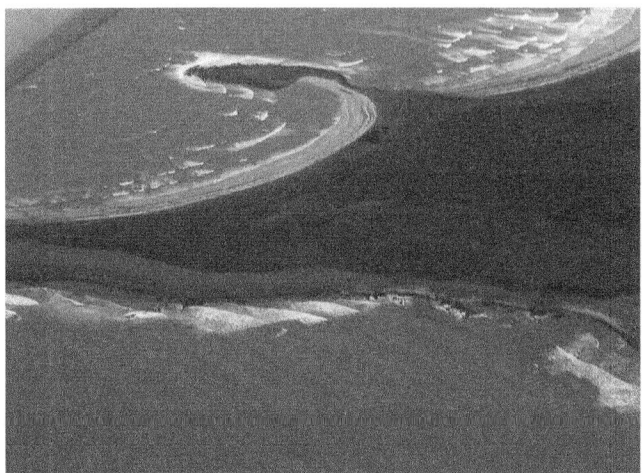

Figure 4.210 Guyton Point with boulder beach RI 6 in foreground, and the curving beach RI 7 located between the points.

Guyton Point also forms the northern boundary of beach **RI 7**, a curving 500 m long east-facing sandy beach, bordered by the low basaltic Marys Island to the south. The two points protrude 200 m seaward and partly enclose the beach in an embayment that converges to 300 m in width at the entrance. Waves refract into the bay with higher waves in the centre averaging over 1 m and breaking across a low gradient sand and rock seafloor. Marys Island is a low rock and boulder point, with waves refracting around either side to form a right- and a left-hand point break. A 100 m wide series of low foredunes backs the beach with low scrubland behind.

East Beach (RI 8) is a 3.8 km long northeast-facing beach located between Marys Island and the southern Cape Elie, a low basalt and boulder point. The beach receives waves averaging up to 1.5 m in the centre, decreasing to either side owing to deeper reefs off the beach. The waves and fine beach sand maintain a low gradient bar that widens to 100 m in the centre and which is cut by rips when waves exceed 1 m (Fig. 4.211). The beach is backed by a continuous series of low foredunes that widen from 100 m in the north to 400 m in the centre, and include some vegetated blowouts in the south. A vehicle track runs along the rear of the dunes, with cleared farmland behind.

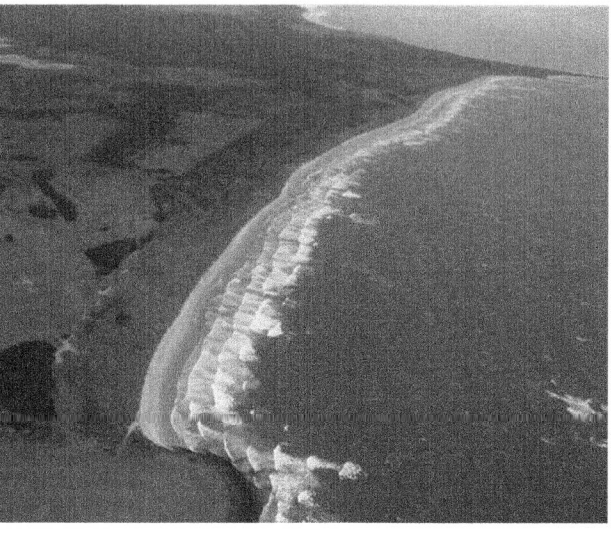

Figure 4.211 East Beach is a moderately exposed rip-dominated beach backed by a hummocky foredune (photo W. Hennecke).

wide sand flats, then the deeper water of the passage. Beaches RI 9-11 are located along the spit.

Beach **RI 9** lies 200 m west of the tip of the cape and is a 200 m long strip of high tide sand and cobbles that faces southeast out of the passage across 200 m wide sand and rock flats. Waves begin breaking at the cape, refract around the point and are lowered to about 0.5 m at the beach with a left-hand surf break off the cape. Cleared farmland backs the cape and beach.

Beach **RI 10** lies another 700 m to the west and is a curving 250 m long sand and cobble high tide beach fronted by 300 m wide inner rock and outer sand flats, then the deeper channel. Beach **RI 11** is located at the end of the spit another 700 m to the west, with a 100 m long groyne forming its western boundary. The sand flats narrow to 200 m off the beach with waves less than 0.5 m. Both beaches are backed by the low hummocky scrub-covered spit, then the 500 m wide wetland and tidal flats at the mouth of Robbins Creek.

RI 9-11 CAPE ELIE (W)

No.	Beach	Rating HT LT	Type	Length
RI 9	Cape Elie (W1)	2 1	R+sand flats	200 m
RI 10	Cape Elie (W2)	2 1	R+sand flats	250 m
RI 11	Cape Elie (W3)	2 1	R+sand flats	200 m
Spring & neap tidal range = 2.0 & 1.5 m				

Cape Elie is a low basalt and boulder point that forms the eastern tip of Robbins Island and marks the eastern entrance to Robbins Passage. At the cape the shoreline turns and trends due west for 2.2 km as a low, crenulate, low energy sand and cobble spit fronted by 200-300 m

T 974-975 **PERKINS BAY**

No.	Beach	Rating HT LT	Type	Length
T974	North Shore	4 4	R+UD	7.2 km
T975	Anthony Beach	4 4	R+UD	13.3 km
Spring & neap tidal range = 2.6 & 2.0 m				

Perkins Bay is a 15 km wide embayment bordered by Cape Elie and Robbins Island to the west and North Point and Stanley to the east. The bay extends 10 m to the south and faces north between the two boundaries. The southern bay shore is composed of two prograding barriers, the 7 km long Perkins Island and its North Shore beach (T 974) and the 13 km long Anthony Beach (T 975). The two beaches and barriers have a combined area of 1,500 ha and represent a major area of Holocene sediment accumulation and shoreline progradation.

North Shore beach (**T 974**) forms the northern side of 1,000 ha Perkins Island. The island beach is backed by a 1-2 km wide well developed foredune ridge plain containing up to 40 ridges, the innermost ridge grading into a series of western trending recurved spits. The island is separated from the mainland by a shallow 200 m wide tidal channel called The Jam, which can be crossed by vehicle at spring low tide. Perkins Channel and Big Bay border the western end of the island, with tidal shoals extending up to 2 km into the bay. At the eastern end, the 400 m wide Duck Bay tidal channel forms the boundary with its 200 m wide deep tidal channel and tidal shoals extending 1 km north into the bay. The beach commences at the western Shipwreck Point and trends to the southeast for 7.2 km to Kingston Point and the inlet. Waves are refracted into the bay and average about 1 m and they combine with the 2-3 m tides and fine sand to maintain a 300-400 m wide ultradissipative intertidal zone containing four to five sand ridges. A low foredune and the well vegetated foredune ridges back the beach, with several 4WD tracks providing access to and along the beach.

Anthony Beach (**T 975**) commences at Eagle Point on the eastern side of Duck Bay and curves to the east for 13.3 km to 500 m wide West Inlet, where a deep tidal channel and tidal shoals extend 1 km off the inlet (Fig. 4.212). This beach is backed by a continuous well developed foredune ridge plain which widens from 400 m at the ends to 700 m in the centre where there are up to 50 m low, closely spaced ridges. The island is linked to the mainland in the centre, with a 4 km road from the Bass Highway terminating at a beachfront car park in the centre of the beach. Duck Bay backs the western 5 km of the island, while West Inlet backs 3 km of the eastern end, with generally low marsh in between. The beach consists of a reflective high tide beach fronted by a low gradient 400-500 m wide ridged ultradissipative system.

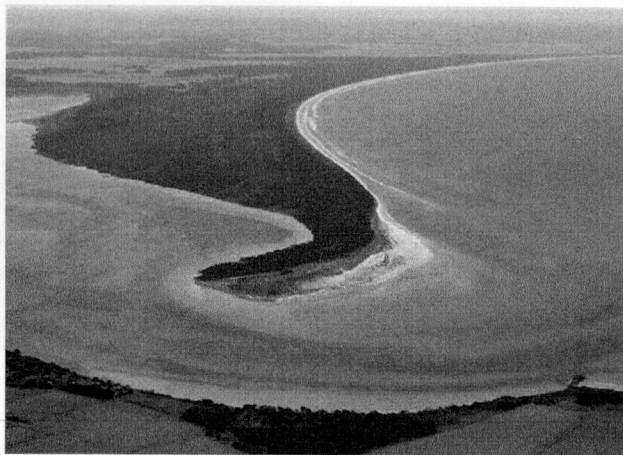

Figure 4.212 The eastern end of Anthony Beach at West Inlet.

T 976-980 **WEST INLET-CABLE POINT**

No.	Beach	Rating HT LT	Type	Length
T976	West Inlet	2 3	R+tidal channel	1.2 km
T977	Green Hills	2 1	R+ridged sand flats	4.2 km
T978	Cable Pt (S3)	2 1	R+ridged sand flats	150 m
T979	Cable Pt (S2)	2 1	R+ridged sand flats	100 m
T980	Cable Pt (S1)	2 1	R+ridged sand flats	200 m
Spring & neap tidal range = 2.6 & 2.0 m				

The eastern shore of **Perkins Bay** is bounded by the 9 km long northward-projecting peninsula occupied by the town of Stanley. On the western side it consists of a low 300 m wide isthmus, which widens as the Green Hills rise to 70 m, and widens further as the shoreline trends northwest to Cable Point and finally terminates at North Point. Two longer sandy beaches (T 976 and 977) occupy most of the western shore, with the smaller beaches T 978-980 located amongst the rocky shore south of Cable Point.

Beach **T 976** is a curving 1.2 km long strip of high tide sand that faces west to Anthony Beach across the deep 500 m wide West Inlet channel and terminates at a low rock groyne. The beach is sheltered by the island in the south and 1 km wide tidal sand flats to the north resulting in usually calm wave conditions, but strong tidal currents within the channel. It is backed by a strip of trees then cleared farmland, with the Stanley Road located 300 m to the east

Beach **T 977** commences at the groyne and trends north for 4.2 km paralleling the base of Green Hills to a 500 m westerly projection of the hills. The narrow high tide beach is fronted by 1 km wide ridged-sand flats, containing up to 16 low sinuous shore-parallel ridges cut diagonally across the southern half by the West Inlet tidal channel. It is backed by the green slopes of Green Hills in the north and a series of up to 20 low grassy beach-foredune ridges in the south, which reach up to 400 m in width. These have largely been cleared for farming. There is access via the Green Hills road to the northern end of the beach.

Beaches 978-980 are three pockets of sand and cobbles located along an otherwise low rocky shore extending 2 km south of Cable Point. Beach **T 978** is a curving west-facing 150 m long high tide cobble beach fronted by inner rock and outer ridged sand flats, totalling 200 m in width. Beach **T 979** is located 700 m to the north and is a straight 100 m long strip of high tide sand and cobbles located at the mouth of a drainage ditch. It faces west across inner rock and outer ridged sand flats totalling 200 m in width. Beach **T 980** lies to the lee of Cable Point and is a similar southwest-facing 200 m long high tide cobble beach fronted by 300 m wide rock then ridged sand flats. All three beaches share the continuous rock and sand flats and are backed by a fringe of scrub and cleared low-lying farmland.

T 981-984 CABLE-NORTH POINTS

No.	Beach	Rating HT LT	Type	Length
T981	Cable Pt (N1)	3 4	Cobble+rock flats/reef	400 m
T982	Cable Pt (N2)	3 4	Cobble+rock flats/reef	250 m
T983	North Pt (W2)	5 6	Cobble+rock flats/reef	200 m
T984	North Pt (W1)	5 6	Cobble+rock flats/reef	200 m
Spring & neap tidal range = 2.6 & 2.0 m				

North Point forms the northern tip of the Stanley Peninsula. It is composed of low basalt rocks and boulders, with shallow rock flats surrounding the point and all backed by cleared grassy farmland. Cable Point is a similar low basalt point that forms the western tip of the peninsula. Between the two low points are 2 km of west- to northwest-facing rocky shoreline containing four beaches (T 981-984). All are backed by farmland with no public access.

Beach **T 981** commences on the northern side of Cable Point and trends to the north as a double crenulate cobble beach for 400 m. It is fronted by 200-300 m wide shallow rock flats and reefs, together with patches of sand. Waves averaging about 1 m break over the reefs with usually low wave to calm conditions at the shore. It is backed by a low sand and cobble ridge, then farmland. Beach **T 982** occupies the next embayment 500 m to the north. It is a 250 m long west-facing cobble and sand high tide beach fronted by shallow 200 m wide rock flats, with waves averaging less than 1 m and breaking out over the reefs. It is separated from beach T 981 by a 300 m long series of cobble ridges that form a small cobble foreland.

The Cable Point beaches are separated from the northwest-facing embayment containing the two North Point beaches (T 983-984) by a westerly protruding low cobble point. Beach **T 983** is located immediately east of the point and is a curving 200 m long northwest-facing high tide cobble beach, fronted by shallow reefs that extend up to 300 m offshore. Waves averaging 1-1.5 m break well seaward over the shallow reefs. The reefs continue east to North Point with beach **T 984** located in the next small embayment 300 m southwest of the point. It is a 200 m long north-facing cobble beach with reefs

extending to the point and a long right-hand surf break running from the point towards the beach. Both beaches are backed by a 200-300 m wide splay of cobble ridges then farmland (Fig. 4.213).

Figure 4.213 Between Cable Point (left) and North Point (top) are two cobble beaches (T 983 & 984), with waves breaking over offshore rock reefs and flats.

T 985-989 NORTH POINT-HALFMOON BAY

No.	Beach	Rating HT LT	Type	Length
T985	North Pt (E1)	5 6	Cobble+rock flats/reef	100 m
T986	North Pt (E2)	5 6	Cobble+rock flats/reef	150 m
T987	North Pt (E3)	5 6	Cobble+rock flats/reef	500 m
T988	Halfmoon Bay (N)	5 6	LTT+reefs	150 m
T989	Halfmoon Bay	5 6	LTT+reefs	1.25 km
Spring & neap tidal range = 2.6 & 2.0 m				

To the east of **North Point** the shoreline trends to the southeast for 4 km to 40 m Highfield Point, with two embayments in between containing five beaches (T 985-989). All the beaches are backed by farmland with no public access.

Beaches T 985-987 are located in a series of three crenulations within the first embayment commencing at North Point and trending to the southeast for 1.2 km. Beach **T 985** occupies the first small crenulation and is a curving 100 m long strip of high tide cobbles fronted by rock reefs extending up to 300 m offshore. Beach **T 986** lies immediately to the east in the next curving 150 m long crenulation and is a similar high tide cobble beach to the lee of the continuous reef. Beach **T 987** continues southeast for 500 m to the end of the embayment where it is bordered by a low basalt boulder point that protrudes 200 m seaward. All three beaches face northeast and receive wind waves averaging 1-1.5 m, which break across the 100-300 m wide shallow rock flats and reefs. They are backed by continuous cobble-boulder ridges, with a 100 m wide series of older ridges behind, then cleared farmland.

Halfmoon Bay occupies the next 2.5 km wide northeast-facing embayment, with Highfield Point forming the southern boundary. It contains two beaches (T 988 and 989). Beach **T 988** is a curving 150 m long sandy beach, backed by a low foredune and fronted by an inner low tide terrace and outer rocky seafloor. It is separated from the main beach by a section of high tide boulders. Halfmoon Bay beach (**T 989**) extends to the southeast for 1.25 km terminating at the western base of Highfield Point with grassy slopes rising to the 40 m high crest of the point where a small lighthouse is located. The beach consists of a strip of high tide cobbles fronted by a narrow intertidal sand beach and an inner low tide terrace with rock reefs increasing to the south. It is backed by a low vegetated foredune and a 20 ha wetland in the centre surrounded by farmland. Waves averaging 1-1.5 m break up to 100 m offshore with several reef-controlled rips forming during periods of higher waves.

T 990-991 GODFREYS & TATLOWS BEACHES

No.	Beach	Rating HT LT		Type	Length
T990	Godfreys Beach	5	6	R+LTT	1.1 km
T991	Tatlows Beach	3	4	R+UD	4.5 km
Spring & neap tidal range = 2.6 & 2.0 m					

Stanley is an historic and picturesque small town located in lee of the prominent 143 m high volcanic plug called The Nut. It is tied to the mainland by two beaches, Godfreys (T 990) to the north and the longer Tatlows (T 991) to the south (Fig. 4.214). The town is a popular year round tourist destination and holiday centre during summer and offers a wide range of services and facilities. The Nut has provided sufficient shelter on its southern Circular Head side for the development of a port facility and fishing boat harbour.

Figure 4.214 Stanley is located at the base of the 140 m high volcanic remanent known as The Nut.

Godfreys Beach (T 990) is a curving 1.1 km long east-facing beach, which is protected from the strong westerly winds. It receives easterly wind waves averaging 0.5-1 m, which combine with the 2-3 m tide range to produce a narrow high tide beach, which at low tide may be up to 100 m wide, with rips in the low tide surf zone. In addition there are prominent rocky headlands at each end and an extensive rock reef off the northern end of the beach. The beach is backed by a 200 m wide series of seven grassy foredune ridges, with the road running along the ridges, then a dredged 10 ha wetland in the centre (Fig. 4.215). There is a large car park, playground, amenities block and sailing club at the southern end.

Figure 4.215 Godfrey Beach with Stanley behind and The Nut to the left.

Tatlows Beach (T 991) is tied to the southern side of The Nut, with Stanley located on the 600 m wide isthmus in between. This beach faces east into the open Sawyer Bay. It trends to the south for 4.5 km terminating in East Inlet. The northern end of the beach curves round to faces south in lee of The Nut and is relatively sheltered. This is followed by a 2 km long more exposed east-facing section which has wide low gradient ultradissipative intertidal zone paralleled by one to two low tide bars. The southern 2 km are located to the lee of East Inlet channel and tidal shoals, which widen to 1 km at the 500 m wide inlet mouth. Waves break over the tidal shoals resulting in a low energy beach, however strong tidal currents flow though the inlet and out into the bay. The beach is backed in the north by the town, caravan park and golf course. The 57 ha Tatlows Beach Coastal Reserve occupies the central-southern section and consists of a 100-200 m wide zone of eight low scrub covered foredunes. The main Stanley Road parallels the rear of the reserve and golf course.

Swimming: These are low to moderately hazardous beaches at high to mid tide under normal low wave conditions, however wave breaking at low tide can produce strong rips. Stay clear of the headlands and rocks on Godfreys and beware of the strong tidal currents along Tatlows Beach and at East Inlet. Also strong westerly winds can blow people on flotation devices out to sea, so watch children particularly at low tide and on windy days.

T 992-993 BLACK RIVER & PEGGS BEACHES

No.	Beach	Rating HT LT		Type	Length
T992	Black River Beach	6	6	UD	5.5 km
T993	Peggs Beach	6	6	UD	3.5 km
Peggs Beach Coastal Reserve			*208 ha*		
Spring & neap tidal range = 2.6 & 2.0 m					

The southern half of Sawyers Bay is bordered by the two relatively long straight Black River and Peggs beaches. **Black River Beach (T 992)** commences as a 1.5 km long 100 m wide spit on the southern side of East Inlet and trends relatively straight to the southeast for a total of 5.5 km to the 200 m wide Black River mouth (Fig. 4.216). The beach faces northeast and is well exposed to north through easterly wind waves, which average over 1 m and maintain a low gradient 400-500 m wide ultradissipative beach. The beach is backed by a 500 m wide well developed series of eight foredune ridges, then backbarrier flats, with 350 ha East Inlet backing the northern half of the barrier and 60 ha Black River mouth the southern section. The barrier has been partly cleared for farming. There is a vehicle track along the northern side of Black River, which provides access to the beach.

Figure 4.216 Black River inlet with Black River Beach (T 992) to the right and Peggs Beach (T 993) to the left.

Peggs Beach (T 993) commences on the southern side of the sandy Black River mouth and curves slightly to the southeast for 3.5 km, terminating at a low rock reef. The beach receives waves averaging 1 m, which break across a 500 m wide low gradient ultradissipative beach, paralleled by a low tide bar, with wave height and beach width decreasing slightly to the south. It is backed by a series of up to 12 well vegetated foredune ridges, which widen to 500 m in the centre and north. In the south there are also several vegetated blowouts. The highway clips the eastern end of the beach where there is a campground and park in lee of the boundary reef. The road then follows the rear of the ridges, before turning inland to cross the Black River 1 km in from the mouth. The whole beach and barrier system is contained within the 208 ha Peggs Beach Coastal Reserve.

T 994-998 LITTLE PEGGS BEACH-COWRIE POINT

No.	Beach	Rating HT LT		Type	Length
T994	Little Peggs Beach	4	3	R+LTT	550 m
T995	Brickmakers Bay	4	4	R+LTT+reef	250 m
T996	Cowrie Pt	3	3	R+reef	150 m
T997	Cowrie Pt (E1)	4	3	R+reef	100 m
T998	Cowrie Pt (E2)	4	3	R/LTT+reef	200 m
Spring & neap tidal range = 2.6 & 2.0 m					

Little Peggs Beach marks the beginning of a 6 km long section of rock-dominated shoreline containing 16 small tide-modified beaches (T 994-1009) with Port Latta located in the centre. The first five beaches (T 994-998) are located to the west of Port Latta. The Bass Highway parallels the shoreline providing good access to all the beaches.

Little Peggs Beach (T 994) is an eastern continuation of the longer Peggs Beach, with a 100 m long cluster of low rocks and reefs separating the two, most of which are exposed at low tide. The beach faces north-northeast and receives waves reduced slightly by inshore reefs to 1-1.5 m, decreasing in height towards the eastern boundary rocks. These maintain a high tide reflective beach and a 200 m wide low tide terrace, with rock reefs bordering either end. There is a car park and toilets on the boundary point, with the highway clipping the western end of the beach.

Brickmakers Bay is located 1 km to the east and contains a curving 250 m long north-facing beach (**T 995**) bordered by low rocky points. It has a reflective high tide beach fronted by a 150-200 m wide low tide terrace, hemmed in by rocky points, which converge to the centre leaving a 50 m wide sandy gap at low tide. It is backed by a narrow band of scrub, with a car park and small picnic and camping reserve at the western end of the beach and the highway immediately behind the eastern end.

Cowrie Point lies 300 m east of Brickmakers Bay and is associated with three small beaches (T 996-998) (Fig. 4.217). Beach **T 996** is located along the western side of the low rocky point. It faces west and consists of a high tide cobble beach fronted by 100-150 m wide intertidal rock flats. Waves averaging over 1 m break across the low rocky point and reefs, with waves usually less than 0.5 m at the shore. A few houses are located between the southern end of the beach and the highway. Beach **T 997** is located on the eastern side of the point and backs onto the cobble ridge of beach T 996 forming a low 50 m wide tombolo. It is a curving 100 m long east-facing sand and cobble beach fronted by a small rocky bay that drains at low tide, and has waves breaking across the 100 m wide entrance at high tide. Waves are usually low to calm at the shore. Beach **T 998** is located immediately to the east and consists of a curving 200 m long north-facing beach, bounded by low rocky points that converge to form a

100 m wide gap. Waves are lowered by the rocks and gap to less than 1 m at the shore. They break across a high tide reflective beach with 100-150 m wide low tide terrace extending out to the converging rock reefs at low tide. Dense scrub, a house, and then the highway back the beach.

Figure 4.217 Cowrie Point and beaches T 996-998.

T 999-1003 CRAYFISH CREEK

No.	Beach	Rating HT LT	Type	Length
T999	Crayfish Ck Beach	4 3	R+LTT	800 m
T1000	Crayfish Ck (W2)	4 3	R+LTT	100 m
T1001	Crayfish Ck (W1)	3 3	R+LTT/channel	150 m
T1002	Crayfish Ck (E1)	4 3	R+LTT	150 m
T1003	Crayfish Ck (E2)	4 3	R+LTT/reef	150 m
Spring & neap tidal range = 2.6 & 2.0 m				

Crayfish Creek is a small upland creek that reaches the coast 1 km east of Port Latta finally flowing as a narrow 600 m long tidal creek. The small 50-house holiday settlement of Crayfish Creek occupies the east side of the creek mouth, with five beaches (T 999-1003) located to either side of the creek.

Crayfish Creek Beach (T 999) is the longest of the beaches and begins in lee of the 250 m long attached breakwater that is part of Port Latta. The beach curves to the southeast for 800 m terminating against a 150 m long section of low rocks. The beach receives wind waves averaging over 1 m, which maintain a 300 m wide ultradissipative beach backed by densely vegetated low dunes. There is vehicle access from the highway to the southern end of the beach.

Beach **T 1000** is located on the east side of the rocks and is a 100 m long strip of high tide sand and rocks fronted by a 200 m wide continuation of the intertidal sand. A 50 m long strip of rocks separates it from 150 m long beach **T 1001,** which is located on the western side of the Crayfish Creek mouth, while the intertidal sand continues past both beaches. Waves are reduced by rock reefs extending 500 m seaward of the creek to less than 1 m at the two beaches. A narrow tidal channel cuts across the

low tide sand flats, accompanied by strong currents during mid to high tide. Dense vegetation, then the highway, backs both beaches, with a bridge crossing the creek 50 m west of beach T 1001.

A low rocky point forms the eastern side of the 50 m wide creek mouth with beach **T 1002** extending east of the rocks for 150 m to the next section of low rocky shore. This beach is backed by the Crayfish Creek houses, including a row of beachfront houses, with the highway 200 m to the south. The reflective high tide beach is fronted by a 300 m wide intertidal low tide terrace, which extends south along the side of the boundary rocks and reef. It is sheltered by the rock reefs and point with waves averaging about 0.5 m.

Beach **T 1003** is located on the eastern side of the small settlement with an irregular low 200 m long rock platform separating it from beach T 1002. The beach faces east into a small rock-bordered cove, with the rocks and reefs reducing waves to 0.5 m at the beach. The beach consists of a 150 m long strip of high tide sand, bordered by a low rocky point and platforms, with some rocks outcropping on the high tide beach, fronted by a 200 m wide intertidal low tide terrace, bordered by rock reefs to either side and all exposed at low tide. When waves exceed 1 m and at mid to high tide a rip runs out between the boundary rocks. It is backed by some low scrub, a grassy reserve, road and the Crayfish Creek houses. A vehicle track crosses the reserve to the beach, which is used to launch boats.

T 1004-1009 EDGCUMBE BEACH

No.	Beach	Rating HT LT	Type	Length
T1004	Edgcumbe Beach(W)	4 4	R+rock flats	100 m
T1005	Edgcumbe Beach	4 3	UD	150 m
T1006	Edgcumbe Beach(E1)	4 3	UD	200 m
T1007	Edgcumbe Beach(E2)	4 3	UD	100 m
T1008	Edgcumbe Beach(E3)	4 4	R+LTT+rocks	50 m
T1009	Edgcumbe Beach(E4)	4 4	R+LTT+rocks	80 m
Spring & neap tidal range = 2.6 & 2.0 m				

Edgcumbe Beach is a collection of six small beaches (T 1004-1009) spread along a 700 m long section of rock-dominated shore, with the small settlement of Edgcumbe Beach located behind the two main beaches (T 1005 and 1006) (Fig. 4.218). The highway runs right behind the beaches and settlement with good access to all the beaches.

Beach **T 1004** lies amongst the rocks that form the low rocky eastern point of Edgcumbe Beach. It consists of a double crenulate 100 m long narrow high tide beach fronted by a 20 m wide strip of sand, then 100 m wide intertidal rock flats, with low rocky points extending 100-200 m seaward to either side to form a small embayment. Waves are lowered by the rocks, reefs and point with usually low wave to calm conditions at the shore. It is backed by low grassy terrain and a solitary house.

Figure 4.218 Five of the Edgcumbe beaches (T 1004-1008) and the small settlement of the same name.

The main **Edgcumbe Beach (T 1005)** commences on the southern side of the rocky point and curves to the southeast for 150 m to a 100 m long section of intertidal rocks. This is a more exposed beach with waves averaging over 1 m and breaking across a 150 m wide intertidal bar. It is backed by a low grassy reserve then ten houses that front the reserve and beach. During low wave conditions the western end of the beach is used to launch boats. Beach **T 1006** continues on the other side of the rocks for another 200 m curving round to face north at its eastern end where it is bordered by a 100 m wide low rocky point and rock platform. The highway clips the centre of the beach, with two houses behind the eastern end in lee of the point. It shares the 150 m wide bar with the main beach with both beaches having a wide, low gradient dissipative surf zone. When waves exceed 1 m the surf is up to 100 m wide and rips drain out against the boundary points.

Beach **T 1007** is located on the eastern side of the point and is a curving, 100 m long north-facing beach fronted by a 150 m wide intertidal bar with rock reef bordering either side and extending to low tide. During higher waves a rip flows out against the western point. It is backed by 20 m wide low vegetated bluffs in the centre and then the highway, with an access path to the western end of the beach. Rock platforms and reefs extend east of the beach for 250 m with beaches T 1008 and 1009 located in amongst the rocks.

Beach **T 1008** is a 50 m long strip of high tide sand wedged in between rock outcrops, and at low tide is fronted by 100 m wide intertidal rock flats. Beach **T 1009** lies immediately to the east and is a similar 80 m long strip of high tide sand fronted by the continuous 100 m wide rock flats which link to the west with the main beach bar. Waves break over bar and rocks resulting in lower wave conditions at the shore and tidal pools forming in the rocks. A short vehicle track from the highway leads to beach T 1008.

T 1010-1011 HELLYER & FORWARDS BEACHES

No.	Beach	Rating HT LT		Type	Length
T1010	Hellyer Beach	4	5	UD→D+reef	2.5 km
T1011	Forwards Beach	4	5	UD→D	3 km
Spring & neap tidal range = 2.6 & 2.0 m					

Between the rocks of Edgcumbe Beach and the prominent Rocky Cape is the 7 km wide north-facing Pebbly Bay containing the two longer Hellyer and Forwards beaches centred on the mouth of Detention River, with the rocky shore of the cape extending another 2.5 km to the east. The highway backs the western Hellyer Beach, with Pebbly Bay and the river separating it from Forwards Beach.

Hellyer Beach (T 1010) is a 2.5 km long slightly curving north-northeast-facing sandy beach, bordered by low rocky points and platforms in the west and the 200 m wide shallow mouth of Pebbly Bay and the Detention River in the east (Fig. 4.219). The beach receives waves averaging over 1 m, which maintain a 600 m wide ultradissipative beach system consisting of a 200 m wide low tide terrace and two shore-parallel subtidal bars. Waves usually break across the inner intertidal bar, only breaking on the outer bars during higher wave conditions. In addition several low reefs outcrop along the low tide beach. It is backed by a well-developed series of four to five foredune ridges with the highway running along the crest of the inner ridge, and a 500 m wide wetland behind. Most of the area between the highway and beach is a coastal reserve. The small settlement of Hellyer is located at the eastern end of the beach between the highway, beach and bay. The highway crosses the river 800 m in from the mouth and then trends southeast, not nearing the coast again till Boat Harbour 18 km to the east.

Figure 4.219 The western end of Hellyer Beach, with Hellyer township and the Detention River mouth.

Forwards Beach (T 1011) commences on the eastern side of the sandy river mouth and trends east-northeast for 3 km to the beginning of the rocky cape. This is a

similar beach with wind waves averaging about 1 m and maintaining a 150 m wide ultradissipative inner low tide terrace, then two shore-parallel outer bars, the outer 400 m seaward of the high tide beach. The beach is backed by a well developed series of 10 foredune ridges up to 500 m wide in the centre, then the drained 700 m wide Forwards Plain. The outer ridges and beach are part of a coastal reserve. There is vehicle access off the Rocky Cape Road at the eastern end, with a vehicle track running along the ridges to the river mouth.

T 1012-1017 PICNIC-ROCKY CAPE BEACHES

No.	Beach	Rating HT LT	Type	Length
T1012	Picnic Beach	4 5	R+LT rips	250 m
T1013	Picnic Beach(E1)	4 5	R+LTT/rocks	200 m
T1014	Picnic Beach(E2)	4 5	R+rocks	70 m
T1015	Picnic Beach(E3)	4 4	R+LTT	300 m
T1016	Picnic Beach(E4)	3 5	R+LTT/rocks	100 m
T1017	Rocky Cape Beach(W2)	3 5	R+rock flats	80 m
Spring & neap tidal range = 2.6 & 2.0 m				

Rocky Cape is a prominent 120 m high headland composed of steeply dipping Precambrian mudstone and sandstones. The rocks begin to outcrop 2 km west of the cape at Picnic Beach and dominate the shoreline for 10 km as far east of the cape as Breakneck Point. In between are 17 km of rock-dominated shoreline containing 37 generally small rock-bordered or -bound beaches. Beaches T 1012-1017 occupy the first 1.5 km of shoreline extending up to the boundary of Rocky Cape National Park.

Picnic Beach (T 1012) commences at a low vegetated rock outcrop, which extends 100 m seaward across the low tide beach. It trends to the east-northeast for 250 m to the next rock outcrop, with waves decreasing in height to the lee of the rocks. It has a continuous low gradient high tide sand beach, fronted by a 100 m wide low tide terrace (Fig. 4.220). Waves average about 1 m and usually maintain a 50 m wide surf zone, with two to three rips forming along the base of the beach during and following periods of higher waves, while there is surf off the western point when waves exceed 1 m. A vehicle track runs out from the Rocky Cape Road to the beach and provides vehicle access to the beach. Most of the beach is backed by dense coastal scrub, with a clearing for informal camping along the rear of the western half of the beach.

Beach T 1013 is located immediately east of Picnic Beach with a low partly vegetated rock outcrop separating the two. The beach trends to the east-northeast for 200 m to the next main rock outcrop, with several smaller outcrops along the intertidal beach. Wave energy decreases to the east with the low tide bar narrowing to 50 m and waves dropping to less than 1 m and the surf zone less than 50 m wide. During periods of higher waves small rips form against the inter- to low tide rocks. A vehicle track leads to the western end crossing the low

foredune to the beach. The remainder of the beach is backed by a low vegetated foredune with a small usually blocked creek reaching the centre of the beach.

Figure 4.220 Picnic Beach showing waves breaking across the attached bar towards high tide.

Beach **T 1014** is a curving 70 m long pocket sandy beach located in the centre of a 300 m long section of rocky shoreline. The beach faces northwest and is bordered by steeply dipping sedimentary rocks, with a small rock islet extending most of the way across the beach, leaving a 20 m wide gap at its western end. Because of the islet and associated reefs waves are usually very low at the shore. All the rocks are emerged at spring low tide. However when waves are breaking over the rocks a rip current flows out through the western gap. The beach is only accessible on foot from the walking trail that follows the shore.

Beach **T 1015** lies 100 m to the east at the end of the rocky section. It curves slightly to the northeast for 300 m to a slight foreland formed in lee of inshore reefs, terminating at a low 50 m long vegetated rocky point. Wave energy continues to decrease east towards the cape, with waves averaging about 0.5 m at the shore and the low tide terrace narrowing to about 50 m. In addition to the boundary rocks and eastern reef, a reef also lies across the western low tide beach, with two pockets of clear low tide sand either side of the reef. The beach is backed by a low vegetated foredune, then coast heathland extends to the road 300 m inland. The beach can only be accessed on foot along the coastal track.

Beach **T 1016** is located on the eastern side of the small boundary point. It is a narrow, curving 100 m long northwest-facing high tide beach, fronted by continuous inter- to low tide rock flats that extend 100 m offshore, with a deeper section in the centre. It is backed by dense scrubs and accessible via a vehicle track from Rocky Cape Beach that reaches the eastern end of the beach.

Beach **T 1017** lies 100 m beyond and is an 80 m long pocket of high tide sand, bordered and fronted by steeply dipping sedimentary rocks. In addition rock reefs extend 200 m offshore resulting in low waves at the high tide beach, with the rocks and reefs exposed at low tide. The beach can only be accessed on foot around the rocks.

Rocky Cape National Park

Established:	1967
Area:	3064 ha
Coast length:	13 km (1907-1918, 1921-1923 km)
Beaches:	30 (T 1018-1041, T 1045-1050)

Rocky Cape National Park covers an area of rugged Precambrian rocky shoreline together with the backing Sisters Hills that parallel the coast for 12 km and rise to 200-300 m with slopes covered in low coastal heath. The irregular rocky shoreline extends for 16 km between Rocky Cape Beach and Breakneck Point and consists of 30 small beach systems, which occupy 5.6 km (35%) of the shore. The park is accessible by vehicle in the west at the small Rocky Cape community and via Sisters Beach in the east. A ridge-top walking track runs the length of the park and links to several coastal tracks.

T 1018-1021 **ROCKY CAPE BEACH**

No.	Beach	Rating HT LT	Type	Length
T1018	Rocky Cape Beach(W1)	3 5	R+sand/rock flats	100 m
T1019	Rocky Cape Beach	3 5	R+LTT	200 m
T1020	Mary Ann Cove	3 3	Cobble+rock flats	250 m
T1021	Mary Ann Cove E	3 4	Cobble+rock flats	50 m
Spring & neap tidal range = 2.6 & 2.0 m				

Rocky Cape Beach is the site of a collection of 35 fishing and holiday shacks and houses located just inside the western boundary of Rocky Cape National Park. The houses front two beaches (T 1018 and 1019) (Fig. 4.221) with the adjoining beach (T 1020) used for launching small boats.

Figure 4.221 Rocky Cape Beach (T 1018 & 1019) and the small settlement (right) with Mary Ann Cove (T 1021 & 1022) (left) showing the reef-dominated nearshore and eastern boat ramp.

Beach **T 1018** is located at the western end of the Rocky Cape community. It is a low curving 100 m long narrow beach, bordered by rocky shoreline to the west and an attached islet in the east. Between the two rocky boundaries is a 30 m wide gap, which permits only low waves to reach the shore. Within the small bay is a shallow sand and rocky seafloor exposed on spring lows. The beach is usually calm, with a central rock outcrop, a grassy backbeach and several houses located 50 m behind.

Rocky Cape Beach (T 1019) commences on the eastern side of the small islet and continues to the northeast for 200 m to a small rock point and reef. The houses continue along the rear of the beach, as well as two additional rows to the south and some spread along the entrance road. The beach is bordered by the rocks and reefs with a central 50 m wide sandy low tide terrace and a moderately steep high tide beach. This is the main swimming beach for the community and usually receives waves averaging less than 0.5 m. A small creek runs along the rear of the houses and crosses the western end of the beach.

Mary Ann Cove (T 1020) is located on the eastern side of the small boundary rocks and curves slightly to the

northeast for 250 m to the next rock outcrop (Fig. 4.221). This is a steep, narrow cobble beach, fronted by near continuous intertidal rock flats that extend 100 m offshore at low tide. The beach is sheltered by three small islets off the flats, with usually low wave to calm conditions along the shore. It is backed by a low vegetated foredune, then a gravel road that runs to a boat-launching site at the eastern end of the beach. Some of the rocks have been cleared to provide a sandy channel for the boats to use.

Beach **T 1021** is located on the eastern side of Mary Ann Cove, 50 m east of the boat launching area. It is a 50 m long pocket of high tide cobbles fronted by sand and rocky intertidal flats. It is backed by dense coastal heath with access only on foot around the rocks.

T 1022-1023 **ROCKY CAPE (W)**

No.	Beach	Rating HT LT	Type	Length
T1022	Rocky Cape (W2)	4 5	Cobble+rock flats	200 m
T1023	Rocky Cape (W1)	4 5	Cobble+rock flats	200 m
Spring & neap tidal range = 2.6 & 2.0 m				

The 1 km wide tip of Rocky Cape consists of a high sloping irregular rocky shoreline, with the steeply dipping sedimentary rocks striking north-northwest and forming resilient linear ridges along the shore. Most of the cape consists of rocky shore with only two small high tide beaches (T 1022 and 1023) on the western side of the beach.

Beach **T 1022** is a 200 m long northwest-facing strip of high tide cobble, crossed by several low rock ridges and fronted by continuous 50-100 m wide rock ridges interspersed with pockets of intertidal sand. Waves are usually low at the shore, with the rocks exposed at low tide. A walking track runs through the dense coastal heath 50 m inland from the beach.

Beach **T 1023** lies 100 m to the east with a protruding 300 m long intertidal ridge separating the two. It is a similar 200 m long high tide cobble beach with more extensive rock flats extending 100 m seaward, together with some pockets of sand. The walking trail continues past the rear of the beach and onto the tip of the cape located 300 m to the northeast.

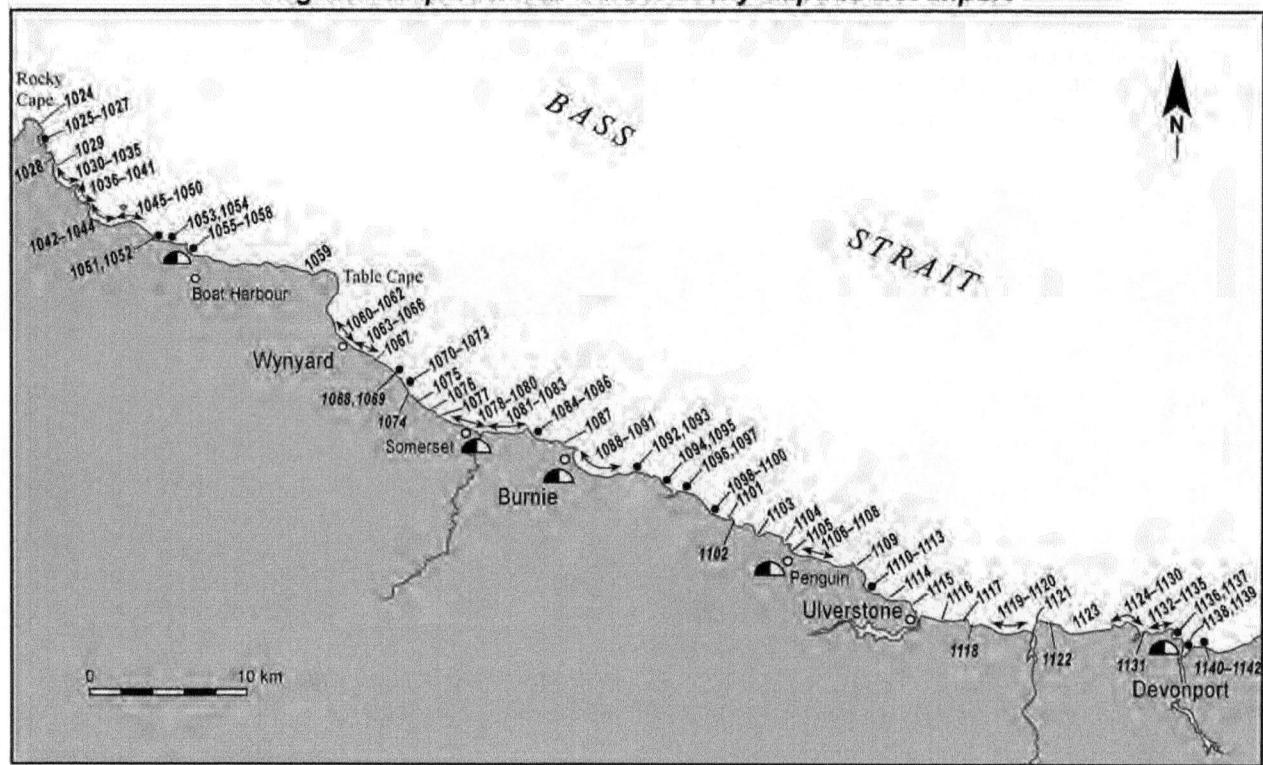

Regional map 15 North Coast: Rocky Cape to Devonport

Figure 4.222 The North Coast region between Rocky Cape and Devonport.

T 1025-1035 ROCKY CAPE-THE GUT

No.	Beach	Rating HT LT		Type	Length
T1024	Cave Bay	3	7	Cobble+rock flats	50 m
T1025	Cave Bay (S)	3	7	Cobble+rock flats	50 m
T1026	Burgess Cove	4	8	Cobble+rock flats	250 m
T1027	Burgess Cove (S)	4	8	Cobble+rock flats	60 m
T1028	Blue Rocks Point	4	8	Cobble+rock flats	50 m
T1029	Cathedral Rocks	4	8	Cobble+rock flats	100 m
T1030	Castle Rock (1)	4	6	Cobble	50 m
T1031	Castle Rock (2)	4	8	Cobble+rock flats	300 m
T1032	Castle Rock (3)	4	8	Cobble+rock flats	300 m
T1033	Castle Rock (4)	4	8	Cobble+rock flats	150 m
T1034	Doone Creek	4	8	Cobble	150 m
T1035	The Gut (W)	4	6	Cobble	50 m
Spring & neap tidal range = 2.6 & 2.0 m					

At **Rocky Cape** the shoreline turns and trends initially to the southeast for 6.5 km as a continuous irregular rocky shoreline backed by steep heath-covered slopes rising up to 290 m and all located within the national park. Between the cape and The Gut, 5 km to the southeast, are 12 small beaches (T 1024-1035) located in rocky indentations in the shore. All are composed of high tide deposits of cobbles and all are fronted by intertidal rock flats. The only one accessible by car is Burgess Cove (T 1026), with only two of the remainder (T 1024 and 1031) accessible via walking tracks, the remainder inaccessible by land. None of the beaches are suitable for swimming owing to the dominance of rocks and their exposed nature with most receiving easterly wind waves averaging 1 m and more, which maintain several permanent rips amongst the rocks and reefs.

Cave Bay beach (**T 1024**) is a 50 m long pocket of high tide cobbles located at the base of the narrow east-facing Cave Bay. Vegetated slopes rise steeply on both sides of the bay and in the rear to 120 m high Flagpole Hill. A walking track reaches the slopes above the bay.

Beach **T 1025** is located 250 m south of Cave Bay and is a 50 m long pocket beach located at the base of a curving 150 m wide bay. It is composed of high tide cobbles fronted by 50 m wide intertidal rock flats. The North and South caves are located on the slopes to either side of the bay.

Burgess Cove (T 1026) is the only section of the shore accessible by vehicle from a road off the Rocky Cape Road. The road leads right to the beach where there is a car park and boat-launching ramp across the beach. The beach extends for 250 m, faces due east and is composed of high tide cobble and boulders, fronted by irregular ridges of intertidal rocks and boulders. The boat ramp is located in a 40 m wide gap between two of the rock ridges (Fig. 4.223). Beach **T 1027** is located 100 m to the south at the southern end of the cove. It consists of a 60 m long strip of high tide cobbles fronted by a 30 m wide zone of intertidal boulders and rocks. It can be accessed on foot from the boat ramp.

Figure 4.223 Burgess Cove (T 1026 & 1027) is a moderately exposed rock and reef-dominated beach, with a boat ramp located in a gap in the rock.

Blue Rock Point is a narrow 15 m high 250 m long rocky point on the south side of which is a 200 m wide bay containing beach **T 1028**. The steep beach is composed of cobbles and curves for 50 m around the base of the east-facing bay. It is crossed by two rock ridges and at low tide 30-50 m wide ridged rock flats are exposed at the base of the beach.

Cathedral Rocks are a sea stack located on the northern side of a 250 m wide semi-circular bay with beach **T 1029** located in its northwest corner. It is a 100 m long cobble beach located at the base of a steep, narrow valley, with steep partly vegetated slopes to either side and rock flats widening from 30 m in the south to 80 m at the northern end.

Beach **T 1030** is located 300 m to the south between two elongate rocky points. The 50 m long high tide cobble beach faces east and curves between the base of the

points. It slopes into the deep water of the bay, with a rip running out between the points during high waves.

Beaches T 1031-1034 occupy the shoreline of an open 1.5 km wide northeast-facing rocky bay, bordered in the south by Anniversary Point. All are exposed to the easterly wind waves, which average 1 m and more. They are all backed by dense low heath that rises gently to 20 m then steeply to more than 200 m, 1 km inland. Beach **T 1031** commences in the northern corner of the bay and trends to the southeast for 300 m to a 100 m long section of bare sloping rocks. The beach is composed of cobbles, fronted by continuous 50 m wide ridged-intertidal rocky flats. Beach **T 1032** continues on the southern side of the rocks for another 300 m and consists of two slight crenulations located either side of a central shallow rock reef. The two embayed sections of the beach have 20 m wide gaps in the reefs that contain permanent rips when waves are breaking.

Thirty metre high **Castle Rock** separates beaches T 1032 and 1033. Beach **T 1033** is located on the eastern side of the rock and curves round for 150 m to face northwards out of the bay mouth. It is a narrow high tide cobble beach with scattered rocks and reefs extending 200 m offshore. A permanent rip flows through a gap in the reef off the northern end of the beach. Beach **T 1034** lies 100 m further east and straddles the mouth of Doone Creek. The crenulate beach consists of high tide cobbles fronted by 200 m wide inter- to sub-tidal rocks and reefs, with waves breaking well seaward of the beach. Low gently rising heathland backs both beaches, with steep valley slopes to either side.

Beach **T 1035** is located in The Gut, a 100 m long cobble section that links the central section of Anniversary Point, a 100 m wide, 20-30 m high rocky point that extends 600 m to the northeast. The steep, cobble beach is 50 m long, faces northwest and is sheltered from easterly waves. It usually has low wave to calm conditions, with shallow cobble and rock flats exposed at low tide.

T 1036-1041 ANNIVERSARY BAY

No.	Beach	Rating HT LT		Type	Length
T1036	The Gut (E)	3	4	Cobble	50 m
T1037	Anniversary Bay (1)	4	5	T+LT rips	800 m
T1038	Anniversary Bay (2)	4	5	T+LT rips	200 m
T1039	Anniversary Bay (3)	4	5	T+LT rips	150 m
T1040	Lee-Archer Cave	3	4	Cobble	50 m
T1041	Wet Cave Point	4	7	Cobble+rocks	80 m
Spring & neap tidal range = 2.6 & 2.0 m					

Anniversary Bay is a 1.5 km wide open exposed northeast-facing rocky bay bordered by Anniversary Point to the north and Wet Cave Point in the south. It is backed by 240 m high Broadview Hill, with the entire bay area located within the national park. There are walking tracks to either end of the bay, the remainder accessible along the shore. Three longer beaches are

located along the bay shore (T 1037-1039) and three pocket beaches on the boundary points (T 1036, 1040, 1041).

Beach **T 1036** is located on the eastern side of The Gut and backs onto beach T 1035, the two beaches linking this part of the point. The 50 m long cobble beach is wedged in between steeply dipping rocks that extend 50-100 m seaward forming a small cove. The beach receives waves averaging about 1 m, which surge up the steep beach face. It can only be reached on foot from Anniversary Bay.

Beach **T 1037** commences at the base of Anniversary Point and initially curves, then trends to the southeast for 800 m to a 100 m long collection of low narrow rock ridges that link 500 m offshore with the Five Sentries reef (Fig. 4.224). The sandy beach has a 100 m wide intertidal zone crossed by several linear rock ridges, one linking with reefs located 300 m offshore. Waves average over 1 m and maintain several rips against the low tide rocks. Moderately sloping coastal heath extends 300 m inland to the steep slopes rising to Broadview Hill.

Figure 4.224 Anniversary Bay (beaches T 1037-1039) with the Five Sentries reef off the centre.

Beach **T 1038** continues on the eastern side of the boundary rock ridge for another 200 m to the next small rocky outcrop. This is a 50 m wide high tide beach fronted by 50-100 m wide intertidal rock flats. Permanent rips flow out against the boundary rocks at high tide, while the rocks are exposed at low tide. Beach **T 1039** extends for another 150 m from the small rock outcrop to the base of Wet Cave Point, with slopes rising to 130 m above the eastern end of the beach. It is a similar high tide sandy beach fronted by rock flats, with a permanent rip against the western rock boundary. Both beaches are backed by coastal heath, then the steep slopes of the hill. A walking track from Sisters Beach crosses the rear of Wet Cave Point and provides foot access to this end of the bay.

Wet Cave Point protrudes 500 m to the northeast and separates Anniversary Bay from the Sisters beaches. The point rises inland to 130 m and is located within the national park. Most of its shoreline is steep and rocky apart from two small pockets of cobbles (T 1040 and

1041). Beach **T 1040** is a 50 m long high tide cobble beach located at the mouth of a steep densely vegetated narrow valley that contains Lee-Archer Cave. The beach is bounded by the rocky shore, with a shore-parallel reef 100 m offshore lowering waves at the beach to less than 0.5 m, however during high waves a strong current flows between the reef and shore. A walking track leads to the cave and beach. Beach **T 1041** is located in the next small embayment, 200 m west of the tip of the point. This is a hazardous 80 m long high tide cobble beach fronted by irregular intertidal rock flats. It is exposed to north through easterly waves backed by steep slopes. The walking track runs along the slope above the beach with a spur down to the shore.

T 1042-1049 **SISTERS BEACH**

No.	Beach	Rating HT LT	Type	Length
T1042	Razor Beach	4 5	R+rock flats	500 m
T1043	Sisters Beach (1)	4 4	R+LT rips	500 m
T1044	Sisters Beach (2)	4 4	R+LT rips	1 km
T1045	Sisters Beach (3)	4 4	R+LT rips	800 m
T1046	Sisters Beach (4)	4 5	R+rock flats	150 m
T1047	Sisters Beach (5)	4 4	R+LTT	400 m
T1048	Breakneck Pt (W)	4 5	R+rock flats	300 m
T1049	Breakneck Pt	4 7	R+rock flats	100 m
Spring & neap tidal range = 2.6 & 2.0 m				

Sisters Beach is a small but growing coastal settlement that straddles the mouth of Sisters Creek and spreads for 2 km along the western half of the 3.5 km long Sisters beaches. The beach is bounded by the high Wet Cave Point in the west and Breakneck Point in the east, which is backed by the 250 m high Two Sisters hill. Rock outcrops, reefs, the creek mouth and sandy forelands divide the beach into seven sections (T 1042-1048).

Razor Beach (**T 1042**) is located at the western end of Sisters Beach. The 500 m long beach commences against the base of Wet Cave Point and its steep 60 m high slopes. It curves to the southeast as a narrow high tide beach fronted by 100 m wide intertidal rock flats. There is a long boat ramp in the centre of the beach, with some of the rocks cleared to form a narrow channel for the boats. It is backed by a coastal reserve consisting of a low vegetated foredune backed by a car park for the boat ramp, then the houses of Sisters Beach.

Sisters Beach commences immediately east of the rock flats and the first section (**T 1043**) continues to curve to the southeast for another 500 m to a protruding section of beach tied to an intertidal reef. The beach consists of a high tide sand beach and a mixed sand and rocky low tide beach, with rips forming against the rocks during higher waves. It is backed by a low foredune and beachfront houses. The main beach (**T 1044**) continues east of the foreland for 1 km to the small sandy mouth of Sisters Creek. It is a continuous high tide beach with a 100 m wide low tide terrace, and a few scattered rock flats exposed at low tide. Waves average about 1 m, with

higher waves generating rips at low tide. A low foredune and beachfront houses back the entire beach.

On the eastern side of the creek mouth is a series of four continuous sandy beaches (T 1045-1048) (Fig. 4.225), separated by reef-tied sandy forelands and backed by a gravel road that runs out to a car park in lee of beach T 1049 near Breakneck Point. Beach **T 1045** commences at the creek mouth and trends due east for 800 m to a sandy foreland tied to a low rock reef. Wave height decreases east along the beach owing to sheltering from the reef with the low tide bar narrowing from 100 m to 50 m at the foreland, while during high wave two to three rips form along the low tide beach. At the creek mouth there is a small park, then a few houses that extend 200 m east along the beach to the boundary with the eastern section of Rocky Cape National Park. The remainder of the beach has a natural well vegetated foredune with a gravel road behind.

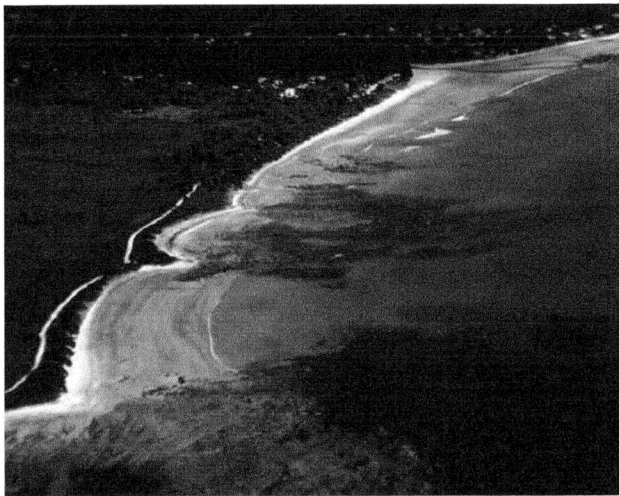

Figure 4.225 The eastern Sisters beaches (T 1045-1047) shown at low tide exposing the wide low tide terrace and central rock reefs.

Beach **T 1046** is located between two reef-tied sandy forelands. It is a curving 150 m long sandy high tide beach, which at mid tide grades into intertidal rock flats that fill the small embayment and link the two boundary reefs. The foredune and road continue along the rear of the beach. Beach **T 1047** continues east of the boundary foreland for another 400 m to a large attached reef that extends 300 m offshore. A continuous curving northwest-facing sandy beach links the two boundary reefs. It consists of a narrow high tide beach fronted by a 100 m wide sandy intertidal beach with the rock reefs to either side. The road and foredune continue along the rear of the beach, with a small car park and access track at the western end of the beach.

Beach **T 1048** commences on the eastern side of the foreland and curves to the east for 300 m to a low vegetated rocky point, which marks the end of the Sisters beaches. The sandy high tide beach is interrupted by rock outcrops towards the east and the entire beach is fronted by intertidal rock flats that extend up to 100 m offshore and surround the points. A vegetated foredune and the

road parallel the rear of the beach, the road terminating at a car park just past the end of the beach at beach T 1049. There is an access track across the foredune towards the centre of the beach.

Beach **T 1049** is located at the end of the road with a small gravel car park behind the centre of the beach. The rock-dominated beach faces east and is fully exposed to easterly waves. It consists of a series of four small pockets of sand totalling 100 m in length, each separated by low east-trending rock ridges, that link at low tide into continuous 50 m wide intertidal rock flats. A low rocky point extends 100 m seaward on the northern side of the beach, with the steep slopes rising to 50 m high Breakneck Point to the south and 250 m high Two Sisters hill behind. Because of the rocks and its exposed nature the beach is usually unsuitable for swimming.

T 1050-1052 WALKERS COVE

No.	Beach	Rating HT LT	Type	Length
T1050	Walkers Cove	4 7	R+rock flats	60 m
T1051	Banksia Grove (1)	4 6	Boulder+rocks	80 m
T1052	Banksia Grove (2)	4 6	Boulder+rocks	200 m
Spring & neap tidal range = 2.6 & 2.0 m				

Breakneck Point marks the beginning of a 20 km long section of rocky coast consisting of Precambrian sedimentary rocks between the point and Boat Harbour followed by Tertiary basalts from Boat Harbour to Table Cape. Most of the shoreline is steep and rocky, with only ten small beaches (T 1050-1059) located along the base totalling only 1.5 km in length. The first three beaches (T 1050-1052) are located within 2 km of the point.

Walkers Cove beach (**T 1050**) is a 60 m long high tide sand and cobble beach located in a 300 m wide rocky cove on the south side of Breakneck Point. The beach is divided in two by a central rock outcrop and irregular rocks and reefs extend 50 m into the surf zone. It faces due east into easterly wind waves which average over 1 m and maintain hazardous conditions with waves breaking across the rocks. There is no formal access to the beach, apart from around the rocks from beach T 1049.

Beaches T 1051 and 1052 are adjoining boulder beaches located 1 km east of the point. Beach **T 1051** is an 80 m long high tide boulder beach, with irregular rock ridges extending 50 m into the surf and exposed at low tide. Beach **T 1052** lies 50 m further east and is a similar 200 m long boulder beach with irregular intertidal rock flats running the length of the beach. Both beaches are exposed to north through east waves, which average about 1 m and maintain hazardous beach conditions. The beach is backed by cleared farmland that rises steeply to 100 m with a farmhouse on the backing ridge adjacent to Banksia Grove.

T 1053-1058 BOAT HARBOUR BEACH (SLSC)

No.	Beach	Rating HT	LT	Type	Length
T1053	Western Bay	2	3	R+rock flats	80 m
T1054	Boat Harbour	2	3	R+rock flats	150 m
T1055	Boat Harbour beach (1)	4	5	R+LT rips	200 m
Boat Harbour Beach (SLSC)					
Patrols:Dec-March: Weekends & public holidays					
T1056	Boat Harbour beach (2)	4	5	R+LT rips	350 m
T1057	Boat Harbour beach (3)	4	5	R+LTT/rocks	200 m
T1058	Boat Harbour beach (4)	4	5	R+LTT/rocks	100 m
Spring & neap tidal range = 2.6 & 2.0 m					

Boat Harbour is a small coastal community located between a strip of coastal sand and slopes rising steeply to 100 m. The 1 km long settlement is based around a sheltered cove in lee of Shelter Point within which is the boat harbour. It has a store and restaurants, with limited car parking in lee of Shelter Point and the small Boat Harbour Beach Surf Life Saving Club, established in 1984 (Fig. 4.226). One beach is located to the west of the harbour (T 1053) and five beaches to the east (T 1054-1058) (Fig. 4.227).

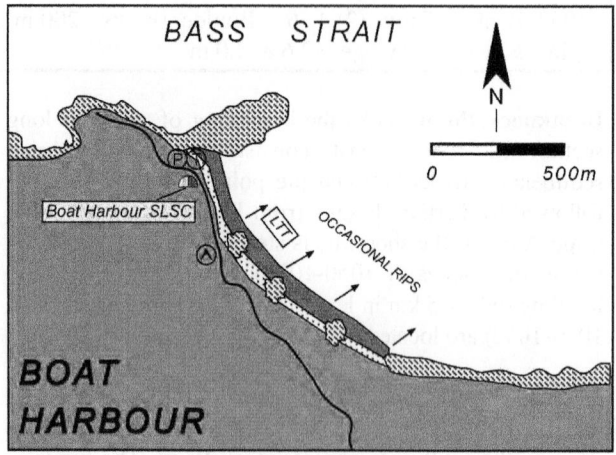

Figure 4.226 Boat Harbour beach is cut by occasional rips.

Western Bay is located 300 m west of Boat Harbour and consists of a 300 m long rocky cove sheltered by shore-parallel rock reef across most of the entrance. Inside is a lower energy rocky shore, with an 80 m long beach (**T 1053**) tucked in the eastern corner between two 100 m long narrow rock ridges. The beach faces west and is sheltered by the rock ridge and its orientation with usually very low wave to calm conditions at the shore. The low gradient sandy beach is replaced at mid tide by shallow rock flats. It is backed by partly cleared, tree-covered slopes, with an access road from the harbour terminating 100 m from the beach.

The **Boat Harbour** is a 200 m wide shallow semi-circular north-facing cove located in lee of the low vegetated Shelter Point, which extends 300 m to the northeast. The original low energy beach (**T 1054**) has been largely replaced by a seawall, with a grassy coastal reserve and car park behind. The cove can only be used around high tide as low tide exposes intertidal rock flats.

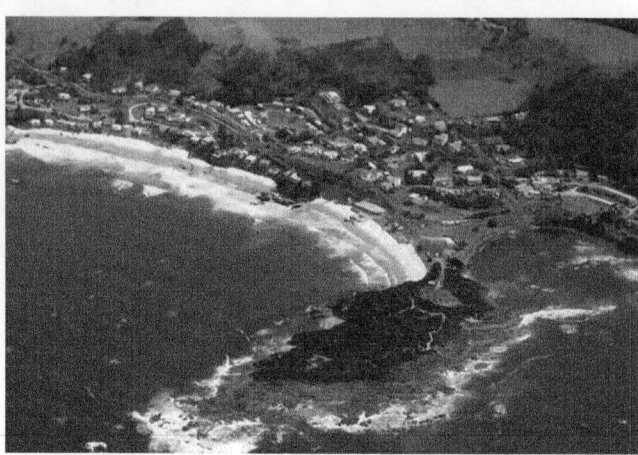

Figure 4.227 Boat Harbour with the sheltered harbour beach to right (T 1054) and the more exposed surfing beaches (T 1055 & 1056) and the surf life saving club to east (photo W. Hennecke).

On the eastern side of Shelter Point are the four Boat Harbour surfing beaches (T 1055-1058) which form a near continuous 800 m long sandy high tide beach, divided into four by small protruding rock outcrops and reefs. **Boat Harbour Beach** (**T 1055**) commences on the southern side of Shelter Point, with a 50 m wide grassy reserve and car park separating it from the harbour. This is the main swimming and surfing beach for the community and the site of the Boat Harbour Beach Surf Life Saving Club. The 200 m long beach faces northeast into waves averaging over 1 m, which usually break across a 50 m wide surf zone. It curves between the island and a 50 m long rock outcrop with a low gradient high tide beach grading into a 100 m wide low tide bar with rips forming during high wave conditions. The surf life saving club is located behind the centre of the beach, with car parking between the club and the point. The northern end of the beach has a boat ramp, which is used by 4WD to launch off the sandy beach during low waves.

Beach **T 1056** is the longest of the Boat Harbour beaches, continuing for 350 m from the rock outcrop to the next major outcrop and small headland, with some rocks also exposed along the high tide beach. The 100 m wide intertidal bar continues along the beach, with low tide rips also forming during periods of higher waves. Beachfront house are located on the rising slopes, with the rental units across the road.

Beach **T 1057** continues past the last outcrop for 200 m. Wave height decreases along the beach and the low tide bar narrows to 50 m, with intertidal rocks bordering each end of the beach. It is backed by steep partly vegetated slopes rising to 40 m at the eastern end of the beach, with the road running up the slopes. The beach can only be accessed along the shore from the main beaches.

Beach **T 1058** is the easternmost of the Boat Harbour beaches. It is a 100 m long strip of high tide sand located at the base of steep 50 m high slopes. The intertidal is dominated by rock flats making the beach usually unsuitable for swimming.

Swimming: Beach conditions at Boat Harbour depend on the winds and tide. Normal westerly winds produce low waves and least hazardous swimming conditions, however higher waves, particularly accompanying easterlies, can produce 1-2 m waves and strong rips, particularly at low tide. Best swimming is at mid to high tide and clear of the many rocks. At low tide the beach may be over 100 m wide, with many rocks exposed and rips in the surf.

Surfing: Easterly winds and swell can produce a good beach break which tends to be better at mid to low tide.

T 1059 CHAMBERS BAY

No.	Beach	Rating HT LT	Type	Length
T1059	Chambers Bay	4 5	Cobble+LT rips	100 m
Spring & neap tidal range = 2.6 & 2.0 m				

Chambers Bay is a small remote beach located 8 km east of Boat Harbour and 1 km west of the 180 m high Table Cape. The 200 m wide cove is indented 100 m into the backing slopes that rise steeply to 100 m. The beach (**T 1059**) extends for 100 m along the base of the slopes, and faces northeast into the prevailing wind waves, which average over 1 m at the shore. It is a continuous high tide-storm cobble beach, fronted by a moderately steep 50 m wide intertidal sand bar (Fig. 4.228), with rips forming against the boundary rocks during high waves. While the beach is located within the Table Cape Coastal Reserve, it is backed by ridge-top private property with no public land access.

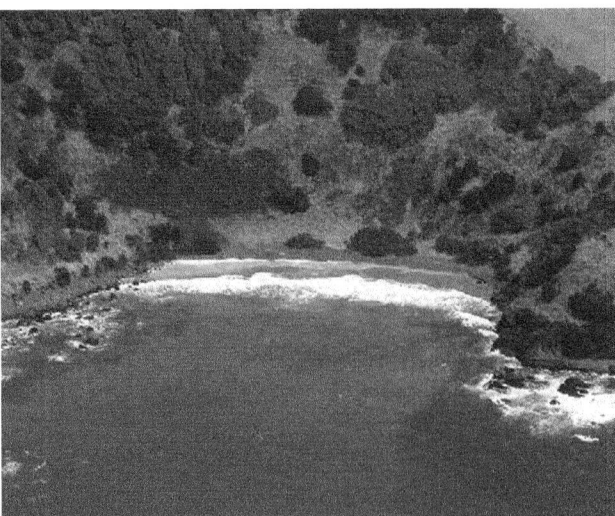

Figure 4.228 Chambers Bay is a sand and cobble beach (T 1059) located at the base of 100 m high slopes.

T 1060-1062 FOSSIL BLUFF

No.	Beach	Rating HT LT	Type	Length
T1060	Fossil Beach	4 4	R+LTT	200 m
T1061	Wynyard Golf Course 1	4 5	R+rock flats	250 m
T1062	Wynyard Golf Course 2	4 5	R+rock flats	300 m
Spring & neap tidal range = 2.6 & 2.0 m				

Fossil Bluff is a 50 m high coastal bluff composed of Tertiary marine sediments that are rich in fossils. It is located 3 km south of the prominent Table Cape. The 5.5 ha Fossil Bluff Coastal Reserve includes the bluff and adjoining **Fossil Beach** (**T 1060**). The 200 m long beach extends northwest of the bluff to the beginning of the steep basalt slopes that continue north to Table Cape. The beach is exposed to easterly waves, which average about 1 m and usually maintain a series of well developed gravel and sand cusps along the low gradient high tide beach (Fig. 4.229). The beach grades into a sandy low tide bar bordered by converging intertidal rock flats. While the beach is bordered by steep bluffs, it is backed by a low foredune, 100 m wide grassy reserve, then a subdivision, with a beach car park at the end of the houses.

Figure 4.229 Fossil Beach (T 1060) contains a mixture of sand and usually gravel cusps.

Wynyard Golf Course occupies an area of low land between Fossil Bluff and the mouth of the Inglis River. This section of coast has prograded seaward between the bluff and a river-mouth training wall that extends out across shallow reefs to Blackboy Rocks. Two north-facing beaches (T 1061 and 1062) front the golf course, separated by a central reef-controlled sandy foreland. Beach **T 1061** is a curving 250 m long high tide sand beach fronted by 150 m wide intertidal rock flats. Beach **T 1062** is a similar 300 m long curving beach fronted by the continuous rock flats that extend to the training wall. Both beaches are backed by continuous low beach-foredune ridges that comprise the golf course, while the beach can only be accessed on foot across the course.

T 1063-1067 EAST WYNYARD BEACHES

No.	Beach	Rating HT LT	Type	Length
T1063	East Wynyard Beach	4 4	R+LT sand/rocks	1 km
T1064	East Wynyard Beach	4 4	R+LT sand/rocks	200 m
T1065	Port Creek	4 4	R+LT sand/rocks	100 m
T1066	Seabrook (W)	4 5	R+seawall/rock flats	350 m
T1067	Seabrook	4 5	R+rock flats	1.1 km
Spring & neap tidal range = 2.6 & 2.0 m				

Wynyard is located at the mouth of the Inglis River and spreads for 4 km along the southern banks of the river and the adjacent eastern coastline. To the east of the river mouth are 4 km of near continuous sandy beaches (T 1063-1069), most fronted by 300-500 m wide intertidal rock flats (Fig. 4.230). The old Bass Highway follows the shoreline providing good access to all beaches. The first five beaches (T 1063-1067) are located between the river and the low Burntwood Point.

Figure 4.230 The East Wynyard beaches (T 1063-1065) consist of narrow high tide beaches fronted by intertidal wide sand and rock flats.

East Wynyard Beach (T 1063) commences against the 200 m long eastern training wall of the Inglis River. It curves to the east for 1 km to a low sandy foreland tied to intertidal rock flats by a 300 m long partly submerged curving groyne. It consists of a low gradient high tide beach grading into 200-300 m wide intertidal sand flats fringed by reefs extending up to 400 m seaward. It is

backed by a caravan park against the groyne, a 50 m wide grassy reserve with three car parks and a small central swimming pool, all backed by the old highway. Beach **T 1064** continues east of the foreland for another 200 m to the next reef-tied sandy foreland. The high tide beach grades into 100 m wide low tide sand flats which are partly encircled by the groyne and outer rock flats. A narrow grassy reserve then a row of houses and the old highway back the beach.

Beach **T 1065** extends east for 100 m from the sandy foreland to the small mouth of Port Creek where the highway crosses a small bridge over the creek The low gradient high tide beach is fronted by 100 m wide sand flats bordered by rock flats to either side, with detached rock flats extending up to 400 m offshore. The reserve, houses and old highway continue along the rear of the beach.

Beach **T 1066** continues for 350 m east of Port Creek mouth. The once sandy foreland beach has been replaced by a continuous seawall to protect the backing 30 m wide reserve and old highway. The seawall has largely failed permitting the shoreline to continue to erode behind the wall, thereby forming a sheltered elongate lagoon behind the wall. Intertidal rock flats extend up to 500 m seaward of the seawall/shoreline.

Seabrook Beach (T 1067) is a 1.1 km long curving narrow high tide sandy beach that terminates at a prominent low sandy foreland called Burntwood Point. The point is attached to intertidal reefs that extend 400 m seaward. A narrow grassy reserve and the old highway parallel the rear of the beach, which is fronted by patchy inshore sand flats, then more extensive rock flats extending 400-500 m seaward at both ends of the beach, with deeper water in between. The highway cuts across the rear of the point with a few beachfront houses to the lee of the point.

T 1068-1073 BURNTWOOD POINT-DOCTORS ROCKS

No.	Beach	Rating HT LT	Type	Length
T1068	Seabrook (E1)	4 5	R+rock flats	300 m
T1069	Seabrook (E2)	4 5	R+rock flats	750 m
T1070	Seabrook Ck	4 5	R+rock flats	150 m
T1071	Doctors Rocks (1)	4 5	R+rock flats	300 m
T1072	Doctors Rocks (2)	4 5	R+rock flats	100 m
T1073	Doctors Rocks (3)	4 5	Cobble+rock flats	300 m
Spring & neap tidal range = 2.6 & 2.0 m				

The 2.5 km long section of northeast-facing shoreline between Burntwood Point and Doctors Rocks consists of a crenulate sand and cobble shoreline containing six beaches (T 1068-1073), all fronted by irregular 200-300 m wide intertidal rock flats and backed by the abandoned railway line and old highway with a narrow undeveloped coastal reserve in between (Fig. 4.231). The coastal plain that extends east of Wynyard narrows to the

east terminating at Doctors Rocks, which is backed by slopes rising to 80 m high Misery Knob.

Figure 4.231 Burntwood Point (foreground) and the reef-dominated beaches T 1068-1070.

Beach **T 1068** commences on the eastern side of the **Burntwood Point** sandy foreland and curves to the southeast for 300 m to the next small foreland, both forelands tied to shallow rock flats, with deeper rocky seafloor in between and sand along the shoreline. The curving beach is backed by a low, narrow vegetated foredune, with three houses on the western foreland, then the old railway and highway and Seabrook Golf Course. It is suitable for swimming at mid to high tide on the inner sandy section, with the rock flats exposed at low tide.

Beach **T 1069** continues southeast from the small foreland for another 750 m to the next reef-tied foreland, just west of Seabrook Creek. The rocky reefs are also linked by deeper rock seafloor, with an inner 30-50 m wide sandy section, with some scattered inner rock reefs, including some against the shoreline. A low, narrow vegetated foredune backs the beach then the old railway, road and golf course.

Seabrook Creek is a small creek flowing out of the backing hills and across the eastern boundary of the golf course to reach the shoreline in a small embayment. Beach **T 1070** extends from the last sandy foreland for 150 m to the shallow 20 m wide creek mouth. A shallow rock reef extends 300 m northeast from the foreland, partly enclosing the beach, with the old creek bed winding out around the reef and largely filled with sand and scattered rocks. A low grassy reserve backs the beach, with the old railway and highway behind.

Beach **T 1071** commences on the eastern side of the creek mouth and is a protruding crenulate 300 m long beach fronted by continuous inner shallow rock flats, with deeper intertidal rocks extending 200-300 m offshore, the rocks inducing the crenulations in the shore. As it protrudes seaward of the old highway, three houses

occupy the central section of the foreland, the remainder being part of the continuous coastal reserve.

Beach **T 1072** is located on the eastern side of the foreland. It is a curving 100 m long east-facing sandy high tide beach bordered by shallow rock reefs, with rocks and reefs fringing the entire shoreline and extending up to 200 m offshore. The old highway clips the centre of the beach, with wider vegetated reserves to either end. The small settlement of Doctors Rocks is located opposite the beach along the southern side of the old highway.

Doctors Rocks protrude 100 m north from the shore rising to 20 m in height. Beach **T 1073** extends for 300 m west of the rocks to the junction of the old and new Bass highways, with the old railway paralleling the rear of the beach and a narrow vegetated reserve between it and the shore. It is a crenulate northeast-facing high tide cobble beach fronted by continuous intertidal rock flats apart from a 50 long patch of sandy seafloor against the eastern rocks.

T 1074-1078 **MCKENZIES BEACH-WOODY HILL POINT**

No.	Beach	Rating HT LT	Type	Length
T1074	McKenzies Beach 1	3 4	Cobble/R+rock flats	600 m
T1075	McKenzies Beach 2	3 4	Cobble/R+rock flats	1.3 km
T1076	Woody Hill Pt (W)	3 4	R+LTT/rock flats	300 m
T1077	Woody Hill Pt (E 1)	3 4	R+rock flats	500 m
T1078	Woody Hill Pt (E 2)	3 4	R+rock flats	200 m
Spring & neap tidal range = 2.6 & 2.0 m				

At Doctors Rocks the shoreline trends southeast for 4 km to the mouth of the Cam River at Somerset. In between are five near continuous high tide cobble and sand beaches (T 1074-1078) all fronted by intertidal rock flats and finally two predominantly sand beaches (T 1079-1080). The old railway line and highway hug the rear of the beach providing views and access to the shoreline.

McKenzies Beach commences 100 m southeast of Doctors Rocks and trends to the southeast as a double crenulate system containing two beach sections (T 1074 and 1075). Beach **T 1074** occupies the first 600 m extending southeast to a protruding cobble foreland formed in lee of shoaler inner rock flats, the intertidal flats averaging 250 m in width. Beach **T 1075** continues southeast of the foreland for another 1.3 km to a section of seawall built to protect the railway line. The entire beach has a storm/high tide cobble crest, with a moderately steep mid tide sand beach grading into the irregular rock flats and reefs. The only parking is located on the southern side of Doctors Rocks.

Beach **T 1076** commences at the end of the seawall and curves for 300 m to the cobble-boulder beach surrounding the low **Woody Hill Point**. In between is a moderately steep sandy beach, whose low foredune is

clipped by the railway. The beach has an attached reef at its western end and a mixture of sand and rock flats extending 200 m offshore. The backbeach area widens towards the eastern point where there is informal parking.

Beaches T 1077 and 1078 are two continuous beaches separated by a central sandy foreland. Beach **T 1077** commences on the eastern side of Woody Hill Point and trends to the east-southeast for 500 m to a slight sandy foreland. It is a moderately steep sandy high tide beach fronted by a patch of sand in the west, then continuous intertidal rock flats. Beach **T 1078** lies between the two small forelands with the eastern foreland extending 250 m to the northeast as a shallow reef. It is a 200 m long continuous high tide reflective sand beach fronted by continuous 200 m wide intertidal rock flats. The old railway and highway back both beaches.

T 1079-1080 FAIRLANDS & SOMERSET BEACHES (SLSC)

No.	Beach	Rating HT LT	Type	Length
T1079	Fairlands Beach	4 4	R+LTT	1 km
T1080	Somerset Beach (SLSC)	4 4	R+LTT	1.5 km
Somerset Beach (SLSC)				
Patrols: December-March: Weekends & public holidays				
Spring & neap tidal range = 2.6 & 2.0 m				

Somerset is a small town located on the western banks of the Cam River 6 km west of Burnie. It straddles the Bass Highway, with the area between the Highway-Somerset Road and Somerset Beach given over to an elongate 100 m wide coastal reserve which is backed by a large park, oval, caravan park, playground and picnic areas (Fig. 4.232). These amenities attract large numbers of summer holidaymakers as well as day-trippers to the beach.

Figure 4.232 Somerset is located by the mouth of the Cam River.

Fairlands Beach (**T 1079**) commences at the sandy foreland formed in lee of the shallow rock reef that marks a change to a more sandy beach system to the east. The beach is a low gradient high to mid tide beach extending 50-100 m seaward where it inter-fingers with low tide rock flats, particularly off the boundary forelands. It is backed by a 30 m wide reserve then the railway and highway.

Somerset Beach (**T 1080**) commences at the foreland and trends straight east then east-southeast for a total of 1.5 km finally curving south into the 50 m wide sandy mouth of the Cam River. The beach is narrow at high tide with a sandy low gradient mid tide, grading at low tide into two sandy channels bordered by intertidal rock flats. Waves depend on wind conditions, with low wave to calm conditions during westerlies, but higher waves during onshore and easterly conditions. The entire beach is backed by a coastal reserve, with sporting facilities located at the wider western end, then Somerset road and township. The Somerset Surf Life Saving Club is located towards the east end of the beach where sand delivered by the river spreads out over the rock flats and forms a low tide ridge (Fig. 4.233). The Anzac Park picnic area is located across the road from the surf club.

Figure 4.233 Somerset Beach and surf life saving club (T 1080 right) and the small Cam River mouth and beach T 1081 (left).

Swimming: Somerset has a low-moderate hazard rating under normal low wave conditions, with best swimming at mid to high tide. However higher easterly wave conditions induce rips, particularly at low tide.

Surfing: Waves depend on wind conditions, with the best surf accompanying easterly winds and waves, with best conditions at mid to low tide.

T 1081-1083 COOEE BEACHES

No.	Beach	Rating HT LT	Type	Length
T1081	Camdale	3 3	R+LTT/rock flats	1.4 km
T1082	Ocean Vista	3 3	R+LTT/rock flats	400 m
T1083	Cooee Beach	3 3	R+LTT/rock flats	600 m
Spring & neap tidal range = 2.6 & 2.0 m				

The three Cooee beaches (T 1081-1083) are located between the mouth of the Cam River at Camdale, and Cooee Point 3 km to the east. The beaches all face due north, with the old railway line and highway running along the rear of each.

Camdale beach (T 1081) commences at the reef-tied point that forms the eastern boundary of the 50 m wide Cam River entrance. The beach initially protrudes in lee of the reef and then curves to the east for 1.4 km to the next reef-tied foreland. Intertidal rock reefs dominate the western half of the beach, with a 100 m wide low tide bar along the eastern half then the boundary reef. An undeveloped foreland, once occupied by an abattoir, backs the eastern end of the beach, with a narrow grassy reserve and the highway paralleling the remainder.

Ocean Vista beach (T 1082) occupies the centre of the next small embayment, with reef-tied sandy forelands to either end. The 400 m long sandy beach has a 50 m wide upper sandy intertidal zone, grading into mid to low tide rock flats and reefs. A shallow reef lies off the eastern foreland while a narrow sandy channel runs down its western side. The narrow reserve and highway back the beach, with a car park in lee of the eastern foreland, and the small Ocean Vista community across the highway.

Cooee Beach (T 1083) commences at the reef-tied foreland and curves to the east for 600 m to the base of the low Cooee Point, which protrudes 300 m seaward. It is a sandy high tide beach, paralleled by a 50 m wide band of mid tide sand, then 50-100 m wide low tide rock flats, with sandy seafloor beyond (Fig. 4.234). A grassy reserve backs the beach, with car parking at the eastern end, and the highway and Cooee township behind.

Figure 4.234 Cooee Beach (T 1083), with the intertidal rock flats covered by the high tide.

T 1084-1086 **RED ROCK BEACHES**

No.	Beach	Rating HT LT		Type	Length
T1084	Cooee Point (E)	4	4	R+LTT/rock flats	500 m
T1085	Red Rock (W)	4	5	Cobble+rock flats	60 m
T1086	Red Rock (E)	4	5	R+rock flats	80 m
Spring & neap tidal range = 2.6 & 2.0 m					

To the east of **Cooee Point** is an open 2 km wide north-facing embayment containing along its western half three small beaches (T 1084-1086), with rock and rock flats dominating the eastern half.

Beach **T 1084** extends from the eastern base of Cooee Point 500 m to the southeast to a low sloping dolerite point. The beach faces northeast and is moderately exposed to east through north waves, which surge up the steep high tide beach. An intertidal low tide terrace extends 100-150 m seaward grading into rock flats at low tide. The Cooee Point Road backs most of the beach, with a narrow reserve with a boat ramp located towards the northern end of the beach, while Cooee Creek drains out across the southern end of the beach, with the Bass Highway right behind.

Beach **T 1085** is a 60 m long cobble beach located between the small dolerite point and the low red metasedimentary Red Rock Point and reef. The old rail line, now a bike path, backs the beach then the highway. A sandy channel abuts the dolerite point, with intertidal rock flats surrounding the southern point.

Beach **T 1086** is an 80 m long strip of high tide sand that extends south of the 100 m wide Red Rock Point to the seawall that protects the widened highway and which covers more than half of the former beach. The beach has a small foreland in lee of a shallow reef fronted by intertidal rock flats.

T 1087 **WEST BEACH (BURNIE SLSC)**

No.	Beach	Rating HT LT		Type	Length
T1087	West Beach	4	5	T+LTT/rock flats	700 m
Burnie (SLSC)					
Patrols: December-March: Weekends & public holidays					
Spring & neap tidal range = 2.6 & 2.0 m					

Burnie is the second largest city in northwest Tasmania with a population of over 20 000. It has a major port and associated industries and is a major service centre. The town is located on low ground in lee of Parsonage and Blackman points, with the port in lee of Blackman Point. Wharfs and breakwaters extend nearly 1 km east of Blackman Point providing more shelter and anchorage for shipping. Today the port and its facilities form the eastern boundary of Burnie, while West Beach forms the northern (Fig. 4.235). The beach is located adjacent to the main business area and is backed by both a road and railway line. Wedged in between the railway and the sand is a reserve containing the Burnie Surf Life Saving Club, which was established in 1921, a large elongate car park , playground and picnic facilities (Fig. 4.236).

West Beach (T 1087) is a 700 m long northeast-facing sandy beach bounded to the west by the low Parsonage Point, while a seawall, Blackman Point and port facilities form the eastern boundary. In addition rocks lie across

the centre of the beach, just west of the surf life saving club. The beach is composed of medium sand, which combines with the usually low waves to produce a moderately steep narrow high tide beach, which widens up to 100 m at low tide.

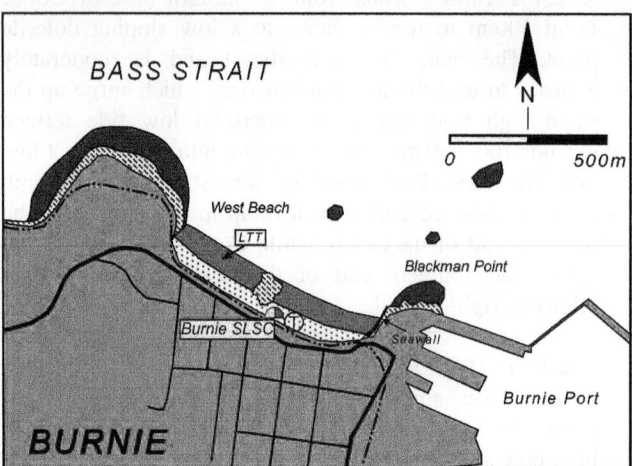

Figure 4.235 West Beach is located adjacent to Burnie town centre and port.

Figure 4.236 West Beach (T 1087), site of the Burnie surf club (centre), is located adjacent to the centre of Burnie.

Swimming: West Beach is relatively safe under normal low wave conditions, with best swimming at mid to high tide. However care must be taken to avoid the rocks at both ends and in the centre, and during higher waves when there is a heavy shorebreak.

T 1088-1090 **SOUTH BURNIE BEACHES**

No.	Beach	Rating HT LT	Type	Length
T1088	Oakley	2 2	R	80 m
T1089	South Burnie Beach	4 4	R+LTT	750 m
T1090	Wivenhoe Beach	4 4	R+LTT	1.3 km
Spring & neap tidal range = 2.6 & 2.0 m				

Burnie port is spread for 1 km along the southern side of Blackman Point, which also forms the western boundary

of 4 km wide Emu Bay, an open north-facing embayment bordered by Round Hill Point to the east. Between the two points are 5 km of shoreline containing the port and four beaches (T 1088-1091). The Bass Highway parallels the shore and runs past each of the beaches.

Oakley Beach T 1088 is located in the southeastern corner of Burnie harbour and has formed from sand accumulating against the rock jetty which has a boat ramp located towards its northern end. The beach is wedged in the corner and faces northwest across the port. The Burnie yacht club is located at the western end of the beach, with a large car park backing most of the beach and jetty. The beach is very sheltered with usually low wave to calm conditions.

South Burnie Beach (T 1089) commences on the eastern side of the rock jetty and trends to the east-southeast for 750 m to the sandy mouth of the Emu River (Fig. 4.237). The low gradient beach is narrow at high tide widening to a 100 m wide low tide terrace at low tide, with the river draining across the western end. It is backed by a vegetated reserve, then the highway, with parking at the western end adjacent to the jetty.

Figure 4.237 South Burnie Beach (T 1089) extends east to the small mouth of the Emu River.

Wivenhoe Beach (T 1090) extends east of the shallow river mouth for 1.3 km to the rocky base of 225 m high Round Hill. The beach is relatively straight and narrow with a 100 m wide low tide terrace and a few rock flats towards the eastern end. A seawall has been constructed in front of the Naval Reserve building towards the centre of the beach, while the remainder is backed by a narrow reserve, the highway and then South Burnie.

T 1091-1093 **ROUND HILL & POINT**

No.	Beach	Rating HT LT	Type	Length
T1091	Round Hill	4 5	Cobble+rock flats	70 m
T1092	Round Hill Pt (E)	4 5	Cobble+rock flats	100 m
T1093	Titan Pt (W)	4 5	R+rock flats	70 m
Spring & neap tidal range = 2.6 & 2.0 m				

Two hundred and twenty five metre high Round Hill dominates the 5 km of coast between the Emu and Blythe

rivers, with 100 m high Round Hill Point forming the eastern boundary of Emu Bay. Three small beaches (T 1091-1093) are located in three indentations in the rocky shore, with the old railway line and highway hugging the base of the slopes.

Beach **T 1091** lies 500 m east of Wivenhoe Beach amongst the basal rocky shore of Round Hill. The beach consists of a 70 m long high tide cobble beach, bordered by low rocky bluffs and fronted by 150 m wide intertidal rock flats. It is backed by a 100 m wide zone of undeveloped land, then the highway.

Beach **T 1092** is located 700 m east of Round Hill Point and consists of a double crenulate 100 m long strip of high tide cobbles, fronted by ridges of metasedimentary rocks and intertidal rock flats extending 200 m seaward. The old rail line clips the rear of the beach, with some scrub and a house between the line and highway.

Beach **T 1093** commences 200 m to the east where the old rail line rejoins the highway at the base of a steep 100 m high hill. In order to widen the highway a seawall has been constructed over most of what was the beach. The once 400 m long beach that curved to the lee of Titan Point now consists of an 70 m long wedge of sand between the western boundary rocks and the seawall, with the small Chasm Creek draining out against the rocks. Intertidal rock flats extend 100 m seaward of the beach and seawall.

T 1094-1097 **BLYTHE HEADS**

No.	Beach	Rating HT LT	Type	Length
T1094	Blythe River	4 5	R+rock flats	1 km
T1095	Blythe River mouth	4 5	R+river channel	200 m
T1096	Blythe Heads	4 5	R+rock flats	200 m
T1097	Heybridge	4 5	R+rock flats	100 m
Spring & neap tidal range = 2.6 & 2.0 m				

The **Blythe River** emerges from a steep, narrow V-shaped valley along a rocky section of coast dominated by steeply dipping Precambrian conglomerates. Four beaches (T 1094-1097) are located either side of the 50 m wide river mouth.

Beach **T 1094** extends west of the river mouth to the eastern rocks of the low Titan Point. It is a moderately steep high tide sandy beach that extends for a total of 1 km to the sandy western side of the river mouth. It is fronted by steeply dipping rock flats that extend 100 m seaward, with a more sandy channel and seafloor adjacent to the river mouth. The highway runs around the base of the point and clips the western end of the beach with a seawall backing the first 200 m of the beach and a 50 m wide vegetated reserve in between. A vehicle track runs through the reserve to reach the river mouth (Fig. 4.238).

Blythe Heads is a low rocky point that marks the eastern entrance to the river. Beach **T 1095** is located just inside the heads, extending for 200 m south to the highway bridge. It is a crenulate west-facing narrow beach, with usually low to no waves, fronted by some rocks, then the narrow deeper river channel. There is a small reserve on the heads with picnic and toilet facilities and a boat ramp, with houses behind.

Figure 4.238 Howth beach (T 1094) is wedged between the highway, a reserve and the intertidal rock flats, with the Blythe River forming the eastern boundary.

To the east of Blythe Heads is a 200 m long section of rocky shore and rock flats, followed by beach **T 1096** which curves to the east for a further 200 m terminating at a low protruding rocky point. This is a narrow sandy high tide beach, backed by some cobbles and fronted by 200 m wide ridged rock flats. A row of house parallels the rear of the beach, then the highway. Beach **T 1097** commences on the eastern side of the rocky point, 200 m to the east. It is a curving 100 m long pocket of high tide cobbles and sand, fronted by 200-300 m wide rock flats. Houses border the western side of the point with a bike track on the old railway and the highway running right behind the centre of the beach, and a seawall bordering the eastern side. The community of Heybridge is located on the southern side of the highway.

T 1098-1100 **HOWTH BEACHES**

No.	Beach	Rating HT LT	Type	Length
T1098	Howth 1	4 5	R+rock flats	300 m
T1099	Howth 2	4 5	R+rock flats	80 m
T1100	Howth 3	4 5	R+rock flats	400 m
Spring & neap tidal range = 2.6 & 2.0 m				

Howth is a locality at the junction of the Nine Mile road and the Bass Highway. Spread along the shoreline either side of the junction are three beaches (T 1098-1100). All are backed by a narrow undeveloped vegetated coastal reserve, the old railway line and the highway.

Beach **T 1098** commences against a seawall built to protect the highway and trends to the southeast for 300 m past the small protruding mouth of Heybridge Rivulet, to a 50 m long outcrop of rocks and boulders. The crenulate beach has a narrow sandy high tide swash zone, fronted by 100 m wide intertidal rock flats, grading into deeper

rocky seafloor, with linear patches of sand amongst the ridged rocks. Beach **T 1099** is located on the eastern side of the boundary outcrop and curves to the southeast for 80 m to the next 100 m long protruding outcrop. Shallow rock reefs border each end, with the narrow high tide sandy beach fronted by the continuous inter- and sub-tidal rocky seafloor.

Beach **T 1100** lies on the eastern side of the outcrops and curves to the east for 400 m to the next section of rocky shore. It is a moderately steep high tide sandy beach with continuous intertidal rock flats and a couple of patches of intertidal sand. The old rail line and highway parallel the rear of the beach, with the houses of Sulphur Creek across the highway at the eastern end of the beach.

T 1101-1102 SULPHUR CREEK & MIDWAY

No.	Beach	Rating HT LT	Type	Length
T1101	Sulphur Creek	4 5	R+LTT/rock flats	250 m
T1102	Midway Beach	4 4	R+LTT	900 m
Spring & neap tidal range = 2.6 & 2.0 m				

Sulphur Creek is a small community located on the old Bass Highway immediately west of the low Sulphur Creek Point. Two beaches are located either side of the point (T 1101 and 1102).

Sulphur Creek beach (**T 1101**) is a curving 250 m long sandy beach bordered by rocky shore and boulders to the west and the low 100 m long Sulphur Point to the east. The moderate gradient high tide beach grades into a 50 m wide low tide terrace, with rock flats continuing into the subtidal, and rocks of the point bordering the eastern end. It is backed by a narrow grassy reserve, which widens in lee of the point and has a car park and toilets, then the old highway and the eastern houses of Sulphur Creek.

Midway Beach (**T 1102**) commences on the eastern side of the 50 m wide Sulphur Point and trends to the southeast for 900 m to a rocky eastern point. The high tide beach is moderately steep and narrow, with some rock flats extending 300 m east of Sulphur Point. The remainder of the beach grades into a 150 m wide low gradient intertidal beach. A narrow vegetated reserve backs the beach, then the old highway and a row of houses with car parking on the points at either end of the beach.

T 1103 PRESERVATION BAY (PENGUIN SLSC)

No.	Beach	Rating HT LT	Type	Length
T1103	Preservation Bay	4 4	R+LTT	700 m
Penguin (SLSC)				
Patrols: December-March: Weekends & public holidays				
Spring & neap tidal range = 2.6 & 2.0 m				

Penguin is a small coastal town located just off the Bass Highway between Burnie and Ulverstone. The main part of the town sits on low ground behind Penguin and Watcombe beaches, with a small shopping centre providing basic facilities. The old Western railway line runs along the back of the beaches and to the west of the town between the highway and the coast. There are five beaches in the area, Preservation Bay Beach (T 1103) 1.5 km west of the town and the site of the newer Penguin Surf Life Saving Club; Johnsons Beach (T 1104), a small popular town beach; and Penguin and Watcombe beaches (T 1105-1107) (Fig. 4.239). All five beaches receive waves less than 1 m and are exposed to tides up to 3 m. All five are very accessible and popular during the summer period.

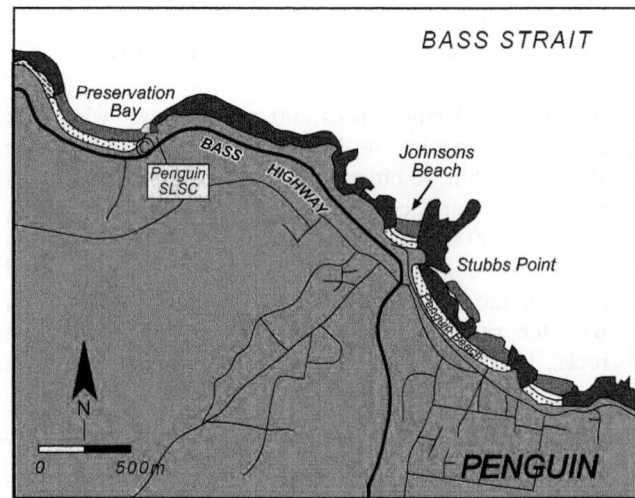

Figure 4.239 Penguin SLSC is located at Preservation Bay west of the town, with smaller rock dominated beaches in the town area.

Preservation Bay (T 1103) is a 700 m long north-facing beach that curves round between low rocky bluffs. The beach is backed by a low grassy foredune, the old railway line and old highway, with a row of houses on the southern side. There is good access to the beach from the large car park next to the Penguin Surf Life Saving Club located behind the rocky shore at the eastern end (Fig. 4.240). All motorists travelling the old highway get a good view of the beach and club house. Waves average 0.5-1 m, and with the tides produce a narrow high tide beach and 150 m wide moderately sloping low tide beach, consisting of a continuous low tide bar (Fig. 4.241). Rips do however occur during higher waves at low tide, with a strong rip running out against the eastern clubhouse rocks during northwest wave conditions. A small creek drains across the central part of the beach.

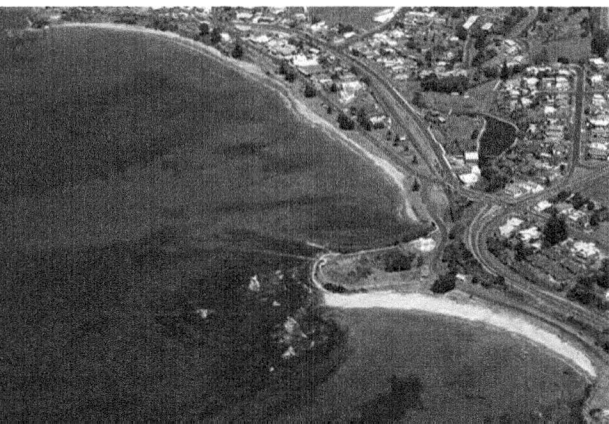

Figure 4.240 The western end of Preservation Bay (T 1103) with Penguin surf life saving club located on the point, shown here at high tide.

Figure 4.241 Preservation Bay (T 1103) at low tide showing the wide, low gradient, low tide bar.

T 1104-1107 PENGUIN BEACHES

No.	Beach	Rating HT	LT	Type	Length
T1104	Johnsons Beach	3	4	R+LTT/rock flats	200 m
T1105	Penguin Beach	4	5	R+LTT/rock flats	800 m
T1106	Watcombe Beach	4	5	R+LTT/rock flats	450 m
T1107	Watcombe (E)	3	5	R+rock flats	150 m
Spring & neap tidal range = 2.6 & 2.0 m					

Penguin township occupies 2 km of coastline to the east of Dial Point, with four beaches (T 1104-1107) dominating most of the shoreline, all backed by 10 m high bluffs rising to Main Street, with the town behind.

Johnsons Beach (T 1104) is a curving 200 m long, north-facing beach, bordered by a caravan park and the rocks of Dial Point to the west and 10 m high Beecraft Point to the east, both surrounded by intertidal rock flats (Fig. 4.242). It is a centrally located and popular beach during low wave conditions. The beach has a moderately steep high tide beach grading into a 50-100 m wide low tide terrace, with the rock flats to either side and some in the centre, all of which are exposed at low tide and hazardous when waves are breaking on the beach. A bike path, narrow reserve, highway and houses back the beach.

Figure 4.242 Johnsons Beach (T 1104 foreground) and Penguin Beach (T 1105) are both located adjacent to the town and are dominated by intertidal rock flats.

Penguin Beach (T 1105) extends for 800 m southeast of 80 m wide Beecraft Point. The point was once the site of the town jetty and has a boat ramp and parking area. Penguin Creek flows out against the point with the crenulate beach extending to the east. It is a steep, narrow high tide beach grading into a mixture of intertidal low tide terrace and rock flats, the rocks dominating the centre. A narrow blufftop reserve backs the beach then the main road and town centre. The Penguin Surf Life Saving Club was located here on the eastern Surf Club Point from 1931 until it moved to the sandier Preservation Bay in 1979.

Watcombe Beach (T 1106) lies on the eastern side of Surf Club Point. It is a 450 m long, north-facing beach with a 50 m wide sandy low tide bar, bordered and fringed by extensive rock flats, particularly to the east. A low narrow foredune, then an embankment rising up to the old rail line, back the beach, the line now used as a bike path with the road behind the beach. A Lions Club picnic area is located on the western Surf Club Point.

Beach **T 1107** lies in the next small embayment, 200 m east of Watcombe Beach. It consists of a narrow sand and cobble high tide beach, bordered by rocky shore and fronted by 150 m wide intertidal rock flats. A seawall built for the old rail line backs the beach, then the Main Road, with houses on the southern side of the road.

Swimming: The Penguin beaches have a relatively low hazard rating under normal low wave conditions. However care must be taken on all beaches when waves exceed 0.5 m as rips develop, particularly at low tide and near the rocks, as well as the hazards posed by the many exposed and submerged rocks and reefs.

Surfing: None of Penguin's beaches are known for their surf. However the best breaks will be on the more exposed Preservation Bay Beach when swell is running, with a right-hander forming off the eastern point.

T 1108-1113 TEA TREE POINT-GOAT ISLAND

No.	Beach	Rating HT LT	Type	Length
T1108	Tea Tree Pt (W)	3 5	R+rock flats	200 m
T1109	Penguin Pt (E)	2 5	R+rock flats	200 m
T1110	Three Sisters (1)	3 5	Cobble+rock flats	300 m
T1111	Three Sisters (2)	3 5	Cobble+rock flats	200 m
T1112	Three Sisters (3)	3 5	Cobble+rock flats	300 m
T1113	Goat Island	3 5	Cobble+rock flats	150 m
Three Sisters-Goat Island Coastal Reserve				
Spring & neap tidal range = 2.5 & 2.1 m				

To the east of Penguin is an 8 km long section of crenulate rocky shoreline, that turns to the southeast at Penguin Point, then south at Lodders Point, finally curving round to Goat Island. Most of the shoreline consists of irregular metasedimentary rocks, with some boulder beaches and six narrow high tide sand and cobble beaches (T 1108-1113) all fronted by irregular intertidal rock flats. Lonah Road parallels the shoreline providing views and access to all the beaches.

Beach **T 1108** is a slightly protruding 200 m long high tide sand beach located immediately west of the low **Tea Tree Point**. A large rock outcrops in the centre, with intertidal rock flats extending 100 m seaward. A narrow strip of grass, then the old railway and Lonah Road back the beach, then farmland spreading up the backing slopes.

Beach **T 1109** is located on the eastern side of **Penguin Point,** a 15 m high metasedimentary headland with a house on its crest. The 200 m long beach curves from the eastern side of the point round to parallel the Lonah Road along its southern half. The narrow, moderately steep high tide sand and cobble beach is fronted by 100 m wide intertidal rock flats which link at low tide to two small rock islets. A fringe of trees then the house and road back the beach, with farmland on the southern side of the road.

Beaches T 1110-1113 are four adjoining beaches that occupy a curving northeast-facing section of shore between Lodders Point and Goat Island, and all contained in the Three Sisters-Goat Island Nature Reserve. Beach **T 1110** trends to the south for 300 m as a narrow strip of high tide sand and cobbles, with the road running right along the rear of the beach. It is fronted by 50 m wide rock flats then a sandy bay floor.

Beach **T 1111** lies 200 m to the east and is a similar slightly curving, north-facing 200 m long strip of high tide cobbles, with some rocks along the beach. It is fronted by 200 m wide rock flats to either side, and a 100 wide central more sandy channel. Beach **T 1112** occupies the next slight embayment, 200 m to the east, and consists of a narrow high tide cobble beach, with numerous rocks outcropping along the shore all fronted by 200 m wide intertidal rock flats. A narrow strip of vegetated bluff backs the beaches with the Lonah Road running right along the rear.

Goat Island is a 23 m high 1 ha islet tied to the shoreline by 100 m wide intertidal rock flats. Beach **T 1113** lies to the lee of the island. It is a narrow high tide cobble beach bordered by low protruding rocky points, with rock flats extending out to the island. It is backed by a narrow tree-covered reserve, two houses and the main road.

T 1114-1115 PICNIC POINT

No.	Beach	Rating HT LT	Type	Length
T1114	Picnic Point (W)	4 4	R+LTT/rock flats	1.8 km
T1115	Picnic Point (E)	3 3	R+LTT/rock flats	800 m
Spring & neap tidal range = 2.5 & 2.1 m				

Picnic Point is a low reef-tied cobble foreland located on the western side of the River Leven mouth. Two beaches extend either side of the point (T 1114 and 1115), with the town of West Ulverstone backing both beaches and the point.

Beach **T 1114** commences immediately east of Goat Island and extends east for 1.8 km to the point. It is initially a cobble high tide beach, containing rock outcrops and intertidal rock flats. As it extends to the east the cobbles are replaced by a narrow high tide sand beach fronted by a mixture of rock flats and a 100 m wide low tide terrace. It is backed by a narrow reserve then the road, with houses increasing to the east. Waves average less than 1 m and spill across the low gradient beach and flats.

Picnic Point Beach (T 1115) commences at the point and curves slightly to the southeast for 800 m to the western training wall of the River Leven (Fig. 4.243). This beach has largely accumulated since the construction of the training wall and is occupied by a large recreation reserve, with a campground on the point, a caravan park in the east, a reserve in the centre and tennis courts in the west. The narrow high tide sandy beach is fronted by a 200 m wide low gradient low tide terrace.

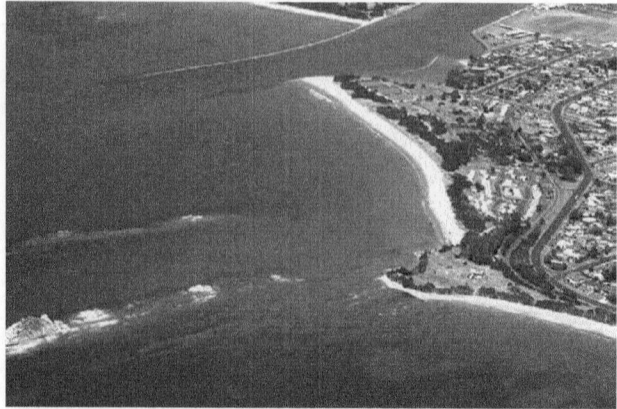

Figure 4.243 Picnic Point (foreground) and beach (T 1115) extend east to the mouth of the River Leven.

T 1116 BUTTONS BEACH (ULVERSTONE SLSC)

No.	Beach	Rating HT LT		Type	Length
T1116	Buttons Beach	3	4	R+LTT	2.7 km
Ulverstone (SLSC)					
Patrols:December-March: Weekends & public holidays					
Spring & neap tidal range = 2.5 & 2.1 m					

Ulverstone is the third largest town on Tasmania's north coast, after Devonport and Burnie, with a population of 10,000. The Bass Highway bypasses south of the town, with the old highway linking Ulverstone and West Ulverstone, located on either side of the River Leven. The town is well laid out, with its 4 km of sandy coastline given over to coastal reserves, caravan parks, parks, sporting facilities and various other recreational pursuits. The town has two main beaches, Picnic Point Beach (T 1115) located west of the river mouth, and the longer Buttons Beach (T 1116) to the east (Fig. 4.244). Both beaches receive waves usually less than 1 m and are exposed to tides up to 3 m.

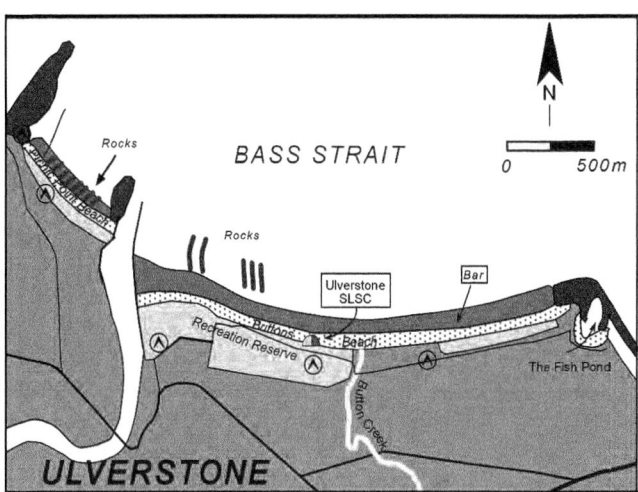

Figure 4.244 Ulverstone is fronted by a large coastal reserve and two beaches.

Buttons Beach (T 1116) is a 2.7 km long north-facing beach, bordered by the 1 km long training wall of the River Leven in the west and the low rocks of The Fish Pond in the east. The entire beach is backed by a wide recreation reserve containing numerous facilities including a large caravan park, ovals, campground and picnic areas. The Ulverstone Surf Life Saving Club is located toward the centre of the beach (Fig. 4.245), just west of the small creek that drains across the beach and in front of the larger of the two reserve caravan parks. The beach consists of a narrow high tide beach, with a 150 m wide low gradient low tide terrace and extensive rock flats toward either end. The small Buttons Creek drains out across the centre of the beach.

Figure 4.245 Buttons Beach (T 1116) shown at high tide, Ulverstone Surf Life Saving Club and backing caravan park.

Swimming: Picnic Point and Buttons beaches are moderately safe under normal low wave conditions, apart from near the exposed and submerged rocks. During higher waves rips can also form in the low tide surf zone and around the rocks. The safest swimming is in the patrolled area in front of the surf life saving club, otherwise at mid to high tide away from the rocks.

Surfing: Waves are usually low at Ulverstone, however occasional swell can produce breaks over the rocks, with conditions depending on the state of the tide.

T 1117-1119 FISH POND-CLAYTONS BAY

No.	Beach	Rating HT LT		Type	Length
T1117	The Fish Pond	2	2	Cobble+sand flats	150 m
T1118	Clayton	3	5	Cobble+rock flats	1 km
T1119	Claytons Bay	3	5	Cobble+rock flats	900 m
Spring & neap tidal range = 2.5 & 2.1 m					

The Fish Pond is located at the eastern end of Buttons Beach. Between the pond and Claytons Bay are 2 km of cobble shoreline containing three beaches (T 1117-1119).

The Fish Pond beach **(T 1117)** is located inside two recurved cobble spits that have converged on the point to partly enclose a shallow 100 m wide embayment called The Fish Pond. The narrow cobble beach curves for 150 m along the eastern side of the pond, with a small stream draining out at its western end, while the 1 ha pond has a shallow sandy bed, which is exposed as sand flats at low tide. A low tree-lined backshore and private house back the pond, with no direct public access.

Beach **T 1118** commences on the eastern side of the pond and curves to the east for 1 km to a broad cobble foreland. The steep narrow high tide beach is composed of cobbles and fronted by uniform cobble flats up to 100 m wide. It is backed by drained grass-covered wetlands, the old railway line, with the highway 500 m to the south and no direct public access.

Beach **T 1119** commences at the tip of the cobble foreland and trends to the southeast for 900 m to the end of the cobbles at the shallow mouth of Clayton Rivulet and the beginning of the sandy Turners Beach. It is a crenulate high tide cobble beach with uniform intertidal cobble flats extending up to 100 m offshore. A 50-100 m band of trees backs the beach, then a drained wetland containing two ovals. A road from the highway runs straight out to the tip of the foreland.

T 1120 TURNERS BEACH

No.	Beach	Rating HT LT	Type	Length
T1120	Turners Beach	3　4	R+LTT	2.2 km
Spring & neap tidal range = 2.5 & 2.1 m				

Turners Beach (T 1120) is a straight north-northwest-facing sandy beach that extends from Claytons Rivulet to the 100 m wide mouth of River Forth (Fig. 4.246). It is a narrow moderately steep high tide beach composed of sand and cobbles, fronted by a low gradient sandy low tide terrace, which widens to 150 m at spring low tide. Waves averaging less than 1 m usually spill across the low gradient beach, with rips only forming in the low tide zone during periods of higher waves. The eastern 100 m of beach curve into the river mouth, which has a deep channel and strong tidal current flowing though the mouth. A boat ramp is located 100 m into the river mouth.

Figure 4.246　The River Forth mouth with Turners Beach (T 1120) to the west and the Leith beaches to the east (T 1121 & 1122).

The beach is backed by a narrow discontinuous recreation reserve, which is filled with trees in the west, has a central car park and picnic and recreation area, followed by a row of beachfront houses and finally a caravan park in the east. The small township of Turners Beach extends for 200-300 m between the reserve with the highway crossing the river 700 m upstream.

T 1121-1124　LEITH-LILLICO BEACH

No.	Beach	Rating HT LT	Type	Length
T1121	Leith	2　4	R+LTT/channel	700 m
T1122	Leith (E)	4　5	Cobble+rock flats	1.5 km
T1123	Lillico Beach	4　5	Cobble+rock flats	2.4 km
T1124	Lillico Beach (E)	4　5	Cobble+rock flats	750 m
Spring & neap tidal range = 2.5 & 2.1 m				

Between the River Forth and Don River is a 7 km long section of 100 m high dissected Tertiary sediments, including a 2 km long section of Tertiary basalt in the east. The sediments have been reworked to form cobble beaches and rock flats along the shore, while the basalt section forms a series of steep cliffs and some small rocky coves. The small community of Leith is located on the eastern banks of the River Forth while the remainder is farmland with the highway hugging the central section of the shore.

Beach **T 1121** commences at the 50-100 m wide sandy entrance to the River Forth and trends to the north for 700 m as a narrow sandy high tide beach, fronted initially by widening river mouth shoals, then rock flats widening around the northern boundary point. However, the deep river channel and tidal current parallel the beach. The entire beach is backed by a tree-covered recreation reserve, then the Leith community. Waves are usually low and run along the shore moving sediment toward the river mouth.

Beach **T 1122** begins at the northern boundary to the river mouth and trends to the east for 1.5 km, terminating at a gap in the rock flats cut by Norfolk Creek. The crenulate beach consists of a steep narrow high tide cobble beach fronted by 100 m wide intertidal cobble flats. It is backed by a 200 m wide cleared, but undeveloped recreation reserve, then a road and a few houses, with the highway passing 200 m south of the eastern end of the beach.

Lillico Beach (T 1123) commences at the mouth of the small Norfolk Creek and curves gently to the east as a crenulate 2.4 km long cobble beach, terminating at a more prominent cobble foreland. The entire beach is composed of steep cobbles, fronted by 100 m wide intertidal flats composed of cobbles and rocks with sand increasing to the east. The narrow 14 ha Lillico Beach Coastal Reserve backs the beach, with the highway right behind.

Beach **T 1124** commences on the eastern side of the foreland, adjacent to where the highway turns to the south. This is a double crenulate 750 m long high tide cobble beach, bordered by 100 m wide cobble and rock flats, with deeper reefs in between. It is backed by a fringe of scrubs, then cleared farmland with slopes rising to 70 m in the east.

T 1125-1130 **DON HEADS**

No.	Beach	Rating HT LT	Type	Length
T1125	Don Heads (W5)	4 5	Cobble+rock flats	150 m
T1126	Don Heads (W4)	4 5	Cobble+rock flats	50 m
T1127	Don Heads (W3)	4 5	Cobble+rock flat	100 m
T1128	Don Heads (W 2)	2 3	R+sand/rock flats	150 m
T1129	Don Heads (W 1)	4 5	Cobble+rock flats	70 m
T1130	Don Heads	4 5	Cobble+rock flats	200 m
Spring & neap tidal range = 2.5 & 2.1 m				

Don Heads is a 50 m high basalt headland that forms the western entrance to the 100 m wide mouth of the Don River. The steep basalt shoreline extends for 2.5 km to the west and contains six small cobble beaches (T 1125-1130) all fronted by rock flats and all backed by steep grassy slopes of the backing farmland which rise to 50-60 m, with car access only at the river mouth beach (T 1130).

Beach **T 1125** is a curving 150 m long high tide cobble beach, bordered by rocky points backed by 20-30 m high cleared slopes. In between steep vegetated bluffs back the beach, which is fronted by intertidal rock flats which dominate all but a central sandy channel. Beach **T 1126** is located 100 m to the east, and is a 50 m long pocket of high tide cobbles, bordered by rocky points fronted by 100 m wide intertidal flats, with a deeper central channel between. It has two trees and generally cleared sloping land behind.

Beach **T 1127** lies at the base of steep 60 m high slopes. It is a 100 m long slightly curving high tide cobble beach, bordered by rocky points which extend 100 m seaward, with a deeper rock seafloor between. A low 50 m wide basalt point separates it from beach **T 1128**. This is a curving sandy beach located to the lee of a near continuous arc of basalt rocks and reef, with waves only passing through a central 50 m wide gap at high tide, forming a tidal pool. Inside the gap is a fringe of rock flats, with a central intertidal sand flat off the centre of the beach. It is backed by cleared slopes gradually rising to 60 m.

Beach **T 1129** is a 70 m long strip of high tide cobbles and sand, located 500 m west of the heads at the base of a 50 m high basalt cliff. It is fronted by sloping 50 m wide intertidal rock flats, with two low-lying basalt arms extending 100 m offshore to either side.

The western **Don Heads** beach (**T 1130**) is a cobble recurved spit which is attached at its western end to the base of the 50 m high heads, and curves to the southeast for 200 m into the river entrance. An earlier recurve has impounded a 2 ha wetland, which is encircled by the Don Heads Nature Trail. The narrow cobble ridge is fronted by 100-200 m wide intertidal rock flats, with the river channel hugging the eastern tip and rear of the spit (Fig. 4.247). The beach is accessible by car from the Don Heads Road.

Figure 4.247 The Don River mouth bordered by beaches T 1130 and 1131 (photo W. Hennecke).

T 1131-1135 **COLES-BACK BEACHES**

No.	Beach	Rating HT LT	Type	Length
T1131	Don Heads(E)	2 3	Cobble+sand/rock flats	200 m
T1132	Coles Beach	4 4	R+LTT	600 m
T1133	Coles (E 1)	4 5	Cobble+rock flats	70 m
T1134	Coles (E 2)	4 5	Cobble+rock flats	60 m
T1135	Back Beach	4 4	Cobble+LTT	150 m
Spring & neap tidal range = 2.5 & 2.0 m				

Between the Don River mouth and Mersey Bluff are 2 km of shoreline containing Coles and Back beaches, and three smaller beaches (T 1131-1135). All the beaches are located within a large coastal reserve and front some of the western suburbs of Devonport, while they are accessible off the Coles Beach Road.

Beach **T 1131** is located just inside on the eastern side of the shallow 200 m wide Don River mouth and trends south into the mouth for 200 m as a crenulate cobble beach. This is a very low energy beach fronted by rock flats that widen to 100 m at the mouth, where it is bordered by intertidal basalt rocks and reef. It is backed by a grassy park, with parking at the northern end.

Coles Beach (**T 1132**) is located in a semi-circular north-facing bay, bordered by a low cobble point to the west and 20 m high bluffs to the east. The Coles Beach Road and the old railway line parallel the back of the beach, with houses behind. There is a large reserve and car park toward the western end and a second car park at the eastern end, with a low scrubby foredune in between. The beach is moderately well exposed to west through northerly waves and is a popular surfing beach. At high tide it consists of a steep, narrow sand and cobble beach, while at low tide a 100 m wide, continuous bar is

exposed, with rock flats, including some large boulders to either end. During higher waves rips form in the lower surf zone.

Beaches T 1133 and 1134 are located on the rocky 500 m long dolerite point that separates Coles and Back beaches. Beach **T 1133** is a 70 m long strip of high tide cobbles fronted by a 50 m wide band of intertidal dolerite rocks. A car park backs the entire beach, with the road behind. Beach **T 1134** lies 150 m to the east and is a 60 m long pocket of high tide cobbles, also fronted by rocks extending 100 m offshore. The road clips the rear of the beach.

Back Beach (T 1135) is located on the western side of Mersey Bluff. The Coles Bay Road clips the western end of the beach where there is a small car park. The beach is 150 m long, faces northwest and is almost surrounded by rocky bluffs and reefs. It has a high tide ridge of cobbles grading into sand in the west, with a 100 m wide low tide bar, fringed by large rocks and boulders (Fig. 4.248). This is one of the more exposed beaches in the area and picks up any westerly swell, when it is popular with surfers. When waves exceed 0.5 m strong rips are generated in the small embayment, and conditions become increasingly hazardous as wave height increases.

Figure 4.248 Back Beach (T 1135), shown during calm conditions, is a popular surfing spot during higher waves.

T 1136-1137 BLUFF BEACH (DEVONPORT SLSC)

No.	Beach	Rating HT LT	Type	Length
T1136	Bluff Beach	4 4	R+LTT	300 m
T1137	Bluff Beach (E)	4 5	R+rock flats	700 m
	Devonport (SLSC)			
	Patrols: December-March: Weekends & public holidays			
Spring & neap tidal range = 2.5 & 2.1 m				

Devonport is a city on the north coast of Tasmania. It has a population of 25 000 and is the major port of entry for people arriving by car ferry from Melbourne and Sydney.

As the ferry passes through the narrow entrance to the Mersey River, the Bluff Beach is one of the first sights. The city is located on both banks of the river and divided into East Devonport, Devonport and North Devonport. The city has all facilities for travellers and tourists, as well as extensive coastal reserves backing the beaches and river. The main surfing areas are Coles and Back beaches (T 1132 & 1135) and the Mersey River mouth (T 1137), all located in North Devonport 1-2 km from the city centre. The beaches are bordered by rocks and bluffs and vary in orientation and exposure, providing a range of beach and surfing conditions (Fig. 4.249).

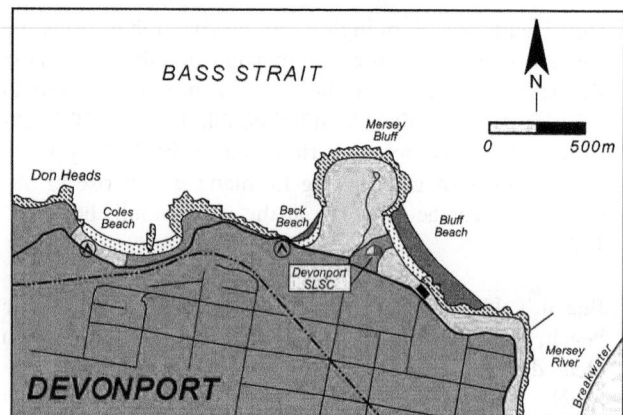

Figure 4.249 Devonport's main surfing beaches and the surf life saving club are located on the eastern side of The Bluff.

Bluff Beach (T 1136) is a low gradient 300 m long northeast-facing, sandy beach located on the more protected eastern side of Mersey Bluff (Fig. 4.250). The 20 m high Bluff and its rich aboriginal occupation sites is a major tourist destination and provides a good view of the beach. The beach is backed by a large foreshore reserve containing the Devonport Surf Life Saving Club, a skate park, large car park and picnic and playground facilities (Fig. 4.251). Additional recreational facilities are also available on the Bluff. Waves average 0.5 m, while tides range up to 3 m, and combine to produce a very narrow high tide beach, with waves sometimes reaching the low backing seawall, while at low tide the low gradient beach may be up to 100 m wide. Rocks and rock flats begin to dominate off both ends of the beach.

Figure 4.250 Bluff Beach (T 1136) at low tide, exposing the wide low tide bar.

Beach **T 1137** commences at the low rocks that mark the end of Bluff Beach and curves to the southeast then east for 700 m to the western breakwater of the Mersey River mouth (Fig. 4.252 The wide reserve continues the length of the beach to the river. The beach is steep and narrow and composed of cobbles, with the intertidal rock flats extending 100 m offshore. The *Mersey River* surf break runs along the side of the breakwater.

Swimming: Bluff Beach is the least hazardous, because of the usually lower waves and fewer rips and the presence of the surf life saving club. Coles Beach is moderately hazardous with rips forming when waves exceed 0.5 m, while Back Beach is one of the more hazardous on the north coast, and is only suitable for board surfing.

Surfing: *Coles Beach* is the more popular, while more experienced surfers will also surf *Back Beach* being careful to avoid the many rocks. During bigger northerly swells there are also breaks along the inner banks of the *Mersey River* mouth.

Figure 4.251 Bluff Beach (T 1136) at high tide, with Devonport Surf Life Saving Club and backing recreational facilities.

Figure 4.252 The Mersey River mouth at Devonport forms the boundary between the lower energy western from the more exposed eastern sections of the North Coast. This view shows beach T 1137 (right) to 1138-1139 (both left of river).

NORTH COAST: EASTERN SECTION

Devonport to Cape Portland

Coast length:	226 km	(2011-2237 km)
Beaches:	131	(T 1139-1269)
Regional maps	Figure 4.253	Page 282
	Figure 4.272	Page 295

The eastern half of the north coast commences at the Mersey River mouth at Devonport and extends for 226 km to Cape Portland, the northern tip of the mainland. In between are 131 beach systems including all the longer and higher energy north coast beaches, which occupy 157.5 km (70%) of the coast, the most beach-dominated section of the Tasmanian coast. The coastline trends to the east-northeast, with many beaches exposed to the predominant westerly wind waves and wind resulting in higher energy surf zones and backing longwalled parabolic dunes, including massive Pleistocene dune systems. As a result of the greater exposure of the coast and often blanketing with dunes, coastal settlements are few and either restricted to sheltered estuarine locations including Port Sorell and Georgetown-Launceston, or to the lee of headlands such as the small communities of Tam O'Shanter, Weymouth, Bridport and Tomahawk.

Regional map 16 North Coast: Devonport to Weymouth

Figure 4.253 The eastern side of the North Coast between Devonport and Weymouth.

T 1138-1139 MERSEY RIVER MOUTH

No.	Beach	Rating HT LT	Type	Length
T1138	Regatta Point	2 3	R+sand/rock flats	1.1 km
T1139	Police Point	2 3	R+sand/rock flats	250 m
Spring & neap tidal range = 2.5 & 2.1 m				

The **Mersey River** flows out of a narrow elongate drowned river between Regatta and Police Points. Training walls extend north of both points, with two low energy beaches (T 1138-1139) located just inside the 250 m wide river mouth.

Beach **T 1138** extends south of the **Regatta Point** training wall for 1.1 km to the beginning of the Devonport port facilities. It is a narrow, at times discontinuous low energy high tide sand and cobble beach. The north half has a fringe of rock and sand flats extending up to 100 m into the river. These narrow to the south with the southern half fronted by the deep river channel. While waves are low, strong tidal currents flow off the edge of the beach and flats. It is backed by a continuous foreshore reserve, then Victoria Parade and the houses of Devonport.

Police Point forms the eastern side of the river mouth. The Police Point beach (**T 1139**) commences at a small rock groyne on the point and curves slightly to the east for 250 m to the base of the eastern training wall, which curves to the north for 700 m. The river channel clips the western side of the beach, with sand and rock flats widening to 200 m by the eastern end of the beach. Waves are usually very low to calm. It is backed by a grassy reserve and picnic area, then the houses of East Devonport.

T 1140-1143 EAST DEVONPORT BEACHES

No.	Beach	Rating HT LT	Type	Length
T1140	East Devonport Beach	3 3	R+LTT	400 m
T1141	Pardoe Downs (1)	4 5	Cobble+rock flats	400 m
T1142	Pardoe Downs (2)	4 5	Cobble+rock flats	400 m
T1143	Pardoe Downs (3)	4 5	Cobble+rock flats	750 m
Spring & neap tidal range = 2.5 & 2.1 m				

East Devonport occupies the eastern banks of the Mersey River and extends 1.5 km east of the river mouth to the Pardoe Downs subdivision. Four beaches (T 1140-1143) are spread along the 2 km of north-facing shoreline (Fig. 4.254). The Heritage Walking Trail commences at the river and follows the shoreline and beaches all the way to Pardoe Beach (T 1144).

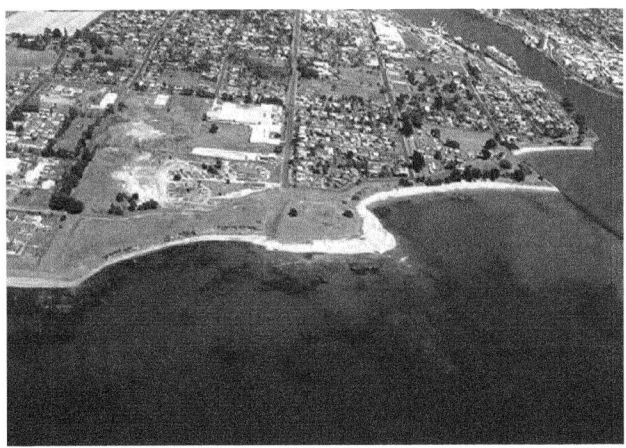

Figure 4.254 Police Point (right) and the East Devonport beaches (T 1140-1142).

East Devonport Beach (**T 1140**) is the main beach for the area and extends for 400 m from the eastern side of the river training wall to a low reef-tied sand and cobble foreland. The beach faces north between the training wall and foreland and consists of a high tide sandy beach fronted by a 100 m wide low tide terrace, with rock flats bordering the eastern end. The beach has prograded 100 m northwards along the edge of the training wall, with a reserve backing the entire beach and a caravan park behind the western half. This is a low gradient usually low energy to calm beach.

Beaches T 1141-1143 surround a low protruding section of cobble shoreline that fronts the Pardoe Downs subdivision. Beach **T 1141** commences at the foreland

that borders East Devonport Beach and curves to the northeast for 400 m to the next foreland. It is a steep cobble beach fronted by 150 m wide rock flats, with some patches of intertidal sand. Beach **T 1142** trends to the east for another 400 m to the next foreland and is a similar cobble beach with 100 m wide rock flats. Both beaches are backed by a low grassy reserve and the expanding subdivision, with North Caroline Street terminating behind the centre of beach T 1142. Beach **T 1143** commences at the northernmost cobble foreland and trends to the southeast for 750 m to the beginning of the sandy Pardoe Beach. The rock flats narrow southwards to about 50 m, with a narrow scrub-covered reserve behind the beach then the subdivision and vacant land.

T 1144-1147 PARDOE, MOORLAND & NORTHDOWN BEACHES

No.	Beach	Rating HT LT	Type	Length
T1144	Pardoe Beach	4 5	R+LT rips	3 km
T1145	Moorland Beach	4 5	R+LT rips	2.1 km
T1146	Moorland Pt (E)	4 5	Cobble+rock flats	500 m
T1147	Northdown Beach	4→6	R+LT rips→UD	6.3 km
	Pardoe-Northdown Coastal Reserve			*39 ha*
Spring & neap tidal range = 2.5 & 2.1 km				

Between Pardoe Beach and Point Sorell is a 12 km long section of west-northwest-facing sandy shoreline that marks a dramatic change in the nature of the north coast. The beaches to the west tend to face north to northeast and are dominated by the secondary easterly wind waves. Beginning at Pardoe Beach and to the east the beaches face more to the northwest and are consequently more exposed to the dominant westerly wind waves and strong westerly winds. The beaches respond with higher energy beach systems, larger sand barrier accumulations and the beginning of extensive transgressive dune systems. Four beaches (T 1144-1147) are located along this section, most within the narrow 39 ha Pardoe-Northdown Coastal Reserve.

Pardoe Beach (**T 1144**) commences against the end of the cobble beaches that surround Pardoe Downs, with a car park marking the boundary. It trends to the east-northeast for 3 km to the cobble, reef-tipped Pardoe Point. The first 500 m are a transition from rock flats to sand bar, with a 150 m wide low tide terrace dominating the remainder of the beach. It receives the full force of the westerly wind waves, which average over 1 m and maintain rips in the low tide surf during periods of higher waves. The beach is backed by a 150 m wide series of hummocky foredune ridges, with a waste treatment plant in the east and the western end of Devonport Airport to the west, and farmland extending inland.

Moorland Beach (**T 1145**) extends east-northeast for 2.1 km between Pardoe and the low Moorland Point. There is a slight protrusion in the beach caused by wave refraction and attenuation to the lee of Wright and Egg islands, located 1-1.5 km offshore. The beach has a near

continuous 150 m wide low tide bar, with low tide rips forming during higher waves, while closer to Moorland Point intertidal rocks and reefs are located in the intertidal zone. A hummocky 50-100 m wide foredune system and narrow elongate wetland back the beach, with the airport, then farmland, behind.

Moorland Point is a low reef-tied sand and cobble foreland. Beach **T 1146** curves to the east of the point for 500 m to the next slight foreland, located at the end of Moorland Beach Road. The beach has high tide cobbles, then sand grading into irregular low tide rocks and cobble flats that extend 100-200 m offshore. A boat ramp is located at the end of the road while a vehicle track runs along the crest of the beach to Moorland Point.

Northdown Beach (T 1147) is a relatively straight north-northwest-facing 6.3 km long sandy beach, fully exposed to the westerly waves and one of the higher energy beaches on the mid-north coast. The beach has a low gradient high tide sandy beach grading into a lower gradient 150 m wide intertidal zone, with usually low tide rips in the west spaced every 200-300 m (Fig. 4.255). Wave height increases to the east where under high wave conditions more dissipative surf with two to three shore-parallel bars prevails. The entire beach is backed by a barrier consisting of a 100 m wide series of low vegetated transgressive dunes in the west, which widen to a 200 m wide series of foredune ridges in the east. The ridges are backed by a cleared 500-700 m wide drained wetland, then in the west slopes rising gradually to 150 m. To the east the ridges are backed by an interbarrier depression and an inner 500 m wide series of 15 low Pleistocene (?) ridges. The beach finally terminates against The Water Rat, a low reef-headland that marks the first rocks of Point Sorell.

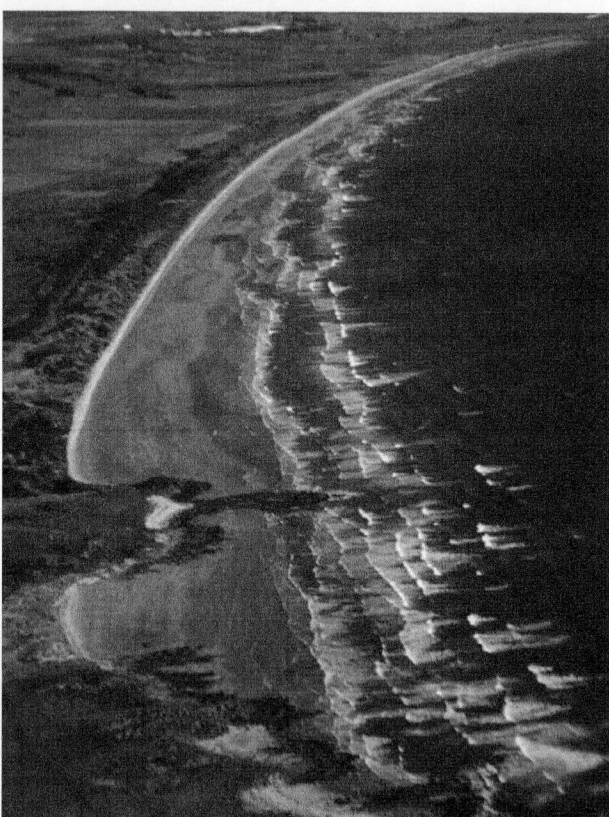

Figure 4.255 Northdown Beach (T 1147) shown at low tide with rips dominating the low tide surf zone, with beaches T 1148 & 1149 in foreground.

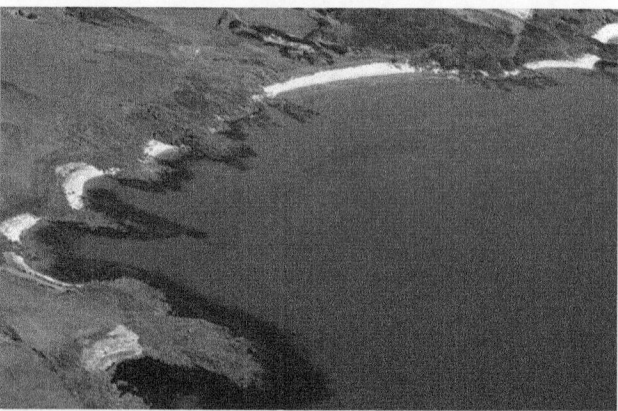

Figure 4.256 Beaches T 1148-1153 are six moderately sheltered pocket beaches located between The Water Rat and Margaret Rocks, shown here at high tide.

T 1148-1154 POINT SORELL (W)

No.	Beach	Rating HT LT	Type	Length
T1148	The Water Rat	4 5	R/rocks+UD	150 m
T1149	The Water Rat (E)	4 5	R+UD	250 m
T1150	Margaret Rocks (S3)	4 4	R+LTT	50 m
T1151	Margaret Rocks (S2)	4 4	R+LTT	60 m
T1152	Margaret Rocks (S1)	4 4	R+rock flats	60 m
T1153	Margaret Rocks	4 4	R+rock flats	50 m
T1154	Point Sorell (W)	4 5	R+rock flats	80 m
Spring & neap tidal range = 2.5 & 2.1 m				

The Water Rat is a partly submerged rock tied to a low dolerite headland that marks the beginning of 1.5 km of rocky shoreline that trends north to Point Sorell. Seven small beaches (T 1148-1154) are located amongst the rocks (Fig. 4.256). All are bordered by dolerite rocks and points, with cleared slopes rising to 30 m high Eagles Lookout in the south and the 30 m high point in the north. There is no public access to any of the beaches, which are all backed by farmland.

Beach **T 1148** is a 150 m long small sandy foreland located to the lee of The Water Rat. Sloping dolerite points border each end, with grassy dune-covered slopes rising behind. The beach and rocks grade seaward into the eastern surf zone and double outer bar system of Northdown Beach.

Beach **T 1149** is located 100 m to the northeast and is a slightly curving 250 m long sandy beach, that also grades straight into the easternmost section of the Northdown surf zone and bars. The beach is backed by a low grassy foredune and two vegetated parabolic dunes that have spread 200 m inland over the eastern slopes, then farmland, with a farmhouse behind the western end of the beach.

Beaches T 1150-1152 are three adjoining pockets of sand and cobbles that during moderate to high waves face west across the outer surf zone of Northdown Beach. Beach **T 1150** is a 50 m long pocket of high tide cobbles and sand wedged in between 50 m long dolerite points, with a narrow low tide terrace then the outer surf zone of the main beach. Beach **T 1151** lies 50 m to the north and is a similar 60 m long pocket of cobble, with a 50 m wide sandy low tide terrace then the outer bars and surf zone. Beach **T 1152** is another 50 m to the north and consists of a curving 60 m long pocket of cobble and sand with a central outcrop of rocks, grading into boulders against its northern point, with a rip flowing straight into the outer surf zone of Northdown Beach.

Beach **T 1153** is located 200 m further north in a small rocky embayment located adjacent to the 10 m high Margaret Rocks. The 50 m long beach faces northwest and consists of a steep high tide cobble beach fronted by sloping intertidal rocks.

Beach **T 1154** lies on the western side of the tip of Point Sorell. The slightly curving 80 m long beach is composed of cobble and boulder and backed by cobble overwash flats. It is bordered by rocky shoreline and boulders with inter- to subtidal rocks and reefs linking the boundary rocks. The grassy slopes of the point rise to the 30 m high crest of Point Sorell above the southern end of the beach.

T 1155-1158 POINT SORELL-FISHPOND ROCKS

No.	Beach	Rating HT LT	Type	Length
T1155	Point Sorell (E)	3 3	R+sand/rock flats	150 m
T1156	Edies Point (N)	3 3	R+sand/rock flats	70 m
T1157	Edies Point (S)	2 2	R+sand/rock flats	80 m
T1158	Fishpond Rocks (N)	3 3	R+sand/rock flats	100 m
Spring & neap tidal range = 2.5 & 2.1 m				

Point Sorell marks the western head of the entrance to Port Sorell, a large drowned river valley system, with the town of Port Sorell located 5 km south of the point and 2 km inside the shallow 1.5 km wide estuary entrance. The port is the oldest in the north, but was superseded by Devonport and today is a quiet settlement of 1,200. Between the point and town are nine low energy beaches (T 1155-1163). The first four (T 1155-1158) are located 1-2 km southeast of the point.

Beach **T 1155** is a curving, north-facing 150 m long high tide sandy beach, located in lee of The Carbuncle islet, as well as sheltered by rock reefs extending up to 250 m offshore. The beach itself is narrow and steep and fronted by a mixture of fringing rock reefs with a central sand channel. It is backed by a fringe of scrubs then low cleared farmland, with no public access. A waste treatment pond is located 200 m south of the beach, with an outlet pipe discharging off the western end of the beach.

Beach **T 1156** is located between The Carbuncle and Edies Point. The curving 70 m long beach faces east between converging low rocky points, with rock reefs to either side and a narrow central patch of sand flats. Low scrub-covered bluffs and cleared farmland back the beach.

Beach **T 1157** lies on the southern side of the 100 m wide 10 m high Edies Point. It is a slightly curving 80 m long strip of high tide sand fringed by 50 m wide rock flats, with sand flats off the northern corner of the beach. Dense trees and the treatment pond back the northern end of the beach, with cleared farmland to the south.

Beach **T 1158** is located 300 m to the south. It is a 100 m long narrow high tide sandy beach, fronted by a 150 m wide mixture of intertidal sand and rock flats, which at spring low tide link to the small Spy Island in the north and the intertidal Fishpond Rocks to the south, both located 200 m offshore. It is backed by a row of trees, then farmland, with a farmhouse behind the northern end of the beach. The Hawley Beach Road terminates at the southern end of the beach.

T 1159-1161 HAWLEY BEACHES

No.	Beach	Rating HT LT	Type	Length
T1159	Hawley Beach(N)	2 2	R+sand flats	500 m
T1160	Hawley Beach	2 2	R+sand flats	750 m
T1161	Taroona Point	2 2	R+rocks/sand flats	50 m
Spring & neap tidal range = 2.5 & 2.1 m				

Hawley Beach is the main recreational beach for the nearby town of Port Sorell. Hawley Beach is a small holiday settlement located 3 km north of the port on the eastern side of Point Sorell. It faces east into the 1.5 km wide entrance to the port, a large natural estuary. The road from the port follows the shore and terminates at the northern end of beach T 1159, with three low energy beaches (T 1159-1161) extending south along the shore between Fishpond Rocks and Taroona Point (Fig. 4.257).

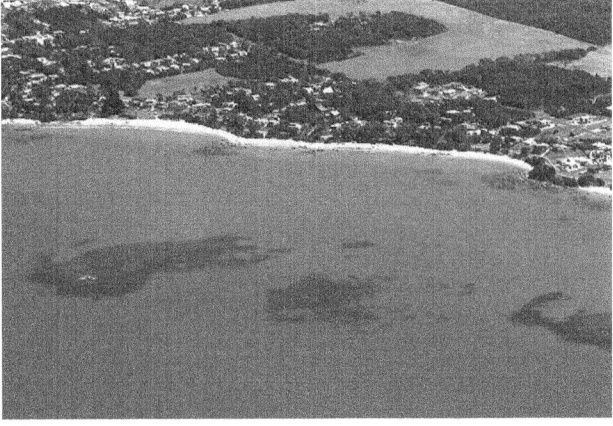

Figure 4.257 The Hawley beaches (T 1159-1161) are sheltered inside Port Sorell.

The northern end of Hawley Beach (**T 1159**) commences in lee of Fishpond Rocks and curves slightly as it trends to the south for 500 m to a cluster of rock and boulders that separate it from the main beach. Sand flats extend 250 m offshore in the north linking to Fishpond Rocks, narrowing to about 200 m in the south, where rock flats fringe the bordering rocks. It is backed by a fringe of low scrubs, then Hawley Beach Road with a few houses in lee of the southern rocks.

The main **Hawley Beach** (**T 1160**) is a double crenulate 750 m long, east-facing beach, lying between the low boundary rocks in the north and the boulders and rocks of Taroona Point to the south, together with a central cluster of dolerite rocks, which induce a slight foreland. A narrow reserve and the road parallel the back of the beach providing good access the length of the beach, with houses behind. The beach receives waves usually less than 0.5 m, which with the 3 m tide range produce a narrow high tide beach, fronted by a 200 m wide continuous sands flat, with rocks scattered along the high tide beach and extending off the central rocks.

Taroona Point beach (**T 1161**) is a small rock-bound extension of Hawley Beach almost surrounded by rock and boulders. It is a popular swimming beach with a diving tower off the beach and a boat ramp immediately to the south, both usable only at high tide.

Swimming: The Port Sorell beaches have a relatively low hazard rating, with usually low to calm waves and shallow bars and sand flats. The best swimming is at mid to high tide. However care must be taken of the rocks on Hawley and Taroona, and in particular if walking or wading out over the sand flats and reefs at low tide. People have been caught on the reefs and high shoals by the rising tide, in addition there are strong tidal currents across the flats at high tide and in the channel at all tides. Finally, the prevailing westerly winds at times blow people, and particularly children on flotation devices, out into the deeper waters of the port.

T 1162-1163 **FREERS-PORT SORELL BEACHES**

No.	Beach	Rating HT LT		Type	Length
T1162	Freers Beach	2	2	R+sand flats	1.7 km
PORT SORELL SLSC					
Patrols:					
December-March: Weekends & public holidays					
T1163	Port Sorell	2	3	R+sand flats/channel	1 km
Spring & neap tidal range = 2.5 & 2.1 m					

Freers Beach (**T 1162**) curves from the southern rocks of Taroona Point for 1.7 km to the south, then southeast to the 500 m entrance of the more constricted inner entrance to the port. A road parallels the back of the beach, with several seawalls and groynes crossing the beach, including one at the southern end (Fig. 4.258). It is usually calm, with a narrow, in places eroding, high tide beach. Intertidal sand flats extend up to 1 km into the port

and at spring lows link with Penguin Island, 1.2 km offshore (Fig. 4.259). A narrow coastal reserve and road back the beach, with a few houses behind the centre of the beach. The Port Sorell Surf Life Saving Club, was founded in 1986 and is located at the northern end of Freers Beach.

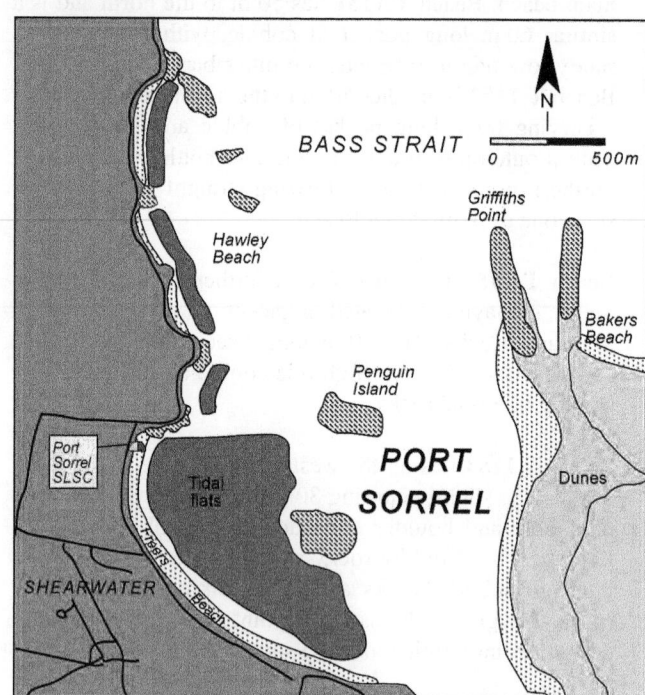

Figure 4.258 Hawley and Freers beaches are sheltered inside Port Sorell. They are fronted by wide tidal flats and deeper tidal channels.

Figure 4.259 Sign at Freers Beach (T 1162) warning of the hazards out on the wide tidal flats off the beach.

Port Sorell is located on a low terminal end of a 3 km long, up to 800 m wide sandy spit complex, which includes Freers Beach. At the end of Freers Beach the shoreline turns at the groyne and trends to the southeast for 1 km as beach **T 1163** and forms the western side of the narrowest part of the port entrance. The port settlement has been built on top of the approximately 15 low beach ridges that comprise the spit. The beach receives very low wave to calm conditions, however the tidal channel lies just off the 50-200 m wide sand flats with its deep water and strong currents (Fig. 4.258). The beach is backed by a 200 m wide coastal reserve

containing a range of facilities and camping areas, a jetty across the centre and boats moored in the channel. The entire beach is very dynamic with shoreline oscillation induced by the tidal flow. As a consequence some primitive shore protection measures including groynes have been placed across the shoreline.

On the southern side of Port Sorell, across 100 m wide Appleby Creek, lies a 2 km wide series of approximately 30 inner Pleistocene beach ridges. The ridges apparently formed when the entrance was more open and the Barkers Beach barrier system did not exist.

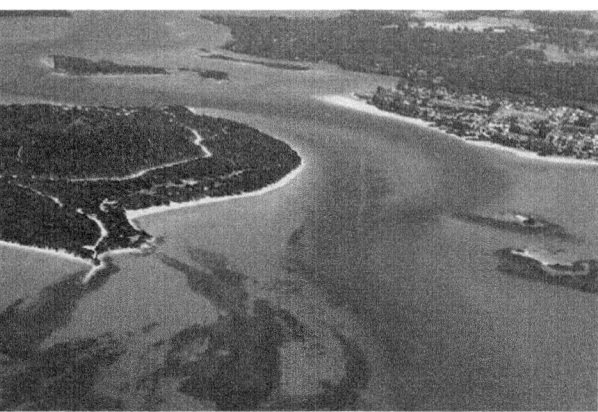

Figure 4.260 The entrance to Port Sorell with Port Sorell beach (T 1163 to the right) and Bakers and Griffiths points beaches (T 1165 & 1166) (left). Note the deep tidal channel in between.

Narawntapu National Park

Established:	1976
Area:	4281 ha
Coast length:	24 km (2036-2060 km)
Beaches:	11 (T 1164-1174)

Narawntapu National Park (formerly known as Asbestos Range National Park) covers an area of coastal wetlands, beaches, and transgressive and regressive barriers, all backed by the densely vegetated valleys and ridges of Precambrian metasediments rising to 390 m. It extends along the coast for 24 km between Griffiths Point and West Head, incorporating the large central Badger Head. The park can be accessed in the west at Bakers Beach, in the centre at Badger Beach and on foot from Greens Beach in the east. Besides the beaches and ranges it provides a number of picnic and camping areas, and walking trails.

T 1164-1166 **BAKERS-GRIFFITHS POINTS**

No.	Beach	Rating HT LT	Type	Length
T1164	Springlawn Beach	2 2	R+sand flats	750 m
T1165	Bakers Point	2 2	R+sand flats	1.8 km
T1166	Griffiths Point	3 3	R+LTT	100 m
Spring & neap tidal range = 2.5 & 2.1 m				

Griffiths Point forms the eastern head of Port Sorell where the 1.5 km wide entrance narrows to 500 m at Bakers Point. Three beaches (T 1164-1166) are associated with the eastern side of the entrance (Fig. 4.260) and are located in Narawntapu National Park.

Springlawn Beach (T 1164) is a very low energy beach and recurved spit that extends east of Bakers Point into the sheltered waters of the port. The 750 m long beach includes a distal 400 m long spit, which has been generated by westerly winds blowing across the 1 km wide section of the port, assisted by flooding tidal currents which erode the point and move the sand eastward along the spit. A gravel road terminates at the beach where there is a camping and picnic area, boat ramp and toilet facilities. It is backed by densely vegetated overwash flats that extend 1 km north to the rear of the Bakers Beach foredune ridges.

Beach **T 1165** commences at the low sandy **Bakers Point** and protrudes west into the port, curving round for 1.8 km to terminate at the low rocky Griffiths Point. The sheltered beach has been reworked by tidal flows and low ocean and westerly wind waves, resulting in an eroded southern half, with a 100 m wide series of low foredunes along the northern half, all backed by the vegetated overwash flats, and in the north the western end of the Bakers Beach foredune ridges. It is fronted by 100 m wide sand flats, then the deep port tidal channel, with flats widening to 200 m off the northern point. A track off the Bakers Beach Road leads to a picnic and camping area towards the northern end of the beach.

Griffiths Point consists of two low points that extend northward as 700 m long intertidal arms of Tertiary rocks, with 100 m long beach **T 1166** located in between. It is a narrow high tide beach grading into a 200 m wide low tide terrace with waves averaging about 0.5 m. A gravel road runs out to the rear of the beach where there is a picnic area and toilets. During low waves the beach is used to launch small boats.

T 1167 **BAKERS BEACH**

No.	Beach	Rating HT LT	Type	Length
T1167	Bakers Beach	5 6	R+LT rips	6.9 km
Spring & neap tidal range = 2.4 & 2.0 m				

Bakers Beach (T 1167) is an exposed high energy 6.9 km long northwest-facing north coast beach. It extends from the low Griffiths Point in the west, at the entrance to Port Sorell, to Little Badger Head and the beginning of a rugged 7 km long section of rocky coast. The beach is the longest in the Asbestos Range National Park and is accessible along the park road. The ranger station, access points and picnic and toilet facilities are located in the centre as well as the facilities at Griffiths Point. A walking trail follows the beach to Little Badger Head with a campsite at the mouth of Freshwater Creek, which drains across the eastern end of the beach.

The beach is exposed to the dominant westerly wind waves, which average 1-1.5 m and increase in size east along the beach. These maintain a 100 m wide intertidal bar with rips forming in the low tide zone, usually spaced every 200-300 m, particularly along the central-eastern part of the beach (Fig. 4.261). The beach is backed by a 500 m wide series of up to 15 10-15 m high vegetated foredune ridges, with wetlands behind the centre and the North East Arm of Port Sorell in the west. A series of now stable elongate blowouts have transgressed across the ridges, one extending all the way to the backing wetlands.

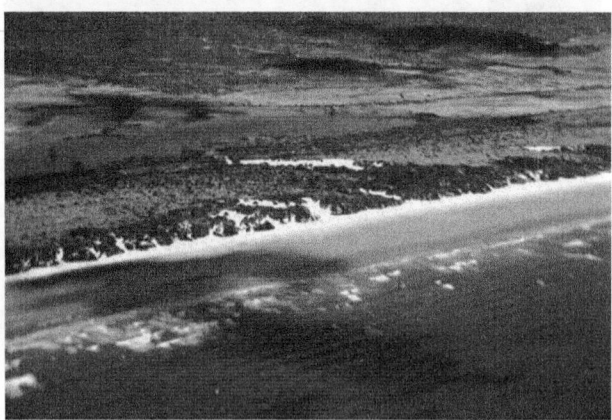

Figure 4.261 Section of Bakers Beach (T 1167) at low tide with surf and rips dominating the low tide surf.

T 1168-1172 LITTLE BADGER HEAD

No.	Beach	Rating HT LT	Type	Length
T1168	Little Badger Head (1)	5 6	R+rock flats	30 m
T1169	Little Badger Head (2)	5 6	R+rock flats	40 m
T1170	Little Badger Head (3)	5 6	R+rock flats	80 m
T1171	Little Badger Head (4)	5 6	R+sand/rock flats	150 m
T1172	Little Badger Head (5)	5 6	R+rock flats	150 m
Spring & neap tidal range = 2.4 & 2.0 m				

Little Badger Head is a protruding section of Precambrian metasedimentary rocks that rise steeply to 50 m. It forms the eastern boundary of the long Bakers Beach and the beginning of a rugged rocky section of coast that extends 7 km west to Badger Beach. Five rock-dominated beaches (T 1168-1172) are located along a 1 km long section of shoreline on the eastern side of the head. They are only accessible on foot from the coast walking track.

Beach **T 1168** is a 30 m long pocket of sand and cobbles wedged in between steep slopes rising to 50 m. It is bordered by two steep rocky points and fronted by rocky seabed and reefs. Beach **T 1169** lies 100 m to the east and is a similar 40 m long pocket of high tide cobbles fronted by exposed rocks and reef extending 200 m offshore. Beach **T 1170** is located immediately to the east and is an 80 m long cobble beach bordered by rocky points and backing slopes and fronted by rocks and shallow reefs

extending 100 m offshore. All three are backed by steep vegetated slopes.

Beach **T 1171** commences 50 m to the east and is a slightly curving 150 m long high tide cobble beach, with a central sandy section. It has a few rock outcrops along the beach and scattered reefs extending off either end. It is backed by slopes rising more gradually to 50 m, with a walking track following a small valley to the centre of the beach. Beach **T 1172** commences at a rock-tied inflection in the shore and continues to the northeast for another 150 m as a relatively straight high tide sand and cobble beach, fronted by shallow intertidal rock flats. Windred Creek drains across the centre of the beach and is the main access point for hikers.

T 1173 BADGER BEACH

No.	Beach	Rating HT LT	Type	Length
T1173	Badger Beach	5 6	R+LT rips	4.5 km
Spring & neap tidal range = 2.4 & 2.0 m				

Badger Beach (T 1173) is an exposed relatively high energy beach that faces directly into the prevailing westerly winds and wind waves, with an energetic surf zone backed by massive dune transgression. The beach extends for 4.5 km from the eastern side of 220 m high Badger Head to the base of 63 m high West Head, both headlands extending 1-2 km to the northwest. Waves average 1-1.5 m and maintain a narrow moderately steep high tide beach (Fig. 4.262), backed towards the eastern end by cobbles and fronted by a wide low gradient inner bar, grading into a low tide rhythmic transverse bar and rip to rhythmic bar, the entire bar system up to 200 m wide, with the surf zone 100 m wide at low tide (Fig. 4.263). Rips are spaced approximately every 200 m the length of the beach, with up to 20 rips operating during periods of high waves, with their topography remaining during periods of lower waves.

Holocene longwalled parabolic dunes extend up to 2 km in from the centre of the beach to the national park boundary. All but one northern blowout are vegetated and stable. Older Pleistocene transgressive dunes underlie the Holocene dunes and extend 3-4 km in lee of the centre of the beach, with rising ground to either side.

The beach and backing dunes lie inside the national park with access to the southern end via the Badger Head Road, which terminates adjacent to a creek mouth. There are several holiday houses and a recreational camp, located in adjacent freehold land, with a beachfront picnic area in the national park. Walking tracks lead to Badger Head and along the beach to West Head. At West Head a gravel road from Green Beach crosses the rear of the head to a car park that overlooks the northern end of the beach, with foot access down a valley to a boulder shoreline that links to the main beach.

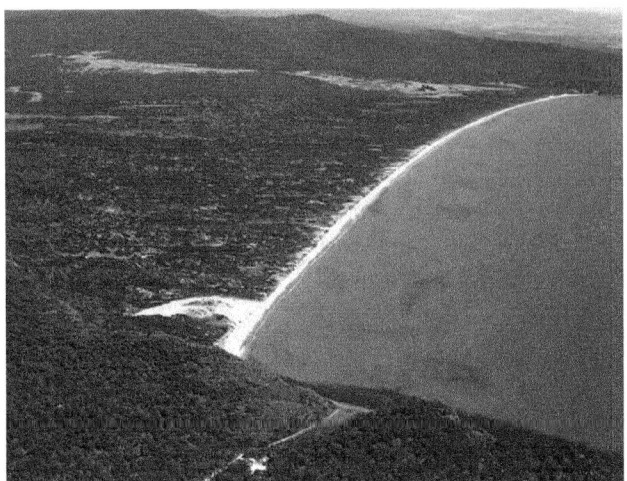

Figure 4.262 Badger Beach (T 1173) on a calm day at high tide, with the low tide bar morphology clearly visible.

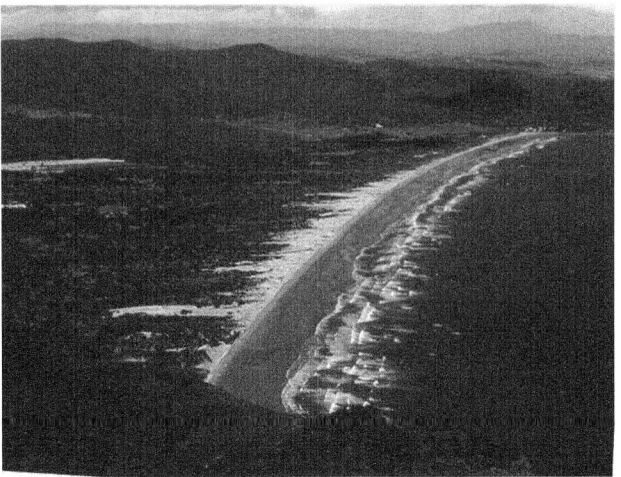

Figure 4.263 Badger Beach (T 1173) during higher waves at low tide showing the wide intertidal zone and low tide surf and rips.

T 1174-1175 WEST HEAD (E)

No.	Beach	Rating HT LT		Type	Length
T1174	West Head (E)	3	3	Cobble+LTT	80 m
T1175	Nudist Beach	3	3	R+LTT	120 m
Spring & neap tidal range = 2.4 & 2.0 m					

To the east of West Head is a 4 km long section of sloping rocky shoreline that extends to Greens Beach. It has two open northeast-facing embayments, which contain beaches T 1174 and 1175. The beaches are sheltered from westerly waves, which average about 0.5 m at the shore.

Beach **T 1174** is located 1.2 km southeast of the head and is an 80 m long pocket beach containing a narrow strip of steep high tide cobbles fronted by a 70 m wide low tide bar, with sloping rocky shore bordering either side, and rocks also outcropping across the bar. The beach is located just below the West Head vehicle track, with a picnic area behind the beach.

Nudist Beach (T 1175) lies in the second embayment 1.5 km northwest of Greens Beach. It is a slightly curving 120 m long moderately steep sandy beach fronted by a 40 m wide low tide bar, grading in deeper water to a rock-bordered sandy bay floor. It is bounded by sloping rocky shore, with tree-covered slopes behind. The northern houses of Greens Beach are located 100 m in from the southern end of the beach.

T 1176-1179 GREENS BEACH-KELSO

No.	Beach	Rating HT LT		Type	Length
T1176	Greens Beach	3	2	R+LTT	1.9 km
T1177	Friend Pt (W)	2	1	R+sand flats	600 m
T1178	Friend Pt (W)	2	1	R+sand flats	2.8 km
T1179	Kelso	2	1	R+sand flats	2 km
Spring & neap tidal range = 2.4 & 2.0 m					

Greens Beach and Kelso are two small coastal communities located along the western side of the entrance to Port Dalrymple and the mouth of the Tamar River. In between the two are 7.5 km of increasingly low energy shoreline, hinged on Friend Point, and most of which has experienced Holocene shoreline progradation as sand has been moved into the low energy port.

Greens Beach (T 1176) is a low energy 1.9 km long beach that commences in lee of the base of West Head and curves to the east, then northeast to the low reef-tied Friend Point. Low refracted westerly waves reach the moderately steep beach and maintain a low gradient high tide beach grading into a 50-100 m wide low tide terrace. The western half of the beach is backed by a narrow vegetated reserve, then a row of houses, camping area and a golf course, all located on a 500 m wide series of up to 25 low beach-foredune ridges (Fig. 4.264).

Beach **T 1177** curves for 600 m between two low sandy reef-tied forelands, the easternmost being Friend Point. The beach faces north and is fronted by 500 m wide rock and sand flats, which result in low waves at the shore. It is backed by partly cleared beach ridges up to 500 m wide which continue east from Greens Beach and around the rear of the point.

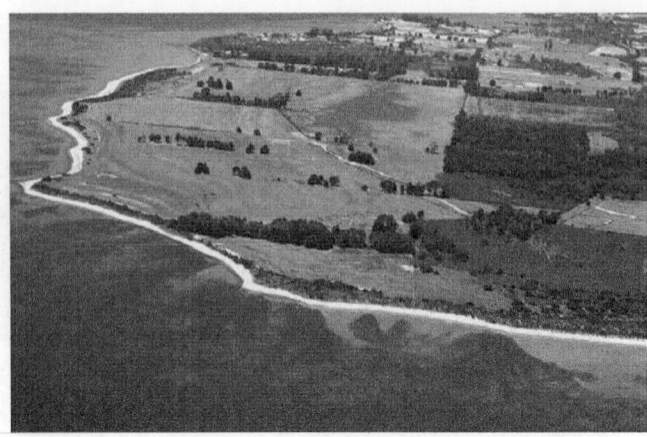

Figure 4.264 The low Friend Point (foreground) with Greens Beach (T 1176) to the right and the Friend Point beaches trending south towards Kelso (T 1177-1179).

Beach **T 1178** commences at Friend Point and trends to the southeast for 2.8 km as a narrow very low energy crenulate high tide beach, fronted by sand and rock flats that induce the crenulations and widen from 400 m in the north to 700 m in the south. A 300 m wide zone of low cleared, grassy beach ridges, including a set of recurved spits located in an embayment, parallel the rear of the beach.

Beach **T 1179** commences at a boundary low sandy foreland and continues to the southeast for 2 km to the end of the beach at the Kelso jetty and boat ramp on the north side of Kelso Bay. This is a crenulate, very low energy beach fronted by sand and rock flats that narrow from 300 m in the north to 100 m at the jetty. While waves are usually low to calm, strong tidal current flows along the edge of the flats. The small Kelso community extends the length of the beach, with a caravan park at the northern end.

T 1180-1186 **LOW HEAD BEACHES**

No.	Beach	Rating HT LT	Type	Length
T1180	She Oak Pt	1 1	R+sand/rock flats	150 m
T1181	Lagoon Bay	1 1	R+sand flats	700 m
T1182	Pilots Bay	1 1	R+sand flats	400 m
T1183	Pilots Bay harbour	1 2	R+sand	80 m
T1184	Pilots Bay (N1)	1 2	R+sand/rock flats	30 m
T1185	Pilots Bay (N2)	1 2	R+rock flats	70 m
T1186	Low Head (W)	2 3	R+rock flats	100 m
Low Head Lighthouse Reserve			*19 ha*	
Spring & neap tidal range = 2.4 & 2.0 m				

Low Head is a 20 m high dolerite headland that extends 1 km northwest of the small town of Low Head. The head forms the eastern head of the 2.5 km wide entrance to Port Dalrymple and the Tamar River. Ocean wave height decreases south into the port with seven low energy beaches (T 1180-1186) extending 3 km south to She Oak Point. The beaches are primarily exposed to wind waves generated across the 2 km wide port. The Low Head Road follows the coast and provides good access to all beaches.

She Oak Point is the site of a small lighthouse, which marks the narrowing of the port entrance, as well as the site of the local hospital. Beach **T 1180** extends for 150 m north of the point to the next low dolerite point. The narrow high tide beach is fronted by 100 m wide sand and rock flats, widening to 150 m in the north. A narrow vegetated reserve, then the road, back the beach, with a boat ramp and car park at the southern end next to the lighthouse.

Lagoon Bay beach (**T 1181**) curves to the north for 700 m, spiralling round to the west in lee of the low rocky Cordell Point. It is a very low energy west-facing sandy beach, with sand and rock flats widening from 100 m in the south to 200 m off the point. A low foredune and backing trees parallel the rear of the beach, then a cluster of houses, with the road 100-200 m inland.

Pilots Bay is a sheltered west-facing shallow bay, bordered by Cordell Point to the south and a 500 m long point and breakwater to the north. The old pilot station is located on the northern headland. Four beaches are associated with the bay (T 1182-1185) (Fig. 4.265). Beach **T 1182** is the main bay beach and extends for 400 m along the eastern side of the bay. It is a narrow, low energy beach sheltered by the boundary point and shallow rock flats that dominate the southern half of the bay. It is backed by a low grassy foredune, with houses behind the southern half and the centre of Low Head township and a narrow reserve and road behind the northern half. Several small boats are usually moored off the northern half of the beach.

Figure 4.265 Pilots Bay (top) and the boat harbour (foreground) with beaches T 1182-1185 in between.

Beach **T 1183** is located inside the small inner boat harbour. It is an 80 m long strip of sand backed by a low foredune. It is sheltered by an attached breakwater that extends 350 m to the southeast, as well as two small entrance groynes, with no ocean or wind waves entering the harbour. The Pilot Station Reserve extends between the boat harbour and the main beach.

Beach **T 1184** is a 30 m long pocket of sand wedged in between the northern end of the breakwater and a low rock reef. While it is fully exposed to wind waves generated across the port it remains sheltered by rock

reefs that extend 100-150 m offshore. Beach **T 1185** extends for 70 m immediately north of the breakwater, with the road to the breakwater running along the rear of the beach. It is a low energy narrow high tide beach, fronted by 200 m wide shallow rock flats.

Beach **T 1186** is located 400 m south of Low Head. It is a 100 m long west-facing reflective beach that is exposed to westerly wind waves entering the outer port area. It is a moderately steep sandy beach, fronted by shallow rock reefs to either end and rocky seafloor extending 100 m offshore. The 19 ha Low Head Lighthouse Reserve backs the beach, with the lighthouse located 300 m north of the beach.

T 1187-1188 EAST BEACH

No.	Beach	Rating HT LT	Type	Length
T1187	East Beach	3 4	R ı LTT	1 km
T1188	East Beach (E)	4 5	R+LTT/rock flats	1.1 km
Spring & neap tidal range = 2.4 & 2.0 m				

East Beach (**T 1187**) is located on the eastern side of Low Head and is the closest surfing beach to Georgetown and Launceston and consequently a relatively popular beach. The Low Head Surf Life Saving Club operated at the beach between 1950 and 1984. The beach commences at the base of Low Head, which extends 2 km to the northwest. It curves to the northeast for 1 m, past the small mouth of Cimitiere Creek, to a cobble-sand foreland tied to rock flats that separates it from the eastern beach (Fig. 4.266). The beach is relatively exposed to westerly waves, which average 1 m, but can be considerably higher during strong winds. The waves combine with tides up to 3 m high to maintain a moderately steep sandy high tide beach grading into patches of cobbles along the rear of the beach and fronted by a usually continuous intertidal bar and a wider surf zone usually cut by several low tide rips (Fig. 4.267). It is backed by a near continuous foredune increasing in height and width to the east, with vegetated transgressive dunes beginning east of the creek. Rock flats derived from reworked Tertiary sediments increase to the east of the creek and contribute cobbles to the high tide beach. There is road access, a car park and caravan park at the western end of the beach.

Beach **T 1188** continues northeast of the boundary foreland, as a mixed cobble and sand high tide beach, with inter- and subtidal rock flats and reefs alternating with the sandy low tide beach. Waves break over the reefs and generate several rips during higher waves. The beach is backed by vegetated Pleistocene dunes, which extend 2-3 km inland and are overlapped by semi-stable transgressive dunes extending up to a few hundred metres inland. A gravel road off the Aerodrome Road reaches a small car park above the centre of the beach.

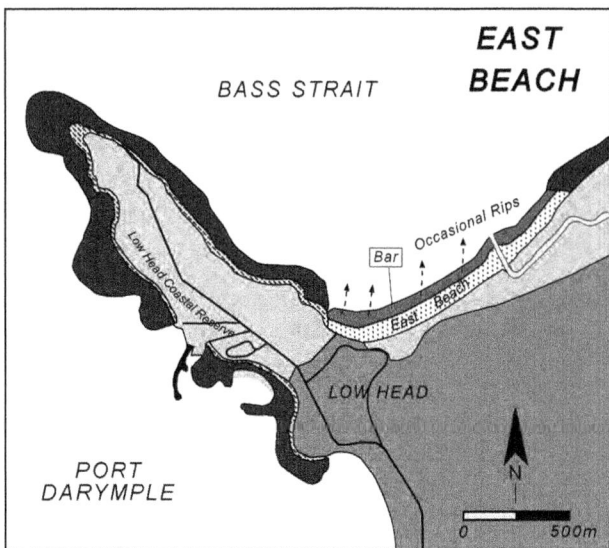

Figure 4.266 East Beach is located immediately east of the low Low Head, it is the closest surfing beach to Launceston.

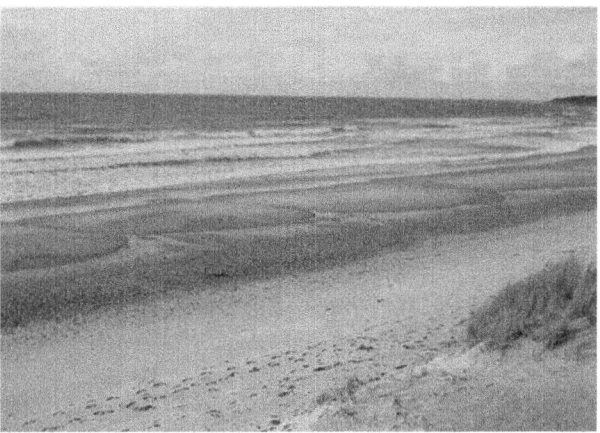

Figure 4.267 East Beach (T 1187) at low tide showing the low tide bar and wide rip-dominated surf zone.

Swimming: East Beach is a moderately hazardous beach owing to its exposure to higher westerly waves and the presence of rips at low tide. The safest swimming is at the more popular western end, toward high tide and close inshore. Be careful of the rips at low tide and the increasing rocks to the east.

Surfing: This is a popular surfing spot for the Launceston surfers and one of the first places to check out. It usually has beach breaks with conditions determined by the waves, wind and state of the tide.

T 1189-1193 FOUR-FIVE MILE BLUFFS

No. Beach	Rating HT LT	Type inner	outer bar	Length
T1189 Potato Hill	4 5	Cobble+LTT/rock flats		1.25 km
T1190 Bellbuoy Beach	5 5	Cobble+LT rips		1.6 km
T1191 Four Mile Bluff	5 6	R+LT rips	RBB	1.8 km
T1192 Five Mile Bluff (W)	4 5	R+rock flats		200 m
T1193 Five Mile Bluff (E)	3 4	R+rock flats		200 m
Spring & neap tidal range = 2.4 & 2.0 m				

Between Potato Hill and Five Mile Bluff are 5 km of northwest-facing relatively exposed shoreline, containing five near continuous beaches (T 1189-1193), each separated by low bluffs of Tertiary basalt, including the more prominent Four Mile Bluff. Most of the shoreline is backed by cleared farmland, together with a small collection of holiday houses at the western end of Bellbuoy Beach.

Potato Hill is a subdued 30 m high hill located 500 m south of the southern end of beach **T 1189**. The beach extends from the low cobble-based basalt headland that separates it from East Beach, for 1.25 km to a narrow cobble foreland that extends 200 m seaward. The beach has a continuous high tide cobble swash zone with a 150 m wide sandy low tide bar, that grades seaward into subtidal rocky seabed. A 500 m long ridge of intertidal cobbles extends straight out to a low islet from near the centre of the beach. It is backed by a 10-15 m high-vegetated foreland, and then vegetated Holocene and Pleistocene transgressive dunes that extend up to 2.5 km inland. There is 4WD access at the north end of the beach.

Bellbuoy Beach (T 1190) commences on the eastern side of the 100 m wide, 10 m high, boundary cobble-basalt headland and curves slightly to the northeast for 1.6 km to Four Mile Bluff. The beach consists of a continuous narrow high tide cobble beach, a 150 m wide intertidal bar, grading in deeper water into the continuous rocky seabed. A steep continuous 10-15 m high vegetated foredune then the older vegetated Holocene and Pleistocene transgressive dunes extend up to 3 km inland, now all cleared for farmland. The small Bellbuoy Beach subdivision of about 20 houses is located behind the southern corner of the beach, where the beach is also used for launching small fishing boats. British Creek, which drains the backing Pleistocene dune field, flows across the northern end of the beach.

Four Mile Bluff is a low 600 m long basalt headland that protrudes up to 50 m seaward of the line of the adjoining beaches. Beach **T 1191** extends from the northern end of the bluff for 1.8 km to the basalt rocks and boulders of Five Mile Bluff. This is one of the more exposed and higher energy beaches on this section of coast with the westerly wind waves averaging up to 1.5 m. They maintain a 300 m wide double bar system consisting of an inner transverse bar and rip system, usually cut by six to seven rips, including a permanent rip against Five Mile Bluff, then a rhythmic outer bar (Fig. 4.268). The 150 m wide inner bar grades landwards into a high tide sand and cobble beach. The beach is backed by a semi-stable 10-15 m high foredune and recently vegetated Holocene transgressive dunes, which in the south extend for 3 km across the base of Five Mile Bluff to reach the eastern shoreline and beach T 1194. There is no public access to the beach.

Five Mile Bluff contains two small beaches on either side of the western tip of the bluff. Beach **T 1192** commences at the eastern end of the main beach and is a narrow 200 m long northwest-facing beach, backed by the 10 m

high vegetated sand-draped bluff fronted by 200 m wide intertidal rock flats and boulders. The flats only permit lower waves to reach the beach at high tide. Beach **T 1193** commences on the eastern side of the tip of the bluff, 100 m to the east. It is a slightly curving 200 m long more sheltered northeast-facing sandy beach, fronted by deeper 100 m wide rock flats, and backed by a low vegetated dune. Basalt bluffs rising to 25 m extend east of the beach, curving round the eastern tip of the bluff and extending for 2 km to beach T 1194.

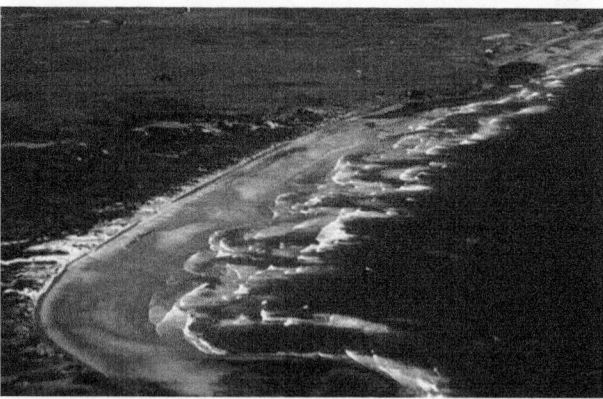

Figure 4.268 The exposed Four Mile Bluff beach (T 1191) at low tide exposing the well developed rip channels and outer bar.

T 1194-1197 FIVE MILE BLUFF-BEECHFORD

No.	Beach	Rating HT LT	Type	Length
T1194	Five Mile Bluff (E1)	4 5	R+LT rips	700 m
T1195	Curries Rivulet (E)	5 6	R+LT rips/rocks	800 m
T1196	Beechford (W2)	5 6	R+LT rips/rocks	700 m
T1197	Beechford (W1)	5 6	R+rock flats	1.6 km
Spring & neap tidal range = 2.4 & 2.0 m				

To the east of **Five Mile Bluff** is an 11 km wide curving, north-facing embayment that extends to the western side of Stony Head. In between are 12 km of predominantly sandy shoreline containing seven beaches (T 1194-1120). The small community of Beechford is located in the centre at the mouth of Curries Rivulet and provides the only public access to the shore.

Beach **T 1194** is located 2 km southeast of Five Mile Bluff and is a curving north-facing 700 m long beach, bordered to either end by vegetated basalt slopes rising to 20-30 m. The beach receives moderate protection from the bluffs with waves averaging up to 1 m, which maintain a 150 m wide low tide bar. During higher waves two to three rips are formed across the low tide bar, their morphology persisting into lower wave conditions. The beach is backed by vegetated Holocene transgressive dunes that drape Pleistocene dunes, both extending up to 1 km east to Curries Rivulet. A 4WD track reaches the eastern end of the beach.

Beaches T 1195-1197 are three continuous beaches separated by rock-tied sandy foreland that terminate at

the mouth of the Curries River. Beach **T 1195** commences 1 km east of beach T 1194 and 3 km west of the river mouth. It is a curving, north-facing 800 m long sandy beach fronted by a 300 m wide mixture of intertidal rocks and low tide bar, with a 300 m long sand-backed, cobble-boulder beach extending east of the boundary headland. Waves average just over 1 m and during higher waves generate reef-controlled rips across the surf zone. It is backed by a hummocky 250 m wide marram-covered transgressive dune, with a small creek draining through the dunes and across the centre of the beach.

Beach **T 1196** continues to the east for 700 m as a curving 700 m long sandy beach also fronted by the continuous mixture of sand bar and rock reefs which narrow to 150 m in the east. The hummocky dunes continue along the rear of the beach, which is also cut by a small creek. Beach **T 1197** extends east of the boundary foreland for 1.6 km to the small Curries River mouth. The crenulate north-facing beach becomes increasingly dominated by shallow basalt reefs and boulder flats, with the river mouth flowing out across an extensive boulder flat. The hummocky dunes continue along the rear of the beach to the river mouth, with the small settlement of Beechford located on the southern side of the river. Besides a score of holiday houses, Beechford has a shop, camping area, sports ground and footbridge across the river to the beach and to the Stony Head beach.

T 1198-1201 **BEECHFORD-STONY HEAD**

No.	Beach	Rating HT LT	Type	Length
T1198	Beechford (E)	4 6	R+rock flats	1.8 km
T1199	Stony Head (W)	5 6	R+LT rips/rock flats	3.8 km
T1200	Stony Head	4 5	R+rock flats	150 m
T1201	Maitland Bay	5 5	R+LT rips	1 km
Spring & neap tidal range = 2.4 & 2.0 m				

The Curries River mouth at Beechford marks the beginning of a 5.5 km long section of sand coast (beaches T 1198-1200) that extends northeast to the western side of Stony Head (Fig. 4.269), with Maitland Bay (T 1201) between the western head and the 90 m high Stony Head. Most of the shoreline is backed by extensive Holocene and Pleistocene dunes, which are now part of the Stony Head Artillery Range, with restricted public access to the range and beaches.

Beach **T 1198** commences amongst the boulder flats at the small Curries River mouth and trends to the northeast as a double crenulate high tide sand beach, fronted by near continuous intertidal boulder flats averaging 100 m in width and in places extending 200 m seaward. The beach is backed by a 100 m wide fringe of Holocene foredune then Pleistocene dunes extending up to 4 km inland. A dune-controlled creek flows west to the centre of the beach. The beach can be reached via the footbridge from Beechford and along a vehicle track on the northern side of the Curries River.

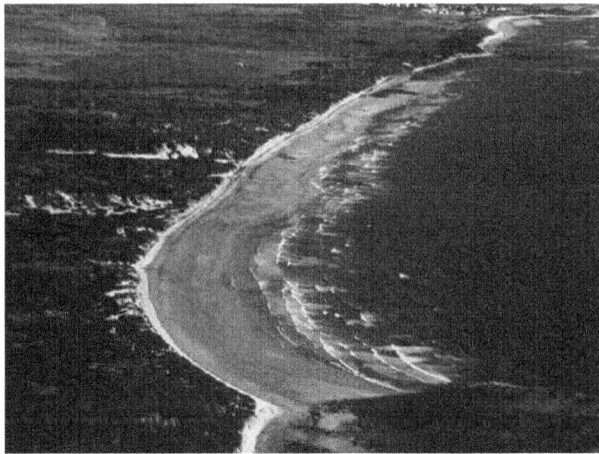

Figure 4.269 Stony Head (foreground) and the higher energy ultradissipative beaches (T 1198-1200) shown at low tide.

Beach **T 1199** commences at the boundary sandy foreland and continues to the northeast for 3.8 km to the first rocks of Stony Head, which extend westward as 500 m wide intertidal rock flats. The beach is exposed to westerly winds and waves which average over 1 m and maintain a 150 m wide low tide bar usually cut by up to 10 rips along the central-northern section, with rock flats dominating the first few hundred metres of the beach. Vegetated Holocene longwalled parabolic dunes extend up to 2 km inland, with Pleistocene dunes paralleling the coast for several kilometres to the east. Three small creeks flow out of the dunes and across the beach, which is entirely located within the artillery range.

Beach **T 1200** is a 150 m long strip of high tide sand located to the lee of the boundary rock flats. It only receives lowered waves at high tide, with the wide flats exposed at low tide. The beach narrows to the north as the rock flats dominate the shoreline. It is backed by a scarped 15 m high foredune and older transgressive dunes.

Maitland Bay is an open 1 km wide, north-facing bay located between the western head and Stony Head. Beach **T 1201** curves around the base of the bay for 1 km and is exposed to slightly reduced westerly waves, which average over 1 m. The waves maintain a 100 m wide low tide bar, usually cut by two central beach rips, with permanent rips against the rocks at either end (Fig. 4.270). A range road runs out to the western end of the beach, which is backed by vegetated foredune, then older dune-covered basalt slopes, which rise to 90 m at the head. A small creek and wetland run along the rear of the foredune and drain across the centre of the beach.

Figure 4.270 Maitland Bay has a moderate energy surf zone dominated by beach and headland rips (T 1201).

T 1202-1207 TAM O'SHANTER BAY

No.	Beach	Rating HT LT	Type	Length
T1202	Stony Head (E)	4 6	R+rock flats	1.5 km
T1203	Black Rock Pt	4 6.	Cobble+rock flats	800 m
T1204	Tam O'Shanter Bay	4 5	R+LT rips	1.6 km
T1205	Tam O'Shanter Bay (E1)	4 6	R+rock flats	600 m
T1206	Tam O'Shanter Bay (E2)	4 6	R+rock flats	1.3 km
T1207	Tam O'Shanter Bay (E3)	4 6	R+rock flats	400 m
Spring & neap tidal range = 2.4 & 2.0 m				

To the east of **Stony Head** is a 10 km long section of north-facing shoreline dominated by Tertiary basalt to either end, with the central Black Rock Point composed of Devonian marine sediments. The only sand-dominated shore is located in Tam O'Shanter Bay (beach T 1204), the site of the small Lulworth community. Scattered along the remainder are five rock-dominated beaches (T 1202, 1203, 1205-1207).

Beach **T 1202** is a crenulate 1.5 km long strip of narrow discontinuous high tide sand backed by generally steep vegetated rocky slopes, which are cliffed in places and rise to 40-50 m. It is fronted by continuous intertidal rock flats averaging 100 m in width and in places extending 200 m offshore, with sandy seabed beyond. The beach faces north and is moderately sheltered from westerly waves by Stony Head, with waves averaging about 1 m along the rocky shoreline. There is 4WD access to the top of the backing bluffs, however access is restricted as the beach is located within the artillery range.

Black Rock Point is a 30 m high headland composed of Devonian marine metasediments. Beach **T 1203** is located along its relatively straight northeast-facing eastern side. The beach extends for 800 m along the base of the vegetated slopes of the point and consists of a narrow high tide cobble-boulder beach fronted by 50 m wide intertidal rock flats.

Tam O'Shanter Bay is an open 1.7 km wide north-facing bay, with beach **T 1204** curving for 1.6 km along the base of the bay (Fig. 4.271). The beach is moderately sheltered from westerly waves by Black Rock Point, with wave height increasing eastward along the beach. Waves average over 1 m and maintain a low tide bar, with five to six rips forming during periods of higher waves, particularly along the central-eastern section of the beach. A left-hand point break known as *Tom O'Shanter* is located off the western rocks. Now vegetated parabolic dunes extend up to 700 m west of the central-eastern half of the beach, and overlie older Pleistocene transgressive dunes. The small community of Lulworth is located along the more sheltered western end of the beach, with the western end used to launch small fishing boats.

Figure 4.271 Tam O'Shanter Bay and beach (T 1204).

Tertiary basalt dominates the eastern boundary of the bay and the next 10 km of coast to Noland Bay. Beach **T 1205** is a 600 m long narrow strip of high tide sand and cobbles that commences in lee of the eastern headland and curves to the southeast. It is fronted by 100-200 m wide intertidal basalt rock flats and backed by low vegetated bluffs. There is vehicle access to the centre of the beach, where boats are launched off the rock flats in lee of a small cove in the rock flats.

Beach **T 1206** occupies the next broad rocky V-shaped embayment. It is a narrow 1.3 km long high tide sand and cobble beach, fronted by 200 m wide intertidal rock flats, and backed by recently vegetated transgressive dunes that extend up to 700 m across the backing point to reach Fanny Bay. The beach is exposed to the dominant westerly winds and waves, which maintain hazardous conditions across the rocky surf zone. There is vehicle access to the southern base of the beach.

Beach **T 1207** lies immediately to the east in a curving 400 m long rock-based embayment. It continues as a narrow high tide sand and cobble beach, with rock flats extending up to 300 m seaward at either end and deeper rocky and sandy seafloor in between.

Regional map 17 North Coast: Weymouth to Cape Portland

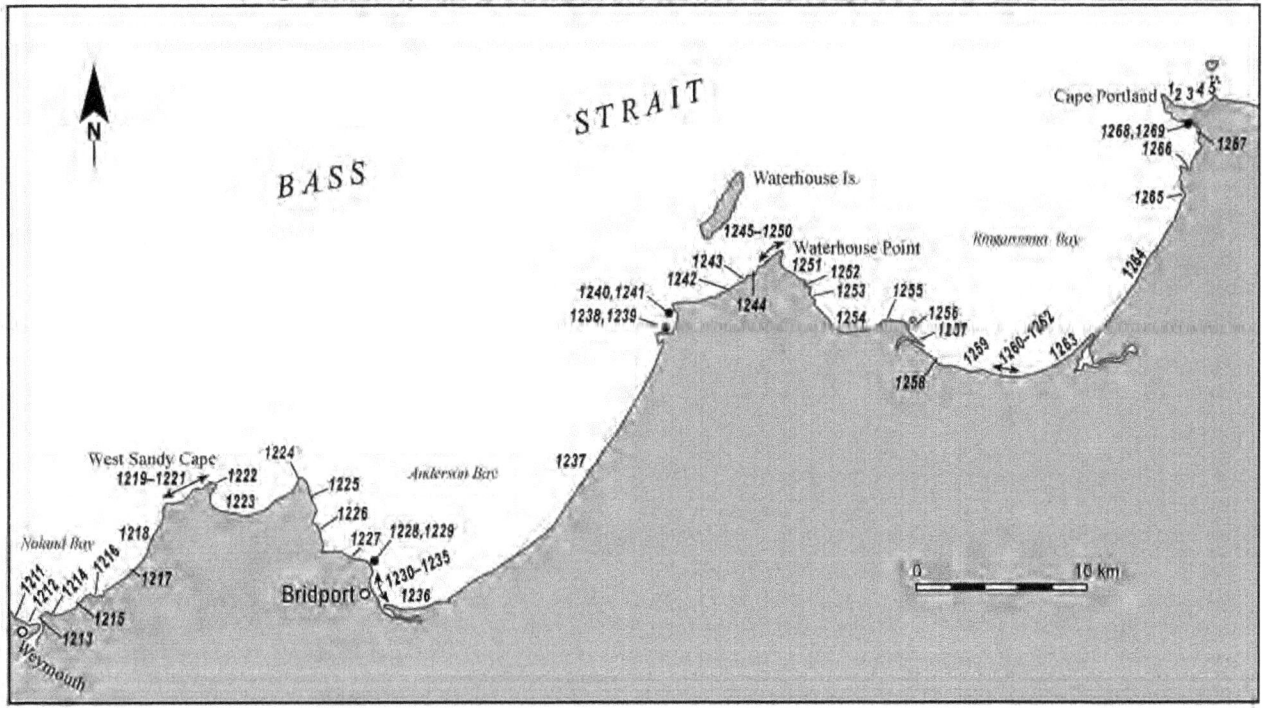

Figure 4.272 The eastern section of the North Coast between Weymouth and Cape Portland

T 1208-1213 **FANNYS BAY-WEYMOUTH**

No.	Beach	Rating HT LT		Type	Length
T1208	Fannys Bay	3	4	R+LTT/rocks	300 m
T1209	Fannys Bay (E1)	3	4	R+LTT/rocks	200 m
T1210	Fannys Bay (E2)	4	5	R+LTT/rocks	150 m
T1211	Weymouth (W)	3	4	R+LTT/rocks	150 m
T1212	Weymouth	4	4	R+LT rips	1 km
T1213	Pipers River (E)	4	5	R+rock flats	500 m
Spring & neap tidal range = 2.4 & 2.0 m					

Noland Bay is an open 7 km wide north-facing embayment bordered by the small Fannys Bay in the west and the dune-covered point at Fordington to the east. In between are 9 km of alternating rocky and sandy shoreline containing eight beaches (T 1208-1215), with the small communities of Weymouth and Bellingham located in the centre to either side of the small Pipers River.

Fannys Bay is a curving east-facing 700 m wide embayment containing along its southern shore 300 m long beach **T 1208**. The beach is a narrow strip of high tide sand fronted by a central low tide terrace with rock reefs to either end and a small creek draining across the centre. Until the 1960s the beach was supplied by sand blowing across the western headland from Tam O'Shanter Bay. These dunes are now vegetated and stable, and as a result the beach is slowly diminishing. Beach **T 1209** lies 100 m to the east past a low basalt point. It is a relatively straight, north-facing 200 m long

sandy beach with a western low tide terrace grading into rock flats in the east, with the rocky shore continuing on for another 1.2 km. Both beaches are sheltered by the western point with waves averaging about 0.5 m in Fannys Bay and slowing increasing height to the east. They are both backed by a fringe of vegetated slopes, then partly cleared farmland.

Beach **T 1210** is located at the end of the rocky section of shore and consists of a 150 m long north-facing high tide sandy beach, fringed by a 50 m wide band of intertidal rocks, then a sandy seafloor. A low slightly protruding 250 m wide basalt point borders its eastern side, with beach **T 1211** located on the eastern side of the point. This is a similar 150 m long high tide beach, fringed by 50 m wide intertidal rock flats with a central sandy section. A road from Weymouth runs along the rear of the beach to a boat ramp located at its eastern end.

Weymouth Beach (T 1212) is a curving 1 km long, north-facing sandy beach, with shallow rock reefs and sand off the western end and a low tide bar grading into the tidal shoals of the Pipers River to the east (Fig. 4.273). The beach widens to the east as wave height increases to 1 m at the river mouth. The beach is part of a low 500 m wide barrier that forms the western side of the river mouth. The small community of **Weymouth** occupies most of the barrier, with a 100-150 m wide vegetated foreshore reserve between the houses and the beach, which includes a large camping ground and caravan park at the western end. A tidal pool and boat ramp are located on the rocky point that forms the western boundary, with a second boat ramp in the river.

Figure 4.273 Weymouth Beach (T 1212) and the small settlement of Weymouth at the mouth of Pipers River.

Beach **T 1213** extends along the eastern side of the river mouth. It commences at the 50 m wide sandy river mouth and trends to the north, then northeast for 500 m to the low rocky sand-draped **Pipers Head**. It is a narrow high tide beach, fronted in the south by the deep river-tidal channel, with intertidal rock flats composed of steeply dipping greywacke that widen to the north and extend 200 m off the head. The small community of **Bellingham** is located just inside the eastern side of the river mouth, with recently vegetated transgressive dunes climbing the 60 m high slopes behind the beach. A 4WD track reaches the head from the eastern side.

T 1214-1216 PIPERS HEAD-FORDINGTON

No.	Beach	Rating		Type	Length
		HT	LT		
T1214	Pipers Head (E1)	4	5	R+rock flats	500 m
T1215	Pipers Head (E2)	5	6	R+LT rips/rock flats	2.1 km
T1216	Fordington	5	6	R+rock flats	400 m
Spring & neap tidal range = 2.4 & 2.0 m					

To the east of Pipers Head the shoreline curves to the southeast, then northeast for 3 km to the mouth of the Little Pipers River, with rocky shore dominating the shoreline at either end and three beaches located in between (T 1214-1216). The beaches are exposed to moderate westerly waves and westerly winds, with extensive dunes backing the main beach.

Beach **T 1214** commences 500 m east of the tip of Pipers Head and consists of a crenulate narrow discontinuous, 500 m long strip of high tide sand and cobbles. It is fronted by steeply dipping folded greywacke that forms ridges across the beach and extends seaward as intertidal flats that average 100 m in width. A 4WD track from Bellingham reaches the rear of the beach and spreads out into a series of tracks that link to several fishing shacks located in the scrubby vegetation along the beach.
Beach **T 1215** commences at the eastern base of Pipers Head and trends straight northeast for 2.1 km to the extensive rock reefs off the Little Pipers River mouth. It is a continuous high tide sand beach, fronted along the central section by a 50 m wide low tide terrace, with rock flats bordering each end and rock reefs in deeper water off the entire beach. Densely vegetated longwalled parabolic dunes back the beach, increasing in size to the north and extending across the rear of the north point, some reaching 1.6 km to the Little Piper River. The beach is accessible via the tracks from Bellingham with a few fishing shacks located towards the southern end.

Beach **T 1216** extends east, from a small collection of rocks that separates it from beach T 1215, for 400 m to the narrow sandy mouth of the Little Piper River. More than half the beach is fronted by steeply dipping ridges of greywacke extending up to 500 m offshore, with sandy patches in between the ridges. A small collection of shacks called Fordington is located on the western side of the river mouth in lee of the 500 m wide transgressive dunes.

T 1217-1218 SINGLE TREE PLAIN

No.	Beach	Rating		Type		Length
		HT	LT	inner	outer bar	
T1217	Single Tree Plain (S)	6	6	R+LT rips	RBB	4.8 km
T1218	Single Tree Plain (N)	6	6	R+LT rips	RBB	2.5 km
Spring & neap tidal range = 2.4 & 2.0 m						

The mouth of the **Little Piper River** marks the beginning of one of the longer and higher energy beach systems on the north coast, backed by massive Holocene and Pleistocene dune systems that form the Single Tree Plain. The two **Single Tree Plain** beaches (T 1217 and 1218) extend for a total of 7.3 km to the northeast to a low rocky point that forms the western end of West Sandy Point.

Beach **T 1217** commences at the small sandy river mouth (Fig. 4.274) and curves gently to the northeast for 4.8 km to a 100 m wide outcrop of greywacke that divides the beach in two. Waves average about 1 m at the river mouth increasing to 1.5 m along most of the beach. These maintain an inner low tide bar cut by 15-20 rips spaced every 150-200 m, with a permanent rip against the boundary rocks. A rhythmic outer bar extends most of the way along the beach with more widely spaced rips. The beach is backed by a continuous hummocky stable foredune, apart from a blowout 200 m east of the river mouth and several small creeks that drain through the dunes and across the beach. The foredune is backed by massive, predominantly vegetated, longwalled Holocene parabolic dunes that extend up to 6 km inland, with more subdued Pleistocene dunes extending up to 14 km to Bridport. Some of the inner parabolics are still active, however there has been considerable stabilisation of the dunes in the past 30 years.

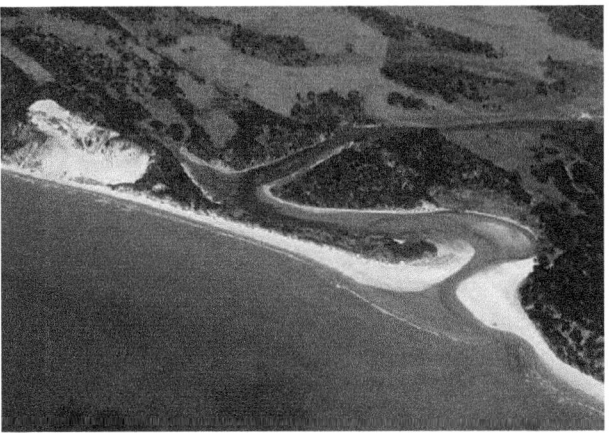

Figure 4.274　The Little Piper River marks the beginning of the 5 km long beach T 1217.

Beach **T 1218** continues north of the boundary rocks for another 2.5 km to a 200 m long section of dune-capped rocks. It is a similar beach with a slightly higher wave energy double bar system, usually containing 10 inner bar rips and the rhythmic outer bar. A moderately stable foredune and more active parabolic dunes extend up to 4 km inland, with the older Pleistocene dunes crossing the 9 km of plain to reach the coast east of East Sandy Cape. In total the two beaches are backed by approximately 2000 ha of Holocene transgressive dunes, which average 30-40 m in height, of which approximately 30% remain unstable and are actively transgressing to the east (Fig. 4.275). The dunes have for the past 20 years been actively stabilised by dune planting to prevent them migrating onto the backing farmland located on the Pleistocene dunes. The only access to the beaches is via 4WD along a few tracks through the dunes and along the beach.

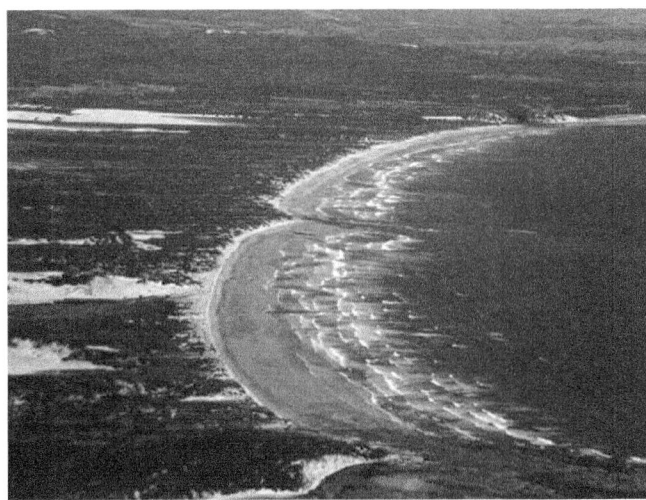

Figure 4.275　Single Tree Plain consists of extensive parabolic dunes originating from the exposed beaches T 1217 & 1218, shown here at low tide.

T 1219-1221　**WEST SANDY POINT (W)**

No.	Beach	Rating HT LT	Type	Length
T1219	West Sandy Pt (W3)	4　5	R+rock flats	250 m
T1220	West Sandy Pt (W2)	4　5	R+rock flats	1.5 km
T1221	West Sandy Pt (W1)	4　5	R+LTT/rock flats	1.3 km
Double Sandy Point Conservation Area　　*640 ha*				
Spring & neap tidal range = 2.4 & 2.0 m				

West Sandy Point is a low but prominent sand-draped greywacke point that forms the western boundary of St Albans Bay. Beaches T 1219-1221 extend for 3 km west of the point to the northern end of the Single Tree Plain beaches. The three beaches are all dominated by northwest-trending ridges of greywacke that form intertidal rock flats.

Beach **T 1219** is a curving northwest-facing 250 m long strip of high tide sand and cobbles located to the lee of linear rock flats that extend up to 400 m offshore, with deeper reef beyond. The beach is sheltered by the reefs with usually only low waves reaching the shore at high tide, and the rocks exposed at low tide, apart from a tidal pool along the beach between the boundary rock flats. It is backed by densely vegetated transgressive dunes that extend up to 4 km east to St Albans Bay.

Beach **T 1220** extends east of the boundary foreland for 1.5 km as a crenulate high tide sandy beach, dominated by rock flats along its more crenulate western half, with more sandy foreshore along the eastern half, through rock outcrops in the intertidal the length of the beach. The rocks are exposed at low tide and only permit low waves to reach the shore at high tide. Stabilised transgressive dunes back the beach, with one large active parabolic in lee of the eastern end of the beach reaching 1 km across to St Albans Bay. A 4WD track follows the parabolic from the bay to reach the beach. The parabolic and the area to the north are part of the Double Sandy Point Conservation Area.

Beach **T 1221** occupies the final curving embayment to terminate at the northern tip of West Sandy Point. The 1.3 km long northeast-facing beach is fronted by a continuous sandy low tide bar and seafloor, which grades into deeper reef 200-400 m offshore, together with boundary rock flats and reefs to either end. Densely vegetated transgressive dunes back the beach and extend 500-1,000 m across the rear of the point to the bay shore.

T 1222-1225　**EAST & WEST SANDY POINTS**

No.	Beach	Rating HT LT	Type	Length
T1222	West Sandy Point	3　4	R+rock flats	500 m
T1223	St Albans Bay	3 →5	R→R+LT rips	6.2 km
T1224	East Sandy Point	4　5	R+rock flats	700 m
T1225	East Sandy Point (E)	2　3	R+rock flats	2.1 km
Spring & neap tidal range = 2.4 & 2.0 m				

East and West Sandy points are composed of low-lying, steeply-dipping Devonian greywacke that extends off each point as rock flats and reefs. The points are located 5 km apart and both are covered by active and vegetated Holocene transgressive dunes, and are linked by the curving St Albans Bay beach. Both points and the adjacent beaches (T 1221-1225) are all included in the 640 ha Double Sandy Point Conservation Area, which was established in 1982. The beaches can only be accessed via 4WD, either though the dunes or along the beaches.

West Sandy Point beach (**T 1222**) extends from the northern tip of the low point for 500 m to the southeast. The beach protrudes to the northeast as it curves round the tip of the point, with intertidal rock flats extending 200 m offshore. The rocks only permit waves to reach the beach at high tide. The beach consists of a narrow strip of high tide sand, with a few close in tidal pools amongst the rock flats. It is backed by well vegetated transgressive dunes rising to 20 m.

St Albans Bay is a curving 5 km wide, 1.5 km deep north- to northwest-facing sandy bay that links the East and West Sandy points. The bay beach (**T 1223**) commences at the end of the West Sandy Point rock flats and initially trends southeast, then east and finally northeast for 6.2 km terminating at the beginning of the rocks of East Sandy Point. In lee of West Sandy Point the beach is sheltered, receives low waves and is narrow and reflective. As its trends to the east it becomes increasingly exposed to the dominant westerly wind waves, which average 1-1.5 m towards East Sandy Point. The beach transforms to a low tide terrace in the south, which widens to the east and becomes cut by several low tide rips along the eastern 2-3 km of beach, with a permanent rip against the eastern rocks. A range of dune systems backs the beach. In the west the dunes from the western side of West Sandy Point reach the shores of the bay. They are now well vegetated and stable. Along the centre is a narrow foredune system, cut by a small creek that drains the backing Jerusalem Plains. The foredune increases in width and height to the east and as soon as the beach curves to the northeast facing the dune into the westerly winds it transforms to a series of longwalled parabolic dunes (Fig. 4.276) that extend up to 3 km east right across the base of East Sandy Point to reach the rocky eastern shore (beach T 1225). These dunes reach 30 m in height and are moderately active, though they are also being actively stabilised with dune planting.

East Sandy Point beach (**T 1224**) commences with the first rocks of the point and trends to the northeast for 700 m to the northern tip of the point. Irregular, steeply dipping linear rock flats extend 100-200 m offshore. Waves break over the rock flats, with a permanent rip located across an inner sandy section, which is bordered by two rock reefs at the western end of the beach. Well vegetated parabolic dune walls parallel the rear of the beach.

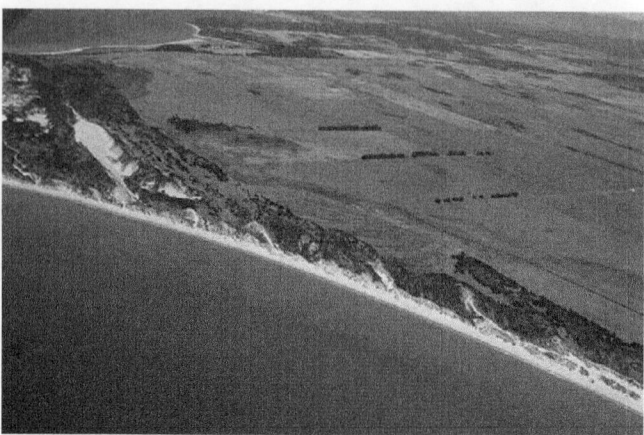

Figure 4.276 St Albans Bay beach (T 1223) with the backing foredune expanding to parabolic dunes (left).

Beach **T 1225** commences at the tip of the point and trends to the southeast for 2.1 km. This is a sheltered low energy beach. It is a narrow crenulate discontinuous high tide sand beach interrupted by and fronted by continuous, irregular 100-200 m wide intertidal rock flats. The beach is only supplied with sand from dunes transgressing across the rear of the point. As the dunes are now largely vegetated through planting, the sandy supply has decreased resulting in beach erosion and greater exposure of the rock flats.

T 1226-1227 LADES & ADAMS BEACHES

No.	Beach	Rating HT LT	Type	Length
T1226	Lades Beach	3 3	R+sand flats	2.2 km
T1227	Adams Beach	3 4	R+sand flats-LTT	2.2 km
Granite Point Conservation Area				
Spring & neap tidal range = 2.4 & 2.0 m				

Lades and Adams beaches are two moderately sheltered northeast-facing sandy beaches located either side of the sandy mouth of the Little Forester River. They are bordered to the west by the southern rocks of East Sandy Cape and the small Granite Point to the east.

Lades Beach (**T 1226**) is a dynamic but low energy crenulate beach consisting of a low migratory spit that is fed by sand transgressing across the base of East Sandy Cape (Fig. 4.277). Low refracted westerly waves move the sand southeast towards the river mouth where it has accumulated as sand and river mouth flats up to 1 km wide at the mouth and extending to within 500 m of Forester Rock. Because of the dynamic nature of the spit the nature, length and location of the actual beach varies at time periods of months to years, with at times a spit forming and impounding a narrow lagoon, with the narrow mainland beach behind. At other times there is no spit and just the mainland beach. At its maximum it can extend for 2.2 km right to the river mouth. However as the East Sandy Point dunes are becoming increasingly stabilised the beach can be expected to diminish and increasingly expose the narrow mainland beach to waves and erosion. Cleared farmland backs the entire beach, with access to the beach along the Sandy Point Road.

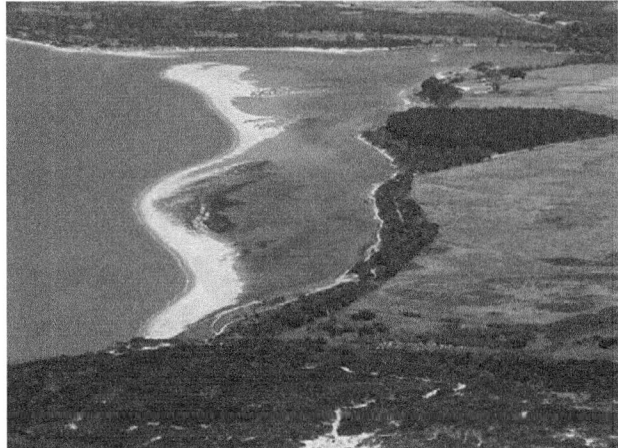

Figure 4.277 Lades Beach (T 1226) is a dynamic spit that transports sand into the bay.

Adams Beach (T 1227) commences at the river mouth in lee of the wide sand flats and trends to the northeast, then east for 2.2 km to the small Granite Point. It is backed by a 100-150 m wide series of low foredunes and a drained 1 km wide wetland, all part of a series of spits that extend west towards the river. The first 1 km of beach lies in lee of the sand flats, with low waves at the shore. The sand flats narrow to a low tide terrace along the eastern kilometre, with waves averaging 0.5-1 m reaching the shore and forming rips at low tide closer to Granite Point. The entire beach and backing low vegetated foredunes are part of Granite Point Conservation Area, with farmland on the drained wetland behind. The eastern end of the beach is located 100 m west of the Granite Point car park, which overlooks the beach.

T 1228-1235 **BRIDPORT**

No.	Beach	Rating HT LT		Type	Length
T1228	Granite Point	3	3	R+LTT	100 m
T1229	Granite Point (E)	3	3	R+LTT/rocks	40 m
T1230	Mermaids Beach	3	3	R+LTT/rocks	100 m
T1231	Old Pier Beach	3	3	R+LTT	200 m
T1232	Mattingleys Beach	3	3	R+LTT	60 m
T1233	Croquet Lawn Beach	3	3	R+LTT	100 m
T1234	Eastmans Beach	3	3	R+LTT	100 m
T1235	Goftons Beach	3	3	R+LTT	400 m
Spring & neap tidal range = 2.4 & 2.0 m					

Bridport is a popular holiday town of 1000. It is the largest town east of Launceston and one of the few settlements on this remote part of the coast. The town has limited commercial facilities, but does offer an excellent 100-200 m wide coastal reserve, which contains a caravan and camping area on the shady bluffs overlooking most of the eight small Bridport beaches (T 1228-1235) (Fig 4.278). In addition there is the more exposed Adams Beach (T 1227) on the western side of Granite Point. While Adams Beach is exposed to moderate westerly waves, the eight bay beaches face west and are usually calm. All beaches are accessible by road.

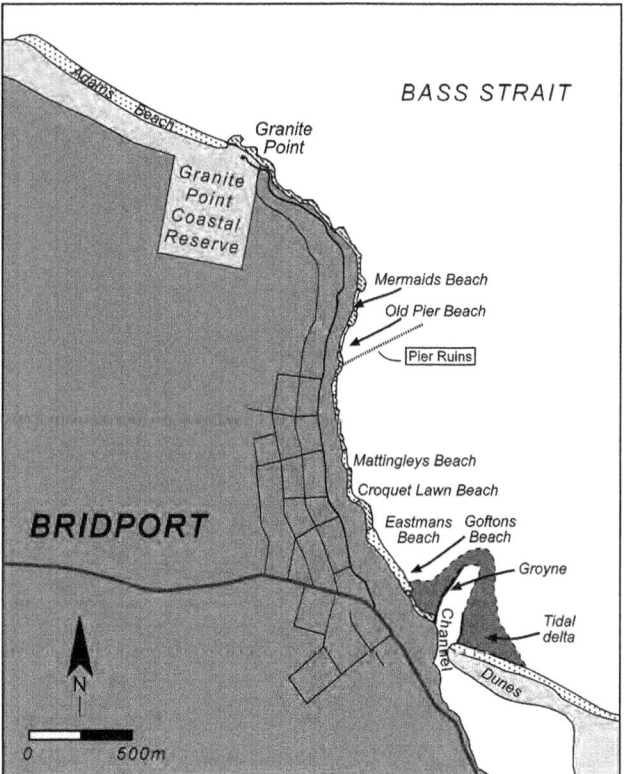

Figure 4.278 Bridport faces east and has a series of small sheltered beaches.

Granite Point marks the beginning of a 2.5 km long section of east-facing rock and sand shoreline that forms the Bridport shoreline, extending south to the small trained mouth of the Brid River. Beach **T 1228** is located in amongst the rocks 200 m east of the point. It is a 100 m long strip of high tide sand and rocks, grading into a low tide terrace with rock outcropping across and off the beach. Beach **T 1229** lies 50 m to the east and is a 40 m long pocket of sand bounded by the sloping granite rocks, with rock reefs extending 100 m offshore. Both beaches are backed by the road out to the point car park, then houses on the backing tree-covered slopes.

Mermaids Beach (T 1230) is a curving 100 m long strip of sand, bounded by granite rocks, with rocks also outcropping across the low tide bar. It faces east into Anderson Bay and is backed by the tree-covered sloping reserve then the road. **Old Pier Beach (T 1231)** (also called Murphys Beach) lies immediately to the south and is a slightly curving 200 m long east-facing beach and wide low tide terrace, with the remains of the old pier extending 500 m off the southern end, an indication of the shallow bay seafloor (Fig. 4.279). The beach is usually calm except under easterly winds, and consists of a low sand beach surrounded by rounded granite rocks and boulders. There is also a boat ramp on the southern side of the pier.

Mattingleys Beach (T 1232) lies 500 m further south and is a 60 m pocket of sand surrounded by blufftop caravan park and camping area. **Croquet Lawn Beach (T 1233)** is 100 m long and located 100 m to the south at the southern end of the camping area, with a boat ramp across the southern end of the beach. Both beaches are

bordered by sloping granite points and backed by the tree-covered slopes of the reserve. They face west and are usually calm, except during easterly winds and waves.

Figure 4.279 The Bridport beaches (T 1230-1235) with the remains of the old pier in the foreground.

Eastmans Beach (T 1234) is located 200 m to the south and is a 100 m long pocket of sand bordered by low rocky points, with sand linking around the southern point to Goftons Beach. A grassy park, footpath, then the trees of the reserve back the beach, with a few boulders scattered across the low tide bar at the southern end. **Goftons Beach (T 1235)** continues immediately to the south as a 400 m long sandy beach that has prograded up to 100 m seaward at its eastern end against the training wall for the Brid River. The prograded beach is backed by a low grassy foredune with the trees in the reserve marking the original shoreline. The town centre of Bridport lies 200 m south of the beach. The low tide bar widens to 300 m wide river-mouth shoals towards the river mouth, with extensive sand flats exposed at low tide (Fig. 4.280).

Figure 4.280 The Brid River mouth with Bridport and Goftons Beach (T 1235) to the right and the tip of Barnbougle Beach to the left (T 1236).

Swimming: The eight Bridport bay beaches are all usually calm with a low hazard rating. Beware however of the many boulders along the beaches and the tidal

channel and currents at the river mouth. Adams Beach offers the only surf and is more hazardous with rips occurring when waves exceed 0.5-1 m, particularly at low tide.

Surfing: *Adams Beach* usually has beach breaks during westerly swell.

Waterhouse Conservation Area

Established:	1996
Area:	6953 ha
Coast length:	35 km (2165-2200 km)
Beaches:	18 (T 1237-1254)

The Waterhouse Conservation Area covers a 70- km^2 area that includes 35 km of predominately sandy coast backed by extensive Pleistocene and Holocene transgressive dune systems, and associated lakes and wetlands.

T 1236-1237 **BARNBOUGLE-WATERHOUSE BEACH**

No.	Beach	Rating HT LT	Type inner outer bar	Length
T1236	Barnbougle Beach	4 5	R+LTT	3.7 km
T1237	Waterhouse Beach	6 6	T+LT rips RBB	20 km
	Waterhouse Conservation Area 6953 ha			
Spring & neap tidal range = 2.4 & 2.0 m				

To the east of Bridport commence Barnbougle and Waterhouse beaches. The beaches begin at the trained mouth of the Brid River and curve to the east for 3.7 km as Barnbougle Beach (T 1236) to Adams Cut, then curves to the northeast for 20 km as Waterhouse Beach (T 1237) to South Croppies Point. They are the longest beach system (24 km) in Tasmania, backed by the most extensive Holocene and Pleistocene transgressive dune systems in the state, which in places extend 12 km to the east. Most of Waterhouse Beach and its backing Holocene dunes, as well as all of Croppies to Waterhouse points, are contained within the Waterhouse Protected Area, gazetted in 1996 to protect both the dunes and associated lakes and wetlands. To the lee of the Holocene dunes most of the Pleistocene dunes have been cleared for grazing. Both beaches are only accessible by 4WD, with the only public access in the north via the South Croppies Road to South Croppies Point.

Barnbougle Beach (T 1236) extends from the eastern side of the 50 m wide Bird River mouth for 3.7 km to Adams Cut, a small creek mouth that drains the backing Pleistocene dunes. The beach receives refracted waves, which increase in height up the beach to average up to 1 m by the Cut. The waves maintain a sandy high tide

beach and low tide terrace which increases in width to the east, with low tide rips forming during periods of higher waves. The first 800 m of beach is a low narrow spit, with oblique vegetated transgressive dunes commencing by 1.5 km and backing the remainder of the beach. The dunes average 500 m in width and reach 10-15 km in height.

Waterhouse Beach (T 1237) commences at the Cut and curves to the northeast and finally north-northeast for 20 km to the 42 m high doleritic South Croppies Point. It is a continuous high energy sandy beach dominated by low tide rips for its entire length, with an outer rhythmic bar also paralleling most of the beach. The rips average 150 m in spacing with more than 120 rips forming along the beach during periods of higher waves, their morphology usually remaining into the following calmer periods. The inner surf zone and rips average 100 m in width with the outer bar located 200-300 m offshore. The beach is backed by a generally well developed foredune, backed by Holocene parabolics to longwalled parabolic dunes, which average 1-2 km in width in the south increasing to 3-4.5 km in the north (Fig. 4.281). Approximately 50% of the dunes are currently active and migrating east. They average 20 m in height reaching up to 50 m in locations. The beaches have impounded three lakes - Blackmans Lagoon, Big Waterhouse Lake and Little Waterhouse Lake, with two of the lakes drained by creeks, which reach the beach. The Sanderson Rocks lie 1.5 km off the northern end of the beach, off Lake Creek, and induce a slight protrusion in the shoreline.

Figure 4.281 The northern end of Waterhouse Beach (T 1237) showing the massive dune field, and rip-dominated inner and outer bars.

T 1238-1241 **CROPPIES BAY**

No.	Beach	Rating HT LT	Type inner	outer bar	Length
T1238	Croppies Beach	6 7	TBR	RBB	200 m
T1239	Croppies Bay (1)	6 7	TBR	RBB	350 m
T1240	Croppies Bay (2)	6 7	TBR	RBB	80 m
T1241	Croppies Bay (3)	6 7	TBR	RBB	100 m
Spring & neap tidal range = 1.2 & 1.0 m					

Croppies Bay is an exposed west-facing bay located between South Croppies and Croppies points. The 1.5 km wide bay is dominated by resilient dolerite rocks that form the points and divide the bay shore into four small beaches (T 1238-1241) exposed to westerly wind waves averaging 1-1.5 m. The entire area is located within the Waterhouse Protected Area, with vehicle access via the South Croppies Road to the southern point and beach and other 4WD tracks to all the beaches.

Croppies Beach (T 1238) is an exposed 200 m long west-facing beach that has a wide low gradient beach and inner bar drained by one rip against the northern point, with an outer bar that extends continuously off all four beaches. It is bordered to the south by 42 m high South Croppies Point which extends 700 m to the west, and an irregular 500 m long more subdued point that separates it from beach T 1239 (Fig. 4.382). It is backed by vegetated longwalled parabolic dunes that extend 3 km inland to 116 m high Hardwickes Hill.

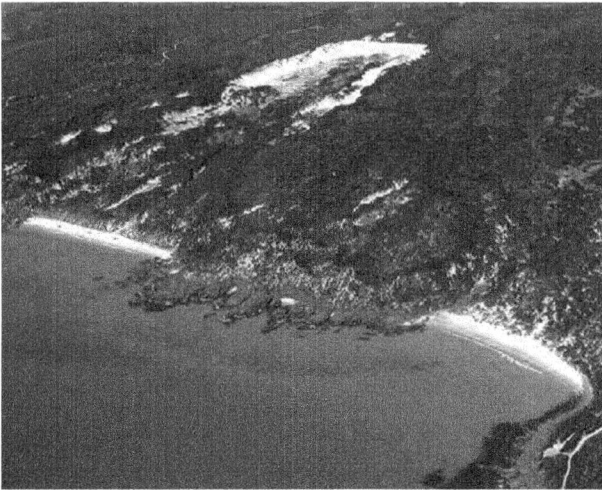

Figure 4.282 The two Croppies beaches (T 1238 & 1239) are both backed by largely vegetated longwalled parabolic dunes.

Beach **T 1239** is a straight 350 m long low gradient beach with an inner bar drained by a rip against the northern rocks, and the crescentic outer bar located 300 m offshore. A large parabolic dune backs the entire beach, with the depositional lobe actively migrating to the east 1 km in from the beach and a small creek draining out of the deflation basin onto the centre of the beach, while older vegetated dunes extend over 2 km inland. It is only accessible by 4WD from the north and south.

Beach **T 1240** lies 150 m to the north and is an 80 m long pocket of sand wedged in between small dolerite points, with rocks and reef extending 100 m offshore leaving a narrow central sandy beach and seafloor. During high waves a single rip drains out the centre of the beach with the outer bar 200 m offshore. Beach **T 1241** lies 50 m to the north and is a straight 100 m long southwest-facing beach, bordered to the north by 15 m high **Croppies Point** which protrudes 200 m to the west. Rocks and rock reef dominate the northern half of the beach, with a permanent rip draining out against the southern rocks, and the outer bar moving to within 150 m of the shore as

waves decrease in lee of the point. Both beaches are backed by well vegetated transgressive dunes. A 4WD track runs out to Croppies Point with a track down to the beach, and another to a solitary shack located on the ridge between the two beaches.

T 1242-1243 BLIZZARDS LANDING

No.	Beach	Rating HT LT	Type	Length
T1242	Croppies Point (E)	4 5	Cobbles +rocks	80 m
T1243	Blizzards Landing	4 5	Cobbles +rocks	100 m
Spring & neap tidal range = 1.2 & 1.0 m				

At Croppies Point the shoreline turns and trends to the east-northeast for 7 km to Waterhouse Point. In between is a predominantly rock-controlled shoreline dominated by resilient sloping dolerite rocks to Blizzards Landing, with only two small cobble beaches in this section (T 1242 and 1243). The final 2.5 km consist of dune-draped granite with seven near continuous sandy beaches (T 1244-1250). While all the beaches face northwest into the prevailing winds, they are moderately sheltered by 4.5 km long Waterhouse Island and smaller islands, rocks and reefs that extend south towards Croppies Point.

Beach **T 1242** is an 80 m long west-facing cobble beach located 2.7 km east of Croppies Point. It is bordered and fronted by dolerite rocks and reefs, while it is backed by an old foredune and vegetated transgressive dunes blanketing the backing rocky slopes. A 4WD track reaches the crest of the backing foredune.

Blizzards Landing beach (**T 1243**) is located 1.5 km further east and is a slightly curving 100 m long high tide cobble and boulder beach bordered by sloping dolerite rock points, with a rocky seafloor off the beach. It is backed by possibly Pleistocene dune-draped slopes rising steeply to 20 m. A vehicle track leads to a boat launching point at the western end of the beach, and then winds up over the rear of the backing slopes.

T 1244-1250 WATERHOUSE POINT (W)

No.	Beach	Rating HT LT	Type	Length
T1244	Waterhouse Pt (W6)	4 4	R+LTT/rocks	800 m
T1245	Waterhouse Pt (W5)	4 4	R+LTT	300 m
T1246	Waterhouse Pt (W4)	4 4	R+LTT	50 m
T1247	Waterhouse Pt (W3)	4 4	R+LTT	150 m
T1248	Waterhouse Pt (W2)	4 4	R+LTT	200 m
T1249	Waterhouse Pt (W1)	4 4	R+LTT	50 m
T1250	Waterhouse Pt	4 4	R+LTT	50 m
Spring & neap tidal range = 1.2 & 1.0 m				

Waterhouse Point is a low granite point covered by 30 m high vegetated transgressive dunes. Beaches T 1244-1250 occupy 2.5 km of northwest-facing shoreline between Herbies Landing and the tip of the point. All the

beaches are moderately sheltered by Waterhouse Island, as well as shallow granite reefs that parallel the shoreline (Fig. 4.283). They are all backed by generally well vegetated Holocene transgressive dunes overlying a Pleistocene core and then granite bedrock. Several informal camp sites are located to the lee of the beaches and in the dunes.

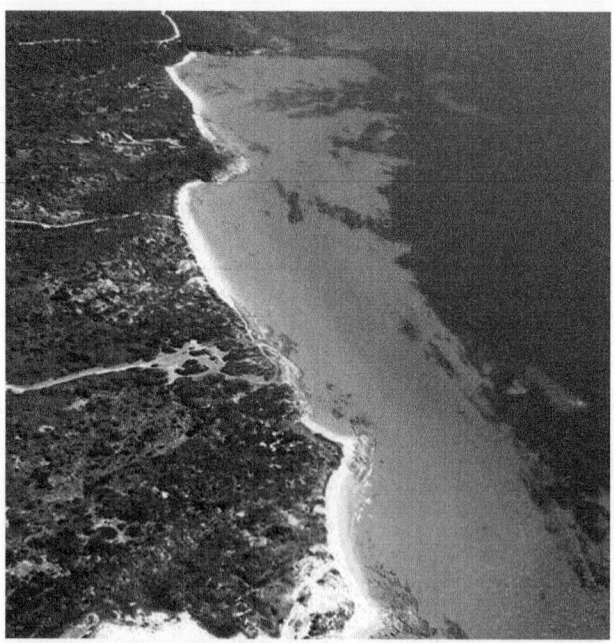

Figure 4.283 Beaches T 1244-1247 extend along the western side of the sheltered Waterhouse Point (Photo W. Hennecke).

Beach **T 1244** commences 200 m west of Herbies Landing with the easternmost dolerite rocks forming its western boundary. It trends to the northeast for 800 m as a narrow high tide beach, with numerous rock outcrops along the beach and a series of rock reefs extending up to 300 m off the centre of the beach. A low tide bar parallels the beach, with an irregular shallow sandy seafloor extending out to the reefs. There is vehicle access off the main track to the southern end of the beach, while vegetated transgressive dunes rising to 30 m back the beach. A 100 m long section of steep rocky shore backed by a now stabilising clifftop parabolic dune separates it from beach **T 1245**. This beach initially curves round in lee of the rocks then trends to the northeast for 300 m to the next section of rocky shore. It is a continuous high tide sand beach fronted by a 100 m wide low tide bar and sandy seafloor. The low tide bar extends continuously linking all the beaches to the west of the point. Four wheel drive tracks reach both ends of the beach.

Beach **T 1246** commences at the end of the 100 m long section of rocky shore. It is a curving 50 m long pocket of more west-facing sand, bordered by a small rocky point to the north. It has a narrow high tide beach and a 100 m wide low tide bar, with a series of rocks paralleling the beach just seaward of the bar. A low foredune and densely vegetated transgressive dunes back the beach, with a 4WD track reaching the southern boundary rocks. Beach **T 1247** lies immediately to the east and is a

curving 150 m long sand beach with a 100 m wide low tide bar, bordered to the east by a protruding sand foreland tied to a small rock outcrop. An older vegetated and an active parabolic dune back the beach, both extending 600 m east to the eastern side of the point, where the sand is spilling onto the rocks.

Beach **T 1248** curves to the northeast of the small foreland for 200 m to the next small sandy foreland, which protrudes to the lee of a small rock islet located 100 m offshore, and is tied to the beach at low tide. Rocks also outcrop along the beach with some rock reefs exposed at low tide. The narrow beach is backed by scrubby transgressive dunes that cover the 150 m wide tip of the point. Beach **T 1249** occupies the eastern side of the foreland. It is a 50 m long strip of sand fronted by a 100 m low tide bar that terminates against the northernmost granite rocks of the point. It faces northwest, with the islet and foreland to the west and other rock reefs off the eastern end.

Beach **T 1250** lies on the eastern side of the tip of Waterhouse Point and faces due north. It is a 50 m long strip of sand, bordered by sloping granite rocks to either side with the small beach and narrow bar linking the rocky points. It is backed by the vegetated dune-covered slopes of the point which rise to 30 m.

T 1251-1255 WATERHOUSE-TOMAHAWK POINTS

No.	Beach	Rating HT LT	Type inner	outer	Length bar
T1251	Waterhouse Pt (E1)	3 3	R+LTT	-	1.9 km
T1252	Waterhouse Pt (E2)	3 3	R+LTT	-	600 m
T1253	Ransons Beach	3 3	R+LTT	-	800 m
T1254	Tomahawk Beach	3 3	R+LTT	D	4.8 km
T1255	Tomahawk Pt (W)	3 3	R+LTT	-	200 m
Tomahawk River Public Reserve					
Spring & neap tidal range = 1.2 & 1.0 m					

Waterhouse Point marks the western boundary of the large **Ringarooma Bay**. Cape Portland, located 24 km to the northeast, is the northernmost tip of the mainland and forms the eastern boundary of the bay. Between Waterhouse Point and Tomahawk Point, 8.5 km to the east-southeast, are 11 km of curving generally north-facing sandy shoreline consisting of five near continuous beaches (T 1251-1255) (Fig. 4.284). The beaches are initially sheltered in lee of Waterhouse Point with waves increasing slowly towards Tomahawk Point where they average about 1 m. All the beaches are located in the Waterhouse Conservation Area, and in the east the Tomahawk River Public Reserve. They are accessible in the west from the Waterhouse Point tracks.

Beach **T 1251** commences in lee of Waterhouse Point, 500 m south of the tip. It curves initially to the south, then southeast as a double crenulate beach for 1.9 km, terminating at a small rock-tipped sandy foreland. It is a continuous sandy high tide beach fronted by a 100 m

wide low tide bar grading into a shallow sandy sea floor, with patchy seagrass beyond and a few granite rocks and reefs out off the beach. It is sheltered by Waterhouse Point from westerly waves, with waves usually 0.5 m or less, which maintain a low gradient beach usually littered with seagrass debris. There is vehicle access to the northern end where a few fishing shacks are located, together with a few shacks located in amongst the scrub that backs the beach.

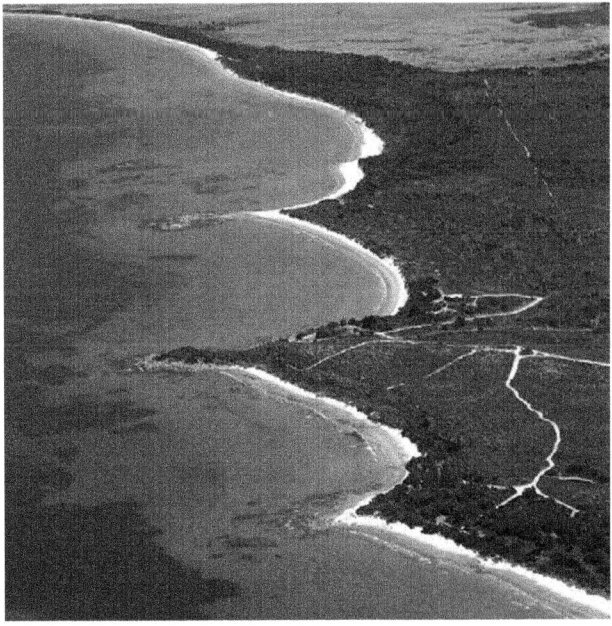

Figure 4.284 The moderately sheltered eastern Ringarooma Bay beaches (T 1251-1254).

Beach **T 1252** curves for 600 m between the northern rock-tipped foreland and a small granite point to the south. It faces northeast and receives waves averaging up to 1 m, which break across a 50 m wide low tide bar backed by the narrow high tide beach, then a low vegetated foredune. Vehicle tracks lead to both ends of the beach, with a shack located behind the northern end.

Ransons Beach (T 1253) commences at the base of the low 200 m long northern granite point and curves to the southeast for 800 m, backed the entire way by a low vegetated foredune, then older grassy transgressive dunes that migrated east across the base of the point. The beach receives low wind waves averaging up to 1 m, which break across a 50 m wide low tide bar. The main vehicle track terminates at the northern end of the beach where a few fishing shacks are located behind the beach and to the lee of the boundary rocks. This sheltered spot is also used by fishermen to launch small boats.

West Tomahawk Beach (T 1254) commences at the sandy foreland and curves to the southeast, then east and finally east-northeast for 4.8 km to a small tombolo that marks the western rocks of Tomahawk Point. The beach receives waves averaging 1 m in the west increasing during strong winds to the east. They maintain a continuous low tide bar, which along the eastern 2 km of beach widens to 100 m and is paralleled by one to two shore-parallel outer bars, which are only active during

higher wave conditions and which maintain a rip against the tombolo point. The beach is backed from the west by well vegetated older transgressive dunes, then by a narrow low foredune backed by cleared grazing land, with the foredune increasing in size and instability as the beach turns and faces more into the dominant westerly winds. Older cleared Pleistocene dunes extend up to 6 km south of the beach and are drained by the small creek that crosses the middle of the beach. The entire Holocene dune system is incorporated in the Waterhouse Protected Area in the west and Tomahawk Coastal Reserve in the east.

Beach **T 1255** forms the eastern side of the 100 m long vegetated tombolo, which is tied to a low 1 ha basalt point. The beach curves to the east for 200 m terminating in lee of a 50 m wide band of intertidal rocks and reefs. It is partly sheltered from westerly waves and is moderately steep and reflective, with only a 20 m long clear sandy section, the remainder fronted by rocks and reef. It is backed by a grassy foreland and some minor vegetated dune transgression, with well vegetated dune-covered rocky shore extending 1.3 km east to Tomahawk Point.

T 1256-1258 TOMAHAWK BEACHES

No.	Beach	Rating HT LT	Type	Length
T1256	Tomahawk Pt (E)	3 3	R+sand flats	700 m
T1257	Tomahawk Beach	3 3	R+sand flats	1.7 km
T1258	Tomahawk Beach (E)	3 3	R+sand flats	2.9 km
Spring & neap tidal range = 1.2 & 1.0 m				

Tomahawk Point and adjoining Tomahawk Island mark the western boundary of a near continuous curving beach system that extends for 22 km to Petal Point. In between rivers and rock outcrops divide the system into ten beaches (T 1256-1265), including the high energy 9 km long Boobyalla Beach (T 1264). The three Tomahawk beaches (T 1256-1258) extend 5.3 km east of the point. They are sheltered by the island and point, their northerly orientation and the extensive sand shoals associated with the mouth of the Tomahawk River (Fig. 4.285) resulting in a series of wide low wave energy though dynamic beaches.

Beach **T 1256** commences in lee of Tomahawk Point and trends to the southeast for up to 700 m to the river mouth. The beach however varies considerably in nature and length in response to floods, sand supply and river mouth conditions. The beach is fronted by 300 m wide sand flats associated with the river mouth. It was until the 1980s backed by usually 100-300 m wide bare overwash flats, which are periodically destabilised by the migration of the river mouth. These were planted in the late 1970s and are now largely stabilised and covered by shrubs. The now low vegetated barrier is backed by cleared grazing land, with public access via a footbridge crossing the 50 m wide river channel to reach the middle of the dunes.

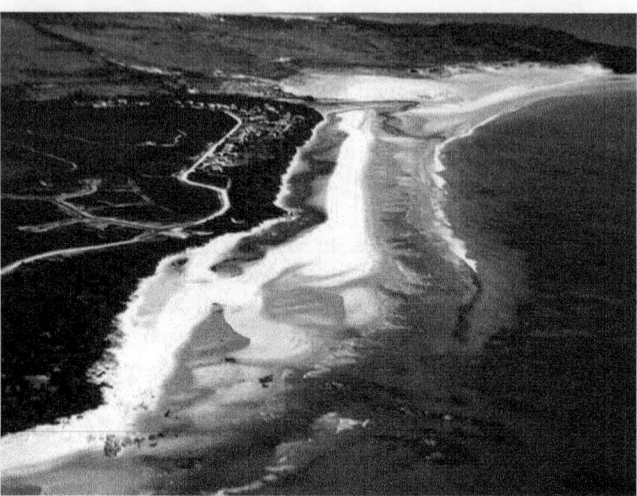

Figure 4.285 The Tomahawk River (top) and the dynamic sand spits periodically migrate from west to east across the front of Tomahawk Beach (T 1257).

Tomahawk Beach (T 1257) fronts the small settlement of Tomahawk, with the Tomahawk River Public Reserve between the beach and houses. The beach receives low refracted waves, which break across a 200 m wide low tide terrace/sand flats, together with intertidal rock outcropping across the flats. The beach extends for 1.7 m to the southeast to a rock-controlled sandy foreland and inflection in the beach. The Tomahawk Road follows the rear of the reserve with a caravan park located behind the eastern end of the beach and the beach used to launch small boats at high tide. The nature of this beach can also undergo considerable variation in response to river mouth conditions and sand supply, with at times a low sand spit and elongate lagoon forming the length of the beach.

Beach **T 1258** commences at the sandy foreland and curves to the southeast, then east for 2.9 km to the beginning of a 2 km long section of low rock and sand shore. The beach receives waves averaging about 0.5 m, which maintain a continuous low tide bar, grading into shallow sandy seafloor, then a mixture of seagrass meadows and shallow rocks and reefs. It is backed by a densely vegetated series of several foredune ridges, which are 250 m wide in the west and narrow to the east. The eastern foreland is used for launching small boats at high tide, while a small creek runs along the rear of the ridges and drains out across the centre of the beach.

T 1259-1262 TOMAHAWK (E)-MURDOCHS (W)

No.	Beach	Rating HT LT	Type	Length
T1259	Tomahawk (E1)	4 4	R+sand/rock flats	300 m
T1260	Tomahawk (E2)	4 4	R+sand/rock flats	150 m
T1261	Murdochs (W2)	4 4	R+LTT/rock flats	200 m
T1262	Murdochs (W1)	4 4	R+rock flats	900 m
Spring & neap tidal range = 1.2 & 1.0 m				

Midway between the mouth of the Tomahawk and Boobyalla Rivers is a 2.5 km long section of Carboniferous granite and granodiorite, grading east into

Devonian greywacke. The low rocks dominate the shore and extend offshore as intertidal rock flats and reefs. In amongst the rocks are four beaches (T 1259-1262).

Beach **T 1259** extends for 300 m east of the start of the low granite outcrops. It is a crenulate beach with numerous rocks outcropping along the shore and across the sand flats that extend 200 m offshore, where they are fringed by seagrass meadows. Beach **T 1260** continues east for another 150 m to the beginning of a 700 m long section of low rocky shore. It also has rocks along the beach, with clearer sand flats and then the seagrass meadows. Both beaches are backed by low densely vegetated undulating terrain.

Beach **T 1261** is a straight 200 m long northwest-facing beach located between the end of the rocky shore and a low rocky point and reef. It is slightly more exposed than its neighbouring beaches and has a narrow low tide bar, then an apron of intertidal rocks, with a shallow sandy seafloor beyond and the seagrass meadows 300 m offshore. It is backed by small foredune then dense shrubby vegetation. A 4WD track follows to the rear of the beach. Beach **T 1262** commences on the eastern side of the small point and trends to the east for 900 m. It is a continuous high tide sandy beach fronted by continuous 200 m wide intertidal rock flats, then sand and finally the seagrass meadows 400 m offshore. Low shrubby vegetation backs the beach with the 4WD track running 100 m inland parallel to the shore. A small creek draining the backing slopes flows across the centre of the beach.

T 1263 MURDOCHS BEACH

No.	Beach	Rating HT LT	Type	Length
T1263	Murdochs Beach	3→4→5	R+sand flats→LTT→TBR	4.7 km
Spring & neap tidal range = 1.2 & 1.0 m				

Murdochs Beach (T 1263) extends from the low diorite rocks of the central beaches for 4.7 km to the dynamic sandy mouth of the Boobyalla River, beyond which curves the high energy Boobyalla Beach. The beach and its backing dunes deflect the river mouth 2 km to the east. The beach is located in a transition zone from the low waves to the west to increasingly higher waves to the east. It begins as a narrow high tide beach fronted by 400 m wide sand flats for the first 1 km and as wave height increases grades into a 100 m wide low tide bar, which along the eastern 1-2 km becomes cut by low tide rips during periods of higher waves.

The beach is backed by longwalled parabolic dunes that extend up to 1 km east to the river channel. These have been stabilised during the 1980-1990s and are now largely well vegetated. The final 1 km however remains a dynamic low 100-200 m wide sand spit, which is periodically breached by the flooding river with the river channel and river mouth shoals extending up to 400 m seaward of the mouth. The entire beach and dune system

is part of a coastal reserve with the only access in the west along a track that follows the rear of the dunes.

T 1264-1265 BOOBYALLA BEACH

No.	Beach	Rating HT LT	Type inner	second	third bar	Length
T1264	Boobyalla Beach	6 6	LTT/TBR	TBR/RBB	D	9.4 km
T1265	Boobyalla (N)	6 6	LTT/TBR	TBR/RBB	-	250 m
Ringarooma Coastal Reserve						
Spring & neap tidal range = 1.2 & 1.0 m						

Boobyalla Beach (T 1264) is the highest energy beach on the northern Tasmanian coast and one of the few ocean beaches in Australia with a triple bar system (Fig. 4.286). The northwest-facing beach extends for 9.4 km from the dynamic sandy mouth of the Boobyalla River to the southern rocks of Petal Point and forms the eastern shore of the large Ringarooma Bay. The low gradient high tide beach grades into a 150 m wide transverse bar and rip inner bar which maintain up to 45 rips the entire length of the beach, with rips averaging every 200 m. The second bar extends 300 m offshore and ranges from a rhythmic bar and beach to transverse bar rip, with usually a similar number of rips. The outer bar lies 500 m offshore and is usually a shore-parallel dissipative system, which merges with the second bar along the northern 1 km of the beach.

Figure 4.286 The high energy Boobyalla Beach (T 1264) showing the inner bar at low tide, the second rip-dominated bar and more dissipative outer bar.

The beach is backed by a continuous series of east-trending longwalled parabolic dunes that reach up to 5 km inland. They cover an area of approximately 4,000 ha with about 25% active, the remainder either vegetated deflation basins or stabilised dunes. To the east they abut and in places have climbed dolerite slopes, the highest climbing dunes reaching 143 m. Older Pleistocene dunes extend up to 20 km to the east and in places reach the Musselroe Bay on the east coast. The dunes are drained by two small creeks, which cross the beach. The river mouth area and a 100 m wide strip along the beach are included in the Ringarooma Coastal Reserve. The only vehicle access to the beach is in the north via a 4WD track off the Cape Portland Road.

Beach **T 1265** is separated from the main beach by a 100 m wide dolerite point. It is a 250 m long beach with the southern rocks of Petal Point extending 200 m seaward at its northern end. The beach usually has a wide low tide bar with a rip against the northern headland then the outer bar. It is backed by a 100 m wide grassy deflation basin and then largely vegetated dunes that climb the backing slopes to reach 70 m in height 1 km inland. A 4WD track runs down the northern side of the dune to the beach and around the southern point to the main beach.

T 1266-1269 FOSTER INLET

No.	Beach	Rating HT LT	Type	Length
T1266	Lemons Beach	5 5	R+LTT	1.8 km
T1267	Home Beach	5 5	R+LTT	800 m
T1268	Semaphore Hill (E2)	3 4	R+LTT	200 m
T1269	Semaphore Hill (E1)	3 4	R+rock flats	200 m
	Cape Portland Wildlife Sanctuary		*823 ha*	
Spring & neap tidal range = 1.2 & 1.0 m				

Foster Inlet is a 2.5 km wide west-facing embayment bordered by 30 m high Petal Point to the south and 27 m high Semaphore Hill in the north. The bay is partly sheltered by the point and by Maclean and Baynes islands which lie 1-2 km off the centre of the bay. As a consequence waves are lowered to about 1 m along the eastern shore. The inlet contains four beaches (T 1266-1269) which together with the backing dune and lagoon systems are all part of the 823 ha Cape Portland Wildlife Sanctuary.

Lemons Beach (T 1266) is a slightly curving 1.8 km long low gradient sandy beach located between Petal Point and a central 250 m long 15 m high rocky point. It faces almost due west, with waves reduced by the two islands, lying directly offshore. The waves spill across the

150 m wide low tide bar and low gradient beach. It is backed by a low grassy foredune, then a series of low active and stabilised longwalled parabolic dunes extending up to 2.5 km inland, where they interfinger with the shallow Tregaron Lagoons and older Pleistocene deflection basins. Lemons Creek drains some of the lagoons and flows out in the southern corner of the beach. The access track reaches the slopes above the southern end of the beach, with an informal car park and camping area and a track down to the beach. This end of the beach is also used for launching small boats at high tide.

Home Beach (T 1267) curves to the north-northwest from the central rocks for 800 m to a sloping grass-covered rocky shore that trends west for 1 km. The beach receives waves averaging about 1 m, which break across a 150 m wide low tide bar, with rips forming against the boundary rock during periods of higher waves. It is backed by a grassy foredune then several well vegetated parabolic dunes, the longest reaching 700 m inland, then cleared grazing land (Fig. 4.287).

Beaches T 1268 and 1269 are located in a 500 m wide south-facing embayment on the northern side of the inlet. Beach **T 1268** is a 200 m long southwest-facing sheltered beach, with a narrow high tide beach and 50 m wide low tide bar, grading 100 m offshore into a rocky seafloor. It is bordered by low dolerite rocks, and backed by an old (Holocene?) east-trending well vegetated dune that extends 600 m to the east. Beach **T 1269** lies 100 m to the west and is a similar south-facing 200 m long strip of high tide sand fronted by a strip of sand then shallow rock flats including a 200 m long rock ridge off the western end, grading into deeper rock reefs. The lower slopes of Semaphore Hill extend 250 m to the southwest as a boundary point. Cape Portland, the northernmost tip of the Tasmanian mainland, lies 1.5 km to the northwest, with low rocky coast in between. Beach T 1 lies on the east coast, 1 km to the north (see Fig. 4.272).

Figure 4.287 Home Beach (T 1267) and the backing well vegetated walls of the parabolic dunes.

FLINDERS ISLAND

Flinders Island is the largest Tasmanian island, with an area of 1376 km². The island is located 55 km north of Cape Portland, the northeasternmost tip of the island, and together with Cape Barren and Clarke islands forms a 120 km long barrier across the southern half of the 220 km wide eastern entrance to Bass Strait (Fig. 4.288). Flinders Island is 65 km long with a maximum width of 28 km, and rises to its highest point at 756 m on Strzelecki Peaks. The island has one small town at Whitemark, with a second smaller community at Lady Barron. It is bordered by the large Cape Barren and Clarke islands to the south, with scores of smaller islands and islets surrounding the island, particularly off the west coast. The island has four coasts: the 73 km long beach-dominated east coast and its backing wetlands all of which is part of a series of reserves; the 44 km south coast that faces towards Cape Barren Island across 10 km wide Franklin Sound; the more crenulate 77 km long west coast which is generally sheltered to the lee of the offshore islands and reefs; and a more exposed 41 km northwest coast dominated by steep granite slopes and 316 m high Mount Killiecrankie.

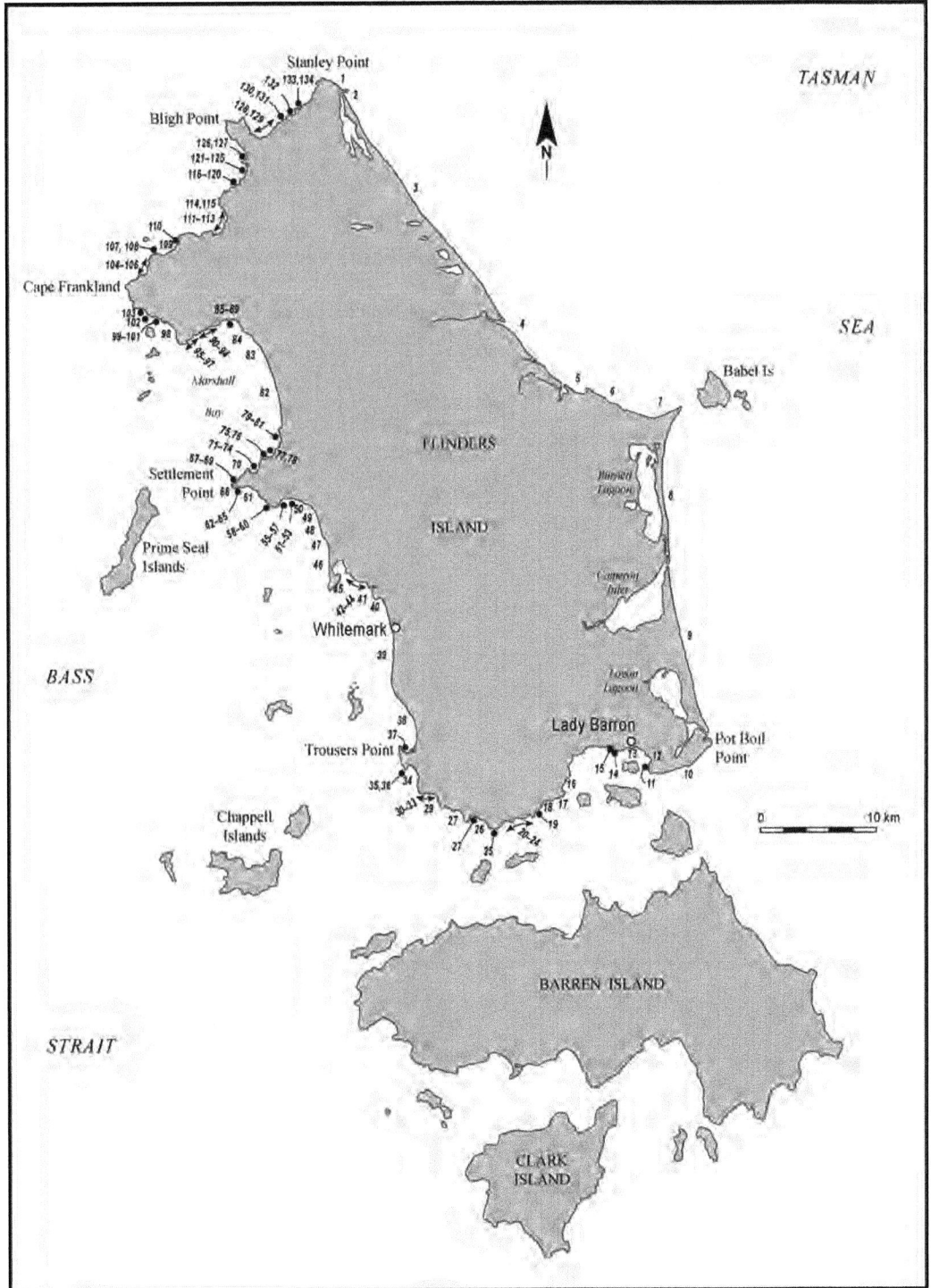

Figure 4.288 Flinders Island is the largest of a series of islands occupying the eastern entrance to Bass Strait.

FLINDERS ISLAND - EAST COAST

Stanley Point-Pot Boil Point

Length:	73 km (0-73 km)
Beaches:	9 (FI 1-9)
Reserves:	Logan Lagoon Wildlife Sanctuary
Settlements:	none

The east coast of Flinders Island extends for 73 km from the northern tip of the island at Stanley Point south to Pot Boil Point, at the eastern entrance to Franklin Sound. Apart from the rocky Stanley-Holloway points in the north and the small Red Bluff in the centre, almost the entire coast (95%) is composed of nine generally long sandy beaches exposed to moderate to occasionally high energy easterly waves, with rips dominating most of the shoreline.

FI 1-2 HOLLOWAY-FOOCHOW BEACHES

No. Beach	Rating HT LT	Type	Length
FI 1 Holloway	6 6	LTT/TBR	500 m
FI 2 North East River	6 6	LTT+tidal channel	50 m
Spring & neap tidal range = 1.3 & 0.9 m			

Stanley Point forms the northern tip of Flinders Island with the granite rocks of the point rising steeply to 148 m. On the eastern base of the point is Holloway beach (**FI 1**), a curving 500 m long north-facing sandy beach that emerges from the rocky base to connect with the small 13 m high granite slopes of Holloway Point. The beach is exposed to waves averaging 1-1.5 m which maintain a steep beach face fronted by a 50 m wide low tide terrace to transverse bar and rip surf zone, with usually one central rip, and rips against the boundary rocks. The beach is backed by a 15 m high tree-covered foredune, with the tidal entrance to North East River lagoon behind. The North East Road terminates at the beach, which has a small picnic area and toilet facilities on the shady foredune.

Beach **FI 2** is located on the southern side of Holloway Point adjacent to the 100 m wide entrance to North East River lagoon inlet. It consists of a 50 m long pocket of sand wedged in between the base of the point and a small granite outcrop, with the inlet channel trending to the west. Waves break across a shallow bar off the beach, with low waves and tidal currents also flowing into the adjacent inlet. This beach is popular with surfers, however it is potentially hazardous to swimmers owing to the deep channel and strong tidal currents. There is a small car park above the beach.

FI 3-5 FOOCHOW BEACH

No. Beach	Rating HT LT	Type	Length
FI 3 Foochow Beach	6 6	TBR/RBB	23.5 km
FI 4 Foochow Beach (S)	6 6	TBR	7.8 km
FI 5 Patriarch Inlet	6 6	TBR	1.5 km
Spring & neap tidal range = 1.3 & 0.9 m			

Foochow Beach (**FI 3**) dominates the northeast coast of Flinders Island. The main beach extends south-southeast from North East River for 23.5 km past the still visible wreck of the *City of Foochow* (1877) to Foochow Inlet and is the longest beach on the island, with the southern part of the beach (FI 4 and 5) extending for another 10.5 km to Red Bluff Point, a total of 34 km. The main beach receives easterly swell averaging 1.5 m which maintains a continuous 100 m wide transverse bar (Fig. 4.289) and rip to rhythmic bar and beach system, with occasionally an outer bar forming during periods of higher waves. The rips are spaced every 200-300 m with at times 90 rips active along the beach. The entire beach has prograded 500-800 m seaward as a series of up to 20 foredune ridges, which in places have been destabilised by overwash chutes extending 2 km south of the inlet and elsewhere by blowouts. These are backed by continuous wetlands drained in the north by Arthurs Creek and North East River Lagoon and Foochow Inlet in the south. The central wetlands include Hays, Thompsons, Hogans, Fergusons and New lagoons. The entire beach and wetland system is crown land, with no development and access only available to the inlet in the north and via Wingaroo farm perimeter to the centre of the beach between Hogans and Fergusons lagoons.

Figure 4.289 A section of the 24 km long Foochow Beach showing the backing foredune ridges and low tide bar with transverse bar and rips.

The southern section of Foochow Beach (**FI 4**) extends due southeast for 7.8 km from Foochow Inlet, past the usually closed Middle Inlet to the large shallow Patriarch Inlet. The beach receives moderate easterly swell, which

usually maintains a low gradient beach face and 50 m wide continuous transverse bar and rip system, with up to 40 rips spaced every 200 m. The beach is backed by a continuous series of up to 20 low foredune ridges, which extend 500-1,000 m inland where they are backed by a wetland, which is drained in the centre by Middle Inlet and to the south by Patriarch Inlet.

Beach **FI 5** commences on the eastern side of Patriarch Inlet and curves to the east for 1.5 km to the lee of the 11 m high sloping granite of Red Bluff. The inlet normally drains out though a shallow 50 m wide channel, which can however widen to 1 km during heavy rain. The beach receives moderate easterly swell which continues the transverse bar and rip system all the way to the bluff, where the bar widens in lee of the bluff to link with the tip of the bluff, providing an angled bar between the bluff and 300 m up the beach adjacent to a granite rock. Easterly waves refract around the point and break along the edge of the bar producing a good right-hand surf break. The beach is backed by a 700 m wide series of low Holocene foredunes, then a 1 km wide mixture of higher Pleistocene dune ridges and wetland, with the steep granite slopes of the 235 m high North Patriarch behind. A 4WD track from the inlet leads along the rear of the beach.

FI 6-7 SWIMMING BEACH

No. Beach	Rating HT LT	Type	Length
FI 6 Swimming Beach	6 6	TBR/RBB	3.8 km
FI 7 Swimming Beach (E)	5 6	TBR/LTT	4 km
Spring & neap tidal range = 1.3 & 0.9 m			

Swimming Beach (FI 6) is a northeast-facing relatively straight 3.8 km long sandy beach that extends between Red Bluff and a smaller granite outcrop. The steep high tide beach grades into a 60 m wide bar dominated by continuous transverse bar and rips (Fig. 4.290), and occasionally shifting to a rhythmic to longshore bar and trough during periods of higher waves. The rips are usually spaced about every 200 m with up to 20 forming the length of the beach, as well as a permanent rip against Red Bluff. The small Flat Islet lies 1 km off the southern end of the beach and the resulting wave refraction produces a slight protrusion in the beach. The beach is backed by a series of up to 25 foredune ridges, which widen from 700 m in the north to 1.5 km in the south, then a 3 km wide series of wetlands and lagoons, which extends back to the base of the 192 m high granite of South Patriarch in the south. Vehicle access is via a 4WD track from the inlet to Red Bluff that continues east along the rear of the beach.

Beach **FI 7** commences on the eastern side of the small granite outcrop with tidal pools around its base. It curves to the east for 4 km to the long low V-shaped **Sellars Point**. The point is a large sandy foreland formed to the lee of Babel Island, a 40 ha 200 m high granite island, located 2.5 km northeast of the point, and linked by an

inter- to subtidal tombolo. The beach is moderately sheltered from easterly waves by the island and tombolo with wave height less than 1 m at the point and increasing slowly up the beach. These maintain a low tide terrace on the point which grades to transverse bars and rips towards the boundary outcrop. A 10 m high foredune runs the length of the beach, which is backed by the 2.5 km wide series of foredunes, which continue east in lee of the beach terminating against the rear of Planter Beach (FI 8), where they interfinger with higher transgressive dunes from Planter Beach. The 4WD track from the inlet runs out to the point and provides access to the beach.

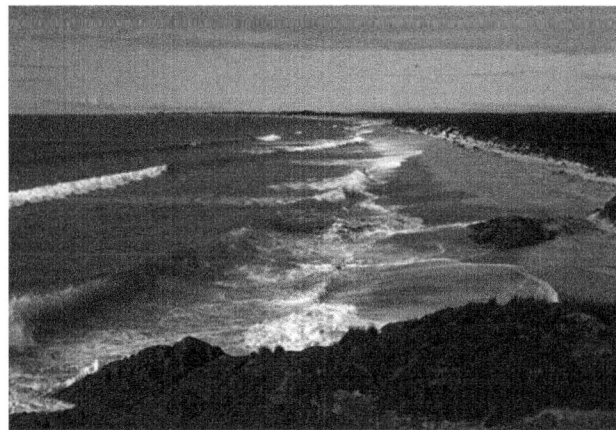

Figure 4.290 View south along Swimming Beach and its rip-dominated surf zone.

FI 8-9 PLANTER BEACH

No. Beach	Rating HT LT	Type inner	outer bar	Length
FI 8 Planter Beach	6 6	LTT	RBB	12.5 km
FI 9 Planter Beach (S)	6 6	LTT	RBB	15.4 km
Logan Lagoon Wildlife Sanctuary				
Spring & neap tidal range = 1.3 & 0.9 m				

Planter Beach is the second-longest beach system on Flinders Island. It extends for 27.9 km from Sellars Point south to Pot Boil Point, which marks the northern entrance to the 3 km wide to Franklin Channel. The beach is usually continuous, but can be divided in two (FI 8 and 9) by the 1 km wide entrance to Cameron Inlet. It is an exposed relatively high energy double-bar beach, backed entirely by crown land and in the south Logan Lagoon Wildlife Sanctuary, with vehicle access restricted to one track at Cameron Inlet.

The northern section of **Planter Beach (FI 8)** commences at the tip of the low Sellars Point and curves slightly to the south for 12.5 km to the northern side of the Cameron Inlet, the entrance usually dammed by a low 1 km long berm blocking the backing 1,200 ha lagoon (Fig. 4.291). The beach is well exposed to easterly waves which average up to 1.5 m and interact with the fine beach sand to maintain a low gradient beach face usually grading into a low tide terrace, which is cut by numerous rips during higher waves. Just south of the point the

beach is paralleled by an outer rhythmic bar the entire length of the beach, which during high waves shifts to a longshore bar. At times up to 60 rips are active across the inner and/or outer bar. The entire system is backed by a narrow Holocene barrier consisting of several foredune ridges grading into transgressive dunes along the northern kilometre, which abut the ridges behind Swimming Beach (FI 7) in the north. The ridges are backed by the 8 km long Sellars Lagoon and the smaller Kidney and Halfmoon lagoons and associated wetlands along the remainder. The only vehicle access runs along the northern side of Cameron Inlet to reach the beach at East River Bluff, an 18 m high scarped foredune.

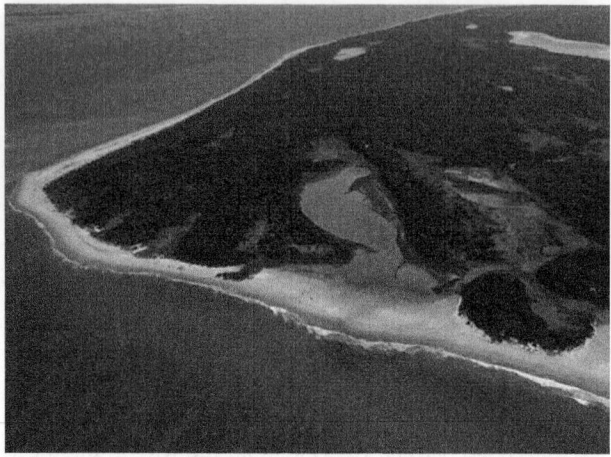

Figure 4.292 Pot Boil Point forms the southeastern tip of the island and is surrounded by strong tidal currents and extensive sand shoals. Planters beach (FI 9) lies to the right and Pot Boil beach (FI 10) extends into Franklin Sound to the left.

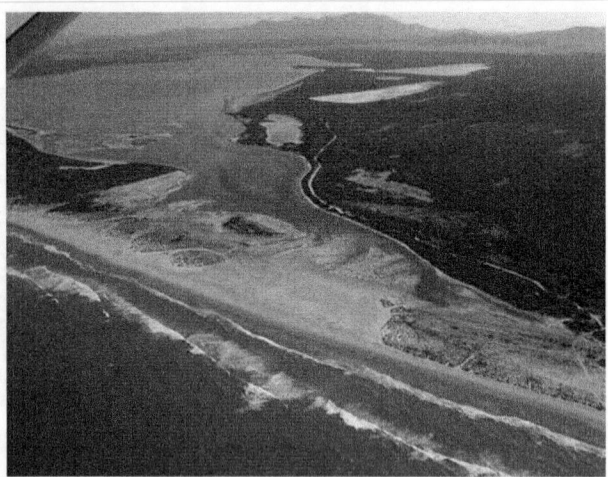

Figure 4.291 The blocked mouth of Cameron Inlet, which divides the long, Planters Beach in two. A longshore bar parallels the beach.

The southern section of the beach (**FI 9**) commences on the southern side of the inlet and continues to curve slightly to the south for another 15.4 km to Pot Boil Point. The moderate easterly waves continue down the beach, as does the inner low gradient beach and low tide terrace, with the outer bar 100 m offshore. Towards Pot Boil Point the beach becomes influenced by the extensive tidal shoals that extend up to 4 km offshore. The shoals lower waves at the beach, induce more crenulations in the shoreline, as well as directing strong tidal currents parallel to the shore. In addition the 800 ha Logan Lagoon occasionally breaks out across the beach, 1 km north of the point (Fig. 4.292). Between Cameron Inlet and the Logan Lagoon inlet the beach is backed by a continuous series of up to 20 foredune ridges which range from 500-1,000 m in width, and which are backed by 3 km wide Logan Lagoon, as well as Muddy, North and South Chain lagoons. There is a 4WD track between South Chain and Logan lagoons, which with difficulty can be used to reach the beach. The whole of Logan Lagoon and the southern 6 km of the beach-barrier, as well as much of beach FI 10, are part of the Logan Lagoon Wildlife Sanctuary.

FLINDERS ISLAND-SOUTH COAST

Pot Boil Point to Trousers Point

Length:	44 km	(73-117 km)
Beaches:	26	(FI 10-36)
Reserves:	Logan Lagoon Wildlife Sanctuary	
Settlements:	Lady Barron	

The south coast of Flinders Island extends for 44 km from the low sandy Pot Boil Point and its extensive tidal shoals, to the granite of Trousers Point. The entire shoreline faces south across the 7-10 km wide Franklin Sound to Cape Barren Island, with several islands located in the sound. The eastern half of the coast is relatively low with granite outcropping around Lady Barron. The western half is backed by densely vegetated granite slopes rising 100-300 m and with all the beaches bounded by granite points and headlands. As a result of the sound and its numerous islands, as well as islands west of the western sound entrance, the shoreline is relatively low energy, with reflective beaches dominating and many fronted by intertidal sand flats and fringed by seagrass meadows. A total of 26 beaches occupy 18 km (41%) of the shore, the remainder dominated by sloping granite rocks.

Lady Barron is the only settlement on the south coast, and has a store, hotel and small port. The Coast Road and Pot Boil Road provide access to all of the eastern beaches (FI 10-16), with the beaches between Badger Corner and Big River (FI 17-26) only accessible on foot, while the Big River Road runs past the western beaches (FI 27-36).

FI 10 POT BOIL BEACH

No.	Beach	Rating HT LT	Type	Length
FI 10	Pot Boil Beach	4 4	R+tidal shoals	6 km
Spring & neap tidal range = 1.3 & 0.9 m				

Pot Boil beach (**FI 10**) is a crenulate 6 km long south- to southwest-facing reflective beach that extends from Dick Davey Shoal in the east to Pot Boil Point in the west where it forms the eastern entrance to Franklin Sound and is dominated by the strong tidal currents that flow through the 3 km wide entrance. The beach is largely sheltered from ocean waves by the Pot Boil tidal shoals that extend 3 km seaward of the eastern end of the beach, as well as the southern shoals off Vansittart Island, which extend several kilometres offshore. The Pot Boil shoals narrow to the west extending halfway along the beach. As a consequence the beach receives low easterly swell together with westerly wind waves generated inside the sound. These processes have built a series of several recurved spits that are hinged to the western end of the beach, splaying to the east where they widen to 2 km and have blocked the southern end of Logan Lagoon. The eastern half of the beach and spits are part of the Logan Lagoon Wildlife Sanctuary. The beach can be accessed in the centre along the Pot Boil road and the track that follows the sanctuary boundary track.

FI 11-15 WHITE & YELLOW BEACHES

No.	Beach	Rating HT LT	Type	Length
FI 11	White Beach	2 2	R	1.8 km
FI 12	Yellow Beach	2 2	R	700 m
FI 13	Silas Beach	2 2	R	700 m
FI 14	Store Pt (W)	1 1	R	150 m
FI 15	Gunters Bay	1 1	R+sand flats	600 m
Spring & neap tidal range = 1.3 & 0.9 m				

Dick Davey Shoal marks the eastern boundary of Adelaide Bay, a 7 km wide south-facing crenulate bay that faces into Franklin Sound, with several islands occupying most of the bay mouth. The backing shoreline receives low wind waves and has several low energy beaches in the east (FI 11-15) with tidal flats dominating the centre and west. To the west of Dick Davey Shoal is a curving 3 km wide southwest-facing embayment sheltered by 80 ha Little Green Island with the small port and settlement of Lady Barron located behind its eastern boundary at Store Point. Three beaches (FI 11-13) occupy most of the eastern shore of the bay, with beach FI 14 located immediately west of the bay.

White Beach (**FI 11**) is a double crenulate low energy reflective beach composed of white sand, that extends for 1.8 km north of Dick Davey Shoal to a sloping granite point, with much of the beach sheltered from westerly wind waves by Little Green Island as well as the small Billy Goat Reefs which lie 500 m off the beach. The beach has a low gradient, with seagrass debris usually littering the high tide line, and seagrass meadows lying within 100 m of the shore. It is backed by a continuous low foredune with vehicle access to the northern end.

Yellow Beach (**FI 12**) extends north of the boundary granite point for 700 m, spiralling to the northwest then west. It is a narrow sheltered low energy beach, with a 10 m wide high tide beach and seagrass growing to within 50 m of the shoreline. It is backed by a low grassy foredune then scarped 15 m high Pleistocene dunes, the source of the yellow sand.

Silas Beach (**FI 13**) lies 150 m to the west, with a sloping granite point and islets in between. The beach curves to the west for 700 m and faces due south towards Little Green Island. This is a low energy low gradient reflective beach, with seagrass growing to within 20 m of the shoreline (Fig. 4.293). Several boats are usually moored off the western end of the beach in lee of the granite point that extends 200 m to the south. The beach is backed by a low grassy foredune and road, with a picnic shed in the centre and scarped yellow Pleistocene dune sands rising to 15 m.

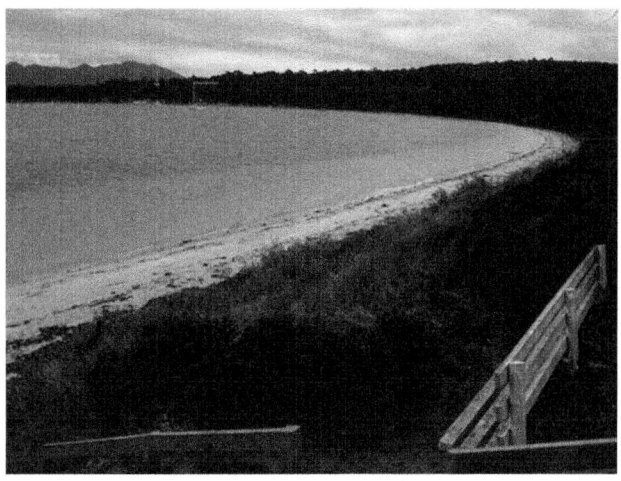

Figure 4.293 Silas Beach, a sheltered lower energy south coast beach.

To the west of Silas Beach are 2 km of granite shoreline backed by the settlement of Lady Barron, with the jetty located on the central Store Point. To the west of Store Point is beach **FI 14**, which occupies a 150 m long strip at the northern base of a 300 m wide granite bay. It faces dues south towards Fisher Reef and Island located 500 m off the shore. It is a narrow high tide beach that grades into seagrass meadows and is bordered by sloping granite points to either end, backed by densely vegetated bluffs rising to 10 m, with the road behind.

Gunters Bay is a 300 m wide southwest-facing very low energy bay that lies to the lee of Point Reid, the westernmost section of the granite shore. The beach (**FI 15**) occupies 600 m of the curving southwest-facing shore of the bay continuing to the west to finally grade into the tidal flats of Petrification Bay. It receives low wind

waves generated across 5 km wide Petrification Bay and consists of a 5 m wide high tide beach fronted by intertidal sand flats, with the South Coast road running right behind.

FI 16-19 BADGER CORNER-TONGUE POINT

No.	Beach	Rating HT LT		Type	Length
FI 16	Badger Corner	1	1	R+sand flats	400 m
FI 17	Tommy Rews Pt(W)	2	1	R+sand flats	200 m
FI 18	Watering Beach	2	1	R+sand flats	600 m
FI 19	Tongue Pt (E)	2	1	R+sand flats	150 m
Spring & neap tidal range = 1.3 & 0.9 m					

Badger Corner is located at the western side of Adelaide Bay, to the lee of Tommy Rews Point, which forms the bay's eastern boundary. To the west of the point are 6 km of southwest-trending shoreline with eight small sheltered beaches (FI 17-24) all bounded by south-trending greywacke rocks and points and all fronted by sand flats that widen to the western end of the beaches. There is vehicle access to Badger Corner, with the remaining shoreline accessible on foot or by boat.

Badger Corner beach (**FI 16**) is a curving 400 m long northeast-facing narrow strip of high tide sand and rock fronted by 200 m wide sand flats. Conditions are usually calm. A gravel road terminates at the point where there is a boat ramp on the point and a small picnic area. Tree-covered slopes gradually rise to 220 m to the west.

Beach **FI 17** lies 1 km southwest of Tommy Rews Point and consists of a 200 m long narrow strip of high tide sand and rocks, fronted by a 50 m wide sand flat fringed by seagrass. It is bordered by rocky shoreline with densely vegetated slopes gradually rising behind, and a rough 4WD track running along the rear of the beach.

Watering Beach (**FI 18**) is a curving 600 m long, south-facing low energy beach bordered by gradient rocks to either end, with a small creek draining across the centre. The beach is only 1-2 m wide at high tide with a 20 m wide sloping beach grading into 100 m wide sand and rock flats. Densely vegetated slopes back the beach, with the walking track running along the rear.

Beach **FI 19** is located midway between Watering Beach and Tongue Point and lies 600 m north of the south-trending 20 m high greywacke point. The beach consists of a 150 m long strip of high tide sand that faces south across 100 m wide intertidal sand flats, with several large rock outcrops across the flats. Densely vegetated points border each side with tree-covered slopes behind. The walking track clips the western end of the beach.

FI 20-24 TONGUE POINT-PIGS HEAD POINT

No.	Beach	Rating HT LT		Type	Length
FI 20	Reddins Ck	2	1	R+sand flats	300 m
FI 21	Reddins Ck (W)	2	1	R+sand flats	100 m
FI 22	Joes Ck	2	1	R+sand flats	500 m
FI 23	Joes Ck (W)	2	1	R+sand flats	50 m
FI 24	Pigs Head Pt (W)	2	1	R+sand flats	500 m
Spring & neap tidal range = 1.3 & 0.9 m					

Tongue Point is one of a series of south-trending granite points that continue 3 km to the southwest to the larger granite Pigs Head Point. In between the two points are five small embayed beaches (FI 20-24), all bordered and backed by densely vegetated granite slopes rising 200-300 m. The small embayments are filled with intertidal sand flats and subtidal seagrass meadows, with a deeper tidal channel running parallel to the shore off the points. A walking track follows the rear of the coast and provides access to most of the beaches.

Beach **FI 20** is bordered to the east by 15 m high Tongue Point, which extends 200 m to the south, and to the west by rocky shore trending 500 m southward. The beach is composed of yellow sand and curves for 300 m between the sloping rock boundaries facing due south into the sound. The beach is a low gradient 20 m wide high tide beach grading into sand flats that widen to 150 m to the west where Reddins Creek drains onto the beach, with seagrass fringing the edge of the flats. It is backed by a low, in places scarped, foredune.

Beach **FI 21** is a 100 m long pocket of white sand located 500 m southwest of Reddins Creek mouth and bounded by two small granite points. The beach has a low densely vegetated foredune, a 20 m wide high tide beach, and sand flats that widen to 100 m against the western granite rocks with seagrass beyond (Fig. 4.294).

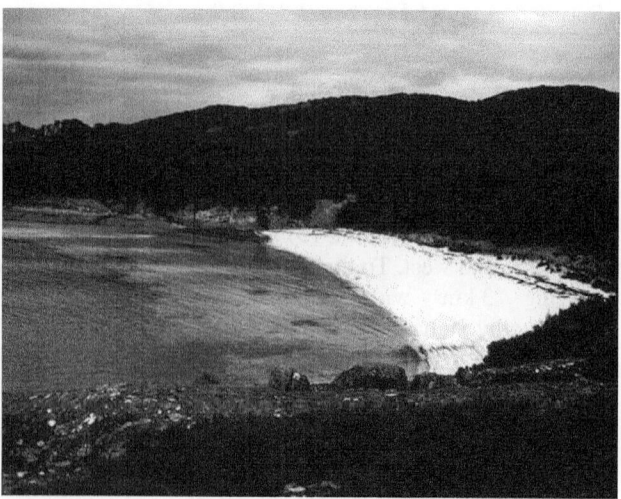

Figure 4.294 The steep white sands and sand flats of beach FI 21.

Beach **FI 22** lies 100 m to the west and is a 500 m long beach with Joes Creek draining across the western end. It is bordered by granite points with the 15 m high western point extending 500 m to the south. The white sand beach is backed by a low scarped dense tea-tree-covered foredune, with a 200 m wide low foredune plain behind, then gradually rising tree-covered slopes. The beach has a sloping 20 m wide high tide beach fronted by sand flats that widen from 50 m in the east to 100 m in the west. Beach **FI 23** is located halfway along the western point and consists of a 50 m long pocket of high tide sand bordered and bisected by sloping granite rocks. It faces east across the outer sand flats of the main Joes Creek beach (FI 22).

Beach **FI 24** lies on the western side of the 100 m wide point and curves to the west for 500 m to the base of Pigs Head Point which extends 1.2 km to the southwest. The beach is composed of slightly coarser yellow sand with a moderate gradient high tide beach and sand flats that widen to 100 m in the west and extend out along the western rocks, with seagrass meadows beyond (Fig. 4.295). It is backed by a 200 m wide series of several foredune ridges, then densely vegetated slopes rising to 300 m.

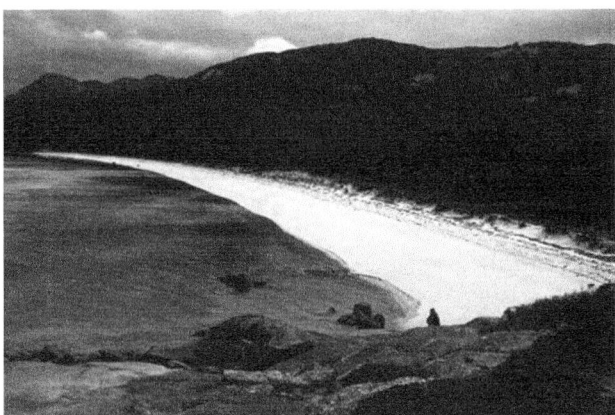

Figure 4.295 Beach FI 24 has a moderately steep beach face fronted by intertidal sand flats.

FI 25-28 **BIG RIVER COVE**

No.	Beach	Rating HT LT	Type	Length
FI 25	Pigs Head Pt (W)	2 2	R+sand flats	50 m
FI 26	Little River	2 2	R+sand flats	900 m
FI 27	Big River Cove	2 2	R+sand flats	900 m
FI 28	Sarah Blanche Pt (W)	2 2	R+sand flats	400 m
Spring & neap tidal range = 1.9 & 1.6 m				

The round granite rocks of Pigs Head Point mark the southern tip of Flinders Island. To the west the shoreline trends west-northwest for 9.5 km to the southern end of Trousers Point. In between are 14 km of crenulate shoreline containing 11 beaches, all bordered by sloping granite rocks and points, with the granite rising inland to 615 m high Mount Razorback. The first four beaches (FI 25-28) are located along the first 4 km of the shoreline. The beaches all face southwest and are more exposed to

the strong westerly winds and low westerly wind waves, whose fetch is limited by the numerous reefs and islands that extend out from the sound entrance.

Beach **FI 25** is a 50 m long pocket of southwest-facing sand wedged in between sloping granite rocks on the western side of the point. The beach receives low wind waves, but is sufficiently exposed to the prevailing westerly winds for some minor dune transgression to have blown sand up over the backing 15 m high rocky slopes. The beach has a 20 m wide high tide swash zone, with central rock outcrops and 50 m wide sand flats, with dense seagrass beyond. It can only be accessed on foot around the rocks at low tide.

Beach **FI 26** commences 700 m west of the point and is a slightly curving southwest-facing 900 m long beach, bordered by 15 m high sloping granite points, with **Little River** draining across the western end of the beach. The beach consists of a low gradient high tide reflective beach in the more exposed east, grading into 50 m wide sand flats in the west, with seagrass fringing at low tide the length of the beach. It is backed by a densely vegetated foredune that increases in size to the east where it has transgressed up to 500 m inland and to an elevation of 45 m. The high foredune is scarped towards the east exposing mid-Holocene paleosols.

Big River Cove is located at the mouth of Big River, with the beach (**FI 27**) curving to the west of the small river mouth for 900 m to the 100 long boundary granite point. The beach faces west-southwest and is sheltered by Sarah Blanche Point, which extends 800 m to the south of the river mouth. The beach grades from a low energy reflective in the east with seagrass growing to the shore, to a reflective beach fronted by 200-300 m wide sand flats adjacent to the western corner and river mouth. The river has been deflected 200 m to the west with a spit backing this section of the beach and a foredune increasing to 25 m in height to the east. The Big River Road terminates at the river, with a walking track through to the beach.

Beach **FI 28** is located 1 km northwest of Sarah Blanche Point. It is a curving 400 m long south-facing reflective beach, bordered to the west by a 10 m high granite point. The beach is low gradient, with seagrass growing along the base of the eastern half while sand flats widen to 50 m in the west (Fig. 4.296). A 4WD track off the Big River Road runs straight down to the rear of the beach.

FI 29-33 **BUFFALOS BEACH**

No.	Beach	Rating HT LT	Type	Length
FI 29	Buffalos Beach	2 2	R+sand flats	800 m
FI 30	Cronleys Creek (W1)	2 2	R+sand flats	60 m
FI 31	Cronleys Creek (W2)	2 2	R+sand flats	40 m
FI 32	Cronleys Creek (W3)	2 2	R+sand flats	30 m
FI 33	Holts Point (E)	2 2	R	50 m
Spring & neap tidal range = 1.9 & 1.6 m				

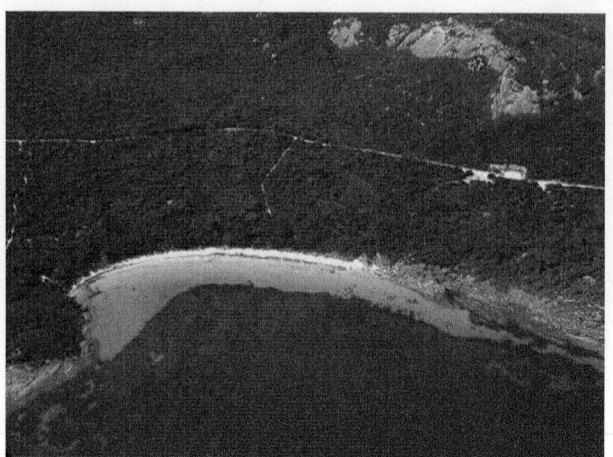

Figure 4.296 Beach FI 28 is a sheltered reflective beach with seagrass going almost to the shore.

Buffalos Beach occupies the eastern side of an open 1.5 km wide southwest-facing rocky embayment, backed by densely vegetated granite slopes rising to 705 m high Mount Belstead, all drained by Cronleys Creek, which crosses the western end of the beach. Fifteen-metre high Holts Point forms the western boundary of the bay. The entire shoreline of the bay is a coastal reserve, however it is backed by private land between the reserve and Big River Road with no public access from the road. A total of five beaches (FI 29-33) are located in the embayment.

Buffalos Beach (FI 29) is an 800 m long southwest-facing reflective beach that grades into patchy seagrass meadows within 50 m of the shore. It is bordered and interrupted by granite rocks in the east and terminates at a small granite point and sandy creek mouth in the west. It is backed by a 200 m long spit in the west, with a 20 m high foredune exposed to the strong westerly winds behind the remainder. A few houses are scattered on the backing slopes, with the road located 500 m inland.

Beach **FI 30** lies 50 m to the west and is a 60 m long pocket of sand wedged between two small granite points. The beach is reflective with seagrass lying 50 m offshore. It is backed by a low grassy foredune then partly cleared slopes with a house behind the western end of the beach. Beach **FI 31** lies another 50 m further west and is a 40 m long pocket of sand wedged between two sloping points that extend 80 m seaward. It is a low energy reflective beach, with the seagrass extending across the seafloor in line with the two points. It is backed by partly cleared slopes. Beach **FI 32** is the final pocket of sand located another 200 m to the west. It consists of a curving 30 m long sandy beach wedged between two low granite points that converge off the beach, with a 10 m wide gap for waves to reach the beach. The points and rear of the beach are covered in dense vegetation, with access only around the rocks.

Beach **FI 33** lies 100 m to the west and 500 m east of Holts Point. It is a slightly curving 50 m long south-facing reflective beach, bordered by sloping granite rocks and backed by a small foredune and a dry lake, with partly cleared slopes behind.

FI 34-36 TROUSERS POINT BEACHES

No.	Beach	Rating HT LT	Type	Length
FI 34	Trousers Point Beach	5 5	LTT/TBR	1.8 km
FI 35	Trousers Point (S 1)	3 3	R	50 m
FI 36	Trousers Point (S 2)	3 3	R	50 m
	Strzelecki National Park			
Spring & neap tidal range = 1.9 & 1.6 m				

Trousers Point is a 2.2 km long 30 m high granite point that forms the boundary between the south coast and the beaches facing into Franklin Sound and the west coast of the island. The point and an area 500 m inland are the only coastal part of the large Strzelecki National Park, with a picnic and camping area on the southern tip of the point. The southern side of the point borders a 1.5 km wide southwest-facing embayment containing three beaches (FI 34-36).

Trousers Point Beach (FI 34) is a curving 1.8 km long beach that trends north of Holts Point finally curving to the west in lee of Trousers Point (Fig. 4.297). The low gradient beach is exposed to periodic higher westerly wind waves, which arrive from either north or south of the Chappell Islands, located 10 km to the west. The waves are sufficiently high to maintain a low tide terrace to occasionally transverse bar and rips system, with up to 10 rips forming along the beach spaced every 150-200 m, while seagrass grows in deeper water about 200 m offshore. The beach is backed by a continuous 10-15 m high grassy foredune, with cleared farmland behind, then steep partly bare granite slopes rising to 670 m high Lovetts Hill. A 40 ha wetland backs the northern end of the beach and occasionally breaks out across the beach. The beach is accessible in the northern corner, which borders the national park.

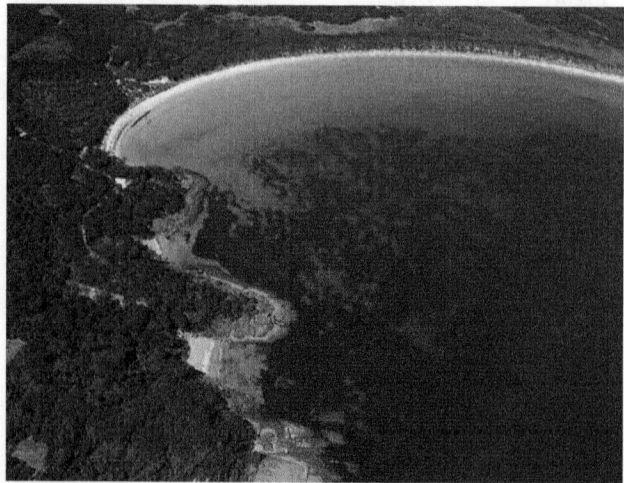

Figure 4.297 Trousers Point Beach (FI 34) curving round to the lee of the point, which contains the two pocket beaches (FI 35 & 36) in foreground.

Beach **FI 35** lies 100 m into the national park and is a 50 m long pocket of reflective sand that faces south along the main beach. It is bordered by sloping granite points and surrounded by densely vegetated slopes. Seagrass grows to within 50 m of the shore. Beach **FI 36** lies 100 m further west and is a near identical 50 m long south-facing reflective beach, bordered by sloping granite points, with a few rocks, then seagrass off the beach. A car park, picnic and camping area are located in amongst the tree-covered slopes behind.

FLINDERS ISLAND - WEST COAST

Trousers Point to Cape Frankland

Length: 77 km (117-194 km)
Beaches: 67 (FI 37-103)
Reserves: Wybalena historic site
Settlements: Whitemark, Emita

The west coast of Flinders Island faces squarely into the prevailing westerly winds, however it is largely sheltered from the high westerly waves of the Strait by numerous islands and reefs that lie along the coast and extend up to 20 km offshore, resulting in reduced and often very low waves at the shore. The island's only town, Whitemark, is located on the coast, with a small settlement further north at Emita. A total of 67 generally small beaches occupy 50 km (64%) of the shoreline, with granite boulders and rocky slopes dominating much of the remainder.

FI 37-40 FOTHERINGATE-WHITEMARK BEACHES

No.	Beach	Rating HT LT		Type	Length
FI 37	Fotheringate (S)	3	3	LTT	100 m
FI 38	Fotheringate Beach	5	5	LTT/TBR	5.9 km
FI 39	Whitemark Beach	2	1	R+sand flats	5.9 km
FI 40	Bluff Beach	2	1	R+sand flats	4.8 km
Spring & neap tidal range = 1.9 & 1.6 m					

The northern tip of Trousers Point marks the southern boundary of Fotheringate Bay, which forms the southern embayment of a double crenulate beach system formed to the lee of Big Green Island, with Parrys Bay occupying the northern portion. Four beaches (FI 37-40) occupy the entire 14 km of the continuous shoreline of the two bays. The island's only town, Whitemark, and its jetty are located in Parrys Bay.

Beach **FI 37** is a 100 m long strip of low gradient sand wedged between the eastern side of Trousers Point and a cluster of round granite rocks that litter the eastern end of the beach and form a low 50 m wide point. The narrow strip of high tide beach grades into a 100 m wide low tide

terrace, which continues past the base of the rocks to the main beach. The beach is backed by a narrow coastal reserve, with the national park to the west and cleared farmland and one holiday shack to the east.

Fotheringate Beach (FI 38) commences at the low rocks and curves initially to the northeast (Fig. 4.298), then east for 5.9 km to Lagoons Point, the long low sandy foreland formed to the lee of Big Green Island. The wide low tide terrace continues for the first few hundred metres past the shallow sandy mouth of Fotheringate Creek. As the beach trends north wave energy increases sufficiently for rips to form during periods of higher waves, their morphology often remaining for some months during the ensuing lower wind waves. Up to 10 rips extending 100 m seaward and spaced 200-300 m can occupy the centre of the beach. The northern section becomes increasingly sheltered by the island and maintains a 50 m wide low tide terrace. The beach is backed by a continuous foredune, which is scarped in places and has transgressed up to 100-200 m inland reaching heights of 20 m, with a drained wetland and farmland behind. The northern wetland is drained by Fergusons Creek across the centre of the beach. The only public access to the beach is in the southern corner.

Figure 4.298 The sheltered southern end of Fotheringate Beach, together with Fotheringate Creek.

Whitemark Beach (FI 39) commences at Lagoons Point and trends almost due north for 5.9 km to the Whitemark jetty, which cuts the once continuous beach in two (Fig. 4.299). Extensive sand flats and seagrass meadows extend to the lee of Big Green Island, linking with Lagoons Point, with 500 m wide flats continuing all the way to Whitemark and beyond. The island and flats lower waves to less than 0.5 m at the shore, where they maintain a steep, narrow high tide beach to the lee of the wide intertidal flats. At Whitemark a channel has been dredged to permit vessels to reach the 100 m long jetty. A low stable foredune continues along the beach past the golf course to Whitemark, with a second drain crossing the beach on the southern boundary of the golf course. There is a boat ramp at the jetty and a picnic area just south of the town.

Figure 4.299 Whitemark with the very low energy Whitemark Beach (Fl 39) to the south and Bluff Beach (Fl 40) to the north.

Bluff Beach (Fl 40) commences at the Whitemark jetty and trends north for 2.5 km, before spiralling round to the west in lee of a low spit at its northern end called The Bluff. The sand flats continue north widening to 3 km off the northern end and The Bluff. The low, narrow high tide beach is backed by a low foredune and vegetated overwash flats extending up to 500 m inland, then a drained wetland called Little Lagoon. The beach can be accessed along Beach Road, which parallels the rear of the beach and in the north along Bluff Road.

Fl 41-45 PARRYS BAY (N)

No.	Beach	Rating HT LT		Type	Length
Fl 41	The Bluff	1	1	R+tidal flats	1.2 km
Fl 42	Pats River	1	1	R+tidal flats	900 m
Fl 43	Parrys Bay (N1)	1	1	R+tidal flats	400 m
Fl 44	Parrys Bay (N2)	1	1	R+tidal flats	800 m
Fl 45	Long Point (E)	1	1	R+tidal flats	500 m
Spring & neap tidal range = 1.9 & 1.6 m					

The Bluff is an 11 m high vegetated dune that marks the northern end of the long Whitemark beaches, and the beginning of the very low energy northern section of Parrys Bay, which is bordered by the low Long Point 3.5 km to the west. Between the two points are 6 km of very low energy southwest- to south-facing shoreline, all fronted by extensive tidal flats.

Beach **Fl 41** commences at the southern tip of The Bluff which recurves round to the east into Double Corner. The beach initially trends west, then curves to the northwest for a total of 1.2 m, terminating at the small mouth of Pats River. The beach consists of a 20 m wide high tide moderate gradient sandy beach, fronted by 100 m wide tidal flats in the south that widen to 500 m off the river mouth where they are also covered with a veneer of sand from the river. A narrow coastal reserve backs the beach, then the densely vegetated Bluff dunes rising to 11 m,

which are part of the largely cleared Bluff farm which extends north to the river.

Beach **Fl 42** commences on the northern side of the 50 m wide river mouth and trends to the northwest for 900 m. It is a narrow 10 m wide high tide beach fronted by 200 m wide tidal flats. It is backed by a continuous low scrub-covered foredune, part of the narrow reserve, then the Flinders Island Airport. Beach **Fl 43** lies 600 m to the west and is a southwest-facing 400 m long very low energy high tide strip of sand, with a central rock outcrop and fronted by 300 m wide tidal flats. Low terrain covered by scrubs and trees backs the beach.

Beach **Fl 44** commences 200 m to the west and is a curving southwest-facing 800 m long narrow strip of high tide sand, fronted by tidal flats that extend up to 1 km west to Long Point. A shallow 100 ha embayment extends north of the two points and backs Long Point and Long Point Beach (Fl 47). Low scrub-covered land backs the beach, with a small creek draining out across the northern end.

Beach **Fl 45** lies on the western side of the embayment on the inside eastern side of Long Point. It faces east towards beach Fl 44 and consists of a curving 500 m long strip of high tide sand fronted by the 1 km wide tidal flats. The low densely vegetated Long Point backs the beach.

Fl 46-49 ARTHUR BAY (S)

No.	Beach	Rating HT LT		Type	Length
Fl 46	Long Point Beach	2	1	R+sand flats	4 km
Fl 47	Blue Rocks	2	1	R+sand flats/rocks	400 m
Fl 48	Blue Rocks (N1)	2	1	R+sand flats	800 m
Fl 49	Blue Rocks (N2)	2	1	R+sand flats	1.4 km
Spring & neap tidal range = 1.9 & 1.3 m					

Arthur Bay is a shallow 7 km wide southwest-facing bay bordered by Long Point to the south and a low granite point to the north. The bay shoreline trends north from Long Point before curving round to the west then southwest in the northern Sawyers Bay, with a total shoreline length of 11 km. While granite rocks dominate much of the northern bay shore it contains 12 near continuous low energy reflective beaches (Fl 46-57). Most are accessible off the Long Point, Palana and Sawyers Bay roads. Beaches Fl 46-49 occupy the first 6.5 km of the eastern bay shoreline and face due west towards the southern Chalky Island, 5 km west of Long Point, and the larger Prime Seal Island, 16 km offshore. The islands shelter most of the bay shore from westerly waves, resulting in more fetch-limited conditions. These combine with the shallow bay floor resulting in a low energy shoreline. As a consequence the beaches receive low (<1 m) short wind waves, with low energy reflective conditions prevailing and seagrass growing close to the shore along the entire bay.

Long Point Beach (FI 46) is a relatively straight 4 km long beach that faces due east toward Prime Seal Island (Fig. 4.300). It is a 20 m wide moderately steep high tide beach, usually littered with seagrass debris, which is fronted by intertidal sand flats that widen from 100 m in the south to 300 m in the north, with seagrass meadows beyond. It is backed by a continuous low grassy foredune grading into scrub-covered overwash flats, which are cleared in the centre, with the 1 km wide intertidal flats backing the southern half of the point. The beach is accessible in the centre and south along the gravel Long Point Road.

Figure 4.300 Long Point Beach extends due north of the point. The west-facing beach is sheltered by inshore islands.

Blue Rocks are a collection of rounded granite rocks and boulders that form the northern boundary of Long Point Beach. Beach **FI 47** is located in amongst the rocks and trends 400 m to the northwest to the end of the rocks. It consists of patches of high tide sand fronted by scattered rocks and 300 m wide sand flats in the south, which narrow to 100 m in the north. It is backed by partly cleared farmland, with a few houses located on the backing slopes and the Palana Road running 300 m inland.

Beach **FI 48** commences at the northern end of the low rounded Blue Rocks and trends straight north-northwest for 800 m to the next collection of rocks. It has a 20 m wide moderate gradient high tide beach fronted by 200 m wide sand flats then seagrass meadows. It is backed by a low grassy foredune, then gradually rising partly cleared private land, with a few houses in amongst the trees.

Beach **FI 49** extends north of the granite boundary rocks and slight shoreline inflection for 1.4 km to the next set of rocks and westerly inflection in the shore. It is a straight high tide sand beach, fronted by sand flats, which narrow to 50 m, with dense seagrass beyond. A low grassy foredune cut by two small creeks backs the beach, with gently sloping cleared farmland behind.

FI 50-57 SAWYERS BAY

No.	Beach	Rating HT LT		Type	Length
FI 50	Sawyers Bay (1)	2	2	R+sand flats/rocks	250 m
FI 51	Sawyers Bay (2)	2	2	R+sand flats/rocks	800 m
FI 52	Sawyers Bay (3)	2	2	R+sand flats/rocks	500 m
FI 53	Sawyers Bay (4)	2	2	R+sand flats/rocks	900 m
FI 54	Sawyers Bay (5)	2	2	R+sand flats/rocks	800 m
FI 55	Sawyers Bay (6)	2	2	R+sand flats/rocks	250 m
FI 56	Sawyers Bay (7)	2	2	R+sand flats/rocks	200 m
FI 57	Sawyers Bay (8)	2	2	R+sand flats/rocks	80 m
Spring & neap tidal range = 1.9 & 1.6 m					

Sawyers Bay is located in the northern corner of the larger Arthur Bay, with the slopes of 216 m high Wireless Hill forming the western boundary of both bays. The entire bay shore consists of granite boulders and reefs, with eight low energy reflective beaches located in amongst the rocks (Fig. 4.301). They are all sheltered by the western point and Prime Seal Island and receive only low wind waves, with seagrass growing to the shore. The entire curving south-facing 4 km long coastal strip is a coastal reserve, with cleared grazing land behind. The only public access is at the end of the Sawyers Bay Road, which leads to a picnic area and beach FI 54.

Figure 4.301 The western end of rocky Sawyers Bay with beaches FI 53-57 located amongst the rocks.

Beach **FI 50** marks the transition from the longer sandy beaches to the south to the rock-dominated beaches to the west. It is a 250 m long, southwest-facing strip of high tide sand, with sloping granite rocks and reefs dominating the intertidal zone and extending 50-100 m offshore to the seagrass meadows, with only a few patches of clear intertidal sand. A low grassy foredune then partly cleared farmland backs the beach, with a small creek draining out across the central rocks.

Beach **FI 51** continues immediately to the west and is an 800 m long sandy beach dominated by rounded granite rocks and slopes to either end, with a more sandy central section, though rocks continue to dominate the low to subtidal area, intermixed with the seagrass meadows which extend to low tide. A 50 m low wide grassy

foredune, then partly cleared grazing land, back the beach.

Beach **FI 52** occupies the next slightly curving 500 m long rocky embayment. It has a near continuous sandy high tide beach, with continuous inter- to low tide granite rocks, then seagrass. It is backed by a narrow grassy foredune, a band of scrubs, then cleared farmland.

Beach **FI 53** is the longest of the beaches and extends west for 900 m to a 100 m long rocky section that protrudes to the south. The high tide beach is continuous, with rocks bordering each end and scattered across the low to subtidal zone in amongst the seagrass. The sand flats average 50 m in width, widening to 100 m at the western end. It is backed by a narrow grassy foredune, a 50 m wide band of scrubs and cleared grazing land to the road, with an access track reaching the centre of the beach.

Beach **FI 54** extends west of the point for 800 m to where the shoreline turns and trends to the south. The sandy beach and 50 m wide sand flats become increasingly dominated by the granite rocks and boulders to the west, with seagrass along the low tide zone. The access road reaches the western end of the beach where there is a small picnic area. A strip of scrub in the coastal reserve then cleared land back the beach.

Beaches FI 55-57 occupy the 800 m long southwest-trending section of low rocky shore that terminates at the western point of the bay. Beach **FI 55** is a curving 250 m long high tide sand beach fronted by 100 m wide sand flats littered with granite rocks and boulders, with the seagrass beyond. A mixture of scrub and cleared slopes, then cleared land rising towards Wireless Hill back the beach, with a track off the access road leading to the northern end of the beach. Beach **FI 56** lies 100 m to the south and is a curving 200 m long sandy beach with scattered rocks on and off the beach, and seagrass meadows extending to within 50-100 m of the shore. Clear grazing land extends right to the rear of the beach. Beach **FI 57** is the final strip of sand before the point. It consists of an 80 m long high tide beach, with some sand off the northern end, the remainder fronted by large supratidal granite outcrops that extend 200 m offshore.

FI 58-61 LILLIES BAY

No.	Beach	Rating HT LT	Type	Length
FI 58	Half Mile Rock (S2)	2 3	R+rock flats	300 m
FI 59	Half Mile Rock (S1)	2 3	R+sand/rock flats	200 m
FI 60	Half Mile Rock	3 3	R+sand flats	200 m
FI 61	Settlement Beach	3 3	R	2 km
Spring & neap tidal range = 1.9 & 1.6 m				

Lillies Bay is a 4 km wide south-facing slight embayment, dominated by low granite points and boulders to either end, with Settlement Beach (FI 61) occupying most of the centre of the bay and Settlement Point forming the western boundary. Three rock-bound

beaches (FI 58-60) are located on the eastern point and five beaches (FI 62-66) on the western Settlement Point.

Beach **FI 58** is a south-facing embayed double crenulate 300 m long strip of high tide sand, bordered by low granite points extending 100 m seaward and totally dominated by granite outcrops along and extending up to 100 m off the beach. Waves are usually low at the shore and only reach the narrow beach at high tide, with seagrass meadows on the seaward of the outer rocks. A veneer of vegetated dune sand covers some of the low backing bluffs, with cleared land behind.

Beach **FI 59** lies 100 m to the west and is a curving 200 m long high tide sand beach bordered by low grass-covered granite points, including Half Mile Rock at the western end. Rocks outcrop along the beach and are scattered offshore, including a small central islet 150 m offshore. The beach slopes seaward into a 50 m wide mixture of sand and rocks, with seagrass beyond. It is backed by cleared low gradient slopes, including a vegetated veneer of older dunes extending 100 m inland.

Beach **FI 60** commences 100 m to the west and is a relatively straight reflective sand beach, bordered by small low sloping granite points. It has some rocks scattered off the beach, and a continuous 50 m wide low to subtidal beach grading into seagrass meadows. A low grassy foredune extends 50 m inland to cleared grazing land.

Settlement Beach (FI 61) is named after the historic and tragic aboriginal settlement at Wybalena located on the gentle slopes 600 m north of the beach. The settlement and western half of the beach is now part of the Wybalena Historic Site. The beach commences as the rocks of Half Mile Rock terminate and trends to the northwest, past a small cluster of rocks, then west for a total of 2 km, to the beginning of the western rocks that continue 1 km west to Settlement Point. The beach receives low wind waves, which maintain a moderately steep reflective beach, with seagrass growing to within 50 m of the shore. The ruins of the settlement jetty are located at the western end of the beach (Fig. 4.302). The beach is backed by a grassy foredune that reaches to 12 m in height in the east where it is backed by older dune transgression that rises to 20 m and extends up to 500 m inland. A vehicle track off the Port Davies Road runs down to the jetty with a small picnic area and toilets located behind the boundary rocks.

FI 62-66 SETTLEMENT POINT (S)

No.	Beach	Rating HT LT	Type	Length
FI 62	Lillies beach (1)	3 3	R+rocks	50 m
FI 63	Lillies beach (2)	3 3	R+rocks	100 m
FI 64	Lillies beach (3)	3 3	R+rocks	150 m
FI 65	Settlement Pt (S)	3 3	R+rock flats	70 m
FI 66	Settlement Pt	3 3	R+rocks	80 m
Spring & neap tidal range = 1.9 & 1.6 m				

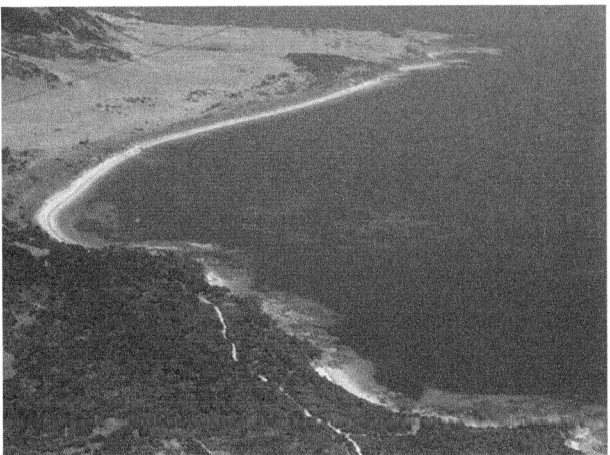

Figure 4.302 Settlement Beach (FI 61 top) and the more rock-dominated Lillies beaches (FI 62-64) on Settlement Point (foreground).

Settlement Point is a densely vegetated 10 m high granite point that has rocky shore extending 1 km east to Settlement Beach where it is backed by 68 m high Pea Jacket Hill. Spread amongst the rocks between the beach and the tip of the point are five low energy beaches (FI 62-66), with the first four including the Lillies beaches facing south out of Lillies Bay. A private 4WD track runs along the rear of the beaches to the point, with foot access down to each.

Beach **FI 62** lies immediately west of the main beach, with a cluster of large granite boulders to the east and a small granite point to the west. The beach is a 50 m long pocket of south-facing sand, with patchy seagrass growing to low tide. Beach **FI 63** lies 100 m to the west and is a 100 m long sandy beach, with rocks to either end and a central outcrop, with a clear sandy seafloor and seagrass growing to within 30 m of the shore.

Beach **FI 64** lies a further 300 m to the west and is a slightly curving 150 m long sandy beach. It has large granite boulders to either end with seagrass extending from the western boulders to lie 40 m off the eastern end of the beach. Dense vegetation backs the beach and boundary rocks, with a spur off the vehicle reaching the western end of the beach.

Beach **FI 65** is located 200 m to the southwest and consists of a discontinuous 70 m long high tide strip of sand fronted by a 150 m wide cluster of intertidal granite rocks and boulders, with waves only reaching the beach at high tide.

Beach **FI 66** is located at the western tip of the point and consists of an 80 m long west-facing reflective beach, bordered by irregular low granite points extending up to 300 m offshore, as well as scattered rocks off the beach and seagrass growing to within 30 m of the shore. Vehicle tracks reach both sides of the beach.

FI 67-70 SETTLEMENT POINT (N)

No.	Beach	Rating HT LT	Type	Length
FI 67	Settlement Pt (N1)	2 2	R+rocks	50 m
FI 68	Settlement Pt (N2)	2 2	R+rocks	80 m
FI 69	Settlement Pt (N3)	2 2	R+rock flats	80 m
FI 70	Settlement Pt (N4)	2 2	R+rocks	40 m
Spring & neap tidal range = 1.9 & 1.6 m				

At **Settlement Point** the shoreline turns and trends to the northeast for 2 km as an indented, highly irregular, granite shoreline, fringed by rocks, reefs and islets. In amongst the predominantly sloping granite shoreline are four small low energy pockets of sand (FI 67-70), all backed by densely vegetated slopes that rise in the east to Pea Jacket Hill. While the beaches are located in a narrow reserve, the access track is through private land and not open to the public.

Beach **FI 67** is a 50 m long pocket of north-facing sand, bordered by granite points and rocks extending 300 m offshore. Only very low waves reach the small high tide beach. A 100 m wide rock point separates it from beach **FI 68**, with a fishing shack located behind the point overlooking the beach. This is an 80 m long high tide sandy beach grading into intertidal rocks and reefs, and facing north along a 300 m long low granite embayment. The beach is used for launching small fishing boats.

Beach **FI 69** lies 400 m to the northeast and is a curving 80 m long strip of high tide sand fronted by continuous intertidal rocks that extend 150 m into the small embayment. It is backed by steep grassy slopes rising to 30 m.

Beach **FI 70** is located to the lee of the 2 ha Bird Island, which is attached at low tide to its western point. The beach consists of a 40 m long pocket of high tide sand grading into a mixture of sand and rocks. It is backed by Pleistocene dune calcarenite rising to 30 m in the east, with a vehicle track running down the eastern point above the beach.

FI 71-74 PORT DAVIES

No.	Beach	Rating HT LT	Type	Length
FI 71	Port Davies	3 3	R+rocks	150 m
FI 72	Cave Beach	3 3	R	600 m
FI 73	Cave Beach (E1)	4 4	LTT+rocks	350 m
FI 74	Cave Beach (E2)	4 4	LTT+rocks	300 m
Spring & neap tidal range = 1.9 & 1.6 m				

Port Davies is a small disused port, with the remains of the old jetty still visible on the western boundary rocks. Today, apart from the Port Davies Road, a wharf reserve and the ruins, there is no evidence of the old port. The port was located on the western side of a 1.2 km wide

northwest-facing bay bordered by granite points, capped by Pleistocene calcarenite in the west. Four beaches (FI 71-74) occupy the bay shoreline (Fig. 4.303).

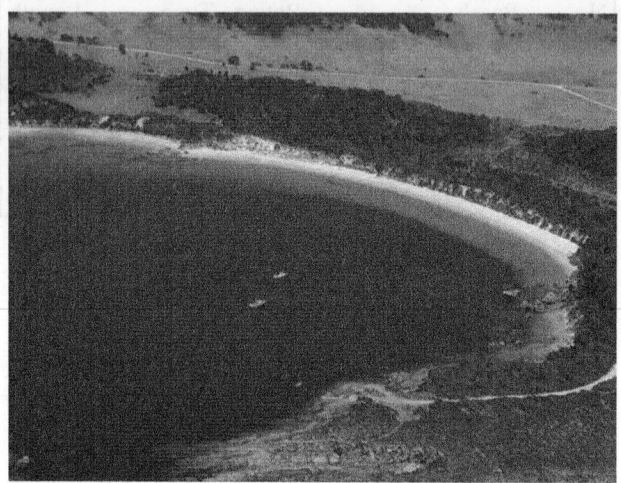

Figure 4.303 Port Davies with the boat ramp and old jetty on the rocks in foreground and the main Cave Beach.

Beach **FI 71** is a 150 m long strip of yellow high tide sand located in lee of the western granite point, with the old jetty located 100 m to the north. The beach is backed and bordered by bluffs of dune calcarenite, with both granite and calcarenite outcropping off the beach and seagrass growing to low tide. The Port Davies Road runs 50 m in from the rear of the beach and terminates at the old jetty, which is now used as a boat ramp.

Cave Beach (FI 72) is named after the caves in the dune calcarenite. It commences at the 100 m long calcarenite boundary and curves to the west then northwest for 600 m to a low granite outcrop, which forms a small backing sandy foreland. This is a moderately steep, white reflective beach with seagrass growing 50 m offshore. A few fishing boats are usually moored off the western end of the beach. It is backed by a 10 m high scarped foredune, then the Wybalena historic site with no public access.

Beach **FI 73** curves northeast of the foreland for 350 m to the next granite-tipped sandy foreland, with the boundary granite rocks extending 100 m offshore, as well as a few scattered off the beach. The beach receives slightly higher waves and is a reflective to occasionally low tide terrace, and which is cut by rips against the rocks during periods of higher waves. Beach **FI 74** continues to the north-northwest for 300 m to the beginning of the western boundary granite point of the port. Besides being bordered by the granite rocks the beach is dominated by reefs, with sandy patches to either end, where during higher waves two rips are located. Both beaches are backed by a scarped 20-30 m high dune that has transgressed 700 m inland climbing the backing slopes to an elevation of 60 m. A narrow coastal reserve backs most of the two beaches, however there is no public access.

FI 75-78 EMITA BEACHES

No.	Beach	Rating HT LT		Type	Length
FI 75	Allports (W)	3	3	R	30 m
FI 76	Allports Beach	3	3	R	150 m
FI 77	Old Jetty Beach	4	4	R	300 m
FI 78	Emita	4	4	R	200 m
Spring & neap tidal range = 1.9 & 1.6 m					

Emita is a small collection of houses located on densely vegetated slopes that face north into Marshall Bay and overlook four small beaches (FI 75-78). The Port Davies Road provides access to the houses, with tracks leading down to two of the beaches.

Beach **FI 75** is a 30 m long pocket of sand located on the western granite headland of Allports Beach. It lies 100 m north of the western end of the beach and is bounded by sloping granite points that extend up to 100 m seaward. It can be reached on foot around the rocks from the main beach.

Allports Beach (FI 76) is a 150 m long slightly curving, north-facing relatively steep reflective beach (Fig. 4.304). It is bordered by dune-capped granite points, with some boulders outcropping along the eastern end of the beach, and seagrass meadows growing 100 m offshore. The Allports Road runs down the backing slopes to a small reserve with a car park, picnic area and toilets at the eastern end of the beach. This is the main Emita swimming beach.

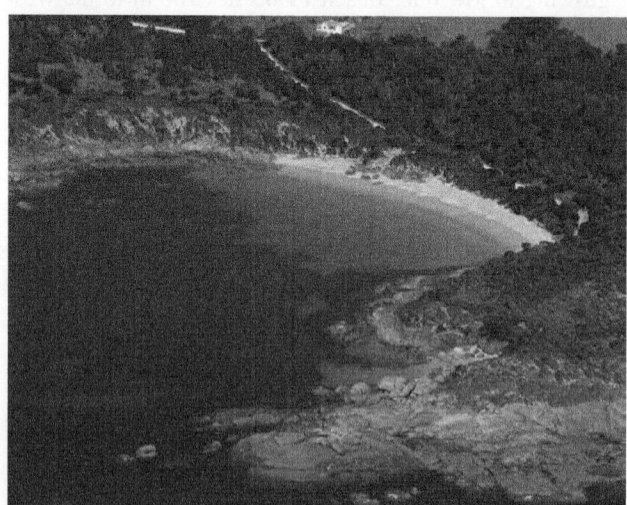

Figure 4.304 Allports Beach is the most accessible and popular of the Emita beaches.

Old Jetty Beach (also called Emita Beach) **(FI 77)** occupies the next small north-facing embayment, 200 m to the east. It is a 300 m long reflective beach, bordered by densely vegetated granite points, with seagrass growing 50-100 m offshore. A gravel road runs down to the eastern end of the beach where there is a small car park, but no facilities.

Emita beach (**FI 78**) lies 100 m further east and is a 200 m long steep northwest-facing reflective beach composed of yellow sand. It is bordered by sloping granite rocks, with bare rocks backing the eastern half of the beach, while an unstable foredune and vegetated climbing transgressive dunes extends 700 m up the backing slopes to reach 50 m in height. The road runs along the slopes 50 m above the beach with no public access.

FI 79-81 CASTLE ROCK POINT (S)

No.	Beach	Rating HT	LT	Type	Length
FI 79	Castle Rock Pt (S3)	4	5	LTT/TBR	900 m
FI 80	Castle Rock Pt (S2)	4	5	LTT/TBR	100 m
FI 81	Castle Rock Pt (S1)	4	5	LTT/TBR	150 m
Spring & neap tidal range = 1.9 & 1.6 m					

Castle Rock Point is located 1.5 km due north of the northern Emita rocky shore. It is a slightly protruding low granite point, with a large rounded castle-like boulder on its tip. In between are three more exposed west-facing beaches (FI 79-81). They are all backed by a continuous narrow coastal reserve, with only 4WD access across farmland to the northern two beaches.

Beach **FI 79** is a straight 900 m long beach fully exposed to the westerly winds and wind waves, which average about 1 m along the shore. The waves maintain a 50 m wide low tide terrace to occasional transverse bar and rip, with up to two beach rips and two boundary rips cutting across the bar. It is backed by a low foredune, and then vegetated parabolic dunes. Beach **FI 80** lies 50 m to the north past some low rocks, and is a slightly curving 100 m long beach, bordered by granite rocks extending 50 m seaward on either side. The waves maintain a 50 m wide bar drained by a rip against the northern rocks. An active parabolic dune backs the foredune and has blown up to 100 m inland. Beach **FI 81** lies 100 m to the north and is a 150 m long beach, with a bar usually cut by a rip against the northern Castle Rock Point. A grassy foredune backs the beach and southern boundary rocks.

The three beaches and points are backed by a continuous series of longwalled parabolic dunes that have extended up to 2 km inland to the Palana Road and up to 38 m in elevation, and cover an area of approximately 200 ha. Hays Creek runs along the southern end of the dunes and out onto the southern end of beach FI 79.

FI 82-85 MARSHALL BAY

No.	Beach	Rating HT	LT	Type	Length
FI 82	Marshall Beach (S)	4	5	LTT/TBR	3.9 km
FI 83	Marshall Beach (N)	4	4	LTT	4.3 km
FI 84	Mines Creek (S)	4	4	LTT	1.1 km
FI 85	Mines Creek (N)	3	3	R+rocks	1 km
Spring & neap tidal range = 1.9 & 1.6 m					

Marshall Bay is a 12 km wide west-southwest-facing bay bordered by two 5 km long granite points terminating at Settlement Point in the south and Bun Beetons Point in the north. Four continuous beaches (FI 82-85) occupy the eastern shoreline and face directly into the prevailing westerly winds. Waves are highest in the centre-south decreasing along the northern half owing to sheltering from the Pasco Group of islands, which extend 5 km south of Bun Beetons Point. The Palana Road runs 1-2 km in from the beaches, with the only public access in the northern corner off the West End Road.

Marshall Beach extends most of the way along the eastern shore of the bay and is divided in two by the small central Marshall Rock outcrop and associated sand foreland. The southern half of the beach (**FI 82**) commences at the base of the Castle Rock Point and trends to the north for 3.9 km to the Marshall Rock. It is the highest energy of the bay beaches with the westerly wind waves averaging over 1 m where they maintain a low gradient 100 m wide bar, often cut by rips spaced every 200-300 m, with up to 10 rips along the beach. It is backed by a grassy foredune, some largely vegetated blowouts and older longwalled parabolic dunes extending 1-2 km inland as far as the Palana Road (Fig. 4.305). The deflation hollows and associated wetland are called the Lughrata Holes.

Figure 4.305 The centre of the long moderately sheltered Marshall Beach is backed by well vegetated remnants of parabolic dunes.

The northern Marshall Beach (**FI 83**) commences at Marshall Rock and continues to the north-northwest for 4.3 km to a 100 wide shallow creek mouth. Wave energy begins to decrease slowly up the beach, with a wide low gradient low tide terrace usually present, and rips only forming during periods of higher waves. The grassy foredune and blowouts continue, with one area of active blowouts and older longwalled parabolics behind. The Curves Lagoons occupy some of the deflation hollows behind the Marshall Rock area.

Beach **FI 84** commences at the boundary creek mouth and protrudes to the northwest as a low energy sandy foreland that has prograded to the lee of Marriott Reef, a 100 ha cluster of granite islets and reefs located 1-2 km offshore. The beach extends to the northwest for a total of 1.1 km to the 50 m wide shallow sandy mouth of **Mines**

Creek. Waves are usually low and break across 200 m wide low gradient low tide terrace, with seagrass growing out from low tide, and seagrass debris littering the high tide beach. It is backed by a low grassy foredune then dense scrub.

Beach **FI 85** continues northwest of Mines Creek mouth for 1 km, finally curving round to face south. Wave height decreases to the north with calm conditions usually prevailing in the northern corner. The beach continues as a low gradient low tide terrace with low granite outcrops also increasing to the north, while the seagrass meadows move to within 50 m of the shore (Fig. 4.306). It is backed by a low 100 m wide grassy barrier, with the deflected Mines Creek behind. The West End Road runs 200 m north of the end of the beach, with a vehicle track down to the northern end.

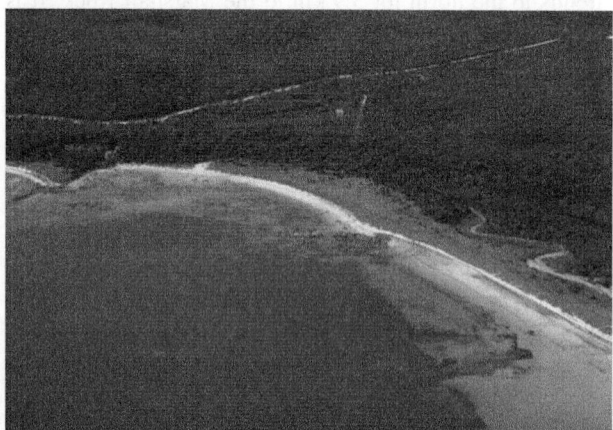

Figure 4.306 The sheltered northern corner of Marshall Bay where beach FI 85 terminates against the granite rocks and seagrass grows to the shore.

FI 86-89 TANNERS BAY (E)

No.	Beach	Rating HT LT		Type	Length
FI 86	Duck Is (E4)	3	3	R+rock flats	200 m
FI 87	Duck Is (E3)	3	3	R+rocks	150 m
FI 88	Duck Is (E2)	3	3	R+rocks	400 m
FI 89	Duck Is (E1)	3	3	R+rock flats	400 m
Spring & neap tidal range = 1.9 & 1.6 m					

Tanners Bay is on open south-facing embayment located in the northern corner of the larger Marshall Bay. It extends west from the northeast corner of Marshall Bay for 5.5 km to Bun Beetons Point, with the 2 km long Marriott Reef also forming a southern boundary. Beaches FI 86-97 occupy much of the northern shore of the bay. The West End Road runs 100-200 m in from the beaches, with access tracks down to a few of the beaches. Beaches FI 86-89 occupy the first 1.5 km terminating in lee of the small Duck Island.

Beach **FI 86** commences against a low eastern rock point that continues south as a 600 m long rock reef and islet. The beach faces southwest out of the bay and consists of a sandy high tide beach backed by a low grassy foredune,

with scattered rock outcrops dominating much of the low to intertidal, particular along the western half of the beach, where a vehicle track runs down to the shore.

Beach **FI 87** lies 100 m to the west and is a 150 m long sandy south-facing reflective beach, with scattered granite rocks occupying about half the low tide foreshore, and seagrass growing to within 50 m of the shore. It has a 10 m high foredune at its eastern end and a lower hummocky grass, then tea-tree-covered foredune along the remainder. Beach **FI 88** lies 50 m to the west and is a 400 m long continuation, with a high tide sandy beach and intertidal dominated by rock outcrops, with sand patches in between. It terminates at a low rock outcrop with a low grassy foredune then tea-trees backing the entire beach.

Beach **FI 89** is located 50 m to the east and trends to the southwest to terminate in lee of 5 m high Duck Island, which is attached to the shore by rock reef. The 400 m long beach is dominated by rock outcrops, reefs and islets resulting in a crenulate beach tied to a few rocks. The sand flats widen to 100-200 m off the beach, with the seagrass lying beyond. A vehicle track runs down to the western end of the beach in lee of the island.

FI 90-97 TANNERS BAY (W)

No.	Beach	Rating HT LT		Type	Length
FI 90	Duck Is (W1)	2	3	R	300 m
FI 91	Duck Is (W2)	2	3	R+rocks	200 m
FI 92	Pine Scrub (1)	2	3	R+rocks	600 m
FI 93	Pine Scrub (2)	2	3	R+rocks	70 m
FI 94	Pine Scrub (3)	2	3	R+rocks	100 m
FI 95	Pine Scrub (4)	2	3	R+rocks	300 m
FI 96	Pine Scrub (5)	2	3	R+sand/rock flats	50 m
FI 97	Bun Beetons Pt (E)	2	3	R+sand/rock flats	300 m
Spring & neap tidal range = 1.9 & 1.6 m					

The northern shore of Tanners Bay extends west from Duck Island for 3.5 km to Bun Beetons Point with eight beaches (FI 90-97) located along the rock-dominated shoreline. It faces south-southeast to the southern shore of Marshall Bay. To the west Bun Beetons Point and the Pasco Group of islands provides shelter from most westerly waves, with generally low wind waves reaching the shore.

Beach **FI 90** is a relatively straight 300 m long south-facing sand beach, bordered by low granite outcrops with seagrass growing to within 50 m of the low tide (Fig. 4.307). It is backed by tea-trees and densely vegetated slopes rising to the road, with a track reaching the western end of the beach. Beach **FI 91** commences immediately to the west and is a crenulate rock-dominated 200 m long strip of high tide sand located in amongst near continuous supra- to subtidal granite rocks and outcrops. There are a few sandy patches between the rocks and dense vegetation growing to the rear of the beach. A vehicle track reaches the western end of the beach.

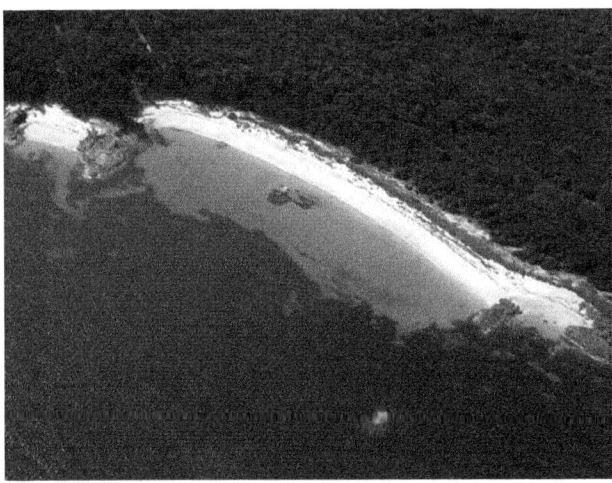

Figure 4.307 Beach FI 90 is typical of the sheltered rock-bound beaches along this section of coast.

Beach **FI 92** commences at a small 7 m high rocky point and trends to the southwest for 600 m to the lee of a small islet. The beach is a crenulate high tide sandy beach dominated by the supra- to intertidal rocks, which extend up to 200 m offshore. The western half is backed by a narrow scrub-filled coastal reserve, then two houses on cleared private land that extends up to the road.

Beach **FI 93** lies on the eastern side of the small attached rock islet. It is a curving 70 m long pocket of sand bordered by low rocky points extending 100 m offshore, with seagrass growing on the intervening sand to within 20 m of the shore. Beach **FI 94** is located on the western side of the small islet and is a curving 100 m long high tide sand beach almost encased within the boundary rocky point and reefs. It has a central sand patch and tidal pool, with seagrass growing close to shore. A dense thicket of tea-tree backs the two beaches, with cleared land behind.

Beach **FI 95** commences 50 m to the west and curves slightly to the southwest for 250 m before turning and running out for 50 m along the side of a low rocky point that extends 100 m to the south. It is a white sandy high tide beach, backed by a low grassy foredune, then a tea-tree-filled reserve, with cleared land and two houses behind. The seagrass grows to within 50 m of the shore, with rocks dominating the western end. Beach **FI 96** is located at the tip of the densely vegetated point. It is a straight 50 m long strip of sand located between and to the lee of granite rocks. The foreshore is a mixture of seagrass-covered patches of sand and rocks that extend 100 m offshore.

Beach **FI 97** lies 200 m to the west and is a curving southwest-facing continuous high tide sand beach that is sheltered by Bun Beetons Point, and reefs that extend 800 m to the south. It is fronted by intertidal rocks and some sand flats, that widen from 100 m in the east to 200 m in the west, with seagrass beyond. Partly cleared scrub and a few shacks back the beach.

FI 98-101 WEST END BEACH

No.	Beach	Rating HT LT		Type	Length
FI 98	West End Beach	4	4	R/LTT	1.2 km
FI 99	West End (W1)	3	4	R	50 m
FI 100	West End (W2)	3	4	R	150 m
FI 101	West End (W3)	3	4	R+rocks/flats	250 m
Spring & neap tidal range = 1.9 & 1.6 m					

At Bun Beetons Point the rocky shoreline turns and trends to the northwest for 7 km to Cape Frankland, the westernmost tip of the island. The rocky shoreline is backed by steep granite slopes rising to 332 m high Mount Tanner and 207 m high The Paps. Offshore lies 77 m high Roydon Island with the Pasco Group of islands spreading to the south. To the lee of Roydon Island are four beaches (FI 98-101) all part of a narrow coastal reserve and all moderately sheltered by the island and associated reefs.

West End Beach (FI 98) lies due east of Roydon Island and extends northwest of Bun Beetons Point for 1.2 km as a slightly curving reflective to low tide terrace beach. It receives refracted waves averaging about 1 m, which maintain the low gradient beach and narrow bar, with clear sand, then seagrass growing 100 m offshore (Fig. 4.308). It is bordered by granite rocks and backed by a well vegetated series of transgressive dunes that have migrated up to 700 m inland and reached 40 m in elevation. A small creek is deflected 600 m to the north and drains across the northern end of the beach. The West End Road runs along the rear of the dunes with an access track to the northern end.

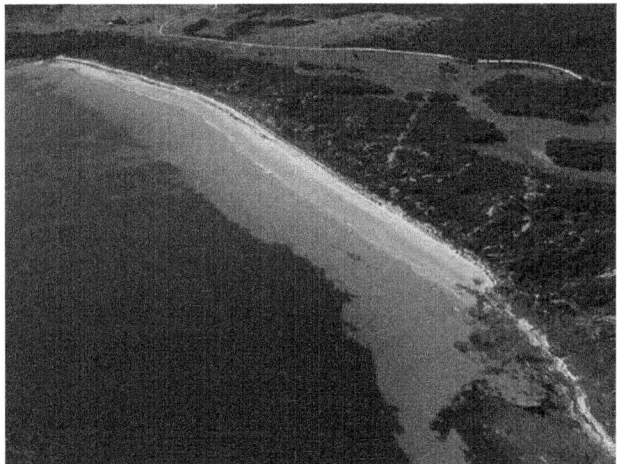

Figure 4.308 West End Beach is a moderately sheltered white sand beach with seagrass growing close inshore.

Beach **FI 99** is located 200 m to the north and consists of a 50 m long pocket of white sand, wedged in between sloping granite points that extend 50 and 100 m seaward. The reflective beach is fronted by clear sand between the rocks with patchy seagrass growing 50 m offshore. Beach **FI 100** lies 100 m further around the rocks and is a curving 150 m long west-facing sandy beach, bordered

by sloping rocks that converge towards the centre with a 50 m wide outer gap for waves to reach the beach. Clear sand and a few rocks fill the area between, with seagrass growing 150 m offshore. Both beaches are backed by densely vegetated dunes extending 100 m inland to the edge of the reserve with cleared sloping land beyond.

Beach **FI 101** lies 300 m further west and consists of a 250 m long high tide sandy beach, bordered by steep granite to the east and a scattering of rocks and boulders to the west. The beach has one clear sandy patch to the east with intertidal rocks dominating the remainder and extending up to 200 m offshore and seagrass beyond. It is backed by a scarped well vegetated foredune, then dense tea-trees, with some cleared land on the backing slopes.

FI 102-103 EGG BEACH

No.	Beach	Rating HT LT	Type	Length
FI 102	Egg Beach (S)	3 4	R+rock flats	50 m
FI 103	Egg Beach (N)	3 4	R+rock flats	80 m
	Egg Beach Coastal Reserve			
Spring & neap tidal range = 1.9 & 1.6 m				

Egg Beach consists of two patches of high tide sand (FI 102 and 103) located either side of a low granite point and reefs that extend 500 m to the southwest. The narrow Egg Beach Coastal Reserve runs around the point and includes the two beaches. The southern beach (**FI 102**) is a 50 m long pocket of high tide sand wedged deep inside a narrow rocky embayment, with dense vegetation of the backing slopes growing down to the rear of the beach. It is fronted by a 50 m wide rocky channel, with seagrass growing along the seabed. The northern beach (**FI 103**) lies 500 m to the northwest and is a steep 80 m long sand and cobble high tide beach, bordered by granite rocks, and facing into the more open northern side of the point. A mixture of rocks, seagrass and patches of sand lie off the beach. It is backed by some low wind-blasted vegetation, with a 4WD track running behind the beach.

FLINDERS ISLAND NORTHWEST COAST

Cape Frankland to Stanley Point

Coast:	41 km (194-235 km)
Beaches:	31 (FI 104-134)
Settlements:	Killiecrankie Bay, Palana

The northwest coast of Flinders Island consists of 41 km of predominantly rocky shoreline backed by densely vegetated slopes rising 100-300 m. In amongst the rocks are 31 beaches, all bounded and often dominated by the granite rocks, reefs, islets and islands. The beaches occupy only 11 km (27%) of the rocky shore. There is public access to only two beaches at Killiecrankie Bay and Palana, with private tracks leading to some of the Boat Harbour beaches.

FI 104-106 BARBERS & BOTTLEROCK BEACHES

No.	Beach	Rating HT LT	Type	Length
FI 104	Barbers (S)	4 5	R+rocks	250 m
FI 105	Barbers Beach	4 5	R/LTT	300 m
FI 106	Bottlerock Beach	4 5	R/LTT	100 m
Spring & neap tidal range = 1.9 & 1.6 m				

Cape Frankland marks the western tip of Flinders Island and the beginning of the 41 km long northwest coast that extends to the northern tip of the island at Stanley Point. Partly vegetated slopes rise 100-200 m along both sides of the cape, with the first of the northwest coast beaches (FI 104) located 2 km to the northwest. Beaches FI 104-106 occupy a 1.3 km long section of west-facing rocky shore and are partly sheltered by a series of rocks and islets, including Boyes Rock, located 2 km to the west. They are backed by a narrow coastal reserve, and then private land, with a rough 4WD access track down the backing slopes to each of the beaches.

Beach **FI 104** is a 250 m long double crenulate high tide sandy beach, fringed by low granite shoreline, with an intertidal rock reef extending 200 m out from the centre of the beach. The reef lowers waves to less than 1 m at the shore. It is backed by a narrow foredune then slopes rising to the 207 m high The Paps mountain. A cluster of about 10 fishing shacks are located above the southern end of the beach, linked by an access track to the main beach.

Barbers Beach (FI 105) lies 200 m to the north and is a slightly curving 300 m long low gradient reflective to low tide terrace sandy beach. It is bordered by granite rocks, with some reefs off the beach and seagrass growing to the shore at either end, and some sandy seafloor off the

centre. It is backed by a 20 m high vegetated foredune, then a valley drained by a creek at the southern end of the beach. The main access track runs down the valley and along the southern end of the beach to the southern shacks.

Bottlerock Beach (FI 106) lies 500 m to the north in a 100 m wide, 300 m deep steep-sided embayment. The slightly curving 100 m long beach lies at the rear of the little bay, with a grassy foredune then steep vegetated slopes rising to 50 m behind. It receives waves lowered by the entrance rocks and reefs to about 0.5 m at the shore, where they maintain a low gradient reflective beach. A rough 4WD track descends the valley, with tracks leading along the steep shoreline either side of the beach.

FI 107-110 BOAT HARBOUR BEACHES

No.	Beach	Rating HT LT	Type	Length
FI 107	Boat Harbour	4 5	R/LTT+rocks	80 m
FI 108	Boat Harbour (mid)	4 5	R/LTT	150 m
FI 109	Boat Harbour Beach	4 5	LTT	1.4 km
FI 110	Boat Harbour (N)	4 5	R+rocks	250 m
Spring & neap tidal range = 1.9 & 1.6 m				

The four Boat Harbour beaches (FI 107-110) are located in a 2.5 km wide northwest-facing open embayment bordered to the north by 9 m high Low Point. They are all backed by a narrow coastal reserve, then private land. The gravel Boat Harbour Road terminates at a gate, with no public access to the beaches (Fig. 4.309).

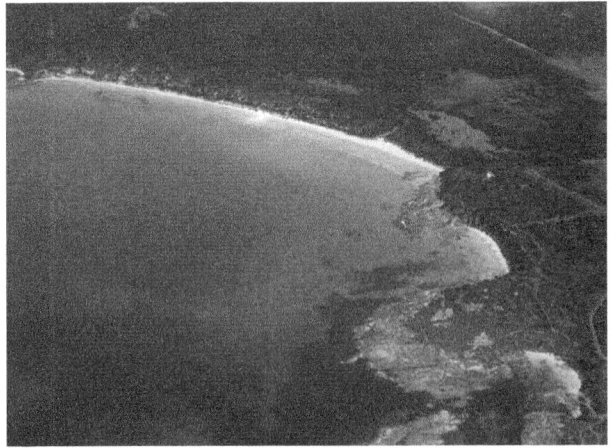

Figure 4.309 Three of the Boat Harbour beaches (FI 107-109), all bounded by prominent granite points.

Boat Harbour is located on the southern point and consists of a 300 m deep, narrow north-facing rocky bay, bordered by low granite rocks and reefs with a curving sheltered 80 m long beach (**FI 107**) at its base, with some rocks also outcropping on the beach. A 4WD track runs out to the beach with access at the western end of the beach where a 30 m long clear patch of sand is used for launching small boats.

Beach **FI 108** is located 150 m to the east. It is a slightly curving 150 m long narrow high tide beach with a 30 m wide low tide bar. It has a sandy seafloor with scattered rocks and reefs and is backed by a steep vegetated 10 m high bluff, with a vehicle track running along the crest and a solitary shack located on the eastern headland.

Boat Harbour Beach (FI 109) commences 100 m to the east and is a relatively straight, northwest-facing 1.4 km long beach. It is exposed to waves averaging about 1 m, which maintain a low gradient beach and narrow low tide terrace. A cluster of rocks and reefs lies off the northern end of the beach, with a low rocky point forming the northern boundary. It is backed by a continuous 10-20 m high foredune and some older dunes that have transgressed up to 300 m inland. Boat Harbour Creek drains the high slopes to the south and crosses the southern end of the beach, with 4WD access to the southern headland.

Beach **FI 110** commences on the northern side of the boundary point and trends northeast for 250 m to the rocky base of Low Point. It consists of a sandy high tide beach, with rocks dominating the western-central section and extending up to 200 m offshore, with a patch of sandy seafloor off the northern end. It is backed by dune-draped slopes, the dunes rising up to 50 m and then slopes continuing to a 200 m high peak.

FI 111-115 KILLIECRANKIE BAY

No.	Beach	Rating HT LT	Type	Length
FI 111	Killiecrankie Bay	4 4	R/LTT	800 m
FI 112	Killiecrankie Bay (N)	4 5	LTT/TBR/rocks	1.9 km
FI 113	Killiecrankie Bay(N1)	4 4	R	60 m
FI 114	Stackys Bight (1)	2 2	R	80 m
FI 115	Stackys Bight (2)	2 2	R	70 m
Spring & neap tidal range = 1.9 & 1.6 m				

Killiecrankie Bay is a 2.5 km wide west-northwest-facing bay, bordered by a 136 m high granite ridge to the south and the bare granite of Old Mans Head to the north which rises inland to 318 m at Mount Killiecrankie. The bay is famous for the 'diamonds' that have been eroded out of the backing granites. In between are 5 km of shoreline containing five beaches, with the small settlement of Killiecrankie located in the southern corner. The bay is partly sheltered by the headlands and adjoining reefs, as well as Nobbys Rock in the south and Little Island and associated reefs located 2 km west of the centre of the bay. Waves average just over 1 m in the centre of the bay, decreasing to either end.

Killiecrankie beach (**FI 111**) occupies the southern corner of the bay, where the Killiecrankie Road terminates, and the small settlement occupies the lower slopes behind the western end of the beach. The beach commences amongst the low granite rock and to the lee of Nobby Rock, a low islet. It curves to the east for 800 m to the mouth of Killiecrankie Creek mouth (Fig.

4.310). The low gradient white sand beach faces north across the bay. Waves are very low to calm in the western corner, increasing to about 1 m at the creek mouth. They maintain a low gradient reflective to low tide terrace beach, with rock reefs and seagrass lying 100 m offshore. The western end of the beach is used for launching small boats and several fishing boats are usually moored off the beach.

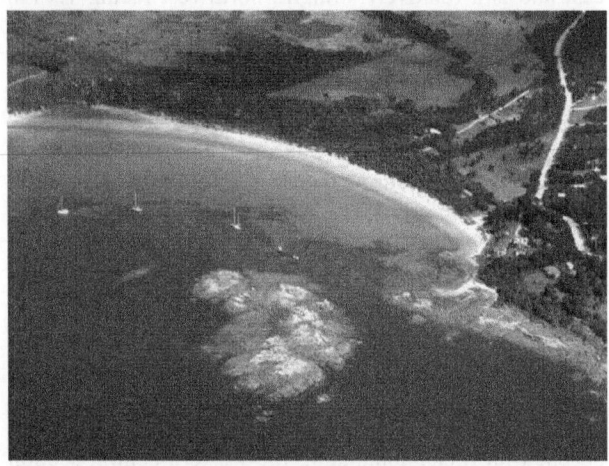

Figure 4.310 Killiecrankie Bay beach curves north from the granite Nobbys Rock to Killiecrankie Creek.

Killiecrankie Bay beach (**FI 112**) extends northwest of the shallow sandy creek mouth for 1.9 km to the beginning of the northern rocky shore. The southern half of the beach is continuous and usually has a low tide terrace, cut by a few rips during periods of higher waves. The northern half is fringed by rock reefs, with the sandy bay floor beyond. It terminates in lee of a small reef-tied sand foreland. The entire beach is backed by vegetated transgressive dunes that have migrated up to 1.2 km inland and to heights of 40 m. A couple of stabilising blowouts are located behind the centre of the beach.

Beach **FI 113** is a curving 60 m long pocket of sand located on the northern side of the boundary foreland. It has rock reefs extending 80 m off either side, with a sandy seafloor in between. It receives waves averaging up to 1 m, which maintain a low gradient reflective beach. The 4WD Quoin Road reaches the rear of the beach, with a solitary shack located behind the rocky slopes 100 m north of the beach. This track also provides access to the northern end of the main bay beach.

Stackys Bight is a 150 m wide, 100 m deep rocky bay, located at the northern end of Killiecrankie Bay at the southern base of Old Mans Head. Two small beaches are located on the northern shore of the bay and face south into the main bay. Beach **FI 114** is a curving 80 m long pocket of reflective yellow sand, bordered by sloping granite rocks, with seagrass growing to within 50 m of the shore. Beach **FI 115** lies 50 m to the west and is a 70 m long low energy reflective beach, with seagrass just 20 m off the shore. The steep partly bare slopes of Old Mans Head rise east of the beaches, with a 4WD track around the base and two shacks located in the dense scrub behind the beaches.

FI 116-120 THE DOCK BEACHES

No.	Beach	Rating HT LT		Type	Length
FI 116	The Dock (1)	3	4	R+rocks	150 m
FI 117	The Dock (2)	3	4	R+rocks	200 m
FI 118	The Dock (3)	3	4	R+rocks	60 m
FI 119	The Dock (4)	3	4	R+rocks	100 m
FI 120	The Dock (5)	3	4	R+rocks	80 m
Spring & neap tidal range = 1.9 & 1.6 m					

The Dock is a 700 m wide northwest-facing rocky embayment, dotted with rocks and reefs, and backed by steep partly vegetated granite slopes rising to Mount Killiecrankie. In amongst the 1 km of rocky shoreline are five small pockets of sand (FI 116-120), all sheltered by the rocks and reefs and backed by vegetated dune-draped lower slopes rising to the densely vegetated higher slopes (Fig. 4.311). Two vehicle tracks off the Palana Road descend to the rear of the eastern beaches.

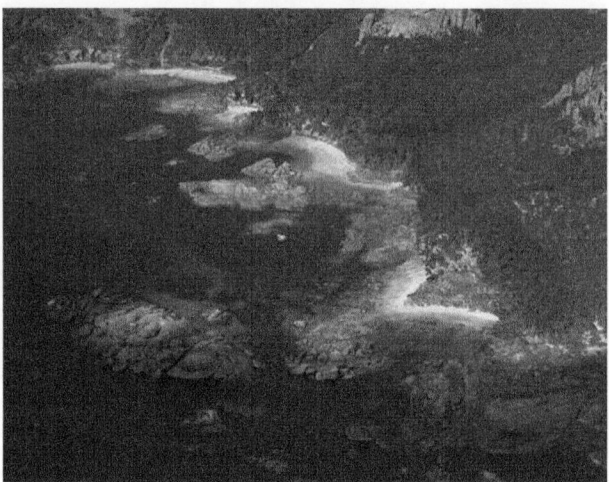

Figure 4.311 The five small Dock beaches (FI 116-120).

Beach **FI 116** is a protruding northwest-facing sand foreland tied to a small bare granite islet with a larger islet immediately offshore. The sandy beach spreads either side of the small foreland, with a low grassy foredune between the two sides, and older densely vegetated transgressive dunes spreading over the slopes to the west. Rocks dominate the foreshore, with only a small patch of clear subtidal sand at the western end of the beach.

Beach **FI 117** lies 200 m to the west and is a curving, protruding 200 m long sandy beach, bordered by granite rocks, with an irregular islet tied to the centre of the beach and clear seabed in between, particularly on the eastern side of the islet. Seagrass grows to within 20 m of the shore. It is backed by a narrow grassy foredune, then vegetated transgressive dunes that trend east up the backing slopes.

Beach **FI 118** occupies the next small gap in the rocks 100 m to the east. It is a 60 m long pocket of sand,

bordered by granite points extending 50 m into the bay, with two small islets off the beach and seagrass to within 20 m of the shore. There is a small area of dune transgression draping the rear of the eastern point.

Beach **FI 119** occupies the eastern end of the embayment and is the only beach accessible by vehicle, with the two tracks descending to either end of the 100 m long beach, the main track through a narrow valley. It faces west out of the embayment, however granite rocks to either side provide only a 20 m wide gap for waves to reach the shore, resulting in a low energy reflective beach with seagrass growing to the shore. The beach is backed by a veneer of dune sand over the base of the backing slopes.

Beach **FI 120** lies 50 m to the north and occupies the remainder of the end of the bay. It is a curving 80 m long reflective beach with seagrass 10 m offshore. It is bordered by low granite points and backed by a scarped dune that has climbed 30 m up the backing slopes. A narrow coastal reserve backs the eastern two beaches, with private land behind.

FI 121-125 GREEN ISLAND

No.	Beach	Rating HT LT	Type	Length
FI 121	Green Island (S3)	5 6	TBR+rocks	250 m
FI 122	Green Island (S2)	5 6	R+rocks/reef	300 m
FI 123	Green Island (S1)	4 5	R+rocks	400 m
FI 124	Green Island (N1)	4 5	R+rocks	300 m
FI 125	Green Island (N2)	3 4	R+rocks	40 m
Spring & neap tidal range = 1.9 & 1.6 m				

Green Island is a low 3 ha vegetation-capped granite islet, attached to the shore by rock reefs. It is located towards the northern end of an open 1.5 km long rocky embayment, with five rock-bound beaches occupying much of the eastern shoreline. A narrow coastal reserve runs along the shoreline, with densely vegetated slopes behind rising to over 100 m, and one access track to the centre of the bay.

Beach **FI 121** is a curving 250 m long sandy beach bordered by granite rocks and fronted by a 100 m wide bar, with a rip running out against the northern rocks during higher waves. It is backed by transgressive dunes, which have climbed 500 m up the backing slopes to an elevation of 40 m. There is some minor instability behind the beach, with the bulk of the dunes densely vegetated. Beach **FI 122** lies 100 m to the north and is a 300 m long strip of high tide sand fronted by continuous irregular granite rocks and reefs that extend up to 150 m offshore, with a sandy seabed beyond. During periods of high waves surf breaks over the sand, with a rock-strewn surf zone in between and a rip draining out against the northern rocks.

Beach **FI 123** is located in the centre of the embayment, with the solitary vehicle track descending to the southern end of the beach. The beach commences amongst granite

rocks and reefs and curves to the north, then northwest for 400 m terminating in lee of the sandy foreland behind Green Island (Fig. 4.312). It consists of a high tide sand beach fronted by continuous irregular granite rocks and reefs extending 100-200 m offshore, with a sandy channel towards the southern end, which is occupied by a rip during higher waves. It is backed by vegetated dunes that have climbed 300 m inland and 30 m up the backing slopes. Beach **FI 124** extends from the northern side of the foreland for 300 m to the northern rocks of the embayment. It is a continuous high tide sand beach, with granite rocks and reefs dominating most of the foreshore and extending out into a rocky bay floor. A sloping grassy foredune, then older well vegetated transgressive dunes blanket the backing slope to an elevation of 30 m.

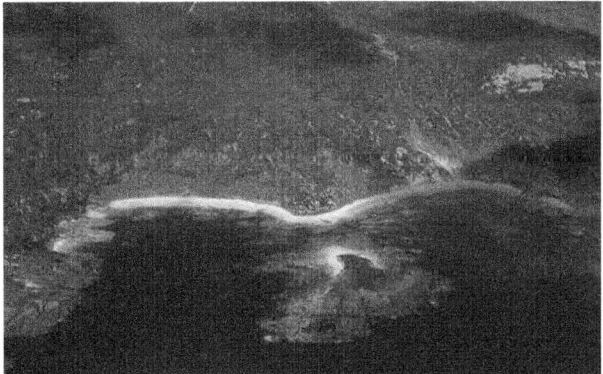

Figure 4.312 Green Island with beaches FI 123 & 124 to either side.

Beach **FI 125** is a 40 m long pocket of sand located in the northern boundary rocks that faces south towards Green Island. It is a sheltered low energy beach with rocks and seagrass extending to the shore.

FI 126-127 LIMESTONE BAY

No.	Beach	Rating HT LT	Type	Length
FI 126	Limestone Bay (1)	4 5	R+rocks	100 m
FI 127	Limestone Bay (2)	4 5	R+rocks	300 m
Spring & neap tidal range = 1.9 & 1.6 m				

Limestone Bay is on open 1.5 km long southwest-facing bay, bordered by a 500 m long point to the south and Gossys Reef, a series of islets and reefs which extend 700 m offshore to the north. The bay shore consists of granite slopes rising to over 100 m, with two beaches (FI 126 and 127) located in the southern corner. These are backed by Pleistocene dune calcarenite, the source of the limestone covered with Holocene dunes that rise to 110 m. There is vehicle access to the northern end of the bay, but none to the beaches.

Beach **FI 126** is a 100 m long reflective beach that faces north up the bay. It is sheltered in lee of a low 100 m long granite point, with several large rocks also off the beach, then a sand bar seaward of the rocks. Waves average about 1 m, with higher waves breaking over the bar and forming a rip against the western point. Beach **FI 127**

commences 50 m to the east and continues north for 300 m, with a 50 m wide band of scattered rocks fronting the entire beach, then a patchy sand bar beyond. Waves average over 1 m with higher waves breaking over the bar and across the rocks. Both beaches are backed by the steeply rising dunes, which extend 1 km inland to the 110 m high crest of the backing ridge.

FI 128-131 BLYTH BAY

No.	Beach	Rating HT LT		Type	Length
FI 128	Palana Beach	4	5	LTT/TBR	1.7 km
FI 129	Palana (E)	4	5	LTT+rocks	500 m
FI 130	Blyth Bay (E1)	4	4	R/LTT	500 m
FI 131	Blyth Bay (E2)	4	4	R/LTT	60 m
Spring & neap tidal range = 1.9 & 1.6 m					

Blyth Bay is a 3.5 km wide north-facing U-shaped bay located to the east of She Oak Point, with the small community of Palana located on the western slopes and southern base of the bay. Steep slopes rise to 150 m on the western side of the bay and partly shelter Palana from the prevailing westerly winds, while the eastern side is exposed to the strong winds and is blanketed in Pleistocene and Holocene transgressive dunes. Four beaches (FI 128-131) occupy the southern and eastern bay shore.

Palana Beach (FI 128) commences in the southern corner of the bay and curves to the northeast for 1.7 km to a subdued sandy foreland formed in lee of granite reefs extending 500 m offshore. The beach commences at the mouth of the small Edens Creek, which drains the backing valley, with the Palana Road terminating behind the western end of the beach and the few houses of Palana occupying the slopes above. The beach receives both refracted westerly wind waves and easterly swell which average over 1 m and maintain a low gradient beach and low tide terrace grading into rips during periods of high waves. The beach between the boundary rocks and creek mouth is backed by a well vegetated foredune and a small picnic area. East of the creek mouth begins a series of large active parabolic dunes, that extend up to 1 km inland and to 50 m in height (Fig. 4.313), with older vegetated transgressive dunes continuing 4 km inland and climbing the backing slopes to 160 m, the largest area of dune transgression on the island.

Beach **FI 129** continues on the eastern side of the foreland and trends northeast for 500 m to a small granite point. The entire beach is sheltered by scattered rocks, reefs and islets that extend up to 700 m offshore resulting in lower waves along the shore. These maintain a low gradient reflective to in places low tide terrace beach, which links to some of the reefs. It is backed by two active parabolic dunes and largely vegetated transgressive dunes, that link with the adjoining dune field.

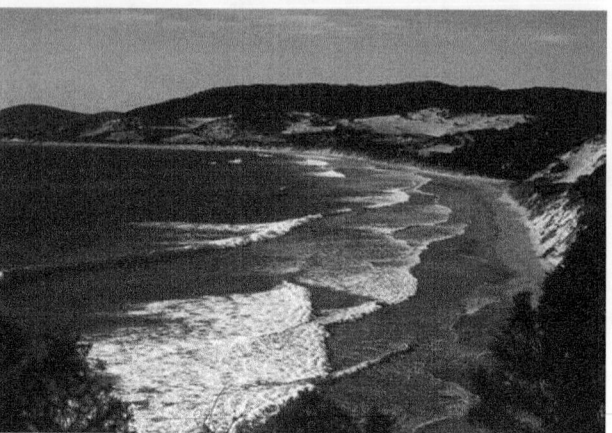

Figure 4.313 Palana Beach receives moderate swell and curves to face the strong westerly winds, where it is backed by three large parabolic dunes.

Beach **FI 130** commences on the eastern side of the 100 m wide boundary point and trends to the northeast for 500 m to a small calcarenite outcrop. It is sheltered by the extensive reefs to the east, as well as scattered reefs further offshore, with waves averaging 1m or less at the shore, where they maintain a low gradient reflective to low tide terrace beach. It is backed by vegetated dune calcarenite and transgressive dunes that trend east parallel to the rear of the beach. Beach **FI 131** lies immediately to the east and is a 60 m long pocket of sand, bordered and backed by 10 m high scarped dune calcarenite, with debris from the bluffs littering the rear of the beach. In addition granite rocks and reefs extend 100 m off each end of the beach resulting in low waves at the shore and usually reflective conditions.

FI 132-134 SLEEPY BEACH

No.	Beach	Rating HT LT		Type	Length
FI 132	Sleepy (W)	4	4	R	80 m
FI 133	Sleepy Beach	4	5	LTT/TBR	600 m
FI 134	Jacksons Cove	4	4	R	100 m
Spring & neap tidal range = 1.9 & 1.6 m					

Sleepy Beach is one of three beaches (FI 132-134) that are located 3 km southwest of Stanley Point and are the northernmost beaches on the west coast. They lie at the base of dune-draped slopes, which rise to 160 m, with a rough 4WD track descending the slopes to the beaches.

Beach **FI 132** lies in a small west-facing granite cove immediately west of Sleepy Beach. It is 80 m long and grades into rocks at each end, with a 50 m wide clear patch of sand in the centre. It is sheltered by the extensive reefs of Blyth Bay to the west with waves averaging less than 1 m and maintaining a reflective beach. The beach is backed by a small foredune, with steep slopes behind draped by older vegetated dunes.

Sleepy Beach (FI 133) commences 200 m to the east and is a curving northwest-facing sandy beach bordered by low granite points, with some rocks scattered along either end of the beach (Fig. 4.314). It is exposed to waves averaging 1 m which maintain a 50 m wide low tide bar which is cut by boundary rips during higher waves. A series of hummocky parabolic dunes extends 300 m up the backing slopes reaching an elevation of 40 m.

Jacksons Cove lies 100 m east of Sleepy Beach and consists of an 80 m wide granite-bound north-facing cove, with a 100 m long sandy beach **(FI 134)** curving around the southern base. The sheltered beach receives low refracted westerly and easterly waves, which maintain a reflective beach with seagrass growing 50 m offshore. The rough vehicle track reaches the rear of the beach.

Figure 4.314 Sleepy Beach (FI 133) foreground, with Jacksons Cove(FI 134) behind.

GLOSSARY

bar (sand bar) - an area of relatively shallow sand upon which waves break. It may be attached to or detached from the beach, and may be parallel (longshore bar) or perpendicular (transverse bar) to the beach.

barrier - a long term (1000s of years) shore-parallel accumulation of wave, tide and wind deposited sand, that includes the beach and backing sand dunes. It may be 100's to 1000's of metres wide and backed by a lagoon or estuary. The beach is the seaward boundary of all barriers.

beach - a wave deposited accumulation of sediment (sand, cobbles or boulders) lying between modal wave base and the upper limit of wave swash.

beach face - the seaward dipping portion of the beach over which the wave swash and backwash operate.

beach type - refers to the type of beach that occurs under wave dominated (6 types), tide-modified (3 types) and tide-dominated (3 types) beach systems. Each possesses a characteristic combination of hydrodynamic processes and morphological character, as discussed in chapter 2.

beach types
Wave-dominated (abbreviations, see Figures 2.6 & 2.7)
 R - reflective
 LTT - low tide terrace
 TBR - transverse bar and rip
 RBB - rhythmic bar and beach
 LBT - longshore bar and trough
 D - dissipative
Tide-modified (abbreviations, see Figure 2.16)
 R+LT – reflective + low tide terrace
 R+BR – R + low tide bar and rip
 UD – ultradissipative
Tide-dominated (abbreviations, see Figure 2.19)
 R+RSF – beach + ridged sand flats
 R+SF – beach + sand flats
 R+TSF –beach + tidal sand flats
 R+TMF – beach +tidal mud flat

beach hazards - elements of the beach environment that expose the public to danger or harm. Specifically: water depth, breaking waves, variable surf zone topography, and surf zone currents, particularly rip currents. Also include local hazards such as rocks, reefs and inlets.

beach hazard rating - the scaling of a beach according to the hazards associated with its beach type as well as any local hazards.

beachrock – see calcarenite

berm - the nearly horizontal portion of the beach, deposited by wave action, lying immediately landward of the beach face. The rear of the berm marks the limit of spring high tide wave action.

blowout - a section of dune that has been destabilised and is now moving inland. Caused by strong onshore winds breaching and deflating the dune.

calcarenite – cemented calcareous sand grains. May form in coastal sand dunes due to pedogenesis, the formation of calcrete soils, commonly called dune calcarenite or dunerock. In beaches it forms from precipitation of calcium carbonate in the intertidal zone and is known as beach calcarenite or beachrock.

cusp - a regular undulation in the high tide swash zone (upper beach face), usually occurring in series with spacing of 10 to 40 m. Produced during beach accretion by the interaction of swash and sub-harmonic edge waves.

dunerock – see calcarenite

foredune - the first sand dune behind the beach. In Queensland it is usually vegetated by spinifex grass and ipomoea, then casuarina thickets.

gutter - a deeper part of the surf zone, close and parallel to shore. It may also be a rip feeder channel.

hole - a localised, deeper part of the surf zone, usually close to shore. It may also be part of a rip channel.

Holocene - the geological time period (or epoch) beginning 10 000 years ago (at the end of the last Glacial or Ice Age period) and extending to the present.

lifeguard - in Australia this refers to a professional person charged with maintaining public safety on the beaches and surf area that they patrol.

lifesaver - an Australian term referring to an active volunteer member of Surf Life Saving Australia, who patrol the beach to maintain public safety in the surf.

megacusp - a longshore undulation in the shoreline and swash zone, with regular spacing between 100 and 500 m, which match the adjacent rips and bars. Produced by wave scouring in lee of rips (megacusp or rip embayment) and shoreline accretion in lee of bars (megacusp horn).

megacusp embayment - see megacusp

megacusp horn - see megacusp

megarip – large scale topographically-controlled rip. Usually requires waves greater than 2-3 m to form.

parabolic dune - a blowout that has extended beyond the foredune and has a U shape when viewed from above; **longwalled parabolic dunes**, have long trailing arms, from a few hundred metres to kilometers long.

overwash – wave swash washing up and over a beach crest; deposits overwash sands as a landward sloping flat.

Pleistocene - the earlier of the two geological epochs comprising the Quaternary Period. It began 2 million years ago and extends to the beginning of the Holocene Epoch, 10 000 years ago.

reef – a submerged or partly submerged object; in Western Australia usually formed of bedrock or calcarenite in the central-south, with coral reefs in the north.

reef flats – intertidal area of coral reef extending seaward of the shoreline.

rip channel - an elongate area of relatively deep water (1 to 3 m), running seaward, either directly or at an angle, and occupied by a rip current.

rip current - a relatively narrow, concentrated seaward return flow of water. It consists of three parts: the *rip feeder current* flowing inside the breakers, usually close to shore; the *rip neck*, where the feeder currents converge and flow seaward through the breakers in a narrow 'rip'; and the *rip head*, where the current widens and slows as a series of vortices seaward of the breakers.
see: megarip, topographic rip

rip embayment - see megacusp

rip feeder current - a current flowing along and close to shore, which converges with a feeder current arriving from the other direction, to form the basis of a rip current. The two currents converge in the rip (megacusp) embayment, then pulse seaward as a rip current.

rock flats – intertidal rocky area extending seaward of shoreline.

rock platform - a relatively horizontal area of rock, lying at the base of sea cliffs, usually lying above mean sea level and often awash at high tide and in storms. The platforms are commonly fronted by deep water (2 to 20 m)

rock pool - a wading or swimming pool constructed on a rock platform and containing sea water.

sea (waves) - ocean waves actively forming under the influence of wind. Usually relatively short, steep and variable in shape.

set-up - rise in the water level at the beach face resulting from low frequency accumulations of water in the inner surf zone. Seaward return flow results in a *set-down*. Frequency ranges from 30 to 200 seconds.

shore platform - as per rock platform.

swash - the broken part of a wave as it runs up the beach face or swash zone. The return flow is called *backwash*.

swell - ocean waves that have travelled outside the area of wave generation (sea). Compared to sea waves, they are lower, longer and more regular.

tidal pool - a naturally occurring hole, depression or channel in a shore platform, that may retain its water during low tide.

topographic rip – a rip current whose flow direction is controlled by a topographic feature (rocks, reef, headland, structure) located in the surf zone. The current is usually deflected seaward by the feature. Also known as headland rips.

transverse dune – a dune form perpendicular (i.e. transverse) to the dominant wind. Usually bare of vegetation; may reach 20-30 m in height, with a wave length of 100-200 m,

trough - an area of deeper water in the surf zone. May be parallel to shore or at an angle.

wave (ocean) - a regular undulation in the ocean surface produced by wind blowing over the surface. While being formed by the wind it is called a *sea* wave; once it leaves the area of formation or the wind stops blowing it is called a *swell* wave.

wave bore - the turbulent, broken part of a wave that advances shoreward across the surf zone. This is the part between the wave breaking and the wave swash and also that part caught by bodysurfers. Also called *whitewater*.

wave refraction - the process by which waves moving in shallow water at an angle to the seabed are changed. The part of the wave crest moving in shallower water moves more slowly than other parts moving in deeper water, causing the wave crest to bend toward the shallower seabed.

wave shoaling - the process by which waves moving into shallow water interact with the seabed causing the waves to refract, slow, shorten and increase in height.

REFERENCES AND ADDITIONAL READING:

Bierens, J M L (editor), 2006, Handbook on Drowning: Prevention, Rescue, Treatment. Springer, Berlin, 713 pp

Blair, L and Horan, C, 2003, Wave-Finder: Surf guide-Australia, Hedonist Surf Co., Norah Head, 317 pp. Great pocket guide to all Australian surfing spots.

Boreen, T, James, N, Wilson, C and Heggie, D, 1993, Surficial cool-water carbonate sediments on the Otway continental margin, southeastern Australia. *Marine Geology*, 112, 35-56.

Burrett, C F and Martin, E L (editors), 1989, Geology and Mineral Resources of Tasmania. Special Publication 15, Geological Society of Australia, 574pp.

Butt, & and Russell, P, 2002, Surf Science – an introduction to waves for surfing. University of Hawaii Press, Honolulu, 142 pp. An excellent introduction to the world of waves and surf.

Davies, J L, 1978, Beach sands and wave energy in Tasmania. In Davies, J L and Williams, M A J (editors), *Landform Evolution in Australasia*. Australian National University Press, Canberra, 158-167.

Easton, A K, 1970, *Tides of the Continent of Australia*. Report 57, Horace Lamb Centre, Flinders University, Adelaide, 326 pp.

Kirkpatrick, J B (editor), *Tasmanian Native Bush – A Management Handbook*. Tasmanian Environment Centre, Hobart, 352 pp.

Kirkpatrick, J B and Harris, S, 1999, Coastal, heath and wetland vegetation. In Reid, J S, Hill, R S, Brown, M J and Hovenden, M J (editors) *Vegetation of Tasmania*. University of Tasmania, Hobart, 304-332.

Laughlin, G, 1997, *The Users Guide to the Australian Coast*. Reed New Holland, Sydney, 213 pp. An excellent overview of the Australian coastal climate, winds, waves and weather.

Readers Digest, 1983, Guide to the Australian Coast. Readers Digest, Sydney, 479 pp. Aerial photographs and information on the more popular spots along the Australian coast.

Ross, J (editor), 1995, *Fish Australia*. Viking, Melbourne, 498 pp. Coverage of all Tasmanian coastal fishing spots.

Short, A D, 1993, *Beaches of the New South Wales Coast*. Sydney University Press, Sydney, 358 pp. The New South Wales version of this book.

Short, A D, 1996, *Beaches of the Victorian Coast and Port Phillip Bay*. Sydney University Press, Sydney, 298 pp. The Victorian version of this book.

Short, A D (editor), 1999, *Beach and Shoreface Morphodynamics*. John Wiley & Sons, Chichester, 379 pp. For those who are interested in the science of the surf.

Short, A D, 2000, *Beaches of the Queensland Coast: Cooktown to Coolangatta*. Sydney University Press, Sydney, 360 pp. The Queensland version of this book.

Short, A D, 2001, *Beaches of the South Australian Coast and Kangaroo Island*. Sydney University Press, Sydney 346 pp. The South Australian version of this book.

Short, A D, 2005, *Beaches of the Western Australian Coast: Eucla to Roebuck Bay*. Sydney University Press, Sydney 433 pp. The Western Australian version of this book.

Short, A D, 2006, *Beaches of the Northern Australian Coast: The Kimberley. Northern Territory and Cape York*. Sydney University Press, Sydney. The northern Australian version of this book.

Surf Life Saving Australia, 1991, *Surf Survival; The Complete Guide to Ocean Safety*. Surf Life Saving Australia, Sydney, 88 pp. An excellent guide for anyone using the surf zone for swimming or surfing.

Warren, M, 1998, *Mark Warren's Atlas of Australian Surfing*. Angus & Robertson, Sydney, 232 pp. Covers main Australian surfing spots.

Williamson, J A, Fenner, P J, Burnett, J W and Rifkin, J F, (eds), 1996, *Venomous and Poisonous Marine Animals - a Medical and Biological Handbook*, University of New South Wales Press, Sydney, 504 pp. The definitive book on marine animals.

Young, I R and Holland, G J, 1996, *Atlas of the Oceans, Wind and Wave Climate*. Elsevier, UK, 241 pp. Global coverage of ocean wind and wave climates.

BEACH INDEX

Note: Patrolled beaches in
BOLD

See also:
GENERAL INDEX page 341
SURF INDEX page 353

LOUISA BAY (4), 169
LOUISA BAY (5), 169
LOUISA BAY (6), 169
LOUISA BAY (7), 169
LOUISA CK, 169
LOUISA IS, 168
LOUISA PT, 168
LOUISA R, 168
LOUSY BAY, 168
LOVE BAY, 251
LOW BAY, 97
LOW HEAD (W), 291
LOW ROCKY PT (E), 187
LTTLE LAGOON BEACH, 147
LUFRA COVE, 110

MABEL COVE, 156
MABEL COVE (N), 156
MACQUARIE HEADS, 200
MADDONS COVE, 96
MAINWARING INLET, 190
MAINWARING INLET (N 1), 190
MAINWARING INLET (N 2), 190
MAITLAND BAY, 293
MARGARET ROCKS, 285
MARGARET ROCKS (S 1), 285
MARGARET ROCKS (S 2), 285
MARGARET ROCKS (S 3), 285
MARGERYS CORNER, 68
MARIA PT (E), 131
MARIA PT (N), 131
MARION BEACH, 108
MARIPOSA (S), 76
MARIPOSA BEACH, 76
MARIPOSA PT, 75
MARRAWAH, 227
MARS BLUFF, 152
MARSHALL BEACH (N), 321
MARSHALL BEACH (S), 321
MARY ANN BAY, 130
MARY ANN COVE, 261
MARY ANN COVE (N), 261
MARY ANN PT, 148
MATEYS GULCH, 68
MATTINGLEYS, 300
MAUROUARD BEACH, 72
MAVOURNEEN ROCKS (N), 178
MAVOURNEEN ROCKS (S), 178
MAWSON BAY (1), 225
MAWSON BAY (2), 225
MAXIES PT (N 1), 229
MAXIES PT (N 2), 229
MAXIES PT (N 3), 229
MAXIES PT (N 4), 229
MAXIES PT (N 5), 229
MAXIES PT (S 1), 229
MAXIES PT (S 2), 229
MAXIES PT (S 3), 228
MAYFIELD BAY (N 1), 93
MAYFIELD BAY (N 2), 93
MAYFIELD BEACH, 93
MAYFIELD PT, 94
MAYS BEACH, 126
MAYSONS BLUFF (S), 91
MCDOWALL RIVULET, 140
MCGUINNESS GUT, 206
MCGUINNESS GUT (N), 206
MCINTYRE BEACH, 76
MCKAYS GULCH, 173

MCKENZIES BEACH 1, 269
MCKENZIES BEACH 2, 269
MEERIM (N 1), 193
MEERIM (N 2), 193
MEERIM BEACH, 193
MEREDITH R MOUTH, 89
MERMAID BEACH, 299
MICKEYS BAY (N), 158
MICKEYS BAY (S), 158
MIDDLE BLUFF (S 1), 98
MIDDLE BLUFF (S 2), 98
MIDDLE BLUFF (S 3), 98
MIDDLE ROCK, 186
MIDDLE ROCK (E 1), 186
MIDDLE ROCK (E 2), 186
MIDDLE ROCK (E 3), 186
MIDDLETON, 140
MIDWAY BEACH, 274
MILES BEACH, 152
MILLERS BAY (N), 241
MILLERS BAY (S), 241
MINES CK (N), 322
MINES CK (S), 322
MITCHELLS BEACH, 130
MITCHELLS REEF (S 1), 95
MITCHELLS REEF (S 2), 95
MONK BAY (N), 119
MONK BAY (S), 119
MOORLAND BEACH, 284
MOORLAND PT (E), 284
MORTIMER BAY (N), 131
MOSQUITO PT (N), 252
MOSS GLEN, 147
MOSS GLEN (S), 147
MOTHER HAYLES BEACH, 151
MT CAMERON (N 1), 228
MT CAMERON (N 2), 228
MT CAMERON BEACH, 228
MUIR ROCK, 80
MUIRS, 88
MUIRS (W 1), 88
MUIRS (W 2), 88
MUIRS (W 3), 88
MULCAHY BAY, 185
MULCAHY BAY (S), 185
MULCAHY RIVER, 185
MURDOCHS (W 1), 305
MURDOCHS (W 2), 305
MURDOCHS BEACH, 305
MURPHYS BEACH, 299
MUSKS BEACH, 130
MUSSELROE PT (E), 61
MUSSELROE PT (S 1), 61
MUSSELROE PT (S 2), 61
MUSSELROE PT (W), 61

NARACOOPA (E), 236
NARACOOPA (W), 236
NATIVE WELL BAY, 212
NATIVE WELL BAY (S), 212
NEBRASKA BEACH, 163
NECK BEACH, 152
NELSON BAY, 220
NELSON BAY (N 1), 220
NELSON BAY (N 2), 221
NETHERBY BAY, 242
NETTLEY BAY, 226
NEW HARBOUR, 171
NEWMANS BEACH, 120

NIELSEN R (1), 196
NIELSEN R (2), 196
NIMBLE CK, 224
NIMBLE CK (N), 224
NINE MILE BEACH, 89, 235
NOLAND BAY (W), 295
NORMAN COVE, 177
NORTH PT (E 1), 255
NORTH PT (E 2), 255
NORTH PT (E 3), 255
NORTH PT (W 1), 255
NORTH PT (W 2), 255
NORTH SHORE, 254
NORTH TINPOT, 158
NORTHDOWN BEACH, 284
NOYHENER, 175
NUBEENA, 116
NUBEENA (N), 116
NUDIST BEACH, 289
NUTGROVE BEACH, 133
NYE BAY, 185

OAKLEY, 272
OCEAN BEACH (MID), 203
OCEAN BEACH (N 1), 203
OCEAN BEACH (N), 203
OCEAN BEACH (S), 202
OCEAN VISTA, 271
OKEHAMPTON BEACH, 98
OKINES BEACH, 125
OLD JETTY BEACH, 320
OLD MAN ROCKS, 69
OLD PIER BEACH, 299
OLD STATION BEACH, 115
ONE TREE PT (N), 151
ONION CK, 73
ONION CK (N), 73
ONION CK (S 1), 73
ONION CK (S 2), 73
ONION CK (S 3), 73
OPOSSUM BAY, 129
ORDNANCE PT (N), 216
ORDNANCE PT (S 1), 216
ORDNANCE PT (S 2), 215
ORDNANCE PT (S 3), 215
ORFORD BEACH, 100
OSMIRIDIUM BEACH (E), 166
OSMIRIDIUM BEACH (W), 166
OYSTER COVE, 138
OYSTER COVE (N), 138

PADDYS PT, 99
PALANA (E), 328
PALANA BEACH, 328
PARDOE BEACH, 283
PARDOE DOWNS (1), 283
PARDOE DOWNS (2), 283
PARDOE DOWNS (3), 283
PARKERS BEACH, 120
PARKINSONS PT (W), 120
PARRYS BAY (N 1), 316
PARRYS BAY (N 2), 316
PARSONS BAY (S), 116
PARSONS COVE, 86
PARSONS COVE (JETTY), 86
PARTRIDGE NARROWS, 157
PASS RIVER, 244
PASSAGE BEACH, 84
PATRIARCH INLET, 309

SASSY CK (S 2), 187
SAWYERS BAY (1), 317
SAWYERS BAY (2), 318
SAWYERS BAY (3), 318
SAWYERS BAY (4), 318
SAWYERS BAY (5), 318
SAWYERS BAY (6), 318
SAWYERS BAY (7), 318
SAWYERS BAY (8), 318
SCAMANDER (SLSC), 75
SCHOONER PT (N 1), 179
SCHOONER PT (N 2), 179
SCHOONER PT (S), 179
SCHOUTEN HOUSE BEACH, 91
SEA DEVIL RUVULET (N), 212
SEA DEVIL RUVULET (S), 212
SEABROOK (E 1), 269
SEABROOK (E 2), 269
SEABROOK (W), 268
SEABROOK BEACH, 268
SEABROOK CK, 269
SEAFORD PT (W), 95
SEAL BAY (N), 240
SEAL BAY (S), 240
SEAL POINT, 239
SEMAPHORE HILL (E 1), 306
SEMAPHORE HILL (E 2), 306
SETTLEMENT, 319
SETTLEMENT BEACH, 318
SETTLEMENT PT (N 1), 319
SETTLEMENT PT (N 2), 319
SETTLEMENT PT (N 3), 319
SETTLEMENT PT (N 4), 319
SETTLEMENT PT (S), 319
SEVEN MILE BEACH, 125
SEYMOUR BEACH, 78
SHE OAK PT (N), 290
SHELLY BEACH, 120, 130
SHELLY BEACH (1), 100
SHELLY BEACH (2), 100
SHELLY PT, 74
SHELLY PT (S 1), 93
SHELLY PT (S 2), 93
SHOAL BAY, 104
SHOAL INLET (E), 249
SHORT BEACH, 133
SILAS BEACH, 311
SINGLE TREE PLAIN (N), 297
SINGLE TREE PLAIN (S), 297
SISTERS BAY, 144
SISTERS BEACH (1), 264, 265
SISTERS BEACH (2), 265
SISTERS BEACH (3), 265
SISTERS BEACH (4), 265
SKELETON BAY, 71
SKIPWORTHS CREEK, 237
SLACKS PT, 143
SLEEPY (W), 328
SLEEPY BEACH, 329
SLOOP LAGOON, 69
SLOOP PT (N 1), 198
SLOOP PT (N 2), 198
SLOOP PT (N 3), 198
SLOPING MAIN, 117
SMITHS GULCH (W), 216
SMOOTHYS PT (S), 162
SMUGGLERS COVE, 128
SNAKE PT (W 1), 149
SNAKE PT (W 2), 149
SNUG BAY (S), 138

SNUG BEACH, 138
SOLDIERS ROCKS (S 1), 136
SOLDIERS ROCKS (S 2), 136
SOMERSET (SLSC), 270
SOMMERS BAY, 121
SOUTH ARM BEACH, 129
SOUTH ARM NECK, 130
SOUTH BURNIE BEACH, 272
SOUTH CAPE BAY (1), 165
SOUTH CAPE BAY (2), 165
SOUTH EAST BIGHT (N 1), 181
SOUTH EAST BIGHT (N 2), 181
SOUTH EAST BIGHT (S 1), 181
SOUTH EAST BIGHT (S 2), 181
SOUTH EAST BIGHT (S 3), 181
SOUTH EAST BIGHT (S 4), 181
SOUTH EAST CAPE RIVULET, 166
SOUTH EAST CORNER, 100
SOUTHPORT, 144
SOUTHPORT BLUFF (N 1), 146
SOUTHPORT BLUFF (N 2), 145
SOUTHPORT BLUFF (N 3), 145
SOUTHPORT BLUFF (S), 146
SOUTHPORT LAGOON, 146
SOUTHPORT LAGOON (S 1), 146
SOUTHPORT LAGOON (S 2), 146
SOUTHPORT NARROWS, 144
SPAIN BAY (1), 177
SPAIN BAY (2), 177
SPAIN BAY (3), 177
SPERO R (1), 191
SPERO R (2), 192
SPERO R (3), 192
SPERO R (4), 192
SPIKY (S), 92
SPIKY BEACH, 92
SPRING BEACH, 100
SPRINGLAWN, 287
SQUARE BAY, 96
ST ALBANS BAY, 298
STACKYS BIGHT (1), 326
STACKYS BIGHT (2), 326
STANLEY, 256
STAPLETON BEACH, 100
STAPLETON PT (S), 101
STEELS BEACH
 (SCAMANDER SLSC), 75
STEPHENS BAY, 176
STEPHENS BAY (N 1), 176
STEPHENS BAY (N 2), 176
STEPHENS BAY (N 3), 176
STEPHENS BAY (N 4), 176
STEWARTS BAY, 114
STINGRAY BAY, 206
STINKING BEACH, 157
STINKING BEACH (S), 157
STINKING COVE, 114
STOKES PT (E), 240
STONY HEAD (E), 294
STONY HEAD (W), 293
STORE PT (W), 311
STUDLAND BAY, 230
STUMPYS BAY, 62
STUMPYS ROCK (S), 62
SUICIDE PT, 68
SUICIDE PT (S), 68
SULPHUR CREEK, 274
SUNDOWN CK (N), 221
SUNDOWN PT (N 1), 221
SUNDOWN PT (N 2), 221

SUNDOWN PT (S 1), 221
SUNDOWN PT (S 2), 221
SUNSET BAY, 160
SURPRISE BAY, 166, 241
SURVEYORS BAY, 141
SURVEYORS COVE, 114
SUSAN BAY (E), 123
SUSAN BAY (W), 123
SVENOR PT (E), 184
SVENOR PT (N), 184
SWALLOW CK, 169
SWALLOW CK (E), 169
SWANSEA (boat ramp), 91
SWANSEA CARAVAN PARK, 90
SWANWICK, 89
SWIFTS PT (S 1), 159
SWIFTS PT (S 2), 159
SWIFTS PT (S 3), 159
SWIFTS PT (S 4), 159
SWIFTS PT (S 5), 159
SWIMCART (N), 69
SWIMCART BEACH, 70
SWIMMING BEACH, 309
SWIMMING BEACH (S), 309

TAM O'SHANTER BAY, 294
TAM O'SHANTER BAY (E 1), 294
TAM O'SHANTER BAY (E 2), 294
TAM O'SHANTER BAY (E 3), 294
TAROONA, 286
TAROONA BEACH, 134
TAROONA HS (S 1), 134
TAROONA HS (S 2), 134
TASMAN BAY, 108
TASMAN R, 205
TATLOWS BEACH, 256
TAYLORS (N), 68
TAYLORS BEACH, 69
TAYLORS REEF (1), 157
TAYLORS REEF (2), 157
TEA TREE PT (W), 276
TEBRAKUNNA BAY (1), 58
TEBRAKUNNA BAY (2), 58
TEBRAKUNNA BAY (3), 58
TEMMA HARBOUR, 218
TEMPLESTWOE BEACH, 78
TENNIS BALL ROCK (N), 63
TENNIS BALL ROCK (S), 63
THE BLUFF, 316
THE DOCK (1), 326
THE DOCK (2), 326
THE DOCK (3), 327
THE DOCK (4), 327
THE DOCK (5), 327
THE FISH POND, 277
THE FRIENDLY BEACHES (1), 82
THE FRIENDLY BEACHES (2), 82
THE FRIENDLY BEACHES (3), 82
THE GARDENS, 68
THE GUT (E), 263
THE GUT (W), 263
THE PORCHES, 79
THE SHANK, 189
THE SHANK (N 1), 190
THE SHANK (N 2), 190
THE SHANK (N 3), 190
THE WATER RAT, 284
THE WATER RAT (E), 284
THREE MILE, 227
THREE SISTERS 1, 276

GENERAL INDEX

A

aboriginal site
 Mt Cameron West, 227, 228
 Sundown Pt, 221
 West Point, 225
airport
 Devonport, 284
 Flinders Island, 316
anchorage
 Woolnorth, 248
Artillery Range
 Stony Head, 293

B

bar, 330
 'collapsing', 36
barrier, 330
Basin
 Kelly, 180
bay
 Adams, 162
 Adelaide, 311, 312
 Adventure, 152
 Ahrberg, 207
 Alginate, 99
 Anniversary, 263
 Anns, 248
 Anson, 65, 66
 Arthur, 316, 317
 Barretts, 141
 Basket, 115
 Bay of Fires, 65
 Bay of Islands, 153
 Bellettes, 121
 Betsys, 198
 Big, 254
 Birchs, 139
 Birthday, 195, 196
 Black Jack Bight, 117
 Blackman, 108, 122
 Blackmans, 135
 Blooming, 105
 Bluestone, 82
 Blyth, 328
 Bond, 180
 Boot, 102
 Breaknock, 122
 Brickmaker, 257
 Bull, 151
 Burns, 72
 Calm, 229
 Cannonball, 205
 Canoe, 111
 Carnarvon, 114
 Carrickfergus, 101
 Cascades, 120
 Cave, 262
 Chinamans, 104
 City of Melbourne, 237
 Claytons, 278
 Clearwater, 193
 Cloudy, 155
 Clydies Corner, 194

Cockle, 102
Cod, 63
Coffin, 179
Coles, 86, 87
Connellys, 123
Courland, 81
Crescent, 115
Crooked Billet, 116
Croppies, 301
Daniels, 159
Darlington, 106
Davisons, 231
Dawson, 216
Deadmans, 167
Deephole, 145
Denbys, 240
Disappointment, 234
Duck, 245, 254
Dunalley, 122
Eaglehawk, 120
Edwards, 199
Eggs and Bacon, 141
Elephant Bight, 104
Elliott, 186
Emerald, 101
Emu, 272
Encampment Cove, 104
Endeavour, 191
Esperance Narrows, 143
Fancy, 161
Fannys, 295
Faults, 175
Fitzmaurice, 241
Flinders, 121
Ford, 161
Fortescue, 111
Fossil, 105
Foster Inlet, 306
Fotheringate, 315
Frederick Henry, 118, 124, 125
Gales, 226
Garden Island, 141
Gardiners Cove, 108
Grassy, 238
Great, 161
Great Musselroe, 60
Great Oyster, 84, 85, 87
Great Taylors, 157, 158
Grindstone, 97
Gunter, 312
Gypsy, 123
Halfmoon, 129, 242, 256
Hardwicke, 208
Hastings, 144
Haulage, 154
Hazards, 217
Heather, 179
Hibbs, 193, 194
Hidden, 171, 172
Honeymoon, 87
Ingram, 217
Ironstone, 119
Island, 174
Isthmus, 160
Johnsons, 211
Kenneth, 214
Ketchem, 172
Killiecrankie, 325
Killora, 163
Koonya Inlet, 214

Ladies, 114
Lady, 143
Lagoon, 109, 290
Lighthouse, 156
Lillies, 318, 319
Lime, 118
Limestone, 327
Little Fancy, 161
Little Musselroe, 59, 60
Little Periwinkle, 139
Little Roaring, 142
Little Sandy, 133
Little Taylors, 158, 159
Lookout, 151
Louisa, 168, 169
Lousy, 168
Love, 251
Low, 97
Maclean, 78
Maitland, 293
Marion, 108
Marshall, 320, 321, 322
Mary Ann, 130
Mawson, 224, 225
Mayfield, 93
Mickeys, 158
Millers, 241
Missionary, 162
Monk, 119
Mortimer, 131
Mulcahy, 185
Native Well, 212, 214
Nelson, 220
Netherby, 242
Nettley, 226
New Harbour, 171
Noland, 295
Norfolk, 118, 120, 121, 122, 123
North, 109
North West, 136
Nye, 185
Opossum, 129
Parrys, 315, 316
Parsons, 116
Payne, 179, 180
Paynes, 178
Pebbly, 259
Pensioners, 140
Perch, 138
Periwinkle, 139
Perkins, 254
Petrification, 312
Phoques, 245
Pigsties, 147
Pilots, 290
Pine Log, 154
Pollys, 219
Porpoise Hole, 108
Port Arthur, 114
Port Esperance, 142
Pot, 128
Prices, 120
Promise, 85
Prosser, 98
Purdon, 63
Quarantine, 245
Quarries, 158
Ralphs, 128, 130, 131
Randalls, 141
Rat, 163

Broad, 64
Broadwater, 67
Bronzewing, 236
Brooks, 216
Bungaree, 245
Burdens Marsh, 117
Buttons, 277
Captain Cook, 153
Cartwright, 134
Chasm, 273
Chimney, 209
Cimitiere, 291
Clarence, 132
Claytons Rivulet, 278
Clements, 93
Cobler, 63
Cockerills, 159
Cockle, 148
Coffin, 179
Connellys, 123
Constance, 93
Cooee, 271
Cooper, 189
Cottons, 237
Counsel, 106
Cox, 171
Cray, 63
Crayfish, 258
Cripps, 116
Cronleys, 314
Crown, 239
Cuffys, 225
Curries, 293
Dale, 190
Dead Horse, 100
Deadmans, 167
Deep, 64
Denbys, 236
Denison Rivulet, 79
Denmans, 114
Doctors, 225
Dorloff, 153
Dove, 87
Drake, 187
Droone, 263
Duck, 121, 206, 207
Dune, 198
Dutchman, 171
Edens, 328
Eel, 245, 252
Eighty Mile, 97
Eldorado, 236
Evans, 193
Fergusons, 315
Fitchetts, 159
Flights, 139
Foam, 209
Folder, 134
Forrests, 236
Fotheringate, 315
Four Mile, 76, 106
Freshwater, 74, 287
Garden Island, 141
Garnetts, 119
Gathercoles, 114
George, 198
George Town Packet, 207
Glenbervie, 143
Goat Hill, 109
Goring, 171

Grassy, 238
Greene, 215
Griffiths, 195
Grimes, 236
Gumhill, 62
Hawkins, 157
Hays, 321
Heybridge, 274
Hoyle, 207
Hughes, 77
Hunters, 209
Imlays, 155
Indigo, 82
Jacks Lookout, 66
Joes, 313
Jones, 194
Kellatie, 179
Kelvedon, 92
Ketchem, 172
Killiecrankie, 326
Kubes, 142
Lagoon, 197
Lake, 301
Lasts, 140
Lawrence, 161
Lemons, 306
Lithograph, 167
Little, 250
Little Beach, 77
Little Eel, 218
Little Friars, 154
Louisa, 169
Marsh, 77
Masons, 139
McDowall Rivulet, 140
Miles, 152
Mines, 322
Missionary, 162
Modder, 195
Monster, 209
Moth, 171
Murgab, 175
Murphys, 160
New Falls, 171
Newdegate, 207
Nimble, 224
No Mans, 217
Nomeme, 185
Norfolk, 278
Norlin, 163
Old Man, 93
Onion, 73
Oxley, 192
Pardoe, 217
Parpeder, 192
Parsons, 116
Pegg, 190
Piccaninny, 77
Pine, 107
Porky, 243, 244
Port, 268
Possum, 217
Randalls, 141
Rankins, 236
Rat, 116
Rebecca, 219
Reddins, 312
Rock, 63
Rocky, 236
Rope Gully, 93

Saltwater, 77, 88, 91, 162, 235
Sandstone, 166
Sandy, 93
Sandy Bay Rivulet, 133
Sardine, 220
Sassy, 187
Scotsmans, 68
Sea Devil Rivulet, 212
Seabrook, 269
Seabyrne, 96
Seal Lagoon, 67
Selfs Rivulet, 143
Settlement, 144
Sheas, 99
Sheepwash, 155
Shell, 227
Simpsons, 160
Sisters, 265
Skipworths, 237
South East Cape Rivulet, 166
Stiffys, 163
Storynga, 84
Suckings, 116
Sundown, 221
Surprise, 207
Surprise Rivulet, 166
Swallow, 169
Swimcart, 69
Symes, 217
Templars, 219
Tiger, 222
Timms, 195
Tin, 76
Trepanner, 184
Tunnel Bay, 115
Two Mile, 100
Twoterer, 184
Tylers, 166
Violet Rivulet, 208
Wakefield, 205
Walpoles, 144
Wells, 225
Window Pane, 173
Windred, 288
Woodside, 224
Yacca, 66
Yarmouth, 74
Yarra, 237
currents
 ocean, 20
 tidal, 50

D

dune
 blowout, 330
 foredune, 330
 'glacial', 145, 146
 Henty, 202, 203
 parabolic, 330
 Peron, 72
 vegetation, 21
dunerock, 330

E

estuary
 Little Swanport, 95

Chatfield Pt (Precambrian metamorphic, 20 m), 175

Chevertons Pt (Permian sandstone, 20 m), 161

Chuckle Hd (Permian sandstone, 30 m), 161

Church Rock (Precambrian sandstone, 16 m), 223

Circular Hd (Tertiary basalt, 143 m), 256

Coal Bluff (Triassic sandstone, 110 m), 165

Coles Bay (Carboniferous granite, 20 m), 87

Conder Pt (Cambrian metamorphic, 44 m), 191

Conical Pt, 121

Cooee Pt (Precambrian metamorphic, 5 m), 271

Cordell Pt (Jurassic dolerite, 7 m), 290

Cowper Pt (sand, 11 m), 235

Cowrie Pt (Precambrian sandstone, 3 m), 258

Cox Bluff (Precambrian granodorite, 320 m), 171

Cray Pt (Triassic sandstone, 15 m), 141

Crayfish Pt (Permian sandstone, 5 m), 134

Croppies Pt (Jurassic dolerite, 15 m), 301, 302

Curtis Pt (Precambrian metamorphic, 20 m), 180

Cygnet Pt (Permian sandstone, 30 m), 141

Davisons Pt (Precambrian metasediments, 11 m), 231

Deadmans Pt (Jurassic dolerite, 50 m), 138

Deer Pt (Triassic sandstone, 10 m), 120

Dennes Pt (Triassic sandstone, 5 m), 163

Dial Pt (Tertiary sediments, 10 m), 275

Diorite Pt (Cambrian metasediments, 10 m), 189

Dixon Pt (Permian sandstone, 18 m), 131

Doctors Rocks (Carboniferous marine sediments, 20 m), 269

Dodgers Pt (Precambrian metasediments, 10 m), 230

Don Heads (Tertiary basalt, 50 m), 279

Dora Pt (Carboniferous granite, 10 m), 71

Dorman Pt (Jurassic dolerite, 19 m), 123

Dripstone Pt (Triassic sandstone, 30 m), 140

Droughty Pt (Jurassic dolerite, 30 m), 132

Dunbabin Pt (Jurassic dolerite, 15 m), 121

Dwarf Pt (Jurassic dolerite, 15 m), 92

Eagle Pt (sand, 5 m), 254

Eagles Pt (Precambrian metamorphics, 20 m), 180

East Cloudy Hd (Jurassic dolerite, 292 m), 155

East River Bluff (sand, 18 m), 310

East Sandy Pt (sand/Devonian greywacke, 30 m), 298

Eddystone Pt (sand/Carboniferous granite, 28 m), 64, 65

Egging Pt (sand, 4 m), 250, 252

Eli Pt (Triassic sandstone, 30 m, 120

Eliza Pt (Jurassic dolerite, 20m), 146

Eric Pt (Carboniferous granite, 56 m), 171

Esperance Pt (Jurassic dolerite, 84 m), 142

Eva Pt (Precambrain sand/mudstone,10 m), 217

Fancy Pt (Permian sandstone, 10 m), 161

Farewell Pt (Precambrian granite, 20 m), 246

Fish Pt (Jurassic dolerite, 10 m), 96

Fisher Pt (Jurassic dolerite, 10 m), 147

Fishers Pt (Jurassic dolerite, 10 m), 148, 149

Fitzroy Pt (Precambrian metamorphic, 10 m), 179

Five Mile Bluff (Tertiary basalt, 10 m), 292

Flensers Pt (Jurassic dolerite, 30 m), 98

Fleurieu Pt (Carboniferous granite, 8 m), 85

Fleurtys Pt (Jurassic dolerite, 20 m), 139

Flowerpot Pt (Permian sandstone, 30 m), 135

Flowerpot Pt (Triassic sandstone, 15 m), 140

Fluted Cape (Jurassic dolerite, 272 m), 153

Flying Cloud Pt (Precambrian metamorphic, 77 m), 173, 174

Forbes Pt (Precambrain metamorphic, 20 m), 177

Fossil Bluff (Tertiary marine sediments, 50 m), 267

Four Mile Bluff (Tertiary basalt, 10 m), 292

Fraser Bluff (Cambrian greywacke, 50 m), 236

Freestone Pt (Triassic metasediments,20 m), 99

Friend Pt (Tertiary sediments, 5 m), 289

Fryingpan Pt (Jurassic dolerite, 10 m), 114

Fulham Pt (Jurassic dolerite, 50 m), 122

Gaffney Pt (Precambrian sandstone, 5 m), 218

Gagens Pt (Jurassic dolerite, 15 m), 148

Garden Pt (Jurassic dolerite, 30 m), 114

Garden Pt (Precambrian metamorphics, 10 m), 180

Gardiner Pt (Precambrian sandstone, 10 m), 222

Gellibrand Pt (Jurassic dolerite, 20 m), 130

George Pt (Precambrain metamorphic, 32 m), 197, 198

Glenila Pt (Triassic sandstone, 30 m), 120

Goat Bluff (Permian sandstone, 30 m), 128

Goodstone Pt (Jurassic dolerite, 5 m), 105

Granite Pt (Carboniferous granodorite, 10 m), 299

Grass Pt (Jurassic dolerite, 274 m), 152

Grass Pt (Jurassic dolerite, 50 m), 153

Green Hd (Triassic sandstone, 10 m), 118

Green Point, 227

Greene Pt (Precambrian sand/mudstone, 8 m), 215

Greys Bluff (Jurassic dolerite, 100 m), 154

Griffiths Pt (Tertiary, 8 m), 287, 288

Grindstone Point (Jurassic dolerite, 74 m), 97

Grundys Pt (Jurassic dolerite, 10 m), 159

Guyton Pt (Tertiary basalt, 8 m), 252

Halfway Bluff (Triassic sandstone, 15 m, 120

Hannant Pt (Precambrain metamorphic, 40 m), 177

Havelock Bluff (Precambrian metamorphic, 434 m), 168

Hellfire Bluff (Jurassic dolerite, 375 m), 107

Helliwells Pt (Jurassic dolerite, 10 m), 139

Henderson Pt (Carboniferous granite, 20 m), 75

Hepburn Pt (Carboniferous granite, 14 m), 88

Hibbs Pt (Jurassic dolerite, 35 m), 193

High Rocky Pt (Cambrian metamorphic, 79 m), 190

Highfield Pt (Tertiary basalt, 40 m), 256

Hippo Pt (Tertiary basalt, 36 m), 231

Holloway Pt (Carboniferous granite, 13 m), 308

Holts Pt (Carboniferous granite, 15 m), 314

Honeymoon Pt (Carboniferous granodorite, 5 m), 68

Hopwood Pt (Jurassic dolerite, 30 m), 156

Horrels (Triassic metasedimentary, 10m), 94

Howells Pt (Permian metasediments, 8 m), 106

Howrah Pt (Jurassic dolerite, 10 m), 132

Hughes pt (Carboniferous granite, 20 m), 77

Sloping, 118
Southport, 145
Spy, 285
St Helens, 73
Swainson, 177
Swan, 59
The Carbuncle, 285
The Coffee Pot, 181
Tomahawk, 304
Trefoil, 231
Trumpeters Islets, 181
Vansittart, 311
Walker, 249, 250, 251
Wallaby, 250
Waterhouse, 302
Wedge, 116
Wendar, 175
West Pyramid, 181
Wright, 284
islet
Flat, 309
Harbour, 248
Murkay, 248
Shell, 248
The Doughboys, 231
isthmus
McRaes, 104

J

jetty, 58, 143
Big Possum Beach, 114
Bramble Cove, 178
Burnie, 272
Coles Bay, 87
Currie, 243
Darlington Bay, 106
Doo Town, 110
Dover, 143
Elliott Beach, 145
Grassy Harbour, 238
Jetty Beach, 163
Kelso, 290
Lady Barron, 311
Lighthouse Jetty Beach, 157
Naracoopa, 236
Nubeena, 116
Old Pier (Bridport), 299
Opossum Bay, 129
Pearl Point, 148
Penguin, 275
Port Sorell, 287
Sadgrove Pt, 161
Settlement Beach, 318
South Arm, 129
Southport, 144
Swansea, 90
Tramway Pt, 114
Whitemark, 315

L

lagoon
Attrills, 241
Bains, 161
Big, 68, 152
Blackswan, 147
Calverts, 128
Cloudy Bay, 155

Cockle Bay, 102
Crooked McGuiness, 104
Curves Lagoons, 321
Dianas Basin, 73
Earlham, 101
Fergusons, 308
Fortescue, 111
Freney, 171
Freshwater, 82
Garden, 67
Gibbs, 152, 160
Grants, 70
Great Swanport, 89
Guards, 104
Halfmoon, 310
Hays, 308
Henderson, 75
Hermitage, 97
Hibbs, 193
Hogans, 308
Jocks, 72
Kidney, 310
Lisdillon, 95
Little Basin, 73
Logan, 310
Lughrata Holes, 321
Miller, 171
Moriarty, 72
Moulting, 89
Muddy, 310
New, 308
New River, 167
North Chain, 310
Okehampton, 98
Old Mines, 79
Paradise, 183
Pearshape, 241
Pennys, 235
Pipe Clay, 127
Pitt Water, 125
Poppys, 218
Rebecca, 219
Rush, 116
Saltwater, 82
Sloop, 68
Sloping, 118
South Chain, 310
Southport, 145, 146
Swan, 109
Thompsons, 308
Top, 109
Tregaron, 306
Windmill, 72
Wrinklers, 75
lake
Big, 240
Big Waterhouse, 301
Blackmans, 301
Blue Lagoon, 212
Little Waterhouse, 301
Martha Lavinia, 235
landing ground
Copper Ck, 189
Walker Is, 250
lifeguard, 330
lifesaver, 330
lighthouse
Cape Tourville, 82
Cape Wickham, 246
Eddystone Pt, 61, 64

Highfield Pt, 256
Iron Pot, 128
She Oak Pt, 290
location
Adventure Bay, 153
Arthur River, 222
Bally Park, 124
Beaumaris, 74
Beechford, 293
Bellbuoy Beach, 292
Bellingham, 296
Bicheno, 79
Bindalong Bay, 70
Boat Harbour, 266
Bridport, 299
Bruny Island, 136
Burnie, 272
Camdale, 271
Carnarvon Bay, 114
Coles Bay, 87
Cooee, 271
Cooksville, 153
Couta Rocks, 219
Crayfish Creek, 258
Currie, 242, 243
Dennes Point, 163
Devonport, 279, 280, 282
Dodges Ferry, 124
Doo Town, 109
Earlham, 101
East Devonport, 283
East Pardoe Downs, 283
Edgecumbe Beach, 258
Emita, 320
Falmouth, 75
Flinders Island, 307
Fordington, 296
Granville Harbour, 205
Grassy, 238
Greens Beach, 289
Gwandalan, 117
Hawley Beach, 286
Hellyer, 259
Heybridge, 273
Howth, 273
Jacks Lookout, 66
Kadens Corner, 153
Kelso, 290
Killiecrankie, 325
King Island, 234
Kingston, 135
Lady Barron, 311
Lauderdale, 126
Leith, 278
Low Head, 290
Lulworth, 294
Lunawanna, 159
Maria Island, 98
Marrawah, 227
Melaleuca, 171
Naracoopa, 236
Ocean Vista, 271
Palana, 328
Park Beach, 124
Penguin, 274
Poole, 60
Port Arthur, 114
Port Latta, 258
Port Sorell, 285, 287
Primrose Sands, 123, 124

W

Y

SURF INDEX

Also see surfing locations by beach name in BEACH INDEX

BEACHES OF THE AUSTRALIAN COAST

Published by the Sydney University Press for the
Australian Beach Safety and Management Program
a joint project of

Coastal Studies Unit, University of Sydney and Surf Life Saving Australia

by

Andrew D Short

Coastal Studies Unit, University of Sydney

BEACHES OF THE NEW SOUTH WALES COAST
Publication: 1993 **ISBN:** 0-646-15055-3
358 pages, 167 original figures, including 18 photographs; glossary, general index, beach index, surf index.

BEACHES OF THE VICTORIAN COAST & PORT PHILLIP BAY
Publication: 1996 **ISBN:** 0-9586504-0-3
298 pages, 132 original figures, including 41 photographs; glossary, general index, beach index, surf index.

BEACHES OF THE QUEENSLAND COAST: COOKTOWN TO COOLANGATTA
Publication: 2000 **ISBN** 0-9586504-1-1
369 pages, 174 original figures, including 137 photographs, glossary, general index, beach index, surf index.

BEACHES OF THE SOUTH AUSTRALIAN COAST & KANGAROO ISLAND
Publication: 2001 **ISBN** 0-9586504-2-X
346 pages, 286 original figures, including 238 photographs, glossary, general index, beach index, surf index.

BEACHES OF THE WESTERN AUSTRALIAN COAST: EUCLA TO ROEBUCK BAY
Publication: 2005 **ISBN** 0-9586504-3-8
433 pages, 517 original figures, including 408 photographs, glossary, general index, beach index, surf index.

BEACHES OF THE TASMANIAN COAST AND ISLANDS
Publication: 2006 **ISBN** 1-920898-12-3
353 pages, 367 original figures, including 314 photographs, glossary, general index, beach index, surf index.

Order online from **Sydney University Press** at

http://www.sup.usyd.edu.au/marine

Forthcoming titles:

BEACHES OF NORTHERN AUSTRALIA: THE KIMBERLEY, NORTHERN TERRITORY AND CAPE YORK (publication 2006) 1-920898-16-6

BEACHES OF THE NEW SOUTH WALES COAST (2nd edition, 2007) 1-920898-15-8

SYDNEY UNIVERSITY PRESS